P O P

POP

THE GENIUS OF

Andy Warhol

TONY SCHERMAN
and DAVID DALTON

HARPER

An Imprint of HarperCollins*Publishers*
www.harpercollins.com

HarperCollins books may be purchased for educational, business, or sales promotional use. For information, please write: Special Markets Department, HarperCollins Publishers, 10 East 53rd Street, New York, NY 10022.

Excerpt from "Statement" reprinted with permission of Claes Oldenburg.

Portions of the first three chapters of this book appeared in altered form in the February/March 2001 issue of *American Heritage*.

FIRST EDITION

Designed by Eric Butler
Photo Editor: Julia Moore

Library of Congress Cataloging-in-Publication Data is available upon request.

ISBN: 978-0-06-621243-2

09 10 11 12 13 OV/RRD 10 9 8 7 6 5 4 3 2 1

FOR LOUISIANA, EVANGELINE, AND COLLEEN
— T.S.

FOR MY SISTER, SARAH DALTON LEGON
— D.D.

CONTENTS

PROLOGUE

August 30, 1960. On this cool, clear, late-summer night, Paul Warhola parked a one-ton GM rental van outside 242 Lexington Avenue, the four-story walk-up where his mother and youngest brother had lived since 1953. Laughter spilled out from Shirley's Pin Up Bar, the club on the ground floor; otherwise, the street was quiet. Paul had chosen the late hour in order to get a parking space—during the day, the corner of 35th and Lexington was too busy.

With his two helpers, seventeen-year-old Paul Jr. and Billy Little, a Pittsburgh friend, Paul was here to move his brother Andy's possessions into the townhouse Andy had just bought: 1342 Lexington Avenue, a pale blue four-story building next door to the New York Fertility Clinic and two doors up from the corner of East 89th Street.

"The town house bought by shoe ads," Andy's friend Emile de Antonio called it, and it was true: everything Andy owned was paid for with a ceaseless flow of hundred-dollar drawings of shoes, hats,

scarves, perfumes, handbags, and other ladies' accessories. He was one of the most successful commercial artists in New York, a minor celebrity. Even gallery artists knew his work, especially those ads for I. Miller shoes; until earlier this year, when Miller & Sons had terminated its arrangement with Warhol, illustrators and art students had looked forward to Andy's weekly appearances in the Sunday *New York Times*. In 1960, Andy would gross $70,000, his best year yet, and when 1342 Lexington had come up for sale he was easily able to put down $30,000, almost half of the building's price.

Andy was working upstairs and Julia, their elderly mother, was asleep as Paul and the boys began loading the van. Into the back went Andy's hoard of what de Antonio had once called "art director bric-a-brac": three chic turn-of-the-century carousel horses, the sort often seen in *House & Garden* and *House Beautiful*; two full-sized mannequins and a Fowler Brothers phrenological head; a Chinese foo lion, bought in Kyoto four years earlier (Andy's friend Charles Lisanby owned its twin and wanted both, but Andy wouldn't give it to him); nineteenth-century advertising tins and a penny arcade machine that squirted perfume; a six-foot Punch, grinning malevolently above its Pierrot collar; Hokusai prints; a handful of weathervanes; an embroidered peacock screen; and several sets of bentwood furniture (the current Americana craze showed no signs of abating).

Next came Andy's fledgling art collection. Lithographs by Toulouse-Lautrec and Jasper Johns; a Klee reproduction; paintings by Tchelitchew, Matta, and Paul Cadmus; drawings by Larry Rivers and David Stone Martin; a collage by Ray Johnson, a strange, antic man Andy had met at New Directions Press, for whom both illustrated book jackets; and two canvases by Jane Wilson, a portrait of Andy and a double portrait of his friend Ted Carey and Carey's lover John Mann.

It was 5:00 a.m. by the time Paul and his helpers carried the last boxes through the doorway at 1342, across the foyer's black-and-white parquet floor, up eight steps to the first floor, around the staircase's

massive, beveled newel post, and into the master bedroom. Andy had just bought a Federal four-poster mahogany bed, but Paul didn't have to worry about that; he'd be gone when it was delivered tomorrow.

Locking up after themselves, the three Pittsburghers piled into the van and drove off from 1342 Lexington—where, Andy Warhol hoped, he would achieve his longed-for transformation. From Andy the lowly commercial artist, the shoe illustrator, the maker of precious, arch drawings and hand-painted chapbooks filled with cute little cats, to art world luminary, lauded by critics, an intimate of Jasper Johns, Robert Rauschenberg, and the others whose work he studied on his Saturday-afternoon rounds of the galleries. At 1342 he would swap his old self for a new one: Andy Warhol, Fine Artist.

There was in truth no specific moment when Andy Warhol ducked into a phone booth, peeled off his Clark Kent suit, and rocketed into the sky, superstar of the art world, darling of society, and enigma to critics. To portray his transition from commercial to Pop as a sudden but basically inexplicable metamorphosis perpetuates a mystique the years have hardened. The new Andy and his new oeuvre marked the convergence of elements that had been brewing for years. Almost as soon as he'd arrived from Pittsburgh in 1949, he had zealously pursued his goal of becoming a fine artist, haunting the galleries as both patron and hopeful exhibitor, mounting show after show at second-rate venues but repeatedly being rejected by the ones he courted. Still, in comparison to most artists' rise to recognition, Warhol's was swift: from February 1961, when he made his first, tentative Pop paintings, to the final months of the year, when the soup cans appeared.

Such a dramatic rise could only have occurred at this moment. When the innovators of Pop—Oldenburg, Lichtenstein, Rosenquist, Warhol, and others—embarked on their mature work, much of which was uncannily similar and all of which explored the same terrain, American consumer culture, almost none of them knew what the

others were doing, or even that they existed. Pop arose spontaneously, an organic response to new realities. Tectonic shifts were rearranging the arts, the broader culture embracing them, and American society itself. The fifties and early sixties saw the birth of a new and restless consumerism: industry and technology boomed, turning out a broad array of consumer goods for the largest new generation in U.S. history. The countless new companies, vying to distinguish their products from their competitors', turned advertising into a $12 billion a year business by 1960. The mass media, television in particular, penetrated all corners of the nation and brought pop culture into almost every home. At the same time, the civil rights and burgeoning antiwar movements provided the new generation with a rallying point. A growing spirit of opposition and transgression and a search for freedom, spiritual as well as political, infected the whole population, but especially the young. The times were ripe for artistic innovators whose work embodied the era's obsessions: pop culture and rebellion. And nobody combined a fascination with consumer culture with the urge to transgress as completely as Andy Warhol.

In 1961, at thirty-three one of New York's most successful fashion illustrators, Warhol rebelled against the good taste of his advertising work and began filling his studio in 1342 Lexington with big, stark, intentionally banal paintings. He took his subjects from the lower reaches of pop culture: comic books, tabloid newspapers, and body-building ads. As clever as he was ambitious, Warhol knew that nothing would enrage the art world more than imagery originally created for the base amusement of lowbrows.

Another factor was at play. Alone among Pop's masters, Warhol, the son of poor eastern European immigrants, was thoroughly working class and wholeheartedly shared the twentieth-century American working class's ardor for the products of consumer culture. His colleagues had a more detached relationship to mass-produced goods, choosing them for aesthetic and intellectual reasons. Lichtenstein went Pop out of an

urgent search for a new look and the parodist's impulse that he shared with Oldenburg; Rosenquist was drawn to the abstract shapes of the huge commercial images he stared at up close in his day job as a billboard painter. Warhol's approach to pop culture was far from purely aesthetic: from childhood on, he loved its products and worshipped its heroes and heroines. His economic disadvantage proved his Pop advantage, giving his work an aura that other Pop works simply don't possess. Because he was equipped for it, he felt the consumer-media explosion of the early sixties more intensely than his colleagues, and he rode Pop's wave brilliantly.

Pop shocked the shockers, its merger of the cultivated and the base a rejection of the high-culture stance of even such a radical genre as its predecessor, Abstract Expressionism. "The initial impact of Pop art appeared to threaten the fortified towers of abstract art with a bombardment of visual and cultural pollution," observed art historian Robert Rosenblum. "[Warhol] was seen on the other side of an unbridgeable gulf that separated a faith in aesthetic purity from the vulgar reality of the life outside the studio door." Critically savaged as lightweight ("mindless" was the usual characterization), Pop was, in fact, knottily complex, its essence and nuances discernible only in retrospect. And unlike Abstract Expressionism, which had spent years underground before winning widespread recognition, Pop zoomed to preeminence, climaxing its rise in the last two months of 1962. "The new vulgarians," as one hostile writer dubbed its practitioners, took the art world by storm.

With the soup can as his inanimate alter ego, Andy became the standard-bearer for perhaps the most crucial event of twentieth-century culture: closing the "unbridgeable gulf" between high and low, refined and commercial. Not only did fine art welcome the vernacular resources that, to the consternation of many, increasingly animated it, but mass culture also became a legitimate object of serious inquiry. Truth and beauty are almost as readily sought today in Kanye West

lyrics as in Keats; intellectuals sift the rubble of mass culture not for gold but for various striking synthetics, alloys, and counterfeits.

Of course, in an important sense the wall between high and low held fast in the art world at least. Having finally arrived, Warhol resolutely remained a fine artist: resident of the tiny *haute bourgeois* world of galleries, museums, and unbelievably high price tags—in 2007, Warhol's 1963 painting *Green Car Crash (Green Burning Car)* sold for $71.7 million. If Warhol were to have truly obliterated the barrier between the refined and the vernacular, he would have sold his paintings in supermarkets, at supermarket prices, not painted supermarket products at Sotheby's prices. To flatten the highbrow-lowbrow wall, whose foundations are largely economic, was probably the last thing Andy wanted to do.

Nonetheless, Pop was a breath of fresh air, auguring the redefinitions, transgressions, and new starts the sixties would bring. True to his times, Warhol made paintings that weren't paintings, movies that didn't move (and were impounded as pornography), and wrote a novel that was neither written nor fiction but more than fifteen hours of taped conversations transcribed by half-literate teenagers and virtually unreadable. In a homophobic day, he made films with openly gay content. One of the inventors of the mixed-media rock-and-roll event, he sponsored his own band (itself hugely influential) and light show. And by silk-screening photographs and other source images, he proved, over a storm of modernist invective, that art need neither be handmade nor consist of original imagery.

Yet despite the breadth of his impact, and the wide-ranging debates that still swirl around him—as much about sociology as they are about art—what may prove to be Warhol's greatest achievement is more concrete than all that: namely, the startling and inexplicable beauty of the best of his breakthroughs, the early- to mid-sixties paintings. As the years pass (and it's been almost five decades since Pop trumpeted its arrival), the impact of other Pop works wanes, leaving the *Marilyns*,

Lizes, and *Flowers* standing alone in their stark, iconic beauty, while the Disaster paintings have lost none of their eerie, disturbing power.

This aspect of Warhol is often overlooked—understandably, given the ease with which his work and persona lend themselves to discussions that have nothing to do with art, not to mention the output of largely forgettable post-sixties work he produced. He reached across so many fields, lent himself to so many interpretations, and, for all his peculiarity, was so representative of his day that it's easy to bypass the irreducible beauty of *Flowers* to read the Warhol story entirely in broad and abstract terms. And yet as with other cultural icons, his individual fate entwined itself inextricably with that of his era. The mystery of Warhol is how his self-transformation not only transformed art but changed us so that we see the world through his own ironic, idiosyncratic lens.

POP

Beginnings

Andy was born as a real person; his adult nature was not that of
a real person. He was more like one of those mulberry caterpillars,
the silk caterpillar who spins a cocoon to enclose himself in, and
lives his life inside that cocoon, and spins silk webs.

—BILLY NAME

Andy Warhol famously said of himself, "I come from nowhere," a claim that makes his spectacular domination of the art world over the past fifty years seem only more mythical—a character without a past, who conjured himself out of his own head. This illusion suited Andy fine, since it meant he could avoid talking about a background that he was ashamed of. Whenever he was asked about his past, Andy would change the subject, turn it into a joke, or make things up.

Just how odd his background was can be seen in *Absolut Warhola*, Stanislaw Mucha's documentary about the Slovakian village of Miková, the birthplace of Warhol's parents. Miková resembles nothing so much as the Kazakhstani village in Sacha Baron Cohen's satire *Borat*. Watching *Absolut Warhola*, one can understand why Andy wanted to

put as much distance from his origins as possible; Miková is a warren of bigotry (the curator won't allow gypsies into the museum), provincial ignorance, dim-witted literalism, grinding poverty (even potatoes won't grow in the sterile soil), alcoholism, and, of course, homophobia. No homosexual, they claim, has ever come from Miková, and Andy was definitely not a "you-know-what."

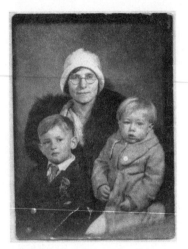

Julia Warhola with her sons Andrew (right) and John, 1932

Even when presented in the plainest of terms, his family history and nationality are complicated and obscure. Warhol has often been described as Czechoslovakian, but this is only an approximation, a way of saying that his family hailed from some murky Eastern European country. His origins are in the Carpathian mountains—the ancestral home of Dracula, a fact that at the Factory would lead to Andy's nickname, "Drella," a combination of Cinderella and Dracula, a fusion of types that aptly captured his sweet bemused nature as well as his cold, calculating, and occasionally cruel disposition.

Warhol's claim to be a man from nowhere is borne out by the shifting fortunes of his homeland. The 800,000 to 1.2 million Slavic people known as Carpatho-Rusyns, or simply Rusyns, have never had their own state; their homeland, the Carpathian Rus', lies within five nations: Slovakia, Poland, Hungary, the Czech Republic, and Serbia. From the sixth century to the fall of the Habsburg Empire, they were dominated by the nobility and landlords of Hungary, Poland, and Austro-Hungary, who kept them in poverty and subjugation. Politically, they are invisible: it wasn't until 2007 that Ukraine officially recognized Rusyns as a distinct ethnic group.

At the turn of the twentieth century, between one-quarter and one-third of Rusyns, driven out by their abject conditions, emigrated to the

United States, especially Pennsylvania, with its concentration of coal mining and industry. As a teenager Ondrej Warhola became part of the wave of immigration, leaving his village of Miková, in Slovakia's Presov region, some half-dozen years into the new century. As was common, he shuttled between America and his Rusyn home, bringing back money for his family. In 1909 he married his fellow Mikován, Julia Zavacky, although she didn't join him in the New World for a little over a decade, when they began raising a family of first-generation Americans in Pittsburgh: Paul, born in 1922, John, in 1925, and Andrew, on August 6, 1928.

Largely prevented until the collapse of the empire from bending their energy to politics, literature, or fine art—or from amassing wealth—Rusyns, like many an underclass, developed vital folk culture, rich with outstanding artistic talents in wood carving, *pysanky* (eggs dyed using a beeswax technique), and embroidery. Rusyn immigrants brought their skill and traditions to their new home in America. The men went to work in western Pennsylvania steel and wire mills, took what they learned there, and crafted jewelry from wire. To this day, western Pennsylvania's Rusyn community has many folk artists. Julia Warhola was an especially eloquent one. When Ondrej was unemployed or ill (he was in poor health from the late twenties on), she made flowers from tin. She was her youngest son's first art teacher, actively encouraging his lessons with one of Pittsburgh's best, Joseph Fitzpatrick, who would recall the boy as "magnificently talented." (Julia was, without doubt, a much greater influence on her youngest son than his father was; among Rusyn Americans this was not uncommon. As members of an oppressed minority under the various regimes they served, Rusyn men were especially liable to be drafted, particularly in such a politically unstable, war-torn part of the world. The mother was the backbone of the Rusyn household.)

Religion has always played an essential role in the lives of Rusyns, a complex people subscribing to a vision of the world not that remote from the Middle Ages. They arrived in America with their own way

of seeing things, a rich religious and folk culture that is at least partly responsible for Warhol's artistic sensibility. Their magnificent wooden churches, many dating to the seventeenth century, are decorated with brightly painted icons of the saints, Mary, and Christ encrusted in gold leaf. Rusyns are Orthodox Eastern Christians, practicing Greek Catholicism (known as Byzantine Catholicism in the United States), a hybrid of Eastern Orthodoxy and Roman Catholicism. Among Greek Catholics, icons—simple, stylized pictures of the venerated religious figures—played a basic role. It's hardly an exaggeration to say that the icons took the place of scripture in telling the Christian story to this largely illiterate population.

This was the atmosphere in which Andy Warhol grew up, attending St. John Chrysostom Byzantine Catholic Church in the neighborhood still known among old-timers as Ruska Dolina (loosely, "Rusyn Valley"), steeped in a culture whose veneration for its saints was expressed not primarily in words but in simple, striking, colorful images.

Ondrej Warhola supported a wife and three sons on his relatively meager wages as a construction worker, coal miner, and common laborer. When Andy was born, the family was living in a two-room slum apartment on Beelen Street, overlooking the Ohio River. Ondrej was a thrifty man, banking his earnings when he could; he had saved enough by 1934 to buy half of a two-family house on blue-collar Dawson Street in the Oakland section of town. The Warholas rented out the second floor, so all five of them slept in the attic. They were in better shape than some of their neighbors, but as Paul said, "Put it this way. Toys and amusement things were way down the line." Andy's boyhood friend, Nick Kish, owned a bike; Andy rode on the handlebars. There was no family car: "No way," said John. "That was a luxury." In his teens, Nick Kish drove a gang of boys, including Andy, to and from Schenley High. Everybody chipped in for gas except Andy, who always told Nick, "I'll get you at home," but never did.

Andy was high-strung and sickly, and the family tiptoed around him. The guarantor of his special status was Julia, who pampered him, nursed him through his various illnesses, and shielded him, when necessary, from his big brothers. Discussing Andy's childhood, Paul and John both used the word *spoiled*.

During his many bedridden episodes, Andy buried himself in his favorite reading matter, movie magazines, which tracked celebrities at least as obsessively as today's checkout-counter weeklies—"The Life of Marlene Dietrich," for instance, ran as a daily cartoon in Pittsburgh newspapers. Depression-era America, sorely in need of inexpensive means of escape, was movie-struck, Andy Warhol especially so. He begged his mother for a projector, with which he showed cartoons on the wall (the family couldn't afford a screen). Saturday mornings were spent at one of two neighborhood movie houses, where 11 cents not only got you in but bought you an eight-by-ten-inch glossy of the star. Andy kept a lovingly assembled leather-bound scrapbook that survives today. Its centerpiece is a photograph of his childhood idol, Shirley Temple, signed, "To Andy Warhola."

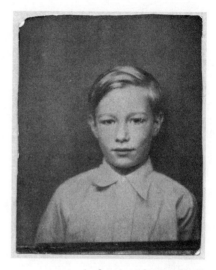

Andy, age eight, Pittsburgh

In late adolescence, Andy would sit for a friend's camera in the same pose Garbo had struck in her famous 1929 Edward Steichen portrait. To the rest of the world, the Andy of the photograph is the same potato-nosed, balding young man as always; to himself, he was Garbo, elusive, lovely, mysterious. Movie stars would be a lifelong fixation for Andy, one of whose most famous paintings, *Marilyn*, features

a movie goddess. For its source photograph, a grown-up Andy drew on one of his prize possessions, just as he did as an eight-year-old: a vast collection of Hollywood publicity shots.

In the fall of 1936, the same year he started his movie star scrapbook, Andy contracted rheumatic fever, then commonly afflicting children in crowded, unhygienic environments. The disease was sometimes accompanied, as it was in Andy's case, by Sydenham chorea, commonly known as Saint Vitus' Dance, a central nervous system disorder that induces uncontrollable twitching. It suited the adult Warhol, who knew perfectly well what he'd had, to call his chorea a "nervous breakdown" and to expand it to three episodes, at ages eight, nine, and ten.

His bouts of chorea (it did return, but only once) changed Andy's family status from spoiled youngest child to semi-invalid. The family considered it a nervous condition, not a physical ailment, and fretted that the least trauma would bring it back. From this point on, Andy got permanent kid-gloves treatment.

His next crisis, his skin problems, is largely assumed to have some-how resulted from his chorea. Yet both Paul and John recall that Andy's skin problems began not when he was eight but a good deal later, at the onset of adolescence, and the surviving photographs sup-port their memory. Two are especially striking. They appear to have been taken at the same time, between ages ten and twelve. The pro-nounced cheekbones and wide mouth, a slight, appealing play at its corners, prefigure the familiar older face. Otherwise, this handsome, plucky-looking boy bears little resemblance to the terribly homely young man Andy became. "Who's that good-looking blond kid?" John Warhola remembered other children asking about his brother. ("He had the prettiest smile," Andy's childhood friend Kiki Lanchester recalled.) Andy lost his looks at the worst possible time, the begin-ning of adolescence—in fact, it makes as much sense to surmise that puberty hit him extra hard, and with a few extra punches, as it does to attribute his altered looks to childhood diseases. In any case, he

would never know the pleasure of feeling attractive, whether to the Pittsburgh boys he must already have been getting crushes on or to the young men he would meet in college and in New York City. His skin not only erupted into what would be a lifelong case of acne, but was chronically vitiliginous—marked by the whitish patches that are plainly visible in photographs of Andy in his late teens (sometimes they look white, sometimes tan). That the cause of the blotches was unknown made things worse: his condition might deteriorate further, take an unexpected turn, or disappear; he couldn't know.

Gretchen Jacob Schmertz knew Andy in college. "His skin was gray-white, with an unhealthy sheen to it," she said. In college pictures one clearly notices a café au lait patch on his cheek. Though he seems to have had the patches removed in the early fifties with a dermatologist's help, Andy's skin would make him a special case for the rest of his life. He couldn't be exposed to the sun (people still often mislabel him "albino"). His college and fifties friend George Klauber summons up ludicrous images of Andy scuttling across the Provincetown dunes clutching a huge black umbrella against the sun. Measures like this made Andy even less of a participant in normal life. During the summer in the mid- and late fifties, friends of the young Manhattanites Ted and Gary Carey flocked to the Careys' family home outside Philadelphia, with its big swimming pool. Everybody splashed all day—except Andy, who sat under an umbrella in long pants, shirt buttoned to the wrists.

As hard to ignore as his mottled complexion was a nose that took on a life of its own, large beyond proportion and lumpy, broken-out, and raw. This was likely a case of what specialists call rosacea. In any case, it must have been hard not to stare at twenty-year-old Andy's nose. In a 1948 profile, his nose gives his entire face a relentless frontward thrust. "You have to understand," said Warhol's fifties friend and printer, Seymour Berlin, with kindly understatement, "Andy wasn't the handsomest-looking guy."

Surgical and cosmetic procedures from the fifties on helped, but the problem was never merely a matter of features. "God knows he was not a very attractive man," said art historian Kenneth Silver, "but he wasn't monumentally ugly. He wasn't a freak. But that's what he communicated. I'm going to venture that people saw him in terms of how he felt about himself. Ugly." Wounded in his essence, standing outside of the circle of human warmth and affection.

Of the physical problems that played such a large role in shaping Warhol's personality, one—whose impact may have been greater than any other—has never been publicly discussed. Evidently present since birth, the condition affected the appearance of Warhol's genitalia. "He had very prominent hemangiomas, or collections of blood vessels, chiefly on the scrotum," according to Denton Cox, Warhol's doctor for almost three decades. "They looked like little collections of rubies, lots of them." To Warhol, it was nothing less than a disfigurement, and he was ashamed, extremely self-conscious. "It put him into a disadvantageous emotional place in every relationship." As a result, he was "only comfortable when things were casual, and where he could be self-protective; where he could mostly watch, or participate in a way that didn't expose him."

In light of this condition one can understand that Warhol's well-known discomfort with sex, while certainly in part psychological, was also tied to a very specific physical problem.

In 1928 or 1929, Ondrej Warhola had his gallbladder removed. Paul felt that the operation wasn't entirely successful. "Dad just never recouped his strength, his ailments lingered." At some point in the late thirties, while he was working a construction job in West Virginia, Ondrej drank tainted water and contracted jaundice. "The other guys got sick, but they recovered," said Paul. "Dad's resistance was so low that he never got better. He died of TB peritonitis," in May 1942.

The Warholas weren't prepared for Andy's reaction to his father's death—rather, to his funeral. Following Greek Catholic practice,

Ondrej's corpse was laid out for three days in the Warholas' cramped living room. Not only could Andy not bring himself to view the coffin—when the body was first brought in, "he was so terrified that he ran and hid under his bed"—but he refused to stay in the house. Until Ondrej's body was removed, he stayed with relatives.

The episode may have had a lasting emotional effect. (John Mann, a friend from the fifties and early sixties, believes that Ondrej's evidently unsuccessful gallbladder surgery may explain why Andy put off for so long his own fateful gallbladder operation in 1987.) And what may have become part of the family mythology—that Ondrej went into the hospital a strong man and emerged chronically ill—may have contributed to a pronounced, abnormal trait in the grown-up Andy: a barely controllable fear of hospitals. A number of friends noticed that when nearing a hospital, Warhol habitually crossed the street in order to avoid walking directly past it.

As distant as Ondrej was emotionally (and often physically), he turned out to have made handsome provisions for his youngest child, whom he had come to see as the brightest and most promising of the three brothers. Quietly, Ondrej had put away enough money to pay for Andy's first two years of college, converting the money to postage bonds, out of grasping relatives' reach. Although less was expected of Andy in some ways, and he was certainly coddled, the family began to pin its hopes on him. And for decades after he left Pittsburgh, he fulfilled their hopes in small but useful ways—including sending Paul and John money every few weeks to help them raise their children.

At the start of his freshman year at the Carnegie Institute of Technology (now Carnegie-Mellon University), Andy was lost. "He could barely write a sentence," said classmate Gretchen Jacob Schmertz. Today, it could hardly be clearer that he was dyslexic. "The adult Andy Warhol became a prolific author and a memorable aphorist," writes Wayne Koestenbaum in his short, poetic biography, "[but] those suc-

cesses have obscured the fact that he could not write. . . . Warhol avoided ever writing anything down." He scribbled the occasional note to people whose opinion he wasn't worried about—a postcard, say, to his mother—"but almost every sentence in his hand is full of bizarre spelling errors." Looking through Andy's jottings, one quickly spots a telltale reversal of letters (as well as many examples of bad—no, atrocious—spelling: "blub" for "bulb," "scrpit" for "script," "herion" for "heroin," "Ned Romer" for "Ned Rorem," "Jerry Malagna" for "Gerry Malanga," "iliminate" for "eliminate," "Mongomerty" for "Montgomery," "polorrod" for "Polaroid," "spickets" for "spigots."

"His writing was at fifth- or sixth-grade level," said Schmertz. But something about him, a wistful, Chaplinesque air, made others want to help, and he was plainly anxious to succeed. Gretchen and Ellie Simon became the core of a group who resolved to get Andy through his freshman year. When it came time to write a paper, Gretchen and Ellie interviewed him and wrote up the result. Andy looked at it, made changes, and handed it in. It was a system not at all unlike that which, many years later, would produce *POPism: The Philosophy of Andy Warhol* and *The Andy Warhol Diaries*.

Andy's years at Carnegie Tech, 1945 to 1949, when he was surrounded by a group of articulate friends and acquaintances, provide the first rounded view of him. For Andy Warhola, freshman in the Department of Painting and Design and future painting major, creating himself meant, above all, negotiating the polarity between helplessness and control: of himself, of others. Quite intuitively, Andy was working out the implications of his childhood discovery that weakness can be a source of power. He was learning, for instance, to turn his extreme shyness (he could barely stammer out a remark in public) into a meticulous watchfulness. "He absorbed everything," said his classmate, the future hard-edged realism master Philip Pearlstein. "He didn't contribute much, he just listened."

Silence was also a way to manipulate people. "I learned when I was

little that whenever I got aggressive and tried to tell someone what to do, nothing happened—I just couldn't carry it off," Warhol wrote in *POPism*, with rare candor. "I learned that you actually have more power when you shut up because at least that way people will start to maybe doubt themselves." Warhola was building a two-tiered personality, learning how to manage others' perceptions of him.

This fledgling persona, the face he showed the world, was in part an attempt to find an expression for his homosexuality. He took to calling himself André, a way of taking a few tentative steps away from meat-and-potatoes masculinity. Roger Anliker, a first-year professor in 1948–1949 who shared studio space with Andy's senior class, remembered Andy's "delicate posture." Anliker made a gouache portrait of Andy, who holds his hands in a conspicuously studied, refined manner. "It looked like Wallis Warfield Simpson," said Anliker, who asked Andy to strike a more natural pose. The boy refused—when it came to poses, he chose his own.

For a self-portrait assignment, Warhola painted a woman. "Is that your sister?" a classmate asked. Andy answered that no, he'd always wanted to see what he looked like as a girl. He decided to take modern dance—according to the dance club's rules, "every woman registered at Carnegie Institute of Techology" was eligible for membership.

Andy very nearly didn't make it to his sophomore year. Despite his friends' efforts, he flunked the freshman humanities requirement, "Thought and Expression," which required a good deal of reading and writing. When it was his turn to address the class, Andy would freeze. "It was a painful experience for all of us," recalled classmate Bennard Perlman. He got a D in Drawing I, the most important freshman course (he had trouble with perspective), and, oddly enough for someone who would prove to be a genius as a colorist, he also did poorly in color class. At the end of his freshman year, he was suspended, "pending improvement in drawing." A professor found him cleaning out his locker in tears.

By repeating Drawing I in summer school, and pulling a respect-

able B, Andy won reinstatement. He also made a series of drawings while helping out on Paul's fruit-and-vegetable truck; when he submitted them in the fall, he was given a prestigious award for work done on one's own. It was a turning point. His teachers gave him another look; his eccentricities became gifts. "In his freshman year," observed his classmate Imilda Tuttle, "he painted the way he wanted and they flunked him. So he went to summer school and painted the way they wanted. In his senior year he went back to painting his own way and they called him a genius."

"He *was* a kind of genius," in Pearlstein's estimate. "That's why we all went out of our way to help him. His drawing was brilliant." He had, moreover, a superb eye for design. "He couldn't put a stamp on an envelope without a developed, individual sense of design," said Tuttle. "You could almost frame the envelope." Leonard Kessler, his classmate and future illustrating colleague, remembered assignments where he'd say to Andy, "'What do you think I should do with this?' He'd move something around; suddenly, it was right. I'd say, 'Wow! Why does that work so well?' He'd say, 'I don't know. That's the way it is.' He was the only person I've ever known who was a truly natural artist." Anliker used the same language: "He was a natural genius."

Andy was learning to trust his talent. Everything else might induce panic; working on his art, he was quick-witted and resourceful. "He had an absolute flair, and he knew it," said Carl Willers, a friend from a few years later. "If you knew him well, you knew that this was a real talent. And he was aware of it, as I think all good artists are. They're sure of their own abilities."

It was never quite clear whether Andy couldn't or wouldn't follow directions. Student work at Carnegie Tech was judged by committee, and Warhola's work routinely split his professors down the middle. Half of them wanted to give him an A, the other half a D—for the same piece. "He wasn't trying to be provocative—he just couldn't do it any other way," said Joseph Groell. Yet Andy had no trouble fol-

lowing the rules when something was at stake. "Andy did what he damn well pleased; he got approval by being impossible," said Anliker. He was learning the value of shock, working out what would be a lifelong role: provocateur. For a project on which a good deal of his grade depended, he made a series of drawings of classmates either picking their noses or sticking out their tongues. A group of self-portraits showed Andy "peeing in the corner, or maybe he was masturbating," Schmertz recalled.

In his final semester, Andy brought the nose picker back, an ink-and-tempera drawing of a boy violently jabbing his finger into his out-sized, lumpy nose. The force of the thrust distorts the boy's entire face. It's an aggressively ugly picture. But the title is equally alarming: *The Broad Gave Me My Face, But I Can Pick My Own Nose.* (Misogyny crops up in other college drawings, such as a *Constipated Women* (sic), splay-legged, her belly distended, perched atop a toilet.) Andy entered *The Broad* in an annual citywide exhibition, innocuously retitling it *Why Pick on Me,* where it created a small scandal. The horrified judges refused it (although one, the great caricaturist George Grosz, defended it). Andy's *refusé* status gave him a lot of notoriety, which he cashed in on at the end of the year: the only student to sell off the contents of his portfolio. He was a tough salesman. As Paul Warhola recalled, "Someone offered Andy seventy-five bucks for one painting. Andy wouldn't sell. He wanted ninety. I says, 'Andy, why can't you use common sense, as bad as we need the money?'"

Andy's college work, especially his drawings, leaps at the viewer with a liveliness, an earthy coarseness that sometimes approaches the grotesque. The influence of Daumier and Toulouse-Lautrec is evident (both were in the air, Daumier in the hoopla surrounding the July Revolution's 1948 centennial, Lautrec in a big 1946 Pittsburgh show). In the drawings from Andy's summer on Paul's produce truck, the neighborhood women, stooping over fruit-and-vegetable buckets, are sexy but lurid, overripe harpies, at once inviting and repulsive. Made

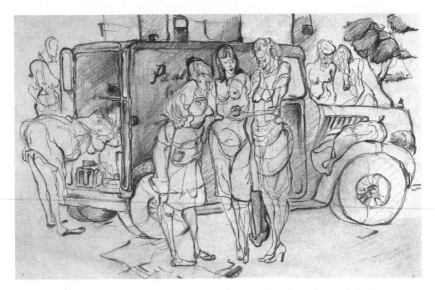

Andy Warhol, Women and Produce Truck, 1946. *Ink and graphite on Manila paper, 13" × 18 ¾". Collection of the Andy Warhol Museum, Pittsburgh.*

quickly, without lifting pencil off paper, these drawings leave a lasting impression, both for the skill with which the draftsman captures the bustle and sensuality of his neighborhood and for the alarm and disgust with which he regards its women and their bodies.

Andy had never been outside of Pittsburgh until he was twenty, when he, Pearlstein, and another Carnegie Tech student visited Manhattan. On Andy's next trip to New York, a week after graduating in June 1949, he came to stay. He and Pearlstein roomed together for eight months, first on the Lower East Side, then in a loft on West 21st Street. "In the beginning," according to Pearlstein, "he was very, very panicky about making money." By the time Pearlstein got married and moved out, in mid-1950, Andy's career was already describing a steep upward arc.

This didn't surprise Pearlstein. "His portfolio was dazzling. It was so much better than anyone else's." He went out of his way to please art directors. "He was a cottonball," recalled one, Peter Palazzo at I. Miller. "He did anything I asked him, anything. Whatever I told him to do,

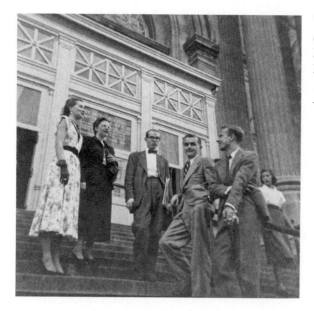

Warhol (center)
*on the steps of the
Metropolitan
Museum of Art,
1953*

he'd say, 'Oh, that'll be fun.'" He never fought with art directors, never tried to usurp their decisions. "He didn't care about that stuff—'Will my drawing be displayed big enough? Are you going to shrink it down?'" said Tina Fredericks, the art director who gave Warhol his first New York job, at *Glamour* (Andy later told Fredericks that he'd known nothing about its content, but was attracted by the magazine's name). He grasped concepts easily. "You could say to him, 'We want this,' and he'd just do it, he'd understand. He was always right on time, and he didn't have to do things over. All of that made him very useful."

He had definite limitations. "He was not a great draftsman," according to Warhol's contemporary and one of the most influential graphic designers of the mid-twentieth century, Milton Glaser. "In terms of what it means to draw beautifully, in terms of control, I don't think he was very notable." And yet Glaser considered Warhol "the perfect commercial artist."

"He had an enormous sense of style," noted Glaser, "and he could bring that burnished style to a product in a way that enhanced its value. That was a very substantial gift. When you gave him a shoe to draw, the shoe became more sophisticated. You got something extra." A favorite

ad business *aperçu* of the fifties was that "you don't sell the steak, you sell the sizzle." Andy delivered the sizzle. "He was really not related to the field of illustration. He was an outsider who came in and proved that you could be an eccentric personality, do an individual thing, and still be used successfully in commercial art."

Glaser's insight was echoed by Warhol's friend Joseph Groell. "Andy was the first person I knew who became a commercial artist on the terms that he considered fine art. He used to say, 'I can't draw a shoe that looks like a shoe.' Then he became successful drawing the kind of shoes he knew how to draw." A remark of Andy's confirms Groell's insight. Asked in 1956 to join Alfred Knopf, Pearl Buck, Tennessee Williams, Saul Steinberg, and others as one of that year's sponsors of *Mademoiselle*'s undergraduate "guest editors," Andy was interviewed for a short profile. "Every time I draw a shoe for a job," he claimed, "I do an illustration for myself." He very early saw through the long-established notion that commercial and fine art were qualitatively different, and that the former was inferior.

Warhol—he'd begun dropping the "a" as early as 1948, perhaps seeking a less ethnic-sounding name—used a special drawing technique he had devised at Carnegie Tech. His line was not solid, but a string of dots and dashes that gave a Warhol drawing a nervous, highly stylized look. According to a college classmate, Andy had hit upon the technique by accident one evening at a local restaurant, when he made an ink sketch and blotted it with a paper napkin. While it may originally have been an attempt to emulate some of Ben Shahn's effects, or those of another well-known illustrator, David Stone Martin, it quickly became Warhol's trademark. It's hardly an exaggeration to say that he owed his success to it.

"I was at one of the best agencies, which used a lot of Andy's drawings," said Vito Giallo, who was Warhol's first assistant for several months in 1954. "And all of the agency's artists would try to analyze Warhol's line, and nobody knew how he did it. Everybody guessed wax paper, but no one ever hit on it. When I went to work for him, I saw

him doing it and I said, 'My God, how simple!'"

The process took several steps. Making an initial pencil sketch, Warhol traced it by "rubbing it down"—putting the paper facedown onto another sheet and rubbing the back of the drawing. He hinged the tracing with masking tape to a piece of good Strathmore drawing paper. Then he went over the tracing with ink, a small bit at a time, folding it over the facing piece of Strathmore at every inking and pressing down. More pressure yielded a denser, "blottier" line; less, a finer one. After many inkings the image was fully transferred—voilà, a Warhol drawing, its stuttering line a perfect blend of accident and preparation.

Thus the final drawing was not, properly speaking, drawn; it was pressed. Warhol's pen nib never touched the Strathmore; the art was in the blotting. In fact, the original mattered so little to Warhol that he didn't even draw it—his longtime assistant Nathan Gluck made the first sketch, rubbed it down to make the tracing, and hinged the tracing to the Strathmore. Andy entered only for the coup de grâce, the inking and blotting. "That was his technique, his signature," said Gluck, who admitted to once or twice doing the whole job himself.

The tiny, cluttered studio at 242 Lexington Avenue was already a factory; Warhol was finding ways to be as much the spirit presiding over the work as the hand that made it. What remained constant throughout Warhol's career, whether he drew, painted, or silk-screened photographs, was his fascination with the simulacrum, the copy, the second-generation image. In commercial art, the division of labor is the norm. When Andy began using it in fine art in the sixties, he undermined the myth of the *auteur*, the sole and solitary fount of art.

Unlike most artists, he did not especially value the irreproducible mark of the artist's hand. The blotted line, a primitive type of printing—literally a "press"—was, when he'd devised it, a way for Andy Warhola, in his Carnegie Tech workspace, to give a drawing a published, or public look—a mode of wish fulfillment. The desire for fame was built into Warhol's very drawing technique. Critics often remark on Warhol's openness to chance, usually citing his highly casual sixties silk-

screening technique, which resulted in smears, blurs, and off-register images. But chance and contingency were inherent in the blotted-line drawings too, with their welcome irregularities, an instance of his lifelong strategy of being what he called "exactly wrong"; as *POPism* puts it, "When you do something exactly wrong, you always turn up something." To be "exactly wrong" was a clever way of getting attention by separating yourself from all the others who were doing things the "right" way. As art critic Dave Hickey writes, Andy "blot[ted] the image to create a splotched and splattered line of the very sort that young illustrators strive *not* to create when they are learning the pen. That line, which was *exactly* wrong, made him the most famous and sought after fashion illustrator in New York."

While he and Andy still roomed together, Pearlstein would come home from pasting up layouts in bathroom-fixture catalogs, work on his paintings, and go to bed. Andy worked on, often until daybreak. As Seymour Berlin recalled, "Anything Andy had to do with anybody was to get more work, more illustrations, more jobs. Every friend he had, every contact he made, was for what he could get out of it. I don't think he made friends for friendship's sake alone. Andy was the most opportunistic person I've ever known." His pitches were calculatedly off-center, the better to root himself in an art director's memory. He phoned Paul Rand, one of graphic design's most intimidating names, and to Rand's pro forma "How are you?" Andy answered in a tiny voice, "I'm okay but I have diarrhea." He knew just when and with whom shenanigans like these would work. Leonard Kessler heard him call an art director cold and tell her he was starving. Shocked, Kessler remarked that he would never say such a thing, even if it was true. Warhol shrugged; he'd just gotten a couple of assignments out of it.

As brazen as Andy could be, if he felt threatened he might retreat, literally. His first encounter with Henry Wolf, *Esquire*'s forceful art director, did not go smoothly. "I came up to shake his hand," said Wolf.

"Andy backed away from me, and kept backing away, right into a free-standing cork wall loaded with photographs. The whole thing came down on top of him."

He preferred the telephone to face-to-face encounters; with its built-in distance, it was made for him. Dialing one of his favorite art directors, Cipe Peneles, Andy would tentatively inflect, "I bought some bird seed yesterday? And I planted it in the park? Do you want to order a bird?" "That was part of Andy's magic," said art director Ruth Ansel, "He got people to disarm by appearing to be so unthreatening. But underneath it, he was manipulating them."

He would deliver coy innuendos to complete strangers—"I'm just sitting here playing with my yo-yo"—leaving interpretations up to them. He had mastered the art of presenting an ambiguous surface for others to grapple with, controlling interactions by throwing others off guard: aggressiveness disguised as wistful charm.

That could serve as a definition of Warhol's fifties persona, precursor to the oblique cool with which he helped shape sixties manners. In the fifties, the era of Holly Golightly (who didn't actually arrive until 1958), rebelliousness was sweetened into whimsicality.

"From the moment I met Andy," said the Englishman John Mann, who lived with Warhol's close friend Ted Carey, "he was this fey sort of butterfly person. He seemed to flutter." Stephen Bruce, another fifties friend and the co-owner of Andy's favorite hangout, recalled a piquant expression: " 'light in his loafers.' That's what they used to call someone like Andy. It meant very effete, very precious, very delicate, very . . . fey." Andy's feyness allowed him to suggest genuine emotions while deftly sidestepping them. Intimacy, for instance. Tom Lacy remembered getting into a Bonwit's elevator at the same time as his friend Andy. "We stepped in, we were alone, the doors closed. It was the first time either of us had ever heard Muzak. Without a word, we began to waltz. The doors opened, we stepped out, we went about our business."

His cute manner of delivery let him allude to his loneliness without

seeming pathetic. "He'd call me up sometimes," said art director Diana Klemin, "and say, 'Please talk to my cat, she's very lonely.'" He could be endearingly whimsical. "Andy always called me 'Miss Marigold,'" said Betty Lou Davis, "because he thought I should [marry gold]. Think about it. How could you not love someone who called you 'Miss Marigold'?" It was great for flattery: "Always these exclamations," said Klauber— "'Ohhh!'—as if you were so brilliant to have revealed something he'd never imagined." For someone in danger of disappearing into the background, fey helped get you noticed. The artist Edward Plunkett met Andy at an early-fifties party. "Andy got there late," Plunkett remembered, "and the first thing he said was, 'Oh, I was going to bring my butterfly on a string but I couldn't find him.' I thought, 'What a funny little fruity guy!'"

Who was the person behind the intensifying charade? In the early fifties, Andy still admitted visitors. "He'd have these phone conversations with art directors," said Groell. "And then he'd hang up and look at me and say, 'Wasn't that ridiculous? Why do I do that?' I guess I always took that as an expression of the fact that we knew each other in some way that transcended his posturing."

"The core, Andy hid," Seymour Berlin said. When he opened up, it was often to people like the unpretentious, utterly unglamorous Berlin, whom he felt no need to impress; as Berlin himself said, "With me he didn't have his guard up." Nor was there any sexual tension—Berlin was straight. For some months in the mid-fifties, Warhol joined Berlin, a dedicated weightlifter, three times a week at the McBurney YMCA on West 23rd Street. "He wanted to build up his chest, mainly," Berlin recalled, and no doubt to check out the boys, too. Berlin would come to 242 Lexington Ave., patiently hear out Julia's exhortations that he find "her Andy" a nice girl, and the two men would head across town to pump iron. Andy worked hard. "He became quite strong," Berlin said, "let me tell you. And when Andy was in the gym, he was very happy, and he would not stop talking. He'd tell me every story, starting with when he moved here.

"A lot of it was about parties he went to." Andy enjoyed shocking Berlin with tales of the homosexual demimonde. "At the time, I wasn't even sure what gay was, and here's Andy telling me all this stuff! He's telling me, 'So *Lenny* walked in with this beautiful, blond, blue-eyed guy. . . .' Leonard Bernstein! My wife refused to believe it! It was very, very interesting for me to be hearing about a completely different world." But when Andy talked about his relationships, Berlin could see that "he didn't like himself. I don't think he was ever capable of thinking highly of himself, no matter how high he went. He never talked about what he had, always what he didn't have."

His shyness could be crippling. The illustrator-designer Bob Gill invited Berlin and Warhol to talk to his class at the School of Visual Arts. "I talked about design for printers," Berlin said, "technical stuff, for maybe ten minutes, and then Andy got up to talk about illustration. He just stood there. Didn't say nothing. He couldn't. Then he sat down again. Andy really cannot speak to more than one or two persons; anything above that he gets a form of, I don't what to call it, stage fright."

The sixties culture hero whose Delphic response to interviewers' questions would have a terrific publicity payoff was the very same person as the intimidated soul who trembled to face a handful of art students. The photographer Duane Michals, who knew Warhol well in the fifties and early sixties, found it "surprising to see him cloaked in this air of mystery that people applied to him as if he was some sort of Zen philosopher and everything he said was a koan. He was always the same person, except that his vagueness became mystery. Before that, it was like he just didn't have it together. When he didn't have an answer for you, it's because he didn't know what to say. But then that became, 'Oh, he's so mysterious.' I thought, 'Boy, Andy, that's really good.'"

Until the mid-fifties, Warhol, though successful, was not especially well known in the commercial art world. He was an accessory artist, batting out economy-sized, and priced, drawings of handbags, shoes, gloves, perfumes, etc. He had far less prestige than top fashion artists

such as the recently deceased Christian Bérard, celebrities who painted full-page color illustrations of the latest couture, or a great cover illustrator like Norman Rockwell. "Warhol wasn't regarded as one of those top people," according to Tina Fredericks. "He was regarded as an accessory artist, and that's not very great."

The picture changed in April 1955, when Warhol was hired by the shoe manufacturer and retailer I. Miller & Sons, which wanted to upgrade and strengthen its image. The campaign, an early instance of today's "branding," aimed to create and reinforce a distinct corporate personality; its ads had to be "the freshest and newest thing in the newspapers," wrote I. Miller's art director, Peter Palazzo, in a trade journal in 1956. Only one artist would be used. Warhol was chosen (according to Palazzo, he was not the first choice) and given an annual retainer of $12,000—not the $25,000, $50,000, or even $100,000 that one sees cited. The campaign ran in Sunday papers and glossier fashion magazines; in New York, Warhol's exaggeratedly elongated shoes— stark, whimsical, and sexy at once—appeared like clockwork in the Sunday *New York Times*. Imaginatively art-directed by Palazzo (who to this day refuses to give Warhol more than slight credit), the ads were blown up to striking proportions: a half-page, sometimes a whole page, once or twice jumping to a two-page spread.

The I. Miller drawings made an impact both with consumers and within the industry. The fabric designer Leon Hecht, an advertising art major in the mid-fifties, "worshipped what Warhol did for I. Miller; he was one of the great names for me. I saved those ads, all of them, until they crumbled." In those days, according to Hecht, "there were star art directors, but not artists. Except for Andy." Palazzo even let Warhol (Julia, rather) sign his own drawings, a rare perk for a fashion artist of the time. Despite a lack of technical virtuosity—an inability, really, to provide a conventionally acceptable drawing—Warhol reshaped the commercial art world to his needs. He was not a great draftsman and his range as an illustrator was limited, but this very limitation was what drove him to invent new ways of depicting the products he was assigned.

Even noncommercial artists were hearing about Warhol. Shortly after arriving in New York in 1956, Claes Oldenburg, Andy's future Pop compatriot, was taken to a Greenwich Village party by some friends who told him that he was "going to meet Andy Warhol." Sure enough, Warhol arrived with a retinue.

Almost a half-century later, Peter Palazzo still fumes. "Those are my compositions. I would say to him, 'Put this over here, put that over there.' Or I'd cut his drawings all apart and make my own compositions. I could have gotten maybe two or three dozen artists to do the ads, we would have gotten I think the same acclaim."

He still didn't get it. He may indeed have done indispensable work, as Gluck had, and as others would. But Andy, who according to Palazzo "couldn't talk and couldn't think," could do something none of them could: take their contributions and, with a nudge so slight that it often seemed he did nothing, upgrade the result from competent to memorable.

As early as the winter of 1951, Andy had begun to feel his way into Manhattan's gay subculture. Given his secretiveness, little is known about his new relationships. One trace is the steady flow of postcards he began to write and receive. On two of them, mailed to Andy in January 1951 without signature or return address, the sender copied out dictionary definitions of *gay* and *daisy chain*. Andy addressed two cards to his friend Jo Slevin but didn't send them. One reads, simply, "*pense à moi*," the other, "tra la / good morning / good morning / i wonder where you've been / my heart is waiting."

Another unmailed message (one wonders how many cards Warhol actually posted), to Tommy Jackson, a friend who was attending Black Mountain College, shows a statuesque Rodin male nude. A card from Jackson to Warhol asks, in big letters, "WHO'S THAT FAGGOT YOU'RE LIVING WITH?" Another from Jackson suggests, "iffen yr out of smog town why not drop down & see us some time, esp. this summer . . . mt. air . . . & lotsa fellas what'll just love to see yas." When

Warhol drew an ad for a French laundry, captioned "I love zee men's shirts," he got back a card from a customer with the ad pasted to it, plus the words: ". . . and zee men in zee men's shirts!" His roommate at the time, Joseph Groell, began to notice lots of Fire Island postmarks, indications that Andy was leaving his college friends for a foreign world. They were newly nervous around him, thus creating their own barriers. "When I was living with him it was a little bit embarrassing to go out with him to the neighborhood bar," said Groell, "because I thought he appeared to be a homosexual." In an undemonstrative way, Pearlstein and Andy had been close, but no longer. "He needed somebody to talk to about all his problems," Pearlstein recalled, "and I didn't want to be that person. I didn't want to know about his adventures. He tried to talk to me a couple of times; I said, 'I'm really not interested.'"

"The fact that Andy was gay ruled his life," according to a friend who knew Warhol intimately during this period. "Andy only hung out with gay people. I don't think he had any friends who weren't gay." An exaggeration, this was nonetheless largely the case in the fifties—and more so in the sixties than is generally realized.

Thanks to the day's virulent homophobia, the fifties gay world had an inclusiveness that cut across professional lines, linking people whose one shared attribute was their homosexuality. "The wonderful thing about the fifties," said George Klauber, a New York native, "was the emergence of the feeling that you weren't isolated. For the first time, one had a sense of being affiliated with a group of sensitive and informed people, and to be proud rather than denying."

At the same time, gays' new visibility made them an especially attractive target. New York's postwar gay world had some of the characteristics of an underground freemasonry, a mutual aid society: a network. There were practical reasons for the network's existence: it was a tool to aid its members' survival. The members of the New York gay world, according to Billy Linich, later one of Andy Warhol's closest compadres, "knew that if it didn't cohere, everybody was going to be victimized." Even

in these pre-militant times, fifties homosexuals clearly saw their network's role as political—for Andy's friend Stephen Bruce, being able to advance another gay man's career "meant turning a trick on society." ·

Sex, the great leveler, may have granted the network a democratic aspect, but the subculture's emphasis on physical beauty created a hierarchy of looks. At the top were the beauties, gay-world celebrities; in between, most people; and languishing at the bottom, undesired, were the homely, Andy Warhol among them. (Apart from his other physical disadvantages, Andy had realized to his horror, as far back as his mid- to late teens, that he was starting to lose his hair, a condition that advanced rapidly. Quite noticeably balding by his early twenties and agonizing over it, he finally took a friend's advice and bought a wig.) In a world where beauty reigned, he was out of luck. "Nobody was interested in him," according to John Mann. "It's awful to say, because obviously he had desires, but Andy having sex is something that never occurred to us."

But it would be a mistake to focus exclusively on Warhol's embarrassments. He may have been a failure in the bedroom, but he was by no means a pariah. "Andy was very much in the middle of the scene, even though he wasn't participating physically," said Mann. "People enjoyed having him around, or didn't mind having him around. He was at more parties than not. When you think about Andy's personality, he just fit that fifties fairyland like a glove." The gay network was Warhol's world and he knew how to navigate it. He would eventually make it one of his escape routes from commercial art.

There were countless subterranean networks, their members' paths crisscrossing constantly. One would have an especially strong negative impact on Andy: the gay arts elite, a tightly knit community of writers, visual artists, and musicians. A sort of member manqué, the filmmaker Emile de Antonio, who was straight, wrote of this group: "I moved among the smirks, talents, shyness, wit and nastiness of the homintern like a spy . . ." To de Antonio and others, the "homintern" (a pun presumably

of W. H. Auden's coinage) was a collective of not inconsiderable power. "Not just a skimpy bunch of brave cavalry but . . . a nation, codifying laws of behavior and living as well as making. . . . They set standards, they controlled . . . aspects of sensibility," and steered each other into positions of influence. Kirstein, Bernstein, and Cage; Columbia professors Marius Bewley, Ben Weber; Philip Johnson, Virgil Thomson, Cecil Beaton, Parker Tyler, Auden, Isherwood, O'Hara, Ashbery. To the young Truman Capote's immense ennui, Andy worshipped him. Capote was, in fact, far too effeminate to be a member in very good standing of the discreetly closeted arts elite ("a walking transgression," the novelist Edmund White called him). Still, Truman's dismissive response set the tone for the arts elite's reaction to Andy and his overtures.

Andy nursed his wounds in a basement on East 58th Street. His professional and social lives intersected here, at Serendipity, a restaurant-boutique opened by three gay men in 1954. "Andy loved that place," said George Klauber. "To him it had real class." Serendipity eventually became what it is today, a destination for Upper East Side and suburban yentas, but in the fifties it was a gay outpost that drew more than its share of names: Capote, Beaton, Tennessee Williams. It was Warhol's headquarters; in 1957 he dropped $1,900.95 there.

"He came in constantly," recalled Stephen Bruce, the only surviving Serendipity "boy" (everyone called the three owners "the boys"). "After he'd made the rounds of the magazines and agencies." With his ad world fame and his deep pockets, Warhol was a desirable escort.

Despite the odds, Andy managed to have at least a few sexual relationships during the fifties. Earlier in the decade, only one, an interlude with a librarian named Carl Willers, is more than a matter of conjecture. But in 1956, Edward Wallowitch entered the picture. A talented twenty-three-year-old photographer, Wallowitch came to New York in December 1955 to stay with his brother John, an aspiring classical pianist. John Wallowitch described the affair as becoming "hot and heavy" very quickly. "Overnight, it seemed to me. . . . One day

I happened to walk through the front room, where Ed slept . . . and they were going at it like crazy people." For a voyeur, Andy was providing his share of thrills. Robert Heide, a friend of the Wallowitches, narrowly missed another sighting: "I was at John's when Andy and Ed came out of the little front room having very definitely just had sex."

According to John, Andy and Edward were excited about collaborating together on art projects. Many of the drawings in Warhol's 1957 *Gold Book*, another privately printed booklet, were traced from Wallowitch's photographs of street urchins and young men. They shared commercial assignments, too; Warhol traced his illustration for "Melissa of the 27 Dreams," a short story in the February 1958 *Seventeen*, from Wallowitch's photograph of his nineteen-year-old sister Anna Mae. The Warhol-Wallowitch collaboration lasted into the early Pop years: Warhol traced or copied many of his 1961 and 1962 paintings and drawings of Campbell's soup cans and dollar bills from photographs by Wallowitch.

By then, the romance was probably long over. In October 1958, Edward, whose mental state had always been fragile, suffered a severe breakdown. The brothers were broke, and John asked Warhol for a loan to hospitalize Edward, which was refused: "He said his business manager told him not to. And that's what stays with me about Andy. He didn't come through for Eddie."

When Edward recovered, he and Warhol resumed at least a friendship and a working relationship. They stayed in touch into the midsixties, then drifted apart. John, who became a cabaret entertainer, remained friends, of sorts, with Warhol; in 1964, Andy would design the sleeve for a John Wallowitch LP, using one of his characteristic mid-sixties formats, a grid of photo-booth portraits. Then they too drifted apart.

While Warhol's relationship with Edward Wallowitch consisted of an explosive early phase and a less intense aftermath, his liaison with

Charles Lisanby, a successful Broadway and television TV stage and set designer, was a long, slow simmer. One is tempted to consider Lisanby the love of Andy's life, the one he never got over.

Lisanby came from an old, well-to-do Kentucky family; there was a Charles Lisanby in the Civil War, and one in the Revolutionary War, too. As a young man—he arrived in Manhattan at the same time as Andy, in the late forties—Lisanby was a good-looking man who did not consider himself gay but didn't mind having sex with men. He had many affairs, including one, he claimed, with James Dean.

Andy and Lisanby met at a party in late 1955. Andy was sitting by himself (strategically, it turned out, in front of a group of his drawings on the wall). They wound up sharing a cab home, after stopping in front of a taxidermist's so that Lisanby could admire a stuffed peacock. A few days later, the peacock was delivered to his door.

Andy was smitten; Lisanby was not. So Andy hung around, which Lisanby didn't mind, although he was never quite sure what Andy wanted. "I don't think he wanted to have sex. He said he thought sex was 'messy.' That was his word, it was too 'messy and distasteful.' He told me he'd had sex a few times, he had tried it and didn't really like it."

What Andy really wanted was for Lisanby to introduce him to Cecil Beaton—the legendary photographer and costume designer was a mentor of Lisanby's. "Finally I took Andy to a party Cecil gave. After I introduced him, he sat in the corner. He made no impression on Cecil, didn't socialize, didn't talk to anyone. He really did not know how to mix. He always looked, and I'm sure felt, so awkward at parties. He didn't know how to join and have fun and meet people. He had no social graces."

They talked on the phone for an hour or two every day; "he came out with things that were so off the wall they were amusing." It was Lisanby who ended Andy's disheveled "Raggedy Andy" phase, taking him in hand and teaching him how to shop for clothes. Warhol's favorite listening had been Broadway show tunes, but now he dressed up to attend the Metropolitan Opera with Lisanby. "I don't think he

ever liked the music," Lisanby said. "He liked being there, and seeing famous people at intermission."

In 1956, Lisanby, an ardent traveler, convinced Andy, who'd never been west of Pittsburgh, to join him on a round-the-world summer trip. It was a disaster. On the second night out, in Honolulu, Andy went into hysterics, according to Lisanby, driven first to fury, then to tears, by Lisanby's interest in a local beach boy. He was near suicidal, said Lisanby, managing to whisper, "I love you," before collapsing. He wanted to go home, but Lisanby talked him into continuing. For the rest of the trip Andy was sullen and uncooperative. In Calcutta, Lisanby contracted dysentery. Andy couldn't have been less helpful: "He didn't want to be involved. I had to get us to the airport." When they got back to New York, Andy simply walked away, leaving Lisanby standing at the airport. It was as if he were furious all over again, as if no time had elapsed since Honolulu. Paul Warhola noticed his brother's gloom: "When Andy came home after that trip, I never saw him so depressed. I said, 'Andy, I mean, gee, what happened?' He said, 'Charles kept all our photographs and won't give me any.'" The explanation satisfied Paul, who'd never liked Lisanby anyway.

But the friendship continued. When Andy made window displays, he painted "AW and CL" inside little hearts on the glass. In December, a few months after the trip Andy had his second show of 1956: gold-leaf drawings of shoes, each named for a celebrity. Lisanby brought his friend Julie Andrews, and Warhol was crushed when she didn't want her namesake shoe—Mrs. Warhola had spelled her name "Julia."

The one-sided affair would wind on all the way to 1965, when it must have been in strange counterpoint to Warhol's increasingly intense Factory life, surrounded no longer by genteel East Coast fifties homosexuals but by speed freaks, transvestites, and S&M specialists. Andy's crush on Lisanby—if it indeed lasted as long as Lisanby maintained—was an incongruous survival of Andy's old Serendipity days into the Factory era.

In 1965, Lisanby fell in love. "I knew nothing was ever going to

happen with Andy. I laid my cards on the table. 'I'm never going to live with you,' I told him. 'I don't think we should see each other so often, on top of talking on the phone almost every day.' He just went ballistic, leaving without a word. I didn't see him for months. And then, when I'd run into him at parties, he was always very polite and civil, but withdrawn. You could see the wheels going. It went on like that for a long time, but it was really the end."

Soon after graduating from Cambridge and moving to New York to work in advertising, John Mann met Ted Carey at a party. At the end of the evening they went home together. "The next morning," Mann recalled, "Ted said, 'Oh, let's go see Andy.' At that time, Andy was living on Lexington and Thirty-fifth, with the seventeen cats. The place smelt—you wouldn't have believed how terribly. Andy said to Ted, 'Oh, was it wonderful?'

"Ted said, 'Oh, yes. Big meat!'

"And Andy said, 'Ohh, I want to draw it!'

"I remember thinking, 'This is sort of weird,'" said Mann. "But Ted said, 'Oh, it would be fun!' And Andy said, 'Please let me do it!' I thought, 'Oh well,' and before I knew it—we were all very young and silly—I was sitting with my pants down, with a daffodil wound around my dick. That was my first meeting with Andy."

John Mann is all but invisible in biographies of Warhol (he is not to be confused with David Mann, the owner of the Bodley Gallery and another Warhol friend). Researchers have generally assumed that Warhol and Ted Carey were a couple, portraying Carey as Warhol's sidekick. In fact, Andy was the sidekick to Carey and Mann.

Ted Carey, who had an affluent, suburban Philadelphia background, came to New York in 1954 after graduating from the Philadelphia College of Art. A slender blond variously described as "gorgeous," "a beauty," or "gloriously handsome," he was a fabric designer by trade but not very ambitious, more interested in sex and old furniture. He and Andy met

at Serendipity. Soon afterward, at the Central Park Zoo, Andy made his version of a pass, asking Carey to pose for him. They may or may not have been lovers; if they were, the affair was as negligible as most of Andy's. In any case, he and Ted became close friends, and Carey would figure in Warhol's move to Pop, prodding Andy into regular Saturday afternoon gallery jaunts with himself and Mann.

"It was such a laid-back, languid, campy environment we were all existing in," said Mann. Nobody would have been surprised to find Noël Coward sipping a cocktail in the Careys' ratty East 88th Street kitchen (Ted shared the apartment with his younger brother Gary, a Columbia graduate student). Indeed, something like this actually occurred. Getting back from school one night, Gary opened the door onto a remarkable tableau: Cecil Beaton absorbedly sketching Ted and John Mann in flagrante delicto (they were only miming, Mann insisted), while Andy, who was there too, kept trying to peer over the seated Beaton's shoulder. When the session was over, Andy asked for the drawings. Refusing, Beaton thanked his models and left.

Warhol was a dedicated voyeur. When his friend George Klauber was in love with a Columbia student, Andy couldn't stop asking about it. He phoned Klauber nightly, after Klauber's lover had left. "We went through that relationship night by night, Andy and I," Klauber said. "We never talked about his relationships, if he had any."

Probing for sexual details "was the one time Andy was bold," said Buddy Radisch, a fifties acquaintance. " 'What did you do last night?' would be asked with a sort of drawling voice. 'How many times did you do it?' 'Did you do this, did you do that?' "

" 'Did you pay the price?' That was the first thing he said," Betty Lou Davis recalled. "Whenever I went out with someone, Andy called the next morning. He was the most voyeuristic person I've ever known."

Warhol made innumerable erotic drawings of men between the early fifties and early sixties; these, far more than actual relationships, constituted his erotic life in the fifties. They range from innocuous

(heads and torsos of decorative young men, with lots of Warhol's telltale hearts floating around) to suggestive (torsos with pants opened to reveal fleecy pubic hair) to coyly graphic (penises adorned with wristwatches, seashells, ribbons, etc.) to hard-core (blow jobs from various angles). A stack of sketchbooks contain the so-called cock drawings, the late-fifties series in which Mann was included. Another anatomical project, a book of famous people's feet, never materialized, although Warhol managed foot drawings of Tallulah Bankhead, Christopher Isherwood, Leontyne Price, Hermione Gingold, Bobby Short, and others. The more graphic drawings, we may assume, were for Warhol's personal collection. "By the time we were sitting on each other's faces," recalled one of Andy's subjects, Dick Banks, "Andy screamed, 'I can't take it anymore!'" Warhol's friend Robert Fleischer, drawn sprawled with a companion in postorgasmic beatitude, described an excited Warhol, who "wouldn't quite join in but . . . loved watching," hurriedly stripping down to his underpants.

Warhol's erotic drawings are (though stylistically light-years away) the precursors of *Haircut #1, Couch,* and *The Chelsea Girls,* as well as much unreleased footage: Warhol movies offering views of male genitals. Both forms, drawings and film, enabled Andy to gratify desires whose expression with another person were too perilous. On the other hand, sometimes Andy drew cocks for sheer fun. Gary Carey and his friend Michael Kahn (later a well-known stage director and producer) talked Andy into doing the set for their Columbia French club production of Cocteau's play *Orpheus.* For the final scene, in heaven, Carey and Kahn wanted the stage bare, with only a backdrop. Andy decided to appliqué typical fifties Warhol motifs (butterflies, cherubs, roses) onto a scrim; when it was lit, the audience would see only the appliqués. The day before the opening, he still hadn't made the scrim. He assured his nervous young producers that he would work through the night and finish the job. As good as his word, Andy hung the scrim himself just before the show. There was no time to look at it; the audience was trickling in, including some very important scholars—these

were the great days of the humanities at Columbia. The play went smoothly, and as the last scene began, the scrim was finally illuminated, to a collective gasp from the audience: all they could see were giant phalluses. Andy had appliquéd them all over the scrim: a few butterflies and roses, but mostly great big penises. "We had to spend the rest of the night taking them off and appliquéing roses," said Carey, "because the French department was not amused."

In a rare strategic error, Warhol misjudged the art world climate badly enough to *twice* submit his "boy drawings" to the Tanager, an influential collective gallery operated by and for second-generation Abstract Expressionists. Predictably, his work was refused both times. Not only was the content unacceptable to fifties mores, but in the heyday of abstraction, art this literary was laughably retrograde. As Joseph Groell, a Tanager member, recalled, Andy asked him in 1952 or 1953 to submit some Warhol drawings for a guest show. The drawings "weren't really erotic," Groell recalled, "they were head drawings. Because I was a friend" (he and Andy were rooming together), "I promised him I'd take the drawings down. I was very embarrassed, but I did it. Of course, they wouldn't show them. I told Andy very nicely that people weren't interested. If he was hurt, he didn't show it."

Philip Pearlstein joined the Tanager in 1954; at some point thereafter, probably 1956, Warhol made his second try. "The Tanager was a gallery that got a lot of attention," Pearlstein said, "so Andy brought me a portfolio of these 'boy drawings' with their tongues in each other's mouths. The macho painters at the Tanager took one look at these and dismissed them. Andy was very hurt. I remember the talk I had with him after that. I said that sometimes the subject matter gets in the way." According to Pearlstein, it was the end of their ten-year friendship (although Pearlstein's retreat from Andy and his romantic problems may have soured things just as much). In any case, Andy hadn't yet learned a tactic that would later serve him well: how to be *creatively* wrong.

"Andy was always looking to do serious work," said George Klauber; "he was always looking for a show." Warhol's friend Leila Davies

Singelis remembered making the gallery rounds with Andy in the early-to mid-fifties, to see what was selling, "to see what he could do like this. But he usually said, 'It's not for me.'" In his spare time, Andy made a number of big canvases: in essence, painted versions of his blotted-line drawings. While interesting as prototypes of future techniques, they are not very strong.

Determined to show whether the top galleries wanted him or not, Warhol dropped his ambitions a notch. Between 1952 and 1959 he had seven shows, all at smallish galleries within the gay network, including shows in 1952 at the Hugo Gallery, in 1954 at the Loft Gallery, and in 1956, 1957, and 1959 at the Bodley Gallery. The shows were reviewed, not at all badly, in the art world press: "an air of preciosity, of carefully studied perversity" (*Art Digest*, July 1952); "an original style of line drawing" (*Art News*, Summer 1954). Two of the three Bodley shows got capsule reviews in the *New York Times* ("clever frivolity *in excelsis*" and "sly, abound[ing] in private meaning . . . might have been done by Jean Cocteau on an off day"). Reviewing the 1956 celebrity-shoe show for *Art News*, Parker Tyler (later to write at length about Warhol's movies), attributed to Andy's shoes "an odd elegance of pure craziness." Warhol's gold-leaf celebrity shoes—named for, among others, Elvis "Presely" (Julia's spelling again), Zsa Zsa Gabor, James Dean, and Truman Capote—earned him his first national exposure, a *Life* spread on January 21, 1957. But *Life* treated Warhol's shoes as novelties, not art; its well-informed art editor, Dorothy Seiberling, turned down an invitation to the show.

Warhol cracked the Museum of Modern Art in 1956, when a shoe drawing was included in the museum's Recent Drawings U.S.A. show. Andy offered the drawing to the Modern's permanent collection, receiving a polite no from the museum's director, Alfred Barr.

As ardently as he longed to break into the art world's higher echelons, Warhol was not going to do it while Abstract Expressionism dictated

tastes. He had never shown any interest in or talent for abstraction and Abstract Expressionism's machismo aesthetic was quite alien to him (although one cannot single out the Abstract Expressionists for aggressive masculinity: Picasso and Braque both thought a painting should be *bien couillarde*, or "ballsy"—a term they'd borrowed from Cézanne.)

The rise of Abstract Expressionism in the half-dozen years after World War II was a triumph for American art. A rebellion against what it perceived as the essence of French art, it toppled Paris's art world primacy. "With the older artists that I knew—de Kooning, Pollock, Rothko, Barney Newman—one of the main elements in their perspective was a declared hostility to French art, to European art as a whole," said painter Alfred Leslie. "Even though they were influenced by European modernism and their roots were in it they wanted to conquer it and declare themselves free. the art they began to make distinguished itself from the European model by its aggressiveness, by its boldness."

"Ab-Ex" was the product of a long, complex stripping-away of modern painting's presuppositions. A priori subjects, whether figurative or abstract, presupposed too much. The subject needed to be brought into being by the act of painting itself; as the Abstract Expressionist Barnett Newman said, "an artist paints so that he will have something to look at." That something was the artist's embodiment of his inner life. The Abstract Expressionists epitomized modernism's heroic inscrutability, their canvases mirroring that of *Finnegans Wake* or Schoenberg's tone rows. Ornette Coleman, who typified the hermeticism that had shrunk jazz's audience since the end of the swing era, fittingly chose Pollock's *White Light* as the cover for his difficult 1960 album *Free Jazz*.

The style was made to bear a heavy ideological burden. Abstract Expressionism, one scholar wrote, was "a monument to the human spirit," one of "the most advanced products of the human mind, comparable in some way to achievements in physics and chemistry." It was

hard to live up to that sort of standard, as Pollock's sad end demonstrated. Abstract Expressionism, wrote Clement Greenberg, its greatest critical adherent, in 1964, "became a fashion, and now it has fallen out of fashion." Abstract Expressionism, Roy Lichtenstein recalled, "had developed into mannerism."

It was as if the zeal with which the Abstract Expressionists outlawed the real world had generated a counterzeal, a hunger not simply to depict real things, but for the things themselves. In a critically reviled 1953 show, his first in New York, a young artist of antic energy named Robert Rauschenberg added earth, rocks, and wood to all-black paintings. Next, he began cobbling together the contraptions he called "combines," part painting, part sculpture, splattering paint on doors, baseballs, bricks, old neckties, jars, stuffed birds, and a stuffed Angora goat with a tire around its belly. "Painting," Rauschenberg announced, "relates to both art and life. Neither can be made. (I try to act in that gap between the two.)" He was rebutting the romantic myth that art is conjured from pure imagination; rather, it was now a matter of creatively reshaping and rearranging materials found ready to hand, the detritus of an overproducing economy. From making things to finding things: a profound shift in the idea of artistic creation was under way.

Rauschenberg's lover from 1955 to 1961, Jasper Johns, cast an even bigger spell on young artists: Johns's paintings of actual but intentionally neutral objects—flags, targets, numerals, letters—have an iconic, brooding power. Johns's very first show, at the new Leo Castelli Gallery in 1958, was a huge success and a media event, showing that a nonabstractionist could achieve as high a visibility as a Pollock or a de Kooning.

Johns's *Flags* and *Targets* of 1954 and 1955, which propelled him from out of nowhere, embodied an intelligent, confident grappling with several of modern painting's basic issues, an audacious but deeply considered attempt to overcome the illusionism of six hundred years of Western painting. Armed with the new science of perspective, Renaissance painters had taken up the challenge of using a flat surface, the

Jasper Johns with Target, 1955

canvas, to create the illusion of space, as if the painting's surface were a window through which viewers beheld an exact replica of the world. From late Impressionism on, painters came to consider illusionism a mere bag of tricks, a fiction that obscured a painting's essential characteristic: flatness. The modernist painter's goal was to make painting own up to what it was: paint applied to a flat surface.

But the eye has its own tricks, restoring depth wherever it can. As soon as a painter makes a mark on a blank canvas, the eye interprets it as being in front of a background, reasserting an illusory depth. Old Masters and Abstract Expressionists used a canvas the same way: metaphorically, to suggest a world, a reality other than itself. The question that Johns asked himself was, "How can I make a painting that's *only* a painting?"

He hit on a deceptively simple solution: the best way to avoid suggesting depth was to paint something that was *already flat*. A flag, for instance. Since the viewer knew the subject to be flat, there was no reason to convince him otherwise. Paint and canvas no longer needed to be anything but themselves, no longer had be forced to impersonate a face, a body, a tree, a valley. That's where Warhol came in—proving himself, despite his know-nothing air, to be absolutely aware of contemporary art's most pressing formal issues.

Warhol's 1961 and 1962 paintings, *A Boy for Meg, Eddie Fisher Breaks Down, 129 Die in Jet!,* and others, were his *Flag* and *Target*: not *representations* of a newspaper's front page, but alternate, if odd, versions of it. Warhol knowingly bypassed the illusionist's dilemma, as Johns had, by painting already-flat subjects. And by silk-screening photographs, he would do this for the rest of his career. "If you want to know all about Andy Warhol, just look at the surface: of my paintings and films and me, and there I am. There's nothing behind it." The well-known aperçu, often taken as a disingenuous, intentionally misleading statement of his own superficiality, proves much more interesting as a metaphor for a supposedly anti-intellectual artist's high-level grasp of the major formal issue confronting painters of his era.

What is interesting is that he began doing something like this before he even knew of Johns. Among Warhol's fifties works is a laboriously handwritten copy of the August 23, 1956, front page of the *Princeton (KY) Leader*—Charles Lisanby's hometown paper. The big title insignia, with its pennantlike flourish, is carefully copied (and, typically, misspelled; it reads "Princton"). In Andy's only tongue-in-cheek touch, he substituted Lisanby's name for the subject's in a story about an apprentice steamfitter. Otherwise, the drawing is completely deadpan. Making it must have been a numbingly boring task—a labor of love, perhaps. If it was indeed made in 1956 and not later, it is an anomaly, a piece of pre-Pop Pop.

But it isn't unique in Warhol's oeuvre. In another drawing, also apparently from 1956, he copied most of a page from the classified section of the then-new scandal sheet (it was founded in 1952), the *National Enquirer*. Some of the ads are seedy indeed—"FIFTYISH MISER WHOSE WIFE STARVED TO DEATH would like to meet woman miser," and so on. In other words, at a time when Warhol was occupied with cherubs, kittens, and slim young boys, he was already drawn not merely to intuitive solutions of major formal problems, but to the type of grim subjects he would explore further in the sixties.

Two years later, he drew his most detailed copy of a newspaper page yet, a simulacrum of the September 21, 1958, front page of the *New York Journal American*. These drawings, none of which were exhibited until the late nineties, show that wholesale, not merely collagelike, appropriation was not a sudden jump Andy would make at the beginning of the sixties. In a casual, hand-hewn way, he had already taken appropriation further in his pre-Pop years than almost anyone. It was Johns's conceptual breakthrough that concretized Warhol's interest in premade, and flat, images, confirming to him that this was the way to go. As the art critic Barbara Rose said in 1973, "I think that unquestionably Andy wouldn't have become an artist if it hadn't been for Jasper Johns."

Warhol was only one of countless New York artists whose careers Johns and Rauschenberg altered between the mid-fifties and early sixties. Largely under their impact, and that of their friend and mentor, the composer John Cage, a new wave of art-making began, its adherents claiming that art needed to embrace raw, unmediated life. If Johns, Rauschenberg, and Cage were at the movement's forefront, its spiritual father was Marcel Duchamp. Born in 1887 in upper Normandy, Duchamp began his professional life as a painter, switched to his so-called ready-mades (1917's *Fountain* is by far the best known, the signed urinal that was voted in 2004 "the most influential artwork of the twentieth century"). Moving to Greenwich Village in 1942, he became an American citizen. Although he was thought to have stopped producing art decades earlier, he unveiled in 1966 the mysterious tableau, *Etant donnés*, its contents visible only through a peephole; he had worked on it in secret for twenty years. Long out of the limelight, Duchamp was rediscovered in the late fifties by post–Abstract Expressionists and feted as a hero who'd dedicated his life to undermining modernist convention, and whose "ready-mades" directly stimulated the growing use of banal, everyday subject matter, "conducting a tireless assault on the traditions of art and the artist," wrote Calvin Tomkins in *The Bride and the Bachelors*, his study on Duchamp's influence.

"Well, Duchamp lies behind Andy," explained Henry Geldzahler, one of Warhol's chief mentors in the early sixties, "but in Andy's case, it's not a direct influence. If Andy got it from anyone, he got it from people like John Cage who'd already gotten it from Duchamp. . . . The ideas were in the air that anything is interesting, that it's the artist who decides what's art. . . . The idea that Cage might have a piece in which the radio would be turned on [halfway through], and whatever comes on the radio at that time is part of the piece . . . isn't radically different from taking a photograph out of the newspaper and saying, 'This is art.' And Cage, leaning on Duchamp, used that kind of thing in his music, and then Bob and Jap and Andy . . . said, 'Whatever we choose to regard as art is art.'"

The new art's locus was Greenwich Village and the Lower East Side, where a few tiny galleries showed the work of Allan Kaprow, Robert Whitman, Claes Oldenburg, Jim Dine, George Segal, and others. Artists lived where they could: walk-up tenements in the Village and the Lower East Side (not yet renamed "East Village" by Realtors), derelict light-industry lofts in what would not be called SoHo for a decade and a half, and outposts like Coenties Slip, at Manhattan's southern tip. "If you saw a light on at night, you'd know it was an artist," recalled the English painter Richard Smith, who came to Manhattan in 1959 and paid $25 a month for a sixth-floor walk-up near Canal Street.

To Smith, Manhattan's post–Abstract Expressionist scene exceeded his expectations. "Ever since I'd started art school, I'd had a romance about Paris in the teens and the twenties," he said, "and here it was. I met everybody; it was a scene you could encompass."

In June 1960, New Media / New Forms, a huge show of assemblages— essentially, junk sculpture—opened at the Martha Jackson Gallery at 32 East 69th Street. It was so successful that a second installment, New Media / New Forms, Version II, was scheduled for September. The uptown address was important: the new art was emerging from the underground to the center stage. Mainstream gallerygoers and estab-

lishment critics were forced to take note of the work of downtown insurgents like Oldenburg, Dine, John Chamberlain, Robert Indiana, and Kaprow, the originator of the loosely scripted performances called Happenings. The conservative critic Hilton Kramer, predictably, hated the show: "Many of the assemblages of junk at the Jackson exhibition have no more connection with the work of art than those pieces of driftwood that people used to take home from their summer vacations," he wrote in the journal *Arts*. On the other hand, Thomas Hess, editor of *Art News*, was intrigued. Hess's enthusiasm was especially noteworthy; he had made his reputation as one of Abstract Expressionism's most vocal champions. Calling the show "a lively, in places a brilliant exhibition," he wrote: "There is a kind of protest in many of these works. . . . It is as if many of these artists were trying to reach out from their works to give the spectator's hand a good shake or nudge him in the ribs. . . . Is there, perhaps, a new collective dive into sociology, into the streets, to the crowded sidewalks . . . ? A soft Revolution?"

Hess had divined what by now amounted to a movement: a fascination with everyday objects, especially the products and signs of mass culture, and an impatience with the modernist view of art as a realm beyond compromised, ephemeral, futile life. In a 1958 *Art News* piece, "The Legacy of Jackson Pollock," Kaprow wrote:

"We must become preoccupied with and even dazzled by the space and objects of our everyday life, either our bodies, clothes, rooms, or, if need be, the vastness of Forty-Second Street. Objects of every sort are materials for the new art: paint, chairs, food, electric and neon lights, smoke, water, old socks, a dog, movies. . . ."

"Comics, picnic tables, men's trousers, celebrities, shower curtains, refrigerators, Coke bottles: all the great modern things the Abstract Expressionists tried so hard not to notice at all." The second list occupies page 1 of *POPism*, Warhol's sixties memoir, as he recalled the look and feel of a world suddenly legitimized as a proper subject for artists. Kaprow's and his colleagues' agenda, to collapse the long-established

opposition of art and life, forcing them into disquieting proximity, established the atmosphere in which Warhol would break conclusively with his past, taking Rauschenberg's and Johns's advances one step further.

Rauschenberg combined found objects (and, after 1963, silk-screened images) into larger wholes, distinct from their components. Johns, with his extraordinary painting skills, elevated replicas of everyday objects—flags, targets, alphabets, etc.—into high art. Both artists' recourse to the banal, the automobile tire and the target, inspired others to break with abstraction and plumb the real world. But Warhol took Johns and Rauschenberg one step further, producing work that was literally indistinguishable from practical objects. The Brillo boxes: what *were* they, shipping crates or art? The question was unanswerable. Warhol didn't simply play around with the distinction between art and life; he exploded it. The very steps that led to Warhol's and his Pop colleagues' ridicule by middlebrow American and its mainstream media were the exact same decisions that made their art cutting-edge.

Emile de Antonio was an impossible man: arrogant, argumentative, and a borderline drunk. Big-bellied and pugnacious, "De," as his friends called him, relished his contradictions and had many: he was a Marxist in love with wealth and pedigree, a romantic idealist and a profound cynic, a compulsive skirt-chaser whose best friends were gay men. He was brilliant, persuasive, charming, and past forty when he finally found his vocation. By then, he had entered, and largely exited, Andy Warhol's life. The brevity of their friendship notwithstanding, de Antonio not only gave Warhol a vital push toward painting (actually, de Antonio called it a "cough"), but into filmmaking, too.

"De was almost the first one," said Henry Geldzahler, "to see Andy's attempts at fine arts." If Geldzahler, in turn, played what Barbara Rose called a "huge, huge role in Warhol's development, De formed his character."

When the aspiring fine artist and the intellectual hustler were intro-
duced by Tina Fredericks—Warhol's onetime boss and de Antonio's
former lover—de Antonio didn't know that he was nearing the end of
at least two decades of drifting: from job to job, career to career, wife to
wife (he had six), affair to affair. Expelled from Harvard's class of 1940
(JFK's class), de Antonio had been a dockworker, a union organizer, a
Communist Party member, and a World War
II bomber pilot (he wrote a novel in the air
force, hated it, and scattered the pages from
the bomb bay of his plane—"De was full of
gestures," said Fredericks). He put the make
on just about any woman he could. "He was
big and fat," according to Ruth Ansel (whom
he chased, unsuccessfully), "he always wore
preppy things—I thought of De as a very
upper-class guy who was rebelling—and a
big Buddha belly coming over a tight belt. A

Emile de Antonio

ruddy but incredible face, intense eyes, a great voice, and an ability to
mesmerize."

De Antonio eventually found himself as a filmmaker, making the
provocative documentaries *Point of Order* and *Millhouse* (as well as
the nonpolitical *Painters Painting*). His initial revelation about the art
world came from his relationship with the avant-garde composer John
Cage, his neighbor in Pomona, New York. From Cage he absorbed the
paradoxical Zen turn of mind that underpinned the art of neo-Dadaists
Jasper Johns and Robert Rauschenberg (as well as Cage's own composi-
tions). But, ultimately, de Antonio's innate cynicism kicked in. Taking
literally Cage's aesthetic pose as metaphysical huckster, de Antonio
came to the jaundiced revelation that the shock tactics of modern art
were as much a matter of chutzpah as profound expression. This con-
veniently meshed with his own hustler's view of life and ambivalence
toward the avant-garde.

In Warhol, de Antonio recognized another opportunist, hungry, resentful, and ego-wounded. Andy had already suspected that art–world success was "all promotion"; de Antonio confirmed it. His "cough in the right direction" was to demystify the art world, convincing Andy that there was less there than met the eye; that success was not scaling a mountain, but a matter of leaping into a vacuum with the most noise.

"It was De," said Alfred Leslie, "who showed Andy how to pick up on ideas with which he could thrust himself forward as fast as possible and find a forum. You could say that Andy modeled himself on that aspect of De, on De's unerring instinct for the jugular, on the way that De could go into a situation, sum it up, and seize the opportunities."

De Antonio was the first person he knew, said *POPism*'s Warhol, "who saw commercial art as real art and real art as commercial art" (though in fact, in those quick 1956 *Mademoiselle* remarks, Andy had come close). But however cynically Andy viewed the gallery world, he still thought of himself as a hack, incapable of bestowing on a work high art's special aura. Nonsense, responded de Antonio: the art world, with its galleries, dealers, and collectors, was just as commercial as Madison Avenue. Conversely, Hollywood movies, ads, fashion photography—the best of these had at least as much meaning as the work of any second-generation Abstract Expressionist.

Later in life, de Antonio hung a placard on his study wall that read, "Stamp Out Bourgeois Culture." What characterized bourgeois culture to de Antonio was its pretension to exist above and beyond the ruck of material life, as an ideal, disembodied realm. If his aim was to reveal the lie behind this notion of culture, to show how art and business were indissolubly linked, he achieved it far more effectively through the ostensibly apolitical Warhol than through his own documentaries, hardly watched today.

In the early seventies, De and Andy sat down in front of a camera crew to shoot the Warhol segment of de Antonio's *Painters Painting*. De kicked things off:

"I wonder if you could tell me, Andy, when and why you became a painter."

Warhol, typically, undercut the whole enterprise, hauling de Antonio out from behind his journalist's cover. The picture of innocence, he replied, "Why, De, you made me a painter."

"Cut!" yelled a flummoxed de Antonio. "Come on, let's have the truth."

"That *is* the truth," said Andy, "isn't it?"

[The conversations] were always basically Andy making me talk. He's a voyeur, by eye and ear, and he's really interested in hearing everything that goes on. . . . He had that quizzical puzzled innocent look and I remember he said, "Oh, teach me one fact every day and then I'll really know a lot."
—HENRY GELDZAHLER

One of the primary reasons behind the move to 1342 Lexington was the need for a "real" studio—none of the cramped rooms at 242 Lexington had been big enough to accommodate making art on the new scale. The building at 1342 Lexington was a spacious four-story brownstone, "a nice old New York house," Warhol's friend Suzie Frankfurt called it, designed in 1889 by the Plaza Hotel's well-known architect, Henry Hardenburgh. Mrs. Warhola lived in the basement, next to the kitchen. One flight up was the main floor, with Nathan Gluck in the jam-packed commercial-art studio that

1342 Lexington Avenue (center)

overlooked the street, and Andy painting in the even messier former living room in the back. The master bedroom, where almost nobody was admitted, was two flights further up, on the top floor. According to several of Andy's friends, he began his Pop paintings in the kitchen, only gradually occupying his main-floor "studio" (into whose expensive ormolu walls he sometimes stuck thumbtacks, driving the fastidious, cost-conscious Gluck nuts).

Before early September 1960, the only paintings Warhol had made were oil-on-canvas versions of his blotted-line illustrations—basically, outline drawings with an afterthought of paint. According to his brother Paul, "he wasn't doing Pop" at the time of his move to 1342 Lexington. "Everything was done after he got up to 89th Street."

So the earliest that Warhol could have begun painting was autumn 1960. But he would simply have been too busy then. He was moving himself, his mother, and an already substantial hoard of possessions; decorating the town house; managing an even heavier than usual workload (his 1960 gross hit $70,000, some $17,000 more than he had

earned the year before); indulging in a time-consuming spat with his ex-landlord—not to mention a four-day hospital stay in early December for an aggravating sexually transmitted condition, condylomata, or anal warts, which required surgery.

Shortly after Valentine's Day 1961, new canvases began to appear, the first Warhol painted in the style that would shortly be known as Pop art. They include *Nancy*; *Storm Window*; two *Popeyes*; several versions each of *Where Is Your Rupture?* and *Before and After* (which Warhol originally entitled *Beauty*); *The Little King*; *Superman*; and two *Dick Tracys*. *Off S* (*Officer's Shoes*), based on a March 1961 *Daily News* advertisement, was surely a conscious counterstatement to Warhol's fifties shoes: his most perfectly hard-edged, unembellished painting, yet with two tiny, fugitive drips. The shoes—men's, not women's—are chunky, polished to a robust gleam, as earthbound and utilitarian as their fifties predecessors are fanciful.

Executed during a three-month spurt between mid-February and the beginning of May, the paintings all drew on comic strips and newspapers for their subjects. *Nancy* was based on two panels from the Ernie Bushmiller comic strip that appeared in the *New York Post* on February 19; *Storm Window*, from an advertisement appearing in the March 2 *New York Daily News*. The original *Popeyes* appeared in the March 18 comics page of the *New York Journal American*. (No paintings can be conclusively dated after May until much later in the year. After such a sustained jag, Warhol most likely needed to get back to his bread-and-butter fashion work.)

The process by which Warhol created these images was simple. He projected the blown-up image onto a canvas using a Beseler Vu-Lite opaque projector and traced it with his paintbrush, usually without an initial pencil tracing. The advertisement-based paintings were done in black-and-white (a few have crayonned cross-hatchings or tinted washes), the cartoon paintings in color.

In these early pieces Warhol did not present commercial images in

the deadpan manner for which he would become famous. He played freely with his sources, omitting details, altering colors, and flattening contours. Although unmistakably himself, Popeye has no features—he's merely a white silhouette. Nancy's boots are just a swatch of red. Nancy herself hovers in a no-man's-land between two panels, their borders half-erased. From the *National Enquirer*, Warhol cropped the text for a plastic surgery ad for the stark two-panel image that became *Before and After*. *Before and After 2* contains some tentative-looking Benday dots, which he probably painted using a wire mesh. *Advertisement* is a bunch of taped-together *National Enquirer* ads with the copy omitted; the images float, disembodied, in a big, empty space. Warhol liked to drop letters or entire words. "Where is your rupture?" became "wher y rupture?" "Strong arms and broad shoulders," next to the picture of a he-man, became "strong arms and broads."

Almost every painting features drips, vestiges of Abstract Expressionism. Besides dripping, Warhol made other attempts, some halfhearted, to emulate New York School–style spontaneity and painterliness: brushstrokes, smudges, erasures, scrumbling, cross-hatching. The paintings tend to be big: *Dick Tracy and Sam Ketchum* is seven and a half feet high, while *Superman, Advertisement*, the three *Before and After* paintings, and both versions of *Where Is Your Rupture?* stand just under six feet. While their size was, in part, another inheritance from the Abstract Expressionists, it also figured into the contextual games Warhol was learning to play. More than any other alteration to their two- or three-inch-square sources, it was the paintings' enormous dimensions—the images yanked from their normal environment (the funny pages, the classified section) and blown up almost beyond recognition—that made them so striking. (It is an irony of Warhol's attack on the notion of the spontaneous, irreproducible work of art that, to get the full effect, his paintings must be seen in the original.)

How to account for the aesthetic distance traveled between the I. Miller ads, all pastel frivolity, and the hard-edged *Superman* and

Dick Tracy? The answer lies in part in the collection of Americana that Andy brought with him to 1342 Lexington—the Fowler Brothers phrenological head, the nineteenth-century advertising tins, the malevolently grinning Punch—and the art he collected, most notably lithographs by Jasper Johns. Card-carrying Modernists like Emile de Antonio disdained Andy's love of Americana, but it was Andy's unsentimental insight that comic strips and ads were in fact contemporary folk art.

The appropriation of existing imagery by Jasper Johns and Robert Rauschenberg in their paintings—especially Johns's flat frontal flags and targets—were an obvious inspiration, but all of these influences might not have gelled into Andy's first leap into Pop art without the spark that would bind them into critical mass: camp.

Camp's prankish approach to straight life and, more important, to art—specifically the epic, Sturm und Drang painting of the Abstract Expressionists—provided a perfect foil to the complex emotions of a sophisticated person living in the mid-twentieth-century United States. Whether poetical-enigmatic, as in the work of James Rosenquist, sculpture in context (George Segal), soft-core billboard (Tom Wesselmann), melting vinyl (Claes Oldenburg), or displaced commercial images (Warhol), all Pop art is often assumed to have grown out of camp.

But Warhol's attitude toward the crass commercialism that Pop seemed to be critiquing may have been given a unique spin by the circumstances of his background. As the only Pop artist to come from a blue-collar background, Warhol did not cast as contemptuous an eye on commercial culture as his compatriots. According to an intriguing theory proposed by Kenneth Silver, "something remarkable happened, when Warhol left commercial art for his own art." Silver argues that by 1960 Warhol had stopped seeing products through the eyes of the well-heeled consumers he'd striven to attract with his fifties magazine ads, and adopted a very different perspective: Julia Warhola's.

"Andy's grown-up world in New York was relinquished for a return to the world of Pittsburgh and his childhood, Cross [sic] and Blackwell was traded in for Campbell's. It was a 'blue-collar' woman's world that Warhol offered New York's sophisticated art consumers. . . ." Likewise, his decision to paint movie stars reflected his own obsession with them rather than the distance implied by other Pop artists. He unapologetically depicted them as idols. "In the repetition of images, the off-register printing, and the general lack of nuance," Silver goes on to say, "Warhol's portraits of stars reveal their source in the daily newspaper and the fan magazines, those [working-class] halfway houses between fact and fiction."

Nevertheless, Warhol understood this displacement of values better than anyone. "It's good because it's awful," Susan Sontag said in her *Notes on Camp*. This could easily have been borrowed from one of Andy's offhand aphorisms. It was the friction between elitist art world cynicism and his own genuine love of consumerism that made him the true apostle of Postmodernism's unholy marriage of art and commerce.

Andy found the ads and comic book images he painted hilarious. Their secret weapon was shock value; they were blitz images, designed to provoke, and part of why they were, in fact, so provocative was their scale, the confrontational exaggeration of size—taking an image the size of a baseball card and blowing it up into a billboard.

As Warhol's later filmmaking colleague Paul Morrissey explained, "He realized that if you wanted to get work as an illustrator, it had to be pleasing, and if it was going to be accepted in an art gallery it had to be the opposite of pleasing." Warhol wanted to insult good taste, not gratify it. In 1961, his subject matter was a calculated insult to the cultivated eye; the style was two-dimensional and crude. As Warhol later wrote, he made a career out of being "the wrong thing in the right space."

Warhol's desire to shock was not only an effort to lasso attention. Part of what lay behind these first Pop paintings was the same spleen

that had fueled Andy Warhola's *The Broad Gave Me My Face* and other adolescent efforts. No matter how well Andy camouflaged his emotions, revenge, anger, and scorn were lifelong impulses.

As we've already seen, these paintings were not representations of objects per se, but of objects as already represented. Taking an extra step back from reality, a distance he would maintain from now on, Warhol made images of images, second-generation pictures: here, newspapers and comic strips. Borrowing premade images was nothing new—Picasso, Braque, and many others had incorporated premade objects into their paintings. Schwitters had made especially imaginative use of newspaper and advertisement cutouts in his collages. Warhol was not a collagist. Neither was Jasper Johns: what made his *Flags* and *Targets* so startling to late-fifties viewers (Johns's first-ever 1958 show made waves beyond the art world, landing the reserved twenty-eight-year-old in the pages of *Time*) was their identity of subject and painting. Johns's subjects entirely filled the canvas—*Flag* wasn't a painting of a flag—it *was* a flag. Still, Johns's lush paint-handling elevated his subjects, after all, while Warhol flung at the audience subjects more or less untransformed, mocking, at least to traditionalists and the relatively uninitiated, standards of skill and craft. Warhol wanted to infuriate critics (imagine de Kooning tracing!), puzzle the public, and titillate the media. And so he would.

On the other hand, it would be unfair to characterize Warhol's wholesale appropriations as purely calculated. Working in this manner seems to have lain deep in his character, for he had been making literal-minded appropriations well before he knew of Johns. If Anliker, his Carnegie Tech professor, remembers correctly, Andy Warhola was drawing paper money at twenty and twenty-one. Among his fifties works is another money drawing, a joke million-dollar bill. Three painstaking appropriations prefigure the newspaper paintings of 1961 and 1962: the previously mentioned front page of the *Princton (sic) KY Leader*, most of a page from the *National Enquirer*, also apparently

from 1956, and much of the September 21, 1958, front page of the *New York Journal American*. Andy had always been interested in making copies—the blotted-line drawing, of course, was a facsimile. Just as the blotted line concretized his yearning for fame, hand-copying a newspaper may have represented a sort of primitive magic for Andy, a way to visualize his private handiwork as an object seen by thousands. As

Jasper Johns (right) and Robert Rauschenberg, 1958

for drawing money, it was another piece of ersatz sorcery, Andy's fantasy of having a million bucks. If these were indeed merely scattershot, intuitive attempts, Warhol's exposure to Johns, to the entire, burgeoning aesthetic of appropriation, must have been exciting proof that his early doodles had pointed in a promising direction.

On January 28, a show of Jasper Johns's new drawings, sculptures, and lithographs opened at the Castelli Gallery. At some point during its four-week run, Warhol introduced himself to his hero. He knew Warhol's work, replied Johns coolly. It turned out that several years earlier, Johns and Rauschenberg had done a Fifth Avenue window display based on Warhol's I. Miller shoe drawings. When Johns mentioned this, Warhol said, "Why didn't they ask me to do it?"—a typically aggrieved response. Andy's insecurities were always near the surface. He was quick to take offense at perceived social slights even when none were intended.

Andy's obsession with Johns (and Rauschenberg too) continued unabated. The two older artists were unfailingly cool to Warhol at gatherings, if they even acknowledged his presence. According to Emile de Antonio, Andy, unable to contain himself, "finally said to me, 'De, why don't Bob and Jap like me?' I said in essence, 'Why Andy, how could they? You're too queer and you know the wrong ones, "fash-

iony" queers rather than Philip Johnson, etc., and your work is so commercial. It probably makes them uneasy' "—reminded them, that is, of the days when they themselves were lowly window dressers, which could always return. In addition, said De, Andy was a well-known collector, and to painters, collectors were class enemies: a gauche, philistine, necessary evil. The more art Andy collected, de Antonio warned, the more a committed artist like Johns would disdain him.

Andy's overt gayness was a problem in a milieu where homosexuality remained a touchy subject. Art historian Robert Rosenblum recalled an astonishing instance of art world homophobia: "I can remember vividly the outrageous statement of [art historian] Dore Ashton. She and Peter Selz were accusing me of liking all of these terrible artists of Leo Castelli. Jasper Johns's name came up. She didn't think Johns and Rauschenberg could be serious artists because they were both homosexuals. It was said with contempt. I think that comment, which was probably from the late fifties, was the first time I ever heard that attached to [Johns's and Rauschenberg's] art—that is, that they were gay artists and that this was offensive for some reason, the implications always being that they upset the Ab-Ex mentality and threatened the bounds."

As Andy recalled, his initial, "stupid" response to de Antonio about Johns and Rauschenberg avoiding him was that he knew "plenty of painters who are more swish than me." De Antonio agreed, but then added: "but the *major painters* try to look straight"—thus managing to efficiently jab Andy twice: he wasn't "major," and he was too swishy to pass.

Outwardly, Andy feigned a plucky, impervious attitude toward his public perception. "As for the 'swish' thing," he would later insist in *POPism*, "I'd always had a lot of fun with that—just watching the expressions on people's faces. You'd have to have seen the way all the Abstract Expressionist painters carried themselves and the kinds of images they cultivated, to understand how shocked people were to see a painter coming on swish."

Andy's pose for the next half-dozen years was as close to masculine

as he could muster. If Andy was still "surrounded by fashion people, boys flicking their wrists, in 1961," as de Antonio noted, they would soon be dismissed, replaced, at least in public, by a mixed homo-hetero crowd. Warhol himself, in his shades, Beatle boots, pipestem jeans, and leather jacket, affected a style more androgynous than gay. In early and mid-sixties mainstream America, including Manhattan, homosexuality was still so far beyond the pale that heterosexuals often revealed a naiveté about who was and who wasn't. Again and again, columnists, without a hint of irony, would refer to Edie Sedgwick or Jane Holzer as Warhol's "latest girl," a misperception Andy certainly did not attempt to correct.

"There was nothing wrong with being a commercial artist," Andy insisted in *POPism*. But the account is disingenuous. Andy did his best, for instance, to hide Nathan Gluck from new art world visitors to 1342 Lexington. "He would say, 'Well, just finish that up and then go downstairs and have lunch and you can leave, because somebody's coming to the house,'" Gluck remembered. "And after I'd got downstairs, he put on the pop records to develop the atmosphere."

Johns later denied ever having had any animosity toward Andy, implying that de Antonio had cooked the whole thing up—and, in truth, it's highly unlikely Johns would have used an expression like "swish" or, for that matter, have attributed his aversion to Andy to his "too gay" behavior. Nevertheless it's indisputable that Andy doggedly pursued Johns and Rauschenberg, despite (or perhaps because of) the scorn he perceived. The results were decidedly mixed. By January 1962 he was having dinner and going to the movies with Johns, with whom he was now on a "Jap" basis—Johns's nickname to his intimates. Johns was amusedly tolerant but condescending; Andy, extremely deferential.

On February 24, the day before Johns's show closed, Warhol bought a drawing, *Light Bulb*, for $450 (it took him all year, and three invoices from the Castelli Gallery, to pay up). The light bulb, rendered in metallic grays of pencil and graphite wash, lies on a gray plinth, a monument to the Unknown Appliance. Andy was spending more and more time

combing galleries, usually with Ted Carey and John Mann. "Andy had a fabulous visual perception," in the opinion of Ivan Karp, at that time the manager of the Castelli gallery and a tireless crusader for Pop art. "He was one of the best collectors among artists. Very few artists collect art. Andy was one of the great ones."

January and February marked the purchase of not only the Johns drawing but three Johns lithographs: *Black Flag* and two *Targets*. In March, it was an Ellsworth Kelly watercolor: *#2, 1960*; in April, a Ray Johnson collage, *Venice*, and a Jim Dine painted shirt, which hung in the front-room studio at 1342 Lexington; in May, six Frank Stellas, miniature versions of Stella's *Benjamin Moore* paintings. Stella's *Moore* series, in which a different-hued painting represented each member of the paint manufacturer's product line, may have been an inspiration for the Campbell's soup cans, begun seven months later.

Gallery-hopping, Mann and Carey could afford to be detached art lovers; Andy, on the other hand, was testily competitive. At the Museum of Modern Art, the threesome saw a Rauschenberg collage. As Carey recalled, "I said, 'Oh, that is fabulous.' Andy said . . . 'That's a piece of shit. Anyone can do that.' And I said, 'Well, why don't you? If you really think it's all promotion . . .' And he said, 'Well, I've got to think of something different.'"

Johns's *Light Bulb* had a galvanizing effect on Andy. As Nathan Gluck put it, "It began to happen when he had bought the little light bulb thing and wanted to paint, meaning he wanted to do art."

Andy's date books provide records of his sudden infatuations—a flurry of lunches, dinners, and other appointments, ending as abruptly as they began. For ten days in late March and early April, his fixation of the moment was Timothy Hennessy, a tall, blond, and extremely handsome painter, a frequent escort of wealthy older women. Andy's brief involvement with Hennessey would have unexpected consequences for his art.

Hennessey, an American expatriate then living in Venice, met Tibor de Nagy director John Myers in Italy and Myers offered him a show, which opened on February 28. During the show, according to Hennessey, Myers said, "'A terrible little man is coming by, a very boring person, but you have to be nice to him because he might buy a painting.' And it was Andy Warhol. He was quite miserable-looking. He had no physique at all. So thin, so little, so miserable. Forlorn. So very neat and clean and well-dressed, in a tweed jacket and necktie, but it didn't come together. He was shy and unassuming, and we talked, and I liked him."

Warhol bought no paintings, but invited Hennessy for lunch in what Hennessy recalled as "a tearoom with Tiffany lamps hanging down"—Serendipity—"and a lot of young men having tuna fish salad sandwiches." Warhol talked about his mother, and then abruptly asked Hennessy if he could draw his feet, mentioning that he had just made an appointment with the gallery owner Betty Parsons to draw hers. The next day, Andy appeared at Hennessy's temporary studio on Sullivan Street "in his little tweed jacket," as Hennessy recollected, "and said, 'Now take off your shoes and socks.' He had a satchel, and out of it he brought twelve American flags. He said, 'Now step on them.' And he did an exquisite line drawing, which unfortunately he didn't give to me. My nude foot on the flags! Of course, that was a crime." The American flag was then considered the property of Jasper Johns and stepping on them was Andy's little joke.

At the end of their session, Warhol took copies of *The Gold Book* and *Wild Raspberries* from his satchel and presented them to his new friend. What Hennessy didn't say is that Warhol drew his feet again a few days later, this time entwined with those of Hennessy's lover, a striking thirty-year-old named Muriel Latow. "I think he would have liked to draw us in bed," said Latow, but Andy had to make do with their feet. "Andy was besotted with Timothy. When he drew us, his eyes got watery and his face was flushed."

Latow owned the Latow Gallery at 13 East 63rd Street. Unable to bankroll big-name talent, she put together eye-catching combinations of lesser-known artists. An advertisement for one of her shows caught the attention of John Mann, who visited the gallery and liked its owner at once: "She had a great eye and an unerring sense of where the art winds blew. You could go with Muriel to any gallery and she'd have an interesting slant." Latow, Mann, and Carey became good friends and dinner companions; before long, Andy was drawn into their circle.

Latow would come to know Andy as an art buyer. "Cheap is hardly the word. He haggled and carried on." She thought his flattering language at odds with his blank manner, and the incongruity "gave me the creeps." He pestered her for suggestions. "I never saw him when he didn't say, 'Muriel, I know you can make me the greatest painter in the world'—'most famous' is what he meant. 'So why won't you?'" Even if there was some tongue-in-cheek facetiousness in his flattery, once Andy decided that someone was of use, he could be relentless. And as it turned out, Muriel Latow would be responsible for the most important idea in Andy's career.

Enter Roy Lichtenstein, a little-known second-generation Abstract Expressionist painter, living in Highland Park, New Jersey, and teaching at Douglass College, the women's school at Rutgers. Bored with pure abstraction, almost a decade earlier Lichtenstein had begun copying figures, first from American history—buffalo, Indians, George Washington—then from comic strips, into his otherwise conventionally abstract pictures. By 1960 he knew the tide was moving away from abstraction, but toward what? His Rutgers colleague and friend Allan Kaprow was the instigator of Happenings, and at Kaprow's show, *Yard*, in May 1961, which involved hundreds of used tires piled in the sculpture garden of the Martha Jackson Gallery, Lichtenstein saw what the new thing was. As he told interviewers thirty years later, this "was the beginning of American things, like tires; uncubist, un-European things."

At some point in March or April of 1961, poring over a Disney car-
toon on a bubblegum wrapper, Lichtenstein had an outrageous thought:
why not paint it just the way it is? "I'm not so sure I was totally aware of
what I was doing," he recalled. "I wanted something that had nothing
of the beauty, the textured richness of the European brushstroke." He
got it. His first paintings based on comic strips—*Popeye, Tweet, Look
Mickey!* and others—have long since lost their power to shock, but in
1961 they were absolutely hair-raising.

"The most startling things, I think, I ever saw in my life," said Robert
Rosenblum. "It was so upsetting in terms of how ugly but how riveting
they were, how I couldn't stop looking." A painter like Alfred Leslie,
with his Abstract Expressionist sympathies, would naturally misinter-
pret Lichtenstein's move to Pop as a camouflaging of his weaknesses.
"Roy didn't discover his hand, he discovered the mechanics of Benday
dots. I don't remember the surfaces of his pictures having any life, and
the drawings I saw were pretty lightweight—they had no real qualities
until they were brought into his conceptual format."

It's wonderfully fitting that Warhol's new paintings made their first
appearance in the windows of a department store. The display director
at Bonwit Teller and Tiffany's, Gene Moore, liked to give the moon-
lighting fine artists among his window dressers a chance to show their
"real" work in the store's windows (it wasn't the Modern, but it beat
your own apartment or loft). In 1956 and 1957, before Jasper Johns's
first show, Moore let Johns put his flag paintings in a Bonwit's display.
So for one week in April 1961, five big paintings—*Advertisement, Little
King, Superman, Before and After,* and *Saturday's Popeye*—were avail-
able to the astonished gaze of passersby, an incongruous backdrop for
mannequins in summer styles.

And then, just at that moment—midspring 1961—two gallery
owners from the West Coast arrived at 1342 Lexington: Walter Hopps,
a laconic fourth-generation Californian, and Irving Blum, Hopps's
codirector at Los Angeles's bellwether gallery, the Ferus. Scouting new
art, the Californians had run into David Herbert, another young dealer

and a friend of Blum's. Herbert, who knew Warhol partly through the gay network and partly through the art world, urged Hopps and Blum to go see Andy's paintings. Hopps knew about Warhol, but only as a fashion illustrator.

Andy agreed to meet them at Serendipity. "It wasn't my kind of place," recalled Hopps. Then they took a taxi "to that incredible big place he had. We go in and climb the stairs and it's just *weird*: the barbershop pole, the gumball machines, the carousel horses, God knows what all." The living room floor "was just awash with endless fanzines and magazines, pulp stuff, fashion magazines, movie stuff, you practically couldn't walk around for tripping over it. I hadn't seen such an array of magazine printed matter. Things were neat except for that." To Hopps, Warhol "was like some strange, isolated figure in his laboratory, who seemed to have removed himself from everything that was normal."

It was virtually the only time that Hopps, who would see Warhol often in the coming years, would experience a talkative Andy. "Every remark I made was challenged: 'Oh, you really think so? Why is that?' There was a kind of funny, bitchy edge. . . . It was as though we had to pass a number of tests." When Hopps and Blum mentioned that the Ferus Gallery was in West Hollywood, Warhol got excited. He talked at length about Rauschenberg and Johns. "He was fascinated by both of them, absolutely, and queried me about them: Did I know them? What did I think of their work? He clearly had them on his mind, both of them."

Finally, Warhol brought out his work: "these amazing paintings," said Hopps, who recalled, among others, *Dick Tracy and Sam Ketchum* and one of the *Before and Afters*. Hopps was struck by the constant yawing between two styles: one stark and hard-edged, almost devoid of Abstract Expressionist brushwork; the other full of drips, brushstrokes, and other compromises with New York School painterliness. This was one of the big differences between Warhol's first Pop paintings and Lichtenstein's: the latter had taken the plunge into the future. As admiring of Warhol's work as he immediately was, Hopps had the feeling that Warhol "didn't have something he was really ready to put out into the world."

Warhol brought out another painting, an extremely large picture of Superman "shooting through the air," said Hopps, "carrying Lois Lane in his arms. Very, very beautifully done, and it never surfaced again. We see this thing, it gets rolled up, and that's the end of it, never to be seen."

Warhol took his guests downstairs to meet his mother, who made everybody tea. Julia would soon stop being routinely introduced; Andy had apparently come to recognize that she, like Nathan Gluck, was a potential embarrassment. Warhol was still handing out his 1950s promotional books—he gave Hopps and Blum "a couple of those goofy books," Hopps remembered. "*Twenty-Four Cats and One Blue Pussy* or whatever."

Hopps was intrigued by Warhol's work; Blum was unimpressed. "His tack didn't really interest me, although I found him completely engaging. He sat and chatted, really interested in the art world, and really bright and wonderful to talk to, much more revealing than he was later. He said what he felt about things." Warhol was highly informed about the art world: "He knew exactly who the players were. He liked the Green Gallery, whose artists then included Richard Smith, Mark di Suvero, George Segal and Yayoi Kusama, but his focus was Leo [Castelli]. He adored the people Leo was showing, he wanted to be associated with them."

In May, a Warhol illustration appeared in the Girl Scouts magazine *American Girl*. On the contributors page, Warhol's biographical blurb identified his "great loves" as travel, painting, Siamese cats, and "collecting modern art and American junk." The cats were gone and Warhol hadn't traveled since the 1956 trip with Lisanby, but the most curious untruth was the final item: "Andy is working on an experimental movie." Was this pure disinformation? It must have been—when he picked up a movie camera two years later, Warhol's helplessness was that of the absolute beginner.

Roy Lichtenstein had finished a dozen comic-strip-style paintings when his colleague Allan Kaprow telephoned the Castelli Gallery on

Roy Lichtenstein (left) *and James Rosenquist* (center) *with Ivan Karp*

Lichtenstein's behalf. Kaprow knew Castelli's new right-hand man, an up-and-coming figure in the art world named Ivan C. Karp.

Pop art would probably not have taken off the way it did without the participation of Ivan Karp. He was a pure Pop person, someone almost preternaturally caught up in the exhilaration of the time. Within a matter of months Karp discovered three of the essential, if not *the* three essential, Pop artists: Lichtenstein, Warhol, and James Rosenquist. Karp talked Leo Castelli into accepting Lichtenstein and, eventually, Warhol; he wasted no time in introducing the two artists to the collectors, and he explained their work to the media. "Ivan and [gallerist Richard] Bellamy were probably the two most astute non-producing people," observed the sculptor John Chamberlain. "They were almost artists themselves, in how they looked at something."

Karp's job title—alternately director and manager of the Leo Castelli Gallery—doesn't begin to capture his cultural impact in the early 1960s. By this time the Castelli Gallery was the most closely watched in New York, and Karp was chief talent scout, house theorist, greeter, bouncer, and interference-runner for the boss. Outside of his gallery

job, Karp wrote occasional but influential magazine pieces (he began his art world career as the *Village Voice*'s first art critic) and lectured widely. He found the time to write satirical novels, one of which, *Dooby Doo*, won some attention, and he was founder, director, and essentially the entire staff of the Anonymous Arts Society (originally named Rubble Without Applause), which salvaged hundreds of architectural ornaments as New York's older buildings were demolished.

Karp had his own highly declamatory, verbal style, a flow that he spun out of sheer antic pleasure, half laughing at his improvised solos, all polysyllables and baroque construction, parentheses within digressions. He was an intellectual *tummler*—a stirrer-up, a provoker of new ideas—part critic of insight, part Broadway press agent. "People came in just to hear Ivan talk," recalled Connie Trimble, who managed the office.

There was an innocence to Karp: Trimble remembered him returning to the gallery after lunch one day, circa 1962, and informing everybody that his new friend Andy Warhol had taken him to a "really decadent" place called Serendipity. Karp's heterosexuality curtailed his friendship with Warhol in a way that the worldlier de Antonio's did not: "Andy never included his friends from the gay world in the social events we had together. Our relationship was about making, exhibiting, and loving art." In any case, Karp preferred to be left in the dark about Warhol's personal life.

Karp's verbal showmanship was a trait he shared with many self-educated intellectuals. He was, in his own words, "an autodidact, strictly that," a high school dropout from Flatbush raised under respectably threadbare Jewish circumstances. The Depression was "a very strenuous interval"; when he got out of the air force in the late forties, he was "a wastrel, a bohemian. I sat in Washington Square Park and read Henry James." After working at the Hansa and Martha Jackson galleries in the mid- and late fifties, he was hired by Leo Castelli in 1959. Castelli's wife and business partner, Ileana, had finally abandoned both roles after enduring Castelli's womanizing for years, and Leo needed a new lieutenant.

With Trimble, Karp served as a buffer between collectors and their boss. Not surprisingly, he was a great salesman. The graphic designer Marcus Ratliff saw him at work in the mid-sixties: "I had a number of Oldenburg drawings. I told Ivan and he says, 'Great, bring 'em over, I know just what to do,' and in three minutes on the phone, he had the whole bunch sold." As much as Karp loved the sales game, he also loved—in the spirit of anarchy and out of an intellectual's ultimate scorn and contempt for business—to give the game away. (When Warhol created wooden, silk-screened facsimiles of Brillo cardboard boxes in 1964, a well-heeled prospective visitor to Castelli once asked Karp, "What are you getting for the Brillo boxes?" "Whatever we can," said Ivan.)

Switching one day between the classical stations WNYC and WQXR, Karp heard a sweet song that fascinated him. It was "Hey Paula," a big 1961 hit. "I thought, 'What in God's name is this? This is metaphysical music.' I couldn't believe the dumbness and the beauty of it. I didn't listen to classical music for two years."

As far as Karp was concerned, early-sixties rock and roll and Pop art were part of the same aesthetic configuration. Both, he felt, "had to do with cleansing away all the traditional, prevailing sensibilities in the arts. The simplicity of the rhythms, the simplicity of the lyrics—that's where rock's confluence with Pop lies. Both are about innocent simplicity, openness to possibilities." Lecturing on Lichtenstein and Warhol, Karp spun Four Seasons records. He was the ringleader of a gang of artists and related characters—Warhol, Lichtenstein, the English painter Richard Smith—who made pilgrimages to the Brooklyn Fox Theater for the concerts put together by the New York deejay Murray the K, package shows featuring the day's top rock-and-roll and rhythm-and-blues acts.

Unlike many dealers, Ivan Karp happily forsook the Castelli Gallery's affluent environs to forage through cold-water flats and studios, prowling for new art. He might visit a half-dozen artists in a single day, bringing other art world functionaries along, forging innumerable

links between artists, dealers, and art buyers. "It was an incredibly rich thing for Ivan to have done," recalled Trimble, "hooking up Leo to this loft world" of young post–Abstract Expressionists. "Leo and I went to Brooklyn, we went to Queens, we went to Staten Island if we'd seen some good slides," according to Karp. "In the early years Leo was willing to do that."

The artists came to Karp, too. Allan Kaprow, whom Karp knew from the Hansa Gallery, phoned him one day. "Allan said there was a colleague of his doing very peculiar work and would I speak to him. 'Allan,' I said, 'you know I speak to everybody.'" His friend—Roy Lichtenstein—would be at Castelli's that afternoon, said Kaprow.

Lichtenstein's first Castelli visit left an indelible impression on Karp. "He was standing there at the top of the stairs, at the entrance to Leo's gallery, with four paintings. One, for sure, was the man in the pilot's seat"—*Emeralds*, based on a Buck Rogers comic strip—"and there were two other cartoony pictures. I said, 'Holy Good God, what in God's name is this?' I said, 'Hey God Almighty, this is going to be very destructive, this kind of thing! Would you leave a couple of these for me to show to Leo, because they are really strange stuff!' I showed them to Leo and he said, 'Ivan, I'm not sure an artist is allowed to do this kind of thing.' I said, 'Why not? Jasper does flags. So this guy does cartoons.' Leo said, 'They certainly are bright.' I said, 'Yeah, they are very bright. They're fierce. Let's leave them around the gallery and see how we warm up to them.'"

Feelings were mixed, at best. "Everyone at the gallery considered the Lichtenstein kind of wicked," according to Connie Trimble. The paintings continued to confound Castelli, who, along with Karp, showed them to visitors as a sort of Rorschach test. Marcel Duchamp came in, regarded them, and approved vigorously. Jasper Johns disliked them intensely, as did Rauschenberg. To Karp's mind, "there was a climate of hostility. The work was brash. There were no currents of sensibility evident. There was no evidence of the artist's quivering hand."

Over the summer, Lichtenstein welcomed a stream of art world visitors to his house, including Ileana Sonnabend, now remarried and a dealer in Paris, who bought three paintings; the Bell Labs engineer and frequent artists' collaborator Billy Klüver, who bought one; and Karp, who kept the painter's spirits up despite his boss's unwillingness to commit himself. Lichtenstein worked on, his paintings stacking up in the Castelli Gallery's back room.

It took a lot to pry Andy Warhol loose from Manhattan. The wealthy gay socialite and art collector Henry McIlhenny was one of the few who could occasionally lure him away. "Henry would take over a hotel in Bucks County for the weekend, or something along those lines," recollected John Mann, "and Andy thought that was just fantastic. He lapped that up. It had to be something good."

But it took something far more magnetic than Henry McIlhenny to get Andy on a train from Pennsylvania Station to Philadelphia on July 20: Cecil Beaton, whose feet Warhol dearly wanted to draw, was McIlhenny's houseguest. Andy caught Beaton napping. Returning to New York the same day, Warhol celebrated his giddy coup at Serendipity with Orlan Fox, a Columbia University student and W. H. Auden's lover; Warhol would have known Fox through Ted Carey's brother, Gary, then at Columbia.

Beaton's weren't the only feet Andy pursued with scatterbrained zeal in the summer and fall of 1961. Like some fey big-game hunter he stalked opera diva Leontyne Price—and on November 11, he bagged her after elaborate negotiations, employing as the go-between Gene Hovis, a chef who sometimes used the surname Peterson ("that Peterson woman," his friends called him) and who happened to be in with a number of performers.

But as Andy's social connections improved, his financial situation deteriorated. In 1961 Warhol's commercial art earnings dropped because of his concentration on art. Still, he cleared almost $57,000,

the equivalent of a mid-six-figure income today. The I. Miller years were over, Miller having decided to advertise with photographs. Andy's top client was now Bonwit Teller, for whom he did more than $10,000 of work (almost as much as Miller had paid him). He also drew illustrations for *Harper's Bazaar*, Blue Note Records, Tiffany, *Dance Magazine*, *Life*, and *Glamour*.

Although Andy had a few new friends, such as de Antonio and the art critic Gene Swenson, he still spent most of his time with his old crowd. Through Jarry Lang, famous in the subculture for the sequinned costumes he donned at drag balls and musicales, Andy had developed a taste for rock and roll by the end of 1960. Its teen idols—Bobby Rydell, Frankie Avalon, and Fabian—were a variation on the ingénues and starlets he worshipped in Hollywood fan magazines.

Lang worked at Elvis Presley's publishers, Hill and Range, and plied Andy with 45s. Andy always begged for more; he loved them so, he told Lang. Swenson, an early 1961 visitor to 1342 Lexington, remembered hearing Johnny Tillotson's "Poetry in Motion," a big current hit. According to the publicist Danny Zarem, who met Warhol later in the year, "We all went to Andy's on Sunday afternoons because he would get the little 45s that disk jockeys had. He collected them. My friend Jimmy Yorke, or Ted Carey, said, 'Let's go to Andy's,' because he had all this music we didn't know about."

But Warhol's big obsession was his appearance. Despite his self-consciousness, he was always eager to be photographed. A big exclamation point punctuates the date September 17 in his appointment book. Andy was having his picture taken, and photographs were proof of visibility, literal markers of his presence and progress. (As he once said in an interview, "It's too hard to look in the mirror. Nothing's there.") The resulting series of photographs taken by John Ardoin (later the classical music critic for the *Dallas Morning News* and Maria Callas's biographer) reveal a blazered and buttoned-down Andy posed outside of Serendipity.

Ardoin had a friend named John Kloss, a ladies' lingerie designer,

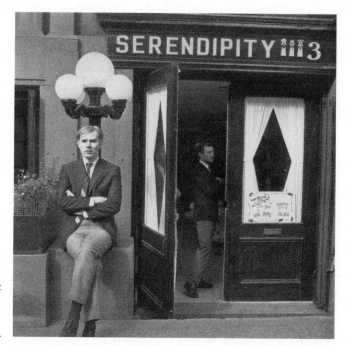

*Andy in front
of Serendipity,
1961*

who lived on Coenties Slip. Kloss's lover Bobby Clark was a young
painter who had changed his surname to Indiana. One evening before
1961, Ardoin had showed up at Kloss's loft with Andy. "Warhol cer-
tainly did not come to meet *me*," recalled Indiana—he was just Kloss's
roommate—but of all those present, it was Indiana who would become
an important early sixties co-conspirator of Pop art with Warhol. The
two painters struggled together to find a dealer.

The fact that Warhol was being introduced to other successful
gays was an indication of his acceptance into that world. The painter
Ellsworth Kelly, who met Warhol sometime before 1960, knew him
not as an artist but through the gay grapevine as "someone who was
interested in art." He rememberd seeing Andy at the opening of
the Guggenheim Museum in October 1959. "Andy was dressed in a
little dark suit and a white shirt and tie, very cute. Afterwards, some
people—it may have been Robert Fraser, later a well-known English
dealer and scene-maker—were talking about going to a leather bar,
and Andy said, 'Oh, can I go, too? I want to go!'"

But social acceptance among the gay elite wasn't enough. Andy was becoming impatient. Although he was, after all, essentially a beginning painter, only months after starting to paint in earnest, he was putting pressure on himself to get a gallery.

One Saturday, most likely in late September, Ted Carey, John Mann, and Andy Warhol wended their way up Madison Avenue through the 60s and 70s, then stopped in at the Castelli Gallery. Karp greeted Carey and Mann by name; he didn't yet recall the third man, "the man with the strange white hair," as Karp called him, as someone he had seen before in Carey and Mann's company.

As Ivan often did with Carey, whom he knew and liked, he invited him into the back room. "I've got something I think you'll be interested in," he said. The others followed. As Karp recalled, the man with the strange white hair said nothing; Carey and Mann did the talking. Reaching into the racks, Ivan took out Lichtenstein's *Girl with Ball*.

"The man with the strange white hair said, 'Ohhh!'" according to Karp. "He went, 'Ohhh! I do work just like that!'" in a small, hurt voice.

"There's no question that Andy was absolutely knocked for a loop, floored," according to Mann. *Girl with Ball*, so uncannily similar to his own paintings (Lichtenstein's was based on a newspaper ad for a Poconos resort), confirmed that he was on the right track—wasn't it sitting right here in the Castelli Gallery, center of the universe? Yet Lichtenstein had run him off the road, pre-empted him—and was going to get the credit.

Andy's sense of victimization kicked in immediately. Lichtenstein had stolen his ideas, he complained as soon as he and his friends were on the sidewalk. Evidently under the misapprehension that Lichtenstein had done window-display work on 57th Street, Andy ranted about how "that window dresser" had seen his paintings in Bonwit Teller's and robbed him.

In fact, as powerful as some of Warhol's paintings were, they were tentative and incoherent compared to Lichtenstein's. "Andy saw that

the work he'd been engaged in wasn't really going to make it," recalled Mann. Even if Warhol hadn't conceded that Lichtenstein's paintings were, as Henry Geldzahler later put it, "harder and cleaner and more what we think of as Pop," the fact was, Lichtenstein was being considered by Castelli and Andy wasn't.

The Castelli Gallery's first show of the fall season was always a group exhibit, a chance for the artists to show their summer work. On September 22, new paintings and sculpture by Johns, Rauschenberg, Stella, John Chamberlain, Lee Bontecou, and the others went up. The show had already been hung when Karp persuaded Castelli to add *Girl with Ball*. The first showing of Lichtenstein's comic book blitzkrieg created a major disturbance among Castelli's artists.

"That painting was considered an abject intrusion," Karp recalled. "A lot of very unpleasant things were said. [Abstract artist and car buff] Sal Scarpitta was the only one, I remember, who said, 'Hey, this is a kind of strange little occurrence here. This is dead-center Americana.'" Considering the antipathy of Johns and Rauschenberg ("Leo paid total homage to them," according to Karp; "if they despised something, he would not show it"), it's surprising that *Girl with Ball* was ever hung. Once it was up, Karp had to argue to keep it there. "'I think maybe we should take it down,' Castelli brooded. 'Leave it up, Leo,' I said, 'it'll only generate more creative energy.'" Not only did *Girl with Ball* stay up, but it was bought by architect Philip Johnson. Meanwhile, several dealers offered to show Lichtenstein, who was trying to use their enthusiasm as a bargaining chip with Castelli.

Ivan Karp's curiosity had been piqued by his initial encounter with Warhol, and shortly afterward he visited 1342 Lexington, which he described as having "a kind of dense Victorian atmosphere." Andy took pains to hide all evidence of his commercial work. "As long as he didn't know anything about me, there was no sense bringing up my advertising background," Warhol later wrote—it had already hurt him with Johns and Rauschenberg. Julia wasn't as easy to hide: "There was

a noise down below," recalled Karp, "and Andy looked at me. 'Oh,' he said, 'that's my mother. She lives down there, she cooks for me, she does all kinds of things.' I said, 'Don't you want to introduce her?' He said, 'Oh, she doesn't want to be bothered.'

"Physically, he was singular. The incredible whiteness of his complexion. Just a shock of hair on a white face with a rough complexion. He was not that slender at that time—soon after that we started going out to eat, and he had a wonderful appetite." Karp couldn't help but notice that his host kept to the shadows; it made him uneasy until it dawned on him that Warhol was acutely uncomfortable about his appearance.

Meanwhile, the record player was spinning the same rock-and-roll song over and over, so loud that Karp had to crane forward to hear Warhol's murmurs. Karp began to bop and shimmy to the beat. Though a little taken aback by Karp's dancing, Andy liked it. In fact, he liked Ivan right away.

"When I walked into his studio that day," Karp remembered, "he didn't know whether what he was doing was art or not." Karp's first impression was of "a lot of color and vividness and lots of imagery. There must have been twenty or thirty paintings against the wall." *Nancy* immediately intrigued him, as well as a *Dick Tracy* and a *Before and After*. (Andy was apparently worried that his nose-job picture might be construed as anti-Semitic, and asked Karp's opinion.)

Karp quickly saw that the work fell into two groups, hard-edged and partly dripped. "I was being quite arrogant, and I said to him, 'Why do you make these splashes?'" Andy replied that he was worried that audiences wouldn't accept something so pointedly unembellished. Pointing to the *Nancy*, Karp said, "'This is a wonderful painting, but are the drips genuine?' He said, 'Oh, but you have to drip, don't you?'" Lichtenstein didn't, Karp reminded him. A few days later, Karp received a package tied with a fat red ribbon. Inside was the *Nancy*, inscribed, "Andy Warhol Oct 61 to Ivan Karp, Thank you for the stone." (Ivan had given Andy an ornamental carving from his Anonymous Arts Society scavengings.)

Something was in the air, as Karp was one of the first to intuit. It was what he recognized as a "sitting-up-in-bed kind of thing"—a movement coalescing before his eyes. Shortly after his visit to 1342 Lexington, he was eating at Sloppy Louie's restaurant on Front Street when a young man approached, asking, "Aren't you the guy who saves the old stones from the buildings?" Karp said that he was. "I have four beautiful old stones," the fellow volunteered. "Would you like to have them? I could use the money." He brought Karp to his apartment, which turned out to be a painter's studio. On the wall was a largish painting whose poetic surrealism was at odds with the banality of its three vertically stacked images: an unappetizing mass of spaghetti, a woman whispering in a man's ear, and the front grille of an old car. The artist was James Rosenquist, and he had just titled the painting: *I Love You with My Ford.* Karp couldn't believe it. "Here was this guy with these paintings just like the others I was seeing. I felt like I was going berserk, I was actually tremulous from day to day. I remember writing in my journal, 'I can't believe what's happening!' I felt a sense of *incredible excitement* within the compass of my given life at that point. 'There's continuity here!' I yelled at people, 'these artists don't even know each other! It's got to be an atmosphere, a national atmosphere!'"

Karp was ecstatic, but for Warhol things had gone from bad to worse. In October, Roy Lichtenstein joined the Castelli Gallery and was given a $400 monthly retainer and a show, scheduled for February 1962. Lichtenstein, Rosenquist, Tom Wesselmann, Jim Dine, Claes Oldenburg, Robert Indiana, Richard Smith—everyone, it seemed to Warhol, was being noticed but him.

A $50 check dated November 23, 1961, in the archives of the Andy Warhol Museum reveals a turning point in the history of modern art—and suggests that Warhol's breakthrough in fact involved a double appropriation.

Unable to reroute himself after the shock of seeing the Lichtenstein a month later, Andy paced back and forth in the former library at

1342 Lexington. He racked his brain, pestering Mann and Carey for a solution. He was "absolutely desperate," according to Mann. A passage in *POPism* belies his agitated state of mind. With a breeziness he was unlikely to have felt, Warhol writes: "It was on one of those evenings when I'd asked ten or fifteen people for suggestions." Ten or fifteen people? Beneath the glossy surface of *POPism's* cool tone lies the sense of someone spinning out of control.

That afternoon, Muriel Latow had gotten a phone call from Ted Carey. Andy was driving him (and Mann) nuts, said Ted. He wouldn't stop asking them where Muriel was; he wanted to pick her brain. In a rotten mood herself—her gallery was going out of business—Latow joined Ted and John for dinner. "Then," she said, "we went to that gloomy, gloomy house, up the stairs and into Andy's rear studio, and he said to me, 'Just tell me what to paint.' I told him it would cost him fifty dollars."

Latow insisted that he write the check first. "Andy sort of hovered and moaned in his miserly, dithering way," according to Mann, but he eventually produced his Andy Warhol Enterprises checkbook, scribbled a check for $50 to Latow, tore it off, and handed it to her.

"Give me a fabulous idea," he said.

As Latow recalled, she asked him to think of the most common, everyday, instantly recognizable thing he could. Something like a Campbell's soup can—in fact, why not a Campbell's soup can? He could paint it in various permutations. His one question, Latow said, was "How big?" Latow proposed that they measure her height—she was five feet, seven and a half inches—and told him, "Make them as tall as me."

Mann's recollection of the evening was very different from Latow's. Muriel, he said, began by feeling Warhol out, asking him what he liked and, at one point, what he disliked. According to Mann, "If you asked Andy a question like that you got a pretty flippant answer, something off the top of his head. And as I recall, he said, 'I hate grocery shop-

ping.'" As it turned out, Mrs. Warhola often asked Andy to run across the street for groceries. "So Muriel mentally took him into the A&P, down the aisles. It was all very languid and flip on Andy's part. Before long, they got to Campbell's soup and Andy said he hated that, too. He said that his mother made it every day for lunch and after all those years, it was like, 'Oh, Mom—*again?*'"

Which particular Campbell's soups, Latow asked, did Andy dislike? All of them, he said. In that case, suggested Latow, why not run over, buy one of each and paint them all? According to Carey, "The next day Andy went out to the supermarket . . . and he [bought] a case of all the soups." But, in fact, Warhol, as was his practice, painted the cans not from life but from existing images: a magazine ad, a piece of Campbell's corporate stationery that he obtained, and the studio photographs of Ed Wallowitch.

Warhol's first famous subject did not immediately strike him as an epiphany. As much as anything, his decision to paint the soup can reflected his faith in Muriel Latow. He chose the subject neither out of nostalgia for his childhood nor because it embodied the commonplace reality he presumably loved. Warhol was clever, but in a practical, strategic sense—"peasant cunning" is the phrase one continually hears from his friends and acquaintances—and would have been quick to appreciate the Campbell's logo as a classic piece of graphic design. The soup can was an ideal solution for Andy's ambivalent sensibility. It fused his love of Americana—the Campbell's label had a folk-arty quality to it—but blown up and hung in an art gallery it would also be provocative enough to shock and draw attention to himself as an avant-garde artist. (And it didn't hurt that the image of the can itself also recalled Jasper Johns's Ballantine ale cans shown at Castelli in 1960.)

Latow remembered suggesting another subject to Warhol: money. Drawing pictures of money was not a new subject for Andy; Latow's suggestion may have simply rekindled the idea. In a 1978 interview, Ted

Carey recalled Latow telling Andy to paint both soup cans and money, and on the same evening. Warhol's *POPism* account echoes Carey's—Andy interviewed his old friend for the book, and probably based his account on Carey's—but demotes Latow to an anonymous "lady friend" who suggests only money, not the soup cans (Andy doesn't, of course, acknowledge that money changed hands). Warhol's well-known candor about his practice of canvassing for ideas was selective—that he also *paid* for them was more than he cared to reveal, as was Muriel Latow's part in the birth of the soup cans. By the late seventies, when *POPism* was put together, the cans were perhaps too canonical, too fundamental to Andy's self-image, for him to cede credit in their inspiration.

Not long after Warhol finished the Campbell's soup paintings in 1962, Muriel Latow left New York for Greece, where she lived until the junta of 1967, when she moved to England. She metamorphosed into Roberta Latow, author of more than a dozen steamy romance-and-intrigue novels, and died in 2003.

One of her books, *Cheyney Fox* (1990), draws on her art world experiences. The raven-tressed title character is Latow herself, Timothy Hennessy is "Christopher Corbyn," Ted Carey and John Mann are "Tom and Paul," while Warhol and other celebrities appear as themselves. An unabashed potboiler, *Cheyney Fox* nevertheless rises above the genre at several points, such as Cheyney's encounters with Warhol, "one of society's natural aliens" who "sighed pathetically when Cheyney shook his limp white hand." Visiting his "house filled with things, and things upon things," Cheyney exclaims, "'Andy, you live in a warehouse.' Puzzled, he looked around as if seeing it for the first time." At Cheyney's gallery, Warhol "bought a painting and went on endlessly worrying whether it was a good investment or not."

He takes Cheyney, Tom, and Paul on a frenetic shopping spree whose details could hardly have been made up: "the constant reassurance he needed that each purchase was a bargain . . . the telephone calls to his mother to accept the parcels stuffed into taxis and vans (one item even

goes by motor scooter) so that everything would be waiting for him at home." At Claes Oldenburg's studio, Andy keeps "taking Cheyney on the side and saying, 'I could have done that, and it's going to make him famous. Is that what I should do? A cupcake, maybe? Should I buy one? If I don't and he becomes famous? You're a dealer, would you buy one? Why don't you buy one? Why is Tom buying one?' He seemed amazingly confused and unhappy." The Warhol passages, though jaundiced, have the ring of truth, down to Andy's favorite exclamation in the early sixties, a drawn-out "Faabulous!"

With Campbell's soup, Andy hitched his wagon to an instantly recognizable icon. Campbell's, with its celebrated turn-of-the-century label, occupied a high level of recognizability as a staple of the American kitchen and supermarket shelves. Aside from its aura of tradition, the soup can contained a wealth of graphic virtues: its simplicity of shape, the red-and-white banded label, and the gold fleur de lis. It was the first product that Warhol painted in color, and with color Andy upped the ante—he was moving into the mainstream.

There are almost four dozen Campbell's soup canvases in all (and one sculpture, a sort of prototype of the 1964 Brillo boxes). They were painted between the end of November 1961 and March 1962, if not later. Georg Frei and Neil Printz, the editors of *The Andy Warhol Catalogue Raisonné*, divide the soup can paintings into three categories: small, single-image "portraits," including the famous *32 Campbell's Soup Cans* series; three big-grid paintings of soup cans arranged in rows, one of two hundred cans, two of one hundred; and the dozen and a half naturalistic "still lifes," less severe, more conventionally pleasing than the rest. *Tomato Rice*, complete with cross-hatches and expressionist drips, was undoubtedly the first Campbell's canvas. It bears a strong resemblance to an earlier painting, *Del Monte Peach Halves*, in which Andy experimented with another household brand, but must have soon realized Del Monte lacked the iconic stature of Campbell's.

If not quite as confrontational as Lichtenstein's comic book frames, the Campbell's soup cans were conceived as an act of irreverence in the same spirit as Duchamp's mustachioed Mona Lisa. "Fools!" the gesture admonished the Ab-Exers and their champions, "this ironic little can will undercut all your high seriousness, your histrionic paint splattering, your Sturm und Drang posturing!" "With Johns's 1958 Castelli show," said William Wilson, "a starter's gun seemed to signal the beginning of a race among artists in varieties of aloofness."

But Andy slyly turned the tables on this elitist point of view, espousing what he was supposed to despise. While he well understood that offering a Campbell's soup can as a work of art was an obvious piece of irony, he also clearly saw it as a glorification of the commonplace. The deadpan presentation of a supermarket product in an art gallery had the additional twist of blurring the line between art and commerce. Art galleries deal in groceries, said the soup can, an argument picked up and run with by Allan Kaprow in 1989: "In offering for sale endlessly reproducible images of Campbell's Soup Cans or Brillo Boxes, [Warhol] underlined art's mercantile role and implicitly undermined the traditional artist's romance of spiritual purity."

Warhol's private tastes may have been those of an unreconstructed fifties aesthete, and he may have once drawn shoes for a living (and plenty of other commodities), but he poeticized, *negated* their everydayness. His Pop style, exemplified by the soup can, while widely considered a purely calculated move—a last-minute leap onto a bandwagon that was threatening to leave without him—in fact synchronized perfectly with his unabashed love of consumer culture.

The soup can, so brazenly and uncritically displayed by Warhol, revealed a genuinely American underworld of brash energy and garish beauty. It was, as philosopher/art critic Arthur Danto writes, a dazzling reversal of values: "standing at an intersection in some American city, waiting to be picked up," he recalls, "there were used-car lots on two corners, with swags of plastic pennants fluttering in the breeze and brash signs proclaiming unbeatable deals, crazy prices, insane bar-

gains. There was a huge self-service gas station on a third corner, and a supermarket on the fourth, with signs in the window announcing sales of Del Monte, Cheerios, Land O' Lakes butter, Long Island ducklings, Velveeta, Sealtest, Chicken of the Sea. . . . The sounds of raucous music flashed out of the windows of automobiles. I was educated to hate all this. I would have found it intolerably crass and tacky when I was growing up an aesthete. . . . But I thought, Good heavens. This is just remarkable!"

If middle- and upper-class artists and critics were ambivalent about, ironic toward, capitalism's shiny output, it was because they'd always been in a position to take for granted its existence in their lives, its easy accessibility. Warhol wasn't ambivalent in the least about mass culture or products. "[T]he other pop artists *depict* common things," said Ivan Karp in 1964, "[but] Andy is in a sense a victim of common things: he genuinely admires them," with an unabashed blue-collar ardor, whether movie stars or the dizzying contents of supermarket shelves.

According to Andy's friend, the art critic Mario Amaya, as far as the New York gay community was concerned, Andy's use of the Campbell's soup can was pure camp. But the idea of camp as a means of sending subversive messages was not restricted to homosexuals. The technique had been a mainstay of Modernism. The displacement of the commonplace into other, bizarre contexts was an integral ingredient in both Dada and Surrealism; furthermore, the shock tactics of Surrealism would eventually drive advertising's startling juxtapositions of images and text.

Critics who complained of Pop's deadpan inscrutability or its apparently mindless endorsement of consumerism didn't get the joke. Andy saw the images he took out of the newspaper as goofy and inane, ludicrous examples of American mercantile mentality gone mad.

Pop was a conversion experience for Andy as it would be for those who saw his paintings. Once you "got" it, your way of seeing the world changed; previously invisible objects zoomed into focus. Detergent

boxes danced off supermarket shelves, ads turned into commercial Surrealism before your eyes, and comic strips came to giddy life.

Remarks about the beauty of the everyday would begin to turn up in Andy's speech in the first half of 1962, and were common thereafter: "Pop art is a way of liking things," "All Cokes are the same and all Cokes are good," and so forth. Pop was a pose that he adopted in the sense that Pop *is* a pose, a put-on, an attitude that's always in quotation marks. It became second nature to him.

By December, Warhol was back at work. Ivan Karp was promoting Andy so enthusiastically that he was repeatedly asked, "If he's so great, why don't *you* take him?" But the Castelli Gallery had already passed. Nevertheless Karp took his boss to Warhol's house in December. Not only did Castelli consider the work too similar to Lichtenstein's paintings (for which he was still catching flak from his other artists), but he was "plainly discomfited," recalled Karp, "by Warhol's manner." Castelli bought two small Campbell's soup cans, but it was only to soften the blow. He did not want this artist. Fortunately, however, the third and most influential of Andy's magic helpers was about to come onstage.

As many New York art world regulars had done since before World War I, Ivan Karp summered in Provincetown, where he ran a seasonal gallery. In the summer of 1960, a chubby young man with an oval face, no chin to speak of, and an air of entitlement had turned up at Karp's cottage. His name was Henry Geldzahler. Geldzahler had just been hired out of Harvard's art history PhD program as a $5,000-a-year curatorial assistant at the Metropolitan Museum of Art. After a few pleasantries, he got right to the point. "Tell me everything you know about the art world," he asked the astonished Karp.

As amused as he was taken aback, Karp found the fellow's way of laughing at his own pretensions disarming. Karp submitted to a half-hour debriefing, and as Karp would say more than forty years later, "I brought Henry into the world."

To dramatize how influential Geldzahler was in the art world of the time, Peter Schjeldahl wrote, on the occasion of Geldzahler's death in 1994, "Imagine the art world of the last thirty years as a party. There, near the center, is Henry." Geldzahler's time was the mid-sixties, and, as much as anyone, he embodied it. For a few years, the attention of the mass media turned what had been a tiny, adamantly bohemian community into the glamorous, high-stakes, international *art scene*, suddenly as highly self-conscious and almost as trend-driven as the fashion world. In this milieu Henry Geldzahler created the impression of being, and to a great extent really was, the scene's most

Henry Geldzahler

effective operator—while still a very young man. "I didn't think of any artist as young," he said years later, "because they were all older than I was."

Henry and Andy were introduced by Karp, but they probably would have found each other anyway. For five years, from 1961 to 1966, Henry and Andy were best friends. The baroquely verbose Henry and the reticent Andy were like a pair of characters straight out of a Pinter play; the game the two of them played in public that of ventriloquist and dummy.

Geldzahler's early- and mid-sixties jobs—assistant, then associate, curator of American paintings and sculpture at the Met—was, like Karp's, tangential to his self-appointed role. He was "the connection, the affable fellow who links the multiple and widely separated circles of the world of art: artists, dealers, ladies' groups, collectors, museum trustees, jet-setters," proclaimed a *Life* profile in 1966. He could "find a gallery for a painter, a museum for a gallery, a critic for a museum and an audience for a critic," Frances Fitzgerald wrote a year later in the

Herald Tribune, deeming Geldzahler's influence surpassed only by that of Clement Greenberg and the Museum of Modern Art.

"When we see him coming around the corner," said a leading sixties dealer, "we practically roll the red carpet right down to the block and wait on our knees at the end of it." The same might have been said of Karp. But there was nothing pompous about Henry or Ivan. Both conveyed the same contagious energy, the sense that everything was inherently connected—and that they were the ones connecting it.

Cultivated but also hip—a pot smoker who, by 1965, had experimented with a wide range of mind-altering drugs—Henry was alive to the next new thing, not only in art but in the realms high or low beyond it. "Henry was fun, he was bubbly," according to Patty Mucha (Patty Oldenburg in the sixties, when she was married to the Pop artist). "He looked like a little baby smoking cigars. He taught me Jewish jokes— he had to explain them to me [a Milwaukeean]. He'd say, 'My son the doctor . . .' and I didn't know why that was funny."

Geldzahler had the plummy, neo-Oxonian drawl of the upper-class New Yorker, even though he was only a generation removed from the Polish ghetto. An extremely bright child with a low boredom threshold (as an adult he was diagnosed with ADD), he was the boy with preternatural connectivity. Geldzahler was fond of telling how, at fifteen, he had gone to a show of Arshile Gorky's paintings, "stayed three hours, came home, threw up, [and] slept for eighteen hours," after which he resolved to become a curator. A curator! How many adolescents fantasize about becoming a curator? No matter that the story has a whiff of self-mythologizing about it, it was all part of Henry's charm. He had the peremptory self-confidence of a charismatic performer, but lacked the *Sitzfleisch* necessary to convert his engaging talk into written sentences. Christopher Scott, Geldzahler's lover from 1965 to the early eighties, made a project of helping Henry improve his pedestrian writing. Eventually they hit on what Scott called "Henry's belles lettres style," which skipped breezily from topic to topic. Yet had he been a

more accomplished intellectual writer, he surely would not have culti-vated such a fluid social personality—and as an academic theorist he would hardly have been much use to Andy.

"He was not deadly serious about all this," according to Karp. "Henry loved the physical world, he loved food and companionship, he loved his sexuality and he was immensely open about it. But Henry was a borderline intellectual. Henry was a surface character, he got a lot of respect that he probably wasn't worthy of." (It's hard not to sense in de Antonio's and Karp's hostility toward Geldzahler a smattering of jeal-ousy: each saw himself as the architect of Warhol's career.)

Calvin Tomkins, profiling Geldzahler for *The New Yorker* in 1970, observed that "never in his life has he seen any reason for being dis-satisfied with himself." Henry exuded such self-confident panache one wouldn't guess he spent a good part of his life in treatment for depres-sion. "Henry was *so* neurotic," according to Mark Lancaster, a young English art student visiting New York in the summer of 1964. "Terri-fied of everything, and at the same time never dreaming that anyone might suspect so. And spent his whole life running around keeping *up* with things. Wanting everyone to know that he knew stuff *they* didn't know." Lancaster remembered going into Downey's, a popular restaurant at the time, with Geldzahler, and sitting down facing out-wards, toward the other diners. "Oh, Mark," said Geldzahler, "let me sit there, people expect to see me here." On the other hand, he was not untroubled by feelings of fraudulence. In an essay on Warhol's 1964 film *Henry Geldzahler*, Henry acknowledged "that [the] one basic Persona in which I could be found was that of an infant emperor, full of self and delusions."

The picture of Geldzahler as a self-accepting gay man is of course oversimplified. His homosexuality, he wrote in a journal he kept when he was twenty-one, was "really rather revolting to me. . . . I am more and more convinced that I will soon settle down to a heterosexual existence. . . . Of course, there will always be some backsliding . . .

but like Alcoholics Anonymous I will have to learn that it is the first drop that is dangerous." Determined not to let his homosexuality circumscribe his vast circle of contacts, like many gay men of his time Geldzahler considered marriage. In 1958 he was engaged, if not entirely in earnest, to the artist Mimi Gross. Years later, after Gross's divorce from Red Grooms, Geldzahler liked to call himself her "first former husband."

Unlike Warhol, Geldzahler was able to laugh at his schlubby looks, which didn't deter him from a very active sex life. "Henry was a little plump, camp boychaser," in the words of John Mann. According to de Antonio, "[Geldzahler] ran a casting couch for attractive male painters. . . . He was looking at the work of young men every day. He chose choice morsels for himself." In photographs of the mid-sixties Factory, Geldzahler looks comically incongruous in his suit and tie, apple-cheeked and chubby amidst the emaciated stoners.

Warhol's and Geldzahler's relationship was platonic; neither was remotely the other's type. Warhol was attracted to tall, blond, slender WASPs; Geldzahler was short, fat, nearsighted, and Jewish. "Henry's men were all young and conventionally sexy," said Scott. "Henry was only interested in perfect bodies, guys with muscle tone." Nevertheless, Warhol could never have been as intimate with someone with whom he did not share a world of taste, presuppositions, prejudices, and unspoken judgments.

When Karp brought Geldzahler to 1342 Lexington, Andy was painting on the floor with the TV on and the sound turned down. The phonograph was blaring. Henry looked at Andy, Andy looked at Henry, and they immediately started laughing. "It just was magic," said Geldzahler; "we were on the same wavelength." The meeting would have occurred between late September 1961, when Warhol and Karp met, and February 19, 1962, Geldzahler's first appearance in Warhol's date book.

Many people were repelled by the decor at 1342; not Geldzahler. Warhol watched him register every item "almost as quickly as a com-

puter could put together the information," he recalled. Geldzahler mentioned the obscure painter Florine Stettheimer. The Met, he said, had her *Cathedrals* paintings in storage; would Warhol like to come see them? Instinctively Geldzahler had pushed the right button. Warhol was thrilled: "Anyone who'd know just from glancing around that room that I loved Florine Stettheimer had to be brilliant."

Actually, it was a pretty safe guess. Just as Warhol's decor amounted to a Rorschach for a hip sensibility, Florine Stettheimer's elaborate, stiffly painted pictures, peopled by weirdly elongated figures, and her set designs for Gertrude Stein's and Virgil Thomson's opera, *Four Saints in Three Acts*, had made her a cult figure. (As Wayne Koestenbaum has pointed out, there are similarities between Stettheimer's work, with its line-drawn, flat figures, and Warhol's fifties illustrations.)

Warhol and Geldzahler almost immediately became what Warhol described as "five-hours-a-day-on-the-phone-see-you-for-lunch-quick-turn-on-the-Tonight-Show-friends," telephoning each other at the start of every day, and again before going to bed. The conversations "were always basically Andy making me talk. He's a voyeur, by eye and ear, and he's really interested in hearing everything that goes on. . . . He had that quizzical puzzled innocent look and I remember he said, 'Oh, teach me one fact every day and then I'll really know a lot.'" Geldzahler's new friend with his faux-naïve manner may have struggled with language, but he was no simpleton, as Henry soon learned. Contemplating a row of early Dalí masterpieces, Andy turned to Geldzahler and said, "Gee, I wonder what he would have done if his watch hadn't melted."

Lots of time on the phone was spent gossiping and plotting Andy's next career move. The telephone conversations with Henry may on one level have been a continuation of the earlier gabfests with Lisanby and Ted Carey—but Geldzahler was also of immense practical use to Warhol. Geldzahler once said that all that he remembered from the early sixties was "running around to Elkon, Janis, and Castelli trying

to get Andy a show." The photographer Duane Michals, who found himself sitting in a cab between Warhol and Geldzahler after a party, remembered feeling "like I was leaving a political rally with a couple of ward heelers: 'Did you speak to Father so-and-so? He's the head of the Catholic vote.' 'Yeah, I got to him.'"

At interviews, Karp and Geldzahler were more than Warhol's interpreters; they were his stand-ins. Asked a question, Andy would nod to whichever of the two he'd brought along that day. If, impatient to hear from Warhol himself, the interviewer repeated the question, Warhol would indicate that he agreed completely with Henry/Ivan. "Once in a while," recalled Geldzahler, "he'd say yes when the answer was no. I'd say, 'When Andy says no he means yes.'" At the end of one radio interview, the interviewer thanked "Mr. Henry Geldzahler, Metropolitan Museum, for being with us today, and Mr. Andy Warhol." Warhol immediately reached for microphone and said, "Miss Andy Warhol," his only contribution to the entire interview.

Geldzahler described their relationship as a latter-day version of those between Renaissance painters and humanist scholars, "who knew the legends or who knew what antiquity was about, and [the artist] would go to the scholar and say, 'Is this a good subject?' or the scholar would suggest a subject. That's the kind of relationship we had."

But one of Geldzahler's first exercises of his judgment constituted an appalling act of hubris. At some point in 1962, he had "the delicious pleasure" of destroying dozens of Warhol's drawings: "Andy brought a pile of drawings over to my house and then we looked through them, and I tore up about 80 percent of them as not being worthy of going out into the world and picked fifteen or twenty or thirty that I thought he might keep. . . . It was a very light-headed kind of illustration." What's remarkable about the story is Warhol's passivity.

On the other hand, a number of Warhol's paintings would not have come into being without Geldzahler's input. His constant pitching, no matter how many ideas were ignored, stimulated Warhol, providing him

a springboard against which he could react. It was a working collaboration, the closest and most fruitful that Warhol would ever enjoy.

When Andy felt empty, Henry said, "one of my roles . . . was to help fill him up." Geldzahler often told of how, early in their friendship, he had gotten a phone call from Warhol. It was one-thirty in the morning. Warhol insisted that they meet immediately at the Brasserie. Was it really important? Geldzahler pleaded in his pajamas. Yes, said Warhol. Groaning, Geldzahler hauled himself out of bed, took a cab to the restaurant, saw his friend sitting in the corner, sat down across from him, and said, "Now, what is it?" Warhol looked up and said, "Say something." As laughable as it was, Warhol's behavior, Geldzahler realized, "was a cry for help."

The year held one more development. Irving Blum, the Los Angeles dealer who had viewed Warhol's work with little interest but liked him personally, was back in town in December. Dropping in on Andy, Blum saw the first of the Campbell's soup canvases.

"I said, 'Where are your cartoon paintings?' He said, 'Well, someone was doing them better than I was,' so he was doing these now." Warhol was "really, really looking for a gallery," according to Blum. "He was discouraged. He talked about how tough it was to find a gallery to take him.

"There were just two or three soup cans, maybe a half-dozen," Blum continued. "He told me it was his intention to do them as a series. 'Would you like to show them at the Ferus?' I asked."

He would love it, Andy replied.

CHAPTER THREE

I thought he was nuts. He said, "Come up to the house, I want
to show you something I'm working on," and that's when I first
saw the Campbell's soup. I remember being embarrassed for him,
knowing how good he was, thinking, "Why would you do this?"
—TOM LACY

I n his 1961 paintings Warhol's style vacillated between the drips
and brushstrokes of Abstract Expressionism and the unadorned
style that would characterize classic Pop art. As the year turned,
he continued to waver between the two. While most of the soup cans
he painted between late November 1961 and April 1962 adhered to a
hard-edged style, others looked back to the fifties, as conventionally
pleasing as any of Andy's commercial work. In some of these (the so-
called still lifes), the soup cans are poignantly squashed; others have had
their labels torn away, the exposed metal rendered with a delicate wash.
The first dollar bill painting, from the same period, is full of folds and

crinkles. It even casts a shadow (as does one of the crumpled soup cans), a nod to three-dimensional illusion.

Andy's Pop epiphany, his decisive break with painterly and illusion-istic styles, came about early in 1962 when he invited his friend de Antonio to come by 1342 Lexington to give his opinion on two large paintings of a Coca-Cola bottle, one hard-edged, the other with paint drips.

"Andy had taken off his casual, quiet air," wrote de Antonio in his journal, "and it was evident that this night counted." One of the two Coca-Cola paintings was, in de Antonio's estimate, "an early Pop art piece of major importance," unadorned and sharply defined. The other "was the same thing except it was surrounded by Abstract Expression-ist hatches and crosses. . . . I said, 'Andy, don't you see one is real? It is what it is. A Coke bottle. The other is a Coke bottle you're frightened of. You're not sure of it. So you surround it with brushstrokes as if to say, "Look, this is art! This is Andy making art!" Burn it! The first is reality, it's a new idea, it's two-dimensional like an ad. . . . It's the Coke bottle in the ad that you've painted, not the real Coke bottle.'"

But no sooner had he settled on a consistent approach than he began experimenting with the process that would take him away from hand-painting canvases for good. In the first half of 1962 Warhol would try out various mechanical techniques, from hand- and spray-painting through a stencil to pounding out images with a rubber stamp. Earlier in 1962, shortly after the first soup can paintings and immediately before the dollar bill paintings, Warhol made two series of stamp paintings: S&H Green Stamps—these were trading stamps that supermarket shoppers could collect and redeem for products—and airmail stamps. The earliest of these were made in January 1962, using designs carved into art gum erasers (the ones he'd used for his com-mercial work). Using the engraved art gum erasers as stamps, he made monoprint impressions on canvas and paper with acrylic paint. For the S&H Green Stamps he first painted a phthalo green background and

stamped the S&H logo in a darker green. On top of that he printed a second element in red. The white dots were painted by hand to simulate perforations. (When the S&H were first exhibited at the Institute of Contemporary Art in Philadelphia from October to November 1965, the curator, Sam Green, wore a tie printed with the S&H Green Stamp logo and Mrs. H. Gates Lloyd a blouse of the same pattern.)

On March 7, David Bourdon, an aspiring writer Warhol had known slightly since 1959, dropped by 1342 Lexington. In notes Bourdon jotted down at the time, he wrote that Warhol was "now painting a series of money because 'he likes it so much.'" Although he seems to have begun the money paintings by hand-stamping them, within a few weeks he switched to the semimechanical process that he would use for the rest of his life.

As 1962 began, Andy's social life was increasingly divided between three groups of people. There were his gay-world friends from the 1950s, his advertising and magazine clients, and his new contacts among gallery owners and artists. None of these groups had any idea of his dealings with the others.

Walking down Madison Avenue with Andy, Ivan Karp recalled: "Every fifth person said hello. 'Andy,' I said, 'who *are* all these people?' He said, 'Oh, Ivan, it's my other life.' I hadn't known that he was in advertising. [Andy had made certain of that.] I didn't know, when I was in Serendipity eating their ice-cream pie, that those were Andy's pictures on the wall, that he made pictures of shoes, ridiculous shoes, right?"

To most of Andy's fifties friends, it was his new work that was ridiculous. Tom Lacy, Andy's friend from the Bonwit Teller art department, "thought he was nuts. He said, 'Come up to the house, I want to show you something I'm working on,'" recounted Lacy, "and that's when I first saw the Campbell's soup. I remember being embarrassed for him, knowing how good he was, thinking, 'Why would you do this?'"

Meanwhile, Andy was tirelessly working his art world connections. On January 3 he had dinner with Jasper Johns and Robert Rauschenberg. And despite Castelli's rejection, Andy continued to court the dealer: on January 9 he lunched with Castelli and Karp at the Schrafft's on Madison and 77 Street (a favorite lunch spot of Castelli's). On January 15 Andy met Karp, Castelli, and Eleanor Ward for lunch. Karp was no doubt pitching Andy to Ward, whose Stable Gallery was one of the top contemporary art spaces.

On January 16, the aggressive collector, taxi fleet owner, and social parvenu Robert Scull jotted in his date book: "Warhall [*sic*] (painter)." On January 17, Andy took in a movie with "Jap." On January 26, after visiting Castelli's and Ward's galleries, he met Karp for dinner at Old Hungary, another art world haunt.

On February 19, Henry Geldzahler made his first appearance in Warhol's date book, joining Andy, de Antonio, the collector David Hayes, and Warhol's friend Marguerite Lamkin for dinner. On March 9, he ate dinner with Frank Stella, Hayes, and Marisol, the beautiful young sculptor who was becoming one of Warhol's chief conduits to other artists ("Marisol," according to the painter Alex Katz, "was Andy's guide"). Two weeks later, Andy visited Stella and Barbara Rose at their Walker Street apartment, and on April 2, after lunch with Castelli and the sculptor John Chamberlain, he met Geldzahler for dinner at the upscale gay restaurant Faison d'Or.

Rose, pregnant with her first child, and de Antonio, still more or less at loose ends, were haunting Times Square double-feature houses that winter, and Andy often joined them. "He called me every day," Rose said. "He was my girlfriend. One day just after my daughter Rachel was born, the buzzer rings and I drag myself to the door with this baby. The entire doorway is filled with this tremendous, six-foot five-inch panda, and from behind it comes Andy's little face. 'Oh,' he said, 'I brought this as a present for your baby.' He was the first person to visit me with Rachel. She grew up with that panda, she called it Andy Panda."

Warhol gave Rose "tons of presents, and he always picked up the tab. It wasn't bribery. I was nothing then, I was this kid." Which was not precisely so—she may not have been the major critic she shortly became, but Rose was married to a painter for whose approval Andy hungered; she lived at the center of the avant-garde community he had targeted as his new milieu.

In the winter or early spring, Andy struck up a friendship with Sam Green, a socially ambitious twenty-three-year-old and Rhode Island School of Design flunkout. Green's father headed Wesleyan University's art department and helped Sam hone his social skills. "He always took me to lunch at Henry du Pont's or Philip Johnson's," Green said of his father, "because he knew I had social-climbing tendencies."

Soon after they were introduced, Andy showed Green his paintings, "which were all stacked up in the stairway of his place. He was definitely courting me. It felt kind of weird, because I wasn't an art expert at all; I was someone who was bumming around, just trying to pay the rent." Actually, Green had multiple attractions: his rich society friends, potential collectors all; his assistant's job at the Green Gallery (the name was an invention of Richard Bellamy's and had nothing to do with Sam). "I had a certain amount of sophistication under my belt. I could do the black tie. Andy would ask me things I could fill him in on, the psychology of American wealth, and past wealth, and who's who in the strata of the higher altitudes."

Andy was relentless, visiting every gallery owner who would see him, but the results were not encouraging. As de Antonio phrased it, "I tried to interest dealers in Andy's work. They laughed." Although Andy got no offers for full-time representation, the dealers Allan Stone and Martha Jackson spent several months planning a Warhol show in late 1962. But this was subsequently followed by a discouraging retraction of her offer while his Campbell's soup exhibit was still up at the Ferus Gallery. Nonetheless, she took a number of Andy's paintings on consignment, and her assistant John Weber sold ten of them. Jackson's

rejection letter aptly depicts Warhol's predicament as both innovator and scandalizer:

> It became quite clear to me that your work is going to be extremely controversial. Apparently, it is not necessary to give you a show to find out the reason—in your case, that is. All I had to do was wave a few photos or transparency in front of faces to get a strong reaction. As this gallery is devoted to artists of an earlier generation, I now feel I must take a stand to support their continuing efforts rather than confuse issues here by beginning to show contemporary Dada. While Jimmy Dine verges on the Dada group, I do not consider him a Dada artist essentially. The introduction of your paintings has already had very bad repercussions for us. This is a good sign, as far as your work and your statement as an artist are concerned. Furthermore, I like you and your work. But from a business and gallery standpoint, we want to take a stand elsewhere. Threfore, I suggest to you that we cancel the exhibition we had planned for December 1962.

The lack of a permanent dealer did not prevent Andy from selling to some of the nation's top collectors. As Andy's informal agent, for which he received a loosely arranged commission, Karp directed a stream of collectors Andy's way. Alfred Ordover bought *Eddie Fisher Breaks Down*, Myron Orlovsky chose a big dollar-bill canvas, and the Los Angeles collector Betty Asher, visiting in April with Irving Blum, bought *64 S&H Green Stamps*. Emily Hall Tremaine, one of the country's most influential modern art collectors, became Warhol's first major buyer—after a May visit to 1342 Lexington, she bought four paintings, writing Andy a check for $1,500. Given his brief painting tenure, Andy ought to have been elated. True to form, he verged on despair: every other young painter, it seemed, had a home.

The spring 1962 season brought about what Clement Greenberg

called "the sudden collapse, market-wise and publicity-wise, of abstract expressionism," and of the tendencies springing up in its wake, the style not yet known as Pop attracted most of the attention. Martha Jackson's show of Jim Dine's new work, in which Dine attached real objects—a bathroom sink, a zipper, etc.—onto painted canvases, opened on January 9. *Time* profiled Dine in its February 2 issue, making him the first of the "common-object" artists to receive mass media attention, but concluded that "a necktie presented so literally remains only a necktie and, for all his obvious talent, Jim Dine has not changed that situation." Nevertheless the show sold out. Three weeks after Dine's opening came James Rosenquist's first show (which sold out before it even opened), followed shortly by Lichtenstein's. The latter two shows, like Dine's, were at prestigious uptown galleries—Rosenquist at the Green, Lichtenstein at Castelli—rather than the Lower East Side storefronts where Dine and Claes Oldenburg had been showing not long before.

In the February 1962 issue of *Arts Magazine*, the critic and painter Sidney Tillim wrote one of the first articles on the emerging style: "In mass man and his artifacts, his cigarettes and beer cans and the library of refuse scattered along the highways of the land with their signs, supermarkets and drive-in motels, the New American Dreamer—let us call him—finds the content that at once refreshes his visual experience and opens paths beyond the seemingly exhausted alternatives of abstraction."

Tillim's reflections were prompted by The Store, sculptor Claes Oldenburg's novel means of showing his new art. Backed by the Green Gallery (which was backed in turn by Robert Scull), Oldenburg and his wife Patty transformed their dumpy storefront studio at 107 East 2nd Street into a mock five-and-dime. All of the merchandise—Oldenburg's paint-splashed, eccentrically modeled plaster simulacra of shoes, pants, shirts, dresses, hats, ladies' lingerie, ties, pies, cakes, fried eggs, sandwiches, candy bars, and more—was for sale, most in the $100 to $300 range. The Store lasted from December 1 to the end of the

month; although the run put the Oldenburgs $285 in debt, the word of mouth it generated more than made up for it.

The Store reopened in mid-January under a new identity, the Ray Gun Theatre, where the Oldenburgs created a series of dream-like, vaguely menacing Happenings. The performers were a grab bag of painters, avant-gardists and proto-hippies: Claes and Patty, Lucas Samaras, Carolee Schneeman, Barbara Rose's roommate (and later Emile de Antonio's wife) Terry Brook, Henry Geldzahler, Johanna Lawrenson (later Abbie Hoffman's wife), Billy Klüver, and many others. Warhol attended at least one Ray Gun happening, *World's Fair*, on May 18.

Oldenburg, as articulate as Warhol was tongue-tied, had launched The Store with "Statement," a manifesto widely recognized as one of the great pieces of writing by a contemporary artist. From its opening stanzas Oldenburg connects his new vision of art to social change:

I am for an art that is political-erotical-mystical, that does something other than sit on its ass in a museum.

I am for an art that grows up not knowing it is art at all . . .

I am for an art that embroils itself with the everyday crap & still comes out on top . . .

I am for an art that takes its form from the lines of life itself, that twists and extends and accumulates and spits and drips, and is heavy and coarse and blunt and sweet and stupid as life itself.

I am for an art that a kid licks, after peeling away the wrapper . . .

I am for an art that is smoked, like a cigarette, smells, like a pair of shoes.

I am for an art that flaps like a flag, or helps blow noses, like a handkerchief.

I am for an art that is put on and taken off, like pants, which develops holes, like socks, which is eaten, like a piece of pie, or abandoned with great contempt, like a piece of shit.

A genuine romantic and egalitarian, Oldenburg erased the distinction among objects, between the useful and the merely aesthetic. His generation, he wrote in his notebook *Store Days*, "will (hopefully) destroy the notion of art and give the object back its power."

On May 17, Warhol bought one of Oldenburg's pieces (it is not known which). Probably two months earlier (Warhol's date book notes a March 15 meeting with the Oldenburgs), Andy had offered Oldenburg one of the four big *Telephone* paintings he'd made in 1961 in exchange for one of the sculptor's pieces, but Oldenburg was unwilling to trade. According to Patty, "Claes didn't like Andy's work, he didn't think Andy was worthwhile. We went up to 89th Street and he showed us his things. It was a disaster. I think Claes was disappointed by what he saw; I think he felt it wasn't heavy enough material for him to make a trade."

In the wake of James Rosenquist's Green Gallery opening, the press spun its own colorful version of Rosenquist's biography: the good-looking North Dakotan was a naif who'd wandered east, hired on as a Times Square sign painter, and gone straight from billboards to galleries. While it's true that Rosenquist had painted billboards, he was also a highly trained, sophisticated former abstractionist.

After seeing Rosenquist's pictures—oversized, fragmentary images of body parts and commercial products—at the Green, Ted Carey telephoned Warhol, raving about the "fabulous," "wonderful" pictures. He was tempted to buy one, he told Andy. "'If you do,'" Carey recalled Andy saying, "'I'll never speak to you again.' . . . He was just so depressed that it was all happening and he was not getting any recognition."

Although Roy Lichtenstein's new gallerymates were still almost unanimously hostile to his work, Andy would have loved to generate such violent feelings. He undoubtedly knew through Karp that not only had every one of Lichtenstein's twenty-two paintings been sold

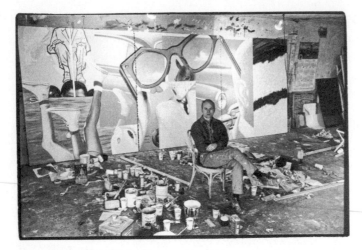

James Rosenquist in his studio

before the show was even hung, but that Castelli had presold Lichtenstein's output for the entire year.

To critics and the educated art public in 1962, Lichtenstein's big cartoon canvases of exploding fighter planes and swooning blondes were a sudden and bewildering invasion of the horribly lowbrow. They hit Robert Rosenblum, then at Princeton, like a blast of oxygen: "It was 'Eureka!'—but what was it? I was confused. I loved it and hated it, I didn't even have an opportunity to let the dust settle. They were ugly, shocking, beautiful, grotesque. I remember in particular that woman cleaning her refrigerator, smiling at us [*The Refrigerator*]. That was a shocker. My whole impression was that the world had changed. This was another planet and you had to start navigating in a new way." The first time Rosenblum saw the Benday dots, "in absolutely flat colors—they were a slap in the face even to Johns. When you first saw Johns, it looked so geometric and predetermined, and now, compared to these, Johns looked handmade and precious."

What infuriated most critics about Lichtenstein was his apparently literal duplication of his originals, his "shanghaiing of the recognizable," as Hilton Kramer observed of Pop in general later that year, "without its

being submitted to any significant transformation." What only became apparent after the shock of Lichtenstein's lumpen content had worn off was that Lichtenstein had completely overhauled his comic book sources and the resulting paintings were shot through with art historical references and in-jokes. In *Okay, Hot Shot!* (1963), for instance, a generic comic book explosion becomes a satirical version of a Morris Louis poured painting.

"What I do is form," Lichtenstein later told Gene Swenson, "whereas the comic strip is not formed in the sense I'm using the word. The comics have shapes, but there has been no effort to make them intensely unified. . . . My work is actually different from comic strips in that every mark is really in a different place, however slight the difference seems to some. The difference is often not great, but it is crucial." (As he would explain while promoting Sam Green's Wesleyan show, The New Art, in 1963, "I take a cliché and try to organize its forms.")

According to the Green Gallery's Richard Bellamy, Leo Castelli worked hard to ensure that Roy Lichtenstein's Castelli debut over-

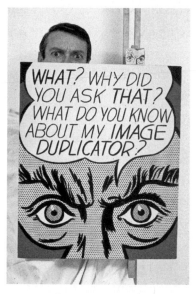

Roy Lichtenstein holding his painting
Image Duplicator, *1963*

lapped with Rosenquist's show in order to generate a buzz. Castelli's behind-the-scenes jockeying brings into focus the extent to which Pop's rise was driven by the savvy marketing of a new breed of art businessmen. A new era had begun with Jasper Johns's sellout 1958 debut at, appropriately, the Castelli Gallery. Before 1960, dealing had been more a nurturing and facilitating than a purely commercial activity; not that much money was at stake. A large percentage of the art world's

essential movers were a remarkable group of largely financially independent women—Peggy Guggenheim, Betty Parsons, Eleanor Ward, Martha Jackson, Eleanor Poindexter, Rose Fried, Virginia Zabriskie, and others—who coddled, exhorted, fed, exhibited, and found collectors for the first great generation of American artists.

Leo Castelli, who founded his gallery in 1957, was a pivotal figure in this shift, though unintentionally so. Leo was a genuinely cultivated Old World connoisseur, but nobody would have described him as an astute businessman. His enthusiasm for his artists did energize the art world, but the idea of Leo Castelli as an international mastermind manipulating the global art market—which some people have posited—is laughable. As James Rosenquist, one of his most successful artists, pointed out, "Leo couldn't manipulate his arm, never mind the art market! Leo loved his artists, he loved art. His only sin was to make the work of young contemporary artists like Jasper Johns and Robert Rauschenberg worth more. Most galleries that showed young painters also sold Old Master paintings—that was their bread and butter. Leo changed that by encouraging a more adventurous group of collectors, like the Sculls and the Tremaines, to buy the work of contemporary artists, and in that way their art became more valuable and they could support themselves."

Pop, with its immediately accessible subject matter, was the perfect vehicle for the commercial transformation of the art market. By early spring 1962, the new movement was generating a low-level hum in the national press. It still had no name, but was being called, variously, Popular Realism, Neo-Dada, the New Sign Painting, Factualism, and Common Object Art. It was at about this time that Andy, walking across 15th Street with two friends, Floriano Vecchi and Richard Miller, remarked that he and several others were trying to start a new movement called "Commonism." Didn't he think the name was a bit loaded? Miller asked. Andy just giggled. The movement finally got a name worthy of its momentum: Pop, which didn't come into use until

later in 1962, had been coined in 1958 by the English critic Lawrence Alloway to describe pop culture itself, not the art based on it.

On May 11, the first mass media overview of the new trend appeared. *Time* magazine's report, "The Slice of Cake School," took as its news peg a New York show by the painterly realist Wayne Thiebaud, whom it mistakenly took to be one of the new pop culture painters: "a segment of the advance guard," according to *Time*, who "have come to the common conclusion that the most banal and even vulgar trappings of modern civilization can, when transposed literally to canvas, become art." (Geldzahler would later make the claim that *Time* had "done the most to foster nonsense about American art of the past two decades.") The article contained thumbnail profiles of Thiebaud, Lichtenstein, Rosenquist—and a photograph of Andy Warhol.

How had Andy, still unexhibited, been chosen over Dine, Oldenburg, Wesselmann, or George Segal, all of whom had shown and been reviewed? Perhaps the researcher was steered to Andy by David Bourdon, who was then beginning his career at *Time*. In any case, Warhol was not only quoted at length, but he was the only artist pictured in the piece, posing in the rear studio at 1342 Lexington, in front of one of the big Campbell's soup still lifes and the final *Telephone*, obligingly spooning Campbell's soup straight from a can (which Andy had klutzily opened and was holding upside down). The caption read, "Just because I like it." When it came to a pitchman's instincts and savvy, the other artists in the story were simply outclassed.

Interviewed for the piece on April 24, Andy, claiming to be thirty (shaving three years off his age), told the *Time* reporter that he had never been to college and gave his arrival in New York as 1952, three years after the actual date. The reporter, clearly made uneasy by so vague a subject, wrote that Warhol "spends apparently no time at all trying to think of any reason for what he does or why the phenomenon of 'commonist' art has come about. 'I have no idea why,' he says, 'I guess it just happened.' He seems shy and a bit vague, certainly doesn't

pretend to think out any plan or rationale for his work, he just does what he likes."

"I don't try to work with light, like Thiebaud," Andy told the reporter, "I just try to make it look like the thing. I'm still working on soups, and I paint ads (mostly on beauty products, cosmetics and such things), and I've been doing some paintings of money. I just do it because I like it."

Later that year he would maintain the complete opposite to Marguerite Lamkin of the London *Evening Standard*: "I want to show the monotony in the way things are. You see these things every day and by painting them you realize how boring life really is." He was equally capable of making generalized statements about his place in the culture: "I feel like I'm very much a part of my times, of my culture, as much a part of it as rockets and television." But as Warhol's old friend, the painter Joseph Groell, observed: "He had the ability . . . while responding in a very personal way, to be ambiguous so that people could write a script that he was willing to recognize and make his own."

When the May 11 issue of *Time* hit the newsstands, Andy bought a stack of nine. On May 3, shortly before the magazine went on sale, Andy had met *Time*'s Rosalind Constable for dinner. Constable wrote a weekly in-house report on the arts that functioned as a sort of tip sheet. Was Andy pumping her for information, trying to find out if he'd made it into the *Time* article? Was he looking for more coverage? He must have been bitterly disappointed when *Life*, following its corporate stablemate's lead, devoted four pages of the June 15 issue to a piece on the new art, "Something New Is Cooking," singling out Thiebaud, Rosenquist, Segal, and Lichtenstein but omitting him.

The June *Mademoiselle*, on the other hand, ran a two-page spread featuring Duane Michals's photographs of Oldenburg, Lichtenstein, Wesselmann, Dine, and Michals's old friend Andy. Michals had been startled to hear Warhol's name among those of the hot new artists he was assigned to shoot. When he went to 1342 Lexington, Andy met

him at the door in all black, with loud rock and roll music playing. "Andy pumped me for information about the *Mademoiselle* piece: who the other artists were, what kind of work they were doing, how I'd photographed them," Michals recalled. "He had changed entirely."

The persona was beginning to jell. Always canny with autobiographical data, Andy had begun to create an alternate past for himself. When David Bourdon had visited in early March, Andy had claimed to be twenty-five. Bourdon had brought along the catalog from the Museum of Modern Art's 1956 Recent Drawings U.S.A. show, which gave Warhol's birth date as 1929, making him thirty-two. All right, Andy admitted, he wasn't twenty-five—but he insisted that the catalogue was wrong, and that he was (as he had told the *Time* reporter) only thirty. He portrayed himself as an unschooled primitive with "no academic background" who had "learned to paint at his mother's knee" (not a total lie, though certainly a stretch).

These early March conversations with Bourdon marked the first instance in which Andy made a self-conscious attempt to speak the language of Pop. "The everyday things we live with are so beautiful and no one realizes it," he told Bourdon, somewhat awkwardly mimicking the Pop pronouncements of de Antonio, Geldzahler, and Karp. Andy would soon add an edge of facetiousness to these effusions. When asked, "Tell us, Andy, why did you paint a soup can?" he would archly reply: "Because I love the product and I love all products, they're so beautiful." Andy had begun to refine an attitude that would perfectly mirror the irony of the work.

When he showed up at Timothy Hennessy's second de Nagy show in February, Hennessy was startled. The forlorn young man of the year before was now almost self-possessed. "Before, he'd just been Andy Warhol. Now he was . . . *Andy Warhol!*"

Instrumental in the radical turn Warhol's art was about to take was the printer Floriano Vecchi. A gifted painter and an Italian government

agriculturist, Vecchi left Rome for New York City in 1952 and found work at Pippin Press, a print shop supported by Lincoln Kirstein. In 1953 Vecchi and his lover, an art dealer and curator named Richard Miller, opened Tiber Press, which specialized in silk screen printing. "We made our money printing almost anything you can imagine," said Vecchi, and they spent most of it on Miller's quixotic projects.

One was the literary journal *Folder*, edited by Miller and the poet Daisy Aldan, whose four issues paired poems by John Ashbery, James Merrill, Frank O'Hara, and others with original screenprints by the painters Alfred Leslie, Grace Hartigan, and Gandy Brodie. Between 1956 and 1960, Vecchi and Miller published the Tiber Press portfolios, a set of collaborations between several of the *Folder* poets and Joan Mitchell, Mike Goldberg, Leslie, and Hartigan. Working closely with Vecchi, each painter made a series of color screenprints.

Years later, Henry Geldzahler liked to say that Warhol's two great innovations were "to bring commercial art into fine art" and "to take printing techniques into painting. Andy's prints and paintings are exactly the same thing. No one had ever done that before. It was an amazing thing to do." The second half of this claim isn't quite true. As early as the mid-forties a number of artists—Hans Hofmann, Norman Bluhm, and others—had already collapsed the distinction between printing and painting, but Warhol's use of the silk screen would prove far more uncompromising than any of these.

In screen printing, the artist cuts a design into a stencil, which is fitted to a finely meshed screen. When ink is forced through the screen's open areas, the design is transferred to the object—generally fabric or a poster—to be printed. For centuries, stencils were hand-cut, which restricted the amount of detail transferable. But sometime around 1910, a photo-stenciling method was introduced that employed the Benday dots used in the reproduction of photographs in newspapers and greatly expanded silk-screening's capacities. Now you could make a stencil from any original—a drawing, a painting, a photograph. But

the medium's new potential went largely untapped among fine artists, most of whom considered it a clumsy process better suited to clothing, greeting cards, and other commercial products.

Andy had frequented Tiber's fourth-floor loft on East 81st Street since the mid-fifties, selling drawings to Vecchi for the printer to use on greeting cards. "Andy's hope and dream in those days," Vecchi recalled, "was for the Museum of Modern Art to buy one of his Christmas-card drawings. If only they had bought one of his designs and put it on a Christmas card [which they eventually did] he would have been so happy." Andy had often seen Vecchi at work on prints. "He was totally aware of silk screen," according to Vecchi, although he showed no interest in it. Vecchi presumed that like most artists, Andy disdained the process.

But in the late winter of 1962, Andy was ready to give it a closer look. He began watching over the printer's shoulder. "He was fascinated," said Vecchi. "I knew he was up to something."

Warhol seems to have begun making his dollar-bill paintings with hand-cut stamps, which, as he must have quickly realized, could never duplicate paper money's intricate designs. It was at this point that he approached Vecchi. "He came to me one day with a drawing of a dollar, and asked, 'Will you make a screen for me?'" Giving Warhol one of the blank acetate sheets that Tiber used as stencils, Vecchi told Andy to go home and redo his drawing, this time on the acetate. Three or four days later, Andy was back with the inscribed acetate. Vecchi taped it to a clean silk screen, which he placed under a high-intensity lamp. The negative image emerged: a finished screen, ready for printing.

"When Andy saw the screen," said Vecchi, "he got oh, so excited. Everything that had to do with that dollar was a new adventure for him. He had brought a roll of canvas and he said, 'Floriano, let's do it together! Let's print it!' He had great, great expectations." Vecchi had a lot of work to do; after making a few quick instructional prints on paper, he again loaded Andy up with supplies, this time for transferring

the drawing to canvas. "I said, 'Go home, enjoy yourself and fill up the canvas.' He went away and that's how it began."

The drawings Warhol made for his first silk-screened works, the one- and two-dollar bills, are stylistically reminiscent of his illustrations from the 1950s, especially the pixieish, androgynous George Washington. But he was no longer restricted to a single, laboriously blotted copy; now he could bang out as many prints as he wanted, quickly and easily. In late March and April, he screen-printed almost four dozen pictures of one- and two-dollar bills, from bite-sized six-by-ten-inch single images (Andy gave lots of these away that spring, to Castelli, de Antonio, Geldzahler, Karp, Ted Carey, Nathan Gluck, Martha Jackson's assistant John Weber, and others) to the massive serial composition *200 One Dollar Bills*, almost eight feet high.

Floriano Vecchi and his friends exposed Warhol to an idea that would lead to another of his Pop provocations. Alfred Leslie, whose impending turn from Abstract Expressionism to hard-edged realism would shortly make big news in the art world, had been a regular at Tiber Press since the mid-fifties. According to Vecchi, Leslie was "a genius at using silk screen, the best of everyone." In mid-1961 and again in late 1962, Leslie was at work on something new: adorning boxes with silk-screened images. For the later series, *Lady with Tomatoes*, he glued a screenprint onto one face of a ten-inch cardboard cube; in *Lady on a Can*, he silk-screened the image directly onto a gasoline can. The result was two proto-Pop art multiples, suggesting labeled products. Andy was fascinated by *Lady on a Can*, said Vecchi, who always considered it the progenitor of Warhol's Brillo box sculptures. If this is so, Andy imparted his own spin, turning Leslie's arty-looking box into something more literal-minded, and more disquieting: a wooden box stenciled with Campbell's soup cans, fabricated at about the same time Andy was painting the series. Warhol never finished the piece, but friends recalled seeing it at his house.

Not only was silk-screening more accurate than hand-stamping,

but it imparted a machine-made look to the big serial compositions that Andy was starting to turn out. As he writes in *POPism*, "The rubber-stamp method I'd been using to repeat images suddenly seemed too homemade; I wanted something stronger that gave more of an assembly-line effect." Screen-printing was more flexible, too—you could make a screen of any size, but cutting a stamp bigger than several inches was a fool's errand.

Between late March and May, Andy produced three series of screen-prints: Martinson coffee can labels, Coca-Cola bottles (including the biggest Warhol canvas yet, the nine-and-half-foot-wide *200 Coca-Cola Bottles*), and shipping labels (*This Side Up, Open This End, Handle with Care—Glass—Thank You*, etc.). According to Bourdon, Warhol conceived the last as a visual pun. Through most of art history, paintings were thought of as windows through which the viewer gazed at the scene in front of him. By stamping "Handle with Care—Glass" on the canvas surface, Warhol, in Bourdon's account, was making a statement about this illusionist "window." But such a conceptual idea seems unlikely given Andy's unintellectual turn of mind. It's a piece of art history gamesmanship more appropriate to Jasper Johns. Johns, it turned out, liked this painting; thrilled, Andy loaned the silk screen to him, and two years later Johns incorporated the label into his painting *Arrive/Depart*.

In *POPism*, Warhol gives the impression that he switched to silk-screening more or less as soon as he discovered it. Actually, he temporized; between March and midsummer he made more than a dozen hand paintings: monumental versions of the single Coke bottle (just under seven feet high); the candlestick phone (eight and a half feet high); and *Before and After* (eight and a half feet wide); five paintings of matchbook covers; the five paint-by-numbers parodies to which Warhol (or Ivan Karp) gave the collective title *Do It Yourself*; and two newspaper paintings, *Daily News* and *129 Die in Jet!*

The matchbook covers reveal how closely Warhol was watching other

artists. These paintings were fitted with actual sandpaper strikers, a touch that echoed not only Johns, who had been attaching real objects (a thermometer, a window shade, a broom) to his canvases since the late fifties, but also Jim Dine. For both Johns and Dine the inclusion of objects was a way of driving home their anti-illusionistic point: the only way to depict a real object was to put it into one's painting. One of the two large matchbook covers, *Close Cover Before Striking (Pepsi Cola)*, had an atypically polished, Lichtensteinian look. Not only were the colors (red, white, blue, and yellow) Lichtenstein's early-sixties favorites, but *Pepsi Cola*'s carefully worked-out design, especially the bold shadows along the cap's serrated circumference, echoed Lichtenstein's aim of drawing attention, through slight but dramatic modifications, to the graphic power of commercial art clichés. The three small matchbook covers are tongue-in-cheek Barnett Newman "zip" paintings; in each, the striker, a broad charcoal gray horizontal stripe bordered by two slender white stripes along its top and bottom, cuts a swath across the colored surface. Andy had a new distance from Abstract Expressionism—now he was spoofing it.

The *Do It Yourself* series, another early-summer product, is a mock version of a popular early-sixties hobby, paint-by-numbers kits allowed anyone to make "real-looking" pictures; all one had to do was follow the color-keyed numbers sprinkled across an unpainted outline. Warhol wondered out loud to the collector Hanford Yang whether to leave the canvases relatively bare or colored in. In the end, each canvas represented a different stage of completion, from the mostly blank *Violin* to the sole "finished" painting, *Seascape*, in which Warhol pulled the slapstick move of pasting numbers on top of the colors, hilariously defeating the exercise's purpose.

Busy with his greeting-card business, and unequipped in any case to make the big screens that Andy was starting to request, Floriano Vecchi steered Warhol to a larger print shop, the Active Process

Supply Company, at 457 West Broadway, just below Houston Street. Andy had his first screens made there on May 24.

In hindsight, one can see Warhol homing in on a specific objective: making painted versions of photographs. His instinct was always for the current, the new. A painting that resembled a photograph was "modern-looking" in an exciting way; the look of hand painting was "corny" and old-fashioned. Andy's efforts in this direction had thus far not pleased him. (The mid-sixties paintings of the now-unparalleled German postmodernist Gerhard Richter, whom Warhol's early Pop affected deeply, give one a sense of what Warhol might have done with virtuoso technique—and without a sense of humor.) Sarah Dalton, a precocious young British neighbor, remembered Andy being "very unhappy" with the picture that turned out to be his last hand-painted appropriation of a photograph, *129 Die in Jet!*

"The silk screens were really an accident," said Warhol. "The first one was the money painting, but that was a silk screen of a drawing. Then someone told me you could use a photographic image, and that's how it all started." According to Sarah Dalton, she was that someone. "Andy, looking at *129 Die in Jet,* said, 'Gee, it looks so smeary I wish it looked sharper, more like a photograph.' I said, 'Oh, but Andy, you can silk screen photographs, too. They use the same Benday process they use reproducing photos in the newspaper.' I was studying design at Traphagen Art School downtown and knew the technique from school. Andy's eyes lit up. 'Oh, really?' he said, and that was that." Soon thereafter, he went to Floriano Vecchi—who confirmed Sarah's observation—and began having his first photo silk screens made. No artist, or none that anyone knew of, had ever tried using the process in painting—but this one act reversed the magical appropriation of reality by photography that had plagued painting ever since Nicephore Niepce took the first photograph in 1828.

In screen-printing of photographic material, the screen's mesh rendered the source image as thousands of tiny dots. When an actual or

reproduced photograph was screened, the print had the grainy look of the latter, which suited Warhol fine. He was not after a picture-perfect, sharp-edged result; he wanted the trashy immediacy of a tabloid news photo.

"Andy didn't want to be a painter, really," Vecchi recalled. "He despised all that: the mess and the slowness," not to mention the apparently inevitable handmade look. "He had something else in mind. Until silk screen came into his head, which let him take a picture from the newspaper and reproduce it, the key was escaping from him. Once he found it, it was like discovering America."

Warhol's first photo silk screen was most likely *Baseball*, from July or August 1962, thirty-plus repetitions of a news photograph of Roger Maris slugging his record sixty-first home run. It's a beginner's effort: so much ink built up on the screen that Maris's mighty swing is almost obliterated.

"He wanted a bad technique," observed Vecchi. "He wasn't printing with a very light hand. You need a professional. These smears and blurs, these things weren't intentional at all. It just came out like that and he said, 'Oh, isn't that interesting.' He would say things like that. 'Oh, I love it this way. Let's leave it.'" Warhol, commented Barbara Rose in the seventies, "is very much the automatist"—embracing chance, that is, was his modus operandi. "He lets things happen," said Rose. "Sometimes they work out and sometimes they don't."

After *Baseball* came a more likely group of Warhol subjects, the teen idols Natalie Wood, Warren Beatty, Tab Hunter, and Troy Donahue. The last was a special heartthrob of Andy's—was it known in the early sixties that Donahue was gay? The teen idols were Warhol's first human serial images, but the conceptual leap from *210 Coca-Cola Bottles* to the *Troy Diptych* was not great: celebrities, as Andy shortly told a reporter, "are also products."

"Many people," recalled the painter Wyn Chamberlain, "including Rauschenberg, including me, including a lot of people, were trying to

combine photographs and painting, and I'll tell you, Rauschenberg must have been chewing his nails when suddenly Andy discovered you could do the same thing with silk screen as he was laboriously doing in those Dante things by putting turpentine on and transferring photographic images."

But, as Henry Geldzahler described this meeting between Warhol and Rauschenberg, it was Andy who was astonished: "I introduced Rauschenberg to Andy. Rauschenberg called me up and said 'I want to do silk screens, can I meet Andy?' And I took him to Andy's studio. Andy couldn't believe it."

Rauschenberg's reason for wanting to learn silk-screening was quite different from Andy's. As Walter Hopps pointed out, the technique was far more characteristic of Warhol's approach than it was of Rauschenberg's: "Andy is real interested in all sorts of techniques that he knew from the commercial art world. That's part of what Andy is. Wanting to be a machine and the mechanical kind of beauty of it. In Bob's case, the reason is that he is wanting to make things larger in format, in size, than you can do with collages, like in the combine."

Another innovation that was becoming pronounced in Andy's technique was the repetition of an image in a grid (also called multiples or serialism). The Campbell's soup can became, almost by accident, the subject of his first serial compositions, an approach that became one of his sixties trademarks.

One of the characteristics of a repeated pattern, as Alfred Leslie pointed out, is decoration: "The idea of a multiple is the idea of taking the image and turning it into a pattern in much the same way as in the decorative arts images are repeated over and over again. If you have no variation and you have 16 images, you create a pattern, much in the same way as if you were making a dress which is stamping the same thing all over again." This aspect of multiples would naturally have appealed to Andy, who had frequently used repeated images in his rubber stamp illustrations.

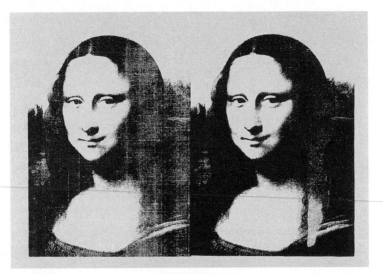

Andy Warhol, Double Mona Lisa, *1963. Silk screen ink on canvas, 38½″ × 37⅛″. Collection of Brooke Hayward and Dennis Hopper, Los Angeles.*

In six of the ten Troy Donahue paintings, Warhol took a major new step: he introduced color. To do so, he had to invent a technique of combining the black ink of the silk screen images with areas of color. First, he screened a preliminary print (in black, the color he almost always used to print a silk screen). This "underimage" served as a guide for the second step: painting swatches of color for Donahue's hair, face, eyes, lips, and shirt. This was the only hand painting in the procedure. Finally, Warhol printed the screen a second time, the photographic image pulling the floating patches of color into a finished whole.

Registration—lining up the screened image with the hand-painted patches—was critical. When Warhol began his silk screens of Marilyn Monroe a few weeks after the teen-idol images, Nathan Gluck, who found Andy's casual registration jarring, suggested that he pin the corners of the screen to the canvas. "That way," Gluck explained, "when he printed he would get perfect registration. But he said, 'Well, I kind of like it this way.' He *liked* them askew. To me, the moral is, if he'd listened to me those things wouldn't be that great, they would have looked just like plain old reproductions."

The implications of Warhol's move to silk-screening, and to photo silk-screening in particular, were tremendous. Traditional, manual virtuosity no longer mattered. The fact that Warhol could draw had no bearing on his art now: how an artwork was made ceased to be a criterion of its quality. The result alone mattered: whether or not it was a striking image. Making art became a series of mental decisions, the most crucial of which was choosing the right source image: as Warhol would contend some years later, "The selection of the images is the most important and is the fruit of the imagination."

Although Rauschenberg's combines, Johns's mundane icons, and similar moves by late-fifties and early-sixties artists had begun to erode the grand criterion of originality, Warhol's photo silk screens upended traditional ideas of what constituted art. With Warhol, originality went out the window, flung open to the countless postmodernists, from Richard Prince to Jeff Koons to Takashi Murakami, whose art consists wholly or partly of borrowed images. While often infinitely more polished and brasher than him, they were licensed by Warhol. ("I suspect that Andy's going to feed a lot of artists for a long time," Henry Geldzahler would say in 1973.)

On June 4, Warhol and Geldzahler met for lunch at Serendipity. Andy, for a change, was feeling pretty good about his prospects. The *Time* and *Mademoiselle* articles had temporarily sated his craving for recognition and his show at the Ferus Gallery was approaching. Ruth Ansel had just put him into a *Harper's Bazaar* spread entitled "The Well-Mixed Party," in which a small crowd of up-and-coming cultural figures, including Andy, Joseph Heller, Joseph Papp, John Chamberlain, and Jason Robards, not to mention the hairdresser and sometime rock singer Monti Rock III, were photographed having cocktails and conversation in a well-appointed Manhattan town house. In the text, Andy was said to be "planning to exhibit this fall" (this was no doubt the later-canceled Martha Jackson show).

Geldzahler, however, was concerned about the public's acceptance

of an art that just reproduced commercial objects. "I thought there was much too much emphasis on the consumerism aspect of Pop art, which is why I wanted Andy to get serious." At lunch, he told Andy, "It's enough life, it's time for a little death. This is what's really happening," and he held up a copy of that morning's *New York Mirror*. The tabloid newspaper's page-one story was headlined "129 Die in Jet!," about a tragic plane crash in France. Not only did Warhol paint the front page, but the suggestion sparked a voluminous series, the Death and Disaster paintings of 1962–1964, which includes some of Warhol's most powerful canvases.

Geldzahler performed the function of aesthetic provocateur. "I loved working when I worked at commercial art and they told you what to do and how to do it," reads a passage from *The Philosophy of Andy Warhol*, published in 1975. "When I think about what sort of person I would most like to have on retainer, I think it would be a boss. A boss who could tell me what to do." A comment like that needs to be taken with a grain of salt; one can almost hear Warhol daring us to take this literally. Warhol may not have had many original ideas himself, but for him that was never the point.

As he famously said of his art, "Pop comes from the outside." Andy didn't do inner states. His domain was external, the world of preexisting objects—images, rather. And since the artist's job is to scour the world for the telling subject, asking for suggestions was, for Warhol, merely to add eyes. "How is asking someone for ideas any different from looking for them in a magazine?" he asks in *POPism*.

And while Andy may have constantly bearded his friends for suggestions, he didn't actually take many. "He asked me for advice, but he never took it," recalled Hanford Yang. "He had a way of saying, 'Yes, yes, a thousand times no,'" according to George Klauber. "He would ask your opinion very sweetly and nicely, and then do as he chose." Among the pieces known to have been suggested by others are: the Campbell's soup and money paintings (Muriel Latow); *129 Die in Jet!*,

Flowers, and probably *Mona Lisa* (Geldzahler); *Cows* and the 1963 *Self-Portraits* (Ivan Karp). No doubt there are others, but suggestions were often as much a springboard for ideas as a source of them.

Eleanor Ward was a high-camp silver-screen heroine come to life, as melodramatic and brittle as Margo Channing; physically she resembled Mildred Pierce's creator, Joan Crawford. "The director of the Stable Gallery had learned the technique of the put-on with a mastery of her own," wrote her assistant Alan Groh, who probably knew Ward better than anyone. "Her execution of it, however, was without humor, even if humor was inherent in the situation." She was precisely the sort of emphatic personality to whom Andy was drawn, with his need for strong initiatives to which he could respond. By turns coddling and withholding, Ward was an authoritarian foil for "Andy Candy," as she called him—at least early in their relationship.

Groh was Ward's longtime, long-suffering alter ego at the Stable Gallery. A strange-looking, pop-eyed fellow (Andy's friend Hanford Yang recalled him as a dead ringer for the comedian Marty Feldman), well-educated but purposeless until he began working with Ward, Groh was known among dealers as the "Ward Healer" for his indispensability to his boss, in particular the many times he ran her business while she lay recovering from her latest binge.

Ward claimed an upper-class, Upper East Side Manhattan background, yet she may have invented much of her past. She is known to have worked in Paris as an assistant to the fashion designer Christian Dior in the years after World War II. Leaving Paris for New York in 1951, Ward founded the Stable Gallery (it had been a former stable on Seventh Avenue and 58th Street) in January 1953. A series of group exhibits that Ward dubbed the "Stable Annuals" made her reputation and helped consolidate that of Abstract Expressionism; among the paintings in the first annual was Pollock's great *Blue Poles*. Ward showed a very young Robert Rauschenberg (whom she hired, and then

fired, as her janitor while she was exhibiting his art); her fifties roster included Isamu Noguchi, Joseph Cornell, Joan Mitchell, and Louise Bourgeois.

Ward could be unbearably imperious—she insisted on making the final selection for a show, and on hanging it herself—and while she championed her artists fiercely, she tended to overlook such prosaic obligations as paying them. When one Stable artist complained that she never saw any money, Ward answered, "Oh, artists shouldn't be interested in money." Nor was such high talk a blind for avarice. As one might expect of someone who, in Groh's words, "preferred to ignore the existence of commerce in her life," Ward was a disaster as a businesswoman and often in financial straits.

In 1960, Ward moved the Stable to East 74th Street, above her apartment, and began showing post-Abstractionists: Alex Katz, the junk sculptor Richard Stankiewicz, and two artists interested in popular culture, Marisol and Robert Indiana. Warhol's date book indicates that he met with Ward in January 1962, but nothing is known to have come of their lunch. Ward recalled another encounter, probably also early in 1962, when, she said, Emile de Antonio brought Andy to the Stable; although she claimed she felt "an instant affinity" with Andy personally, the gallery was full "and I couldn't even consider looking at his work."

De Antonio and Ward have each offered lively (but contradictory) accounts of Warhol's path to the Stable. In de Antonio's version, he brought a "very drunk" Ward to 1342 Lexington. Although she liked Warhol's John Chamberlain sculpture better than the soup can and dollar-bill paintings she saw at Andy's house, de Antonio reminded her that she'd already made a big mistake by rejecting another of his favorites, Frank Stella. Fumbling drunkenly in her bag for her lucky charm, a two-dollar bill, Ward said she'd give Andy a show if he painted it. The chief recommendation of the story, which smacks of retroactive myth making, is that it alone explains the existence of Warhol's two-

dollar-bill paintings. Since Jeffersons were almost as unusual in 1962 as they are today, Warhol would have needed a specific reason to paint one. Unfortunately, the timing makes the story unlikely, since this encounter could not have taken place until June and the first two-dollar-bill paintings are known to have been done in March and April of that year.

Ward's version begins at least in documented fact. The Stable artist Alex Katz had made a series of wooden figures for a play by the poet Kenneth Koch. Since he had provided his set design gratis, Katz was happy to accept Martha Jackson's offer of $1,500 for the pieces. When Jackson mounted a show of Katz's figures in June, Ward, infuriated by his betrayal, dumped Katz from her roster. His canceled show left a hole in her fall lineup. Ward decided not to worry about it for the time being. She went off to her summer house in Old Lyme, where, shortly afterward, the occult, or perhaps Ward's deep unconscious, intervened. She was sunning herself one afternoon, "not thinking about anything in the world, and suddenly a voice said, 'Andy Warhol.' . . . I sat up and thought, 'How extraordinary! My guardian angel.'" She immediately telephoned Warhol, "told him who I was" (although they had met at least once), and made an appointment to see his work. Finding it to be "an incredible collection" which "absolutely stupefied" her, she offered him Alex Katz's vacated slot. (The only thing she remembered Andy saying, repeatedly, was "Wow!")

And then there's a third version. Never one to mince words, Ivan Karp pointed out that "Eleanor hated Andy's work." Karp insisted that the person responsible for getting Warhol into the Stable was neither Ward nor de Antonio: "Andy finally told me that he made the connection through Alan Groh." Karp didn't know the specifics of Groh's role; Groh, he said, "was such a self-effacing person that he never took credit for anything."

Buzz Miller, Alan Groh's companion since the mid-fifties, was one of the top Broadway dancers of the day. Jerome Robbins's former

lover, Miller was featured in the famous "Steam Heat" number of *The Pajama Game* in 1954 (he reprised his role in the 1957 movie version) and appeared in *Me and Juliet*, *Funny Girl*, and many other Broadway shows. Miller was a gay-world superstar in the fifties. Andy, an inveterate stage-door Johnny, longed to meet him. In 1957 he asked a mutual friend to bring him to a party thrown by Miller, whose only memory of Warhol from that evening was, predictably, that he "sat in a corner and observed." They nonetheless struck up a friendship. The hoofer considered it a feather in his cap to introduce his camp follower to Alan Groh—here was an artist he could bring to his boyfriend's attention.

Andy had continued to pay court to Miller, presenting him in 1958 with a watercolor-and-ink boot in the style of the 1956 gold-leaf shoes. For his part, Miller encouraged Andy to pursue his new connection at the Stable. Of course, Alan Groh would not have given Warhol's recherché fifties drawings a second glance. But by 1961, everything had changed. Groh knew as well as anyone that New York's galleries would go under if they stayed with Abstract Expressionism. So when Warhol reappeared with samples of his new work, Groh was ready to take a second look. Groh, moreover, was interested in bringing gay artists into the Stable Gallery; it was his way of countering the still-entrenched homophobia of the sixties art world.

Whatever the path, Andy had his gallery now, and the upcoming show in Los Angeles, which was to consist solely of Campbell's soup portraits—the entire product line, "Bean with Bacon" to "Vegetarian Vegetable." In mid-June, Andy shipped the sixteen-by-twenty-inch paintings to Irving Blum at the Ferus Gallery; on June 26 word came back, via postcard, that "32 ptgs. arrived safely and look beautiful. Strongly advise maintaining low price level during initial exposure here," Blum wrote. They settled on a price: $100 per canvas.

Southern California, circa 1960, was largely devoid of high-cultural resources. Los Angeles had a visual arts avant-garde, centered around the painter Robert Irwin and the assemblagist Ed Kienholz, and no

contemporary art market to speak of. The city's few collectors, largely Hollywood moguls, were interested in nothing more recent than Picasso.

Los Angeles's avant-garde community was, in effect, jump-started by the Ferus Gallery, founded in 1957 by Kienholz and Walter Hopps, a renegade from academia (despite six years of undergraduate work and two of graduate art history, Hopps had no degrees; he'd been too busy promoting jazz and running art galleries, of which Ferus was the second). In 1958 Kienholz exited and Blum, a young businessman-aesthete, entered. Hopps was the gallery's ideologue, Blum its public face. In the lectures and classes he offered at the gallery, Hopps almost singlehandedly created the market for new art in Southern California; Blum tapped it. Blum, blessed with great suavity, was able against all odds to interest upper-class Angelenos in difficult art.

Irving Blum

Since Andy had never indicated to Blum how he wanted the show hung, Blum did it himself, arranging the small canvases in a single horizontal row, resting on a wooden strip that suggested a shelf: a playful if obvious supermarket allusion.

The show opened on July 9. Warhol celebrated in New York at dinner with de Antonio, Geldzahler, Stella, and Barbara Rose. Blum's Ferus artists were, he said, "spooked": confused but curious, "genuinely interested in the work, in what my feeling was, in why I'd taken the guy on." The Los Angeles critical community, such as it was, dismissed Warhol with cheap shots. "The darts he is throwing turn out to be

boomerangs," wrote Henry J. Seldis of the *Los Angeles Times*. "This young 'artist' is either a soft-headed fool or a hard-headed charlatan." Down the street from the Ferus, the Primus Stuart Gallery erected a Campbell's soup can pyramid in its front window, beneath a sign reading, "Do Not Be Misled. Get the Original. Our Low Price—Two for 33 Cents." In the *Los Angeles Times*, a cartoon depicted two beatniks at the "Farout Art Gallery, La Cienega Blvd" pondering Warhol's soup cans. "Frankly, the cream of asparagus does nothing for me," said the woman beatnik to her consort, "but the terrifying intensity of the chicken noodle gives me a real Zen feeling!" Blum wrote to Andy on July 23: "Enclosed, yet another witless review. No matter, the show is glorious . . . and I'm enjoying it enormously." He was putting a brave face on things. The show was a bust: during its four-week run, only one painting was sold, with IOUs for a handful more (including a pledge from Dennis Hopper, an early Warhol enthusiast).

At that point, Walter Hopps and the critic John Coplans made a suggestion: why not keep the paintings together, reconceiving them as a single piece? The idea immediately appealed to Blum, who decided that he wanted them himself. He bought back the sold canvas, canceled the IOUs for the others, and telephoned Andy, asking him to name his best figure for the set. Andy wanted $1,000. Blum asked for a year to pay; that was a big number for him. It was one of the best investments in art history. Thirty-four years later, Blum would sell *32 Campbell's Soup Cans* to the Museum of Modern Art for $15 million.

"It just made sense to keep them together as a group," according to Blum, and he was right. He'd had only one available wall at home, which precluded the single horizontal row in which he had shown them at the Ferus. The configuration that he chose, eight horizontal rows four deep, has remained the standard. And so, thirty-two separate pictures retroactively became *32 Campbell's Soup Cans*: Warhol's first serial image.

It was getting harder and harder for Andy to muster enthusiasm for commercial work. His friend Ed Plunkett remembered seeing him, in late 1962 or mid-1963, scanning a letter from a commercial client who wanted a drawing. "He sort of set it aside," Plunkett recalled, "and said, 'Well, I don't think I want to do anything like that anymore.'" Diana Klemin, who art-directed Andy's many book jackets for Doubleday, felt that "he was getting very uppity. He wasn't going to do book covers for me anymore, he said, 'because if I continue to do jackets for you, the galleries and the fine artists won't accept me.' He knew he had to make the jump."

One of the few commercial outlets for which Warhol still enjoyed doing assignments was *Harper's Bazaar*. Part of what kept him at *Bazaar* was its two hip young art assistants, Ruth Ansel and Bea Feitler. Ansel in particular, a passionate film fan, was one of Andy's most frequent early-sixties dates, always ready to take in an old movie or a Broadway show. But what especially drew Warhol to Ansel, Feitler, and their boss, Marvin Israel, was that they were aware of and interested in his fledgling fine art career. Close friends of Emile de Antonio, Israel and Ansel in particular made the magazine available as a testing ground for Andy's new work—what's more, they were Warhol's only commercial art contacts to have a direct impact on his emerging fine art style.

Pear-shaped, irascible Marvin Israel, a painter at heart, was never comfortable in the corporate world. At *Seventeen* "he was always a rebel and often grumpy," observed Art Kane, whom Israel replaced as art director in 1955. Hired in 1961 to replace Henry Wolf as the *Harper's Bazaar* design chief, Israel was fired in early 1963. In his brief commercial art career Israel opened the pages of *Seventeen* to the photographers Robert Frank, Gary Winogrand, and Lee Friedlander; at *Bazaar* he gave Diane Arbus's portraits of freaks and misfits some of their earliest exposure (Arbus's lover and chief artistic goad, Israel likely played the decisive role in her emergence as an image maker of

genius). He commissioned new work from established fine artists—Richard Lindner, Richard Pousette-Dart, Larry Rivers—and, in the summer of 1962, from an aspiring one. A genre breaker himself, Israel had none of the mandarin's scorn for a commercial artist struggling to break into the gallery world. He had known Andy Warhol at least since 1957, when he gave Warhol and Edward Wallowitch a joint assignment at *Seventeen*.

Whether or not Israel had seen Andy's new paintings, Ansel had. Probably in the spring of 1962, Emile de Antonio brought her to 1342 Lexington. From her account, it sounds as if Ansel's visit occurred around the time of de Antonio's Solomonic judgment on the two Coca-Cola paintings.

"The whole thing seemed like sort of a secret," Ansel recalled of her quick lunchtime viewing. "De said, 'Nobody knows about this. Andy is very nervous and wants me to see this new work.'" Ansel, who until now had known Warhol solely as a commercial artist, was shown two paintings. "I remember vividly those two startling, abrasive, black-and-white images in this wood-paneled, very traditional room. One was a big, *big* telephone—I mean, this thing was huge. And the two noses were next to it. I was much more offended by the noses. The telephone kind of looked like a Leger to me. But the subject matter was shocking, because it was absolutely who the hell was doing a *telephone*? And they were ugly as sin. De said, 'God, Andy, you're onto something.' And Andy said, 'Gee, De, do you really think so?' I said nothing, I was a little girl, I was very young, though opinionated. I just remember De saying, 'Andy, these are terrific.' I thought they were awful. But I had to admit they were his. I'd never seen anything like them."

Warhol may have shown Ansel a miniature version of what she called "the nose-job thing," *Before and After*, as a potential illustration at about this time. "I think I'd given him an assignment," she said, "and he came into the office with *this* and said, 'Do you think I can do this?' I said, 'What the hell is that?' I just remember thinking it was ugly and that he'd lost it."

By the summer of 1962, Ansel had evidently overcome her revulsion. She didn't recall if it was her idea or Israel's, but she remembered telephoning Warhol and asking him to submit some of his noncommercial work for an assignment. The piece, a four-page spread about cars, was to run in November.

"We needed to do cars," said Ansel. "Every magazine was getting more and more commercial. In order to get car advertisements, you now had to drape models over cars in a fashion spread, or do a feature on cars. Marvin hated cars, we all hated doing something commercial, and we were trying to outsmart the editors. I'm amazed we got away with it." The point of the article, entitled "Deus ex Machina," was to be the paintings; the only text was a half-column of vaporous reflections on "the machine," taken from a prepublished source.

Israel and Warhol discussed the assignment at some length—Ansel remembered them having more than one meeting. "This was a big job for Andy. The amount of work, I mean, not the money. He would have been paid nothing. I mean, they paid seventy-five dollars a page, something ridiculous like that." What emerged from the discussions were eight Warhol canvases—photo silk screens, line-cut silk screens, and hand paintings—of late-model American cars. *Bazaar*'s photographer shot the paintings stacked in elegant disorder in Warhol's living room. "I remember Marvin telling Andy, 'Just prop them against the wall,'" said Ansel; "it was a very deliberate artist-in-the-studio, behind-the-scenes kind of thing." Behind the new canvases, Andy propped *210 Coca-Cola Bottles*—why not publicize other work? As in all of Warhol's product paintings, the subjects are decontextualized, severed from their original, magazine-ad environment and made to float disembodied on a featureless ground. Despite the arty layout, the four pages practically leap out of the magazine. He was paid $824 for the assignment. The eight paintings are, of course, worth millions today.

Warhol was here not in his humble illustrator's capacity but in his fledgling high-art role, as the caption made plain: "Commissioned by *Harper's Bazaar* to make a visual comment on the phenomenon of the

American motorcar, Andy Warhol, continuing his experimentation in 'Commonism,' or the art of giving the familiar a supra-familiarity, made the nine oil paintings on these and the two preceding pages: Studebaker Avanti, Buick, Lincoln Continental, Pontiac, Cadillac."

Pinpointing the artistic status, high or low, of Warhol's next *Harper's Bazaar* assignment is not so easy. For the December issue, Marvin Israel asked Andy to provide art for a two-page feature on nine new personalities in the arts: movie actors Tom Courtenay and Anna Karina, conductor Lorin Maazel, filmmaker Jacques Rivette, novelist David Benedictus, ballerina Lupe Serrano, opera singers Grace Bumbry and Jess Thomas, and jazz musician Carmell Jones. The title was, "Stop, Study and Applaud—Names and Faces Worth Remembering."

Starting with photographs of his subjects, Warhol had rubber stamps fabricated, which he used to compose his layout. The stamped faces were blurred, faded, and smudged. Images overlapped, half obscuring each other. The overall effect was of a drunken grid. The piece was lovely in its dishevelment, and Ansel remembered using it more or less as Warhol handed it in. It was almost killed: "None of the editors wanted it," said Ansel. "They hated it—that kind of irregularity was not done in 1962—but we got it through."

Andy received $412 for the piece (including $100 reimbursement for the stamps). Although it was a work of commercial, functional graphic art, it had the look of the fine art that Andy was pitching to galleries. Distinctions between high and low were being undermined, driving many a critic to howls of outrage. Unlike his fellow "commonists," Warhol was going at it from both sides of the plate, as a commercial *and* a fine artist. Nor, by now, was he merely aiming his art at galleries. By the time the December *Bazaar* hit the newsstands, Warhol's show was up at the Stable. Suddenly he was the most talked-about young painter in America.

Marilyn Monroe was not only a Serendipity icon; she was a customer. She often came in with her acting coach, Paula Strasberg, whom the

store's Stephen Bruce knew well. Sometimes she came in alone. She was very quiet. Leaving her chauffeur waiting outside, she would sit in the back and call Bruce over to talk. One day she came in by herself. She was lonely, she said. She wore a raincoat, a babushka, and mules. Sitting across from her, Bruce observed that she was naked under her raincoat. Hurrying into Serendipity one night, she pointed to a dress and said, "Can I wear that? I'm late for a premiere." Bruce didn't have it in her size, only in two sizes smaller. She hurried him into the ladies' room and told him to zip her into the dress. The zipper broke. "So I sewed her into it," said Bruce, "and she went out of there like a battleship. Tits ahoy!"

A few days after Marilyn killed herself on August 5, Warhol's friend Ed Plunkett ran into Andy, who proposed going to Serendipity. When they arrived, "one of the owners rushed up and said, 'Oh, Andy, will you do a book for us on Marilyn?'" Plunkett supposed that he meant one of Andy's fifties-style books of cherubs and kitty cats, which Serendipity sold. "Andy sort of said, 'Well, okay.'" It would be fitting if the *Marilyn* series blossomed over a casual exchange at Serendipity.

Andy's relationship to Hollywood stars was complicated. He spent much of his childhood daydreaming about Shirley Temple and other Hollywood divas. Yet Marilyn's sensual yet breathily innocent persona differed from the classic silk-and-steel stars of the forties and fifties: Joan Crawford, Bette Davis, Marlene Dietrich. Marilyn's image exuded sensual mischief and a childlike joy, but her life was a nonstop disaster—and she came to embody the gap between glamorous appearance and personal tragedy.

Warhol's *Marilyn* is unreal. With those slabs of green eye shadow and those cartoonish lips and fluorescent yellow hair, she's wholly artificial. The colors are those of advertising, which Andy knew how to deploy as well as anyone. Transferred to the art gallery, they became provocatively kitsch—eight of the *Marilyns* came in flavors: *Mint Marilyn, Grape Marilyn, Peach Marilyn, Cherry Marilyn*, and so on. Whether or not Ivan Karp (who claims to have titled most of Warhol's

sixties work) dreamt up this touch, it underscored Andy's identification of celebrities with products. The same is true of the serial *Marilyns*, especially *Marilyn's Lips*, in which Monroe is reduced to a single voluptuous body part.

Despite its artificiality, there seems to be a vulnerability, a resigned and knowing sadness in the Marilyn portrait. And yet it is unclear if the sadness is projected by the viewer. In one of the earliest commentaries on Warhol's art, the art historian Michael Fried went out of his way "to register an advance protest against the advent of a generation that will not be as moved by Warhol's beautiful, vulgar, heart-breaking icons of Marilyn Monroe as I am." Suppose that you didn't know who Marilyn Monroe was, as you don't know the subjects of Vermeer's *Girl with a Pearl Earring*, or Picasso's *Demoiselles d'Avignon*. You have to know the backstory to be moved, Fried was saying: when Marilyn is forgotten, *Marilyn* will lose its power.

But Fried underestimated the staying power of pop-culture icons. He wrote in 1962, at the beginning of the era of media- and marketing-generated celebrity. Forty-odd years later, Monroe's iconic status (and that of another classic Warhol subject, Elvis) are as bright as ever. The power of Warhol's *Marilyn* lies outside of the painting itself, which, of course, is also true of other historic portraits. Separated from its context, which the viewer provides, it is a fuzzy, out-of-register, garishly hued picture of a face, one seemingly freighted with meaning. But this is a game that Andy's playing with the viewer—because there is no one ascertainable meaning in the picture, only the desire to find one.

Warhol was a master at suggesting meaning, without actually committing himself. He managed this in several ways: by choosing highly charged but indeterminate images (the dead superstar, the presidential widow, the suicide in midleap); by the many variations within a multiple portrait, which, though they invite interpretation, are in fact merely accidental and without meaning; and by the lack of clarity in the photo silk-screened image itself, a casually silk-screened print of a

blown-up acetate of an eight-by-ten publicity glossy, itself a mechanically printed blowup of the contact sheet positive, itself a second-generation transfer from the original negative. As the critic David Antin put it, "Somewhere in the image there is a proposition. It is unclear."

But the ambiguities, while appearing accidental, even paradoxical, were inherent from the start in Warhol's subject choices—in the case of *Marilyn*, an image as both saint and kitschy lobby card. Even the technical aspects of the painting add to the indeterminacy of meaning. "This is all accidental," Warhol's assistant Gerard Malanga observed of the smudges on the black-and-white side of the *Marilyn Diptych*. "What happened was, the ink started tacking up on the screen. So when we put the screen back down and screened through, it would create streaks, 'cause some of the ink was drying up on the other side of the screen. And also the screen was still wet. So when we pushed the squeegee across, the paint is blocking the pores in the screen and creating what appear to be streaks. The black is where the screen is very wet [full of ink]. When you put the screen down it's automatically adding more paint to the image."

Although today there is a tendency to streamline early-sixties art history into a one-to-one passage from Abstract Expressionism to Pop, not every younger artist, circa 1960, was preoccupied with popular culture, everyday objects, and erasing the gap between art and life. The art world was a welter of divergent tendencies. Aside from Pop, there were hard-edge Abstractionists (Frank Stella, Ellsworth Kelly, Al Held), hard-edge realists (Alex Katz), color-field Abstractionists (Helen Frankenthaler, Morris Louis, Kenneth Noland), proto-Minimalists (Carl Andre, Walter de Maria), still viable Abstract Expressionists (Joan Mitchell), and unclassifiable mavericks (Alfred Leslie). The status as Pop forefathers of Jasper Johns, Robert Rauschenberg, and Larry Rivers was largely incidental to their respective projects, and each continued on his independent way.

The reasons for the selective memory are several. There had been a substantial lag between Abstract Expressionism's acceptance within the New York art world and the broader public. It was not until the Museum of Modern Art's 1958 New American Painting show, Abstract Expressionism's first endorsement by a major museum, that the style became widely accepted—late in its evolution. Further, when MoMA sent the show on a European tour, it was a smash hit. Once the Europeans accepted it, the American cultural establishment, which still mimicked Europe in matters of taste, made room for Abstract Expressionism in its museums, universities, and Sunday newspapers. Yet no sooner had Abstract Expressionism made it to center stage than it was abruptly given the hook. A dozen-year cycle from hegemony through ossification to decline, including a half-dozen years of ferment from Rauschenberg to Lichtenstein, was invisible to the general public. What the world saw in 1962 was the sudden, dramatic toppling of the leading style of the day by the new media favorite, Pop. The fact that their period in the sun was so short heightened the Abstract Expressionists' already strong resentment; their disdain for Pop art turned into a vociferous near-mania. The art world and mainstream press both picked up on this animosity, providing the raw material for later simplifications of early-sixties art history.

Pop may have been an avant-garde art, but what the public responded to was its populist veneer. Regardless of how often Lichtenstein protested that his purpose was "entirely aesthetic, and relationships and unity are the thing I'm really after," a roomful of Kenneth Noland paintings with their opaque squares and circles were never going to elicit the same level of conversation as a roomful of Lichtensteins. Art based on cheeseburgers and Chevys and Marilyn Monroe offered countless openings for cocktail party conversation and glib witticisms, regardless of whatever formal concerns, irony, or art history references underlay this imagery. America became, briefly, a nation of art critics—and Pop routed the field.

That Pop's triumphant arrival was orchestrated by the dealer Sidney Janis was something of an irony since his gallery was home to many of Abstract Expressionism's great names—de Kooning, Rothko, Adolph Gottlieb, Robert Motherwell, and Philip Guston. Janis's sudden attachment to Pop art only intensified the myth of a showdown between Abstract Expressionism's grizzled old-timers and Pop's young guns.

But Janis was as eclectic as any successful art dealer, and, aware that the bottom had fallen out of the Abstract Expressionist market, was avidly scouting new trends by mid-1962. The English dealer Robert Fraser caught sight of Janis that summer, sniffing out new artists in London: "Mr. Sidney J. paid me a lightning visit," Fraser reported to a New York friend, "expounding enthusiastically about the glories of 'the New Realists!'" Having found his trend, Mr. J. was making ready to unveil it.

Eager to authorize a new international style, Janis roped together what were in fact highly disparate movements: English Pop, that reserved and politely intrigued response to postwar Yank culture; French *Nouveau Réalisme* (from which Janis borrowed the name for his New York show), a somewhat fusty resurrection of Duchamp's art-life border patrols; and Lichtenstein, Oldenburg, Rosenquist, and their fellow Pop artists.

The "New Realists" opened, with a bang, on what Janis's spooked abstractionists no doubt considered an appropriate night: Halloween. Janis had gone overboard, selecting so much art that a second, ad hoc gallery was needed, an empty store just across Fifth Avenue, whose window Janis filled with Oldenburg's garishly painted ladies' underwear: a touch of dumpy Orchard Street on soigné 57th Street. Warhol's contributions were *Big Campbell's Soup Can, 19¢, 200 Soup Cans*, and *Do It Yourself (Flowers)*, one of Warhol's paint-by-numbers exercises. Lichtenstein showed *Blam!* and *The Refrigerator*, Rosenquist showed *I Love You with My Ford* and *Silver Skies*. Oldenburg, aside from the lingerie, showed some of the Store's ersatz pastry ("appetite-wrecking

collations," muttered Harold Rosenberg in *The New Yorker*). There was other memorable work: Robert Indiana's *Black Diamond American Dream #2*, Tom Wesselmann's *Still Life #19*, and a ghostly George Segal family, six plaster figures grouped around a dinner table.

"It was a wild opening," recalled Walter Hopps, in from Los Angeles. Andy spent most of the evening huddling in a side room with Karp; James Rosenquist was "bouncing around"; Jasper Johns appeared and vanished; Bob Rauschenberg, who had broken up with Johns the year before, stayed much longer. Allan Kaprow, originator of the Happening, was there, as were the critics Robert Rosenblum and Leo Steinberg, whom a photograph shows deep in conversation in front of Wesselman's *Still Life #17*. The contraptionist, Jean Tinguely, who had terrified a black-tie gathering at the Museum of Modern Art in 1960 with his *Homage to New York*, a self-destructing machine that included bicycle wheels, a piano, a bathtub, a bassinet, and a barbecue, was back with an icebox—Duchamp's icebox, rescued when the master had discarded it from his West Village apartment. When its door was opened, a horrible siren went off. ("Loud!" said Hopps. "Very loud. This was disruptive to the gravity of the show.") A born insurgent, Hopps was having a great time. He watched de Kooning, the only one of Janis's Abstract Expressionists in attendance, stalk back in forth in front of Jim Dine's *Lawn Mower*. According to Hopps, de Kooning took a swing at Dine's assemblage, Sidney Janis came rushing up waving his arms, and the two men stood shouting at each other. Calming down, de Kooning went back to stalking the art, eventually leaving without a word.

At an opening-night party at Emily and Burton Tremaine's Park Avenue apartment, Warhol, Lichtenstein, Rosenquist, Wesselmann, and Indiana were being served drinks by uniformed maids when de Kooning suddenly appeared in the doorway. "Oh, so nice to see you," Burton Tremaine said. "But please, at any other time."

"It was a shock to see de Kooning turned away," Rosenquist recalled. "At that moment, I thought, 'Something in the art world has definitely changed.'"

"With this show, 'pop' art is officially here," wrote Brian O'Doherty of the *New York Times*, one of the first recorded applications of the word *pop* to the new style. In his November 24 *New Yorker* report, Harold Rosenberg announced that "'New Realism' hit the art world with the force of an earthquake. . . . Within a week, tremors had spread to art centers throughout the country." The critical response was predominantly negative: Hilton Kramer, Max Kozloff, and Dore Ashton condemned Pop outright; Rosenberg, the great phrasemaker, was only slightly less vehement ("contrivances," "misplaced home furnishings," "advertising art advertising itself as art that hates advertising"), and Sidney Tillim, Thomas Hess, O'Doherty, Irving Sandler, and Jack Kroll were mixed to negative.

Clement Greenberg, however, saw the writing on the wall: "Abstract Expressionism had become a fashion, hence disposable, and the art market, whose business was fashion, needed a new look. It arrived in the fall of 1962."

Critics who probed Pop for the signs of subjectivity and point of view they considered the hallmarks of modern art could find nothing to reassure them. "[The Pop artist] is as reticent about his private responses as a newscaster on a network station," complained the poet Stanley Kunitz. Since Baudelaire, most serious artists had been at least implicitly antibourgeois. What drove modernist critics crazy about Pop was that its politics were so slippery. Did it criticize capitalist culture or promote it? Detractors such as Kunitz chose to see Pop as mindlessly affirmative. "The enemy has been consistently identified as bourgeois society and bourgeois values," he said at a hastily convened symposium on Pop in December 1962. "[Pop]'s signs and slogans and stratagems come straight out of the citadel of bourgeois society, the communications stronghold where the images and desires of mass man are produced." The Abstract Expressionists had been nobly oblivious to commerce; the new artists were opportunists. "I would say that all neo-Dadaists are infected to varying degrees by this overweening rage for success and attention," wrote Sidney Tillim.

The real howls of anti-Pop came from those with the most to lose: artists. Robert Rosenblum remembers being grimly buttonholed by Robert Motherwell; all the Abstract Expressionist wanted to know was whether Rosenblum was "for it or against it." The Janis show, Alfred Leslie said, "was perceived by the artists who were not making this kind of art as an announcement that the support they received was being withdrawn, that they were being abandoned, and that the marketplace was doing what it does best, using you up and finding something else to move on to." In the end it was Janis's Abstract Expressionists who abandoned him first, holding a meeting soon after the show and voting to secede en masse. Oddly, given his opening-night performance, de Kooning alone chose to stay with Janis.

For *Newsweek*'s article on the show, a reporter interviewed Warhol. Asked for his thoughts about Abstract Expressionism, Andy responded with an exquisite, faux-naif putdown: he loved it, he said, "but I never did any. I don't know why, it's so easy." The comment was calculated to incite rage. But Andy was not yet completely fluent at parrying all questions with passive-aggressive counterthrusts, and he let slip a succinct, candid remark about his work. It began with a routine untruth— he painted Campbell's soup cans because they obsessed him, he said. But, he added, he painted celebrities as well—because "they are also products."

Warhol's first one-man exhibition as a painter opened at the Stable Gallery on November 6, with The New Realists show only a week old. Being the last of the Pop artists to find a gallery had worked to Andy's advantage: by the time he got his turn, the buzz about Pop had grown truly insistent. The timing could hardly have been better: "There was an enormous amount of excitement" at Warhol's opening, Alfred Leslie recalled, "because the Janis show had caused a great stir."

The Stable was a large, handsome space split into two rooms. A spiral staircase descended into Ward's apartment, where you were

invited if you belonged to the gallery owner's inner circle. Andy spent most of the opening there. Ward and Alan Groh had hung eighteen paintings: the fifty-panel *Marilyn Diptych*; *Close Cover Before Striking (Coca-Cola)*; *Baseball*; *129 Die in Jet!*; *210 Coca-Cola Bottles*; *Red Elvis* (not the famous Elvis paintings of a year later, but one of several grid compositions of Presley's face, painted not long before the show); *Gold Marilyn* (a gold-painted canvas seven feet high and five feet wide with a sixteen-by-twenty-inch Marilyn in the center); *Do It Yourself (Sailboats)*, *Troy Diptych*, and the eight *Marilyn* "flavors."

Although Ivan Karp recalled the evening as less crowded than he wanted it to be, photographs reveal a packed gallery. In the narrow front room, the crowd was shoulder-to-shoulder, pressed up against the paintings. Ward had hung *Gold Marilyn* opposite the entrance, so that it was the first painting that gallerygoers encountered. "It was so brilliant, it glittered like a diamond," observed John Giorno, an aspiring poet whom the painter Wyn Chamberlain had brought. "The gold in it looked somehow . . . *gold*. It was luminescent." Countless commentators have compared the painting to an Eastern Orthodox icon, insisting that it mirrored Warhol's Byzantine Catholic childhood. Giorno did not agree: "The gold is there because Andy was into gold and glitter, into using something really vulgar and making it infinitely elegant. That was its power. The gold in *Gold Marilyn* doesn't represent Byzantine icons; if it represents anything, it represents Miami Beach."

Geldzahler was there, of course, as were Castelli, de Antonio, Karp and his first wife, Lois, Jim Dine, James Rosenquist, Alfred Leslie, Richard Bellamy, Ray Johnson, Arman (the friendliest of the French New Realists toward American Pop), John McKendry, curator of prints at the Metropolitan Museum of Art and a compulsive scene maker, and many others. Ward and Alan Groh passed out big orange buttons emblazoned with a Campbell soup can.

"There were lots of young people there," said Karp, "and I didn't know where they came from; they weren't from the art world."

Although Charles Lisanby didn't think much of the paintings, he enjoyed flirting with Marisol, who impressed him as "a real weirdo, but very nice." Wyn Chamberlain and Giorno approached Andy. Chamberlain, a realist painter, had met Andy before, said Giorno, "so they had three or four sentences—you know, that kind of 'Such a fabulous show,' and then Wyn said, 'I want to introduce you to a young poet.'" Andy turned, offering his "limp, cold, wet little hand," said Giorno, who held for it a moment longer than a handshake. "Oooh!" Andy said flirtatiously.

"I was sort of in love with him from a distance," said Giorno—"not with him, but with the work, we were all excited about Pop art and anyone who did paintings of Marilyn Monroe was a genius in my eyes. So I was a young kid, my big hot hand in his little one, and this 'oooh' of his—I was thrilled. Then somebody else got his attention and that was that. But looking back, that was the moment we made a connection." The connection would be pursued on both sides.

To William Wilson, a young Queens College professor and art critic who brought his twin baby daughters, the Stable opening "was the first circus opening, the first gallery-event. Johns's great opening four years before had been focused on such intensities that it was intellectually and emotionally sobering. Contrarily, Andy's was the first party opening in my experience, with theatricalized and belaboredly self-styled people to a degree I was familiar with from downtown, people in their get-ups, but that I hadn't witnessed or participated in uptown.

"Warhol's paintings looked *fast*," Wilson continued. Unlike a de Kooning or a Rothko, with all of its complexities, one absorbed these paintings instantly. "Everyone was going to have to lay a path of one's own in relation to Warhol's coordinates. I knew immediately that he was deflecting the course of painting, and so apparently simplistically that something like the *Paint by Numbers* painting seemed a gimmick. Painters would need to blaze their own paths now, that would turn away from everything that was securely known up to that point. We were all going to have to think faster in order to keep up."

Henry Geldzahler lived in a big apartment at 112 West 81st Street, where he threw a party for Andy that night. Henry evidently hadn't done much preparing; at the last minute, de Antonio rushed off to buy cocktail glasses, ham, and roast beef. According to Bourdon, the party was a dud—eager to bring Andy out in art world society, Bourdon wrote, Geldzahler had invited an establishment crowd, including a number of Abstract Expressionists, who glowered Andy into the shadows, "a wallflower at his own party." Bourdon must have left early, because a number of others recalled a very different atmosphere, filled with loud rock and roll and a sense of the onrushing future. Jasper Johns, dignified in a brown tweed suit, asked Sarah Dalton to do the twist. It seemed as if *le tout intellectual* New York was there. Susan Sontag was there, and so was Norman Mailer. Ivan Karp was the deejay, playing the Shirelles, the Crystals, and Ben E. King.

When the reviews appeared, Warhol's show fared better than The New Realists had, though Warhol came in for his fair share of abuse. "The air of banality is suffocating," wrote Dore Ashton in "New York Report." "Where Rauschenberg took the daily newspaper and made of it a trampoline for his imagination, Warhol simply lifts the techniques of journalism and applies them witlessly to a flat surface." Warhol's work, Donald Judd wrote in *Arts*, "certainly has possibilities, but so far it is not exceptional." The most coherent review was Michael Fried's. The young Greenberg disciple was surprisingly positive. Correctly identifying the hand-painting, silk-screening technique that Warhol had used for the Monroe, Presley, and Donahue pictures, Fried called the result "brilliant," although he added that Warhol was "capable of showing things that are quite badly painted." At his strongest, the Marilyn paintings, Warhol displayed "a sure instinct for vulgarity (as in his choice of colors). Of all the painters working in the service—or thrall—of popular iconography Andy Warhol is probably the most single-minded and most spectacular."

Almost four decades later, in the *New Yorker*, Peter Schjeldahl amplified Fried's remarks: "The semaphoric image of those eyes, those

lips, and that hair seems fated to be the most lasting artistic icon of the past hundred years. . . . That the works don't seem like disembodied layers but are truly paintings—raw, handmade objects—registers as a shock when they are viewed in person and in glorious variety."

Eleanor Ward sold every painting in the show, at prices that ranged from $250 for each of the *Marilyn* flavors, to $900 for the Coca-Cola matchbook cover, to $1,200 for *Gold Marilyn* (bought by Philip Johnson) to $1,950 for *210 Coca-Cola Bottles*. In his second year as a part-time painter, Andy had earned $5,900, a figure that vastly outstripped those of the typical struggling veteran of Abstract Expressionism. Bored with it or not, he had turned out as much commercial work as ever: his sales for the year, fine art and commercial, were $43,639 (not including an unreported $14,000 that turned up in a 1966 audit).

A full-time artist needed a workable studio. Having outgrown the kitchen table and parlor floor front room at 1342 Lexington, Andy had moved to the living room earlier in the year. At first ornately furnished with Andy's eclectic *objets*, the room was progressively stripped bare; finally, there was nothing left but rolled-up canvases and a few crates for furniture. When he wanted to show paintings, Andy stapled them to the expensive paneled wall, irritating the fastidious Nathan Gluck.

A friend named Don Schrader found an unused two-story firehouse at 159 East 87th Street, between Third and Lexington. On December 21, Andy signed a month-to-month lease for the place at $150 per month.

Nineteen sixty-two was Pop art's heroic year. A nameless underground tendency in January, by December it was the art world's dominant trend. For all of the purchases, media coverage, and hastily planned upcoming museum shows, perhaps the best yardstick of Pop's success was Warhol's, as his crude, bland, "inartistic" work made the fewest concessions to current fine art taste. This willingness to irritate, as well as an eye for images of maximum public resonance and, increasingly, a

need and an instinct for publicity, made Warhol the style's recognized standard-bearer.

His social life, too, improved. He was invited to Zachary Scott and Ruth Ford's apartment in the Dakota for Thanksgiving, where he met Charles Henri Ford, novelist, poet, filmmaker, photographer, and gay boulevardier.

On the day after Christmas, Warhol and nine other artists were invited to make mural-sized works to adorn the exterior of the upcoming World's Fair's New York State Pavilion, designed by Philip Johnson. Days earlier, Johnson had offered Warhol's *Gold Marilyn* to the Museum of Modern Art, which accepted the painting into its permanent collection. Less than ten years had passed since Andy had dreamed of illustrating a MoMA Christmas card; six years since the museum had refused his shoe drawing. Still making commercial images, Warhol had been stamped with modern art's ultimate seal of approval.

CHAPTER FOUR

I said to him, "Who the fuck's going to want to look at an
eight-foot picture of a hideous car crash, Andy? You're going to
kill your economy." He said, "Oh well, it has to be done."
—IVAN KARP

I t didn't take long for the art establishment to line up behind
Pop. Dealers, collectors, and museum curators had been anx-
iously seeking the Next New Thing for some time now, and Pop
filled the bill. It was bright, fun, provocative, and popular with both
the media and the public.

Time and *Life* found Pop, coming on the heels of Pollock's dark
entanglements, a refreshingly facile subject, a foil for headline writers'
witticisms. Pop's bounce and futuristic sheen, moreover, matched the
day's mood. The leaders who had shepherded the country through
poverty and war were at last moving offstage, succeeded by what *Life*,
in its September 14, 1962, issue, called "The Take-Over Generation,"

its embodiment our youngest-ever, handsomest-ever president. America was on a precipitous youthward slide, in which *Life*'s youngish "new breed"—James Watson, Murray Gell-Mann, Thomas Eagleton, John V. Lindsay, Philip Roth, John Updike et al.—were merely the midpoint, temporary fill-ins for the figure shortly to emerge as American culture's dominant voice from the mid-1960s to the present: the adolescent.

In the winter and spring of 1963, Pop went national. Suddenly every museum had to have a Pop show, "all extravaganzas," Claes Oldenburg recalled. Pop's handful of artists barnstormed the country like an old-time baseball team, riding the same train, met at the station like celebrities, or at least curiosities. "When you came to town it was like a circus. All sorts of people asked you stupid . . . hostile questions. You could strike all kinds of poses and have fun with these people. It made one a theatrical figure. You would travel to places like Worcester, [where] there was this Pop art show and then afterwards there was a party and all the members of the museum got rather drunk and extremely hostile. They had to have the show because it was *au courant*, but they really thought it was terrible trash and they wished it would go away."

Between March and December there were exhibitions in New York, Washington, Houston, Kansas City, Oakland, Des Moines, and other cities. "Six Painters and the Object" (Johns, Rauschenberg, Lichtenstein, Dine, Rosenquist, and Warhol) ran from March through June at the Guggenheim Museum in New York. (The "six" were originally seven—Lawrence Alloway had planned to include Harold Stevenson but backed down when he saw Stevenson's proposed contribution, a gigantic nude, its face modeled after Sal Mineo's, called *The New Adam*.) After its Guggenheim run, "Six Painters" was sent on a seven-city tour, from Los Angeles to Boston and back across the country to La Jolla. The Washington Gallery of Modern Art's big Popular Image Exhibition ran in April and May. At the opening, a "pop festival" with an Oldenburg happening, a John Cage concert, and other attractions

drew national coverage, most of it skeptically amused: "Pop art is more than just paint and plaster; it is also a clangor of nonmusic, a babble of tape recorders, and the 'happening,' a nonplay which requires one or two small rooms and the tolerance of the spectators," *Newsweek* informed its readers. But the *Washington Star*'s Frank Getlein wanted to know why, if Pop was breaking down the boundary between art and life, the stuff was being exhibited in an art museum. Getlein's blue-collar skepticism in fact pointed up the disingenuousness of the Pop revolution: if this were really a merger of high and low art, why were the prices still astronomical, why was its home still the gallery?

In March young Sam Green, using his connections at Wesleyan, curated The New Art, a smallish but first-rate show, for which Alloway wrote the catalogue essay; the venerable critic Herbert Read called the show "'the most offensive thing he'd ever seen,' which was great," according to Green. Pop Goes the Easel was at Houston's Contemporary Arts Museum in April. In September, Pop Art U.S.A. was at the Oakland Museum in California, while Kansas City's Nelson-Atkins Museum mounted two Pop shows, Popular Art in April and Mixed Media and Pop Art in October.

If the Pop art that floated out across the nation in the pages of *Time*, *Life*, and *Newsweek* was cheerful and upbeat, a big, red, slightly silly balloon, Warhol wasted no time in taking the precisely opposite tack. Listening to the radio during a late-1962 holiday (he recalled it as either Labor Day or Christmas; it was very likely the latter), he was struck by the relentless predictions of traffic fatalities. "Every time you turned on the radio," he later told Gene Swenson, "it said something like '4 million are going to die.' That started it": a more than year-long preoccupation with death, violence, and their photographic representation. Although Warhol always considered *129 Die in Jet!* and the *Marilyns* his first "death" pictures, death now shifted from an undercurrent to the artist's dominant theme through early 1964.

Some seventy Warhol canvases have come to be loosely grouped

together as the Death and Disaster paintings. More than forty were originally numbered in a single series, *Disasters* (a rubric probably coined by Ivan Karp); the sequencing is substantially lost. The subjects include suicides, car wrecks, an accidental poisoning, an electric chair, and other grim images. A number of others, while not directly treating death, share in the spirit of catastrophe: three call girls under arrest, a police dog attacking a civil rights marcher, a childbirth in a small-town hospital.

Warhol's sources were magazines (he was a faithful clipper of *Life*, which yielded a number of the images), tabloid newspapers, celebrity glossies, and wire service photos. His friend David Bourdon, who was now working in the Time Inc. editorial library ("the morgue," as such collections were fittingly known in journalism), and another journalist friend, John Rublowsky, often provided Andy with pictures. Wyn Chamberlain introduced Andy to yet another source, a young New York City policeman named Jimmy O'Neill, the gay scion of generations of Irish cops, who gave Warhol a thick sheaf of photographs of suicides, car wrecks, and crime scenes.

As always, Andy entertained many more ideas than he used. A friend remembered accompanying him to Eleanor Ward's; Andy wanted her opinion on the potential as a painting of a picture he had just come across: a photograph of a badly deformed thalidomide baby. Ward looked at the picture, crumpled it without a word, put it in an ashtray, and extinguished her cigarette on it. "I guess she didn't like it," said Andy to his friend, back out on the sidewalk.

Most of the Death and Disaster paintings are serial compositions, to which they owe a number of their effects. In four of the ten *Electric Chair* paintings, Warhol screened the same image—a wire service photograph of the electric chair at Sing Sing Prison—a dozen or more times. The relentless repetition used in some of the *Disaster* paintings lends them an even more grisly aspect. Repetition in the early paintings served an aesthetic purpose; here the repeated image delivers

an extra shock—the sickening registration of statistics—while one's imagination supplies the chair's occupants and their stories. The *Burning Car* paintings are repetitions of a photograph from the June 3, 1963, *Newsweek*, in which a mangled, upended automobile sits ablaze at the edge of a suburban lawn. A telephone pole stands nearby. Ten feet up the pole, a spike protrudes; from it hangs the car's former occupant, his weirdly elongated body as stiffly vertical as the pole, his head lolling to one side. The picture's gruesomeness, if not exactly alleviated, is at least made less visceral by its presentation: as the awful image draws the viewer in, the multiple frames push him away in an "alienation effect," to borrow the theatrical concept. The goal of the illusionist painter, to seduce the eye into believing that this is life itself, is explicitly countered. This is not life, the eye reports as it jumps from one frame to the next: it's only a picture. And a particular kind of picture, a cheaply reproduced news photo, everyday fodder for millions of eyes. Magnified to big black blobs, some the size of fingertips, the pressman's Benday dots are as much a part of Warhol's painting as what it represents, reinforcing the Pop insight that a great part of our experience now comes to us not directly but through a photographic, mass media veil.

Burning Car, the grisliest of Warhol's disaster paintings, adds a further twist. In the background is a second man, caught by the photographer in such a way that he appears to be strolling along, ignoring the carnage, a literal representation of Auden's famous thoughts in "Musée des Beaux Arts": "About suffering they were never wrong, / The Old Masters; how well, they understood / Its human position; how it takes place / While someone else is eating or opening a window or just walking dully along." *Burning Car* is Warhol's remake of Breughel's Icarus, twentieth-century pulp style, calamity striking while the world goes about its business, and "everything turns away / Quite leisurely from the disaster."

Almost as shocking as the scene itself was the fact that the image

had simply been appropriated. Except for the streaks and blotches incurred during the silk-screening, the image was essentially the same as the photograph from which it was taken—"a photograph of a photograph," as Warhol's silk screens have been described. The disturbing subject matter, in other words, masked the audacity with which Warhol had taken the image. With one stroke—or pass of the squeegee through a silk screen—Warhol had struck the first decisive blow for Postmodernism.

Much deliberation has gone into the question of what Warhol was trying to say with the disaster paintings. As always, the answers lie closer to the surface than one might suppose. These are "images that anybody walking down Broadway could recognize in a split second," as Andy reminds us—instantly comprehensible, lowest-common-denominator pictures. His success, the stir that he was generating, reinforced Warhol's instinct that a corner had been turned, that less and less was going to be rejected as too shocking or novel, that the more unabashedly a work of art presented itself as nonart, the more readily the art world was going to snap to attention.

Andy could depend on his generally unerring eye to light on the most striking image and magnify its impact with just the right graphic spin. His instinct for the jarring juxtaposition reached a disturbing stage when he silk-screened electric chairs over a prototypically decorative hue, a window dresser's hue, in *Lavender Disaster*. Repetition could almost transform a grisly picture into an abstraction.

Those who read empathy or social criticism into Warhol's *Disaster* paintings miss the point. "There was no profound reason for doing a death series," Andy told a journalist in 1966. "No reason for doing it at all, just a surface reason." A work of art, especially a work of Pop art by as detached an observer as Warhol, could be as easily inspired by a cold-blooded brew of black humor, aesthetics, and audacity as by conventional cultural concern. The emotionless tone of Andy's references to *Race Riot*—"Mongomerty [*sic*] dog Negro," "tan Negro painting,"

"dogs in Birmingham"—belies any involvement in social issues. Andy's simple-minded shorthand indicates, if anything, indifference to the photograph's moral dimensions. The true outrage lay in the equating of flowers, car crashes, movie stars, race riots, and electric chairs.

The source for *Tunafish Disaster* was a *Newsweek* article about two Michigan housewives who died from eating a can of tainted A&P tuna. Many foolish theories have been foisted on this painting; a 1987 essay by the art historian Thomas Crow goes so far as to transform Warhol into a consumer-safety advocate: "The pictures of course commemorate a moment when the supermarket promise of safe and abundant packaged food was disastrously broken." But a notation that Andy scrawled on the back of one of the eleven canvases—"Tin Can Ladies"—reveals that the painting's roots lie less in compassion than in gallows humor.

John Wallowitch had a longtime friend named Neal Karrer, a caustic wit whom Andy especially liked and saw often in the late fifties and early sixties. "Andy and Neal," said Wallowitch, "had a special understanding and it had to do with black humor, like, 'Why not immortalize the ladies who died from tuna fish poisoning?' Neal would come up with ideas like that and we'd all sit around and scream with laughter."

Gene Swenson's famous 1963 conversation with Warhol, which appeared in the November issue of *Art News*, remains one of the few published interviews that convey a sense of an unguarded Andy. As Gerard Malanga recalled, Swenson was cagey enough to hide his tape recorder under the table; as a result, Andy may have been less wary than usual. The Warhol who appears here is not as efficient with his evasions as he was even a year later. His clumsiness is not his later famous faux naiveté, but something like real naiveté, and a deep unease with words. "It's hard to be creative and it's also hard not to think what you do is creative or hard not to be called creative because everybody is always talking about that and individuality." Unfortunately, Swenson seems to have doctored parts of the transcript to make Andy

appear more intellectual (such as a reference to *The Kenyon Review*, not exactly Warhol's bedtime reading).

When Andy makes a comment on a violent incident—even one in which he was personally involved—it's as a detached observer. At one point in the Swenson interview, he says: "We went to see *Dr. No* at Forty-Second Street. It's a fantastic movie, so cool. We walked outside and somebody threw a cherry bomb right in front of us, in this big crowd. And there was blood, I saw blood on people and all over. I felt like I was bleeding all over. I saw in the paper last week that there are more people throwing them—it's just part of the scene—and hurting people."

But that's as far as it goes. Even when recounting an incident in which he was personally involved, the observation is characteristically affectless. Neither here nor anywhere else in the interview is there evidence of the sympathy for the oppressed and anonymous that so impresses Crow and other latter-day commentators.

Not surprisingly, Eleanor Ward refused to show the disaster paintings. (Even later, after Andy had left Ward for Castelli, the pictures moved slowly—they were too "unsettling," according to Ivan Karp.) While it may have appeared that Andy was sacrificing immediate sales for a succès de scandale, the disturbing aspects of these paintings in fact rescued Warhol's reputation. He had been in danger of being seen as a novelty painter; with the *Disaster* series he began to be taken seriously—all too seriously. Ward may have turned up her nose at them, but several years later the pictures would comprise Warhol's first one-man European show, Death in America, at Ileana Sonnabend's new gallery in Paris.

If the Disaster series shocked gallerygoers, Warhol's blank canvases elicited ingenious metaphysical explanations from art critics. Few aspects of Warhol's art have produced more idle speculation than the blank canvases, such as the one he attached to *Blue Electric Chair*. To the critic Alain Jouffroy, the blank canvas "signals the crime of an

absence, become empty, become dead, become the systematic annul-
ment of life." On the contrary, Warhol *liked* the look. He was familiar
with the many blank canvases that had been painted in the postwar
era, and would have appreciated their ability to tease and been drawn
to them, to their provocative and enigmatic quality, to the conun-
drums they posed. He would certainly have known of Yves Klein's
monochromes, and of course he was aware of Rauschenberg's white
paintings. It's also possible, as Bourdon suggests, that "Warhol's imagi-
nation was fired by the possibility that he could persuade collectors
to buy an 'empty' monochrome unit, a notion that appealed to the
Rumpelstiltskin in him." According to his friend Nelson Lyon, Warhol
remarked to him at one point during the sixties, " 'My God, if I could
only sell shit to people, that would be just so great. That would really
be the best.' " Although no one would take such remarks as anything
but Warhol's impish humor, John Chamberlain recalled a similar com-
ment made while Andy was painting *Silver Elvis*: "I remember when
he was at the firehouse painting the *Elvis* and he put a blank silver
canvas next to it and said he oughtta get twice the price for it."

Andy seems hardly to have used his new studio during the first months
of 1963. Despite the second floor's majestically high ceilings and
ornate crown molding, the firehouse lacked both heat and hot water,
and the roof leaked. Nathan Gluck was not impressed: "You came in
and there was a big hole in the middle of the ceiling and you went up
some stairs. On the second floor, you had to be careful you didn't just
back up and fall through the hole." This was where the firemen's pole
had once stood, and there were several such abysses: as Andy recalled,
"You literally had to hopscotch over the holes in the floor." The place
was far from cozy, although friends sometimes stopped by. When Andy
wanted to show his work he rolled it up and brought it home.

Andy was astonishingly busy. His pace was propelled by Obetrol,
a mild version of amphetamine, which he began taking early in the

year—as a diet aid, explained *POPism* disingenuously, and with a pre-scription. According to Factoryite Chuck Wein, "Andy was in denial; he pretended that Obetrols weren't speed." The prescriptions were simply a way to buy speed legally. Andy's use of Obetrol, which he took in pill form, had nothing to do with dieting; he used it, as *POPism* said, for "that wired, happy, go-go-go feeling in your stomach that made you want to work-work-work."

Not only was Andy producing a mountain of work, his emotional life in 1963 was more complicated, and riskier, than ever. During a six-week period in the spring of 1963, Warhol met (in one case remet) three young men with whom he formed intense relationships, two of them sexual. In late April, Wyn Chamberlain invited Andy to dinner at Chamberlain's loft at 222 Bowery. Chamberlain, who had originally met Andy in the mid-fifties, was an independently wealthy Midwest-erner whose realist paintings had won some recognition; friends who knew him as gay in the 1950s were surprised when he married in the mid-sixties and raised a family. (He later became a novelist, publishing two books under his given name, Elwyn.) Among Chamberlain's other guests that night was John Giorno, the stockbroker whom Chamber-lain had introduced to Andy at the Stable opening. An affluent Long Islander and recent Columbia University graduate, Giorno worked on and off on Wall Street; he had already published his poetry in small journals. After dinner, Chamberlain, Warhol, and Giorno went to see *Terrain*, a new Judson Dance Theater piece choreographed by Yvonne Rainer. Giorno and Warhol chatted on the phone the next day and almost every day thereafter for the better part of a year. They went to art openings and poetry readings, to parties and to Andy's new enthu-siasm, underground films. Socially, they were a couple; sexually, the bond was negligible, the relationship settling into a pattern depress-ingly familiar to Andy: Giorno was intrigued by his new friend's turn of mind but sexually unmoved.

"There was lots of hugging," Giorno said, "but we almost never

kissed." Episodes of greater physical intensity were rare: perhaps a half-dozen instances of oral sex, always administered by Andy, who was "not adept," as Giorno put it. Andy always initiated. "I would be in bed," according to Giorno, "and he'd be sitting on the floor talking to me. His hand would come creeping under the covers. I'd go 'oh no.' But he was so nervous, with his hands trembling and his body shaking, that I realized, 'This is more important to him than saying no is to me.'" As one might expect, Warhol refused Giorno's offers to reciprocate—"I never saw him without his clothes on."

Giorno sensed a need in Andy, not only for sexual release but for playful intimacy, an absence of constraint and self-censure. Andy's pleasure in simply looking was apparent too: "Just looking at a real dick that was up close to his face, just seeing it. That was an erotic moment for him." As Giorno came to see, sex, paradoxically, was of paramount importance to this timorous onlooker. "Everything about Andy's life was sexual. Sex was on his mind every hour of every waking day. What intrigued him about somebody, male or female, was sexual energy. Not sexual in the way you read porn to get excited. But everyone has an erotic energy to a greater or lesser degree, and that is what Andy responded to."

Less than a month after he began seeing Giorno, Andy reestablished contact with Billy Linich, a bright, introspective twenty-three-year-old he had known in passing four years earlier. In 1959 Billy had been a waiter at Serendipity, fresh from a Catholic working-class upbringing in Poughkeepsie, New York. He was crew cut, wiry, and lightly bearded, with a pleasant, open face. Warhol had not intrigued him. In Billy's eyes, "this was just some successful professional person who was a friend of Stephen Bruce's, and sort of bland. He sat at a table up by the register and Stephen would come and sit with him and the waiters all came and talked to him."

On May 25, 1963, Linich and Warhol were reintroduced by Ray Johnson, a Lower East Side artist and Zen prankster who would later

be the subject of the documentary *How to Draw a Bunny*. The occasion was the Mr. New York Contest, a bodybuilders' show at the Brooklyn Academy of Music. Andy was dressed in a black leather jacket and black jeans—although his standard outfit was still chinos and Oxford shirts, he was evidently trying out new looks. If Linich had been indifferent to Warhol four years earlier, he was meeting him in a different context now. "He was an artist and a friend of Ray's; I didn't need anything more than that to be sympatico with him." Initially, Billy and Andy saw each other only occasionally, at parties, concerts, and other gatherings of the avant-garde, but their friendship would intensify before the end of the year.

Between his paintings' increasing size and the pace at which he was beginning to turn them out, Andy's need for a fine art assistant—Nathan Gluck still toiled away on commercial accounts—was becoming acute. He began mentioning this to friends, and before long, the poet Charles Henri Ford responded that he knew just the right young man. On June 9, Ford invited Warhol to a poetry reading by Frank Lima and David Shapiro, two Frank O'Hara protégés. Ford made sure that a twenty-year-old aspiring poet he knew would be there, too.

The parallels between Gerard Malanga's and Andy Warhol's backgrounds were striking and, according to Malanga, always fascinated Andy. Both were the children of older, working-class, Catholic immigrants—Malanga's father was from Potenza, near Naples; his mother from Sicily. Both boys were the adored sons of middle-aged mothers. Both were precocious movie fans, starstruck; both were avid collectors, and both drew.

But on a good day, Gerard Malanga, born and raised in the Poe Park section of the Bronx, was matinee-idol handsome: mopey and heavy-lidded, with an aquiline nose and full lips. In 1963 he still wore his hair in a Bronx teenager's pompadour, slicked back and piled high in front. He spoke with a pungent outer-borough accent.

At the School of Industrial Art (today the High School of Art and

Design), Gerard's senior English teacher was the poet Daisy Aldan, a onetime lover of Anaïs Nin and a colleague of O'Hara and the other New York School poets. Aldan made an aspiring poet of Gerard; through her he met some of the day's leading poets. At a party at Kenward Elmslie's Cornelia Street apartment, the once-promising, ruined poet Willard Maas fell on his knees before the seventeen-year-old Gerard, kissed him on the hands and called him "the new Rimbaud." (Although gay, Willard Maas was utterly dependent on his wife of many years, the underground filmmaker Marie Menken; Edward Albee is said to have based George and Martha, the warring couple in *Who's Afraid of Virginia Woolf?*, on the Maases.) Maas and Menken, who became another of Gerard's surrogate mothers, welcomed him into their Brooklyn Heights home.

"The last of the great bohemians," as they are called in *POPism*, the Maases also opened their home to the entire New York avant-garde, as well as the constant stream of hustlers Maas brought home when Menken was at work (she worked nights, at the cable desk of Time-Life). In the fall of 1962, Charles Henri Ford brought Warhol to one of the couple's famous parties, where Menken made a fuss over the rising art world star. Gerard was there too, but, busy paying court to Frank O'Hara, Kenneth Koch, and the other poets present, he could not have been less interested in Warhol. He did remember Marie Menken chasing Andy around the dinner table, trying to hug him.

When Ford finally introduced them eight months later, Warhol immediately offered Gerard a job. It is not clear whether Ford or Warhol knew that Malanga was, of all things, a skilled silk-screener. Andy would have hired the youth on Ford's recommendation and Gerard's looks. As it happened, in the summer of 1960 Gerard had worked for another Aldan protégé, Leon Hecht, who designed ties for Rooster, the then-fashionable tie makers. Gerard's job was to screen-print Hecht's designs onto big bolts of fabric, printing the same screen over and over again. An assistant who looked like Adonis and didn't

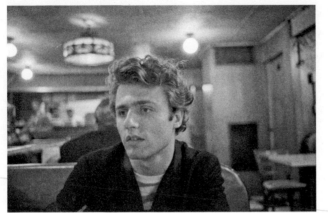

Gerard Malanga

need to be trained—Andy could hardly have asked for more. For his part, Gerard asked for $1.25 per hour, the current minimum, which is what he was paid until 1968.

Gerard showed up for work at the firehouse on Tuesday, June 11. Andy had two visitors, Edward Wallowitch and Barbara Rose. Wallowitch snapped some pictures of Warhol and the new boy, the foursome went out for lunch at a nearby Greek luncheonette, and Andy and Gerard returned to the studio and silk-screened four or five *Silver Lizes*. It was, says Gerard, "a piece of cake." Andy brought Gerard home, introduced him to Julia, put his current favorite record, the Jaynettes' "Sally Go Round the Roses," on the turntable, and vanished upstairs. Gingerly at first, Gerard leafed through the pile of grisly police glossies that sat on a table in the parlor floor front room.

They got a lot done that summer: the *Silver Liz* paintings, the portrait of *Ethel Scull*, the *Silver Elvises*, and others. Gerard took the job seriously. "I did all the run work. I might take a photograph or a newspaper clipping down to Aetna on Canal Street. Mr. Golden, Aetna Silk Screen—they made all of our screens. I took the screens uptown on the subway, tied with twine and a handle. If they were too big to carry, Aetna shipped them up. Once they arrived at the studio, Andy and I would do the prep work": painting—usually spray-painting—

the monotone background, or, in the case of a multihued work such as the *Silver Lizes*, daubing in the face, lips, and eye shadow by hand. (One time, Gerard recalled, when he and Andy had just laid down the color areas on one of the portraits, and the canvas "was just these big, colorful shapes, the face and lips and eyebrows, Andy said to me, 'Oh, my paintings look like Alex Katz paintings before we silk-screen them.'") While the paint dried, they would eat lunch at Schrafft's on East 86th Street or at the Greek's. Sometimes, to Malanga's initial surprise, they went to church, usually at St. Thomas More, a Catholic church two blocks from Andy's house. "He'd just casually say, 'Let's go to the church around the corner.' He'd sit quietly while I kept my mind busy looking around. He didn't sit in an attitude of prayer, and after about ten minutes we'd leave." After lunch they silk-screened. If they were using a small screen, one of them squeegeed by himself; with large screens, they worked together. According to Malanga, he painted several canvases that summer—some *Electric Chairs*, he recalled— entirely by himself.

His competence in the studio only begins to explain Malanga's usefulness to Andy or the multiple roles he filled during the next few years. "Andy wouldn't go out anywhere without Gerard," according to Sam Green. As socially deft as Warhol was inept, blessed with the ease and self-confidence of the very handsome, Gerard took the spotlight off Andy—at least one unknowing newspaper columnist *mistook* him for Andy, which was fine with Warhol. Gerard was a beard when Andy needed one, a visibly heterosexual presence who could kosher Andy to the straight public, the *Life* and *Newsweek* reader. And he was just as happy to be perceived as Andy's lover, raising Warhol's status among other constituencies. He was as relentless a celebrity chaser as Andy, keeping the latter apprised of, and sometimes introducing him to, the latest fashionable socialite or English rock star. He had a sharp eye for talent and looks: many of the people who entered Warhol's mid-sixties orbit—the filmmaker Paul Morrissey, the film scenarist Ron Tavel,

the actress Mary Woronov, and many others—were brought there by Malanga.

In Wallowitch's double portrait, a remarkable document of Malanga's arrival on the scene, the sexual cast of Andy's appraising glance is plainly evident. Warhol standing behind Malanga is the fox eyeing the chicken that has fallen so fortuitously in his lap. But Andy had more than his own immediate gratification in mind. Still smarting from (and still collecting) the snubs of New York's various gay elites, he was probably quick to see, whether consciously or not, that here was a way in. Gerard was bait. As Sam Green noted, Gerard was a magnet for "people with sexual lustings."

Early in their relationship, Warhol was very likely smitten with Gerard. Whatever he felt, there were undoubted benefits to the appearance that they were lovers. The charade fooled a lot of people.

Gerard was a maven of the avant-garde, dragging Andy to poetry readings, underground movies, off-off-Broadway plays. Gerard was spending a good deal of time with Allen Ginsberg, at one point sharing the top floor of a Lower East Side tenement with the poet and his lover, Peter Orlovsky. Through Malanga, Andy would get to know Ginsberg well enough to cast him (and his Beat compatriots Gregory Corso and Orlovsky) in the 1964 film *Couch*, and to socialize with him often. (The young English visitor Mark Lancaster, who spent the summer of 1964 working at the Factory, recalled one such occasion, a visit to Ginsberg's with Warhol and Malanga. "All Allen did was play that little instrument, that harmonium, and talk down to us about Eastern philosophy. Gerard was at his feet.")

In September 1963, Malanga brought John Ashbery to the firehouse to meet Warhol, inititating a relationship that Andy took pains to maintain. Accompanying his *Flowers* show to Paris in May 1965, Warhol took Ashbery to lunch; as Malanga recalled, "Andy didn't pick up the tab, he grabbed it." On Ashbery's return to America later that year, Andy threw the poet a big party; at about the same time, he

gave Ashbery one of the *Jackie* paintings. Getting to know Ginsberg satisfied Warhol's need to rub elbows with celebrities; few writers had a higher profile in the mid-sixties. As for Ashbery, he was not only a member in high standing of the New York gay cultural elite but an art world figure of consequence: the staff art critic for the *International Herald Tribune* and a frequent reviewer for *Art News*, where he would become executive editor in 1965. Whether Malanga's matchmaking was responsible or not, within several months, Ashbery was professionally closer to Warhol than many would have deemed strictly proper, not only writing a near-rave of the Death in America show but contributing an essay to its catalogue.

What did Andy get out of all those poetry readings? In the proto-Pop of Ginsberg's "A Supermarket in California," in Ashbery's magpie embrace of randomness, he would have heard similarities to his own work—and left it at that. It was more a matter of being seen, enhancing his visibility in the tight little gossipy community of the downtown arts world. If Andy were seen talking to John Cage at a Cage concert it would look good for his reputation in the art world. His association with the elite of the avant-garde made him look more like an insider than the parvenu he was. Hitting cultural events was keeping up with, or ahead of, the zeitgeist. Warhol had a consuming passion, omnivorous but not deep, for anything he considered "modern" or "sixties."

One day just after he had begun his assistantship, Gerard came across a book at Andy's house, *The Stars*, by the French sociologist Edgar Morin; he took it home without mentioning this to Warhol and forgot about it. Some weeks later, Andy quietly asked for the book back; Malanga was amazed that Andy knew not only that the book was gone, but where it had gone. Years later in Paris, Malanga picked up *The Stars* in a bookstall and was immediately struck by an illustration he hadn't noticed earlier. A still of Brando in *On the Waterfront*, serially repeated ten times, it was astonishingly similar to—indeed, must have inspired—the *Silver Elvis* series. The illustration was the

frontispiece. Andy, in other words, found one of his classic images in the book, probably without reading a single word.

The first paintings Malanga worked on, the Elizabeth Taylor portraits known as the *Silver Lizes*, were made in the same way as the single-image *Marilyns* of the summer before: a silk-screened face, with some of its features hand-painted, was printed against a monochromatic background. But while the *Marilyns* were set against different-colored backgrounds, each of these *Lizes* had a silver ground. When he began them, Warhol had been painting his canvases silver for three solid months; taken as a group, the eighty-plus silver paintings of 1963, most of which were painted between April and July, outnumber the Death and Disaster pictures.

For the rest of Warhol's life and beyond, silver would be the color most associated with him, the only color to warrant its own passage in *POPism*. "Silver was the future, it was spacy—the astronauts wore silver suits—Shepherd, Grissom and Glenn had already been up in them, and their equipment was silver, too. And silver was also the past—the Silver Screen—Hollywood actresses photographed in silver sets." And maybe more than anything, silver suggested narcissism—mirrors were backed with silver.

Silver and gold, another favorite of Andy's, were tawdry, insufficiently serious, a brash Pop slap at modernist good taste. But unlike gold, with its ancient, luxe connotations, silver was *now*, the color of aluminum, chrome, the color of Reynolds Wrap and a Corvette Stingray's wire wheels. And silver—glittery, lustrous things in general—was especially attractive to amphetamine users. Pondering Billy Linich's fascination with silver, Warhol concludes, "it must have been an amphetamine thing." The same could be surmised of Warhol, whose burst of silver paintings coincided with the start of his daily ingestion of Obetrol.

The silver canvas was one of many filmic references that had been piling up in Warhol's paintings—fades, dissolves, stills, the serially

repeated image's likeness to a filmstrip, and, of course, all those stars—
until, no longer satisfied with vicarious filmmaking, he picked up a
camera. The *Silver Lizes* and the next-completed *Silver Elvis* series were
Warhol's last silver paintings; along with the immediately succeeding
photo-booth portraits, they were the last pictures Andy painted before
he began spending the better part of his time making movies. Irving
Blum wanted a broad overview of recent work for Andy's upcoming
second Ferus show, but Andy overruled him, insisting on showing only
the *Silver Elvises* and *Silver Liz*. His return engagement in Tinseltown, he
decided, would be with art that celebrated—that literally reproduced—
the silver screen.

The Elvis who Warhol chose to depict in the thirty-six *Silver Elvises*
was not the musical phenomenon of the mid-fifties, the Hillbilly Cat,
but the box-office strongman of *Kid Galahad, Girls! Girls! Girls!* and
the schlock western *Flaming Star*. Hollywood's Elvis, pure celebrity,
famous for being famous, was a species of renown that intrigued Andy
more than fame rooted in skill. Most of the canvases contain mul-
tiple figures: two, three, four, and more *Elvises*. The viewer is pulled
between two poles: engrossment through the image's power and the
estrangement that repetition inevitably triggers. The process is *anti-
cinematic*—instead of losing ourselves in the unreal world on-screen,
we are brought up short, confronted with the silliness of losing our-
selves in a picture.

"Those were the quiet days. I didn't talk much, and neither did
Gerard": this is how *POPism* describes the summer of 1963. Although
Andy could hardly have been busier, the firehouse was a quiet, focused
place. At gatherings with Gerard, Andy tended to disappear, one of
the crowd, and gratefully so. In spite of his notoriety, he was still more
tolerated than welcomed. Even artists of a similar bent were suspi-
cious, if not hostile, toward Warhol. His overnight conversion from
commercial art smacked of opportunism. Such a quick success would
have provoked jealousy in any case; to those who considered his art a
gimmick, Warhol's rise was infuriating, his watchful silence at parties

and openings irritating. He only took, people said, and never gave. Nor was their antipathy reducible to homophobia—some of the strongest anti-Warhol sentiment came from gays who loathed the newcomer.

Still, he was an established figure now, and success inevitably generates friends. He had finally won a sort of arm's-length acceptance by his idols Johns and Rauschenberg, although Andy remained deferential. Of the two, Rauschenberg seems to have taken more of an actual liking to Warhol; Johns's manner toward Andy remained somewhat condescending. (Recalling a dinner she and her brother gave for Andy, Johns, and Henry Geldzahler, Sarah Dalton said, "David and Henry were having a very intellectual conversation. Andy started saying things like, 'I wonder why the sky is blue?' at which point Jasper abruptly said, 'Andy, were you educated at home?'")

Charles Henri Ford breezed in and out of 1342 Lexington during the earlier part of the summer. Although Andy may have fawned over him, privately he took Ford's measure—"Charles has never worked a day in his life," he commented caustically to Malanga. The future art historian John Richardson, then a youngish art dealer, stopped by in June with another English art businessman, Robert Fraser, and everybody—the Englishmen, Warhol, Wyn Chamberlain, Giorno, Marisol, and two or three others—went off to Coney Island. Another Coney Island trip was the closest Malanga ever came to seeing Warhol bald: riding the roller coaster, Gerard looked back to see Andy's toupee lifting off his head in the wind. "Oh my God!" he thought, "It's gonna come off!" but the hairpiece held. There were group outings to the rock-and-roll spectaculars at the Brooklyn Fox Theater, where Ivan Karp remembered Warhol "lost in transports to see Dion onstage. He said, 'I can't believe I'm seeing him!'" ("Andy wasn't a real rock fan," according to Malanga, a former regular on the fifties TV dance show *The Big Beat*; the thrill lay in beholding a celebrity.)

Andy did take a brief plunge into rock performance at about this time, in a very short-lived artists' aggregate. "Andy and La Monte

Young and Walter de Maria were going to start a group," Gerard said, "but then Andy realized he didn't know an instrument." The discovery was not immediately fatal: Andy and Lucas Samaras were the backup singers. Patty Oldenburg sang lead, Walter de Maria played drums, La Monte Young played saxophone, Larry Poons was the guitarist, and Jasper Johns wrote the lyrics, "which were really dumb," as Patty recalled. In the routine they worked out, Andy began each song with a breathy, 'Sing it, Patty!'" They met perhaps twice, according to Samaras, who recalled that "[the Bell Lab scientist] Billy Klüver was supposed to record it, but he erased it or something, the idiot."

A good friend of Emile de Antonio's was often at 1342 Lexington that summer: Marguerite Lamkin, a Southern belle from Truman Capote's hometown of Monroeville, Louisiana, whose brother, the handsome, now-forgotten novelist Speed Lamkin, composer Ned Rorem unforgettably dubbed "the poor man's Truman Capote." Arriving in New York in 1961, Lamkin found work at *Glamour* magazine through de Antonio, joining the staff in June 1963 as arts editor and writer of the "What's New" section, which interspersed coverage of the emerging teen culture with opera and TV with fine art—the sort of dizzy high-low mix the fashion magazines of the early sixties specialized in. With Lamkin on staff, *Glamour* plugged Andy again and again. An item in the August 1963 issue, for instance, stated: "Andy Warhol's Campbell's soup can . . . made him famous and helped make Pop art (he calls it O.K. art) the most talked-about movement in years." The article's layout, a spot-on, if technically more exacting, version of Warhol's fifties style, complete with cherubs, smiling suns, and fleurs-de-lis, was created by Nathan Gluck.

"Speed couldn't see what I was doing with Andy," said Lamkin (now Littman). "He called him a 'creep.'" Lamkin taught Andy how to do the Madison ("he really wasn't a dancer," she noted charitably). He gave her a soup can and envied her complexion. "I always called him 'Sweetness,' never Andy. We talked every morning. He would call me

and I would call him back, Atwater 9-1298. We'd talk about what we'd done the night before. We used to eat lunch at his house, sitting on boxes, and he'd say, 'Someday I'm going to be on Easy Street.'"

Following his innovative layout in the December 1962 issue, Andy's first few *Harper's Bazaar* jobs of 1963 had reverted to convention—a cute little blotted-line puppy dog advertising Palizzio shoes in February 1963 and some elegantly drawn perfume bottles in May and June. Andy completed another assignment for the June issue, however, in which the line between commercial and fine art was not merely challenged but erased. In the June 1963 feature "New Faces, New Forces, New Names in the Arts," Andy tried out a format that he used soon afterward for his first commissioned portrait, *Ethel Scull 36 Times*—itself the template for a style he would mine extensively. But the originator of the Photomat portrait was not Warhol, it was Marvin Israel.

Some five years earlier, in February 1958, the cover of *Seventeen* had featured a smiling model in white hat and pinafore; what made the cover unusual was that the pinafore girl was superimposed over a grid of about ninety dimestore-quality black-and-white snapshots of teenaged girls. In the same issue, a short piece exhorted readers to "Smile!" The accompanying illustration featured a vertical row of six snapshots of a pretty girl breaking into a grin, laid out to suggest a photo-booth strip. The pieces were the brainchild of Israel, *Seventeen's* art director at the time, who had become fascinated by the photo booths that had sprung up since the war in pinball arcades, bus stations, and other seedy locales.

The April 1963 issue of *Harper's Bazaar* contained a two-page spread on the photo booth itself: four photo-booth strips of a model making up her face, followed by a treatise, in the best fashion-mag language, on the format's virtues: "What rewards—beside a few casual giggles and a handful of hasty candid-camera art—can one short session in a Photomat reap for any fair lady? . . . Dr. David Harold Fink, the

eminent psychiatrist, says that, by changing our mental concepts of ourselves, we can change our lives." The humble little Photomat, the article promised, can "[direct] you forever away from the rubber-stamp face, toward the individual beauty. . . the essential, the individual, the unhackneyed You."

The piece, called "Instant Self-Analysis, 25¢," was Israel's last as art director. "Marvin was very tuned into this image-making machine," observed Ruth Ansel, whose own fascination began long before she met Israel—she counted among her possessions a Photomat self-portrait she took when she was seventeen. "When I heard him start talking about the excitement of the Photomat, I was very surprised. But whoever invented that machine was brilliant, it was a great toy in its day. Remember, there were no Polaroids, so this was the first instant picture. And I had always liked films, and Photomat pictures looked just like filmstrips. Marvin used to haunt Forty-second Street anyway, the flea circuses and freak shows, with his lover, the photographer Diane Arbus, and I'd go with him because I loved the Photomat machines. So Marvin talked about the Photomat, I was talking about the Photomat, and sooner or later we gave Andy a Photomat assignment."

This was the "New Faces, New Forces" feature. It was her favorite of Warhol's *Bazaar* jobs. She and another editor picked the fourteen subjects, including writers Donald Barthelme and Rosalyn Drexler, composer La Monte Young, dancer Edward Villela, painter Larry Poons, Henry Geldzahler, and Warhol himself. "Andy brought each subject to a Times Square Photomat and played with them," according to Ansel, "encouraging them to loosen up while he dropped quarters into the machine. He came back with tons of photographs." Ansel did the layout herself, tilting Photomat strips this way and that, overlapping them, cutting them to unequal lengths and enlarging some—one snapshot, of playwright-actor Gregory Rozakis, filled an entire page. Andy, with his usual thriftiness, appears to have used some of the outtakes for his own art. The source photographs for a photo-booth self-portrait he

made later that year strongly resemble his self-portraits in the *Bazaar* piece: he wears the same sunglasses, raincoat, Oxford shirt, and mock tough-guy expression.

Andy must have known about photo booths before now—everyone did—yet he had never thought to use them in his work. The June 1963 *Bazaar* assignment inspired the flurry of photo-booth-based portraits that he made shortly afterward. Everything about the booths would have intrigued him: the photostrip's seriality; its resemblance to the filmstrips he itched to handle (the photostrip is, after all, nothing but a slowed-down, very primitive filmstrip); the photo booth's elimination of the photographer, hence its ability to remove Andy's art yet another step from the human touch; and, not least, the sleaze factor—the booths in Times Square were especially disreputable places, where people were said to photograph themselves in every imaginable position.

At some point in the late spring or early summer of 1963, Wyn Chamberlain got a phone call from Andy, inviting him to lunch at Gay Vienna, an Upper East Side restaurant, where Andy introduced Chamberlain to Ethel Scull, the bumptious wife of the collector Robert Scull. During lunch, Mrs. Scull got up and went to the ladies' room, at which point Chamberlain recalled saying, "'Andy, who is this woman? How can you stand her? Look at all those awful, vulgar diamonds she's wearing!' And Andy said, 'Those diamonds are going to be paintings very soon.'"

The portrait of Mrs. Scull—Warhol's first portrait of a noncelebrity—is assembled from individual silk-screened panels, themselves made from photo-booth snapshots. Frei and Printz date the painting to late June and July, citing a July 30 photograph of Andy kneeling in front of part of the canvas. But a September 6 invoice from Aetna for "8 poses of womans face" precisely matches the size of the screens Warhol used for this painting, which would thus seem to have been substantially under way by the end of July but not completed until at least a month and a half later.

If Ethel Scull was taken aback at finding herself, in her Yves St. Laurent outfit, in a 52nd Street pinball arcade—"I had great visions of going to Richard Avedon's, see, of having these magnificent pictures of me taken, and then he [Warhol] would do the portrait"—she recovered quickly enough, hamming it up for an hour. (It's impossible to say how many shots they made: three hundred, according to one source, one hundred according to another; in any event, Andy poured a stream of quarters into the Photomat, an expense borne of course by the client.) "[Andy] would come in and poke me and make me do all kinds of things," she recalled. "He directed me."

Taking his crop of photostrips home, Andy pored over them, narrowing his choices while playing with possible arrangements. Snipping out individual exposures and pasting them on top of others, he improvised new four-photo sequences (unlike in the *Bazaar* piece, where the strips were shortened but otherwise unaltered). But that still left him too dependent on the original photostrip sequence; he wanted even more flexibility in assembling his composition. He finally chose twenty-five exposures. Aetna made a screen for each (and, at Andy's request, "flipped" several, simply reversing an image) for a total of thirty-five bite-sized canvases, sixteen by twenty inches each, which Warhol and Malanga painted thirteen different colors. Presto: *Ethel Scull 35 Times* (thirty-six as of 1968, when another panel was added). According to the Sculls, at Andy's behest they selected the final arrangement of panels, with the artist looking on and making occasional suggestions.

Comparing Warhol's final selection to the hundreds of snapshots that he rejected, one realizes, first, the acuity of his eye: once he decided what he was looking for, he overlooked no snapshot, not one, that even obliquely possessed those qualities. Equally clear is the fact that Andy was interested not in the portraitist's traditional aim of revealing character, but in the presentation, the construction of a glamorous surface. He picked the snapshots that came closest to making his subject, with her fleshy, acquisitive face, look like a *Vogue* or *Harper's*

Bazaar model, circa 1963. He was going after a "look," not character, and he succeeded.

One a magazine assignment, the other a work of art—they are not essentially different. The distinction between Warhol's commercial and fine art phases breaks down here, a melting-together that mirrored an enormous cultural shift. As Andy himself realized, or intuited, drawing a thick black line between high and low art was, by the early and mid-sixties, increasingly futile. What made something art was not its essence but where and how it was presented. It was Warhol's achievement to act on this insight, and his critics' frustration to be unable to prove him wrong.

Andy's *Bazaar*-inspired portrait of Ethel Scull marked a turn in his sixties art, a new way of handling serial imagery. Where he had previously screened and rescreened an image on a single, large canvas, the photostrip, with its four not-quite-identical exposures, got him thinking about building serial compositions that not only had more variety but could be endlessly reconfigured. From now on, a painting was going to be literally assembled—and disassembled, and reassambled, at will. Apart from its aesthetic benefits, this flexibility appealed to Andy's business sense: it was now possible to bang out an infinity of paintings from a few premade components. The Factory was gearing up.

For the second time in three years, Andy peered anxiously into a new and unfamiliar world, crowding the sidelines, trying to determine a way in. His move into painting had not been made as a complete tyro— there were those years of student painting, and his sporadic fifties canvases—but he knew nothing about filmmaking; he didn't even own a camera. Still just a fan, if a rabid one, he haunted the movie houses in the spring and early summer of 1963: avant-garde venues downtown, first-run films on the East Side, cheesier double features on 42nd Street, and revivals at the Upper West Side New Yorker theater run by Emile de Antonio's friend Dan Talbot.

From de Antonio, Warhol learned that an independent filmmaker

wasn't necessarily condemned to $500 budgets. Walking home one evening in 1961, Andy bumped into his friend, who had just been given $50,000 toward his first directing effort, *Point of Order*. "I asked De where he'd gotten the fifty thousand dollars from—those were the things that really interested me," recalled Warhol.

Probably early in 1962, de Antonio had taken Andy to a screening of his film *Sunday* at the newly founded Film-Makers' Cooperative on Park Avenue South. It was Warhol's introduction to the world of New York's film avant-garde. Formally a nonprofit film distribution company, the Coop was also a salon and screening room crowded with contentious dreamers. The Coop's founder lived here, a forty-year-old Lithuanian refugee named Jonas Mekas, filmmaker, poet, and tireless propagandist for what was just becoming known as "underground film." Mekas had starved when he had arrived in America in 1949; fifteen years later he was hardly eating any better (he had lived for the past five years on $400 a year, he wrote in 1963), but he had long since found his métier and cause. A self-described "raving maniac of the cinema," Mekas was happy to forgo bourgeois stability for the sake of film.

Although Andy was soon a regular Coop visitor, Mekas could not recall meeting him until mid-1963. "My loft was a very, very busy place in 1962. After we started Film-Makers' Coop, filmmakers began to hang around and every evening practically show films. I did not even know who was there, sitting on the floor, ten, fifteen, twenty people. And Andy was one of the people watching. I did not know him nor notice him until later. But that is where he began seeing films and got, I guess, excited."

The new underground auteurs had grown up on movies. Television had booted film upstairs, making it look respectable; a number of other factors—auteur theory, the French New Wave, the availability of long-vanished Hollywood classics on television—also gave film a new cultural weight. Artists in traditional media began finding it hard to resist filmmaking's lure; movies were so much hipper and sexier than their now fusty-seeming pursuits. ("Painting is dead. [American artists]

are now quite seriously and enthusiastically embracing our technology," the filmmaker Stan Vanderbeek would announce several years later, at a 1966 symposium at one of the early New York film festivals.) At the same time, a technology that had once been virtually the sole property of big-budget studios was becoming widely available. Not only did everyone want to make movies—they could. "Films will soon be made as easily as written poems, and almost as cheaply," wrote Mekas in 1960 in Movie Journal, his weekly *Village Voice* column and one of underground film's two bully pulpits; the other was *Film Culture*, the irregularly appearing journal Mekas founded in 1955. "The empires of professionalism and big budgets are crumbling. Every day I meet young men and women who sneak into town from Boston, Baltimore, even Toronto, with reels of film under their coats—as if they were carrying pieces of paper scribbled with poems. They screen them at some friend's loft, or perhaps at the [Cafe] Figaro, and then disappear, without making a big fuss about it. They are the real film troubadors." And Andy was always ready to jump to the head of the parade.

In his Movie Journal columns, Mekas hailed underground films and their makers, including Jack Smith's *Flaming Creatures*, Ken Jacobs's *Little Stabs at Happiness*, Jacobs and Bob Fleischner's *Blonde Cobra*, and Ron Rice's *The Queen of Sheba Meets the Atom Man*—as marking an important turn in avant-garde film. Each of these movies was, to a greater or lesser degree, an assault on aesthetic, social, and sexual norms. They were poorly lit, badly exposed (or, in the case of Smith's masterpiece, *Flaming Creatures*, overexposed to literally look steamy), shot on out-of-date or used stock (Smith is said to have stolen the film for *Flaming Creatures* from a camera store's outdated film bin).

They were, essentially, home movies . . . of very strange homes. The filmmaker was his own producer, director, scenarist, cameraman, makeup artist, etc.; the cast was composed of husbands, wives, lovers, friends, passersby, any number of whom might be high on amphetamine, marijuana, and other exotic substances. Scripts were largely abjured, filmmakers relying instead on their untrained actors' impro-

visations. Although Jack Smith planned scenes and shots painstakingly, he had an uncanny way of sabotaging his preparations; what he filmed rarely resembled its conception. Smith's movies, and those of many other underground auteurs, had a broad streak, if not a core, of homoeroticism—*Flaming Creatures*, whose drag queens and actual women are sometimes indistinguishable, whose dangling penises and bare breasts share equal time, is closer to pansexuality. Taboos in general were gleefully smashed; films such as *Flaming Creatures* and Rice's *Queen of Sheba* presented the human body with a frankness that "[made] the censors blush," as Mekas put it. Smith in particular was intensely involved with pop culture, especially the vapidities and excesses of B-movie Hollywood. He was fixated on the forties film star Maria Montez (*Ali Baba and the Forty Thieves, Cobra Woman,* etc.), whose lack of talent lent her a sleepwalker's self-possession that drove Smith into a frenzy of appreciation. Smith's mixing of high and low—the Everly Brothers and Stravinsky—dovetailed readily with this approach; his sense of flow, bodies moving on and off screen, also defied the conventional framing of Hollywood movies.

This was the style of underground film, deplored by an urbane modernist such as Mekas's chief antagonist Parker Tyler as the abandonment of form, that most attracted Warhol. While the minimalist quality of some of Warhol's most notorious movies—*Sleep, Eat,* etc.— might obscure his affinity for filmmakers like Smith (whom Andy deeply admired), Warhol's films, taken as a whole, in fact reflect a tension between minimalism and the overheated and busy campiness of a Jack Smith. Not until Warhol assembled a collection of outrageous personalities would these two aspects cohere, his very refusal to script, direct, or edit his films giving maximum license to the exhibitionists they featured.

Before Charles Henri Ford left for Europe in July, he and Malanga took Andy to Peerless Camera, a well-known store on East 43rd Street, where Andy bought a 16-millimeter Bolex.

The Bolex was the underground moviemaker's tool of choice: small, relatively inexpensive, and versatile (although, as Andy would quickly discover, it was not made for shooting long films). "Very precise camera," according to Mekas. "I was always loaning mine out, to Gregory Markopoloulos for several films, to Barbara Rubin, to Naomi Levine. Whenever I was not using it, somebody else was." Malanga knew about Bolexes from using Marie Menken's. Charles Lisanby knew about Bolexes, too. "Andy called me up," he said, "and asked me what kind of movie camera to get. 'Bolex,' I said. That's what I'd always wanted but never gotten." After making his recommendation, Lisanby did not hear from Warhol for some time: "And then suddenly, here he is, he wants me to show him how to put the film in. If I hadn't shown him how to get the film in the camera there might never have been all those awful movies. But away he went. Then I heard he was taking his film to a drugstore to have it developed. 'At least take it to a camera store, Andy,' I told him, 'send it to the factory, anything.' After that, I heard he was making movies. I sort of shuddered at the thought."

Andy immediately started dropping in on friends, eagerly and indiscriminately trying out his new toy. He visited the Oldenburgs with Charles Henri Ford, Ford's sister Ruth, and Zachary Scott in tow. "He was pointing his camera at Claes's pieces all over the studio," recalled Patty Mucha. "I distinctly remember showing him how to use it. He'd say, 'Charles! Charles! What do I do now? What's this lever for?' and Charles would say, 'Just point it, darling.' He must just have bought it, he totally did not know that camera." This did not deter him from embarking on a project at once utterly simpleminded and hugely ambitious.

The New York avant-garde's chief rural escape that summer was Old Lyme, Connecticut, where Wyn Chamberlain was renting a farmhouse from a family of erstwhile nudists—"great people," according to Wyn, "real hippies from the twenties who'd run a nudist colony there years before." Chamberlain's neighbor and co-renter was, of all people,

Eleanor Ward. She and the ex-nudists didn't get along very well, as Wyn recalled: "Their driveway went past her house, and after a while Eleanor blocked it off. They came through with a bulldozer. Eleanor left after that."

John Giorno was often at the Chamberlains, and when Andy visited they shared a room. Giorno was going through a difficult period, torn between a poet's life in the gay demimonde and parental approval as a businessman. His chief recourse was sleep. He amazed Andy, the quintessential light sleeper, with his ability to sleep for ten, twelve, fourteen hours at a stretch. On Memorial Day weekend, Giorno, Warhol, Marisol, and Robert Indiana headed for Old Lyme. During their stay, Giorno awoke in the predawn darkness to find Andy sitting in a chair watching him.

"Andy, what are you doing?" he asked.

"Gee, you sleep so well," Andy replied. On the train back to the city, he asked Giorno, "Would you like to be in a movie?"

"Absolutely!" said Giorno. Andy proposed a film of Giorno sleeping through the night. He mentioned the same idea several weeks later to Gerard Malanga, but with a less feasible star: Brigitte Bardot. Whoever else Andy fantasized as his sleeper, he settled for Giorno. Long before he had even bought a camera, Andy had conceived and cast his first film.

They started filming in August. Arriving at Giorno's apartment on East 74th Street, Andy set up his tripod, camera, and lights while Giorno had a nightcap, undressed, and, undeterred by the lights, fell fast asleep. Andy shot until dawn and went home, leaving a mess of empty yellow film boxes on the bedroom floor.

Warhol had given little thought to the enormity of shooting an eight-hour film, especially with a camera that used mere hundred-foot rolls. Every three minutes, he had to stop filming, slip the camera into a darkout bag, unload it, rewind the spent film, reload and thread the new roll, and resume filming. The process would have taken him, a

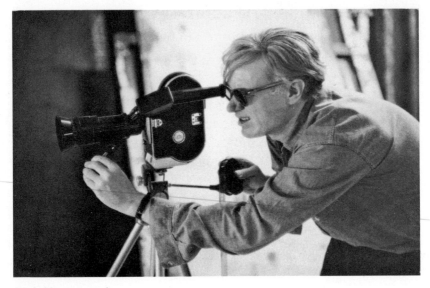

Warhol lining up a shot

beginner, from five to ten minutes. At that rate, he would have been lucky to shoot perhaps a half-hour of footage a night. In addition, the spring-driven Bolex needed to be rewound every twenty-five seconds; unaware that an electric motor was available to do this automatically, Andy spent the first two weeks rewinding the camera by hand. When the first batch of film came back, there was a perceptible stutter every twenty-five seconds. They started shooting all over again. Gerard Malanga, who had until now been basking in Andy's attention, was out of sorts. "Gerard was getting really jealous of me," said Giorno; "suddenly there was this movie, and when he wasn't sweeping the fire-house he was carrying film to the developers."

On the weekend of August 11 and 12, Andy and Giorno were in Old Lyme. Wyn Chamberlain was letting Jack Smith shoot a scene for the latter's new movie *Normal Love*, variously titled *The Great Moldy Triumph* and *The Great Pasty Triumph*. Andy wanted to watch the master at work. Smith descended on the estate with "a whole gang of my favorite urban freaks," as one of them, Diane di Prima, later wrote.

Di Prima has left a wonderful tableau of the scene: "The various drag queens, ballet dancers, performance artists, painters and what-not were hard at work: sewing costumes, hammering at props, painting cloth on the grass out front, their hot pinks and saffrons, whites, chartreuses and lavenders contrasting with the many greens of late summer. . . . They were all in various stages of dress and undress, various stages of make-up and bits of jewelry, and they sat there, utterly unselfconscious, fiercely ascetic, almost austere, in the slanting light that fell through chinks in the barn roof. . . ."

An enormous pink birthday cake, designed by Claes Oldenburg, was built on-site. A dozen or more "Chorus Cuties," as Smith called them, danced on top of it, including di Prima, in pasties and a low-slung skirt and nine months pregnant (she went into labor that night); the transvestite performer Francis Francine; Smith's discovery Mario Montez, the reigning queen of the underground's transvestites; Gerard Malanga; and Warhol, in a lady's wig, a frilly thrift-shop dress, and sunglasses. Smith wanted the actors to snap their fingers and dance, but Andy didn't know how to snap his fingers. (Di Prima described him as "twisting rather tentatively and stiffly.") Smith, laboring at his usual snail's pace, shot at most six minutes of footage all weekend. At one point he determined that he needed a number of heads shaved. "So all these people went back into the meadow between my house and Eleanor's," Chamberlain said, "and shaved their heads. Eleanor went for a walk and saw all these clumps of hair lying there, and she stood and screamed at the top of her lungs, waving her arms."

Andy had brought his Bolex and filmed what he somewhat pretentiously called a "newsreel," a three-minute home movie of the *Normal Love* shoot. At the time of his Old Lyme trip, Warhol was already making the sequences that would become *Kiss*: four-minute movies, each featuring a different couple kissing nonstop. Several of the *Kiss* sequences were among Warhol's first publicly screened films when Mekas showed them that autumn. On September 19, meanwhile,

Mekas announced in the *Village Voice* that "Andy Warhol . . . is in the process of making the longest and simplest movie ever made, an eight-hour-long movie that shows nothing but a man sleeping." Notice had been served. Underground film of the early sixties may have prided itself on its audacity, but now it would learn how a public relations genius functioned. An eight-hour film of a sleeping man: that was how to introduce yourself as an avant-garde filmmaker. As Malanga pointed out, "Those films were a way of introducing himself into filmdom. If he did it any other way he wouldn't be recognized."

In the meatime, Warhol had other matters that warranted his attention: chiefly, his upcoming second show at the Ferus in Los Angeles. This time he planned to attend.

Andy, who had never been west of Pennsylvania, had at some point begun to harbor the desire to drive across America. Wyn Chamberlain owned a new Ford Falcon station wagon, and when he arrived back in New York after Labor Day, Andy asked him if he felt like driving to California. Chamberlain was ready to go. Gerard, whom Andy also invited, had been preparing to start his second year at Wagner College in Staten Island but took a leave of absence at the last moment (now it was Giorno's turn to be jealous; Andy was learning how to divide and conquer). Chamberlain mentioned something about bringing the underground actor Taylor Mead as a second driver—neither Warhol nor Malanga drove—which was fine with Andy. Mead was good company; besides, Andy considered him "famous." Born in 1924, Mead was the outcast scion of a prominent Michigan family. As with many gay men of his generation, his homosexuality prompted an all-out rebellion against conventional America. A beatnik before the term existed, he spent the forties hitchhiking back and forth across the country and the fifties as a coffeehouse poet on both coasts. In 1962, this teddy-bear-clutching protagonist of Ron Rice's *The Flower Thief*, at once childlike and lubricious, became the nearest thing to an underground film star.

The travelers gathered at Andy's house on September 24. Julia came out to the sidewalk to see them off (during the trip Mrs. Warhola and Mrs. Malanga exchanged daily calls to worry about their sons), and Chamberlain steered the Falcon across the Hudson, into New Jersey, and out across the country. East of the Mississippi, the fifties persisted—"the girls were still wearing cashmere sweaters with little round necklines and tight, straight, fifties skirts." In western Pennsylvania Andy told the others, "This is where I come from. Let's get through here in a hurry." They made it to St. Louis in a day, heading south in the morning through Oklahoma and across the Texas Panhandle. Gerard wrote a poem about highway mirages, which he had never seen before. Andy's urge to soak up America was circumscribed by his insistence on eating only in restaurants that accepted his Diners Club card. Somewhere in Oklahoma, Taylor Mead rebelled against "knotty-pine restaurants" and insisted that they stop at a diner. Pulling into a truck stop and settling into their booth, the foursome noticed that the crowded place had abruptly fallen silent. Everyone was staring their way. "We all recognized the potential . . . like a lynching," said Mead, and it was knotty pine the rest of the way.

POPism's account of the drive contains one of Pat Hackett's (Andy's ghostwriter) finest moments, the famous passage impersonating Andy's wonder at encountering Pop in the heartlands. Some of its language, including the great sentence, "The farther West we drove, the more Pop everything looked on the highways," resembles Taylor Mead's various accounts of the trip. Since Hackett interviewed Mead for *POPism*, it would seem that one of Warhol's most-quoted statements was actually based on the reminiscences of Taylor Mead. According to Malanga, Andy was only mildly interested in the sights until they reached Los Angeles, whose billboards, especially for movies, were then at the height of their originality.

They spent the second night in Amarillo, stopped the next day in Albuquerque to pose for some group photo-booth portraits, and crossed

the California border that night, stopping at the Palm Springs Hilton. On the fourth day, they drove into Los Angeles. Dennis Hopper and his wife Brooke Hayward were throwing a party that night for Andy at their Topanga Canyon home—an early Pop collector, Hopper had met Andy in New York earlier that year. The Hoppers rounded up as much as they could of Hollywood's "new generation," including Sal Mineo, Peter Fonda, Suzanne Pleshette, and Dean Stockwell. Andy unconvincingly called the party "dazzling," "the most exciting thing that had ever happened to me." According to Chamberlain, he, Malanga, Mead, and the writer Ben Hecht's daughter Jenny were asked to leave by Hayward when she found them smoking pot in a closet. "That's how hip they were," quipped Chamberlain. Wyn was downbeat about the whole trip, although he enjoyed "the quality of desolation that hung over Venice Beach at that time, and the mercurial presence of Taylor." (The regard was not mutual; Mead remembered Chamberlain as "a would-be artist and writer.")

If Andy had been hoping that his paintings would generate a special frisson here in movieland, he was disappointed. The response to the Ferus show, which opened on September 30, was "quiet," according to Irving Blum. The few reviews were negative, such as one in *Art International*, according to which "Warhol doesn't suggest in any of his works that he is an artist." Some eighteen *Silver Elvis* paintings, including a thirty-seven-foot canvas adorned with sixteen figures of the King, hung in the Ferus's front room; nine or ten *Silver Lizes* hung in the rear room. Andy had not bothered to cut the *Elvises* from their canvas roll, sending the huge, uncut roll to Blum. The misconception persists that he let the dealer decide how many *Elvises* would appear on each canvas, effectively promoting Blum to collaborator. As nicely as the story fits the myth of Warhol intentionally undermining the tradition of the all-decisive auteur, it is not true. Blum remembered the circumstances well. "He sent me a big roll of canvas and stretcher bars. I uncrated everything and called him immediately and said, 'How do you expect

the California border that night, stopping at the Palm Springs Hilton. On the fourth day, they drove into Los Angeles. Dennis Hopper and his wife Brooke Hayward were throwing a party that night for Andy at their Topanga Canyon home—an early Pop collector, Hopper had met Andy in New York earlier that year. The Hoppers rounded up as much as they could of Hollywood's "new generation," including Sal Mineo, Peter Fonda, Suzanne Pleshette, and Dean Stockwell. Andy unconvincingly called the party "dazzling," "the most exciting thing that had ever happened to me." According to Chamberlain, he, Malanga, Mead, and the writer Ben Hecht's daughter Jenny were asked to leave by Hayward when she found them smoking pot in a closet. "That's how hip they were," quipped Chamberlain. Wyn was downbeat about the whole trip, although he enjoyed "the quality of desolation that hung over Venice Beach at that time, and the mercurial presence of Taylor." (The regard was not mutual; Mead remembered Chamberlain as "a would-be artist and writer.")

If Andy had been hoping that his paintings would generate a special frisson here in movieland, he was disappointed. The response to the Ferus show, which opened on September 30, was "quiet," according to Irving Blum. The few reviews were negative, such as one in *Art International*, according to which "Warhol doesn't suggest in any of his works that he is an artist." Some eighteen *Silver Elvis* paintings, including a thirty-seven-foot canvas adorned with sixteen figures of the King, hung in the Ferus's front room; nine or ten *Silver Lizes* hung in the rear room. Andy had not bothered to cut the *Elvises* from their canvas roll, sending the huge, uncut roll to Blum. The misconception persists that he let the dealer decide how many *Elvises* would appear on each canvas, effectively promoting Blum to collaborator. As nicely as the story fits the myth of Warhol intentionally undermining the tradition of the all-decisive auteur, it is not true. Blum remembered the circumstances well. "He sent me a big roll of canvas and stretcher bars. I uncrated everything and called him immediately and said, 'How do you expect

The travelers gathered at Andy's house on September 24. Julia came out to the sidewalk to see them off (during the trip Mrs. Warhola and Mrs. Malanga exchanged daily calls to worry about their sons), and Chamberlain steered the Falcon across the Hudson, into New Jersey, and out across the country. East of the Mississippi, the fifties persisted—"the girls were still wearing cashmere sweaters with little round necklines and tight, straight, fifties skirts." In western Pennsylvania Andy told the others, "This is where I come from. Let's get through here in a hurry." They made it to St. Louis in a day, heading south in the morning through Oklahoma and across the Texas Panhandle. Gerard wrote a poem about highway mirages, which he had never seen before. Andy's urge to soak up America was circumscribed by his insistence on eating only in restaurants that accepted his Diners Club card. Somewhere in Oklahoma, Taylor Mead rebelled against "knotty-pine restaurants" and insisted that they stop at a diner. Pulling into a truck stop and settling into their booth, the foursome noticed that the crowded place had abruptly fallen silent. Everyone was staring their way. "We all recognized the potential . . . like a lynching," said Mead, and it was knotty pine the rest of the way.

POPism's account of the drive contains one of Pat Hackett's (Andy's ghostwriter) finest moments, the famous passage impersonating Andy's wonder at encountering Pop in the heartlands. Some of its language, including the great sentence, "The farther West we drove, the more Pop everything looked on the highways," resembles Taylor Mead's various accounts of the trip. Since Hackett interviewed Mead for *POPism*, it would seem that one of Warhol's most-quoted statements was actually based on the reminiscences of Taylor Mead. According to Malanga, Andy was only mildly interested in the sights until they reached Los Angeles, whose billboards, especially for movies, were then at the height of their originality.

They spent the second night in Amarillo, stopped the next day in Albuquerque to pose for some group photo-booth portraits, and crossed

me to deal with this?' He said, 'Just cut them. You've got the bars. There are double images, triple images, single images'" and precisely the right number of stretcher bars for the different-sized canvases. "He absolutely made the decision that they would be those sizes. No, he wasn't including me in the creative process. He couldn't be bothered to cut the *Elvises*, but he made sure I cut them the way he wanted."

After only a night at the Beverly Hills Hotel, Andy and his friends had checked into the Surf Rider Inn in Santa Monica. Gerard and Andy roomed together, as they had on the way out. One morning while Andy was in the bathroom, Gerard peered into a little valise Andy always carried and saw a pair of scissors and a roll of Johnson & Johnson medical tape—so *that* was how he attached his toupee. ("Actually," Gerard claimed, "it took me almost until then to figure out he even wore a toupee. At first I thought he was just strange-looking. And that was something clever on Andy's part. Andy was into deflecting by the use of camouflage. If someone goes bald they'll usually get, like, a plain brown toupee, something they hope doesn't draw attention. Andy got outrageous silver hair. When you looked at Andy, you didn't think, 'He's wearing a toupee,' you thought, 'My God, look at that guy's hair!'")

Andy threw a party one evening on the Santa Monica Pier. Meeting a girl he liked, Gerard brought her back to the hotel room. Andy, returning sooner than Gerard had expected, erupted when he found the door to his room chained. "He went way over the top, banging on the door and yelling, 'Let me in! Put your clothes on!'" Jumping into his pants, Gerard unchained the door to find Andy speechless with rage. Gerard and the girl left for her house, where Gerard spent the night. Returning in the morning, he found Andy sitting on the beach with the newspaper, reading a review of his Ferus show out loud to himself. Andy didn't mention the previous night's events. The similarity to his tantrum years earlier in Hawaii (if one accepts Charles Lisanby's account of it) is striking. Andy's feelings for Lisanby had probably

been stronger than they were for Gerard. But the two events—Lisan-by's attentions to a young hustler, Malanga's to a girl—were the same sort of abrupt, unexpected reminders of his undesirability, of his exclusion from the circle of desire, and they produced the same angry, panicked response.

Warhol's California visit coincided with Marcel Duchamp's first major retrospective, assembled at the Pasadena Art Museum by Andy's early admirer Walter Hopps. The show triggered a Duchamp boom—in its aftermath, "the international art market could be heard clanking into action," Calvin Tomkins wrote; Duchamp's rise to preeminence as Postmodernism's guardian angel had begun. Andy and his travelmates were invited to the opening reception, where Andy shot some film and engaged in small talk with Duchamp. "Andy and I were like two little giddy kids jumping up and down around Marcel Duchamp," recalled Malanga, but the old man paid more attention to Taylor Mead, inviting the actor to his table. Malanga, never one to pass up an opportunity, approached Duchamp and engaged him in a literary conversation. Gerard received an assignment: "Write me a poem that's not a poem," said Duchamp. All of the artists at the fête signed Duchamp's table-cloth; Andy signed it twice.

While in LA Andy shot *Tarzan and Jane Regained . . . Sort Of* in 110-degree September heat. It bears little resemblance to the Warhol movies already shot or to come. The camera is handheld and jittery and the film is badly overexposed. (It was edited back in New York by Mead, who relied on lots of quick cuts.)

The film has the random quality that one would expect from an ad hoc project with no plot, no script, no dialogue, and into which are thrown whatever characters are at hand—in this case Taylor Mead, Naomi Levine, Claes and Patty Oldenburg, Dennis Hopper, and (briefly) Andy himself.

Taylor Mead reprises his endearing idiot's role from *Flower Thief* (essentially, his one and only character). The audience is treated to Mead frolicking on the beach by himself, Mead mugging, Mead pound-

Dennis Hopper and Taylor Mead in a still from Tarzan and Jane Regained . . . Sort Of, *1963*

ing his skinny chest, Mead gamboling by the pool at the Beverly Hills
Motel, Mead frolicking again (his skimpy bathing suit halfway off like
a dropped diaper). There's a naked Naomi Levine bathing Mead in
the shower, Oldenburg & Co. riding the merry-go-round on the Santa
Monica Pier, and the Watts Tower. At one point Andy appears on-
screen, whipping Mead's bare ass with a sheaf of palm leaves. Then
there's Mead and Dennis Hopper (in leopard skin towel as loincloth)
vying as rival Tarzans, comparing biceps, pounding chests; Patty
Oldenburg arm-wrestling Hopper and Mead; color shots of Mead wres-
tling a garden hose, pretending it's a boa constrictor, which he slays;
Naomi Levine swinging nude from a tree branch; Mead and Levine
locked in mock passionate embraces while being stalked by two great
white hunters (two young guys); Levine in sarong having a hot dog
and milkshake at someplace like Venice Beach or the Santa Monica
pier. And that's pretty much the whole movie. It ends, as it began,
with Mead mugging at the camera.

The New Yorkers drove out of Los Angeles on October 10 or 11,

stopping overnight in Las Vegas and then heading down through Phoenix to Texas and across the Deep South. In Texas they saw enormous billboards that said, "KO the Kennedys!" The group was, with the exception of the irrepressible Mead, tired and glum. Mirroring their mood, the Falcon broke down twice: on October 15 in Meridian, Mississippi, where the battery, fuel pump, and muffler all died (total cost of parts and repairs: $28.69), and two days later in Sylva, North Carolina, deep in the southern Appalachians. This may have been where Andy made his one and only pass at Gerard, halfheartedly groping him in front of Mead and Chamberlain—"I mean, what was he going to do, with other people in the room?" recalled Gerard, who shoved Andy's hand away. Andy repaid him by refusing Gerard cab fare when they got to New York, letting him wrestle his heavy suitcase onto the subway.

Sleep's raw footage, a mountain of celluloid in hundred-foot lengths, more than fifty rolls in all, was far from what Andy had imagined when, a fan innocent of the practical dictates of shooting and editing, he had conceived the movie. Instead of a long, unbroken take of the sleeping Giorno, the footage consisted of many, many separate shots. It seems that, once he began shooting, Andy quickly grew bored with his self-appointed task of holding a single, long shot; his hunger for visual detail and texture drew him to the possibilities of this new machine and he had begun shooting at close and long range, from this and that angle, crisscrossing with his camera the sleeper's body. The shoot, moreover, was a voyeur's playground; as Andy well knew, this was as close as he would ever get to possessing Giorno.

But how was he going to organize this mess? Andy enlisted his young neighbor Sarah Dalton to help with the raw footage. (Dalton had no prior film editing experience, although she later became a film editor.) Every day after school, Sarah Dalton came to Andy's to labor over his primitive editing setup. "Make it more the same" had been Andy's sole, vague instruction. "Whenever it changes"—when either

the camera or Giorno moved too much—"cut that part." He left Sarah to herself, and may have been in California during part of her stint. Julia sometimes wandered up from the basement, invariably observing, "Such a nice girl. I wish my Endy find nice girl like you." When Andy was at home, he materialized at such times to upbraid his mother in Rusyn, telling her to leave his busy assistant alone. "He'd tell her something sharply in Czech or whatever it's called," according to Sarah, "and she would say to me, 'It is always nice to meet you,' and go back downstairs."

Despite her efforts, ultimately the task of editing the film fell to Andy himself, and—perhaps as a consequence—the length of the finished film was reduced to a total of twenty-seven minutes, spliced and respliced. In reel 5 alone, Andy made 133 splices—by no means a tremendous amount of editing for a reel's worth of film, but far more than the beginner had bargained for.

By the time he was through with *Sleep*, Andy knew how to edit film. As film expert Callie Angell suggests, the tedium of editing the movie may well have been a factor in his subsequent, edit-free style. *Sleep* contains by far the heaviest editing he ever did—the only editing, in fact, he would do until *Lonesome Cowboys* in 1968. From *Haircut*, *Eat*, *Blow Job*, and the other films made shortly after *Sleep* until the "sexploitation movies" of 1967—*I, a Man, Nude Restaurant*, and *Bike Boy*—every Warhol film consisted of unedited footage, rolls of film butted end to end.

Even with all that recycled footage, Andy was forced to abandon his eight-hour goal for *Sleep*. The final cut was five hours, twenty-one minutes long, and would have been shorter if projected at standard speed. Andy did film it at twenty-four frames per second but projected it at sixteen, an excellent way to stretch his usable footage as far as it would go. He liked the slowed-down look; he had already screened his *Kiss* segments that way and continued to show his films in slow motion until late 1964, when he started using sound.

In any case, *Sleep* is not what many people continue to think it is—the slowly unfolding tale, in real time, of a sleeper's night—but a series of patently pasted-up pieces; as Andy told an interviewer in 1966, "Actually, I did shoot all the hours for this movie, but I faked the final film to get a better design." Some of Andy's splices are jerkily, amateurishly visible though the hypnotic quality of the film has fooled even seasoned filmmakers. It's the Duchampian turn again, in which awareness of the object becomes awareness of consciousness's role in shaping and determining the object. The value of Andy's minimal-action silents is their boomeranging of perception back onto itself. If they were not boring, if they didn't defeat the ways in which conventional film hurries the eye here and there, Warhol's silents would have no point.

But how valuable is the point they make? In *Sleep*'s endless, near-zero-action unspooling, everything is equally interesting and uninteresting. The concept of *Sleep* was so audacious, so immediately, unforgettably easy to grasp, that Andy managed to lodge himself more firmly than ever in the public mind. "The guy who painted the soup can" was now also "the guy who made the eight-hour movie of the sleeping man" (the originally advertised length proved to be a durable myth indeed; *Sleep* is still referred to today as an "eight-hour film").

Similarly, *Sleep*'s central effect, the Duchampian reversion, is more compelling, once grasped, than the experience of the film itself. Perhaps that's why, reading the reams of critical writing on *Sleep*, one gets the sense of overly agile minds flinging themselves against this big, dumb, inert object, trying to fit it into their conceptual machinery. Meanwhile it just sits there, big, dumb, and inert. (As Pauline Kael wryly commented: "All too frequently, after an evening of avant-garde cinema one wants to go see a movie.")

While the premise of *Sleep* could hardly be more voyeuristic, the movie carries very little sexual charge; Andy was not going to risk anything overtly homoerotic for his first venture into filmmaking. As

Giorno put it: "If you unfocus your eyes a tiny bit, it just looks like a black-and-white abstract painting that moves." Which Warhol's primary scenarist, Ron Tavel, confirmed: "For him, [film] was closer to painting, to what I think of as a 'breathing painting,' than for other filmmakers. With Andy it really was a slightly moving painting, and every slight movement fascinated him."

Despite its specific virtues—the occasionally beautiful chiaroscuro lighting effects, or the displaced perception that extreme duration indeed produces, in which Giorno's body parts stop looking like themselves—*Sleep* exists primarily as an outrageous notion that someone had the nerve to follow through on.

Kiss, in a sense, would be a more accessible version, or series of versions, of *Sleep*: uncut, unedited single-roll films, each depicting a kissing couple.

In his December 5, 1963, Movie Journal column in the *Village Voice*, Jonas Mekas wrote: "Strange things have been going on lately at the Filmmakers Showcase. Anti film makers are taking over. Andy Warhol serials brought the Pop movie into existence. Is Andy Warhol really making movies or is he playing a joke on us? This is the talk of the town. A three-minute kiss by Naomi Levine, is this the art of kissing or the art of cinema?" (Many years later, in the Warhol supplement in the *Voice*, Malanga explained the motive behind *Kiss* to John Perrault this way: "[*Kiss* was] really a comment on Hollywood's imposed moral code at the time in that films couldn't depict a kiss scene for more than 15 seconds on screen.")

Shot between August 1963 and the end of 1964, the movie is essentially a Warhol portrait film in twelve scenes showing couples kissing, with Naomi Levine as the principle kissee and Malanga as the designated kisser. Naomi Levine kissing Pierre Restany, then, on the same roll, kissing Gerard—lots of sexy tonguing in this. There's Naomi and Ed Sanders and Naomi and Rufus Collins—the only one of all the kissers who appears genuinely turned on, having fun, is Naomi. There

are a few gay couples: a blond Andrew Meyer going at it ferociously with another boy, with no shirts, in front of the acetate of *Jackie*, the dark-haired boy reaching below the belt as if to grab Meyer's crotch—actually his lower stomach. A few art scene and scene-maker kissings (Marisol and Harold Stevenson, Jane Holzer and John Palmer) and a few faux-gay kissers.

Despite—or, perhaps because of—the simulated passion, *Kiss* is strangely erotic. It is also disturbing, for a variety of reasons. The silence itself is alienating—there are no moans, no endearments, no heavy breathing. The slowed-down speed highlights odd details such as facial expressions, the pressure of a hand—but it's also a disconcerting experience because the images don't resemble real kissing. The viewer is waiting for something that never comes: a breast, a lowered shot, something other than interminable head shots of enmeshed mouths. There's something mildly frustrating, if titillating in a voyeuristic way, about the whole business. (Another, technical and unintentional, effect of the slowed-down film speed is to accentuate the whiteness of the intervals between scenes.)

The last sequence, depicting a prone pale woman and a dark man, is so still, so static, that at times the images resemble a painting—an effect that is enhanced by the subtle lighting. The slowing down of the action in *Kiss* only calls attention to this. It's as if Warhol wants to turn movies into paintings.

Ever vigilant, permanently on guard against too intimate an involvement with others, Warhol lived at arm's length, emotions well-hidden behind that flat affect, those shades. Only rarely did he venture into something as potentially catastrophic as a love affair. The early films express, in their very structure, the artist's emotional makeup. Their form is voyeuristic: erotic, but in a highly detached sense. What keeps *Kiss* from being a conventional turn-on movie (apart from the paradelike procession of couples) is, first, its unerotic silence, but even more, its slowed-down, underwater, sixteen-frames-per-second pace.

The early films' velvety slow pace is crucial to Warhol's intentions. It dispatches the films to an alternate universe; it's an alienation effect, an arm reaching out to push the viewer away—from overexcitement, arousal, possible distress, the gamut of human emotions.

Viewing *Kiss*, "we watch and wait," writes Stephen Koch. "We are perhaps aroused, but also a bit perplexed. The time of this film is not our own; it implacably withholds itself from us. The lovers on the screen are elsewhere, images absorbed in the grinding of mouth against mouth. Deprived of their tactility, we look on and wait, isolated in our own, voyeuristic audience time."

Sex, says Koch (Warhol's earliest, and still shrewdest, serious film commentator), "is always just on the verge of any Warhol film." But while, say, *Couch*, from 1965, has long stretches of out-and-out pornography, the earlier films "are erotic in a less obvious sense. They are the creations of a profoundly voyeuristic mind."

Voyeurism compensates for its removal, its distance, with its unobstructed, privileged intensity. What makes *Haircut #1*, one of three *Haircut* movies Warhol shot at or toward the end of 1963, interesting, is the self-knowledge it advertises: it ends with a direct, slyly knowing comment on its own structure.

As it starts, Billy Linich and fellow A-men John Daley and Freddy Herko are in the slummy Lower East Side apartment of the gifted, impoverished dancer-choreographer James Waring (who makes a ghostly cameo at the film's very end). Billy's engaged in one of his well-known pursuits, barbering, a skill he evidently learned from his grandfather in Poughkeepsie. As Billy carefully, lovingly snips Daley's already-short tonsure—using snips so tiny that he makes no evident progress for the length of the film—the pair are under the watchful eye of Herko, lounging in the middle distance in a desk chair, shirtless, painfully skinny, hairy-chested, and sporting a cowboy hat. He produces some pot, pours it through a sieve into a pipe, and lights up. The action is almost as imperceptible, the scene almost as still, the

Billy Name giving Chuck Wein a haircut

time as slowed down and otherworldly, as in *Sleep* and *Kiss*. One differ-
ence is that *Haircut* is filmed from six different angles, taking six rolls
to complete its action; the roll-ending leader appears, blanks out the
screen, and a new roll starts: six of them. There is also (minimally)
more action than in *Sleep* or *Kiss*, the eye directed here and there by
the camera. As when, in the final scene, Herko, still sitting at his desk
but now fully nude, uncrosses his legs, flashing the viewer—is this the
first instance of on-screen male frontal nudity outside of a 42nd Street
porn house?—before primly recrossing his legs.

The camera returns to Daley, but with a difference. His eyes, and
Linich's, and then Herko's as he joins them, meet the camera full-on,
meet our eyes in a unbroken stare: the voyeur's gaze, but turned back
onto ours. Two groups of voyeurs sit staring at each other, on-screen
showing off-screen that they're precisely aware of what we've been
doing the whole time: sitting in mute, rapt, voyeuristic passivity. And
then all three actors burst into gales of mute laughter. Joined by their
host, Waring, they rub their eyes, still giggling, either mocking us for

falling so blatantly into a voyeuristic trance or gently showing their awareness of their complicity—their participation in the single scenario that has just unwound, both on-screen and off.

Andy's basically unsatisfying, mostly flirtatious relationship with John Giorno continued through the fall. Giorno conducted a playful, never-published interview in which Warhol comes across as more fluent and relaxed than he does in Gene Swenson's roughly contemporaneous *Art News* interview. Talking to Giorno, Andy delivers a number of the same sort of tongue-in-cheek put-ons that mark the Swenson piece: "Nobody uses imagination anymore. Imagination is finished," or "Oh, art is too hard, I'm going to have to stop painting," a desire Andy repeats later in the interview, adding "I want my paintings to sell for $25,000" (about what a Rauschenberg—Warhol's priciest contemporary—was then fetching). At other points, Andy confides that he would like to go with the Marlborough Gallery, that he is going to an Upper West Side gym ("I want to be pencil thin. I want to like myself"), and that he "believe[s] in living. I didn't before. . . . I had forgot about living."

On the day of John F. Kennedy's assassination, said Giorno, he and Andy sat glued to Andy's TV set weeping "great big crocodile tears while Andy said over and over, 'I don't know what it means!'" Yet it is as hard to gauge Andy's reaction to the tragedy as it is to determine his whereabouts that day. According to Malanga, he was with Andy on November 22, walking through Grand Central Station, when they heard the news, and Andy's sole response after pausing to absorb it was a matter-of-fact "Well, let's get to work." *POPism*, which has Andy painting alone in the firehouse when the news was broadcast, further underscores his indifference: "I don't think I missed a stroke. . . . It didn't bother me that much that he was dead. What bothered me was the way the television and radio were programming everyone to feel so sad. It seemed no matter how hard you tried, you couldn't get away from the thing."

A few days after the JFK shooting, Warhol attended a party thrown by Danny Fields, soon to become a frequent visitor to Warhol's mid-sixties studio. Fields recalled the event as his "assassination party"; he had originally planned it as a Thanksgiving weekend get-together for college friends, and decided to hold it despite the JFK tragedy. Although Warhol is dim in Fields's memory, another future member of Warhol's scene left an indelible impression: the German model Christa Päffgen, who had already been using the professional name Nico for some years. "She came in with [model and actor] Dennis Deegan [another future Warhol figure]. I had a punchbowl, half vodka and half grapefruit juice. It was called a greyhound. When Nico came in, she scooped out a ladle-ful and instead of pouring it into a cup she held it up, put her head back and poured it into her mouth in a perfect little stream. So that's how we met her. You could say she invented herself at that party."

As far back as his late-fifties days at Serendipity, Billy Linich had frequented the San Remo Cafe, an already storied hangout on the corner of Bleecker and MacDougal. It was owned by the Santinis, an Italian family with deep roots in the neighborhood. Since the mid-fifties the San Remo had attracted a largely gay clientele, which the Santinis tolerated if somewhat dourly. Its atmosphere was pointedly different from the midtown Bird Circuit's mannered, histrionic style; it was for talking, not cruising. According to Joe LeSueur, who frequented the place with Frank O'Hara, John Ashbery, and James Schuyler, the San Remo was for "seedy literary types, grubby bohemians and quiescent queers who shunned screamingly gay bars."

The madrone, Betty Santini, a no-nonsense woman who, according to the playwright Robert Heide, looked and acted like an old-world Italian Ethel Merman, patrolled the booths "trying to sort of tamp everyone down," as early-sixties regular Danny Fields described it, "but it was out of control." "At one or two a.m.," recalled Billy, "it would be packed with the whole literary crowd and the theater crowd and the

artists and everyone. You'd show up and there would be a table where Robert Heide sat, and he'd say, hey, sit over here, this is where all the fantastic people are."

A calm point in this tumult, Billy was, in his own words, "extremely shy. I didn't speak unless I was spoken to, and sometimes not then. I was not at all sophisticated or cunning, just a guy who had a nice aesthetic sense." Robert Heide, who met him at the San Remo and developed a crush on him, introduced him to Nick Cernovich, a Black Mountain College product and a gifted lighting designer whose friendships spanned the gay arts world, from Virgil Thomson to Leonard Bernstein to Alvin Ailey to Paul Taylor. Billy became Cernovich's apprentice and lover, helping him light shows by Merce Cunningham, Paul Taylor, and Alvin Ailey, as well as Julian Beck and Judith Malina's Living Theater. In 1962 he traveled with Cernovich to Italy for the Spoleto Festival to work the premiere of Tennessee Williams's *The Milk Train Doesn't Stop Here Anymore.* Billy was soon working on his own, doing lights for James Waring's dance company and for one of the era's great loci of aesthetic experimentation, the Judson Dance Theater. Cernovich also managed Orientalia, an occult bookstore on 12th Street between Fifth Avenue and University Place, where Billy, who worked there in 1962 and 1963, began his lifelong immersion in Eastern mysticism (another Orientalia clerk at the time was a young musician, a Welsh émigré named John Cale).

After living for a year with Cernovich, Billy moved to the Lower East Side, first to Attorney Street ("twenty-eight dollars a month, utilities included"), then to East 5th Street, finally taking over the notoriously eccentric Dorothy Podber's flat at 242 East 7th Street ("fifty-five a month, utilities not included"). Podber, Ray Johnson, and the Judson dancer-choreographers lived in the immediate vicinity.

In the early sixties, what was called the Lower East Side still comprised all of southern Manhattan from East 14th Street south to City Hall; the appellation "East Village" did not come to be applied to the

portion above East Houston Street until the mid-sixties. Although the beatniks on the Lower East Side did not really constitute a distinct world—as Billy put it, "they were just people who were smart and got a great place to live cheap; essentially, they were just part of Village culture"—the neighborhood, with its harsh conditions and cheap rents, attracted a more ferocious breed of underground artists, among them the loose-limbed, second-generation New York School poets who filled the pages of the mimeographed journals C, *The Floating Bear*, and *Fuck You: A Magazine of the Arts*; the Judson dancers' investigations of everyday movement; Jack Smith's perfervid cinematic fantasies; and the all-night performances of La Monte Young's group. In his modest way, Billy located himself at the nexus of this activity, lighting dance concerts, helping the poets assemble their journals, building sets for Smith, chanting in Young's ensembles. Billy was an immensely useful person, his chosen spot offstage. (The teacher-critic William Wilson described him as "a sorcerer's apprentice, who asks nothing for himself and may turn out to be more interesting, valid, and authentic than the sorcerer.")

While Billy lived with Cernovich, according to Robert Heide, "he was—I wouldn't use the word conservative, but kind of normal." After he moved to the Attorney Street tenement, however, one of his fellow residents, a Brooklyn native and a Boys' High graduate named Bob Olivo but better known in the gay demimonde as Ondine, introduced Billy to methamphetamine, amphetamine's more potent cousin. Unlike Ondine, Billy never injected the drug, but from 1962 to 1969 he inhaled or swallowed a daily dose of it. By 1963, methamphetamine had already turned him gaunt and somewhat hunted-looking, and he had developed two other classic speed-freak symptoms: a love of shiny things and a compulsion for busywork, impulses that united in his decision to spray-paint his 7th Street apartment silver.

"I was very taken by spray paint, I really liked Krylon Powder Blue. There was a time when Ondine was staying at my apartment and I was

so high on amphetamines, if you're up for like three days, you turn into that mist. I used to love to spray a short spray of Krylon Powder Blue, and it was this blue cloud in the room that was just so divine. Anyway, after trying some of the different colors I was taken by the silver. It was the total, the ultimate chrome. . . . I started doing the walls and moved to the refrigerator and the tub and the toilet and the telephone. So I just did the whole place. I couldn't keep buying paint cans, I didn't have that much money, so I got some aluminum foil and I stapled it at the top and let it run down. So I did the walls. And I had some spotlights so I made the place blaze."

Whatever the date that he first laid eyes on it, for Andy, who had just spent three months painting nothing but silver canvases, Billy's silver apartment must have confirmed their affinity. They were already meeting socially: at Bourdon's, at Linich's party, at the movies ("I remember going to *America, America* by Kazan, because Andy wanted to see what Kazan was doing. I was so naïve I just watched the movie. When we came out, the only thing Andy said was that he already knew everything Kazan did and what was the big deal?"), and at Warhol's house ("I'd just hang around while he would be doing some Fritzi Miller [Warhol's commercial agent] shoe things. I'd go in the den in the back, just a big wood-paneled library-type thing loaded with big rolls of canvas, the Elvis ones and other canvases. Andy and I got to know each other by steps."

Malanga was around, although Billy recalled seeing little, if anything, of Giorno. For the most part, Gerard and Billy avoided crossing paths. "Gerard and I had the wrong kind of electricity. We did not jibe. I used to get really pissed at Gerard for taking Andy out to these poetry readings and acting like he was Andy's boyfriend, because I was." Gerard, for his part, enjoyed acting the senior associate, the experienced Warhol hand. One afternoon, leaving Andy's house together, the two young men took the subway downtown. "Andy had given me a sun lamp," said Billy. "Since I was his boy, he liked to give me presents.

'You know,' I said, 'Andy's really a nice guy.' Gerard looked at me and said, 'Wait'll you really find out.'"

Gerard took Andy into certain circles. Billy took him into others: the Judson circuit, the Cage and Cunningham circuit, and the Di Prima poetry circuit. Billy introduced Warhol to La Monte Young and to Jack Smith, with whom Andy had barely interacted at the chaotic Old Lyme shoot, and whose directing Andy was able to study at greater length when Billy brought him to another *Normal Love* shoot that fall. "Andy was really interested in seeing how Jack worked. He knew he didn't know how to work with people, and he picked up how Jack was not directing his actors. Simply by implication and hand gesture, they knew what to do. Andy was able to be more comfortable with his own nondirectional style, having seen Jack."

As Andy and John Giorno had done, indeed were still doing, Andy and Billy presented themselves to other gays as a couple. "Andy and I would go visiting other gay people and I'd be Andy's boyfriend. We would go see [collector] Sam Wagstaff, and Sam had his latest boyfriend there. When Rauschenberg got his new studio, we went over to see him, me and Andy visiting Bob and Steve Paxton." They continued in that mode—the prototypical pre-gay-lib couple: an older, more visibly successful man and his kept boy (although Billy had his own apartment).

Their sexual relationship was as negligible, as unfulfilled, as Andy's was with Giorno. "You weren't able to relax with Andy in the sense that two people who are lovers can just lean all over each other. Andy's nervous system was too reactive. Like I remember one time I came up and put my hand on his shoulder—he jumped. His whole neurological state was just always on the edge, to the point where he couldn't relax with you." They made love only once, when Andy gave Billy a blow job. Andy's evident discomfiture made Billy in turn too self-conscious to enjoy the episode. The prospect of sex "became so uncomfortable and awkward that we both just agreed, 'Why bother? We're so awkward

about it, it's not going to be really sexual anyway, it's just going to be some exercise or something.'

"Neither of us had the sense of how you should have a relationship with each other, so what we did was just work. And that overtook us, because that was the developing period of Andy's fame. We were able to avoid that fact that we were both dysfunctional. . . . Andy wanted something so exotic and perfect, and maybe homey, too, and it just wasn't there.

"But it was really easy to love him, I mean, he was so sweet and nice," though perhaps, Billy speculated, not as sweet and nice as he might have been. "Andy's inability to find a lover made him, I wouldn't say unhappy, I would say tart like a lemon. He could have been a nice sweet orange, but he was a lemon, because he never found anybody."

*Here in New York We Are Having a Lot
of Trouble with the World's Fair.*
—FRANK O'HARA

Andy had known since at least mid-1963 that he would have
to vacate the firehouse. He had already been scouting for
new locations in July, circling ads in the *Village Voice* real
estate section. The range of addresses he circled indicated that he was
not particular about where he moved.

He was still studio-hunting several weeks into the New Year, when
he finally found a space that felt right. "New Studio 231 E. 47," reads
the date book entry for January 28, the day he and Malanga began
moving in. One afternoon, according to Henry Geldzahler, Andy
stood puzzling over his new lease. Geldzahler suggested that they visit
his brother, a high-powered lawyer. "So how long you want the studio
for?" Geldzahler's brother asked Andy when they got to his office. Andy

looked at Henry. "He wants it for three years," said Henry. Geldzahler's brother asked another question. Andy looked at Henry, who answered the question. Andy signed the lease and left. "That guy's an idiot," said the brother. "I think he's a genius," replied Geldzahler.

In Gerard's opinion, the new location lacked chic—he would have preferred a downtown address. Andy may well have been hedging his bets by staying within striking distance of the midtown commercial clients he still did jobs for; he also no doubt realized that an anomalous address conferred its own distinction. Dwarfed by new skyscrapers, the six-story building dated to an earlier, earthbound day when the neighborhood had belonged to light industry. Andy's fourth-floor loft had once been a hat manufacturer's. The building had outlived its productivity, and at least two of the other floors were now storerooms: the sixth, where the Albert Einstein College of Medicine kept donated secondhand furniture, and the basement, Billy Linich's haunt, crammed with cast-off furniture from the building's previous tenants, much of which Billy lugged upstairs. The most famous piece of furniture in the Warhol studio, however, was a couch Billy found on the street. "It was in great shape when I found it, beautiful Art Moderne." Others found it not nearly so appealing, especially after a year or two; one person complained he'd gotten crabs from it. ("I was never aware of anybody getting crabs from it," Billy maintained. "If they did, it was after it had been used in movies where people were screwing on it.")

The loft was a long, narrow floor-through some ninety feet by thirty-five feet. The southern end overlooked 47th Street. Three shallow arches were scooped lengthwise out of the ceiling. The ground-floor entrance was a green door flanked by a parking garage and an antique store. An old freight elevator with a sliding gate brought you upstairs; eventually a small sign appeared in the elevator: "Warhol-Linich—4th floor." Because the lift was enclosed on top, the largest of Andy's silk screens had to be lowered from the fire escape to 47th Street. Elevator, stairwell entrance, and a pay phone (which remained the studio's only

phone) were all crammed into the southeast corner. In the opposite corner, all the way in the back, a few grimy windows opened partway onto an airshaft. The only fully opening windows lined the south wall. (Andy wanted to know if it was as big as Bob Rauschenberg's, according to Sarah Dalton.)

The first order of business was to make the place unforgettable-looking, instantly inscribed on a visitor's mind. Andy already knew what he wanted: a mega-version of Billy Linich's silver apartment. Silvering the studio took Billy almost three months of full-time work. Except for a brief interval toward the end, he did the whole thing himself; Andy and Gerard were themselves working long hours getting ready for Andy's second Stable Gallery show. The show was to open in April, and Andy wanted the silvering completed for the opening-night party; when he saw that Billy would not be able to finish alone, he got up on a ladder and helped.

Billy started by covering the walls with foil. Climbing a tall ladder, he stapled a roll of foil to the corner of wall and ceiling and let it unfurl down to the floor. He repeated the process dozens of times. He foiled wherever he could: walls, ceiling, the room's four pillars, the northern windows. (He also took the liberty, without asking the super, of silvering the elevator.) The only areas he spray-painted, with Krylon Silver, were the sink, the south windows, the furniture, the pay phone, and the two toilets along the north wall—anything that wasn't easily covered by foil.

Waiting every night until the place was empty, Billy vacuumed and mopped the floor and then, pushing a long-handled roller, painted it industrial aluminum. Since Andy rarely left before 1:00 a.m., Billy was often still at work when the sun came up. After a while he simply moved in; it was easier than staggering home at five in the morning. (His Seventh Street landlady, irritated by the staple marks he'd left from his first silvering job, kept his air conditioner.) Another reason for Billy's relocation was that he was not good at apportioning his time;

once he gave himself to something, he gave himself entirely. Methamphetamine made it possible for him to work nonstop, for hours on end, and he saw no reason not to.

The concept of the silver studio proved more memorable than the thing itself, seedy-looking, grime-collecting, old walls crumbling. "It was a dismal, wretched, squalid facility," in Ivan Karp's opinion, which Sam Green shared. "Huge, huge empty useless loft which some speed freak was wrapping with tin foil and spraying with paint, and an elevator that was scary. From the sidewalk you entered a vestibule with chipped tiles, found the elevator, somehow got upstairs, and you entered this huge space with a lot of beams and exposed plumbing that was being wrapped by the speed freak."

Before long, tatters of foil hung from walls, ceiling, and columns, despite Billy's constant maintenance efforts. Andy had aspired to a rocket ship but achieved a cave. Its enormous length made it feel lower-ceilinged and narrower than it was, claustrophobic despite all that square footage: an uncomfortable, disorienting, enervating space.

Aside from Billy's bedroom, tucked into the northeast corner, there were few defined areas. The space remained functionally amorphous: Andy might silk-screen here one day, there the next. The sparse, broken-down furniture was constantly shifted around. The place was permanently unsettled and unsettling, everything temporary.

The silvering was probably still going on when Billy, Andy, and Billy's friend Ondine had a conversation. "We have to call this place something," Billy remembered saying. "We don't want to call it the Studio or the Art Studio. I was the one who said, I can think of two things: the Factory or the Lodge. We all said at the same time, 'the Factory.'" The Lodge, with its staid, American Legionish connotations, obviously would not do. "From then on, everyone said, 'I'll be at the Factory,' or, 'See you at the Factory'"—except Andy, who rarely used the appellation. To him it was always "the studio" or sometimes, especially after the sixties, "the office."

Warhol and Malanga

Reams have been written about the significance of the name, its implications of the impersonal style of Warhol's artistic production. According to Linich, it was chosen simply in recognition of the loft's past as a hat factory, but it would soon acquire a second meaning. It didn't hurt that the name portrayed Andy's work in as unromantic and mechanical a light as possible. "I'm becoming a factory," he told a visitor from *Glamour* in late February (the article appeared in May), as he described the rote procedures he was now using to make his art.

At first Gerard lived in the Factory, too. "When Andy found the studio, I thought I had a home base. I moved all my books in from my mother's. I squared out a little area near the telephone with milk crates, those were my bookshelves." Although Andy said nothing, he was clearly less than thrilled. "Billy kept his things more discreet," admitted Gerard. "He was imaginative and obviously I wasn't. He created this enclosure in the back with these big wooden folding screens

that he also painted silver. And that was where his bed and whatever was. My presence was little bit larger than Billy's. I was showing off my butt. So he ended up staying at the Factory, not me." Gerard, who had gotten to know Allen Ginsberg, took over Ginsberg and his lover Peter Orlovsky's apartment on 5th Street between Avenues C and D until June, when the building was condemned. He then moved in with his girlfriend, Debbie Caen, better known in amphetamine circles as Debbie Dropout, at 19 Eighth Avenue. "I must not have been thinking right, because I invited Ondine to stay, and in exactly no time his friends took the place over. Debbie became completely fascinated with the amphetamine people, I lost my girlfriend, and the apartment became a drug den," a hallowed address in underground legend. Gerard spent most of the rest of the sixties "bouncing all over the place. At least I had the Factory to go to during the day." Although he had re-enrolled at Wagner in January 1964, within months the attractions of his current life and the grueling commute to Staten Island put an end to his academic career.

As for Billy, he stayed put; practically the only time he left the studio overnight was to house-sit for Henry Geldzahler (babysit, too; happening by while Geldzahler was suffering alone through a hellish first LSD trip, Billy cradled him in his arms until Henry came down). Unlike Gerard, Billy was never paid; he simply asked for $15 or so for food every two weeks. Despite this infantilizing arrangement, Andy relied heavily on Billy: as the Factory's superintendent, as an all-purpose sounding board, and for an aesthetic sense that Andy esteemed more highly than he did Gerard's. Billy and Andy's unsatisfying romance was over by the earliest Factory days, but instead of ending in alienation, it evolved into something "much more enjoyable," as Billy described it, "because we synchronized so well."

Warhol's affair with John Giorno was also winding down. "Things started to tail off in the spring and summer of '64," Giorno recalled. "By

the fall it was completely over" (although Giorno evidently retained enough feeling for Warhol to be bruised by Andy's failure to invite him to a 1965 party for John Ashbery). For some reason, Warhol was scathing in later judgments of his former lover. "He's just a piece of meat," he said to David Bourdon in 1969. "Never thinks, has nothing to say. He saw my death pictures and decided to do death poems. I mean, I really know him—he's a dunce."

The conventional assumption about Andy's sex life is that there was little activity, and that his desire played itself out largely through his work. The story is somewhat more complicated than that, and his partners more numerous. "In the fifties," said mid-sixties Warhol acolyte Michael Egan, "he'd been too timid to come on to anyone; as he became more famous and successful, he was less reluctant to make a pass."

Andy's affairs, or "attempts at affairs," according to Billy, "might last six to eight months," but only a small portion of that time—the first week, perhaps—normally involved actual sex. "Andy's idea of sex was to have it once or twice and get it over with—with Andy it wasn't about love, it was about companionship."

Warhol's sexual inhibitions ran as deeply as his shame over his Pittsburgh roots. "In terms of how he dealt with potentially intimate relationships," said Dr. Denton Cox, Warhol's friend and physician, "the hemangioma undoubtedly played a role. But parts of it may have been based on a sense of sexual inferiority."

One has to respect Warhol's courage: again and again, despite enormous self-doubts, he sought to find a sexual partner. Ivan Karp introduced Warhol to Robert Pincus-Witten, then pursuing his doctorate in art history. Pincus-Witten remembered visiting the Factory, "which was in the process of being silvered. Andy took a shine to me, I took a shine to Andy, and we saw a good deal of each other. We spoke to each other every day"—typical Warhol behavior with an intriguing new friend. "We had an affair. For me it was very inconsequential, because Andy was a tremendously unskilled and very unrewarding partner."

Pincus-Witten insisted that they meet at the Brasserie restaurant in the Seagram Building, "so I didn't have to deal with all that interface"— the "squirrels," Pincus-Witten's name for Factory hangers-on. "I think he saw me as the intellectual who would teach him a new word every day," the same tutorial role Andy had assigned to Henry Geldzahler. "He said, 'OK, if you don't want to come to the Factory, call me at four o'clock and teach me a new word.' I would tell him a lot about Europe. That was a very important part of our conversation: what Ileana [Sonnabend] was like; what it was like to work for various galleries. What was Yves Klein like? Whatever I said, he was confirming: 'Oh, yeah! Oh, yeah!' Andy was not a conversationalist, not in the way of 'You say something, I say something.' It was not like volleying."

The sexual phase of the relationship lasted briefly. "A few episodes. We had no claims on one another, this affection had not moved beyond the stage of temporary and occasional." Yet they discussed moving in together. "And then I said 'This is nonsense; this is nobody whose sexual skills are really very interesting to me.' It wasn't really like anything ended; we continued to be friends."

And so Andy was "always going home alone," said Billy Linich. "He had really become turned off by the whole thing; it was embarrassing trying to score somebody."

In its earliest days, the new studio was almost as quiet as the firehouse had been. Andy and Gerard screened paintings and worked on Andy's new project, to be unveiled at the Stable in April. Billy did his silvering and built his spartan sleeping area. Films were being made, but not at their frenetic later pace. Andy bought a 35-millimeter Pentax whose workings defeated him—"I got impatient with the f-stops, the shutter speeds, the light readings, so I dropped it." Adopting the camera, Billy converted one of the Factory's two enclosed toilets to a darkroom— and revealed himself to be an instinctive photographer of genuine talent. (Pat Hackett, a Factoryite of a later era, recalled Warhol telling

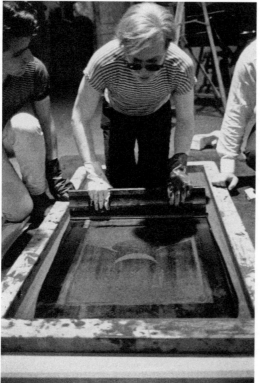

Warhol at work

her, "Billy had timing. You've got to have timing as a photographer, and Billy had it.") Warhol steered him in a direction of Andy's choice: documenting the life of the Factory.

There were a few visitors in these early days, not many. Ed Wallowitch stopped by to shoot some pictures. Ivan Karp put in regular appearances. "In those first two years it was all about production all the time. He was a hard worker. He was in the Factory doing the job. That's how I remember him. On his knees squeegeeing a painting, saying, 'This one's not so good,' or 'Ivan, do you think this is passable?' or 'Put that one in the corner, Gerard.' There were never more than three, four, five people there. The Factory was a production plant, that's all, in the years I attended on a daily basis. The only reason to go there was to watch the silk screens being made on the floor."

Michael Egan, a self-confident University of Massachusetts undergraduate Geldzahler had picked up in Harvard Square (and cofounder of what was surely the world's first Andy Warhol Fan Club, its members including two future art world figures of consequence, Jasper Johns scholar Roberta Bernstein and Deborah Wye, curator of prints at the Museum of Modern Art), remembered "paintings laying around in piles, everything just laying and leaning in the most casual way. There were other people there working the whole time, making paintings. It was a return to the art I was familiar with from reading about sixteenth-, seventeenth-, eighteenth-century painters. This was the whole workshop tradition reinvented. He was inviting everybody into his process, which was a fascinating thing because contemporary artists were supposed to be the maker of it all," sole authors of their work. As Billy Linich said, "At the Factory I was a skilled technician and the name of what we did there was 'Andy Warhol.'"

Mark Lancaster, the art student from Newcastle University who was spending the summer in Manhattan, remembered walking into the Factory for the first time, on July 6. "I pushed the door open and entered the silver space. Andy got up from a silver stool. He was shy and charming. He said they were making a Dracula movie, and that he had to talk to someone from the Voice of America." Jack Smith, whom Warhol had talked into playing Dracula, was "nervously arranging furniture, lamps, mirrors, and fake fruit." Andy, who was soon behind the camera, "was clearly in command." It came time to leave. "It has been astonishing, fascinating, and intimidating. I thanked Andy for having me visit. His total reply was, 'Oh, see you tomorrow.'

"I was there almost every day for the next six or seven weeks. When I hear Dionne Warwick singing 'A House Is Not a Home' or Lesley Gore singing anything, that place and time is instantly recalled. There were the Supremes, Martha and the Vandellas, Barbra Streisand, and the radio, usually tuned to WMCA, the 'Good Guys' station, which was very big on the Beatles and new English groups like the Animals, who

first played New York that summer. When a record ended, if someone else did not change it, Andy would start it from the beginning again; he never changed the record."

Decades later, Lancaster came across his notebook from the summer of 1964. On July 12, less than a week after he had first pushed open the silver door, he wrote, "He's so kind and obviously some kind of genius."

The Silver Factory in its first days "was a very private world," according to Egan. The first outside stream to enter for more than a visit were Billy Linich's friends, the coterie *POPism* calls "the A-men"—A for amphetamine. They never appeared on the public's radar, and eluded even such Warhol proselytizers as John Wilcock, founder-editor of the early countercultural journal *Other Scenes.*

Mary Woronov, a 1965 Factory arrival, called them "the extremely narrow circle that surrounded Warhol during the days of the Silver Factory . . . the Mole People," she wrote in her memoir *Swimming Underground,* "because they were known to be tunneling toward some greater insanity that no one but this inner circle was aware of."

Overlapping with the Lower East Side arts community was a loose network of largely gay, antibourgeois renegades whose major bond, apart from their homosexuality, was methamphetamine, hence the name A-men. Their hierarchy, according to Billy, was codified, the pecking order going something like this. Central core: Billy; Ondine; Kenneth Rapp, or "Rotten Rita," by day a clerk in a fabric store, by night a speed dealer; Freddy Herko, a gifted dancer-choreographer with the avant-garde Judson Dance Theater; perpetual art history graduate student John Daley; and, later, aspiring painter Ronnie Cutrone and Brigid Berlin (a high society dropout, daughter of a Hearst executive, whose two nicknames were "the Duchess" and "Brigid Polk," for the amphetamine pokes she gave). Regulars: hustler Joe Campbell, "the Sugar Plum Fairy"; Johnny Dodd (who succeeded Billy as the Judson Dance Theater's lighting designer); and Binghamton Birdie. High-status

Ondine

irregulars: Arione De Winter (by reputation a practicing witch, who went on to work as a Jungian psychotherapist in the West Village), and Harvard graduate, *New Yorker* fact-checker and scabrous wit Dorothy Dean. Proletarians: Walter Dainwood, Norman Billiardball, Silver George, Ron Vial. Dealers: Rotten Rita (again), Wonton (Bobby Catalbo), and Stanley the Turtle.

Billy having established a beachhead, the A-men infiltrated the new studio. At first appearing only after Andy was gone for the night, they eventually moved in full-time, although they restricted themselves to the studio's shadowy rear. "Right from the beginning it had an aura about it that was sort of secret," says *POPism*. "You never really knew what was going on there—strange characters would walk in and say, 'Is Billy around?' and I'd point them toward the back."

Why were the A-men there? "If you look at all those characters that were in the Factory—Ondine, Mario Montez, Joe Campbell—in New York at that period of time," said musician John Cale, a later part-time Factory denizen, "where the hell else were these people going to go where they'd be able to express themselves and not just get treated like the looneys they would be if they were in the outside world? There was safety at the Factory."

Much has been written about Warhol's attraction to the Beautiful People and their high life, but in the sixties, he had just as strong an

attraction to low life, which the A-men personified. Some excited him sexually, but what really attracted him was their histrionics and flair.

Even before the Factory, Andy had tapped into Freddy Herko's eccentric charisma; *Haircut #1*, which Herko stamped with his seedy grace, could be considered Warhol's first A-man film. The denizens of the Factory, said Billy, "knew that *Andy* knew that the life they lived was in some way fabulous, and that he was there to garner some of it, if he could. He had access to something other filmmakers didn't. They only had professional performers and actors, trained and scripted. Whereas he had access to the so-called fabulous world of brilliant minds and sayings, and that was something that he realized could be uniquely his portrait."

Yet Andy was drawn to them on a still deeper level: he was one of them. When he ventured into the party in Billy Linich's silver lair, he must have felt as if he'd finally come home. The A-men may have been spectacularly unable to succeed in conventional society and Andy spectacularly able; they may have lived beyond the law and Andy within it, taking his safe little doses of prescribed speed, but he and they were, at bottom, fellow pariahs, and Andy knew it. The Factoryites were his compadres. Although his sixties world came to include far more heterosexuals than his earlier milieu had, at bottom things hadn't changed that much.

Gerard Malanga may have been indispensable as a silk-screening assistant, talent scout, social director, and gofer, but he had only an inkling of what animated Warhol's worldview, and to the Factory's gay inner core, with their utter disaffection, impervious shield of irony and lightning-fast entre-nous humor, Malanga—earnest romantic, shameless networker, and indefatigable girl-chaser—was an object of ridicule. "I ignored Gerard most of the time," said Linich. "Gerard was just gauche and tacky. I even put up a sign once—it was the only time Andy told me I couldn't do something—that said, 'People Who Cannot Enter the Factory.' Gerard was at the top of the list." Ondine wasn't any more

enamored of Gerard, whom he considered a thorn in his flesh. If at the time Gerard was the Factory's public face, it was because he was a more acceptable figure than a group of rabid speed freaks.

The A-men were the all-but-invisible hard core of Lower Bohemia, defined by film critic Stephen Koch as "the realm of the more or less inspired outcast. Drug addicts. Transvestites . . . flamboyant hopeless geniuses beyond the pale." For Koch, the sixties Factory was where Lower Bohemia converged with Upper Bohemia, the world of the socialite. (Middle Bohemia, the world of earnest intellectuals and modernist painters, a world Warhol intensely disliked, did not figure here.) As Koch wrote, "orchestrating a link between Lower and Upper Bohemia was the heart of Warhol's social enterprise in the sixties."

By the beginning of the sixties, the old Social Register elite with its debutantes and cotillions had long since faded into genteel oblivion, its stranglehold on manners a distant memory. As socialite jewelry designer, Warhol friend, and doyen of manners Kenneth Jay Lane, noted, "The 400 didn't mean anything anymore."

One of the old order's brightest eulogists, the young Tom Wolfe, finding his voice in *Glamour, Harper's Bazaar,* and the *Herald Tribune's* Sunday supplement, "New York," identified its replacement as "Pop Society," an amorphous congeries of arrivistes: people with money to burn but no inherent style, "their antennae out," Wolfe wrote in the April 1964 *Glamour,* "to make sure they will be in on the new 'in' thing to do. It's amazing how much these people talk about things being 'in' or 'out.'"

Previously, said Wolfe, culture had been the creation of the elite, trickling down from on high. But in the sixties, a new and alarming reversal was taking place: style was welling up from below, from "netherworld, outcast, 'pariah,' groups. Such as: teenagers, artists, beatniks, Negroes, narcotics users, homosexuals and camp culturati." The culturally vacant, culture-craving nouveaux riches eagerly absorbing Wolfe's

pariah styles were venturing into such raffish quarters as Warhol's Factory and Jonas Mekas's Film-Maker's Coop, trailing in their wake the city's gossip columnists and fashion intelligentsia.

"These rich people who would come down to the Factory, to slum," Mary Woronov recalled. "The value thing was shifting. The top was coming down to get something. *We* had the power over *them*. We were just a bunch of smart queers, some of whom weren't queer, and amphetamine heads, smart but bored, who understood that this guy's like a mark. He's an audience. And we played it."

Wolfe's fashion-writing colleague on the *Herald Tribune*, Eugenia Sheppard, emerged from Lower Bohemia with the intelligence that "to be fore or aft an underground movie camera is just about the most 'in' place you can be right now." Soon came a spate of mass media reports on the confluence of the high-society fashion world and the lower depths. A *Tribune* feature, "Well-Dressed Kibitzer," had appeared on April 25, 1965; draped fetchingly on an aluminum ladder, a gorgeous blonde in a B. H. Wragge outfit paid no attention to Warhol scenarist Ron Tavel and Factory assistant Danny Williams, fixedly filming away; in an inset, a second model, looking very much like the cover-girl-turned-Factoryite Ivy Nicholson, showed off a "very Pop" linen coat from Bonwit's. The March 19, 1965, *Life* splurged on "Underground Clothes," six pages of models (Ivy Nicholson again, or a look-alike, and others) posed against wall-projected Warhol films. *Life*'s piece culminated in a full three pages devoted to the "irrepressible, way-out leader of New York's 'in' group . . . born rich and married rich . . . [who] whirls through fashion openings, gallery openings, theater openings, through partiers at messy studios and stylish discothèques, screaming like a teenager at Beatle-type singers and talking with hard sense to movie producers who want to start her in an above-ground movie career."

That would be Jane Holzer, the former Jane Brookenfeld of Palm Beach, Florida, now "Baby Jane" to every gossip columnist and feature writer in New York City, a Park Avenue socialite (but definitely not of

the old order) who, with her coltish, twenty-four-year-old's enthusiasm, embraced Lower Bohemia more avidly than any of the other new Pop socialites. When Warhol met her in 1963, she had already embarked on a modeling career, more or less as a rich girl's lark; in Swinging London in the summer of 1963 she had been transformed almost instantly into a highly sought-after cover girl.

"Bangs manes bouffants beehives Beatle caps butter faces brush-on lashes decal eyes puffy sweaters French thrust bras flailing leather blue jeans stretch pants stretch jeans honeydew bottoms éclair shanks elf boots ballerina Knight slippers, hundreds of them, these flaming little buds, bobbing and screaming." "The Girl of the Year," one of Tom Wolfe's opening New Journalism salvos and perhaps his most famous magazine piece, begins thus, with Baby Jane at a Rolling Stones concert.

"That girl on the aisle, Baby Jane, is a fabulous girl. She comprehends what the Rolling Stones *mean*. Any columnist in New York could tell them who she is. . . . A celebrity of New York's new era of Wog Hip . . . Baby Jane Holzer. Jane Holzer in *Vogue*, Jane Holzer in *Life*, Jane Holzer in Andy Warhol's underground movies, Jane Holzer in the world of High Camp, Jane Holzer at the rock and roll, Jane Holzer is—well, how can one put it into words? Jane Holzer is This Year's Girl." Wolfe later revised himself. "New York's 'Girl of the Year'—Baby Jane Holzer— is the most incredible socialite in history," he wrote in the preface to his first book of collected feature stories, *The Kandy-Kolored Tangerine-Flake Streamline Baby*. "Here in this one girl is the living embodiment of almost pure 'pop' sensation, a kind of corn-haired essence of the new styles of life. I never had written a story that seemed to touch so many nerves in so many people."

The "Girl of the Year" (whatever its provenance), became a marketing concept that Warhol used to promote himself and the Factory. Baby Jane was the charter member of the group. Appearing in *Kiss*, *Soap Opera*, *Camp*, and other early Warhol films, Baby Jane was society's first ambassador to the Factory, a distant precursor of the far more

Model Peggy Moffitt, Mick Jagger, and Warhol at Jane Holzer's apartment, 1964

high-powered seventies and eighties socialites whose inner circle Andy finally managed to penetrate. But now, in the mid-sixties, like a drum majorette, Baby Jane led the curious and style-hungry elite to the 47th Street loft. Already in the spotlight, she shed enough of its glow onto Andy to make her highly useful. She accelerated Warhol's self-transformation from art world figure to celebrity, and when the Factory's atmosphere grew dark, Baby Jane, unlike her "Girl of the Year" successor, Edie Sedgwick, was out of there, back home on Park Avenue with her real-estate mogul husband.

But in 1964 there was little at the Factory (apart from the A-men's excesses, and these were not yet the norm) to horrify a Beautiful Person. Andy made sure of that—he *wanted* the socialites, with their luster and the publicity they brought. Kenneth Jay Lane's remark that "Andy didn't go to the Beautiful People, they came to him, and it didn't take them long" is only half true; the attraction was mutual. The Krylon

Silver was hardly dry, the Reynolds Wrap not yet all hung, when Andy threw open the Factory doors to an eager uptown world. As planned, the Factory's first party celebrated the April 21st opening of Andy's new Stable Gallery show. Marguerite Lamkin and Bob and Ethel had agreed to pay. Somebody hit on the terribly Pop idea of having Nathan's cater the affair, and the Coney Island hot-dog king sent two hundred franks, two hundred burgers, two hundred pieces of corn on the cob, two grills manned by white-capped attendants, and a generous supply of highball mixes.

The Sculls insisted on hiring the Pinkerton agency; the detectives stood downstairs in the filthy vestibule monitoring arrivals: Ahmet and Mica Ertegun, Jacob and Marion Javits, John Houseman, Philip Johnson, Zachary Scott and Ruth Ford (Charles Henri's sister), Allen Ginsberg, Adlai Stevenson's social-lion son, Borden, any number of Tom Wolfe's so-called buds, the Countess Marguerite de Limburg-Stirum, and the Pittsburgh ketchup millionaires and art patrons Drue and Jack Heinz. It is not clear whether Warhol had already made the Heinzes' acquaintance, but to be able to hobnob with the couple who occupied the social apex of the city signified, more than anything else that night, Warhol's social triumph.

Given the crush, the Pinkertons weren't a bad idea. Not long after this first Factory bash, Barbara Rose prevailed upon Andy to let her throw a party for the California painter Larry Bell. "Andy said, 'Maybe we should have Pinkertons,'" Rose recalled. "I said, 'What are you, crazy?' By midnight there were like a million people and I'm running around trying to throw people out. 'I'm sorry, were you invited?' 'I'm sorry, I'll have to ask you to leave.'" Nobody paid any attention to her; the only crasher she succeeded in throwing out, to her mortification on learning his identity, was Cecil Beaton, who left very politely.

The "Factory party," with its uptown-meets-downtown encounters, has become a part of sixties lore. In fact, these parties didn't occur very often, chiefly because, as Billy Linich put it, "the whole thing quickly

became overwhelming. Everyone wanted to throw themselves a party at the Factory." The very first request had resulted in near disaster. Bell Labs scientist and a frequent artists' collaborator Billy Klüver and his wife, Olga, wanted a Factory wedding reception. "Andy told them, 'Gee, I don't know, you'll have to ask Billy.' Billy Klüver was very cool, so I said okay." Late in the party, Linich looked up from his deejay spot behind the turntable to see a group of New York City policemen enter from the stairwell. Time to wind down, they said. "There were a hundred people there," according to Billy, "all very strong anarchist-pacifist-don't-tell-us-what-to-do types. Jill Johnston. Susan Sontag. They all sat down on the floor, not to be moved," ready to fight for their right to party. Leaping onto a desk, Linich told the revelers to go home, that there was no sense turning a wedding party into a mass arrest.

With exceptions, the fifties friends who ventured into such affairs were not made to feel at home. Andy's Carnegie Tech friend George Klauber, once as close to Warhol as anyone, was roundly cut by Andy at a Factory party. "Willard Maas invited me. So I get there and say hello to Andy, and Andy looks right through me, as if he didn't know me. I left very early. He hadn't said hello and he didn't say good-bye. It was like he didn't recognize me." Indeed, he refused to: as good a friend as Klauber had been, he no doubt signified to Andy the bad old world of anonymity and rejection that Andy wanted to forget as badly as he wanted to forget Pittsburgh.

Andy's winter 1964 art season began offhandedly enough, with a joke on Gerard Malanga. One afternoon the previous fall, the pair, who often scoured secondhand bookstores and memorabilia shops in search of source art, were in one of their favorite haunts, a huge cavern of a bookshop on the corner of 23rd Street and Seventh Avenue. Gerard came across a photograph of a woman's breasts that he couldn't stop staring at, so Andy bought the photo and silk-screened it, using specially treated paints so that the breasts were visible only under ultraviolet

light. Serially multiplied nine times, the breasts were included in one of the year's first shows, the Pace Gallery's First International Girlie Exhibit, which opened in January. The show was panned by the *New York Times*'s stuffy chief art critic, John Canaday, in whom it aroused only indignation. "Mr. Warhol has reached what will be some people's idea of a solution to the whole pop art problem. . . . To see [the painting] you have to turn on something called black light. But you don't have to."

Andy's friend John Weber, meanwhile, who had left Martha Jackson for Virginia Dwan's Los Angeles gallery, had spent much of late 1963 planning a novel exhibit for the Dwan, to consist entirely of boxes designed and constructed by artists. Casting about for exhibitors, Weber remembered seeing the unfinished, Alfred Leslie–inspired Campbell's soup box in Andy's house. He wrote Andy (on stationery inspired by the latter's photo-booth magazine layouts), urging him to contribute to "a very special group show of something marvelous. I must swear you to secrecy as it *must* be a big surprise. What I am doing now that I have your attention is a BOX show. . . . Everyone who has ever worked in boxes, beginning with Schwitters. . . . Duchamp, Man Ray . . . through anyone I can find in New York or elsewhere doing something interesting. I very much, very very much want to include your Campbell's soup boxes. This is an absolute must. . . . As [Lord] Buckley used to say, 'Help me out!'"

Weber's idea was a recognition of emerging minimalism. The big show, sixty-one works by thirty-nine artists, opened on February 2, 1964. Andy contributed four new pieces: three wooden *Brillo Soap Pads* boxes and a *Heinz Tomato Ketchup* box. Reviewing the show for *Artforum*, Donald Factor caught part of Warhol's subtle intention: the boxes, he wrote, "demand re-identification and re-evaluation as they assume, in the purity of their projective impact, a kind of perfect cultural abstraction."

It's reasonable to conclude that Weber's request was what gave

Andy the idea for his upcoming, second Stable show. He sent Nathan
Gluck, still working for him on and off, to the Gristedes across from
1342 Lexington to scout out boxes. "I picked out all the interesting
ones graphically, and he said, 'No, no, no, I want something very ordi-
nary,'" without giving Gluck the slightest clue into his reasoning. In a
sense, said Nathan, "you might call it a stroke of genius. I don't mean
the genius of da Vinci's hand, but a thought process: he knew what to
do that was utterly different, that could make people wonder why on
earth he did it." Gerard, already better than Gluck at divining Andy's
intentions, was dispatched next and came back with several suitably
bland specimens. Malanga's next visit was to a woodworker's, and a
few days after Andy's move into the Factory, several hundred empty
plywood boxes were delivered.

As the boxes were dropped off at 47th Street, Andy adopted as effi-
cient a procedure as possible for duplicating the originals. The blank
boxes were laid out on the Factory floor in a gridlike pattern, and
Gerard, Andy, and Billy painted all six surfaces of each box either
white, yellow, or a cardboard-like tan. Then Gerard and Andy pains-
takingly silk-screened five sides with the appropriate graphics and
words. They left each bottom side blank. As with Nathan, Andy gave
Gerard no "specific interpretation as to why he thought up the boxes
in the first place. When I asked, he said merely that he liked to go
shopping."

The job took six weeks. Andy's friend, critic Gene Swenson, wrote
a brief catalogue, entitled *The Personality of the Artist*, a perverse touch
Andy no doubt appreciated. Swenson's text had an earnest matter-
of-factness. "Andy's boxes," he wrote, "do not express the personality of
the artist; they do not express feelings"—they were works of art spe-
cifically intended to efface what Swenson called "those symptoms of
modern art—personality and creativity—which have been sanctified
to the point of blasphemy." Should one be looking for a consistent
Warholvian program, an elaborated system, Swenson cautioned, "As

for Warhol's images, we ought to be wary of reading any articulated philosophy into them."

As always, Alan Groh proved immensely useful not only in assembling the show but in the still more vital capacity of reversing his boss's initial horror at the notion of mounting it. "The Brillo show," recalled Paul Gardner, "was Alan saying to Eleanor Ward, 'You've GOT to do this.' Eleanor thought it was all nonsense. Alan said, 'This is going to be hot and good,' so she finally said, 'Okay, we'll do it.'"

The April 21 opening was a highly festive affair. At Andy's request, Sarah Dalton wore a long white dress with culottes and ruffles, "sort of commedia dell'arte," as Sarah described it, "with FRAGILE—HANDLE WITH CARE—silk-screened repeatedly on it." (Dalton's dress seems to have rivaled the exhibit for attention. Three men asked her if she was the artist, another if she was a member of the artist's family, still another if she was a sculpture, and a sixth if she was a Happening.) De Antonio called it "Supermarket Day on Madison Avenue." "The curious and the dull and the hip smiled conspiratorially," De later wrote, "as they shuffled among the Brillo boxes stacked in Eleanor's gallery. And Andy had trained his blood to run like ice. There he fluttered among the guffaws and heehaws of collectors, fruits, art directors, and those he had left behind. He was at the gate of mystery: about to become a pop star."

Sam Green recalled a decided lack of screams and gasps, which did not at first disturb him: it was sixties art world etiquette. But people seemed a bit *too* muted, "wandering around kind of austerely looking at these very austerely placed boxes." Green began to fret that what he considered his matchmaking efforts between Ward and Warhol "had blown up in my face, because these things were clearly not saleable. I was thinking, 'Andy this is another one of your stunts, and I worked pretty hard to get you here. What are you doing to me?' But surprisingly, Eleanor was pleased with the show."

If the lack of evident excitement bothered Andy, he didn't show

it, but floated serenely through the evening. Michael Egan recalled standing with a glowing Andy, who asked him what he thought. "It's your Temple of Karnak," replied Egan, eyeing the towering box-piles. "Andy said, 'Karnak, I don't see that.' 'It's your classical temple ruin,' I said, after which we had this kind of great banter. Then he returned to the Temple of Karnak. 'Temple of Karnak,' he said. 'Henry will like that.'"

The show was not a commercial success. A disappointed Ward admitted that she and Andy had "had visions of people walking out with boxes under their arms, and it didn't happen." It was, nonetheless, a loss leader; one had only to hear about Warhol's outrageous concept to become newly, heatedly aware of who he was, to wonder anew, likely indignantly, just what Warhol thought he was doing.

What *were* these things: shipping crates or art? The most vehement answer (even if it proved temporary) was given the following March, when an eager Andy was booked into his first solo Canadian show, scheduled to open at a Toronto gallery on the eighteenth. It generated headlines in both the United States and Canada, but in news, not art sections. Given Warhol's and more and more artists' efforts to take dead-center aim at the precise boundary between art and nonart, a flare-up like the one in Toronto was almost inevitable.

Excitedly preparing for his big Warhol show, Toronto gallerist Jerrold Morris planned a veritable Brillo mountain: a total of eighty boxes. When he went to arrange their shipment, however, Morris was informed that the boxes would not be granted the standard tariff exemption for artworks, but were subject to a 20 percent "merchandise duty," or $60 a box (Castelli's had come up with a $300 price tag). The verdict came straight from Canada's chief cultural arbiter, Dr. Charles Comfort, director of the National Gallery of Canada. Warhol's boxes, in Dr. Comfort's estimation, were not "original sculpture" but mere facsimiles of shopping cartons. Comfort further declared his feelings hurt by Morris's "hostility" (the latter had fired off a news release, chal-

lenging Comfort and his institution "to recognize new art forms or make themselves the laughing stock of the art world"). Contacted by the *New York Times*, Andy said, "I don't really care. All the newspapers have been calling. I think with some of the important things happening they must have more to worry about than some dumb little boxes." Canada's culture boss held his ground; Morris, fuming, removed the boxes from the show (which made a big splash anyway). Three months later, the nation's tariff law was amended—just in time for the busy border-crossing of American minimalist art.

As he had with his soup cans, Andy was equating the art gallery with the supermarket, the wares of one with those of the other (but with a greater degree of verisimilitude: the '64 Stable, filled almost to the ceiling with faux grocery cartons, looked for all the world like an A&P storeroom. Ivan Karp had even thought to install a checkout counter where patrons' purchases were wrapped in plastic).

In his initial response to the Stable show, Sidney Tillim chose to center his *Arts* magazine review on a discussion of seriality. "The rooms were filled," he wrote, "only because they were there." Warhol's obsession with quantity was a refusal "to decide that anything in it is important. Decision means isolation, responsibility. The decision not to decide is a paradox that is equal to an idea which expresses nothing but then gives it dimension." Tillim's response offered an insight into minimalism. To Warhol and other Postmodernists, any organic structure was "corny," an artificial overlay; any sense of resolution, artificial. Given such a state of affairs, the only honest response was endless repetition, any variation an accident.

In an article that appeared in the Italian journal *Collage*, Gene Swenson wrote: "One would want one of the boxes primarily as a souvenir of an exhibition that was an idea." This was no conventional show, in other words, a roundup of an artist's recent, disparate works. The show itself was the work, a comment on art itself. Whether intentionally or not, when Tillim wrote that "the boxes as art are not very

interesting," he was echoing Duchamp's well-known remark about Warhol's soup cans: "If you take a Campbell's soup can and repeat it fifty times, you are not interested in the retinal image. What interests you is the concept that wants to put fifty Campbell's soup cans on a canvas." The box show was Warhol's second installment of conceptual art, challenging enough, to some at least, for the philospher and later art critic Arthur Danto to call Warhol "the nearest thing to a philosophical genius the history of art has produced."

Pondering the Brillo show, the *New York Times*'s Stuart Preston wondered "why he didn't just use the original boxes rather than go to the trouble of duplicating them." But Preston had provided the answer to his question a few sentences before he posed it. Warhol, he'd written, "is utterly serious in his determination to suppress totally any elements of personality and creativity in his work." As Preston saw, Warhol wanted to construct art that refused, as it were, to reflect his subjectivity; he was now taking seriously his 1963 response to an interviewer—"I want to be a machine." Up in the Factory, Andy, Gerard, and Billy lined them up and screened them, and delivered the goods to the Stable, where the gallerygoer scratched his head. Danto's characterization may seem somewhat overblown, but it highlights an aspect of Warhol's art not often acknowledged. Preston, in his modest, one-column squib, had seen into the heart of Andy's enterprise: "He has destroyed Art with a capital A."

For Danto, the Brillo boxes inaugurated what he called the "post-historical period of art." He wasn't suggesting that art could no longer be made, but that it had exploded all of its presumably necessary conditions: "[Now] you could be an abstractionist, a realist, an allegorist, a metaphysical painter, a surrealist, a landscapist, or a painter of still lifes or nudes." Warhol himself had said much the same thing in 1963: "How can you say one style is better than another? You ought to be able to be an Abstract Expressionist next week, or a Pop artist, or a realist, without feeling you've given up something." Art was now

inevitably self-referential, a branch of aesthetics, itself a branch of philosophy. Warhol, wrote Danto, "carried the discussion as far as it could go without passing over into pure philosophy." Sam Green put it more succinctly: "Andy was the one who pushed it to all conceivable limits of what is art. He did it. So there was nothing else he could do but go on to rock and roll and movies."

"Here in New York We Are Having a Lot of Trouble with the World's Fair," Frank O'Hara titled an early 1964 poem. Indeed, the New York World's Fair, which opened on April 22, was no boon to gays, underground filmmakers, verbally uninhibited comedians, and other perceived threats to New York's, and the nation's, social order. Anxious to present as respectable a face as possible to the millions of expected visitors, the city initiated a well-coordinated police crackdown on prostitutes, drug addicts, "bums," as the homeless were then known, and gays.

"In preparation for the World's Fair New York has been having a horrible cleanup. All of the queer bars except one are already closed," O'Hara wrote to Larry Rivers. Arriving in Manhattan from the Midwest just in time for the "cleanup," Edmund White found himself repeatedly caught up in police raids. "A gay bar would open, there'd be a raid the next day, and the place was shuttered. The truth is, the police were extremely hostile." On December 17, 1963, the *New York Times* published a front-page feature by veteran reporter Richard Doty, entitled "Growth of Overt Homosexuality in City Provokes Wide Concern." A brainstorm of the paper's new metropolitan editor, A. M. Rosenthal, the five-thousand-word story purported to shed light on "the city's most sensitive open secret—the presence of what is probably the greatest homosexual population in the world and its increasing openness," which "has become the subject of growing concern of psychiatrists, religious leaders, and the police." According to the *Times*, "the overt homosexual has become . . . an obtrusive part

of the New York scene." The article no doubt helped intensify the anti-gay campaign.

The city's self-bowdlerization ("I wonder what they think people are really coming to NYC for, anyway?" cracked O'Hara to Rivers) extended well beyond gay bars. Artists were threatened with revocation of their right to live in lofts. The Metro Cafe, a Lower East Side coffeehouse and a crucial venue for poetry readings, was threatened with a cabaret tax. At least three avant-garde theaters, the Gramercy Arts, the New Bowery, and the Writer's Stage, were shut down for showing Jack Smith's *Flaming Creatures*, Kenneth Anger's *Scorpio Rising*, and Jean Genet's fourteen-year-old *Chant d'Amour*. (In one of two raids on the New Bowery, the police seized, and lost, Warhol's three-minute "newsreel," *Jack Smith Filming Normal Love*.) Arrested twice, Jonas Mekas was convicted on June 12 of showing the "indecent, lewd, and obscene" *Flaming Creatures*. (Since the verdict has never been reversed, *Flaming Creatures* remains technically unshowable in New York City, news to the thousands who have taken it in over the years.) In April, Lenny Bruce, appearing at the Café Au Go Go in the West Village, was arrested on obscenity charges and eventually convicted.

Preparations for the fair pressed on. Philip Johnson—one of the city's leading gay cultural figures, of course, and the architect of the New York State Pavilion—had long since commissioned ten contemporary artists to adorn the pavilion's circular façade: Rauschenberg, Lichtenstein, Rosenquist, Bob Indiana, Ellsworth Kelly, John Chamberlain, Peter Agostini, Robert Mallory, Alexander Liberman, and Warhol. Andy had signed his contract in early 1963.

The fair was genuinely unpopular with countless New Yorkers: a symbol of American imperialism just as the country's Vietnam policies were beginning to draw fire, a racist employer (some three hundred demonstrators were arrested on opening day for protesting the absence of minority supervisors), rampantly commercial and aesthetically gauche—the ailing public works despot Moses's valentine to himself

and a last-ditch attempt to claw his way back into power (it was Moses's second world's fair; he'd created New York's 1939 spectacle as well). Andy's friend Soren Agenoux "came to a real disagreement with Andy about the fair, because it was working for Robert Moses," recalled Billy Linich. "Soren wanted him to refuse the commission, and Andy would just say, 'Oh, Soren, I'm doing it, I need the money.'"

Andy had settled on his contribution, a twenty-by-twenty-foot paneled painting titled *Thirteen Most Wanted Men*, by October 5, 1963, when it was mentioned in a *New York Times* article, "Avant-Garde Art Going to the Fair." But Andy had no image in mind, just a concept and a title, until a parcel arrived at 1342 Lexington, postmarked January 7, 1964, from Jim O'Neill, Wyn Chamberlain's policeman friend. Inside was a fifteen-page booklet, *The Thirteen Most Wanted*, issued by the NYPD. The booklet, dated February 1, 1962, contained thirteen sets of mug shots, their subjects wanted for murder, burglary, assault, and other felonies. Most had been at large for at least a half-dozen years; only four of the warrants had been issued in the sixties.

Now Andy could get to work, screening the images on four-foot-square masonite panels: a five-by-five grid of twenty-five grainy images, some in profile, others head-on. Given the title, one wonders what Governor Rockefeller, Mayor Wagner, and Moses had expected. No sooner was Andy's piece unveiled, on April 14, than all hell broke loose.

"Mural Is Something Yegg-stra," guffawed the *New York Journal American* in a front-page headline. "Unabashedly adorning the New York State Pavilion at the World's Fair today," its story began, "resplendent in all their scars, cauliflower ears and other appurtenances of their trade—are the faces of the city's 13 Most Wanted Criminals." Philip Johnson pronounced himself "delighted" with the painting, which he vacuously called "a comment on the sociological factor in American life."

The words were hardly out of Johnson's mouth when he was com-

pelled to realize that the painting was a very slippery political football. "I don't know who's in charge out there," groused a member of the City Art Commission. An NYPD spokesman told reporters he had no idea how Warhol had gotten his hands on the pamphlet.

But these were merely low-level bureaucrats; according to Johnson, there was "no question about official complaints from any Fair authorities. And if there were, we would not do anything about it."

The value of the great architect's word became evident on April 17, when Johnson not only announced that the mural was to be replaced at once, but lied about the reason. Warhol, said Johnson, "did not feel his work achieved the effect he had in mind, and asked that it be removed so he could replace it with another painting. . . . Since he was willing to do another piece, I didn't think we had a right to hold him to this one." Eleanor Ward took part in the whitewash: "Andy just didn't like the way it looked," she told the *Herald Tribune*'s Emily Genauer, "and I think it's wonderful of Mr. Johnson to let him make another one on such short notice."

Years later, Johnson let it be known that the order to remove the painting had come down from Governor Rockefeller himself: "Andy's was the one the governor turned down. He was a *méchant* boy at that time." Rockefeller, Johnson told Henry Geldzahler, was terrified of angering the Italian American voting bloc—seven of the thirteen were of Italian descent. "It was a very sad story," Johnson said. "I gave each artist the chance to pick his own subject, and he picked—impishly—the most wanted men. And I thought, 'That would be an absolutely delicious idea. Why not?' I thought nothing of it until I got a call from [Museum of Modern Art director] René d'Harnoncourt that the governor wished to have it removed. Well, the governor wanted to be re-elected in the worst way."

Perhaps, but Rockefeller and Moses had *Thirteen Most Wanted Men* removed chiefly because it made a mockery of their solemn authority. Hanging a twenty-foot-square celebration of a baker's dozen of miscreant

goons on the side of the multimillion-dollar New York State Pavilion was an outrageous provocation, a revisitation of 1949's *The Broad Gave Me My Face.* When it comes to Johnson, Andy's motivations are less immediately evident. The architect was a Warhol collector— one of the earliest—and an embodiment of New York's gay cultural elite, nobody that a pragmatic Warhol would want to infuriate. On the other hand, Andy could easily have, and most likely did, resent Johnson's elite cultural status.

Andy's initial suggestion, on receiving the bad news, was to obscure the mural with a coat of paint: silver, of course, as if still determined to leave his mark (at times like this one realizes just how stubborn Warhol was). Oddly enough, his proposal was accepted—but, ghostlike, the faces still showed through. So Warhol made one last offer: to fill the space with a serial portrait of a "ferociously smiling" Robert Moses: twenty-five identical images of the great man grinning. Not only was Andy audacious enough to propose the picture—he actually made it. When some onlookers asked why he was bothering to paint such an obviously doomed picture, he said, "Well, I just thought he [Moses] would like it." (Some years later, Emile de Antonio asked Andy the same question in his movie *Painters Painting,* and Andy answered, "Well, I thought I'd do a portrait of Moses because I really like him.") Mark Lancaster, who helped Warhol screen the Moses panels, put things simply enough: "Andy couldn't have been doing this out of anything but anger—Moses would never have gone for it in a million years."

The portrait was rejected, of course, and has never been shown. According to Richard Meyer, author of a 1994 essay on *Thirteen Most Wanted Men* and homoerotic issues in Warhol's work, it wound up in the Castelli Gallery's collection (although Gerard Malanga is convinced that Philip Johnson bought it).

In the end, a big black cloth was hung over the silvered-over mural. Even this final measure failed to entirely silence Warhol—the big black cloth, staring out at fairgoers from among the other artworks, posed as many questions as it quelled.

Thirteen Most Wanted survived the episode, if in a dispersed and compromised state. At some point that spring, Andy made small canvas versions of the individual mug-shot paintings. When Mark Lancaster stopped by the Factory on July 10, Andy gave him a job: stretching the canvases, which were lying in a heap on the floor. Sold individually, they are today scattered around the world, in collections and museums. What they needed was an Irving Blum, someone far-sighted and shrewd enough to have held them together.

A few days after his stretching assignment, Lancaster arrived at the Factory to find Andy alone and hard at work, on his knees mixing paints. "All over the floor were these small pieces of canvas painted different shades of beige, little twenty-four-inch squares." It was a com-mission, Andy said, going on to complain at some length about having to paint when he would much rather be shooting films, which, he said, were more fun. But what struck Lancaster was that Andy seemed raptly involved—happy—painting. "I remember thinking, 'This is what he wants to do.'" Lancaster felt a surge of elation. "It made me realize right there and then that this guy was no phony. Here's this man crawling around on the floor trying to get a color right, like an old-fashioned artist, in spite of everything he said. It was something he was obviously taking very seriously, and it impressed me to see him like that, literally on his knees, in his shirt and blue jeans, with a paintbrush and a can of Liquitex, mixing it and messing about with cartons and Dixie cups."

The painting, eventually titled *The American Man—Watson Powell*, was a thirty-two-panel serial portrait of a Des Moines, Iowa, insurance company executive. A brief correspondence between Powell's son, Watson Jr., and Andy survives. When the commission, for which Warhol charged $8,500, was sent, Powell Jr. expressed his delight with it, wishing Andy "success as you build an even greater career." Powell Jr. would have been less effusive if he'd known Andy's private name for the portrait: "Mr. Nobody." Bland at first, with repeated viewing the image grows almost macabre, thirty-two repetitions of the same joy-less smile, crew cut, and wire-rimmed glasses. Mid-sixties commissions

meant something different to Warhol than what they would in the seventies, when the aim was flattery.

Despite Andy's increasing absorption in filmmaking, a lot of painting was done at the Factory that summer. Lancaster recalled several forty-by-forty-inch *Marilyns* and *Lizes*, and a large triptych of Marilyn, Liz, and a smiling Jackie Kennedy, screened from a *Life* photograph taken just before JFK was shot. Andy began playing with combinations of the smiling Jackies and others he'd made of her, their sources Kennedy's funeral; these became the finished *Jackies*. By late August, he was at work on *Flowers*, the final home run in a remarkable, and remarkably short, burst of productivity—since the *Campbell's Soup Cans*, a mere two and a half years had passed.

"They weren't Andy Candy very long," was how Henry Geldzahler described the breakup between Andy and Eleanor Ward. Ward was disorganized, neurotically possessive of her artists, fought with collectors, and often vanished, usually to hit the bottle in her apartment behind the Stable. "I never know what she's up to," complained Andy's gallerymate Marisol

Andy considered Sidney Janis. "All I know," Irving Blum wrote Andy, "is that Sidney checks into his gallery for a couple of hours in the morning and then it's off to Roseland or Dreamland or some such place [Janis was a big dancer]. . . . How can you blame him. He's lived through a great deal and he's 105 if he's a day."

But ultimately Andy was drawn only to Castelli, even if he worried about how his work would stack up against that of Johns, Rauschenberg, Stella, Lichtenstein, and the gallery's other stars. "Henry stated in a phone conversation," wrote Blum in the same letter, "[that] you were concerned about certain comparisons etc. at Leo's, which I feel is wholly a mistake on your part. I like to think I have looked at some painting in my day and you are, for me, the most important artist of your generation, complex beyond compare, and unique in the extreme."

Castelli's major objection to Warhol had been the similarity to Lichtenstein's work, but this was no longer an issue. Warhol's spectacular Stable debut had gone a long way toward intriguing Castelli, whom Karp and Geldzahler kept apprised of Andy's subsequent progress. It remained only for the audacious Brillo box show to sway the dealer in Warhol's favor.

Andy had never intended to dally at the Stable. On May 26, two weeks after the Brillo show closed, he signed a letter to Ward (on Castelli stationery), notifying her of his resignation. "Oh! She was enraged," recalled Robert Indiana. "She hated Castelli and all the successful male art dealers. She was beside herself." Ivan Karp wrote the letter; after informally managing Andy for two and a half years, Karp would now do so officially.

Especially in his sixties and seventies heyday, Leo Castelli was, in Calvin Tomkins's words, "an immensely shrewd manipulator of prices and reputations . . . a suave supersalesman who could sell anything." As Robert Rauschenberg, a longtime Castelli artist, put it, "Leo is successful and elegant and European, and in the U.S.A., anyone who's all that *must* be a crook." But the source of Castelli's tremendous art world impact lay elsewhere: in a combination of charm, a good eye, several well-timed business innovations, and perhaps above all, the cultivation of an atmosphere that artists liked and thrived in. "In a country where the artists could barely talk English," Barbara Rose said, "Leo had genuine, high-level diplomatic skills."

Small, dapper and exquisitely mannered, Leo Castelli was fluent in five languages. "When you spoke French with him you were sure he was French," according to the artist Arman. "When you spoke German, you were sure he was German." He always seemed more omni-European than the product of a specific nation, which was close to being the case: the Europe into which Castelli was born was a very different geopolitical entity than today's: it was a group of large, if rapidly decaying, empires.

Castelli was a Hungarian Jew, born Leo Krauss in Trieste, today an Italian city but in 1907, the year of Castelli's birth, part of the Habsburg Empire. Castelli was his mother's maiden name; when Italy claimed Trieste after World War I, the family changed its name to hers. Trained as a lawyer, Castelli married well—his wife, Ileana Schapira, was the daughter of one of Romania's most successful industrialists. Leo's father-in-law backed him in a number of business ventures, but Castelli's heart was clearly not in business. Collectors of folk art, then fine-art dealers, the Castellis opened a Surrealist gallery in Paris just before the Nazis invaded. Seeking refuge in America, Leo and Ileana arrived in New York in 1941. Mihail Schapira continued to back Castelli in business ventures—including sweater manufacturing—in which the no-longer-so-young son-in-law worked dutifully but without enthusiasm; instead, he and Ileana grew more and more involved in New York's art world, then exploding into Abstract Expressionism. Sorely tempted to open a gallery, Castelli was warned by his friend Pollock, "Don't do it, Leo, you're not tough enough," He finally took the plunge in 1957, opening the Leo Castelli Gallery in his and Ileana's East 77th Street apartment ("my overhead was minimal—Ileana's father owned the building"). Within a year, Castelli made his epochal discovery of Jasper Johns, The gallery was established.

But it was by no means the instant success the news magazines, always looking for superlatives, pronounced it. It was under financial stress for most of his decade there, Karp said; even after Johns (and Rauschenberg) broke through, the place survived on its resales of older, established artists, including the Abstract Expressionists it was presumably helping to displace. "The new artists just didn't sell very well," said Karp. "Johns sold out his first show, at prices between maybe $350 and $1,200. Rauschenberg was not selling at all. His pictures were really disagreeable to the larger public. The gallery struggled."

"Leo wasn't a salesman at all," according to Barbara Rose. "He wasn't a good businessman at all. In fact, he had no interest in money whatsoever. He believed gentlemen did not discuss money." Ivan Karp

agreed. "Leo had no business acumen; he wasn't interested. He would have preferred not to be involved in the actual handling of numbers and making sales."

Yet it's an exaggeration to portray Castelli as a detached and incompetent businessman, a romantic. As an adopted American, naturally eager to prove to his European mentors and colleagues the validity of new American art, he was ultimately more responsible than any other dealer for opening the European market to American painting and sculpture. When he died in 1999, at age ninety-one, the *New York Times* cited his essential role in convincing Europeans in the sixties that the new American art was of the highest international importance.

His practice was to set up a network, what he called "collaborative relationships" with European galleries (unlike Eleanor Ward, Castelli was smart enough not to hoard artists), reducing his commission but gaining his artists broad exposure. Castelli's European beachhead was the Galerie Sonnabend, which brought Johns, Rauschenberg, Stella, Lichtenstein, and Warhol to Paris, to sensational effect. Sonnabend then dispatched the same shows to Rome, Milan, Hamburg, Munich, Zurich, and other European cities. Warhol's immense popularity, from the early sixties on, in France, Italy, and especially Germany, was undoubtedly due to this strategy. The Abstract Expressionists may have convinced Europeans of the significance of new American art, but it took Castelli to sell it to them. The operative virtue here, more than deal-making acumen and aggressiveness, was the ability to take the longer view. "It always seems he's given up an enormous amount," Irving Blum said, "but then you see that he has been enormously clever. . . . All these satellite galleries"—Blum's Ferus included—"are willing to sacrifice for him, because he's done so much for them."

The same went for his artists, few of whom ever left Castelli. Unlike in America, where artists were paid only when they made a sale, European dealers had for some time paid artists a monthly retainer, keeping them in food, rent, and paint during hard times. Castelli brought the practice to America, enabling Warhol, for instance, to buy a steady

supply of film instead of waiting for a sale and a paycheck. Castelli's 1960s stipends ranged from $400 to $3,000 (Warhol's began at $2,000 in 1964, later increasing to $3,000). Applied against sales, the stipends could, in the case of artists in less demand, add up to big deficits (one such artist, whom Castelli stuck with for decades, ran up a deficit at

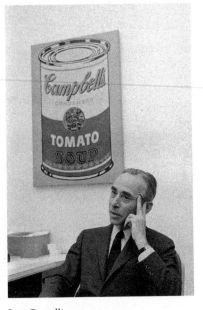

Leo Castelli

one point exceeding $200,000). Although the gallery consistently made money on Warhol in the sixties, Andy didn't sell nearly as well as is generally assumed. "Among the Pop artists, Warhol in particular wasn't easy to sell," according to Karp (who was actually surprised when Castelli finally took Andy into the gallery, attributing it to Geldzahler's badgering). "Especially the big paintings, some of which lay around for months. I used to have to discount them. Andy was not difficult about that. 'Just get what you can'—he always said that to me. He may have changed later on, but when I was working with him, Andy was very easy about money."

Castelli may have been an intellectual and a feckless businessman, but unlike his fellow gallery owners he understood, as the French art critic Otto Hahn wrote, that "television, advertising and the press now constitute Art's fourth dimension . . . and that one had to come to terms with the mass media." When a new show opened, Castelli not only went out of his way to make his artists available for that *Time* or *Newsweek* interview, but was right there himself, more then willing to oblige with quotes (as was Karp, the journalist's dream). Not that most journalists were capable of anything but caricatures of Castelli—Tom

Wolfe, for one, entirely missed the dealer's core of humane intelligence, turning him into a sort of super maître d', in "Bob and Spike," Wolfe's 1967 *Herald Tribune* magazine profile of Robert and Ethel Scull.

If Castelli had a downside as a dealer, it was his inability to extend his usual personal warmth to some of his artists. "He couldn't relate to John Chamberlain," said Karp, "because John was a ferocious physical force, though a pussycat inside. And he had a very formal relationship with Roy [Lichtenstein]; there was no warmth or intimacy there, as there was with Rauschenberg and Johns. Both of whom, ironically, were looking hard for a father figure, a role that Leo could not play. Leo was not paternal, he was a fraternal character, strictly fraternal—he wanted to be one of the boys."

Nor did Castelli ever become comfortable with Andy. Karp described their relationship as "circuitous," heavily mediated, while he was around, by Karp himself. When Warhol announced his "retirement" from painting less than two years after joining the gallery, however, Castelli responded with typical equanimity (bolstered, no doubt, by the realization that a little scarcity never hurts prices).

"Well, you have to take him, you have to take everybody . . . as they are. I would never impose on any artist or anyone to work according to my specifications because that's not the way artists like to be treated. At first, well, of course, you have to express certain wishes, but even that seems to me a little bit too much, so I always let them do what they want. Always."

On January 17, 1964, *Sleep* had made its public debut, running from Friday through Monday at the Gramercy Arts Theatre. The 8:00 p.m. screening guaranteed a late night for anyone stubborn enough to sit through the whole thing, but there were few enough of these. The *New York Post*'s Archer Winsten (the only major-daily film critic to review the premiere) counted only "six sturdy viewers" on opening night. Winsten stayed for an hour "before deciding that the gist of the picture

had been communicated." He was back two nights later, again counting six viewers, one of whom soon left. There were more people in the lobby than in the theater, Winsten noted, including the filmmaker himself, who stood talking with Mekas and Ken Jacobs. Andy was "glowing and optimistic," apparently bemused by the evident "good humor among the experimentalists" in the face of such crushing public indifference. Over the course of the four-night run, *Sleep* lost $382.05.

At his second visit, Winsten either stayed until the end or returned for it: as he told his readers, the movie "lasted a mere 5½ hours," not the advertised eight. Still, his critical tone was surprisingly gentle: although he warned that the movie would infuriate "the impatient or the nervous" or the busy, "we find that the more that is eliminated, the greater concentration is possible on the spare remaining essentials."

Andy's early, minimal-action films split their audiences into two contesting camps, with the fans insisting on the films' value as either (1) some form of meditation, in which eye and mind, repelled by the lack of on-screen action, turn inward toward self-awareness, or (2) avenues to a new, heightened awareness of the beauty of previously overlooked, everyday movements. The rest, the unswayed majority, booed, threw coffee cups at the screen, and stormed out of the theater, yelling for their money back.

Eat, another slow-motion, fixed-camera portrait, which spends almost forty minutes watching Robert Indiana eat a single mushroom, like the others, was a film to talk about, rather than to see: its April 2 debut with *Haircut* lost $266.55.

Blow Job, presumably filmed several weeks after *Eat*, represented a turn for Warhol, a move, at once startlingly direct and typically distanced, into frankly homoerotic material. Unlike *Sleep*, *Eat*, or *Kiss*, *Blow Job* builds not merely to a climax, but to a literal one: the young male protagonist's orgasm, which we don't see, the camera staying well above his waist throughout, trained on his face (the film has been called the world's longest reaction shot). The nearly forty minutes it takes

the protagonist to reach orgasm seems an absurdly, artificially long time until one realizes that the "action," of course, is unfolding in slow motion; the real-time interval, from the hero's downward glance as he unzips his fly to his postorgasmic cigarette, was considerably less. (The movie has always had its skeptics, but according to Gerald Malanga it was an actual blow job performance by Willard Maas. Andy had originally asked his actor friend Charles Rydell to appear in the film; Rydell had absentmindedly agreed, but failed to show up for the shooting. Hardly anything is known about Rydell's last-minute replacement, who strongly resembles James Dean. Malanga claimed he was an out-of-work Shakespearian actor who'd also done a bit of work in porn; in *POPism*, Andy says he spotted him years later playing a bit part in a Clint Eastwood movie.)

Shot outdoors against a nondescript brick wall and lit brightly from above, *Blow Job* has the most pronounced chiaroscuro effects of any early Warhol; at times, as when the actor's eyes, deep-set to begin with, are plunged wholly into shadow, the on-screen image is strikingly beautiful. It is, in several respects, a classic Warhol joke: a provocateur's attempt to force film critics and other easily embarrassed intellectuals into uttering a taboo phrase out loud (several early advertisements discreetly called the film "Andy Warhol's BJ"), as well as a film about a sex act in which the act itself remains invisible. It was also a way for Andy to explore and reveal a major aspect of gay erotic life while evading censorship; *Blow Job* offers neither explicit physical details nor payoff.

Nineteen sixty-four, the year in which moviemaking first took up a sizable percentage of Warhol's Factory time, saw the initiation of one more important film project. The *Screen Tests*, which Andy started filming in January, weren't real screen tests, used to determine a candidate's fitness for a particular screen role. Nor were they merely what Paul Morrissey has called them: a product of his boss's social awkwardness. (As Andy became increasingly famous, goes Morrissey's argument, more and more of the curious headed to the Factory to catch a

glimpse of him; turning the tables on his stalkers and would-be interrogators, the chronically ill-at-ease artist invited them to face the pitiless eye of his 16-mm Bolex.)

What led Warhol, rather, to shoot these 472 silent, three-minute, black-and-white films of Factory visitors and regulars from January 1964 to late 1966 was that they were portraits, filmic portraits. The *Screen Tests* are Warhol's ingenious conception of a mid-twentieth-century portrait.

When movies were invented, their critics claimed there was one thing they couldn't do: capture the soul, the distillation of personality. Ironically, this turned out to be one of film's greatest capacities. Operated close up, the movie camera lets us read, perhaps more clearly than any other instrument, a subject's emotions. As his hundreds of sixties, seventies, and eighties photo-silk-screen portraits attest, Warhol was compelled to portray the human face. The Bolex let him home in on flickering expressions and shifting moods, a near-instant raising and lowering of eyebrows, a quick sidelong glance, pensive and thoughtful slow nods, or a three-minute slide from composure into self-conscious giddiness—fleeting emotions that neither paint nor a still camera could capture. Andy's ambition for the *Screen Tests*, as for film in general, was to register personality. As he said in *POPism* about filmmaking, "I only wanted to find great people and let them be themselves and talk about what they usually talked about and I'd film them for a certain length of time and that would be the movie."

All of the *Screen Tests* were filmed at the Factory, almost all by Andy on his Bolex. Aesthetic interest aside, the *Screen Tests* (which weren't known as such at the time—Factory people initially called them "film portraits" or "stillies") are a compelling social document, a "map of the downtown New York arts scene during a watershed period," writes Callie Angell, whose careful collation of the *Tests* constitutes volume one of the eventual two-volume catalogue raisonné of Andy Warhol's movies. The subjects of *Screen Tests* were painters; poets; sculptors; folk,

rock, and avant-garde musicians; filmmakers; Billy Linich's buddies; art critics; dancers; actors; and a mysterious, recurring category: wives of well-known artists. A partial list of the portraitees includes: Peter Hujar, James Rosenquist, Donovan, Salvador Dalí, Henry Geldzahler, Dennis Hopper, John Ashbery, Ingrid Superstar, Marcel Duchamp, Susan Sontag, Cass Elliot, Jonas Mekas, Lou Reed, Kenneth King, Ondine, Billy Linich, Barbara Rose, Andrew Sarris, Bob Dylan, Harry Smith, Jack Smith, Eric Andersen, Stephen Holden, Amy Taubin, Bea Feitler, and Sarah Dalton.

In the early *Screen Tests*, Warhol asked sitters to strive for the type of "static pose," as Angell calls it, whose pictorial result—"flat, graphic, meticulously lit, and nearly entirely free of movement"—looked like a high-quality studio photograph. Later in 1964 Warhol even considered packaging the *Screen Tests* as thousand-dollar pieces of living-room art: "Living Portrait Boxes" that, Andy said, "would be just like photographic portraits except they would move a little."

But gradually, stasis became less and less the goal: it was too hard, resulting in weeping, squinting, trembling, gulping, sniffling, or, perhaps, a resolute determination not to succumb to the camera's heartless stare, to match the power of its gaze. "These provoked responses," writes Angell, "gradually became the overt purpose or content of the films, superseding the original goal": the trompe l'oeil photo, the static image.

By the summer of 1964, Andy's entourage was "minuscule" no longer. A growing number of stray souls bobbed at the periphery of a core group, Malanga and Billy the only constants. Various castelike rituals quickly sprang up. "There was some sort of system," Mark Lancaster noticed early in his summer stay, "where you were either encouraged to stay on at the end of the day or ignored until you left."

Geldzahler's partner Christopher Scott observed the same phenomenon, but less equably. "You realized that Andy was taking this group

of people downtown, and you knew whether you were included or not. Everyone was standing around talking, and then suddenly Andy and his chosen few were in the elevator and the doors closed and they were off. The others were left behind. It was the way high school cliques operate, and it was ugly and destructive."

Warhol's increasing emphasis on film had, within months, turned what had begun as a painter's atelier into "a constant open house." The outlandish young men Billy Linich brought around—Freddy Herko, Ondine—and other flamboyant visitors—Naomi Levine, Taylor Mead, Mario Montez—were never, to Andy's mind, simply hangers-on. He wanted them there. They served a function: not simply peopling, but inspiring—providing, via the exhibitionistic streak they largely shared, the shape and content of his films.

But these people were also capable of provocative and dangerous behavior. One day toward the end of September, Billy's histrionic friend Dorothy Podber paid an unforgettable visit to the Factory. Stepping out of the elevator, Podber pulled out a pistol, took aim at one of Andy's new, forty-square-inch *Marilyns*, and put a bullet through Monroe's forehead (and through two more *Marilyns* propped behind it). "Andy was really disturbed by that," Billy noted. "She even stayed awhile afterward, which agitated him even more. He asked me to tell her to leave and never come back, the only time he ever asked me to do that about someone."

According to the artist Jack Champlin, the incident grew out of the risky games that Podber and other amphetamine addicts played: "At some party, Andy said to Dorothy, 'Can I shoot you?' And she said, 'Sure, if I can shoot you.' And he said, 'Well, come on up tomorrow.' She took him literally. It was really a piece of conceptual art. That's what her life was about, playing games. Her life was a play on words."

Warhol was drawn to drug users and desperate characters, who, by nature, tend to self-destruct. On October 27, Freddy Herko committed suicide. According to his friend Diane di Prima, Herko's drug habit had

been steadily accelerating, from popping Dexedrine pills to inhaling Methedrine to shooting it, but as another close friend, Johnny Dodd, put it, Herko was "crazy even when he wasn't on drugs." By 1964 he was homeless. One midautumn day Dodd found him at a Jones Street diner; Herko was dancing on the counter (the clientele didn't mind; Freddy did it all the time). But he was "covered with filth," recalled Dodd, "his body was quivering, and he hadn't slept for several days." Dodd took Freddy to his Cornelia Street apartment, where Herko took a long bubble bath. Getting out of the tub, he put Mozart's "Coronation March" on Dodd's turntable and, still naked, improvised a dance solo with increasingly long runs, the last of which took him, still holding his pose, through Dodd's open sixth-floor window to the street below. The force of his leap nearly carried him to the opposite sidewalk. Herko had recently given several rooftop solo concerts—"suicide performances," Dodd called them, during one of which Dodd had stopped Herko from leaping only by slapping him around. Watching Freddy this time, Dodd "knew it was happening." For whatever reason—exhaustion, perhaps, from trying to stop the inevitable—this time Dodd simply watched.

August 22 was a Saturday, so the Factory was quiet as Mark Lancaster slid open the elevator door. Partway across the empty room, he stopped, startled by the brightness of the unstretched canvases that lay at his feet: the first 10 of an eventual 120 versions of a single image: four hibiscus blossoms against a backdrop of foliage. In his journal that evening, Lancaster wrote, "Andy's *Flowers* are all things bright and beautiful."

Just one image, in many incarnations, made up Warhol's first show at the Leo Castelli Gallery. According to Henry Geldzahler, he and Andy were in the Factory one day that spring, "and I looked around the studio and it was all Marilyn and disasters and death. I said, 'Andy, maybe it's enough death now.' He said, 'What do you mean?' I said, 'Well, how about this?' I opened a magazine to four flowers."

Actually, there were seven. When Andy decided to silk-screen a two-page foldout in the June 1964 issue of *Modern Photography*, he cropped the photograph heavily, cutting out three flowers. Then he asked Billy Linich to run the photo repeatedly through the Factory's new photostat machine—"a dozen times, at least," said Billy, to flatten out the blossoms, removing their definition, the shadows that lent the photo its illusion of three-dimensionality. "He didn't want it to look like a photo at all. He just wanted the shape, the basic outline, of the flowers."

Warhol, Malanga, and others worked on the *Flowers* series from mid-August right up until the show's November 21 opening. The Castelli Gallery's one room was filled with flower paintings, including one giant canvas more than thirteen feet across and almost eight feet high.

The show drew big crowds: "A livelier bunch of swinging human-oids couldn't be found this side of Vegas," wrote Thomas Hess; the *Art News* editor, in mourning for Abstract Expressionism, clearly felt the noisy sixties breathing down his neck. Yet Hess glimpsed Andy's double personality long before the rest of the world: "Underneath his turtleneck disguises—white wig, black glasses, deprecating shrugs in frugging bashes—you sense a diamond-sharp mind," he wrote. As an art world insider, Hess was free to wander into Castelli's back room, and so became the first American critic to see one of Warhol's *Jackies*. In the single painting that Hess mentioned—and Warhol made eight Jackie images, multiplied many times in different arrangements, so it's impos-sible to guess which one Hess saw—he beheld an atypical "tenderness and respect." Warhol "had better keep these lapses into 18th-century impulse under control, or he might turn into a human artist," was Hess's parting jibe.

But by now, such critical rejections were in the minority. *Art Inter-national*'s Lucy Lippard, for instance, and David Bourdon, writing for the *Voice*, praised the show warmly, Bourdon calling Warhol "a genius." The most deeply felt praise of *Flowers* came from Peter Schjeldahl, in

1965 a twenty-two-year-old college dropout, aspiring poet, and rock critic, and several decades away from becoming America's most articulate, clearest-eyed art critic. Kicking around Europe in the mid-sixties, Schjeldahl had "an epiphany. Actually, two. One was Piero della Francesca. The other was the *Flowers* paintings," which he happened to see at Ileana Sonnabend's gallery in 1965.

"They were so goddamn beautiful. And so simple. And their glamour was so intense. What killed you, *killed* you, was the grainy black-and-white of the stems. That grainy look with that Day-Glo color was *killer*, and still is.

"I think it still hasn't been acknowledged that the whole critical debate should have been over at that moment. Because these *Flowers* paintings had all the Kantian principles that Greenberg was pushing. Suddenly there were so many things that were supposed to be problems that were not problems. The *Flowers* resolved all the formal issues Greenberg had been talking about, but with a realistic, not an abstract, image. And why not? Who bought it as a picture of flowers anyway? It was about the mediation.

"Does it matter how much was going on consciously in him? There were artists at the time who were mulling over these issues very consciously. I don't see him doing that. That's why we reach for the word 'genius.' Genius is what goes, 'That's not a problem.' He sees clearly. He just does it."

A challenge to Andy's authorship of *Flowers* was not long in coming. Walking down Broadway one day in 1965, a photojournalist named Patricia Caulfield happened to see a poster of *Flowers* in a bookstore. Struck by its familiarity, she bought one, compared it to a picture she had taken, and called her lawyer.

Andy evidently was sanguine about accusations that he was illegally helping himself to others' work. After some mutual posturing in the press—Caulfield's lawyer claimed that if his client won, she'd be entitled to impound, and even destroy, every *Flowers* painting sold; "wouldn't

that be marvelous!" Warhol responded—the two sides settled out of court. Andy gave Caulfield two *Flowers* canvases (a $6,000 value at the time) and a small royalty for any future uses Warhol made of the image.

But Caulfield was still upset when she spoke to an interviewer from *Art News* fifteen years later. "The reason there's a legal issue here is that there's a moral one. What's irritating is to have someone like an image enough to use it, but then denigrate the original talent." The same *Art News* story quoted the photographer Arnold Newman, who was angered when his well-known portrait of Picasso turned up in a print series by Larry Rivers: "They think it's just a photograph. It doesn't occur to people that there is a person behind a photograph just as there is a person behind a painting."

Other sixties photographers protested Warhol's unauthorized use of their work: Charles Moore, who took the *Life* pictures Andy used in *Race Riot*, and another *Life* photographer, Fred Ward, whose cover of a grieving Jacqueline Kennedy became the source image for one of the *Jackies*. "You can't just rip off a photographer's work," Moore told Andy when they met. As payment, Warhol gave Moore a print folio—of *Flowers*. Ward received a *Jackie* based on his photograph.

On December 7, while the show was still generating plenty of art world attention, Warhol received recognition from another quarter: *Film Culture's* Sixth Independent Film Award. It amounted, in essence, to receiving Jonas Mekas's personal imprimatur. Previous awards had gone to such filmmakers as Stan Brakhage, Ricky Leacock, the Maysles brothers, and John Cassavetes. Warhol, who could still hardly load a camera, was officially in the company of cinema artists who had devoted years to the medium.

The avant-garde film community was already grumbling about this novice's rocketlike ascent. Compared to his anxious campaign for admission into the art world, Warhol's entry into underground film had been a cakewalk. Mekas, incorruptible in his aesthetic beliefs,

was more flexible when it came to real-world tactics. As *Film Culture's* editor doubtless realized, the best-known young painter in America was capable of generating tremendous publicity for Mekas's beloved underground films.

The outcast's ardent dream of fame was actually coming true. *Artforum*, the new bellwether of the art world, ended the old year and kicked off the new with a special Warhol section in the February 1965 issue. The lead essay, by the magazine's founder and editor Philip Leider, was entitled (remember, this was the age of *The Persecution and Assassination of Jean-Paul Marat as Performed by the Inmates of the Asylum of Charenton Under the Direction of the Marquis de Sade*) "Saint Andy: Some Notes on an Artist Who, for a Large Section of a Younger Generation, Can Do No Wrong."

1965

Sixty-five and sixty-six is a whole new Factory, the real Factory,
the exploding Factory. Before that, it's still Andy's art studio.
—BILLY LINICH

In less than three years Warhol had virtually killed off painting and reinvented the portrait photograph as a still-frame film. He made movies in which the camera didn't move, the actors didn't act, the script was plotless and pointless, and the dialogue only a mad approximation of human speech. By the time *Film Culture* gave Warhol an award for those motionless motion pictures, he had all but stopped making films like this.

He was now busy creating superstars whose films would be seen by only a few hundred people. After experimenting with the sound-equipped Auricon camera, Warhol bought one late in 1964. The Auricon was essentially a newsreel camera and had the advantage that film could be processed quickly. With the conversion to sound and the

arrival in 1965 of several new characters on the scene, Andy was on to a far more ambitious venture. He would attempt, more or less, to make the Factory a permanent film studio—a kind of anti-Hollywood whose modus operandi would be an inversion of the studio system.

Andy's movies from autumn 1964 through summer 1965, the period that embraced both Edie Sedgwick and Ron Tavel, exemplified two qualities in particular: Warhol's willingness to let accidents happen and his instinct for provocation. His target as a Pop artist had been the fine-art establishment; now it was Hollywood—not simply its romantic clichés, but the very notion of the carefully plotted, crafted, "well-made movie." He wanted to go beyond convention into chance, relying on his actors to leave the viewer with something memorable. Andy the commercial artist was nonetheless disdainful of the commerciality, corniness, predictability, and pandering of mainstream filmmakers.

Visual art can tolerate, and benefit from, a level of indeterminacy that film cannot. "Andy made movies with a contempt for the audience," according to Donald Lyons, who would work on many of the mid-sixties movies. "But his love of film was real. He was determined to have a film studio, but he couldn't, because of what a movie is—a narrative movie, at least. Hollywood was a church we'd all grown up on. That's why his movies were so exciting to us." And they *were* exciting: after exposure to nothing but stylized commercial entertainment, the grainy ambiguity, the deliberate unprofessionalism, the inscrutable on-screen events, even the deep tedium, of underground film were thrilling. But only for a while. Even Warhol was wondering how far he could push the meandering, hapless nonmovies, and, for the first time, he showed signs of concern about his films' unwatchability.

In the same way that he had taken on Abstract Expressionism with the disaster series, Impressionism with the flower paintings, and Minimalism with the Brillo boxes, Warhol would now chew through film genres. In rapid succession he took on the western (*Horse*), S&M (*Vinyl*), bio pics (*Harlot, The Life of Juanita Castro, Lupe*), gay pornography (*My Hustler*), and science fiction (*Outer and Inner Space*).

Andy's alternative to the old, crumbling Hollywood empire might have been called Factory Films, if it had ever taken itself that seriously. It was to be Andy's idealized—and mock—Hollywood, not the industry as it existed in 1965 (which he knew to be at a creative low ebb) but a parody of the Tinseltown of old, where moguls ruled over indentured, glamorous stars: the dreamland for thirties and forties America in general and for gay men of Warhol's generation in particular. This new movie factory, with its own stable of players and its own new style of glamour, would mix adoration and ridicule, simultaneously parodying and paying tribute to the real, vanished thing.

In place of the old Hollywood model, he would create a new psychological cinema that would examine the personalities of his eccentric crowd with mantislike obsession. The studio system masked the flawed psyches of its stars with illusion, plot, and glossy production values, but Andy intended to do just the opposite. This might seem a perverse ambition for someone who worshipped the old stars of Hollywood—Bette Davis, Joan Crawford, Liz Taylor, Marilyn Monroe—on bended knee; his home at 1342 Lexington Avenue was a shrine to Hollywood stars, from the great divas like Garbo to frothy starlets and vacuous dreamboats like Tab Hunter, with breathless fan magazines littering the floor with the lives and loves of debased saints. But like almost everything Andy felt deeply about, it was a love-hate relationship. He idolized Hollywood stars but thought the plots kitsch and the dialogue corny. Both, in Andy's peculiar approach, were unnecessary, because all you needed to see was the star *as she was*. His films would ruthlessly expose the neurotic behavior of his superstars. No need to pretend you were a Russian empress or the scheming wife of a railroad baron.

The Factory had its own resident central-casting pool of eccentric and good-looking characters. And then there was the occasional socialite or debutante who wandered onto the set out of curiosity or boredom with her life.

Just as Andy had envisioned, a new crop of beautiful freaks were about to appear onstage, ready for their close-ups.

On December 13, 1964, Warhol filmed *Harlot*, presumably a meditation on the iconic figure of Jean Harlow. Like most Warhol films of this time, *Harlot* was seventy minutes long, the duration of two 1,200-foot reels. The movie simply ended when the second reel ran out. *Harlot* is a mildly scatological vehicle for the drag queen Mario Montez, who fellates one banana after another while Ronald Tavel, Billy Name, and the English writer Harry Fainlight comment on the action, often straying from it:

> Tavel: How much cash do you get for your cheeks?
> Name: Indoors or outdoors?
> Tavel: Outdoors. Forty-Second Street.
> Name: Two ninety-eight.
> Tavel: Do you realize that you are compromising your fellow workers?
> *(Montez starts to undulate, rubbing her leg with a banana. She sticks it between her knees.)*

This was Warhol's first sound movie. The newly found writer Ron Tavel thought it was wonderful. In his postshoot notes he called the ending "so aesthetically satisfying, so in keeping with the underground and out of keeping with Hollywood. . . . The cinema shall rebuild closer to its material."

Tavel, who would write most of Warhol's middle-period scripts, entered the Warhol scene in the usual serendipitous way people came into Andy's life. In the summer of 1964, Gerard Malanga, who often read at the Café Metro, met Tavel, a poet and the author of a long, then-unpublished novel called *Street of Stairs*. It turned out that Tavel was a friend and admirer of Jack Smith, who shared Smith's devotion to Maria Montez and had helped out on *Flaming Creatures*. Impressed with Tavel, Malanga arranged a meeting with Warhol, who had recently charged Malanga with finding a scenarist.

What piqued Andy's interest, at least at first, was not so much Tavel's writing as his wryly insinuating voice, described by a friend, Tavel recalls, as "the wet snake in the garden of Eden." "I had a very deliberate way of reading in public. I caressed every syllable." Was he interested, Andy wanted to know, in reading something as the sound track for a movie?

"Reading what?" Tavel asked.

"Well, anything," said Andy. "Your poetry, your fiction. Or the phone book might be a good idea. You'll make it interesting." For most people, a voice conveys information—facts, a narrative. "But I don't think that's what it represented to Andy," said Tavel. "It was *sound*. That's what he was interested in."

Andy ordered up some scripts from Tavel, and for much of 1965 and 1966 Tavel was Warhol's principal scenarist (though not the only one, as Tavel has been wont to claim; Robert Heide, for example, wrote a couple of Warhol screenplays). He had an idiosyncratic style: dense with wordplay, often very funny, often threatening to veer off into random obsessions, but never deliberately obtuse. On the other hand, there was something willfully hermetic about Tavel's writing, as if he were addressing an impeccably credentialed in-group of his own choosing. Chuck Wein described him as "the high school playwright gone berserk."

In late January, Andy & Co. attended a cocktail party at Lester Persky's penthouse apartment on 59th Street. Persky would go on to produce the movies *The Last Detail, Shampoo,* and *Taxi Driver,* but at that time he was a hustler of blaring TV commercials for products like Roto-Broiler and Glamorene. There, at the court of the "Wax Queen," as Persky was affectionately known, was an incandescent twenty-two-year-old beauty in a beehive hairdo and faux-leopard suit. Her name was Edie Sedgwick.

Andy was fascinated. Beautiful, pixieish, and aristocratic, Edie gave off an indefinable glow. But Andy saw something else in her, too: a mesmerizing instability, a frantic and doomed quality—just his thing.

"She gave off this eerie light and energy," according to Robert Heide. "It's as if Edie was illuminated from within. Her skin was translucent; Marilyn Monroe had that quality."

Andy was immediately taken with Edie's quicksilver charm and was impatient to see how she looked on film. He invited her to the Factory, and soon she was showing up regularly with her inseparable Cambridge companion Chuck Wein. Edie, with her huge, dark chocolate eyes, innate sense of style, aristocratic charm, and amphetamine radiance, was so perfect an apparition it was as if Andy had invented her. She was the mirror in which he would see his reflection idealized. In place of the terrible rubbery skin, the bulbous nose, the wispy hair was the beautiful, adored Andy, Andy the wellborn debutante.

Edie was part of what became known as the Factory's "Harvard-Cambridge crowd": among them Chuck Wein, Danny Williams, Gordon Baldwin, Danny Fields, Tommy Goodwin, Ed Hennessy, Ed Hood, and Donald Lyons: privileged members of the first American generation to be raised amid affluence, and the first to feel the emptiness just beneath that affluence. "Up in Cambridge," recalled Danny Fields, "all they could think was, 'Oh, God, we're so bored, we're tired of going to classes. We want to move out into the real world.' Moving out into the real world meant getting their pictures in the papers and getting written up in the magazines." Coming to New York, they'd found their way to the Factory as one of the "happening" places.

Edith Minturn Sedgwick was the second youngest of eight, born in 1943. Her great-great-great-grandfather Theodore was one of the first Speakers of the House of Representatives; her great-great-uncle Endicott founded Groton; her grandfather Ellery was a longtime editor of the *Atlantic Monthly*, and another great-great-uncle, Robert Shaw, commanded the black Civil War regiment memorialized in the movie *Glory*. Just after the American Revolution, Judge Theodore had built a mansion in Stockbridge, Massachusetts. A large section of the town cemetery, known as the Sedgwick Pie, remains reserved for the family.

Her father, Francis, known to his friends as Duke, or Fuzzy, was a preening, domineering physical culturist who suffered two nervous breakdowns before he was twenty-five. He moved his family cross-country to a three-thousand-acre ranch near Santa Barbara; a dozen years later, he bought one twice as large. (Duke himself was penniless, his ranching career underwritten by his long-suffering wife, Alice Delano de Forest, daughter of a railroad millionaire.)

Edie was raised in near-total isolation, her entire education consisting of two unqualified tutors and two brief stays at boarding schools. When she developed bulimia ("pigging out," she called it), Duke insisted that she be sent to a mental institution. She went to two, Silver Hill in Connecticut and Bloomingdale, New York Hospital's Westchester branch, moving to Cambridge in autumn 1963.

Fuzzy may or may not have sexually abused his children. Edie claimed that he had tried to seduce her since she was seven, and she had spent her life alternately worshipping and loathing him. He certainly terrorized his children emotionally. Her older brother, Minty, while in his third mental hospital, confessed his homosexuality to his father, whose response was, "I'll never speak to you again; you're no son of mine!" A few days later, Minty hanged himself. "The whole family story is not to be believed," Edie told Nora Ephron in a 1965 *New York Post* story. "Very grim. It teaches you a great deal, really tremendous amounts of things about human nature and all the terrible things people do to each other. I'm going to find my own way, free of my parents."

Edie's psychological instability translated into mercurial charm. With her tiny frame and huge eyes, she was at once vulnerable and inaccessible. "As soon as there were men who were interested, she would wriggle away," observed one of her sisters. In Cambridge she saw a psychiatrist, studied sculpture, and plunged headlong into the town's bohemia. Men instantly fell in love with her, but her closest friends were gay. As Ed Hennessy, her friend in Cambridge and at the Factory, said, "She knew she was safe with me, because [I] wasn't going to go,

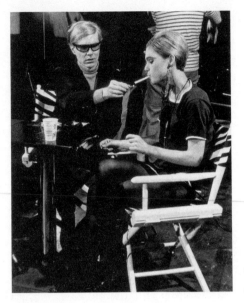

Warhol and Edie Sedgwick

'C'mon, honey, take your bra off.' We never spoke about this; it was implicit." As René Ricard, another of the Factory's Cambridge group, put it, "She wanted high, very sophisticated, brilliant faggot friends who posed no threat to her body."

In the summer of 1964 Edie turned twenty-one, inherited some $80,000 from her grandmother (the equivalent of $550,000 in 2008) and moved to Manhattan, ostensibly to pursue a career in modeling. Modeling was quickly forgotten; instead, "Edie got into spending her inheritance," according to Goodwin, whom she hired as her chauffeur. By his reckoning, Edie went through the money in six months. "It was the gravy train," said Danny Fields. "She didn't know half the people she took to those dinners of hers."

Andy's genre parodies had relied on mainly all-gay casts, but with the arrival of Edie he saw new possibilities. She was already a star in her social circle, and since his films were essentially studies of human behavior, she would be the ideal protagonist in his rambling, willful movie experiments. And she would project a riveting presence on film.

Warhol had bought nonexclusive rights to *A Clockwork Orange* for

$3,000 with the thought that Ron Tavel would have an easier time adapting an already existing story; ultimately, only two key scenes from Burgess's novel made their way into Tavel's script for *Vinyl*. The first featured Gerard Malanga as Victor (Alex in *A Clockwork Orange*), who attacks an intellectual (Larry Latreille) for the crime of reading books; close inspection of *Vinyl* reveals these "books" to be a pile of old *Playboy* magazines. (This scene would later become a classic set piece in Stanley Kubrick's 1971 adaptation that features Malcolm McDowell as Alex brutally kicking the writer, played by Patrick Magee, to the strains of "Singing in the Rain.") The second finds Malanga being tortured a little too realistically by a group of S&M aficionados. "I end up getting seriously beat up," Malanga recalled. "Pummeled and crushed. Poppers, marijuana blowing down my throat."

Warhol and Tavel had identified S&M as the next unexplored area in film yet to be exploited; *Vinyl* was to be another all-male movie featuring stylized violence, beefcake, and ceremonial sadism. Though Gerard played the lead, *Vinyl* is more often cited as the screen debut of Edie Sedgwick, who arrived on-screen wearing a black tank top and her signature black tights.

"In *Vinyl* I was giving my juvenile-delinquent soliloquy when Andy threw Edie into the film at the last minute," Gerard told biographer Jean Stein. "I was a wee bit peeved at the idea because it was an all-male cast. Andy said, 'It's okay. She looks like a boy.'"

The juxtaposition of the exquisite Edie, occasionally flicking ashes on Gerard's chest, against the brutal S&M sequence, adds a perverse twist to the scene. Edie sits on a silver trunk, legs crossed nonchalantly, smoking and filing her nails while "the cops" torment Gerard. Her only line is virtually inaudible, but a walk-on was all it took; her quirky career was launched. Edie's fusion of artifice, grace, and mischief was irresistible. "After we saw a few reruns of *Vinyl*," Ondine recalled, "some of us got an inkling of what was going on there with her in the Factory . . . a power that we hadn't expected."

But Warhol's fascination with Edie was not merely cinematic. Her presence alone generated publicity; as Chuck Wein pointed out, "Edie drew the press." Warhol's previous diva Jane Holzer was a nice Park Avenue Jewish girl with flair, but Edie was electric—and a Brahmin, the most patrician of the "Cambridge kids."

With this sparkling, immensely photogenic aristocrat on his arm, Andy seemed only half as bizarre. "Edie and Andy," clattered the headlines. And Edie had another advantage—she was a girl. As "his constant companion," as *Time* reported, Edie helped neutralize the homophobia that inevitably hounded him. Hey, the guy had a girlfriend! As "Edie's guy," Warhol's profile rose immensely during 1965. "It was a whole new paparazzi scene," said Billy Linich, "more like Vadim with Brigitte Bardot, than just Andy the fag artist. That's what happened when Edie came."

But if Andy and Edie were narcissistic reflections of each other, her self-described "roommate, shrink, astrologer" was Chuck Wein. Wein was born in Rhode Island in 1939 but grew up, as he put it, "between Beverly Hills and Las Vegas," claiming his dad was "a mob lawyer in Vegas." His appeal to Andy went well beyond his having lived next door to Elizabeth Taylor. A handsome, blond Harvard graduate, Wein was articulate, sophisticated, someone who had traveled. But he was peculiarly directionless—"I can never remember having a single career ambition," he said. "I think Chuck wanted a lot," observed his Cambridge (and, later, Factory) acquaintance Gordon Baldwin, "but I don't think he had any specific way of getting what he wanted." With apparent casualness, Chuck admitted to Warhol, "I have something, I don't know what it is. I misuse it all the time."

In Cambridge, according to Baldwin, Chuck was more interested "in the interaction between people" than he was in anything else. Some saw malevolence in this curiosity; including, evidently, the novelist John Hersey, who used Wein as the prototype for Chum Breed, the Mephisophelean villain of Hersey's 1966 retelling of the Faust myth, *Too Far to Walk.*

"I had some fantasy of Arthurian knighthood and Lancelot, and—being sort of rebellious—I thought I could challenge this sickening family that had destroyed this girl," Wein told Warhol biographer Steven Watson. It's not clear whether Wein's interest in filmmaking crystallized before or after he met Warhol. But in the Factory films, Chuck and Edie worked very much as a unit: Edie the vehicle, the star-in-the-making; Chuck the strategist and shaper.

While Edie settled into her East 63rd Street apartment, Chuck took a room at a dive called the Hotel America on West 47th Street, a short crosstown walk from the Factory. He described their schedule in June and July of 1965: "She'd sleep until three or four, come over to the Factory, and call up Huntington Hartford or Mrs. Javits to get the A-party list. Occasionally we'd get a camera and go over to Edie's place and shoot something. The rest of the time was just hanging around the Factory, which was a pretty boring place." In addition to trying to jump-start Edie's career, Chuck seemed to be trying to take over Malanga's social-director role; as one onlooker observed, "At seven or eight o'clock you'd start going out with the group and it was always Chuck who'd say, 'Let's go here, let's go there.'" When the evening's activities—at the Factory, at a club or discothèque, or crashing some fashionable Manhattanite's party—were over, Edie would still not want to go to bed. She'd drive Wein back to the Hotel America, park the Mercedes on Sixth Avenue, "and we'd talk," according to Wein, "until it got light."

Vinyl was a test Edie passed with flying colors. She didn't have to do anything: just sit behind Malanga, her long, slender legs in black tights, commenting on the action with the mere flick of a cigarette. A few weeks later, Andy asked Ron Tavel to write a script as a vehicle for her. "We're going to make her our superstar," Andy told Tavel. "She will be the queen of the Factory."

The vehicle for this coronation would be *Kitchen*. Despite his infatuation with Hollywood, whenever a scene in one of his films began

to look like a Hollywood movie, it always made Warhol nervous. Of course, with Ron Tavel as screenwriter he had nothing to fear. Warhol told Tavel to get rid of any residue of plot. The idea was a story that goes nowhere.

"Art and film have nothing to do with each other," Andy famously maintained. "Film is something you photograph, not show a painting on." But he seems to have conceived some of his films in painterly terms. Tavel described how these movies were planned: "Andy had in mind a series of all-black and all-white films, and *Kitchen* was Andy's first experiment with the all-white film. Since *Vinyl* had come out all black, it gave him the idea that an all-white film would be interesting juxtaposed with it. . . . Andy wanted a *situation* rather than a plot for *Kitchen* because he wanted it to look presentable to Hollywood people. I naturally wrote it in an absurdist mode; that was the thing of the day. It's the closest of all my works to Ionesco, but there's also a sense of Abbott and Costello, who are one of my favorites. Andy thought it was the best script I'd done to date, but it failed because Andy couldn't make it work either as an absurdist play or as realism—hence the mess that it is. But Andy was very shrewd about this from a publicity point of view. He said, 'Good or bad doesn't matter. Extreme bad and extreme good is very good. What's no good is in between.'"

The mise-en-scène of *Vinyl* had been S&M, which is, by its very nature, theatrical—sexualized melodrama set in a world of darkness. *Kitchen* represented its opposite: apathy in a bright white space. It was shot in Bud Wirtschafter's kitchen (he was briefly a soundman on early Warhol films). Actor Roger Trudeau plays Edie's beefcake boyfriend/ husband, Donald Lyons the gay neighbor, Warhol superstar Electrah the gum-cracking slut, and René Ricard an unlikely houseboy—with walk-ons by photographer David McCabe and Gerard Malanga.

Mixed in with the aimless banter and forgotten lines are snatches of sexual innuendo. Trudeau tells Edie he's had sex with someone in the shower and proposes they have sex on the beach when it's dark

and there's no one around. To which Edie languidly responds, "You know how much sand hurts." When Electrah arrives she rants about what Edie and Trudeau do behind closed doors: "He does dirty things between your legs."

But nothing happens—and as a consequence there's nothing to distract from Edie in striped shirt and tights—not plot, not dialogue, not even common sense. When Edie offers a piece of layer cake to Donald Lyons he says, "That's the story of my life too, one meaningless layer after another." At this, Edie begins to cry. "That's just it," she says, "I don't have a layer of my own." Edie was prone to bursting into tears.

Kitchen is the classic example of what critic Stephen Koch called Warhol's "fertile carelessness." The actors unrehearsed, their parts unmemorized, they are seen visibly reading their lines from off-screen prompt sheets. Disembodied voices give off-screen directions; clapboard announcements appear periodically (Donald Lyons announcing, midscene: "Reel 2 of Andy Warhol's *Kitchen*, starring Edie Sedgwick"); people at the periphery of the shoot find themselves unwittingly on camera, as happened to David McCabe, who was shooting stills of the movie but wound up in the film. The poet and boulevardier René Ricard, a friend of Gerard's who happened to stop by the Factory, ends up washing dishes—real dirty dishes, of course—during the course of the movie.

"I threw René into *Kitchen*," Malanga recalled. "I said to him, 'Get in there. Be in the background.' He was a houseboy in the movie. But he had no speaking part. Nobody knew him. No one wanted him. Donald Lyons was shouting to get him off the set, but nothing changed. As if *anybody* would have been out of place in this movie!"

Like almost everyone else in Warhol movies, Edie had a hard time remembering her lines. Pages of script were secreted in cabinets, in the refrigerator, in drawers, on chairs, hidden in books. On-screen she seems at a loss as to what to do, frequently looking off-set to seek guidance. If Edie forgot her lines she was told to sneeze and someone

offstage would whisper them to her. Needless to say, there's a lot of Edie sneezing throughout the film.

To Norman Mailer, the sneezing became an apocalyptic metaphor. "I suspect that a hundred years from now people will look at *Kitchen* and say, 'Yes, that is the way it was in the late fifties, early sixties in America. That's why they had the war in Vietnam. That's why the rivers were getting polluted. That's why there was typological glut. That's why the horror came down. That's why the plague was on its way.' *Kitchen* shows that better than any other work of that time."

Kitchen's very inscrutability is part of its appeal. Its real purpose, though, was to exploit the startling promise Edie had shown in her enigmatic debut a month or so earlier. *Kitchen* ends in entropy: the actors seem to forget they're in a movie, wandering in and out, getting drinks from the refrigerator. Finally, the camera itself gives up the ghost and the film runs out.

Tavel's scripts possessed their own internal logic, but Edie found the absence of motivation unnerving. She'd ask Tavel, "What does this mean?" For Tavel, the lack of meaning *was* the point—he was *trying* to say nothing, as eloquently as possible—following the model of that genius of tautological poetics, Gertrude Stein.

"One of Edie's tricks when she found herself in situations she didn't like was pretending to be dopey," according to Danny Fields. "'What does it mean?' was a thing she used to say. It was just kind of to be irksome, in a way. To be troublesome."

In one scene, Edie, clearly annoyed with the aimless, monotonous dialogue, turns on the blender and drowns out the words completely.

"This was the first falling-out with Edie," Billy Linich explained. "Because she wouldn't do the lines Tavel wrote in the script for *Kitchen*. She couldn't understand what it was about—and since it was *deliberately* absurdist dialogue there was no way to make sense of it. There was no coherence to the scenes, and Edie couldn't work like that. She didn't want to memorize these nonsense scripts."

Edie had illusions of becoming a mainstream movie star, but Andy understood better than Edie that she wasn't an actress so much as a presence—all she needed to do was walk in front of the camera, something she was more at ease with than coping with life. Even at this point, she was already having problems simply navigating reality.

As her intimates admitted, Edie was barely capable of day-to-day functioning. Given her fragile grasp of ordinary life and its contents, even the simplest of tasks become overwhelming. Arriving at her apartment with Malanga and Warhol (who had his tape recorder with him) on the evening of July 16, Edie phoned the eatery and asked to have an order delivered to 16 East 63rd Street. Did they have roast chicken? Oh, yes—apartment 3A. No, they didn't have roast chicken, she reported back to Warhol. Chicken what? No, that was not so good. Right, she didn't like it. A whole turkey? Too big. They were four, she said, miscounting. Did the restaurant make platters of anything? Vegetables? That wasn't a vegetable. What she wanted, she explained, was something that was not a sandwich.

Biscuit? Oh, *brisket.*

"Beef brisket," said Andy, adding that the place made very good goulash.

But was it tender, Edie asked. "Oh shit!" she said, about nothing discernible. What was goulash, anyway?

Potatoes and meat, said Andy, likely a lifelong consumer of Julia Warhola's goulash.

"Christ!" Edie said under her breath, "they shout as much as I do!" This was too nerve-racking; they should shut up and let her talk. They were out of it? Good God, what *did* they have? Oh, that sounded yummy! How about four of that? Did it have meat? Was the cabbage stuffed with *meat*? All right, then, four of those and the goulash. And also, did they have shrimp cocktail? Or grapefruit? Andy suggested sherbet.

Oh yes, how about sherbet? That would be so great. And could she also have a fruit salad for four? Oh, and there were some other

things. . . . After much hesitation, Edie settled on two quarts of sherbet, fruit salad for four, and a strawberry cheese pie for Warhol.

"Thank you very much," said Edie, and hung up. "Oh, I know what we might want is potato chips."

Edie's dalliances with lipstick and makeup were similarly epic. Chronically late, she could easily spend three hours doing her face to the exasperation of anyone who happened to be waiting for her to show up. Her belated arrivals at parties and openings, hours after she was expected, created a sense of drama and seemed the sign of a true diva. But to those who were a part of her everyday life, she had become a maddening, self-absorbed child. Her inveterate tardiness turned even the implacable Andy into a scolding parent.

She was a conundrum in other ways as well. Her air of self-assurance notwithstanding, interviews terrified Edie. On an audiotape Warhol made in July, the day before she was to audition for *Merv Griffin* and *Les Crane*, he tried to advise and placate her. She would be expressing her own ideas *and* getting paid for it, he said. "It's fan-*TAS*-tic. I mean, it'll keep you around." Don't be too clever, he cautioned, just charming—that's what she was selling. She'd meet interesting people and get paid for it—"and that's what you really need"—while hardly working.

"Shit!" said Edie. "If all I cared about was me, I could make a million!" Nobody understood her! Some days later, she fretted about an upcoming *Life* interview. The reporter, she worried, would find her ideas too esoteric. Be as esoteric as you want, said Andy—*Life* would simplify it. By the time the art department got the story, she'd hardly recognize herself—it was *Life* magazine, for God's sake, *Life magazine*!

Andy quickly featured Edie in a series he initially called *The Poor Little Rich Girl Saga*, made up of three independent films: *Poor Little Rich Girl*, *Afternoon*, and the originally nameless *Restaurant*, referred to at the time simply as "the party sequence." All but a few of Edie's films were made between April and July 1965. Some of them were scripted, some not; it hardly mattered, since she never learned her lines anyway.

Beauty #2 is the only Sedgwick vehicle that rises, and momentarily at that, above the banal chatter that litters *Afternoon* or *Restaurant*. Shot one June day, *Beauty #2* sputters aimlessly for most of its seventy minutes—but redeems itself just before it ends. Warhol proudly called it "our best movie so far" and considered its final frames the high-water mark of Edie's short career.

Filmed in the East 50s apartment of costume designer Miles White (one of Andy's friends from the fifties with whom he kept in regular touch), *Beauty #2* starts with Edie, clad only in bra and G-string, reclining on a big unmade bed.

Joining her in bed is Gino Piserchio, one of the many good-looking, inexpressive young men Andy liked to have around. Shirtless, Piserchio soon strips down to his white cotton briefs. Seated just off-screen is Chuck Wein, Edie's interlocutor throughout; Piserchio hardly speaks. Wein's tone, at first light and bantering, grows progressively sharper. He needles Edie, dredging up unpleasant topics, such as how she beat a childhood horse. Yet their animosity seems feigned. Edie and Gino start making out; Chuck responds by reading out loud from John Lennon's *A Spaniard in the Works*. Their kisses are unconvincing; near-nudity notwithstanding, Piserchio politely keeps his hand from slipping under her panties or bra, Edie hers from working its way into his briefs. Finally they stop.

Wein points out that if he were a voyeur, he would be very disappointed. Eventually, they start making out again. "If you're not enjoying it," says Wein, "why don't you just stop?"

"Shut up!" shouts Edie, but still unconvincingly. When she throws an ashtray at him, it's still staged petulance.

Wein finally succeeds in getting Edie mad, saying to Piserchio:

"If you were only older, Gino, then you could be her daddy, and she could—"

"I wish you'd *shut up*," she hisses—the real Edie, truly angry. Unlike many of the other speed freaks in Warhol's menagerie, Edie hated

confrontations. She was, in fact, more of a hippie than the cool nihilistic beauty of reputation, so her reaction to Wein's constant provoking comes as a shock as she slips out of the dreamy, sensualist she's been playing during the past seventy minutes of narcoleptic foreplay and erupts.

The film ends with an unbroken stream of nasty remarks from Wein, who has clearly drawn blood. Furious, but lacking Wein's glibness, Edie can only glare. She could never be the acidly witty, Dorothy Parker–like sophisticate Chuck was trying to create.

Along with snippets of the following year's *Chelsea Girls*, *Beauty #2* achieved what Warhol the filmmaker constantly and nearly always unsuccessfully sought: moments of real life produced spontaneously, the expression of an actor's strong innate personality. It was only such moments that could yield something he didn't consider "corny," a favorite Warhol insult.

On July 19, Edie and Andy sat in a restaurant with a new friend, the rising folksinger Eric Andersen, who had appeared that day as "The Man with the Guitar" in the forgettable film *Space*. They were talking about Warhol's *Beauty #2*, which Andersen had recently seen. The film was very real, Warhol said; there had almost been a real-life fight between Edie and Chuck Wein.

"That cat, man, he was really attacking you," said Andersen to Edie. Was the guy really like that? Well, it was a little bit planned, Andy confessed. What they were trying to do in the movie was half real, but real.

"It was *incredibly* real!" said Andersen.

They should keep a bodyguard on the set, Edie chimed in, in case things got too real.

Andersen agreed—somebody could fly off the handle. But the whole idea was groovy. "If you got some very groovy people, man, you could do incredible things. Wow! I'd love to do something again. I had some groovy lines that were . . . groovy."

The films still weren't showing in commercial houses. The money Warhol earned from his films didn't come close to covering costs. A typical check from his distributors, the Film-Makers' Coop, for the June 19 and 20 showings of *Vinyl* and *Poor Little Rich Girl*, came to $177.32 after expenses and the Coop's 25 percent cut. That week, Andy's unpaid bill at Video Film Labs topped $1,100. Several days later, Andy received a desperate note from Video's owner—one of many such—to "please let me have a payment before the end of the month, as I need it to pay my bills."

Contrary to what people believed, Warhol was not making huge amounts of money at this time. In 1965, Andy Warhol Enterprises earned $47,153.66. Of that, $32,426.25 came from Castelli; the rest came from paintings sold directly to a client, without Castelli's involvement, and from the commercial jobs Andy continued to do and dislike. Expenses, meanwhile, came to $47,040.89. Andy Warhol Enterprise's 1965 net income was $112.77.

Warhol had an obsession with the minute particulars of his daily life— which principally involved the daily lives of his familiars: Ondine, Edie, Gerard, Chuck, and Billy. In 1965 Andy began tape-recording *every minute* of his day—in the Factory, in taxicabs and restaurants, any-where he happened to be. He would pursue this enterprise for the rest of his life. He eventually began calling his tape recorder "my wife."

Of course Andy, who would go on to create the novel *a* simply by recording conversations, was obviously more aware than anyone else on the tapes that their words were being preserved. On the other hand, there are entire stretches when the immediacy of the conversation imposes itself; in such instances, Warhol is as oblivious to the record-er's presence as his companions, presenting as acute and unvarnished a portrait of him and his interlocutors as would ever be available.

Almost a decade later, while giving Pat Hackett the interviews that she and others turned into *The Philosophy of Andy Warhol*, Andy tried

to remember just why he had bought that first tape recorder. "Well, I was trying to do a book: *a*, which wasn't published until 1968," Andy says. "I just bought a tape recorder and taped Ondine for a whole day. . . . Because I was so curious about meeting all these people that could stay up for a week. And so I got so curious, I got a tape recorder and I was determined to stay up all day and tape Ondine, and so we started." Some kids, part of the nameless crowd that floated in and out of the Factory, asked Warhol if they could help out with anything, and he gave them the job of transcribing the *a* tapes into what he always called his "novel."

In *a, A Novel*, Andy's lack of editing is again apparent, and the approach proves as unsuited to literature as to film. The indiscriminate aesthetic may result in interesting innovations in the plastic arts, but when the scattered, randomly treated elements are words, whose purpose is to convey meaning, the result (especially a 450-page result) is guaranteed to confound. None of these shortcomings, of course, remotely bothered Andy, who cherished mistakes. (Billy Linich oversaw the editorial process in 1968 and delivered the manuscript to Grove Press with all errors intact.)

A small sampling of phrases lost in transcription: "I've got a serious question to ask you" becomes "I've got a student special head" and "She's not nice to her mother, though" is rendered as "She's not nice to Mother Bell." *Turandot* becomes "chewing gum"; *Fidelio*, "McDaniel." "Do you have a big cock?" turns into "Did Jeffrey call?" "Pièce de résistance" becomes "But the next thing is this doll." "I have to bathe" becomes "And I want to be saved," "shyness" is rendered as "Shineass," "Seagram" as "secret," and "We want somebody to blow him for seventy minutes" is "We want some body to draw them for a certain" Speakers are identified at the transcriber's whim and exchanges melt together, making the printed *a* torture to read.

The tapes from *a* are another matter. Buried amidst Warhol's thousands of archived recordings, they convey Warhol's and Ondine's

mid-sixties world with a fascinating immediacy. There is the pitch and timbre of voices and all the information they so clearly convey: Ondine's plangent, outerborough "Hannh?" or "I would *nevuh*" or his "terlet" for "toilet" and "mis-*cheev*-ee-us" for "mischievous," or Billy Linich's clipped intelligence, or Andy's cautious, hipster's cool. There is the full-textured picture of the life that Andy, Ondine, Edie, Chuck Wein, Billy Linich, Paul Morrissey, Brigid Berlin, and others led during the course of a single day—four or five days, actually; Ondine, Andy, and the others repeatedly ran out of steam and didn't finish recording the tapes until almost two years after they'd started, in May 1967. By then, some new characters had been added to the mix, including Lou Reed.

But very little of the tapes' rich material makes it into the pages of *a*. Even a careful reader of the first dozen pages would miss not only the nuances but almost certainly these pages' main event, a presumed slight that deeply mortifies Andy.

The tape begins with a relaxed air, upbeat and expectant, at about 2:00 p.m. on Friday, July 30, 1965. Andy and Ondine enter Stark's restaurant on 77th and Madison. Andy spots David Whitney, New England WASP, boyfriend of architect Philip Johnson, and a Leo Castelli employee—a young art-world figure, that is, of some consequence. Warhol tries, unsuccessfully, to get Whitney's attention.

"He knows who I am," says Andy grimly. "He's mean. Isn't that awful? I can't believe it!" He tries again, in vain. "Uh, David. . . ." Refusing to consider that Whitney neither sees him nor has heard his rather timid salutations, Andy insists that he's being snubbed.

Maybe it's a private fling, Ondine suggests. Andy's not listening. "I'll fix his wagon," he says, teeth audibly clenched.

Ondine wants to know if he's one of *the* Whitneys. No, he's Philip Johnson's lover, says Andy. Ondine doesn't know who that is.

"He built the Seagram Building."

A lovely building, in Ondine's opinion. Andy offers some Obetrols to Ondine, who swallows five, Andy two. In a few minutes he'll do a

back flip, gloats Ondine. Suddenly, Andy catches a glimpse of Whitney's tablemate and gasps. It's *Rauschenberg*! The great artist is evidently seated in such a way that he can't see Andy. Still anxious to save face (although Ondine couldn't care less), Andy offers to walk him over to meet Rauschenberg. Ondine doesn't know who *he* is, either.

"He's . . . uhh, the number one artist."

Impossible, says Ondine, Andy is.

Edie is so Pop, Warhol says abruptly. As Pop as a comic strip. Eventually, at Ondine's urging, they settle up and leave. Andy stops off at Whitney's and Rauschenberg's booth on the way out. Contact finally made, pleasantries exchanged, Andy is audibly relieved. But the episode will burn in his mind. A dozen hours later, recalling the day's events, he will mention that at Stark's, "David Whitney was there and he refused to say hello to me."

When *a* came out at the end of 1968, *Time* reviewed it under the headline "ZZZZZZZZ." But the book would eventually develop an intense cult following, and scholars, like archaeologists sifting through buried shards, would comb its mangled syntax for clues to a vanished culture.

The only topic more urgent than drugs in *a* is sex—or the lack of it. A few minutes after the David Whitney incident, Ondine wonders when he's going to be sated. "Not mated, sated." And when will he find somebody, Andy asks, "who'll like A.W.?"

They'll find a way, Ondine answers. "If there's ever been a way, darling, we'll find it."

Andy tried his luck with young men on several occasions in mid-1965. His initial interest in the precocious sixteen-year-old photographer Stephen Shore, whom he met in May, was not in Shore's work. "It was a sexual thing," according to Shore. "I didn't know that at the time." After Shore had appeared several times at the Factory, Andy made a typically oblique pass: as he and Shore were sitting on the

couch chatting, Andy put his hand on Shore's thigh and said, "Henry thinks you're mean."

At that point, Shore "realized what was going on and told him I was straight. He totally backed off; it was as if it never happened." Over the next two years, during which Shore took his remarkable series of Factory photographs, Andy was avuncular, a mentor. "This totally other kind of relationship developed, where he gave me advice." They lunched together at the Schrafft's on 57th and Third, where Andy "would very discreetly open up a pillbox and take speed. It was sort of . . . proper. It was like we were sixty-year-old ladies having lunch at Schrafft's, and that's what you did."

In the last week of June, Warhol shot footage for the film *Restaurant* at the restaurant L'Avventura in which Gordon Baldwin, a graduate architecture student at Harvard, had a small part. The next day, Andy and Baldwin went to see the Hollywood comedy *What's New, Pussycat*; afterward, they went drinking, which for Andy meant visiting perhaps two bars, and wound up at 1342 Lexington. A brief sexual episode occurred, which for Baldwin was not sublime; throughout, Warhol insisted that Baldwin keep talking, as if to soothe Andy's nerves.

Baldwin returned to Cambridge and "for some minutes in the ensuing weeks was rather taken by the idea of an involvement." An assiduous note-taker, he jotted down some of Andy's remarks during their relationship. "Andy doesn't believe in anything," says one; "eating is not important," another. "Lots of things are 'terrific'" was Baldwin's comment on Andy's discourse of the moment. "I've got a crush on you. . . . Do you care at all?" And then an ultimatum: "You have until Thursday," presumably to indicate a commitment. But an affair never materialized. For one, Baldwin felt no physical attraction for Warhol. Spurned passes, quickies leading nowhere. "The only thing I could call vocalizing sexual desire on Andy's part," Chuck Wein recalled, "was a sort of whining—'When is there some for Andy?' Along those lines. Plaintive. That's the real Andy, in terms of sex."

Andy could console himself with his rising international profile. In May he flew to Paris, Edie and Chuck in tow, and Malanga, too (somebody had to do the heavy lifting) for the opening of "Flowers" at the Galerie Sonnabend. Andy's first European show, it was a hit. Writing in the *International Herald Tribune*, John Ashbery was effusive. "Andy Warhol Causes Fuss in Paris" read the headline. Warhol, he wrote, was "causing the biggest transatlantic fuss since Oscar Wilde brought culture to Buffalo."

The Pop foursome received as much press as Andy's paintings. They posed for photographers in their hotel suite: Gerard in the bathtub while Andy, in dress shirt and jockey shorts, looks on; or all four in bed together, Edie in her nightie, her hair mussed, Gerard affecting languorous androgyny, holding hands with Chuck and Edie, his head in Edie's lap. Andy lies with them, but holds himself stiffly apart. At Castel's, a fancy Parisian restaurant, the hatcheck girl asked Edie if she'd like to check her mink coat. "No," she says, "it's all I've got on."

In Paris, Andy announced he was retiring from painting and would henceforth devote his life to making films. "Paintings don't go far enough," he said. "Films are easy." He had decided, he says in *POPism*, "to make the announcement I'd been thinking about making for months: I was going to retire from painting. Art just wasn't fun for me anymore; it was people who were fascinating and I wanted to spend all my time being around them, listening to them, and making movies of them." He had gotten "an offer from Hollywood," he almost certainly fibbed to a reporter at the opening, and was "seriously thinking of accepting it."

Back in America in June, *Pop Art*, one of the first books on the subject, was published. The authors, journalist John Rublowsky and photographer Ken Heyman, were feted at the Factory on June 29.

"As I leafed through the pages and looked through the colorplates," said Andy, "I was completely satisfied at being retired: the basic Pop statements had already been made." And they had been. He had pushed

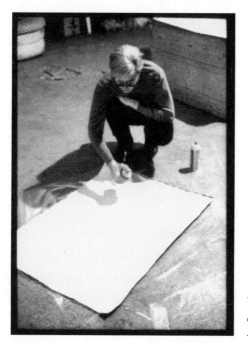

*Warhol with spray paint,
ca. 1965*

his position—that everyday objects are art—to its logical conclusion, moving right off the canvas and into a virtual replica of the real thing, his Brillo boxes.

Yet as Ronnie Cutrone recalled, "A lot of people assume that Andy stopped painting, but that was sort of a public posture. Andy never stopped painting." Cutrone may have liked hanging out, but his real fascination was watching Andy paint. "He was really accessible. He was doing the *Self-Portraits* and there were *Marilyns* and *Disasters* hanging around, and *Flowers* being done on the floor—he continued to do those on demand. I'd take the train in after high school, and Andy would let you stand next to him and watch him paint for two hours."

But as far as his public profile was concerned, he was a former painter. As he told an interviewer in 1966, "I don't paint anymore. I gave it up about a year ago and just do movies now. I could do two things at the same time, but movies are more exciting. Painting was just a phase I went through."

In July, Warhol and Paul Morrissey met for probably the second time, the occasion a Cinematheque screening of Warhol's *Beauty #2* and *Restaurant*. Andy taped the conversation. Morrissey is very friendly, almost ingratiating, perhaps looking for a way in. . . .

Who was running the camera in the latter? Morrissey wanted to know. Well, he did everything, Andy replied. The camera, too? asked Morrissey in apparent admiration. The composition was beautiful, he said; the camera hadn't moved, but it shouldn't have.

No, it wasn't supposed to move, Warhol allowed. He kept trying all sorts of things.

Well, the audience liked it, said Morrissey.

Andy called the sound "of the party movie [*Restaurant*] terrible"; Morrissey felt the noise was "appropriate." Andy then asked if Morrissey knew of somebody who might want to work on sound, "for nothing." They'd be filming the following Monday at five.

Whether it was the following Monday or not, Morrissey turned up at a subsequent Warhol shoot, which he recalled as his first Factory visit, and saw about twenty-five people against one wall.

"I recognized some of them. Edie was there. I recognized a famous folksinger of the period named Eric Andersen. I realized that Andy didn't have the slightest idea what to do with them. Maybe somebody said, or Andy said, 'Well, they can just talk.' I said, 'OK, we'll line them all up and we'll put the camera here and we'll move the camera back and forth.' He said, 'I can't move the camera.' I said, 'Well, you can.' He said, 'I don't know how to do it, and I'm afraid it'll jump and shake.'

"I said, 'I'll show you. Watch me,'" and Morrissey panned back and forth slowly, telling Andy, "'Now you do it. See, it's very easy.' He said, 'Oh, okay. All right, let's try it.'"

When they were finished shooting, recalled Morrissey, Andy was so happy with the outcome that he invited him back "to do another one."

"After I showed up two or three times, [Andy] said, 'Come up and

we'll figure out things. . . .' I must have said, 'Well, I have to have some kind of income'"—Morrissey was living on unemployment from his previous job, as a caseworker in Harlem for the city Welfare Department—"and he said, 'Well, maybe we can make some money and then you can have a part of it.' And that was the whole concept."

The twenty-seven-year-old Morrissey grew up in Yonkers, the son of a judge. He majored in English at Fordham, where he met the classics major Donald Lyons. Morrissey, according to Lyons, was basically the same in college as in the sixties. "He was always a tyrannical, funny, self-assured dictator. Paul is a likeable person, but a person with an agenda."

"I just always was interested in movies," Morrissey recalled. "When I got out of college I read an article in the *Village Voice* by Jonas Mekas that said, 'You should go out and buy a camera and make your own movies all by yourself.' That was it. I continued to do that throughout, in whatever films I made."

As a beginning filmmaker, said Lyons, "Paul aspired to make dark comedies . . . comedies involving the craziness of life on the streets in New York." While friendly with many of downtown Manhattan's independent filmmakers, Morrissey "was not particularly admiring of them."

Morrissey was in many respects a strict film traditionalist. "The best films ever made," he maintained, "either I saw them in the fifties or they were made in the fifties: *Gone with the Wind*, *Richard III*, *On the Waterfront*, *Shane*, *How Green Was My Valley*, *The Third Man*. The fifties was a high point, and it was all downhill from 1960 in America." Morrissey was never interested in abstract film or montage; for him, film was narrative. The one early underground film he remembered liking was Ron Rice's *The Flower Thief*, because, he said, "it followed a character about in a narrative." If Warhol approached film as a painter, interested in the arresting image far more than in narrative, he and Morrissey did share one important taste: both regarded film as largely

Paul Morrissey

a vehicle for memorable, and not necessarily trained, personalities. "Who gives a shit about acting?" Morrissey asked, "I've seen enough acting for ten lifetimes. What interests me is when I see a personality emerge. Without that, the acting is worthless."

Within a very short time, Morrissey occupied an important dual role at the Factory. Initially he served as the films' sound recorder, but ultimately became their general technical supervisor—and, as Morrissey saw it, the de facto director. "Any film that was made after I got there, I had some input into. I wasn't acknowledged as director, even though what direction there was, I put in. I was the arranger of all those films." He handled everything but the camera work, he said, which remained Warhol's prerogative. He was also Warhol's personal business manager, trying to think up ways of exploiting Andy as a brand. "As Andy said, 'Maybe we can make some money off my name, and you can have some money that way and won't have to get a regular job.' I said OK. The ball was in my court to think of things."

Warhol's accountant, Stanley Shippenberg, had been, in essence, his business manager since 1957, but Andy wanted somebody to handle the growing opportunities to cash in on his notoriety. "There were regular requests coming in for him to appear here or there," according to Morrissey. "Andy would say, 'Somebody wants me to go here, somebody wants Edie to go there, what should we do?' Someone had

to handle things. I filled a vacuum." He was also good at brainstorming frivolous moneymaking gambits—appearances, endorsements, and soon concerts and lecture tours. "I then had to do [i.e., organize] them, and then to pretend that [Andy] was involved" in whatever the project was. "I had a full-time job after a certain point; it became that very quickly." For his efforts, Morrissey received 25 percent of all income not derived from Warhol's art sales—that was Castelli's preserve. Morrissey's pay was soon formalized with respect to films; for the rest, the understanding remained verbal.

Not everybody was thrilled with Morrissey's arrival on the scene. Some saw him as an opportunist. In Billy Linich's opinion, "He was just there for what he [could] get for himself. . . . He didn't have any morals or standards at all, couldn't care less. If Morrissey later paid such cinematic attention to Joe Dallesandro's body, it was because he knew that sells. He did it as a commodity. Andy didn't do it like that when he made *Sleep*. Paul did it as exploitation."

Living on seedy 47th Street a few blocks north of Times Square, Chuck Wein had ample occasion to ponder the subject of hustling. Before long, Chuck had an idea. Although he shared Warhol's impatience with artifice and love of spontaneity, Chuck had something more easily digestible in mind than the usual Warhol fare—something, that is, with commercial potential.

"*My Hustler* wasn't an Andy Warhol film, it was a Chuck Wein film," Paul Morrissey grumbled. "Andy told me, 'Chuck has an idea. Dorothy Dean has some friends with a house on Fire Island we can use,' and I said 'Great.'" According to Morrissey, Dean—a part-time Factoryite and lethal wit—put up the money for the film: $500.

When he assembled the cast for the Labor Day weekend shoot, "Chuck was on the outs with Edie," according to Malanga, "so she [was] conspicuously absent. Chuck sidestepped her, he left her out." The choice was Edie's, Wein maintained; more broke than ever, she

was losing patience with Warhol's failure to pay his stars. Even though Warhol was proud of *Beauty #2* and Edie's shimmering presence in it, he was increasingly frustrated with her shortcomings as an actress. *Kitchen* was intended to be her true acting debut, but she had flubbed almost all her lines.

Instead, the lead female role in *My Hustler* was taken by Genevieve Charbin. Wein was eager to inject an air of erudite bitchiness into the film, and he knew just the person for it: the literary scholar Ed Hood, a Southern roué of independent means, a permanent Harvard graduate student and semilegendary inhabitant of Cambridge's gay nightlife. "Talking, Ed was able to really sort of hypnotize people," his friend Gordon Baldwin recalled. "His bed was known as 'Logan Field' because so many people landed on it."

Warhol films are filled with odd characters that appear in only one film and then vanish. Joe Campbell was one of these idiosyncratic personalities. He was a charmer; Dorothy Dean adored him (she was responsible for his nickname, "the Sugar Plum Fairy") and wanted him to play the main role. But the part went to a last-minute arrival, a handsome kid from Michigan named Paul Johnson whom the ad man Lester Persky had picked up hitchhiking. "Paul was brought to Andy's studio by Lester Persky," said Henry Geldzahler, for a time one of Johnson's lovers. "Paul was just astonishingly beautiful, and he immediately changed from Paul Johnson to Paul America," perhaps because he was staying in the same fleabag, the Hotel America, as Wein.

On the morning of the shoot, according to Morrissey, Wein tried to initiate a coup. "Chuck wanted to get Andy off the camera; he wanted me to shoot it." Morrissey stuck behind the boss. "I said, 'No, I don't want to do that, that's not nice to Andy.'" Morrissey claimed that, eventually, Chuck wandered off in a huff—"When the film was shot, Chuck had nothing to do with it"—which is contradicted by photographs showing all three—Andy, Wein, and Morrissey—clustered around the Auricon. As Genevieve Charbin insisted, "Chuck stayed.

Andy Warhol, "Car," 1950s. Ink and Dr. Martin's Aniline dye on Strathmore paper, 13 ¼" × 25 ⅝". Collection of the Andy Warhol Museum, Pittsburgh.

James Rosenquist, *President Elect*, 1960–61. Oil on isorel, 228 cm × 366 cm. Musée National d'Art Moderne, Centre Georges Pompidou, Paris.

(*Above*) Claes Oldenburg, *Pastry Case*, 1961. Painted plaster sculptures in glass and metal case, 14 ½" × 10 ¼" × 10 ⅝". Mary Sisler bequest. Museum of Modern Art, New York.

(*Right*) Robert Rauschenberg, *Tracer*, 1963. Oil and silk screen on canvas, 84 ⅛" × 60". Purchase of the Nelson Gallery Foundation. Nelson-Atkins Museum of Art, Kansas City, Missouri.

(Above) Jasper Johns, *Target with Four Faces*, 1955. Assemblage: encaustic on newspaper and collage on canvas with objects, 26" × 26", surmounted by four tinted plaster faces in wood box with hinged front. Gift of Mr. and Mrs. Robert C. Scull. Museum of Modern Art, New York.

(*Left*) Roy Lichtenstein, *Girl with Ball*, 1961. Oil and synthetic polymer paint on canvas, 60 ¼" × 36 ¼". Gift of Philip Johnson. Museum of Modern Art, New York.

Bonwit Teller window display of five Warhol paintings, 1961.
Collection of the Andy Warhol Museum, Pittsburgh.

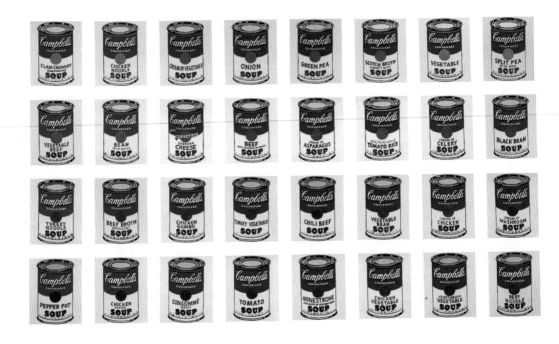

Andy Warhol, *32 Campbell's Soup Cans*, 1962. Synthetic polymer paint on thirty-two canvases, each 20" × 16". Gift of Irving Blum, Nelson A. Rockefeller bequest, gift of Mr. and Mrs. William A. M. Burden, Abby Aldrich Rockefeller Fund, gift of Nina and Gordon Bunshaft in honor of Henry Moore, Lillie P. Bliss bequest, Philip Johnson Fund, Frances Keech bequest, gift of Mrs. Bliss Parkinson, and Florence B. Wesley bequest (all by exchange). Museum of Modern Art, New York.

Andy Warhol, *Do It Yourself (Flowers)*, 1962.
Synthetic polymer paint and Prestype on canvas, 69" × 59".

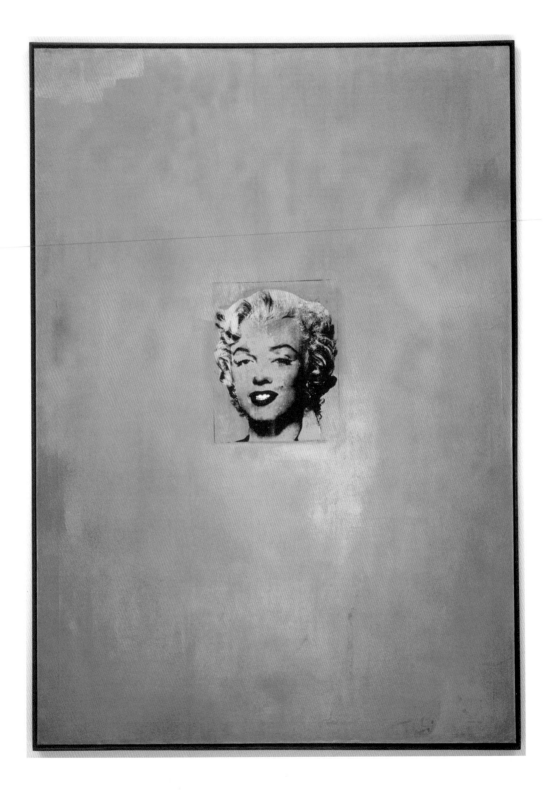

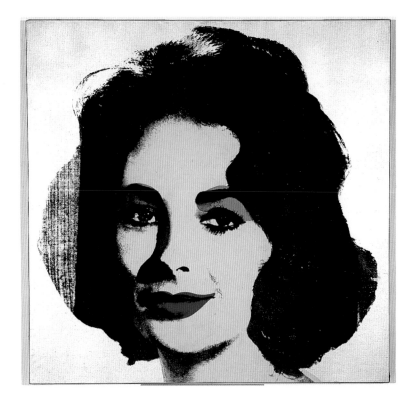

(*Above*) Andy Warhol, *Silver Liz*, 1963.
Synthetic polymer paint and silk screen ink on canvas, 40" × 40 ½".
Collection of the Andy Warhol Museum, Pittsburgh.

(*Opposite*) Andy Warhol, *Gold Marilyn*, 1962.
Silk screen ink on synthetic polymer paint on canvas, 83 ¼" × 57".
Gift of Philip Johnson. Museum of Modern Art, New York.

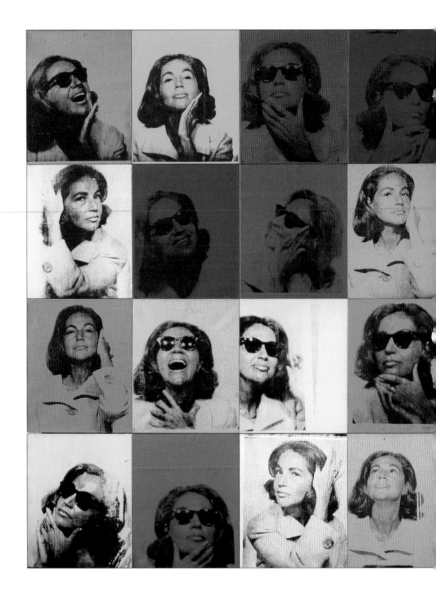

Andy Warhol, *Ethel Scull 36 Times*, 1963. Synthetic polymer paint silk-screened on canvas, 79 ¾" × 143 ¼" (overall); 19 ⅞" × 15 ⅞" (each panel). Jointly owned by the Metropolitan Museum of Art, New York, and the Whitney Museum of American Art, New York. Gift of Ethel Redner Scull. 86.61-a-jj.

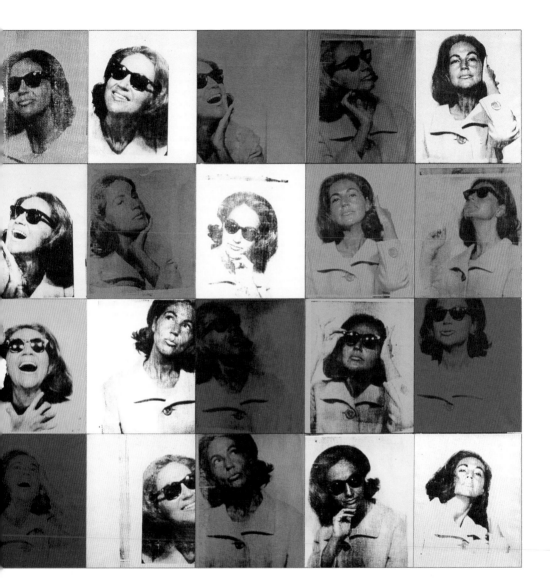

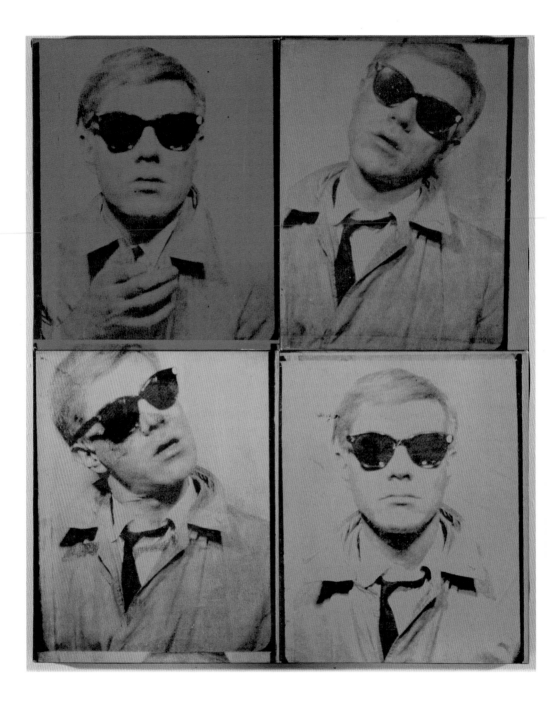

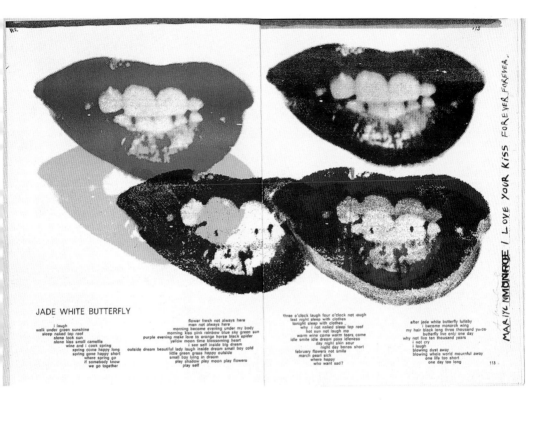

(Above) Andy Warhol, "Marilyn Monroe I Love Your Kiss Forever Forever," 1964. Lithograph printed on Arches paper, 16" × 22 ¾".

(Opposite) Andy Warhol, *Self-Portrait*, 1964. Synthetic polymer paint and silk screen ink on canvas. Four panels, each 20" × 16".

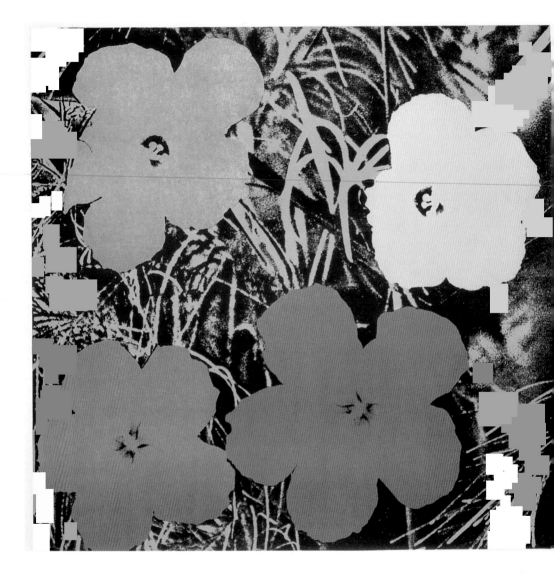

Andy Warhol, "Flowers," 1964.
Screenprint printed on white paper, 23" × 23".

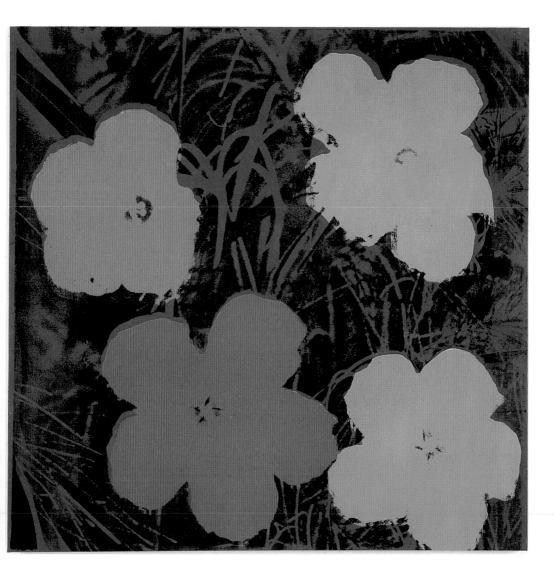

Andy Warhol, *Flowers*, 1964.
Synthetic polymer paint and silk screen ink on canvas, 48" × 48".

Nico in *The Chelsea Girls*, 1966. 16mm film,
black-and-white and color, sound, 204 minutes in double screen.
Collection of the Andy Warhol Museum, Pittsburgh.

To the extent that there was a director in that film, it was Chuck. Absolutely."

The film's premise is that a wealthy queen (Hood) has obtained the services of a peroxided young stud (Johnson/America) from an agency called "Dial-a-Hustler." As the first reel starts, Hood sits on his beachfront veranda, peremptorily ordering his servant about while lecherously eyeing America, who basks by the surf. Hood's neighbor (Charbin) and Campbell sit covetously eyeing America as Hood dispenses insults about Charbin: "She doesn't really *like* men, she just gets some sort of perverse pleasure from stealing them away from faggots."

The beachfront scene presented a technical challenge which, at least in Morrissey's memory, traumatized Andy. It would clearly be necessary to pan back and forth between the trio on the porch and America out on the sand. "He told me, 'You do the panning, I can't do it.' So I operated the camera and Andy just sort of sat down," making this, according to Morrissey, the only reel in a Warhol-directed film shot by someone other than Andy.

Charbin's memory was somewhat different. Warhol didn't want to pan—"he just wanted to focus on Paul America on the beach"—but Morrissey and Wein did. "They fought about that so much that I threatened to leave and go back to the city." At one point early in the scene, she said, Morrissey and Andy literally struggled over the camera. The result was a very wobbly pan; watching the film years later, Charbin had to laugh at the memory of Morrissey trying to force Andy to pan the camera. (Eventually, according to Charbin, Andy just stopped fighting and let Morrissey make his pans.)

Critic Stephen Koch considers reel 2 "a document of male coquetry without parallel." While the two hustlers wash up, the latter gives his young companion advice. America is a novice full of questions, Campbell the veteran with the answers. But the improvised conversation is secondary to what's really going on: two nearly nude male bodies in close proximity and the tension this creates. One by one, Charbin,

Hood, and a final suitor, Dorothy Dean, enter and exit, making his or her pitch to the young stud, whose blank face betrays no preference.

After the postshooting dinner, it became evident that somebody had spiked the food with LSD. According to photographer Stephen Shore, there was no debate. "Chuck did it. I saw him." Malanga agreed. "Chuck to me was a very sweet guy, but that was a nasty thing to do. We all got completely high on LSD—Andy too, who had never been on acid. At six in the morning I go into the kitchen, whacked out myself, and there's Andy with the dustpan and broom sweeping, but there's nothing to sweep. 'Andy, what are you doing?' 'I'm cleaning up!'" Morrissey, an antidrug zealot, was found under the boardwalk in the fetal position, muttering that he was seeing everything through a crack in his head.

With its frank portrayal of hustlers, johns, and their transactions, the movie brought Warhol a new audience: New York's gay community. It was the first Warhol film that Edmund White, for instance, remembers in any detail. Much more of a conventional narrative than any previous Warhol film, it gave its audience something to hold on to. If Warhol the filmmaker wasn't yet headed for the mainstream, he was at least moving into view.

Chuck Wein had ideas but no film expertise; Danny Williams had both. After dropping out of Harvard after his junior year, Williams, already an accomplished still photographer, began looking for and quickly finding film work. By the time he turned up at the Factory, just after his twenty-sixth birthday, Williams had edited two movies for the documentarians Albert and David Maysles, *Showman* and *What's Happening! The Beatles in the U.S.A.*, and worked on projects for WGBH-TV and Time Inc. Anxious to make his own films, Danny clearly saw the Factory as a good place to start. His father was a Harvard-trained architect; his mother worked for *Architectural Forum* as a researcher and headed the Massachusetts branch of the League of Women Voters. Williams quickly

Danny Williams

made himself a useful person around the Factory; a skilled electrician, for instance, he set about upgrading the studio's substandard wiring.

By late September, Wein, Charbin, and Williams were hard at work on a new film project, the Factory's most commercially ambitious yet, based on the Charlotte Brontë novel *Jane Eyre*. Wein claimed the idea arose during a meeting between Warhol and Huntington Hartford, the eccentric A&P food chain heir and arts patron from whom Andy was trying to extract a commission to paint Hartford's wife. Nothing came of the portrait, but Hartford offered Andy the mothballed costumes from his 1958 Broadway version of the Brontë classic *and* his Caribbean hideaway as a location. Wein hated the idea; Andy, perhaps unable to resist a bargain, loved it. Before long, Wein came to see it as a commercial vehicle for Edie, whom he urged back into the fold.

Given office space at Hartford's *Show* magazine, a glossy sixties *Esquire*-like publication, Wein and Charbin drafted a narrative-driven, naturalistic screenplay. Williams worked out a detailed budget (for more than $42,000) and shooting schedule. According to Wein, Williams managed to get David Watkin, cinematographer of the Beatles' *Help!*, interested. *Jane Heir* was to be the first Warhol movie shot on 35-millimeter stock, the standard format for commercially released films.

"We plan to make money from it," Warhol told an interviewer from *Cavalier*, a soft-core men's magazine. "Not just enough to cover the rent

here at the Factory and the cost of processing film but a good deal of money. It's to be our first full-length picture. By that I mean it will have a large cast and a complete crew of technicians and a carefully prepared script." The project received other coverage: in the December issue of *Mademoiselle*, Leo Lerman mentioned "the new Andymovie, *Jane Heir* (Edie's Jane)" and Leonard Lyons's September 24 *New York Post* column announced that Warhol, Sedgwick, and Huntington Hartford were about to go to the Caribbean "to do a film version of Hartford's play, 'Jane Ayre [*sic*].'"

Danny Williams's involvement in *Jane Heir* became more complicated when, in late September, he and Warhol became lovers. By October, Danny was living at 1342 Lexington—to Julia, no doubt just another of the nice boys, new in town and with nowhere to stay, that her Andy put up in one of the big house's unused rooms. The relationship was almost certainly sexual, although probably not for long—the usual pattern where Andy was concerned. But as Wein noted, "For a brief period there, Danny and Andy were all over each other. There they suddenly were, nibbling each other's ears at Arthur [the discothèque], and I thought, 'My God, Andy's actually doing something!'" Andy inscribed an October show catalogue "to Dannie," dashing off a sketch of a flower at whose center is an unmistakable penis and two balls. "I know Andy had a very sexual relationship with Danny," according to Robert Heide. "You just sensed it when you were with them; all the levels of their relationship were plain."

"Danny stood out from the others," said Stephen Shore. "I just liked him. He wasn't trade, he was a substantial person, intelligent and sweet." He was also fragile: ambitious but ruminative, easily hurt, and possibly alcoholic; there was a history of depression and emotional instability in his family. Billy Linich, who may have been jealous of Andy's relationship with Williams, called Danny "semipsychotic." To Heide, Williams "was extremely angry and competitive. From time to time the anger would surface, like at this coffee shop on the corner

of Bedford and Christopher where Andy liked to go. One night with a lot of people around, Danny tried to pull Andy's wig off; Andy was screaming, 'Stop it! Stop it!'"

"Danny Williams was not crazy," in Wein's opinion. "Danny Williams drank too much, and when he did he got very emotional and self-destructive." He was also one of the few of Warhol's lovers who reciprocated Andy's romantic and sexual feelings. At the same time, he was plainly critical of his lover. Looking back at the broken-off affair in 1966, Danny wrote in his journal: "Love with Andy would have been beautiful if Andy had wanted to share my experiment & see me but all he wanted was to give me meals and have me meet his glamorous friends."

As Warhol had once given Billy his Pentax, he gave his new lover-cum-protégé free use of the Bolex. Between October and December, Williams shot more than a dozen films, ranging in length from three to thirty-five minutes. By underground film's deliberately unslick standards, the movies contain passages of real beauty, especially *Harold Stevenson*, whose virtuoso camera work and lighting distill Stevenson's joie de vivre. Danny Williams was a resourceful and expressive young filmmaker.

The most famous social event ever held at the Factory took place on April 25, 1965, soon after Edie entered the fold: the Fifty Most Beautiful People party. Just who the fifty were was never clear, but it was a catchy name, dreamt up by Lester Persky, who cohosted the event with Warhol. Judy Garland came on the arms of Persky and Tennessee Williams, uncharacteristically early and sober, according to Billy Linich: "She sat down with Tennessee on the couch, and that's where she stayed for the rest of the night, perfectly charming." Linich deejayed all night long, "playing only dancy Motown stuff. It was very crowded and everybody was dancing. Montgomery Clift came in. Montgomery Clift—incredible!" One Rolling Stone, Brian Jones, was there, as well as Juliet Prowse, William Burroughs, Edie, Allen Ginsberg, and many

Tennessee Williams and Marie Menken dancing at the Fifty Most Beautiful People party

others. Malanga danced with Rudolf Nureyev, although another young man evidently made a far more vivid impression on the recent defector.

Allen Midgette, a proto-hippie and nominal actor (he had recently won some acclaim playing a distraught young man in Bernardo Bertolucci's *Before the Revolution*), knew Billy Linich but not Linich's employer—to Midgette, this was just another bash. "Montgomery Clift and I were friends at the time," says Midgette, "and he invited me. His closest friends would tell me, 'Don't go out with Monty, you'll just be embarrassed,' because he could be pretty wild. But he was cool when I hung out with him. So Monty asked me to go, and I knew that he couldn't go by himself, he was way too shy."

When they arrived, Clift made straight for the couch and his friends Garland and Tennessee. "I was very happy that Monty had someone to talk to, but I didn't really want to hang out with Judy Garland and Tennessee Williams," recalled Midgette; in the meantime, he recognized Billy Linich. "So we went into his little back area and smoked

a joint, and I went out and the music was really good, it was the first time I'd ever experienced nonstop music on tape. I started dancing by myself. Nobody else was dancing. I was a bit stoned, and pretty soon I was really, really dancing. And I could see that Judy Garland and all these people were looking at me. Sometimes you're in a position where you know everybody thinks you're hot.

"Anyway, if you're aware of how the Factory was—when the elevator opened up, you heard it, even with music playing. So the elevator opens and Nureyev steps out. I continued dancing because I didn't see any reason to stop. He walked over to me, and just stood there. I finally stopped and put my hand out and said, 'I have to say I am very pleased to meet you.' And he just looks at me and says, 'Are you a madman or a sexy bitch?'"

The party raged on until 5:00 a.m., music blasting, people coming and going, which attracted attention in an area usually deserted at night. In mid-November 1965 Andy received a letter from the Factory's landlord, which stated: "We have been advised that you have been giving parties, generally large parties, held after usual office hours. . . . Your lease, of course, does not permit such use, and you are thereby directed not to have any such parties in this building." There were fewer parties after that.

In July of 1965, Norelco loaned a prototype of the first home video camera to Warhol for promotional purposes. It was futuristic-looking and expensive (they ran around $5,000). "It wasn't portable, it just stood there," Andy says in *Popism*. "It was on a long stalk and it had a head like a bug and you sat at the control panel and the camera rejointed itself like a snake and sort of angled around like a light for a drawing board. It was great looking." One of the technical drawbacks was that you couldn't edit with it—but this didn't bother Andy; he didn't edit anyway. One advantage for Andy was that—unlike film— you could see what you'd filmed played back instantly.

According to Andy, Norelco had given him the video camera in order to get his rich friends to buy one. One of the first things he taped was Billy cutting Edie's hair on the fire escape. Warhol gave a long-ish technical interview to *Tape Recording* magazine about the video recorder.

WARHOL: We took the recorder onto our fire escape to shoot street scenes.
TAPE RECORDING MAGAZINE: What did you get?
WARHOL: People looking at us.

There was also a party at the Scene where guests could watch themselves being videotaped on the monitors. It was on this machine in August that Andy made *Outer and Inner Space,* his most haunting portrait of Edie. Lips glossed, wearing a pair of giant dangling earrings, her eyes sparkling, she's seated on a stool next to a television monitor on which her image is displayed, a slightly larger than life Edie.

Andy had previously videotaped Edie talking about space, the supernatural, gossip, the past. The cosmic Edie, an unfamiliar side of her, speculates on the fate of the universe, mutation, and self-destruction, a theme that she often dwelt on: "We're enter[ing] a whole new state of, a whole new conditioning, and world, that we have nothing to relate back to, except—I mean, this is where the transition is either to be destruction or there will be this whole new world of space. Which I don't see how we can make the jump, though. I mean, at this stage. If mentally people can develop. What I mean is . . . there will be no normal basis of things pretty soon. The whole thing is getting out into another world, it is even literally [she pronounces it "*lit*-rally"] another world, leaving this sphere, which was once the universe, now there are total other, thousands of universes maybe."

Andy, using a monitor displaying the first video of Edie as a source of illumination, had reshot Edie next to her videotaped image. Alter-

nately agitated and reflective, Edie talks on and on, pausing only to take a drag on a cigarette or make a face at something her other self has just said on the videotape, occasionally becoming disturbed by the sound of her own voice. ("It makes me nervous to listen to it," she says.) Edie can't see her other self, can only hear the sound track, but her attention is distracted by this sonic double.

It's difficult to make out what her overlapping monologues are about (the sound quality is terrible), but we catch the occasional wistful phrase: "We had better times than anybody else" or "I don't believe it." But it doesn't matter what the exact words are, they're just words and phrases leaking from the inner chambers of her mind. Reviewing *Outer and Inner Space* for the *New York Times* in 1998, J. Hoberman said of Edie's distracted, ethereal manner, "She acts as though it's tea time on Mars." Hoberman calls it "a masterpiece of video art made before the term even existed." (It was also made a few months before Nam June Paik, the grandfather of video art, got his first Sony Portapak.)

When it was screened in January 1966, it was shown on two screens, so you had four Edies altogether. "Never less than animated," Hoberman observed, "Sedgwick seems to approach hysteria—perhaps annotating her video monologue, perhaps freaked out by it."

A demographic shift took place in the Factory of 1965. The Ivan Karps and Jane Holzers were disappearing, replaced by a new, wilder breed of people who had abandoned middle-class values altogether. "It was getting very scary," Holzer told Jean Stein. "There were too many crazy people around. . . . The whole thing freaked me out . . . I couldn't take it. Edie had arrived, but she was very happy to put up with that sort of ambience." Heretofore a faithful Factory visitor, Karp rarely came around anymore; when he did, it was strictly on business: "It became very dense and to me discomfiting. It was just a chaotic scene with people I didn't find attractive." Ivan, Holzer, & Co. were replaced by escapees from conventional society.

With the loft an increasingly disquieting locale, the Beautiful People's willingness to meet Andy on his own turf faded. (Nor were they necessarily eager to meet him on their turf—there is more than one story of Andy and his retinue having the door slammed in their faces.) The loft's denizens had gone beyond anything Tom Wolfe could shock his Sunday readers with—with Brigid "Polk" Berlin running around amok, needle in hand, jabbing people through their jeans, and even more violent folk starting to appear, things had gotten too strange. It would have been hard for Wolfe to find the right tone for parody.

No matter how many strangers poured through, the door remained open. "It was perhaps the most interesting place in New York that was easily accessible," according to Gordon Baldwin. At first this baffled photographer Stephen Shore. "Here was this star artist who encouraged people to hang around, even though he pretended he wanted to get rid of them and would put up signs saying, 'If you don't have an appointment, don't come in.' If you really don't want people to come in, there are ways of doing that, like lock the door."

As Shore came to realize, watching Warhol work on the cow wallpaper, "Andy wanted to have people around, stuff happening around him, he drew energy from it. He would say in his vague way, 'Oh, what color do you think the cows should be, Stephen?' It's not like he's going to take my opinion, or Edie's opinion, but it kept his energy going." Shore spent a lot of time watching Warhol work, quietly focused amid the noisy goings-on. These sessions, during which nothing of consequence was ever said, deeply informed Shore's later work. "He had a worktable in the front of the Factory, and he'd come there in the early afternoon and work. We never discussed aesthetics, but just seeing him make decisions influenced me. I'd watch him trying different color combinations for the cow pictures. He would cut out different-colored pieces of paper and put them together, and try this-color cow against that-color background."

Shore's comment that Warhol "wanted people around, stuff hap-

pening around him" was an understatement. "Andy was the biggest Al-Anon case I ever met in my life," according to Ronnie Cutrone, another talented teenager, an aspiring painter who began frequenting the Factory at about this time. "By which I mean that almost every 1960s friend of his was a drug addict," or if not an addict, a heavy user—Ondine, Billy Linich, Edie, Brigid Berlin (perhaps the most disturbingly amoral soul in the Factory crowd), and many others. "Andy lived vicariously through their insanity. He always thought that this made the best scripts. . . . He needed addicts around him, because his own life was so *dull*—workaholics' lives are always dull. He always told us never to do drugs, but at the same time he reveled in our dramas and excitement."

The Factory pecking order had become semiformalized. "If you happened to get to the Factory before Andy was there," said Gordon Baldwin, "there was all this sort of jostling, mental and physical. The elevator doors open and heads turn: 'Who is it?' everyone of course trying to appear as cool as possible. When Andy finally came in, there were always things he needed to pay attention to right away, but there was also an awful lot of 'Okay, who gets to talk to him?' and all this funny business about which toupee he was wearing"—the messy one was supposed to indicate he was in a bad mood and was not to be approached.

There were often strangers, including curatorial types, floating through. Many people had no idea who anyone else was. "Which made for some pretty desperate small talk," recalled Baldwin, who tended to stick with Tommy Goodwin and Edie—"if Edie was talkable to, and sometimes she was too spaced."

With Tavel, Sedgwick, Wein, Morrissey, and Danny Williams all entering the picture within a very short period—between March and August, Tavel excepted—there was suddenly a surplus of talent surrounding Warhol, and a thicket of conflicting egos and ambitions. The Factory was not merely busier; it was tenser, teeming with subplots and sometimes desperate rivalries.

And of course every ounce of this new energy, ambition, and approval seeking was directed at Andy. The problem was not merely that he played rivals off against one another, both as a voyeuristic spectator sport and as a strategy for maintaining power; the problem was equally that Andy was far too self-absorbed, vulnerable, and at times simply clueless as to what move to make next, which plan to follow. As a result of his distractedness and his arbitrary bestowal of approval, his subordinates began to transfer their frustration to one another. People began shouldering perceived rivals into the ditch. The tougher, meaner, and better organized ultimately prevailed, the fragile and less focused fell away. "I knew that I couldn't be around this to the degree that Gerard Malanga was able to be," said Robert Heide. "He was tougher and stronger."

The scene wasn't always chaotic. There were plenty of days when there weren't many people around and a calm descended over the Factory. "I just remember the general atmosphere was dreamlike," said Gretchen Berg, a young journalist and photographer who visited the Factory a dozen or so times. "When the big floor fan was put on, things would flap, and there's a particular kind of sound, things blowing in the wind on a hot day, in the city."

Jackson Pollock, the previous generation's art star, had once observed that "Fame, success, is what they're after. But that's not what it's about." Pollock became famous at the age of thirty-five (around the same age as Warhol); two years later, in 1949, *Life* magazine asked, "Is he the greatest living painter in the United States?" Within two years of the article's publication, Pollock's reaction to fame had become so toxic that he slid into a decline of alcoholism and depression from which he never emerged.

If Pollock hadn't known what to do with it, Andy found fame a lot easier to live with. It was all he ever wanted. And on Thursday, October 7, Andy officially became a media superstar.

In early 1965, Samuel Adams Green III was appointed director of the Institute of Contemporary Art in Philadelphia. (He was convinced that he was confused with his father and namesake, the head of Wesleyan University's art department. Perhaps to abet the confusion, Green had tendered his ICA application on Wesleyan art department stationery.) But there he was: the twenty-four-year-old dubiously credentialed director of a museum that, if only in its third year, was well connected and bent on making its mark in the art world. The ICA was housed on the campus of the University of Pennsylvania, which paid its day-to-day costs; a board of well-heeled Philadelphians, meanwhile, raised the money for shows.

In the mid-sixties Penn was a conservative Ivy League university with what Green called "a *very* conservative art school." Green proposed as his debut project that the ICA give Warhol his first one-man museum show. "The trauma I had getting that show approved! The board was already looking very skeptically at this twenty-four-year-old upstart, me, and here I'd gone and proposed this outrageous, publicity-seeking Pop artist, Warhol." Luckily for Green, he had a friend in the board's chairman, the society matron Lally Lloyd, who swayed the board in Green's and Warhol's favor.

The exhibit was scheduled to open on Friday, October 8, and run through November 21. Green immediately set about plotting a four-month publicity campaign. Not every preparation went smoothly. There were one or two problems, for instance, with the artist. The museum's board wanted a poster, of course. Andy "just didn't want to do it," Green recalled.

"I said, 'Andy, if you want the show, you have to do a poster.'

"He said, 'Gee, what shall I do?'

"I said, 'Andy, just take one of your images that everyone's familiar with.'

"'Well, gee, which one?'

"'Oh God, do S&H Green Stamps!' Because that was my last name.

So he did Green Stamps. Warhol wasn't going to sign any more paintings, just use a rubber stamp. My board said, 'He's *got* to sign the posters so we can sell them for fifteen dollars each and the board members can get one free—all of this has already been arranged!'" So Green just signed them all himself: "Andy Warhol 65."

Green arranged for Warhol films to be shown at a number of Philadelphia venues, including private homes. Kenneth Jay Lane recalled an incident after one such screening. "There was a showing of Andy's films at which some very grand Philadelphia society ladies were present. One of the films was called *Couch*," in which Gerard Malanga anally penetrates a young woman on the Factory couch. "Well, at a big, grand buffet dinner after the film, one of the ladies was offered a plate by Gerry Malanga, and you heard this scream. . . ."

Green gave each of three competing TV stations exclusive rights to cover Friday night's opening, merrily anticipating the vicious competition for a scoop. Campbell's was practically a neighbor in Camden, New Jersey—great! Sam cajoled them into donating hundreds of "cream of mushroom" labels as invitations to Thursday night's press and VIP preview. Then he mailed out six thousand invitations to the following night's opening. The little museum's three rooms, crammed into the ground floor of the campus's old Furness Building, could hold at most four hundred. "I knew exactly what I was doing," admitted Green: paving the way for a spectacle just this side, hopefully, of a debacle, a Happening beyond Allan Kaprow's wildest dreams.

Somehow, Green found time to chaperone groups of ICA benefactors on visits up to Manhattan and the Factory. One such field trip was covered at length by the *Philadelphia Bulletin*'s society editor, who wrote:

"The Philadelphians lingered in Mr. Warhol's astonishing studio for two hours. . . . Mr. Warhol was 45 minutes late . . . arriv[ing] with his girlfriend, Miss Edith (Edie) Sedgwick and an entourage. Music blared and everybody danced. . . . Edie was rather talkative. Mr. Warhol spoke only when spoken to." The reporter eagerly anticipated the Philadel-

phia opening, a week away: "Warhol movies will be shown on the wall. Loud music will be played nonstop. There will be television cameras. There will be dancing. And on display will be Warhol's works, which are bound to focus national attention on Philadelphia."

But at Thursday night's reception, the three rooms were so packed with hundreds of reporters, ICA members, and friends of friends that one of Warhol's *Tunafish Disasters* was punctured by a television light stand. Green, finding himself flattened against a canvas by the crowd "realiz[ed] he was up against something big," as the *Village Voice* put it, and ordered the walls stripped bare. Well, nearly bare—myth has it that all the art was taken down, but a number of pieces remained.

On Friday night, Andy arrived an hour or so late, with Edie, Green, Malanga, and Wein in tow. By this time a crowd estimated at a thousand had gathered. There was supposed to be dancing in the back room, where Andy's entourage repaired, "but already," Green recalled, "the room had crowded to the point where several people were pushed out the window, broke things, and wound up in the hospital. Then we heard there was a wave of more people coming. We not only called the campus police, but they called the Philadelphia police. Andy was afraid for his life. He thought he'd be torn to pieces." Linking arms, the Warhol group ran for cover just as the second wave surged through the entrance. Zigzagging toward the front, the crowd clutching at them, Andy's little band was saved by a couple of security guards who shouted to Green, "Get up there!" and pointed to a wrought-iron staircase. It had once led to the second floor, but the stairwell had since been boarded over; after a few spirals, the stairs ended in a landing just below the ceiling. It was as far as they could retreat.

"And there we were, stuck in this birdcage," according to Green. Four campus police stood at the staircase's base, but Green still didn't feel safe. "We were trapped, and that crowd was angry: partly because there was nothing to see and partly because people had come to see and meet Andy Warhol, and nobody could get close to him. There

were also people who hated Andy's art—there were placards protesting Pop." With the camera lights and the crush of people, the room grew hotter and hotter. People began to panic; they were pushed to the back and more were still coming in. Everyone was getting hotter, more angry, more disappointed, more crowded, more pushed around. A chant went up: "We want Andy!" "Get his clothing!" someone shouted; Andy whirled around at that "to look back horror-stricken," in Green's words.

"Giddy" might better express his feelings, seesawing between terror and elation. David Bourdon saw "a rapturous smile" light Andy's face: "He had attended enough rock-and-roll shows to know that young fans liked to scream and carry on over their stars." All the same, "he was really freaked out," according to Green. "He was as white as a sheet. I thought he was going to faint, or have heart palpitations. He said, '*Oh my god, oh my god, they're gonna kill us.*' " Malanga, on the other hand, was quite at home. And Edie adored it.

It was Edie who largely defused the situation, in what *POPism* regarded as "the performance of her life."

The television crews passed a mike to her, "and she was like Evita on the balcony," Green recalled; she cooed to the multitudes: " 'Oh, all you people who've come here to see this wonderful artist, and this wonderful show at the University of Pennsylvania. There's my friends down from Harvard—hi, Pete!—and we're all here, we just love Philadelphia. Wave to them, Andy! And here's Gerard—take a bow, Gerard! And wait a minute, is that you, Steve—Steve from Harvard? Come on up!' And Steve so-and-so would come and so-and-so would go up, and she'd talk with them and kiss-kiss and send them back down again.

"It was partly narcissism," according to Green, "but it was partly, she realized, her job. She kept everybody down there kind of calm, she kept the focus on herself rather than on the unpleasantness of being down below shoved around. She was very smart; her sense was, 'These people came to see something. They're not having a good time. What-

ever they came for, I'd better give 'em something, whatever I can, to calm down this situation.'" Wearing a Gernreich dress "with twenty-foot rollup sleeves, she dangled them from her perch and people were *jumping* to try and grab them. If they had, she'd have been pulled into the mob"—but her act was so kittenish and playful it went a long way toward placating the crowd.

Green, meanwhile, was thinking of ways to get Andy and Edie out of there in one piece and with their clothes still on. Peering into the crowd, he saw an architecture student he knew and motioned for the guards to let him up. "And I hissed at him, 'You've got to get us out of here, do you realize how dangerous this is? You know the building; you've got to get security up onto the second floor and rip a hole in it. That's the only way we're going to get out of here.' And he did. They

ripped up the floor above us." Boosted up through the hole, Andy's group made its getaway: up onto the roof, down a fire escape to a waiting cop car, and away to a cocktail party. Andy had finally gotten to live out *A Hard Day's Night*. "He was overjoyed," Green said. "Put into a car with sirens and sped through the city of Philadelphia to a party in a penthouse. He was the star, and he knew it. He was, 'Ohhh, that was fan-*tas*-tic!'"

The crowd at the ICA that night numbered anywhere from two to four thousand, between five and ten times the place's capacity. "It was simply *everybody*," by Green's account. "The university, society, collectors. Lots of art people had come down from New York." But mostly there were kids, drawn by his long hair and his cool and his embrace of the pop culture they'd been weaned on. The kids were drawn by Edie, too. In the crowd was a teenaged Patti Smith; Edie's ballet-pose picture in *Vogue* had "represented everything" to Smith: "intelligence, speed, being connected to the moment." (Starved for glamour, Smith had gotten into the habit of "com[ing] all the way up to New York to loiter in front of a discothèque, watch people go into Arthur's or Steve Paul's The Scene." She'd even seen Edie dance once, which was "the big moment of my life.")

Most of the socialites and art world figures were safe from the main hall's pandemonium. "Since this was a great big building," as Green explained, "they sat around in the library, which is not where the action was, thinking, 'Oh my God, it's come to this. This is what's happening to culture.'"

The ICA explosion couldn't have happened in New York: too big, too blasé. Philadelphia was perfect—provincial and old-guard enough to be scandalized by Andy, his art, his movies, his randy entourage, and small enough to be blanketed by Green's strenuous publicity efforts. And, perhaps most important, saturated with youth—the University of Pennsylvania, Temple University, the Philadelphia College of Art— Warhol's ripest audience. At the ICA, Sam Green's well-laid plans and

deeper, cultural forces converged to create an emblematic moment, one that proved that a gallery artist could be a rock-and-roll star, inspiring hysteria and tears, like a Rolling Stone.

The ICA show was Edie's brightest public moment, the pinnacle of her six-month "career." The newspapers and magazines continued to report on their public appearances together at this or that discothèque or movie premiere, but the tide of "Edie and Andy" stories crested that fall. Edie's working relationship with Warhol was essentially over.

Edie, who had never really seen the point of Warhol's movies, was becoming frustrated with their willful aimlessness. She didn't really get Andy's concept of good-bad films and, in any case, didn't want to, and soon developed doubts about Warhol's film enterprise and its value to her. As captured on tape, she berates Andy more than once, sharply criticizing him as indecisive, his aesthetic as incoherent. As they discuss an upcoming film, Edie complains: "Andy, you won't even talk, it's not fair. But you've got to make up your mind about a few of those things. 'Cause we really don't want it to be like . . . like in *Kitchen* you got nothing of any specific personality. [Andy agrees.] And you should get personality. You got more people in the party movie [*Restaurant*], and their real selves, just by taking closeup shots, but you don't want to do that again. . . . What do you want? . . . What is your concern? Just a nothing? Just a bunch of people? Who cares? You have fabulous people that you want to take advantage of. . . . The point is, what are you going to make of it on film?"

Outer and Inner Space was Andy's final love song to Edie. (After *Outer and Inner Space* Edie made only one more Warhol movie that was screened during her lifetime, *Lupe,* filmed in December 1965.) Isolated in its spectral imagery she seems already a ghost interacting with other shades of herself. As J. Hoberman wrote in the *New York Times,* covering its revival in November 1998, it is "ultimately the poignant spectacle of watching a beautiful wraith reacting to her own

Edie on the phone in the Silver Factory

past. . . . In a way, the piece makes literal the celebrity's dilemma: the superstar is trapped between her own disembodied image and the implacable, voracious eye of Warhol's camera."

Just as Edie was becoming impatient with Warhol's filmmaking, a new character was about to come onstage who would offer her an alternative. An old Cambridge friend of Tommy Goodwin's named Bob Neuwirth, artist, folksinger, and onetime student at the Boston Museum School, had since become Bob Dylan's inseparable sidekick— Dylan's "court jester," as someone put it. Deciding that Edie would intrigue Dylan, Goodwin gave Neuwirth her telephone number, and Dylan phoned her.

They arranged to meet at the Kettle of Fish, a West Village tavern where Dylan held court; Neuwirth characterized the evening as "a terrific time." The pair's acquaintance continued. They both turned up at a party Sam Green gave in early 1965; according to Green, "they spent the whole time in the corner." Green was enchanted by Edie, less so by Dylan: "He was all about 'I don't need to communicate with you, man, you people are all assholes.'"

According to Gerard Malanga, Dylan and Edie were never lovers. "That was a ruse. Dylan and his manager [Albert Grossman] were interested in her as a possible matchup for a film with Bob, but when they found out she was a bundle of no talent, they dumped her." A fairly brutal assessment, but it's true that Edie wasn't talented in the way a show-biz manager like Albert Grossman could use—she couldn't sing, and as an actress she probably wouldn't have been able to sustain more than a cameo role in a mainstream movie. On top of which she was delusional—in an entirely mesmerizing way, but delusional. (Her delusions were in fact the most interesting things about her—something Andy understood, but few others did.)

Billy Linich agreed that Edie's romance with Dylan, portrayed in kitschy romance-novel tableaux (logs crackle in the fireplace as Edie and "Dylan" make love at his Woodstock hideaway in the movie *Factory Girl*) is "a myth, a fabricated myth." But Danny Fields insisted that they were romantically involved, and that he had the sacred artifact to prove it. "Oh, indeed. Edie gave me the leopard-skin pillbox hat, which I kept for years." (The reference is to Dylan's song of the same name.)

Dylan himself, second only to Andy Warhol as an unforthcoming, evasive, and cunningly mendacious interviewee, told a 1985 interviewer: "I never had that much to do with Edie Sedgwick. I've . . . read that I have had, but I don't remember Edie that well. I remember she was around, but I know other people who, as far as I know, might have been involved with Edie. Uh, she was a great girl. An exciting girl, very enthusiastic. She was around the Andy Warhol scene, and I drifted in and out of that scene"

Whether Dylan and Edie were sexually involved or not, she left an indelible imprint on his lyrics. You won't get a better snapshot of Edie than the fog, amphetamine, and pearls of "Just Like a Woman," and one of his most haunting lines, "the ghost of electricity howls in the bones of her face," from "Visions of Johanna," offers a spectral X-ray of Edie's agitated spirit. In Ivan Karp's perturbed memory of Edie: "There were sparks flying off her brain!"

No shortage of explanations have been offered for the souring of Warhol and Edie's relationship: that Edie's ego became inflated by the publicity she'd received—a *Times* profile, a *Life* photo spread, countless newspaper stories and gossip-column entries; that she was finally driven away by Warhol's failure to pay her a living wage; that she wanted to pursue a modeling career (which she did, with some success, the following year); that she slowly became convinced that Warhol's intentionally desultory films, in which she "stood around doing nothing" (as Andy has her say in *POPism*), were making her a laughingstock; and that she was increasingly distracted by her relationship with Bob Dylan.

None of these suffices by itself; each probably contains a degree of truth. When the thrill of sudden fame, and Warhol's constant flattery, began to pall; when, flat broke, Edie realized that underground celebrity did not translate into money—she could look at Gerard Malanga, downtown's heartthrob, scraping by on $1.90 an hour, part-time—she pursued alternatives, fecklessly, as she did everything.

In any case, it wasn't Andy who severed the relationship. As he told David Bourdon several years later, "We were going to get an agent together. And then she was trying to get an agent without me. That's what was so funny—I thought she was trying to do it with me, but she was trying to push me out of the picture."

The agent Edie was trying to get was Bob Dylan's powerful manager, Albert Grossman. Interest in Edie among the Grossman crowd was strong, Danny Fields recalled: "Grossman wanted to manage her as an actress, singer, girl of the year—first get her, then do something with her. They courted her," possibly as Dylan's costar in a commercial movie. "I know that Bob Dylan expressed an interest in doing a film with Edie," Bob Neuwirth told Jean Stein.

While all of these developments were brewing, Edie couldn't have been spending much time with Dylan, who was on the road almost

constantly from early October through December. But according to Robert Heide, he was very much in the picture. "In the fall of 1965, I used to run around with Edie in what I realized later was Bob Dylan's limousine." The shift in Edie's allegiances became clear to Heide one cold night in the West Village, in December 1965.

Andy had asked Heide for a script for Edie, which Heide had written: *The Death of Lupe Velez* (released as *Lupe*), based on the real-life suicide of "the Mexican spitfire," a flamboyant screen goddess. Curious about the fate of his screenplay, Heide accepted Andy's invitation to meet at the Kettle of Fish. Arriving, he found Edie, whom he hadn't expected, sitting alone. It occurred to him that Warhol was trying to work things out with her and wanted Heide there as a buffer. Edie was crying, he recalled, "which was not unusual for her, and saying, half to herself, half to me, 'I tried to get close to him but I can't. He's like an iceberg. He doesn't understand me.' She was choked up, in a state of anxiety." Was she talking about Warhol, Heide wondered, or Dylan?

"And then Andy comes flying in, with the dark glasses on, looking very natty in a blue suede outfit. He sat down next to me and across from Edie. 'How's everything, blah blah.' I asked about my script. He said, 'Oh, we filmed that this afternoon.' I remember being kind of pissed off about that: their going ahead and shooting without even telling me," said Heide. "Not that I showed it. Back then, the idea was that you were cool. You never showed your temper."

The doors opened again, and this time Dylan walked in, "with the hair and dark glasses and everything, pencil-thin, and sits down. He's very sullen. There's this real tension going on. Nobody's talking. After a while Dylan says to Edie, 'Let's split,' and they went off." If Andy had arranged to meet Edie to work things out, she'd called his bluff. The Kettle of Fish was Dylan's hangout, and his appearance there could have been a coincidence—but it hardly mattered: Andy had been jilted.

"I stayed there with him," recalled Heide. "He said he wanted to go see

the exact spot where Freddy Herko had jumped. When we got there, he looked up, and then he looked at the street and said, 'I wonder when Edie will commit suicide. I hope she lets us know, so we can film it.' I was in a little bit of shock about that. But I'd heard these glib remarks from him before. I think he probably cared about Edie a lot. I think he was trying to sound detached. I think he was clenching his teeth."

Whatever Warhol's feelings, they weren't simple. In the screenplay he'd assigned Heide, "he had wanted me to write something in which Edie commits suicide," according to Heide. He'd written a playlet in which the over-the-hill Velez downs a handful of Seconals with a flourish; unable to resist chowing down to some rich Mexican food, she becomes violently nauseated and clatters high-heeled into the bathroom, where she collapses headfirst into the toilet, vomits, and dies.

In the filmed version, Edie/Lupe wakes up in bed, lights a cigarette, makes a phone call. Billy Linich appears and gives her a haircut. Everything is haphazardly improvised, until the camera suddenly cuts to the ignominious death scene: the dead heroine's head jammed into the toilet. She is seen from several angles, with the last shot holding interminably.

But then there's a second reel, in which Edie wanders about a very ornate dining room, sits down at the table, and swallows a huge pill. She eats listlessly, dances solo, more and more dopily—and again action cuts abruptly to the bathroom and the death scene. Today, the reels are normally viewed sequentially, so the ending appears twice. But when Warhol premiered the film at the Film-Makers Cinematheque in February 1966, the reels played simultaneously on two screens. The temporal, narrative thread is severed, but the same grim ending remains.

What to make of Warhol's use of Edie here? Heide in particular was always sensitive to what he called the "sad little waif" in Warhol, in love with death. By suiciding Edie on camera, in Heide's view, Andy was vicariously satisfying his own death wish. Or was something more sadistic at work: a death sentence, provoked by his mounting feelings

of abandonment and betrayal? Or maybe Andy was just standing back and dispassionately depicting what he thought was inevitable. (Edie would die in 1971, not by outright suicide but from an overdose of barbiturates.)

Genevieve Charbin recalled, "I stayed with Edie for a few weeks, and Andy was always the last to call at night and the first in the morning. He really, *really* cared about her." To Charbin's mind, the suicide scene in *Lupe* was an attempt on Warhol's part to help Edie purge her demons, to help her achieve catharsis—or maybe to give her a wake-up call. Chuck Wein believed that *Jane Heir* would have established Edie as a star, freeing her from her parents' destructive grip and giving her the means for self-fulfillment. Wein therefore blamed Andy for Edie's slide into self-destruction, but, as Charbin pointed out, "There's absolutely no way that anything was going to save Edie Sedgwick, let alone a screenplay. She was very far gone, right from the beginning."

CHAPTER SEVEN

1966

I'm going back to New York City
I do believe I've had enough.
—BOB DYLAN

A round the time of their short, awkward encounter at the Kettle of Fish, Andy and Bob Dylan had a slightly longer awkward encounter at the Factory. It was arranged by Barbara Rubin (the girl mussing Dylan's hair on the back cover of *Bringing It All Back Home*), a groupie with a cultural agenda—according to her hero and sometime boyfriend Allen Ginsberg, Rubin was a "visionary" who saw him, Dylan, the Beatles, Warhol, and a few others as "heroes of a cultural revolution involving sex, drugs, and art" and considered it her role to bring them together.

It was most likely one day in January 1966, during a month-long break from his 1965–1966 world tour, that Dylan, accompanied by Bob Neuwirth, parked his station wagon on East 47th Street below the

Factory's bank of windows. Dylan may have had his own reasons for paying Andy a visit, not the least of which was a hip twenty-four-year-old's eagerness to be on top of what was happening. A more complex motive may have been one of gamesmanship. Dylan and Bob Neuwirth were "out to walk all over Andy," Malanga felt: to demonstrate Dylan's superior cool.

As for Andy's motives, he was clearly starstruck, in awe of Dylan's sudden, vast celebrity. He had a more practical agenda, too: to get Dylan to appear in a Warhol movie. According to Malanga, "Andy thought that to get Dylan in a movie, maybe to match him up with Edie, would've been a big coup on his part." But Dylan had his own cinematic plans, and Warhol was emphatically not in the picture.

Warhol may also have felt, even unconsciously, an affinity with Dylan's purpose and achievement. With his most recent albums, *Bringing It All Back Home* and *Highway 61 Revisited*, the singer was usurping the role of so-called legitimate poetry by setting imaginative writing to a rock-and-roll beat. As Taylor Mead is quoted in *POPism*, "the minute I heard Bob Dylan with his guitar, I thought, 'That's it, that's what's coming in, the poets have *had* it.'" Each in his own way, Warhol and Dylan had toppled the mandarins, muddying forever the distinction between high and low art.

For all of its potential as a seminal encounter of two sixties titans, Dylan's Factory visit was, as Malanga recalled, "a nonevent": "So the elevator opens, and Dylan and Bobby Neuwirth walk in. Barbara Rubin's there, Danny Williams is there, and a few others. Dylan is acting cool, pretty much keeping his mouth shut. He had this way of saying, '*Wellll, yeahhh*.' We were able to do his screen test, and then Barbara and I ended up shooting movie footage, three minutes of black-and-white and three minutes of color." Malanga may have shot some footage—he and Rubin owned a Bolex together—but photographs of the episode show Danny Williams, not Gerard, filming Dylan.

Robert Heide recalled that when the screen test was over, Dylan "got up and walked over to one of the panels of Elvis with the gun"—one

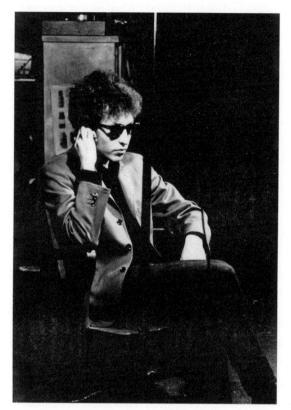

Bob Dylan's screen test

of several *Double Elvises* standing against the Factory walls—"and said, 'I think I'll just take this for payment, man.' That was only the second time I ever saw Andy blushing, just kind of *cringing*. Somebody demanding payment!"

According to Billy Linich, Andy had offered the painting, but in order to initiate an exchange. "It wasn't supposed to be just for the screen test; Andy was hoping for an ongoing interaction. Maybe Bob would ask him to do his album covers. Andy made that offer anticipating an ongoing relationship," but Dylan called his bluff, walking off with the Elvis as his pay for three minutes of work. As Linich said, "He closed the door and disappeared."

"There's no question that Andy intended to give Dylan the painting," according to photographer Nat Finkelstein, on hand to document the meeting. "But, for what? The night before, I had photographed

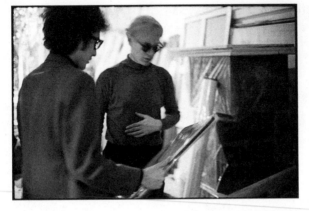

Dylan holding Elvis

Andy touching up the double Elvis he intended to give to Dylan. He was beside himself that Dylan was coming up."

Malanga believed that Andy had some sort of partnership in mind. Andy wanted to win Bob over. "Dylan didn't simply commandeer the *Elvis* painting," he insisted; "Andy *offered* him the painting. Because Bob may indeed have said, 'I'll take that,' but it was after Andy made the offer. And Andy purposely picked the *Elvis*. It wasn't as if he had a lot of different paintings lying about. He figured 'Ah, Elvis Presley, singer; Bob Dylan, singer'—in other words, that Bob would appreciate the *Elvis*."

Dylan and Neuwirth shouldered the big canvas, carried it downstairs and tied it to the top of Bob's station wagon, totally unprotected, and drove off.

After unloading it at his Woodstock home, Dylan showed nothing but disdain for the *Elvis*. "I don't want this," he finally told Albert Grossman; "why did he give it to me?" and he swapped the picture with Grossman for a sofa. But in the end "the joke was on Bob," as Howard Sounes, Dylan's most recent biographer, writes. In 1988 Grossman's widow Sally sold the painting for $720,000; it is worth far more than that today.

The circumstances leading to Andy Warhol's encounter with the Velvet Underground will never be established with absolute accuracy: there are too many stories by now, with too many conflicting claims

of at least partial credit. At best, one can sift through and weigh the various tales to shape the most plausible account.

According to Gerard Malanga, in mid-December 1965, Barbara Rubin told him, " 'Hey, you've got to see this group at the Café Bizarre,' " a West Village tourist joint. Rubin knew three of the band members, Lou Reed, John Cale, and Sterling Morrison, from the Film-Makers Cinematheque, where the musicians had improvised live sound tracks during several screenings.

Malanga liked the band—so much, in fact, that he got up to dance, brandishing a bullwhip he liked to carry around. "Whip-dancing, that was just something I invented," he said. "I happened to walk into a weird shop that sold whips and I bought a little whip I could tie to my belt." At the Café Bizarre, "I pulled the whip off my belt and started dancing with it," so close to Cale and Reed—there was no riser for the band—that he could have lashed them if he'd wanted to. "Lou and John loved it," said Gerard. Later on, Malanga's whip dance became part of the band's show, a lapse of taste on Cale and Reed's part. (Years later, thinking back on Gerard's strenuous workouts, John Cale's first response was an enormous laugh.)

Three or four days after this first encounter, according to Malanga, "I brought Andy to see the band, and after the show he invited them up to the Factory to practice. Then he realized he could film them. He wasn't really looking for a rock-and-roll band to work with. That's a Paul Morrissey theory."

Morrissey dismissed Malanga's account as "totally wrong. I found them. Who else found them? Barbara Rubin was nobody, nobody; she was just a groupie for Bob Dylan and asked Gerard to film a friend of hers whose band was playing at the Café Bizarre. Gerard had just bought a camera and didn't know how to use the light meter, and asked me to come to this Bizarre Café and set the light meter."

Morrissey happened to have fielded an offer some weeks earlier from the Broadway producer Michael Myerberg, then preparing to open a discothèque in Garden City, Long Island (in a former airplane hangar

at defunct Roosevelt Field, from which Charles Lindbergh had launched his transatlantic flight). Myerberg wanted to cash in on Andy's celebrity by hiring him to appear at the place "with as many people like Edie Sedgwick as he wanted, to bring it publicity." According to Morrissey, he immediately thought, " 'Why not hire our own rock-and-roll group and manage it?' I understood that we couldn't make money off these experimental films. But maybe we *could* make money presenting a rock-and-roll group." Morrissey's interest was piqued largely by John Cale—his saturnine charm, the novelty of his electric viola, his rhinestone necklaces. "But even more fascinating was the drummer, this person named Moe. It was impossible to know if she was a boy or girl, she just hit the drums and didn't move her face and she was totally androgynous. She was extremely distinctive. As soon as it was over I went up to them and said, 'You're very good. Do you have a manager?' "

According to Morrissey, Andy resisted the notion of joining forces with a rock band "every step of the way" and had to be "babied," cajoled by Morrissey, into signing them to a management contract. "He didn't want to do it, and I said, 'No, it's a good thing; yes, they're not so nice . . . but maybe we can make money like the Beatles.' " (It wouldn't have occurred to Morrissey, who had known Andy only for a matter of months, that his boss's evident reluctance was likely nothing more than Andy's customary hemming and hawing on the way to a decision.)

Malanga's and Morrissey's versions of events both omit the crucial player. Andy had tried at least twice in the previous six months to connect with a pop musician. The encounters with Eric Andersen and Dylan indicate that he was indeed casting about for a direct, if still undefined, involvement with rock and roll, something more hands-on than spinning the latest 45s at the Factory or at home. As usual with Andy, more than one motive was at work. Not only was he fascinated with youth and its ever-shifting tastes, but he himself was acutely aware

of the need to finance his film habit with something solidly profitable. As his friend Bourdon saw, Andy was "eager to annex himself to the pop music scene," believing that rock music offered not merely "promises of glamour" but "pots of gold."

The irony was that Warhol and Morrissey, dreaming of pots of gold, were attaching themselves to what one critic has called "the first important rock-and-roll artists who had no chance of attracting a mass audience."

Three members of this incarnation of the Velvet Underground—Reed, Cale, and rhythm guitarist Sterling Morrison—had been together for most of 1965; Moe the drummer, a young woman named Maureen Tucker, had played with them for a month. Before they were the Velvet Underground they had been the Warlocks (a name shared, incidentally, by an early version of the Grateful Dead); before that, a duo—just Reed and Cale—who called themselves the Falling Spikes, after their mutual interest in heroin.

Cale and Reed, a classically trained Welsh violist and a Long Islander bred on doo-wop and rhythm and blues, met by an outlandish fluke. Reed, who'd managed to graduate from Syracuse University despite a very relaxed attitude toward coursework and an avid interest in most drugs, from cough syrup to heroin, had found work in late 1964 as a staff songwriter for the third-rate record label Pickwick, based in Long Island City. His job was to turn out knockoffs of the latest hot teen style. One day he came up with a novelty dance song called "The Ostrich," which his bosses decided was a hit; all that was needed was a suitably scruffy-looking "rock band" to promote it. Chancing to meet Cale and Tony Conrad, who both needed haircuts, the record men hired them on the spot. That they were avant-garde classical musicians mattered not a bit—these were the days when Mike Clarke and Skip Spence, original drummers for the Byrds and Jefferson Airplane, were hired solely for their looks, neither ever having been within yards of a

drumkit. Cale, Conrad, and their friend, the sculptor Walter de Maria, who happened to play drums, joined Reed. Pickwick, christening them the Primitives, sent them out to play "The Ostrich" at supermarkets, local radio stations, and similar venues. The song went nowhere, but Cale and Reed connected strongly.

They were both twenty-two, born a week apart. Reed had played in bands since childhood and even recorded a handful of his own doo-wop tunes under a pseudonym. Loathing suburbia, he rebelled in all directions; when he began to flaunt homosexual mannerisms, his parents sent him to a psychiatrist, who prescribed eight weeks of electro-shock. Reed never lost his fury over the experience; it leaps out of a song like "Kill Your Sons," recorded a decade and a half later.

At Syracuse, Reed fronted a series of bands and hosted an unconventional radio show that revealed his eclectic tastes called "Excursion on a Wobbly Rail," after a piece by the jazz avant-gardist Cecil Taylor. But he had also become very interested in writing, apprenticing himself to the poet Delmore Schwartz, then near the end of a troubled life. Schwartz remained a major influence on Reed, but it wasn't until Reed heard Bob Dylan that he realized that pop lyrics needn't be juvenile. Abandoning his plans to pursue graduate studies in writing, he began turning out some of the songs, including "Heroin" and "Waiting for the Man," that would surface in the Velvet Underground. When Cale met him at the beginning of 1965, Reed "was a high-strung, intelligent college kid in a polo-neck sweater . . . trembling, quiet and insecure." His parents kept him on a tight leash and still sent him to a psychiatrist; "I think I'm crazy," he told Cale, who developed a protective stance toward his volatile new friend.

Cale studied music at London University's Goldsmith College, corresponded with both Aaron Copland and John Cage, and won a conducting scholarship to Tanglewood in 1963. Once stateside, he fell completely under the sway of the American avant-garde, moved to New York's Lower East Side, and became an earnest disciple of La Monte Young, for whom

he also worked as a drug courier: Young supported his musical experiments as the avant-garde's biggest marijuana dealer.

Young's primary musical interest had always been in the effects of blending notes held for an extremely long time; in Young's ensemble (in which Billy Linich occasionally chanted), Cale would hold the same two viola notes for, say, two hours. As it happened, these practices worked well with Lou Reed's own brand of minimalism, two- and three-chord rock songs. In fact, Cale once cited La Monte Young's theories as "a basis for the Velvet Underground. If they were three-chord songs, I could just pick two notes on the viola that really fit for the whole song. It would give a dreamlike quality to the whole thing." In an era of light pop music, go-go dancers, and an emerging hippie culture of sweetness and light, the Velvets studiously cultivated their dark side. "Acid? Fuck off! Give people hard drugs—heroin, amphetamine. It wasn't so much the flavor of the drug; it was the mentality involved that we really resented. We thought doing evil was better than doing nothing."

This was especially true for Reed, whom Cale has called "the most difficult person to work with I have ever known." Reed was "gratuitously vicious"; he instinctively homed in on others' weakness, which made him feel he was in control, rather than living in a state of uncertainty and paranoia. He might, Cale recalled, "befriend a drunk in a bar and, after drawing him out with friendly conversation, suddenly ask, 'Would you like to fuck your mother?' I thought I was reckless, but I'd stop at goading a drunk. That's where Lou would start."

But Reed was also full of ideas. In 1966 he would write an essay called "Life Among the Poobahs" for *Aspen*, an innovative magazine-in-a-box (Andy co-art-directed the issue with David Dalton in which Reed's piece appeared). The essay shows how thoroughly Reed had absorbed Andy's antiestablishment stance, but also how these ideas already served as Reed's second skin, a worldview he'd been developing since Syracuse and earlier.

A sort of musico-literary equivalent to a Pop art manifesto, "Life Among the Poobahs" rails at what Reed considered the sterile cultivation of a "Robert Lowell, up for a poetry prize without a decent word ever written. The only decent poetry of this century was that recorded on rock-and-roll records."

Of the smothering suburban fifties of Reed's teens, he ranted: "everything was dead. Writing was dead, movies were dead. . . . And through all those years were those beautiful rock groups, tweeting and chirping like mesmerized sparrows. . . . The music is the only live, living thing. Draft only those over forty. It's their war, let them kill each other. They're killing young kids who haven't even balled yet. . . .

"The colleges have to be destroyed. They're dangerous. Music Appreciation courses. Metaphysical poetry. Theology. Playboy Jazz polls. Tests. Papers. Psychological tests. Doctors trying to 'cure' the freaks. . . . It's the music that kept us all intact. It's the music that kept us from going crazy. . . . "

Reed and Cale eventually found dependable bandmates in Sterling Morrison and Maureen Tucker, and with this, the classic Velvet Underground lineup played its first job as the opening act for a New Jersey band called the Myddle Class; the occasion was a dance at Summit High School.

"Nothing could have prepared the kids and parents assembled in the auditorium for what they were about to experience that night," recalled one attendee. "Before we could take it all in, everyone was hit by a screeching surge of sound. . . . About a minute into the second song, which the singer introduced as 'Heroin' . . . most of the audience retreated in horror for the safety of their homes. . . . Backstage after their set, the viola player was seen apologizing profusely to an outraged Myddle Class entourage for scaring away half the audience." All British politeness on the outside, Cale was inwardly delighted: the band was as soothing and cheerful as a chain saw.

At about this time Reed, a guitarist with a good ear for sonic textures

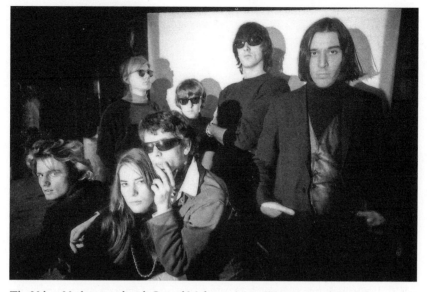

The Velvet Underground with Gerard Malanga, Mary Woronov, and Warhol

but very limited technique, let it be known that he considered himself "the fastest guitarist alive." This claim reached the ears of Robbie Robertson, the young guitarslinger who, prior to his summer 1965 hiring by Bob Dylan, had honed his chops in the rougher honky-tonks of the South and the Midwest, crossing paths with Bo Diddley and going head to head with Roy Buchanan. Curious, Robertson went to check Reed out. "He ain't nothin'" was the quick verdict. But nobody had ever heard rock-and-roll lyrics so starkly revealing of the lower depths of urban life: heroin, pushers, and other taboo topics. The mild protest songs and paeans to marijuana that slipped onto the airwaves paled by comparison. Although their lyrics and sonic harshness prevented the Velvet Underground, which had taken its name by mid-1965, from aspiring to AM radio, or even the new, "progressive" FM playlists, the band began to attract a core of young followers who were astonished at Reed's lyrical frankness and the band's refusal to sweeten its sound.

The Café Bizarre gig began in mid-December, a fortnight's stand from which the Velvet Underground was fired for its abrasive sound.

But by then Andy had appeared, invited them to the Factory, and offered a deal: for 25 percent of the gross, he would find them jobs, pay for a studioful of brand-new guitars and amps, and shop them to record labels: in short, manage them (a complex setup, indeed: Warhol was himself managed by Morrissey). A corporation was founded: Warvel, Inc., Andy Warhol, president; Paul Morrissey, vice president, though the papers weren't prepared until the end of April.

Given their status as Andy's new pet project, the band's instant notoriety was all but assured. Barely had they tuned up in public than they were gossip-column fodder; on January 27, the *New York Journal American's* "Voice of Broadway," Jack O'Brian, offered his readers the lowdown on Cale's torrid new romance with Edie Sedgwick: "Andy Warhol's 'Velvet Underground' rock group is led by a young Welshman who's leading Edie Sedgwick around by the heart." (The affair lasted some six weeks; Cale characterized his lover as "desperate and on her last legs with Warhol," "fragile," and "totally lost.")

Six days earlier, O'Brian's fellow *Journal American* gossip Suzy Knickerbocker noted (between items on Barbara Hutton and Joan Crawford), "You see, Andy Warhol and Edie Sedgwick were at [the Manhattan club] the Phone Booth with a group of their own called The Velvet Underground"—a gig that seems to have slipped past the legions of Velvet's scholiasts. "Andy and Edie got up on the stage"— here Suzy comically confused Andy with Gerard Malanga, unleashing his ludicrous bullwhip routine—"and did a number all their own— Andy with a bullwhip which he flicked around like crazy, catching Edie around the waist and other places with the big old thing. Don't you know they were a sensation?" The Velvets, Suzy blithely informed her readers, had been hired to work at the Phone Booth: patently untrue, but who cared?

Arriving at the Factory soon after accepting Warhol's offer, the four Velvets were introduced to a five-foot, nine-inch, twenty-seven-year-old German woman of almost flawless beauty, with a mane of dyed

blond hair. As Mary Woronov memorably described her in *Swimming Underground*, Nico "was so beautiful she expected everyone wanted to fuck her, even the furniture."

Christa Päffgen had called herself Nico since embarking on a successful modeling career in the mid-fifties. In 1960 she appeared, briefly but strikingly, in Fellini's *La Dolce Vita*; since then, half deciding on a singing career (though deaf in one ear), half on acting, she had shuttled between the Continent, England, and the States. In 1965 she released a British single, a folk-pop version of the Gordon Lightfoot song "I'm Not Sayin'"; the Yardbirds guitarist and London session ace Jimmy Page produced it.

As Morrissey recalled, Nico had visited the Factory in the fall of 1965. "She played me her record, and I thought it was great and she was absolutely beautiful. She came up looking for work, and said she was going to be managed by Bob Dylan's manager, Mr. Grossman, and I kept her in mind."

Deaf to the very qualities that made Lou Reed distinctive—his abrasiveness and hard ironic edge—Morrissey considered Reed a poor front person for the band: "a terrible singer, he had no personality, he was offputting, and he was negative. Okay, a few years later all that negative punk shit paid off for him." In any case, Morrissey took credit for the solution, as it were, to what he regarded as the Velvets' front-person problem.

"I said to them, 'We want this girl to sing with you.' Andy had been connected with Jane Holzer and Edie Sedgwick, so if he's going to go out with this rock-and-roll group, better that he's got some wonderful girl, another Girl of the Year. It was common sense, and it was my idea." Perhaps, but adding Nico to the mix strikes one as a characteristic Warholian touch, an element of visual incongruity: a Nordic goddess in the midst of four scruffy-looking individuals.

Warhol, Morrissey, and Nico wanted her to sing every song: a staggeringly inappropriate notion, given Nico's icy cool and the music's heat, her shaky grasp of English and Reed's dense, vernacular word-spew.

The Velvets felt invaded; they considered themselves a unit. But

afraid to blow the deal, they compromised. Fine, let the lady sing three songs a set; she could spend the rest of the time hitting a tambourine and looking beautiful (or knit onstage, Reed sourly suggested). As it turned out, shoehorning Nico into the band was fortuitous, to an extent. Forced to write songs for a female voice, Reed tapped a new, less reflexively ironic side of himself in songs like "Femme Fatale," or even the relatively strident "All Tomorrow's Parties" (which Nico delivers with full Teutonic rigor); further, Reed and Nico fell in love, at least briefly, and the love song he wrote for her, "I'll Be Your Mirror," is one of the most tender of his long career. And Nico was visually striking at shows, in her sheer beauty and her aloofness, her apparent oblivion to the raucous din surrounding her. But ultimately she was a graft that didn't take. By their second album she would be gone.

"Bringing Nico into it, I didn't understand," admitted Cale. "But over time, what I learned from it was the way Andy's mind thought. It was a visual attraction. He brought an ingredient that broadened the whole damn thing."

Despite her commanding appearance and stage cool, Nico, according to Cutrone, was "one of the two most insecure women I've met in my life. Like we'd be going out—Eric, me, and Nico. Just go out dancing, like let's go out dancing. And Nico'd be in front of a full-length mirror going. . . . And we'd go, 'What are you doing?' and she'd go, 'I'm practicing.' And we'd go, 'For what?' And she'd go, 'To go dancing. Just to see what it looks like.' And we'd be like, 'Hey, Nico, we have no time for this. We wanna go out dancing.' 'WAIT.' Like that, totally insecure. Totally insecure."

Nico's accent in the Velvet Underground songs is hypnotic, gothic, and alien sounding, but hardly a voice for the masses circa 1966. As if in acknowledgment of her exoticism, she was listed on the band's first album as "chanteuse"; Reed's singing credit was simply for "vocal."

Just as Andy had moved from single to multiple painted images, in 1966 he began to multiply projectors and screens. The double screen,

according to Stephen Shore, was Andy's attempt to make his films less static. Shore recalled a conversation in which Andy impatiently dismissed his movies, "They're just so boring. I think I'm going to show them on two screens. Then people will have more to look at and they won't be as bored."

Warhol was trying to saturate the audience's attention, to make the viewer "uptight"—an expression Andy would briefly adopt as the title of his next enterprise. Instead of merely multiplying the projected image, Warhol was now getting interested in multiplying *media*, in engaging not merely more of his audience's visual attention but as many of their senses as possible. His instincts fed a larger trend, championed by the *Voice*'s Jonas Mekas as "intermedia art," "expanded cinema," and other such catchphrases. As Mekas noted, the storm had been gathering for years—a sensorily overloaded environment begets an equivalent artistic response. But what probably kicked intermedia into high gear was the mid-sixties proliferation of psychedelics. Hallucinogens induce synaesthesia, a fusing of different sensations, which the multimedia light shows of the late sixties attempted to simulate.

Although *The Chelsea Girls* is commonly thought of as Warhol's first double-projected film, a number of others actually preceded it, including *Outer and Inner Space*, *Lupe*, and *The Bed*. In November of the previous year, Danny Williams and Warhol had shot a film together, Warhol on the Auricon, Danny using the Bolex. The script was Robert Heide's close adaptation of his one-act play *The Bed*, an off-off-Broadway hit that summer at the Caffe Cino and ultimately one of the Cino's most-performed plays. The text was standard-issue existentialist angst; the wrinkle was the gay subtext: the entire set was a big white bed (which filled the Cino's tiny stage), the cast two handsome young men in underwear. The play fascinated Warhol, who saw it again and again, recalled Heide, adding that Andy may also have had a crush on one of the actors.

Although it's unclear how much of Williams's footage was included, *The Bed* was shown on April 26, 1966, at the Filmmakers' Cinematheque.

Projected onto two adjacent screens, it anticipated Warhol's far better known double-screen film *The Chelsea Girls* by some months. (Danny Williams's journals and notes include a series of "Notes on Double Screen," and it isn't far-fetched to conjecture that Danny's ideas had an impact on the ways that Warhol used double projection in *The Chelsea Girls*.)

By this point, Danny had moved out of 1342 Lexington; the affair was over. According to Billy Linich, Warhol "couldn't handle" Williams's constant seesawing between two extremes: black depressions and a mounting amphetamine habit that kept him manic for days on end. "His depression," in Billy's opinion, "was so horrendous that it was overpowering, and that's why Andy had him leave."

Chuck Wein saw things differently. Andy's core of self-loathing, according to Wein, made it impossible for him to accept Williams's affection; terrified, Andy turned Danny away. Wein had yet another hypothesis: that the relationship was ruined when Warhol soured on the *Jane Heir* movie. This devastated Danny, recalled Wein. "He'd had his heart set on our doing a real movie. He said, 'Andy, you can't do that! We've got the whole thing. It's going to be wonderful!' And Andy said, 'I don't think this is working out, Danny,' and asked Danny to take his things and leave the house."

The end of the affair by no means ended Williams's involvement with Andy's rapidly expanding activities. Danny had become too valuable an assistant, even collaborator, to be simply cast off. With Andy's consent, and over Billy Linich's strenuous protests, Danny moved into the Factory.

On January 13, Andy and the Velvet Underground appeared at the forty-third annual dinner of the New York Society for Clinical Psychiatry at Delmonico's Hotel: one of those intensely awkward black-tie events that were becoming increasingly characteristic of the era, encounters between widely disparate groups where the old protocol frayed and gave way, and naked lust, anger, and anxiety came body-

ing forth. As the gifted neo-Beat writer Seymour Krim, then on staff at the *Herald Tribune*, reported in his next-day story, "Shock Treatment for Psychiatrists," a "swinging post-Freudian," Dr. Robert Campbell, the program chairman of the psychiatristy group, had wanted "to brighten up things for the hardworking psychiatrists" by choosing Andy as that year's guest speaker. Andy responded with an evening entitled (by Morrissey or perhaps Malanga) "The Chic Mystique of Andy Warhol." After Andy screened *Harlot* and *Henry Geldzahler* for the assembled guests, the Velvet Underground took the stage for what Dr. Campbell termed "a short-lived torture of cacophony"; Malanga launched into his whip dance (with Edie Sedgwick as his partner, twisting demurely), and Jonas Mekas and Barbara Rubin waded into the audience with floodlights and cameras, filming everything as Rubin verbally assaulted the psychiatrists and their spouses with questions along the lines of "What does her vagina feel like?" and "Do you eat her out?" While Mekas and Rubin filmed, Danny Williams and Andy filmed *them*. There was a substantial early exit; as Bourdon amusingly noted, the headline in a second *Tribune* edition—"Psychiatrists Flee Warhol"—helped magnify the notion "that the artist's perversity was uncontainable, terrifying even professionals in the field."

According to both Linich and Malanga, in the fall of 1965 Jonas Mekas had offered Andy a week's stint at what were about to become the Cinematheque's new 41st Street quarters. Warhol's initial idea— an Edie Sedgwick retrospective—was eventually discarded; relations with Edie were simply too frayed, although she still showed up at the Factory from time to time. Andy decided on something else for his week at the Cinematheque: a show featuring the Velvets. The move was appropriately symbolic: in Linich's words, "After Edie and Chuck left, the orbit went to the Velvet Underground" almost as smoothly and inexorably as 1965 became 1966.

But the show offered more than music. Two new Warhol films, *Lupe* and *More Milk, Yvette*, were projected onto the Velvets as they performed.

With Billy Linich standing backstage and playing a strobe light across both band and audience, Andy was presenting his first, primitive light show. Barbara Rubin, meanwhile, reprised her manic audience interrogation, rushing from seat to seat, hectoring attendees. Rubin had also come up with the show's name: "Andy Warhol, Up-Tight."

"Andy Warhol, Up-Tight" ran from Tuesday, February 8, through the following Sunday. The event's ads, which ran in the February 3 and February 10 issues of the *Village Voice*, boasted an interesting assortment of names: in the first ad, running vertically, "The Velvet Underground, Edie Sedgwick [as Malanga's dancing partner, quite a comedown from the subject of a retrospective], Gerard Malanga, Donald Lyons [presumably along as moral support for Edie], Barbara Rubin, Paul Morrissey, Nico, Daniel Williams, Billy Linich." Seeing his surname on this and other advertisements in early 1966, Linich, struck by its lack of glamour, began playing around with possible substitutes. He came up with one while filling out a form; in the space that asked for his last name, he wrote, "Name." It seemed a nice little conceptual touch, and he kept it.

The show "was all very explosive and loud and wild," according to Linich/Name. To the ever-practical Morrissey, "Andy Warhol, Up-Tight" was a dry run for what they were going to present at Michael Myerberg's huge discothèque-to-be. Manhattan's critics—save for Mekas, who saw the show as a triumphant confirmation of his theories and enthusiasms—circled "Andy Warhol, Up-Tight" warily. Was it a movie? A rock concert? It didn't fit into the cultural vocabulary. Bosley Crowther, the *New York Times*'s veteran film critic, opted to review it as another Warhol movie premiere, quickly dispatching both films; at the bottom of his review, Crowther mentioned in passing that the Velvet Underground were "also on the bill." While the *Post*'s Archer Winsten refrained from pigeonholing it, calling it "a something," it wasn't one he cared for in the least. The Velvet Underground ("a string, percusssion, rattle & roll group"), "prodigiously amplified, prepares itself in a tuning

session" and then "prov[es] the session may not have been necessary. The gyrations of the dancers accompanying 'Heroin,'" Winsten wrote, "cannot be accurately described in a family journal. . . . Andy Warhol, the king of the put-on, bring-down, nothing movie, has here thrown together some meaningless stuff well calculated to reflect not only a meaningless world but an audience so mindless that it can sit still and take it and come back for more."

But "something" was clearly happening (though Mr. Winsten didn't know what it was); the house, he duly reported, was packed.

In an interview for *Cavalier* conducted toward the end of 1965, Andy was asked if he paid any attention to critics' reactions to his work. "No, just Henry Geldzahler," said Andy. "He's a good friend—a fan." But by the time the interview came out, in September 1966, Warhol and Geldzahler were not on speaking terms. Just as Andy had walked away from almost all of his fifties friendships, he was growing apart from the friends and supporters of the early sixties: de Antonio, with whom Andy was amicable but hardly close; Karp, put off by the unwholesomeness of the Factory, had come to restrict his dealings with Andy to business; and now his erstwhile confidante, Geldzahler, noted that Andy's regular reshufflings of his circle were his way of saying, "Don't get to know me too well."

But the rift wasn't all Andy's doing. Henry's position at the Met was precarious, and his association with Warhol wasn't helping. Furthermore, at the beginning of 1966, Geldzahler, who had always lived alone, invited his new lover, Christopher Scott, to share his apartment. No longer would Andy be able to stave off loneliness by gossiping on the phone with Henry until dawn. As Geldzahler told journalist John Wilcock in 1971, "What I think really upset him was that I wasn't available anymore every night. . . . I was busy setting up a household." Further, said Geldzahler, he had come to perceive Andy's manipulativeness, the way he had intuitively set up the Factory so "there were

always more people around than can be used. . . . There's constant sort of fighting to get into the royal enclave. And I just finally understood it; and it was so unattractive that I walked away." One day he could only recall as some time during 1966, Henry impulsively grabbed a piece of chalk and scrawled across the Factory blackboard, "Andy Warhol can't paint anymore, and he can't make movies yet." Andy had never forgotten the incident, according to Geldzahler.

Art world politics drove the final wedge between the two. When Geldzahler was asked to choose the U.S. entrants to the Venice Biennale, the most prestigious of all international art shows, Andy was considered a shoo-in. Instead, Geldzahler chose Ellsworth Kelly, Helen Frankenthaler, Jules Olitski, and Roy Lichtenstein. Although it couldn't be ignored, Pop was no longer the art world's latest sensation. But the main reason for Warhol's omission was his friend's survival instinct. Geldzahler's later explanation was candid enough: "I knew I couldn't bring Andy to Venice in '66 without the Velvet Underground and that whole newspaper thing," the sort of gossip column uproar that Henry's employers at the staid old Met would certainly frown upon. They were already frowning: after *Life*'s February 18, 1966, Geldzahler profile, which featured Henry in an Oldenburg happening, leisurely reclining in a little rubber boat in a bathrobe, puffing on a cigar, "the trustees were a little bit shaky about me," he recalled. Henry was eager to succeed the museum's curator of American art, then nearing retirement, and "I knew that if I took Andy to Venice I would never succeed Bob Hale."

After not speaking for most of 1966, Andy and Henry accepted each other's extended olive branch: they attended Truman Capote's famous Black and White Ball together on November 28. Geldzahler continued to champion Andy's work, and the two maintained a residual, distanced fondness for the rest of Andy's life.

Straddling the months of Warhol's most intense involvement with the Velvet Underground—January 1966 through the end of that spring—Andy had a series of conversations with an aspiring twenty-

two-year-old photographer and journalist named Gretchen Berg. The young woman, whose father, the film historian Herman Weinberg, was a longtime associate of Jonas Mekas, taped two of the conversations, jotting down the rest from memory after leaving Warhol's studio. Assembling her material into a long, unbroken first-person statement by Warhol, Berg published it in the November 1, 1966, issue of the *East Village Other* as "Andy Warhol: My True Story." Expanded, reedited, and retitled as "Nothing to Lose," the interview reappeared on March 17, 1967, in the *Los Angeles Free Press* and in the May 1967 issue of *Cahiers du Cinéma*.. The most substantial Warhol interview since Gene Swenson's 1963 *Art News* piece—and containing some equally questionable quotations—Berg's interview is still a remarkable document. Many times reprinted and anthologized, it has become one of the touchstones of the literature on Warhol: the source, probably, of more Warhol quotes than any piece of writing other than Andy's own *POPism* and *The Philosophy of Andy Warhol* (some of Berg's quotes reappearing in those books):

"I don't talk very much or say very much in interviews; I'm really not saying anything now."

"If you want to know all about Andy Warhol, just look at the surface: of my paintings and films and me, and there I am. There's nothing behind it."

"I never wanted to be a painter. I wanted to be a tap-dancer."

"Pop art . . . is just taking the outside and putting it on the inside or taking the inside and putting it on the outside. . . . "

"The artificial fascinates me; the bright and shiny."

"*Esquire* asked me in a questionnaire who would I like to have play me and I answered Edie Sedgwick, because she does everything better than I do. It was just a surface question, so I gave them a surface answer."

"I still care about people but it would be so much easier not to care . . . it's too hard to care. . . . I don't want to get too involved in other people's lives . . . I don't want to get too close . . . I don't like to touch things . . . that's why my work is so distant from myself."

"I see everything that way, the surface of things, a kind of mental Braille, I just pass my hands over the surface of things."

"Mental Braille" reads falsely, as do a few other selections from the Berg conversations. The interview is full of aperçus and good quotes ("I don't know where the artificial stops and the real starts," etc.), but one feels the presence here and there of Berg's editing, improving hand in many of Andy's responses.

Every once in a while, when it's a matter of fairly neutral fact, he seems to be speaking candidly. Andy mentions to Berg that he wants to shoot an autobiography, and that he wants the playwright and actor Jackie Curtis, then nineteen years old, to appear in the title role. (Curtis would subsequently become a "superstar" in Warhol movies such as *Flesh* and *Women in Revolt*; he's also "Jackie" in Lou Reed's "Walk on the Wild Side.")

"A few people connected to him strongly," Berg observed, "who had not had parenting, who had not had anyone who seemed interested in them. He was very sort of fatherly. . . . Jackie Curtis used to come up and hang around. He even slept there for a while when he ran away from home. . . . [Andy] would become interested in someone if they were dressed incorrectly for an interview. He knew how the straight world ran, he said that you should always dress very quietly and very straight (when entering straight world). He said it was very hard to promote yourself in life. That there were many talented people but they didn't know how to present themselves, they didn't know how to push themselves. They needed a brand, he said."

In the *New York Times* later that year, Elenore Lester also touched on Andy's attraction to disturbed youth: "Andy's boys and girls find their way to him, the neglected, rejected, overpsychoanalyzed children of the rich, and the runaways from jobs as supermarket checkout clerks in the bleak suburbs of New Jersey. They find their way to the enchanted silver playroom on East 47th Street in Manhattan, to Mother Andy—neutral, cool and withdrawn in goggles and leather

jacket. . . . He listens to each one, watches each one, an open shutter. They tell him about a new job, the lost earring that got found, an obscure little shop that sells marvelous old uniforms, a problem with the equipment, a problem with a parent, a friend."

By the time the Velvet Underground arrived on the scene, the Factory had become a showcase for decadent behavior. When Mark Lancaster visited in the summer of 1966 he noticed a marked difference between what he had seen there in 1964 and two years later: "By '66 there was an air of what people would call decadence which wasn't there in '64. Strange people who were not friendly. In '64, people were nice. . . . I think it was drugs, basically. And '64 was pre-superstars. It was pre-Ingrid and pre-Viva and pre-Edie. The fame thing became much bigger then. They were sort of famous then in a way they weren't in '64. There was a lot more attention. When I visited in '66 it was like I didn't know them and they didn't know me. Only Andy knew me. Everything else had changed, except for Ondine."

The Factory had already served Reed the lyricist well (and would continue to). "I kept notes of what people said, what went on," Reed recalled, "and those notes would go directly into songs." In the liner notes, Reed calls the opening "a very apt description of certain people at the Factory at the time."

One month after "Andy Warhol, Up-Tight" played the Filmmakers' Cinematheque, the show ventured out across the country—first to nearby Rutgers University on March 9, then to the University of Michigan in Ann Arbor on March 12. Both shows were billed as "film" events, indicating that no appropriate rubric or venue yet existed for something this new and amorphous, inventing itself with each show.

Edie was no longer with the troupe; she was gone for good. Malanga's dancing partner was Ingrid von Scheven, a part-time hooker (Bourdon diplomatically referred to her as an "office temp") whom Chuck Wein had befriended at the Hotel America. When she appeared at the

Factory, she was at once renamed Ingrid Superstar. Among Warhol's retinue, it was felt that Ingrid, whose bobbed blond haircut resembled Edie's, was an insult aimed at Edie.

At Rutgers, Ondine and Barbara Rubin joined Ingrid and Gerard as dancers, but neither ever appeared onstage again. Backstage, Malanga told Ondine that the stage was getting too crowded and that his services were no longer needed; Ondine reportedly threw a chair across the room in a rage. As for Barbara Rubin, Paul Morrissey found her presence unsettling. Rubin could push an agenda very hard, demanding Andy's ear, and Morrissey didn't like competition. According to Bockris, he "began to torture her, making fun of everything she said, refusing to take her seriously," and essentially driving her out of the Factory.

Danny Williams was turning into another Factory casualty. Alcohol and the amphetamines he had begun using heavily—in part because of the long hours he was devoting to an increasingly complex light show—made him unstable and, coming down from speed, disconsolate. Warhol had no patience for his ex-lover's depressions, and on one occasion, visibly enraged, he hectored Williams in front of the others. Now the Factory scapegoat, Williams retreated more and more into self-pitying outbursts—all the while working around the clock.

"We couldn't figure out why Danny went everywhere with that strobe light," recalled John Cale. "Until we were in Philadelphia and Ondine told us that Danny came into the dressing room and everybody was shooting up and Danny opened up the back of his strobe and that's where he kept his stash."

Of the internecine Factory fights, Cale noted, "You know, those are the kind of things I made sure I stayed away from. That's the benefit of heterosexuality. I mean, there was a witching hour in that group. I'd go to the Ginger Man, but then I'd go running off to find myself a girlfriend. I would get entertained for a certain period of time, but I really didn't have patience with it after a while, and all the bitching and the backbiting. The creative side of it was such a joy, and it was difficult enough with Lou, and holding us together, anyway."

For the trek to Ann Arbor, the eleven-member entourage, including Warhol, rented a big van, driven by Nico, who despite her languorous feminity turned out to be a hell-for-leather, drive-all-night road warrior who thought nothing of jumping a sidewalk. The van came equipped with a 140-volt generator, which not only let the Velvets play through their amplifiers all the way to Michigan and back but came in handy when, on the return trip, the van's headlights died. Clamping the troupe's floodlights to the front bumper, Danny Williams wired cables to the generator and got everyone safely home. During the 1,300-mile trip the van was several times approached, inspected, and tailed by police; it was getting dangerous, Sterling Morrison reflected, to cross the Hudson.

On Monday, April 4, Paul Morrissey got a nasty surprise. Myerberg, his new Broadway-mogul contact, had seen "Andy Warhol, Up-Tight" at the Cinematheque and been unimpressed. In addition, surmised Morrissey, "there was . . . let's say an Italian influence in [the Roosevelt Field discothèque], and I think they had their own plans for the opening." Those plans definitely did not include Andy Warhol's intermedia rave-up.

"Andy Warhol, Up-Tight" had been dropped in favor of the Young Rascals, a band with whom the Velvets couldn't hope to compete commercially. The Rascals had a big local hit, "I Ain't Gonna Eat Out My Heart Anymore," and their just-released "Good Lovin'" would be the nation's number one song by the end of the month. Murray the K, whose Brooklyn Fox extravaganzas Andy had so recently attended, replaced Warhol as host and sponsor of the discothèque, heretofore dubbed Murray the K's World. The deal was dead. The Velvets had expected as much—visiting the still-unfinished discothèque some days before, Sterling Morrison and Lou Reed had bumped into Reed's fellow Syracuse alumnus, the Rascals' Felix Cavaliere, "who must have known what mischief was afoot," according to Morrison, but had said nothing, speaking volumes. Warhol and the Velvets had reportedly

been offered $40,000 for the first four weekends, a hard sum to put out of one's mind.

Disconsolate, Morrissey was sitting in the Café Figaro downtown brooding aloud to Andy. He was overheard by the couple in the next booth, who happened to be the pioneering light-show artists Jackie Cassen and Rudi Stern. "They said, 'You need a place for a rock-and-roll group?'" Morrissey recalled. "'Go to the Dom on Eighth Street'": the Polsky Dom Narodny, or Polish National Home, at 23 St. Mark's Place, a huge social hall for the East Village's diminishing Polish population. Cassen and Stern were currently leasing it for their own shows, but did not need it for April.

"Andy Warhol, Up-Tight" had been laid to rest. Pacing the Factory trying to brainstorm a new, more expansive name that would reflect the show's increasing scale and complexity, Morrissey had picked up a copy of the current Dylan album, *Highway 61 Revisited*. Misremembering it as its predecessor, *Bringing It All Back Home*, Morrissey recalled scanning Dylan's stream-of-consciousness liner-notes prose poem—"some amphetamine Bob Dylan gibberish liner notes," Morrissey called them—and randomly picking three words: "exploding," "plastic," and "inevitable." The liner notes' surreal cast of characters indeed mentions a "hundred Inevitables made of solid rock & stone," but the closest Dylan got to "exploding" was "erupting," and he made no mention of plastic at all. By whatever means, Exploding Plastic Inevitable (EPI) emerged, the new name for Andy Warhol's multimedia experience.

The Warhol troupe was not given access to the Dom until mid-afternoon on Friday, April 8, five hours before showtime. Climbing a ladder and slapping paint onto the stage's rear and sidewalls as fast as he could, Malanga created a film- and slide-projection surface; he was still working when the doors opened. Meanwhile, Warhol, Morrissey, Billy Name, Danny Williams, and others hauled in hundreds of pounds of film projectors, spotlights, strobe lights, slide projectors, and hand-

painted slides borrowed from Jackie Cassen and Rudi Stern. Cassen and
Stern helped run the light show early in the month. As Cassen recalled,
Andy paid for the use of her equipment but not for her services.

"They didn't have very good equipment," Cassen said. "They were
working on a wing and a prayer, as far as projectors went. I had Kodak
Carousel slide projectors; they were using only film projectors. . . . But
what they were really interested in was doing the films [as opposed to
the slides]. The setup involved slide projectors on the balcony; film
projectors on, or raised just above, the floor; strobe lights onstage.
That was about it."

Other Factory members—Stephen Shore and Danny Williams—
were enlisted to work the lights. "Danny Williams was really in charge
of the lights, as I recall," according to Shore. "It was totally improvised.
I'd stand behind a big flood or spot that I could move around the room,
or adjust the colors, or at the Dom there was a mirrored globe and I
could aim it at that, or flash it at the people in the audience or on the
stage."

Describing the old immigrants' dance hall before and after its trans-
formation, John Cale noted, "The Dom had absolutely no charm what-
soever. You trudged upstairs to this place that smelled of urine. It was
filthy and it had no lights in it, but Andy took it over and turned it
into something totally different. He projected films all over the wall
behind us, and we had slides projected on another wall, shown through
gauze. . . . While a film played in the background and Nico sang 'I'll
Be Your Mirror,' the spinning silver ball he'd bought at an antique shop
and hung over the centre of the stage splintered the strobe's power-
ful beams and sent its light skittering across the room, the band, and
the screen, so that the whole mass was reduced to a throbbing entity
wrapped up in colored light. Nobody had seen or heard anything like
this before."

Opening night was a big success, with a crowd of up to 750 people,
at $2.50 a head. "Friday, Saturday, Sunday were *packed*," said Morrissey.

"They came in droves. Big story in the *New York Times*. It was extra-ordinary."

The story, which appeared the following Monday in the *Times*, wasn't all that big, and the reporter, Marylin Bender (who had previously profiled Edie Sedgwick), maintained an appropriately *Times*ian feature-story air of mildly stuffy, mildly amused distance. Showgoers,

The Dom

wrote Bender, could sit and be "simultaneously bombarded" by "kinetic lighting," Warhol films, and rock and roll. "Or they can grope their way to the dance floor in blackness that is broken only by hallucinatory flashes of multicolored lights in order to wriggle, writhe and tremble to the music of the Velvet Undergrounds [*sic*], a four-piece band whose chanteuse is a fashion model answering only to the name of Nico." Bender likened to "the unmelodic manner of early Marlene Dietrich." Bender was careful to note the odd mix of classes and types: the daughter of the late dictator Trujillo mingling with bell-bottomed suburbanites, Allen Ginsberg and Peter Orlovsky, and a still younger generation of East Village longhairs (the term *hippie* would not catch on, at least in the *Times*, for another year).

A college newspaper, the *Columbia Spectator*, noted Warhol's "talent for finding the good bad," and singled out Malanga's literal-minded "interpretations." (During "Heroin," Gerard knelt, ripped off his belt, tied off, and "mainlined" with a cake icer or a ballpoint pen.)

A reporter from New York University's newspaper, the *Washington Square Journal*, corralled Ginsberg in the opening-night audience. The poet was in tiptop rhetorical form: "We're living in an expanding universe," he said, or shouted, to the young reporter. Ginsberg loved the show, whose "multiple association symbolically represents the LSD experience, but we need some flesh orgies and copulation on the stage." In the coming weeks, Barbara Rubin would arrange for Ginsberg to join the Velvets onstage and chant Hare Krishna while Malanga did his whip dance. (It may have been shortly after this that Morrissey finally drove Rubin out: she "left the Factory one day screaming, never to return.")

Few incidents better illustrate the shift from New York's fifties artistic subculture to the new sixties version than the reaction of Ginsberg's fellow poet John Ashbery, recently returned to New York after almost a decade in Paris. Standing in the midst of the strobe lights and guitar feedback and biomorphic slide-projected shapes, Ashbery was traumatized. "I don't understand this at all," he said and burst into tears.

Two days later—on Saturday, April 2, or six days before the Exploding Plastic Inevitable took over the Dom—Andy's second show at the Leo Castelli Gallery, Cow Wallpaper and Silver Clouds, opened. One doesn't need the evidence of Andy's pharmacist receipts to realize that he must have been flying on speed, and likely on more than one or two Obetrols a day: He was extraordinarily busy right now, whether supervising the installation of the wallpaper, helping to inflate the plastic pillows—his "clouds"—that made up half the show, or lugging slide carousels up to the Dom's third-floor balcony.

As if to confirm his "retired" status as a painter, Andy displayed no paintings (although the show announcement featured a photograph of Andy that he silk-screened a few months later into one of his best-known series of paintings from this time, the 1966–1967 *Self-Portraits*). In the gallery's front room hovered helium-filled, pillow-shaped silver

Andy Warhol, Silver Clouds (Castelli series), 1965–66.
Scotchpak and helium, 34" × 49 ¾" each, edge to edge.

balloons. In the back room, the only image was found on the wallpaper itself. All four walls had been overlaid with a single repeating image, a hot pink cow's head on a vaguely mottled, yellow background. The original, a photograph, had been silk-screened by Warhol and Malanga, the final product printed and installed by a professional wallpaperer. Rolls of it were for sale, marking Leo Castelli's debut as a household-décor retailer.

According to Holly Solomon (whose portrait was one of a number of paintings with which the ostensibly retired painter was busy), the idea of painting-as-wallpaper was hers. In any case, Andy was working out ideas for wallpaper long before the Castelli show. In one of the July 30, 1965, tapes for *a*, he mentions to Ondine that Rotten Rita, who worked in a fabric store, had just given him some valuable information about wallpaper. "You know, I'm doing wallpaper now," he tells Ondine. In films made during the latter part of 1965—*Camp*, for instance—photo silk screens of the cow are plainly visible on the studio wall.

Ivan Karp claimed credit for the wallpaper's imagery. "Henry inspired the flowers; with the cows it was me. I said to Andy, 'Every painter has to make cows at one time or another, right? It's one of the most important emblems in art making for five hundred years!' He said, 'Cows! Oh, Ivan, that's wonderful! Isn't a cow like a mother?' I said, 'Yes, a cow is very much a symbol of a mother in many ways!'"

Malanga found the source image in a secondhand book and magazine store that then occupied the southeast corner of 23rd Street and Seventh Avenue. "I bought a stack of agricultural industry magazines, and they had these oval shots of these cows and I saw this one and said, 'Oh, Andy, this is the shot! It's so maternal!' He hated it. I had to force him to use it, but he used it." The bookstore was one of Gerard's favorite picture-research haunts. Andy himself liked to go there, and during a joint browsing trip, Malanga had happened across a European edition of *Harper's Bazaar* with a Warhol cover drawing. "He made me promise not to buy it," said Gerard. "He was that uptight about his commercial art"—about people knowing, that is, that he still did it. "So of course I went back the next day and bought it for myself." Whether he wanted it known or not, Andy had kept right on working for at least several of the old clients, and in the old, pre-Pop style, even after his "retirement" from making Pop paintings. As late as February 1966 Nathan Gluck was still putting in stints at the front-room drawing table at 1342 Lexington. A full-page shoe-and-handbag drawing for Palizzio appeared in the February 15, 1965, *Vogue*; on February 5, 1966, Andy billed Palizzio for "6 shoes ads formats"; a day later, he sent *Vanity Fair* a $2,000-plus invoice for "drawings of birds," "counter cards," and other work.

The cow wallpaper was a further installment—a more sustained, more elegantly literal-minded incarnation of the ideas behind the soup cans and Brillo boxes. Andy, aware of the impasse he had created for painting, realized that he was starting to repeat himself. The Pop statement had been made: art and life—or, for Warhol, art and commercial products—were one and the same, which made fine art a sham. It

was a deeply cynical if sincerely held view, and it's no wonder that so entrenched an art world member as Andy's onetime boyfriend Robert Pincus-Witten, reviewing the show in *Artforum*, was furious, calling it "an embarrassment."

The silver pillows were a somewhat different affair. Although stating as emphatically (and deceptively) as *Cows* that Andy was no longer a painter—that painting was dead, retrograde, finished, an increasingly widespread view among Andy's fellow artists at the time—these helium-filled *objets* were benign, gentle, and fun, bobbing about, bumping into gallerygoers and one another, their shiny surfaces offering fleeting funhouse reflections.

As far back as 1964, Warhol had asked his Bell Labs scientist friend Billy Klüver to calculate the feasibility of building a floating light bulb (a high-tech homage to Johns?). Impossible, came the reply. When Klüver showed him a sheet of 3M's Scotchpak, Andy's thoughts turned to making clouds: bumpy, fluffy, real-looking silver clouds. Couldn't be done, said Klüver, so Andy opted for a simple, rectangular form that could be pumped up into a three-foot-by-four-foot pillow—basically big, gas-inflated rectangles that Andy whimsically referred to as "clouds." (They had to be weighted with little lead pellets to keep them from floating away.) The pillows were a characteristically sly, offhand reference to current and former art world trends: minimalism in motion, they referred, too, to Oldenburg's soft sculpture and Calder's mobiles.

Even Pincus-Witten found the clouds "visually and haptically engaging," although he couldn't resist likening them to "stray works from last month's Abstract Inflationist Exhibition." But for someone presumably so mercenary, Andy was behaving strangely indeed—the show was sales suicide. Even at a mere $50 each, the pillows were a bad buy: the helium inevitably leaked, leaving a limp silver patch of deflated plastic on the floor. Klüver and Castelli each proposed clever but impracticable solutions: Klüver a ten-year service contract for periodic reinflations; Castelli a helium pump to go with each pillow.

The wallpaper was a similar act of defiance. "I said, 'Andy, there's nothing to sell!'" recalled Karp. "'Why not at least some individual cows?' Well, we sold about fifty sheets of wallpaper, and that was it." During the show and for the rest of 1966, Castelli sold $3,540 worth of wallpaper and pillows, half of which, $1,770, went to Andy.

Yet while Cow Wallpaper and Silver Clouds may have been a financial disaster, it generated enormous publicity for the artist himself, who was beginning to emerge as his own best product: "the Most Famous Artist," in Calvin Tomkins's term—the fine artist as pop celebrity, interchangeable with other celebrities, his output more or less beside the point.

Halfway through the Velvet Underground's stand at the Dom, they decided, along with Warhol and Morrissey, that it was a good time to go into the recording studio. Morrissey got in touch with Norman Dolph, a Columbia sales executive turned live deejay who had worked the previous October's mob scene at the ICA in Philadelphia and was now handling the recorded interludes at the Dom. Booking a studio as grand as Columbia's famous Studio B on the West Side was beyond Warhol's budget, but a friend of Dolph's, John Licata, was the staff engineer at the independent record label Scepter, which had its own studio. Warhol and Dolph put up the money, some $700 apiece, for a small amount of studio time to be squeezed in among Scepter's regular sessions; as Dolph recalled, the Velvets worked in the patches of time between sessions by Ronnie Milsap, a Scepter rhythm-and-blues artist before he made millions singing sappy country ballads. The Velvets worked for parts of four days, from Tuesday, April 19, to Friday, April 22. On Tuesday and Wednesday they recorded; for the rest of the week Licata, with the input of Reed, Cale, and Morrison, mixed the tracks. The money also bought Licata's services, which were indispensable—Dolph had no experience behind a recording console. As payment for organizing the session, Andy gave Dolph one of the *Tunafish Disaster* paintings.

Scepter, one of the great small rock-and-roll, rhythm-and-blues labels of the early and mid-sixties (the Shirelles, Dionne Warwick, the Isley Brothers, and Chuck Jackson were all Scepter artists), had recently relocated to 254 West 54th Street. (Ironically, ten years later, the address would be taken over by Studio 54, frequented by Andy in the seventies.)

On the day the Velvets lugged their gear into the studio, Scepter was still building the studio, so the place was a shambles. As Cale recalled, "we set up the drums where there was enough floor" and went to work: the band in the main room and Dolph and Licata in the recording booth.

"My basic responsibility was to keep people on the clock and moving forward," Dolph said. He might interrupt a take if he or Licata heard an obvious glitch, but once a complete take was made, the decision to keep it or make another try was, said Dolph, made by Reed, Cale, and Morrison. Dolph remembered Andy being present only a small amount of time: if the session lasted a total of twelve or sixteen hours, said Dolph, Andy wasn't present for more than two, and Morrissey made merely token appearances.

Taking no more than a few passes at each song, the Velvets cut ten songs: "All Tomorrow's Parties," "Femme Fatale," "Run Run Run," "There She Goes Again," "I'll Be Your Mirror," "The Black Angel's Death Song," "European Son," "Heroin," "Venus in Furs," and "I'm Waiting for the Man." The last three were recut the following month with Tom Wilson, who produced one more song, "Sunday Morning." The four songs cut with Wilson and the seven kept from the hurried Scepter session were released—but not for a full year, to the band's immense frustration—as *The Velvet Underground and Nico*, "one of the finest rock debut albums ever," according to *Rolling Stone's* David Fricke and many others. The album is rarely excluded from rock critics' 50 Best Albums lists.

Despite the musical limitations of the band, *The Velvet Undergound and Nico* spans a wide stylistic terrain: quiet folk-pop ("Sunday Morning," "I'll Be Your Mirror," "Femme Fatale"), jangly suburban rhythm and blues of the sort the Rolling Stones were inspiring thousands of

Lou Reed and Nico at Scepter Studios, recording The Velvet Underground and Nico

American teen bands to take up ("Run Run Run," "There She Goes Again"), the stentorian pomp of "All Tomorrow's Parties" and "Venus in Furs," the free-jazz-inspired guitar maelstrom of "European Son," La Monte Young–style minimalism (all over the place, courtesy of Cale), and more.

When the Scepter sessions were finished, Norman Dolph sent the tapes to his artist-development friends at Columbia Records and got back a memo: "It was corporately worded," he recalled, "but between the lines you could hear someone saying, 'What the fuck is this?!?!'"

FLIP OUT! SKIP OUT! TRIP OUT! Andy Warhol and his Velvet Underground and Nico with light shows and curious movies. . . . THE PLASTIC INEVITABLE SHOW is happening now!

According to Cale, "April 1966 was our best month with [Andy] and we did our best work during it. Our expectations rose daily throughout the month of April, when it seemed that everything was perfect." By the end of the month, they were preparing to export their

noise and nihilism to sunny Los Angeles: a promoter had lined up a three-week engagement at the Los Angeles club the Trip. Before they left for the coast, they had a date in Washington, D.C. In the *Washington Post*, for April 27, 1966, Leroy F. Aarons titled his article: "New Theater's 'Happening' Amuses, Angers Audience."

Warhol, Morrissey, and the EPI, an entourage of between twelve to fourteen members, flew into Los Angeles at the beginning of May. To coincide with the EPI performance, Irving Blum had scheduled a show of Warhol's inflated "clouds" at his Ferus Gallery on La Cienaga.

On opening night, swinging Los Angeles turned out in force to see and be seen. Dennis Hopper brought Jennifer Jones, Joseph Cotton, and Tuesday Weld. According to Bourdon, Sonny and Cher walked out; another source had only Cher leaving while an intrigued Sonny stayed. Ryan O'Neal was there, along with Cass Elliot of the Mamas and the Papas, a young Jim Morrison, and other luminaries past, present, and future.

The *Los Angeles Times* by no means disapproved. "For once a Happening really happened," wrote reviewer Kevin Thomas, "and it took Warhol to come out from New York to show how it's done." The review deemed the Velvet Underground "a rock group that goes beyond rock. . . . It was like a searing sound from another planet." Thomas found Malanga-Woronov's performance "sort of fetishistic, perhaps, but effective." (The article ended on a very different note, as if a censorious editor had tacked on the final paragraph at press time: it called Warhol "part con man, part prophet . . . the biggest put-on of them all.")

The *Los Angeles Free Press* (Southern California's version of the *Village Voice*) found the show bleakly bracing. Paul Jay Robbins saw it as a "revelation of blackness, the fiery char of your hope . . . a catharsis and an enlightenment. When I left, it was good to breathe the cool night air, sweet to savor laughter. I had come through an intense spatter of nihilism. . . . Warhol's show is decadence, clean as a gnawed skull and

honest as a crap in the can." A photograph of the band playing the Trip found its way into Marshall McLuhan's 1967 book *The Medium Is the Massage: An Inventory of Effects.*

But according to Cale, after the hubbub of the opening, "the club was suddenly almost empty." The EPI's din and sadomasochism were simply the wrong message for the sunny West Coast. On the third night, "we were put out of our misery" by an unrelated dispute between the club's owners that shuttered it. Learning that they could collect their full fee if they stayed in Los Angeles for the length of the original engagement, Andy and company had little choice but to sit out the next three weeks.

Idle and out of their element, the company—like vampires caught in sunlight—sank into a Southern California funk. "Our pale skin and black clothes were no longer threatening under the relentlessly happy California sun," wrote Woronov. "Without the protective shell of New York, we seemed to have lost our magic."

Most of Warhol's group stayed at a down-at-heels faux-medieval castle part-owned by the actor John Law and his brother Tom, who worked for Albert Grossman; considered a hip place to stay at the time, the Castle's clients included, among others, Dylan. But "there wasn't much partying at the Castle while we were there," according to Sterling Morrison, "because of our reputation," which he characterized as "horrible. Everybody figured we were gay. They figured we must be, running around with Warhol and all those whips and stuff."

The rest of the company stayed at the Tropicana, a seedy strip hotel. Woronov chose the Castle, Malanga the Tropicana, which occasioned a power struggle between Warhol, Malanga, and Woronov, as well as the end of Gerard and Mary's relationship. According to Mary, "There was this thing where Andy said, 'I want to go to the Castle, you come too.' And Gerard said, 'No, stay at the motel with me.' I said, 'No, I want to go to the Castle,' because I wanted to be in the midst of things."

The San Francisco rock impresario Bill Graham was eager to capitalize on Warhol's name and book a cutting-edge New York band into his Fillmore Auditorium. "We kept telling Bill Graham we didn't want to go up to San Francisco," according to *POPism*, "that all we were interested in was getting back to New York, which was so true." When Graham came all the way down to LA to plead his case, Warhol and Morrissey relented. Arrangements were made for a three-day Fillmore engagement, from May 27 to May 29. Despite its bohemian legacy, the city did not open its arms to Warhol, who flew ahead with Malanga for press conferences on May 23. Not only were the calls to a radio show overwhelmingly negative—"You've always had the best program on the air," complained one listener; "this is the first terrible thing you've ever had"—but Andy and Gerard were bounced from their hotel; according to Warhol, the manager objected to Malanga's beads. The pair relocated at the Hotel Beresford, and several days later the rest of the EPI, sprung at last from their enforced idleness in LA, flew north to San Francisco.

The Velvets and their crew didn't think much of Bill Graham, nor did they hesitate to point out the primitiveness of his light show. "We said, 'That's not a light show, Bill, sorry,'" recalled Sterling Morrison—which didn't further endear them to him. Graham's initial enthusiasm quickly soured: "He hated us and we hated him," said Cale. *POPism* has the promoter, after simmering at length, finally explode: "You disgusting germs from New York with your disgusting minds and *whips*." But Graham was eager enough to cash in on Andy's fame, putting Warhol's name atop the show poster, above all the bands. The Velvet Underground headlined, going on after the Mothers of Invention (whose leader, Frank Zappa, reportedly announced onstage that the Velvets "really suck") and the opening act, a newish band called the Jefferson Airplane.

The Bay Area could hardly have been less prepared for Andy and his brand of entertainment. Writing two years later, a partisan of the scene, the critic A. D. Coleman, angrily recalled Warhol's invasion as

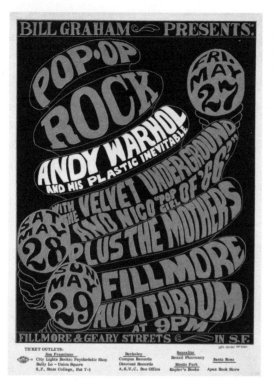

Poster for Bill Graham's show at the Fillmore Auditorium, designed by Wes Wilson

the defiling of Haight-Ashbury's psychedelic Eden: "Into this healthy body Graham injected Warhol, the epitome of uptight New York paranoia. . . . Most of the audience, bewildered by the absolute malevolence of the Warhol entourage, went into shock."

Psychedelics were the drug of choice here, not speed and heroin; the cultural thrust was toward an ecstatic collectivism. Bay Area bands like the Grateful Dead saw themselves as energy sources for communal love-ins. The Velvets took the very opposite tack: solipsistic withdrawal, the alienation-unto-death of "Heroin"; no wonder "they scared the fucking socks off everybody," as one attendee recalled. At least Los Angeles's critics had been generally respectful; here, the jazz and rock pundit Ralph J. Gleason, about to help found *Rolling Stone*, called the Velvet Underground "a dull group" and the EPI "a bum trip. . . . If this is what America's waiting for, we are going to die of boredom."

"We were entering enemy territory," said Cale. "The people and the

kind of music were anathema to us, and we didn't mind telling anybody that would listen what we thought of it and them. And people really didn't take to Andy that much."

The troupe flew out of San Francisco on May 31. Danny Williams stayed behind, partly because he wanted to, as he wrote in his journal, and also because the company was carrying too much equipment for its return flight to New York. Danny and eight hundred pounds of gear were to rejoin the EPI in Chicago, where they were booked into Poor Richard's for a week, starting June 21.

To Mary Woronov, San Francisco was "the culminating horror. . . . By that time, we'd really had it. The group returned broken up. When I went out there I was very close to Gerard. When I came back I wasn't. And also Warhol was very upset. He expected people to look at his movies. They didn't even talk to him, they wouldn't see his band, they wouldn't do anything. When we flew back, it was like we desperately needed air to breathe, we had to get a New York fix or we would perish."

Actually, the group, or at least part of it, flew to Boston, where Nico had been hired to introduce a vintage-movie series on the city's RKO affiliate, WNAC—no doubt the same offer that Morrissey had fielded a few weeks earlier at the Castle. The "Inevitables" were to fly to New York on June 2, evidently broke.

Eager to promote Nico as the Velvet Underground's centerpiece and the Factory's latest "Girl of the Year," Morrissey and Warhol had arranged for her to host a late-night series of campy B movies (*The Lone Ranger and the Lost City of Gold*, the Maria Montez vehicle *White Savage*, *King Kong*, *Mothra*, the first *Tarzan* talkie, *Tarzan the Ape Man*, etc). Camera-shy as always, Andy was to serve as "consultant." In its press release, Boston's WNAC-TV heralded itself as "the first station in the nation to go Camp with Pop Art Movies for the In Group."

WNAC announced that Nico had been named "Miss Pop-Off of 1966" (maybe Andy and Morrissey were trying to distance themselves

from "Girl of the Year," itself pretty moldy by now). After she taped her introductions to the movies, WNAC threw "a 5:30 to eternity Pop Art–Las Vegas Gambol Party" for Warhol, Nico, "and other glamazons from his underground movie entourage," plus five hundred industry functionaries. According to WNAC's lengthy press release bio, Warhol "paints the gamy glamour of mass society with the lobotomized glee that characterizes the cool-it generation." His home was described as "crammed with eccentrically elegant artifacts of a bizarre civilization. . . . To Warhol, everything and nothing is art. . . . Warhol is an artist, a catalyst and a perceptive observer of contemporary life whose comments are sometimes astute by being no comments at all."

When the travelers finally arrived in New York, Lou Reed checked into Beth Israel Hospital with hepatitis. In Reed's version, "I was one of the first Medicare patients. A drug I shot in San Francisco froze all of my joints. The doctors suspected terminal lupus, but this turned out to be untrue." In any case, he was in no condition to fly to Chicago for the band's next job. Nor was Nico available; she'd flown to Paris to visit her four-year-old son Ari, whom she'd deposited with friends earlier in the year. Several personnel shifts were called for. Sterling Morrison played all guitars and helped Cale with vocals, Maureen Tucker switched to bass, and Angus MacLise made a return visit as drummer—strictly for now, Reed underlined to the ex-drummer, summoning MacLise to the hospital. "You're on a temporary basis," Reed made sure to say. ("Lou was always nice like that," Sterling Morrison recalled.)

Despite the absence of Reed, Nico, and Warhol (Andy evidently promised to turn up, but didn't), the EPI was a big hit at Poor Richard's, which gave the band a second week, through July 3. *Variety*, reviewing the show at length in its June 29 issue, was highly positive. The influential showbiz weekly called the show "a three-ring psychosis that assaults the senses with the sights and sounds of the total environment syndrome." The Velvets, "a four-piece big beat band that specializes in

discordant music," kept up "a pulsating tempo. . . . The Velvet Underground's throbbing cadences prove to be extremely interesting."

That *Variety* singled out the lighting—Danny Williams's bailiwick—as "the most impressive part of the show," would by itself have ratcheted Morrissey's jealousy higher still (probably irritating Andy as well). But the paper went even further, applauding "lighting man Dan Williams" as the "mastermind of the 'Exploding Plastic Inevitable.'"

The rivalry between Morrissey and Williams inevitably exploded into a fistfight. "I was playing the piano," Cale recalled. " 'Waiting for the Man,' I think it was—and I couldn't figure out what the hell the audience was looking at. At the end of the number, I hear this rumpus up in the balcony, where everybody was looking. Sterling told me afterwards that Paul and Danny were going at it because Danny had stolen one of the extension cords and Paul couldn't move the projector around."

The reviews were scathing, but the held-over audience took to the band enthusiastically. "The Velvets tried to make the most of their Chicago stay," according to Sterling Morrison. "We didn't lay low just because we didn't have Lou, Nico, or Andy. On the contrary, I would say we made ourselves rather conspicuous," appearing on Studs Terkel's radio show, among others, "doing all of that sort of on-tour stuff, we made a ruckus," but this didn't translate into commercial success. Despite having signed with Verve, there was no sign of the album. Only two singles were to come out in all of 1966, and despite Danny Fields's efforts to talk them up in the mushrooming teenybopper market, the outlook for the Velvets was downbeat.

The notebooks Danny Williams kept during May and June 1966 form a sort of subtext to the EPI's western tour, offering glimpses both into Williams's active mind and into the dynamics of the 1966 Factory: an increasingly volatile web of rivalries presided over by someone who had probably as little an idea as his minions where they were all headed.

The notebooks teem with Williams's technological, business, and aesthetic ideas; with career plans—one of which was to go to work designing light shows for Bill Graham; with insights into Warhol, more often than not disillusioned; with a constant struggle between ambition and self-doubt ("I think I can do anything but I don't know what to do," Danny muses); with bare-bones strategies for daily survival (like most of the entourage, he got by on almost nothing).

One of the most surprising strands of Danny's thought is his preoccupation with marketing ideas. This was no Thoreauvian hippie but an embryonic marketing strategist. The idea Danny returns to again and again is that of somehow franchising the EPI: "So long as billing is kept separate, Andy Warhol & his exploding plastic inevitable can be staged with any band. We needn't be stuck with one group or be one group. There could even be six Andy Warhol & plastic inevitable shows."

As imaginative as he is prescient, Danny nevertheless obsesses over details. "How much current can be obtained from cigarette machine?" he asks himself. "Can power be sent by lasers. . . . Put prisms on bicycle wheels. . . ." There are designs for a flexible plastic ballpoint, movie ideas, including one about a "guy who goes to heaven and becomes straight." Or, he ponders, what about a Madison Square Garden wedding? "6 rock bands, a choir of 100 ministers saying the vows etc." Williams's frustrations with his overextended, underpaid role also bubble through: "I won't continue to create the show and get no billing, no extra pay & no part of corporation." His influence eroding, his relationship with Andy falling apart, he begins to have dark, paranoiac thoughts: "I see where factory is at but am not part of it yet . . . as it is I am a shadow—sometimes shouting—sometimes asking for attention sometimes turning everyone on (rarely)."

Ultimately it would all come down to a competition with Paul Morrissey. Though he lacked Danny's imagination, Morrissey was far better organized, far more reliable, and a lot tougher. In a power struggle

between the two, which is precisely what occurred from late 1965 to mid-1966, Williams was doomed.

By the time Danny had filled several notebooks with his audacious, sometimes brilliant ideas, he was writing in a vacuum, for he no longer had Andy's ear. His only real hope was to leave, which he half realized. He understood Andy's shortcomings and finally realized Morrissey's formidable self-interest. But the unfortunate Danny could not disentangle his emotions from Warhol and the Factory.

While the EPI was in Chicago, Warhol likely started work on several paintings: the self-portrait based on his April show-announcement photograph and two commissioned portraits, *Frances Lewis* and *Holly Solomon*. The latter, a nine-panel photobooth-based silk screen, is arguably one of Warhol's finest paintings. It came about by accident.

Sam Green had known Holly Solomon, a bright, restless woman and former actress, since his early sixties days manning the front desk at Richard Bellamy's Green Gallery. "Holly and I were big buddies and telephone gossips," Green recalled. "I sat at the Green Gallery with nothing to do and she sat in her bed off Sutton Place and we'd gossip all day long on the phone. She was not getting many acting jobs, and I told her to get smart and to use the publicity garnered by the new artists to get herself noticed—to have Andy Warhol, for instance, do a portrait of her."

Green got Holly's husband Horace, a cultivated Yale graduate who ran the family hairpin business, to commission the sculptor Richard Artschwager to make Holly's portrait. "And then I remember dragging Horace and Holly up to Christo's loft with the idea of getting Christo to do her portrait. Roy Lichtenstein wouldn't do a portrait but said he'd do a painting that was *like* Holly but was basically just another Lichtenstein cartoon painting."

Holly had first visited the Factory in 1964, when "Sam took me to see an *Elizabeth Taylor*. He wanted me to get one, because I was a baby

collector then." She and Warhol "talked, not very much, but pretty personally. He'd say, 'Hol, Hol, why don't you do . . . soaps?'" It's possible that Solomon put the notion of silk-screening wallpaper into Andy's mind: according to Holly, "I wanted him to do the identical image [Marilyn] as wallpaper, printed on cloth. A whole room. I was into the eighteenth century à la Mrs. Kennedy and all these ritzy decorating books, like Joy Baldwin copying a Matisse."

A seasoned hand by now at photobooth-based portraits, Andy led Solomon to a Photomat "and gave me like forty dollars' worth of quarters," she said, recalling the session as occurring in 1965, long before the painting was sold. "I was so bored in there, I vamped," precisely what Andy had in mind.

He also wanted a prohibitively high $6,000. Horace Solomon balking at paying—he preferred Lichtenstein, in any case, from whom he commisioned what became the well-known *Portrait of Holly Solomon* (*I'm Sorry*).

When Holly turned up at Castelli's with the balance of Lichtenstein's money, probably in June 1966, the assistant David Whitney mistakenly assumed it to be a down payment for the long-languishing Warhol portrait. "Andy phoned me," Holly recalled, "and said, 'Gee, Hol, I'm glad we're doing the portrait.'" Putting two and two together, Holly was horrified. She immediately telephoned Ivan Karp, who told her, "Let him do the portrait." If she didn't like it, Karp reasoned, Castelli's could probably sell it eventually.

A short time later, the Solomons drove Horace's Aston-Martin to the Factory. As Horace Solomon recalled, the studio was practically empty. There were six 30-by-30-inch canvases of Holly on the floor.

"Horace was standing there looking at them," said Holly. "So Andy and I asked him, 'Well, which ones do you like best?' because I couldn't decide. And Horace looked up and said, 'Andy, are they dry?' Andy said yes. And Horace said, "We'll take them all, it's a masterpiece.' He'd like to paint two more panels, Andy said, and include the piece

in an October retrospective in Boston; grudgingly Horace granted both requests.

When the painting came back from Boston, the Solomons unwrapped the panels. "Put them around the room," said Holly. "I had an *Elizabeth Taylor*, the best one; Sam Green had helped me pick it out. I had two *Marilyn Monroes*. I had the best gold *Jackie*, and Lichtenstein's *Anxious Girl*. Horace said, 'Goodnight, sweetheart,' and went to bed. And I just sat in the living room and I remember that my cheeks got red hot. I really got embarrassed. Because this new painting, Andy's, was the inner, sexual Holly, that I really didn't want exposed to the world. Here I was presenting myself as . . . hot to trot is putting it nicely. . . . Ethel is the *Vogue* lady, every hair in place. Lita Hornick [another 1966 photobooth Warhol subject] looks like a Buddha, a priestess of art culture, which she was. But me he does as this disturbed, this *sexual*, person. He understood. Andy was empathetic. That's why I called the picture 'Holly being split up.'

"When this painting was shown at the Whitney, it was one of Andy's first portraits that wasn't of a known icon," which led to some comments. "Some time around then," said Solomon, "Jasper said to me, 'How does it feel to be dead, Holly?'"

But as Michael Egan pointed out, "That portrait of Holly Solomon, which is ravishing, is also a scary, terrifying, nightmarish, Rimbaud-like image. I'm sure people who posed for Lucien Freud feel the same way. His obligation was to his art and she was just a momentary subject for his art, and she became a momentary product."

As if to make up for the half-year spent mostly away from a movie camera, Andy went on a filming jag that summer. In a four-reel sequence shot at George Plimpton's Upper East Side town house, Ed Hood reenacted his put-upon john role from *My Hustler*, fending off interlopers while trying to make time with his trick of the moment. Brigid Berlin let Andy bring his camera into her Chelsea Hotel flat,

Front row: René Ricard, Susan Bottomly, Eric Emerson, and unidentified woman
Second row: Mary Woronov, Andy Warhol, Ronnie Cutrone

where he captured one reel's worth of Berlin's overwhelming personality. Another project, *Hanoi Hannah*, was based on a script by Ron Tavel about a Vietnam-era Tokyo Rose (World War II's notorious Axis propagandist). Three color sequences were probably shot in late July or early August: *Their Town*, based on another Tavel scenario; at least four reels of Eric Emerson, a short, blond muscular dancer Warhol had first met doing a spectacular leap at the Dom (Emerson talks to the camera while taking off his clothes); and a single reel of Nico alone. Most likely in early- to mid-August, Andy shot the two-reel *Gerard Malanga Story*, ostensibly a vehicle for Gerard, still in there pitching for underground-film stardom. But he was foiled by Marie Menken, who played his mother. According to the third actor, Woronov, "Gerard couldn't control Marie and she just talked talked *talked* about anything that came into her head."

Fascinated by Ondine's occasional habit of posturing as "Pope Ondine," the spiritual leader of Lower Bohemia—"homosexuals, perverts

of any kind, thieves, criminals of any sort, the rejected by society. OK? That's who I'm Pope for"—Andy filmed three reels of the Pope hearing confessions from Woronov, Susan Bottomly (a fashion model better known under her Factory nickname, "International Velvet"), the new-comer Angelina "Pepper" Davis, Ingrid Superstar, and others.

Whoever else Andy filmed or didn't film that summer, the end result would be his commercial breakthrough, *The Chelsea Girls*. The film, in other words, was not conceived until after it was shot. As Paul Morrissey said with characteristic asperity, "It was not a film, it was not *made* as a film, these were experiments"—Morrissey's disparaging term for Warhol's spontaneously shot, unedited footage—"from during the time I was managing the Velvet Underground. There was a lull, of which there were a lot, and we said, 'Let's shoot something.'" Malanga phrased things more generously, calling *The Chelsea Girls* "a divine accident because it was shot as individual . . . movies. . . . Toward the end of shooting all these films, Andy decided, 'Well, let me show all these films as double-screen, and see how successful they'll be.'"

It's difficult to know how long Warhol considered gathering all of this disparate footage into a single movie. Perhaps for weeks; perhaps it came in an intuitive flash. As Malanga's 1967 remark indicates, the decision probably came late. In any case, as soon as it was made, a loose but effective structure was quickly erected.

Although the summer's footage was shot all over town—the Factory, critic Stanley Amos's crash pad, Plimpton's Upper East Side town house—much of it wound up being filmed at the Chelsea Hotel ("the well-known West 23rd Street hostel for bohemians," as the *Times* deco-rously described it), where Brigid Berlin, Nico, Susan Bottomly, and other Factory regulars were currently staying. Presenting his footage as a series of glimpses into the lives of the Chelsea's raffish residents piqued Andy's imagination. A dozen or so reels (the number wasn't fixed at first) were plucked from the mass of footage. Each reel was assigned a fictional Chelsea Hotel room number, as if that's where the action had

been shot. Andy's two-projector conceit finally had a tangible payoff: one's gaze, moving back and forth between two simultanerous scenes, generates an effect of "meanwhile": of lives unfolding (or unraveling) in adjacent rooms. When the effect works, that is. Characteristically, Andy's hotel conceit was only half thought through. When the same actor is in two scenes at once, or when a scene—say, the choruslike *Their Town*, drenched in Southwestern ambience—couldn't possibly take place in a hotel room, the illusion of peeking through two separate keyholes collapses.

According to Malanga's diary, they were shooting as late as September 10, five days before *The Chelsea Girls* opened. The Cinematheque's weekly *Village Voice* ads were usually tersely factual; this week, however, Mekas pulled out all the stops. The advertisement read: "Announcing the World Premiere of Eight Hours of the New Epic Film by Andy Warhol, 'The Chelsea Girls' . . . in color and black-and-white."

The big *Voice* ad, playing with the Chelsea Hotel fantasy, listed each scene by room number: "Room 723—Pope Ondine; Room 422—The Gerard Malanga Story; Room 946—George's Room; Room 202—Afternoon; Room 116—Hanoi Hanna; Room 632—The John; Room 416—The Trip; Room 822—The Closet." *The Chelsea Girls'* earliest viewers saw a very different film from the standard version that audiences have come to know. Three of the ad's sequences had been pulled by the end of the year: "George's Room," two reels featuring Silver George Milloway, one of Ondine and Billy Name's A-head friends; "Afternoon," a reel of the previous year's Edie Sedgwick vehicle; and "The Closet," with Nico and Randy Bourscheidt, an occasional Factory visitor.

According to Bob Cowan, the Cinematheque's projectionist in 1966, viewers in September saw a different film each night, sometimes a radically different one. In Cowan's memory, opening night was "more in the nature of a run-through" than a premiere. Technically "hopeless" reels were rejected ("a lot of the sound was incredibly bad") and the reels' order was altered on the spot. On the second night,

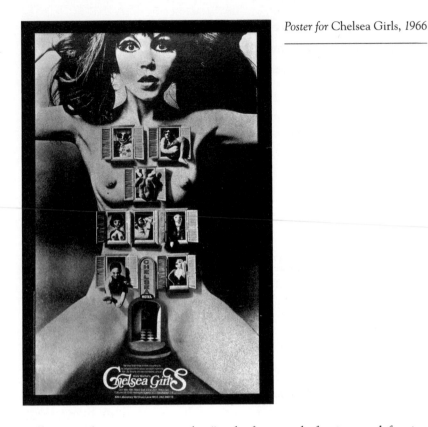

Poster for Chelsea Girls, *1966*

still more changes were made, "and after much fussing and fuming around, Warhol and crew left the theater and wished me luck. During the entire run of the film, I never saw them again." In true avant-garde spirit, Cowan (a filmmaker himself) never showed *The Chelsea Girls* the same way twice "if I could help it." He tried to make each screening a challenge, to see "what new combinations I could produce." The only constant was the split-screen format; otherwise, Cowan played things fast and loose. Sometimes he waved a piece of glass in front of one of the projector to make the on-screen image flicker; sometimes, using a mirror, he beamed the picture onto the ceiling—shades of the EPI.

Billy Name (who insists that the "Warhol crew" stuck around for the rest of the first run) recalled the same type of experimentation, especially with the choice of reels. The way *The Chelsea Girls* is shown

now—the same twelve reels in the same order—"is not how we used to do it," according to Name. "We played with it each night, deciding which reels we were going to show, which would have sound and which wouldn't, and our choices were different every night."

Attendance for the first Cinematheque run, from September 15 to September 28, was solid but by no means remarkable: on only three of the fourteen nights did the two hundred-seat theater draw more than one hundred viewers. The nightly average, just under seventy, was at the bottom end of what Mekas had, nine months earlier and probably optimistically, estimated as the 41st Street Cinematheque's average crowd in its opening month.

On the other hand, September's Cinematheque numbers eclipsed Warhol's usual business. The two weeks netted Andy $339.18; in the previous four months, nationwide theatrical rentals of his films had brought Andy a net profit of $330. Within weeks of that first September run, Andy's chunk of *The Chelsea Girls'* weekly gate would no longer be reckoned in three-digit sums: the street buzz the film was generating, incited by Mekas's and Morrissey's *Village Voice* ads and news releases, would see to that.

When Danny Williams got back to New York from Chicago, he continued to live at the Factory. It's impossible to know whether he took part in any of the filming that eventually became *The Chelsea Girls*, although he would very likely have been involved in anything shot before late July. On the 24th of that month he took an overnight train to Boston, arriving the next morning at his parents' house in Pigeon Cove, part of the North Shore town of Rockport; Danny's family had summered there since before he was born.

According to observers at the Factory, Danny was by this time completely strung out on amphetamine. Arriving in Pigeon Cove, he seemed in good spirits, if "exhausted"—his mother's description. On the afternoon of the 25th, he took his mother's car to his brother's

nearby cottage, where he ate supper with his brother and sister-in-law. After dinner he drove off, saying he needed some air before joining a party in progress at his parents' house. To his sister-in-law, he seemed agitated, he left "hurriedly" and possibly upset—or high on speed after popping pills in the bathroom before dinner.

In the morning, assuming that he'd spent the night with friends, Danny's mother washed the cardboard box of dirty clothes he'd left next to the family washing machine. That afternoon, Danny's brother and sister-in-law found the car parked atop the breakwater that shelters Pigeon Cove Harbor from the stormy North Atlantic. The gravity of the situation immediately hit the family. At that point—late afternoon of the 26th—his parents telephoned the police. Despite a thorough search of the area, no trace of Danny was found. Frantic by now, the Williamses spent the following day searching the shoreline and phoning Danny's friends in Cambridge and New York.

In the following weeks, the family did all they could to find Danny. On August 17, still holding out hope that her son was alive, Nadia Williams called the Factory, where Andy evidently refused to come to the phone. So she wrote him: "If you hear any word of his whereabouts," she asked, "please let us know. To know he is alive would be such a help. If he wants to remain apart, that is his choice, but we'd like to know roughly where he is for we love him very dearly." Two weeks later she wrote Andy again. By now she was trying to come to terms with the reality of her son's death. Danny had drowned, she believed, the victim of a cramp from his 'three-helping' meal." Her family's "only consolation" she wrote, "is the fact that this is a beautiful spot—a place Dan loved—where as a boy for three summers he had lobstered off his orange skiff. He had set his pots some of those nights off those same rocks."

Andy never wrote Nadia Williams back. Housepainters eventually found Danny's pants, keys, and watch. They had snagged on a license plate that was lodged in the rocks. The police said they could not con-

clude that he had removed his pants; they might have come off in the water. But the worst part of Nadia Williams's scenario was confirmed: her son had clearly drowned. Whether he died by accident or not is impossible to say.

The Williamses never received a letter of consolation from anyone at the Factory. On October 8, a mutual friend of Andy's and Danny's, Logan Smiley, wrote Mrs. Williams. According to Smiley, he mentioned to Warhol that he planned to write Nadia; Andy encouraged him to do so and gave Smiley the address.

Eleven months after Danny vanished, his father killed himself.

Early critical reactions to the second and third Cinematheque screenings of The Chelsea Girls were positive. According to Toby Mussman, critic at large for the East Village Other: "The Chelsea Girls is Warhol's masterwork to date. There will be several more to come." The first mainstream encomium came from Newsweek's Jack Kroll, who had been one of Andy's first Pop art supporters in the national press. In the magazine's November 14, 1966, issue, Kroll wrote a review entitled "Underground in Hell," heralding The Chelsea Girls as "a fascinating and significant movie event." Warhol's earlier films, said Kroll, had "asked, with idiotic relevance, primitive questions in a time whose supersophistication is simply another form of insanity. Now Warhol has turned his baleful, catatonic camera on the dropout generation and asked them to show us how they drop. . . ." The movie "sets the eyes on alert, the teeth on edge and the heart on trial. . . . Sad, bad, mad, glad world, caught in the convolutions of its own put-on. But The Chelsea Girls is one of those semidocuments that seem to be the most pointed art forms of the day. It is as if there had been cameras concealed in the fleshpots on Caligula's Rome." (From the mid- to late sixties, American commentators delighted in drawing parallels between their time and the last days of Rome.)

The third Cinematheque stint was a near sellout for two weeks,

after which it moved on December 1 to Cinema Rendezvous. Elenore Lester, in a *New York Times* article entitled "So He Stopped Painting Brillo Boxes and Bought a Movie Camera," noted the film cost $1,500 to make.

As mentioned previously, a major innovation in the screening of *The Chelsea Girls* was the use of a split screen: two independent adjacent scenes, one with sound, the other without (or almost so) would be projected simultaneously. The two scenes were always staggered, the scene on the left (the odd-numbered reels) starting about five minutes after the one on the right. According to instructions sent out by Warhol's then-distributor, the Filmmakers Distribution Center, odd-numbered reels—"Nico in Kitchen," "Brigid Holds Court," "Hanoi Hannah," etc.—were to be shown to the right, even-numbered reels to the left.

The Chelsea Girls starts with a typically Warholian sense of languor and inconsequence. In the cluttered kitchenette of her Chelsea Hotel flat, Nico trims her bangs, interminably. Although Eric Emerson, who was briefly Nico's lover, and her small son Ari are here, too, the scene is really an excuse for an extended Nico portrait.

The action has barely begun when the sound cuts off. Lit by Billy Name in sharp black-and-white chiaroscuro, Ondine appears to the left, with a blanket draped over his head, an improvised cassock—he's here as Pope Ondine. Two filthy Factory sofas have been shoved back-to-back as his confessional; sitting on one, Ondine impatiently calls for sinners. Enter Ingrid Superstar, and the two improvise a spirited badinage. (When she muted her hysteria, Ingrid could be deftly funny.)

Nico, Emerson, and Ari interact noiselessly on the right; Ondine and Ingrid begin swapping insults on the left. He's a fool, she's a twerp, a mongoloid, a pig. Clearly a lesbian. Ingrid denies it. Nonsense, says Ondine; he's seen her at Page Three, the Bagatelle, and other dyke joints. And I'll twist your tits if you don't tell me the truth. *Why are you*

a lesbian? He cuffs her lightly; no patsy, she returns the blow, Ondine ducking it.

They're still scrapping, but soundlessly now, as the opposite frame empties itself of Nico's threesome and fills with Brigid Berlin's fat dimpled face, eyes darting left and right: amoral glee personified. She lovingly fills a hypodermic needle as Ingrid Superstar drops in. "Another Korvette's special?" sneers Brigid at Ingrid's paisley pants suit; yanking down Ingrid's pants and panties, Brigid injects her in the butt.

"Seen Andy lately?" she asks Ingrid. She herself never goes to the Factory anymore, she allows. "That was last year. There's nothing to do up there now," and she can't handle Andy's paranoia about her drugs. "Are you in love with Andy?" she asks Ingrid. No, Ingrid scoffs. Is Brigid in love with Rotten Rita? Indeed she is, and with "Genevieve [Charbin] and Debbie [Caen]" too. "Kinda mixed up, aren't you?" says Ingrid. "You really love to destroy people, don't you?"

"Yes," Brigid says, "I'd love to destroy *you.*" She tries phoning "that Jew uptown," Arthur Loeb. No answer. She tries "Dropout" (Debbie Caen); merely dialing Dropout's number "makes me so hot I feel like I've had a trip of niacin!" She laughs madly. No answer there either. "Let me fix that for you," she tells Ingrid, grabbing a hand mirror from Ingrid's grasp and shattering it on the floor. She mimics Ingrid, moaning, "Brigid, I need a *downnn,*" then turns her ire on herself: Rotten Rita won't fuck her because "I'm a fat fucking horse. Besides, I'm a girl."

The phone rings. Brigid discusses LSD prices with the caller. She scoffs at the notion of going to a party for the Rolling Stones and announces, ex post facto: "I feel like breaking things." The phone rings again. "I don't have time to talk, I'm on the john," she lies, hanging up. It rings again immediately. She answers it. "Wanna buy some? You know anyone who wants to buy any amphetamine, it's crystal-clear like snow in the middle of January on the windowpane, I mean it's the *end.*" She sets up a deal for midnight; she'll be at the Café Figaro, she says, "or anywheres down there. I'll be on my bike. Riding along. Oh,

I've gotten thinner. And I wear a very smart jacket that covers everything." She holds a shard of the broken mirror to her face: "Are my eyes yellow?"—the needle user's worry.

"The Duchess" is a bravura, harrowing performance. As Morrissey recalled, "Brigid had never really been in front of the camera before"— in fact, Danny Williams had already shot a still-unreleased *Brigid at the Masque*—"but she had something to talk about. She was such a great character, great personality, still is. That was a lucky thing."

Not surprisingly, Morrissey insisted that he was responsible for much of the movie's directing. "By the time *Chelsea Girls* came along," according to Morrissey, "I was talking to each person for quite a bit before a scene started," and after, too. "Do you notice who Ondine's talking to? Watch it again—he's talking to me. These people were not taking direction from Andy, they were taking direction from me."

Billy Name strongly disagreed. Morrissey was a significant factor in the films "only in the sense that Paul took over what Gerard or I had done earlier"—logistical, not directorial, work. "Anything Paul claims about taking a directorial hand in anything pre-fall 1968 is horseshit. Because Andy would not have it. They had discussions about it. Andy had to tell Paul that when he said he didn't want them to act, or wanted it to be 'wrong,' he meant it. These were the only times I remember Andy feeling that he had to tell somebody what his art was, and to quit trying to stop him from making it. It was the only time I ever heard Andy stand up for his aesthetic to anybody: when he finally had to tell Paul, 'NO!'"

For most of Brigid's rant, Ed Hood has been across the screen, in bed with an increasingly drunken-looking young man who wears only a pair of underpants. Hood looks on as Susan Bottomly, Mary Woronov, Gerard Malanga, and the poet and art critic René Ricard vie for his trick's attention. At some point after the sound kicks in, Hood distastefully calls Woronov "a large female with a belt," which Woronov uses to truss Hood's trick: rolling him onto his stomach, she ties his hands behind his back. As they wrestle listlessly the trick's penis comes into

view for a long second: the first frontal view of male nudity in a widely seen American movie.

Reels 5 and 6, which follow Brigid and Ed Hood, respectively, were shot in Bottomly's apartment in the Chelsea. They contain some of the film's only scripted material, a few stray chunks from Ron Tavel's play *Hanoi Hannah*. The title character is one of the few Vietnam references to issue from Warhol's hermetic world. The script calls for Hannah (Woronov) to broadcast American propaganda to homesick GIs, all the while terrorizing her three female companions (Susan Bottomly, Ingrid Superstar, and Pepper Davis): a typically surreal Tavel premise. But only Woronov, and occasionally Davis, make stabs at delivering the text. "I was an actress," recalled Woronov, "or wanted to be. The others just wanted to be stars. They were not really thinkers. Bottomly was not the brightest thing in the world. Pepper was insane. For the most part it was total fucking chaos."

The first *Hanoi Hannah* reel ends with Hannah going about her propaganda work, broadcasting an interview with a combat GI (Davis). The soldier's memories of his Midwestern home aren't pastoral enough for Hannah, who hectors Davis into spinning a more sentimental picture. It's one of the few points at which Tavel's caustic politics are conveyed; his intentions are otherwise sabotaged by the actors' failure to follow the script.

With the second *Hannah* reel still playing in the left frame, we return for another round of Ed Hood's amatory travails. Hood asks his uncooperative trick about "this cabinet officer that you've been dealing with," a reference to the 1964 Walter Jenkins scandal (in which the top aide to Lyndon Johnson was caught performing oral sex in a YMCA bathroom). "How could you betray your Irishness by hustling up a member of the Johnson administration?" Hood drawls. At this point Mario Montez enters, pleading, "I'm just a housewife, that's all." Five minutes into the scene, the left-hand frame blossoms into *The Chelsea Girls'* first color reel.

The Gerard Malanga Story presents a strange threesome: Malanga

as a loutish, self-satisfied aesthete; Marie Menken as his mother, a sulfurous harridan who berates her son nonstop; and Mary Woronov as Malanga's evidently browbeaten fiancée. Sitting stiffly and primly off to one side, she is silent throughout, refusing to speak even when Menken asks her name. The set, intended as the title character's apartment, was actually a corner of Stanley Amos's crash pad off Washington Square. The walls are covered with free-form illustrations and graffiti. In the elaborately cursive hippie calligraphy of the day, someone has written "Fuck for Peace" next to a painting of an enormous engorged penis. Off-screen, the Velvet Underground jam meditatively. Gerard's bullwhip hangs from his bedstead. There's a smaller whip, too, with which Menken punctuates her outbursts, whacking the bed. "I don't know why I even bore you into the world!" she fulminates. "I should have had an abortion. It's too late now."

Opposite *The Gerard Malanga Story*, reel 9 begins with Eric Emerson's solo turn, sometimes called "The Trip," sometimes "Eric Says All." Throughout, Emerson affects the semicultivated drawl that Ronnie Cutrone called "part of Eric's hustle. Eric was all street smarts. He could meet you and within thirty seconds he knew what made you tick, knew your darkest fear, what you loved, who you were. And if he didn't like you, he could tear you apart."

Warhol's directive to Emerson was to take off his clothes while talking about anything that came into his head. "I don't really have anything to say," Eric begins, clearly whacked out on something; staring into his one prop, a shiny piece of sheet metal. "So I won't say anything. I'll just sit and groove on myself. Do you ever just groove on your own body? I like the feeling of having nothing on. I try to wear less, or least as possible." He doffs his shirt to reveal a perfectly shaped torso, then his jeans, showing us most of a reddish-blond pubic patch and the thick top of his cock. Fashioning his shirt into a loincloth, he wears it for the rest of the scene.

As Eric ponders the hustler's life, a new scene unfolds to the left, Ron

Tavel's second contribution to *The Chelsea Girls*. Tavel's scenario, usually called "Their Town," is a gay outsider's negation of *Our Town*, Thornton Wilder's hymn to American inclusiveness (ironically, Wilder himself was gay). The idea for "Their Town" came from Andy, who had avidly clipped *Time*'s and *Life*'s several late-1965 and early-1966 stories about Charles Schmid, an Arizona serial killer. Not only did Schmid's age—he was twenty-two when he began his killing spree—give Andy another chance to offer a picture of American violence, but Schmid displayed a narcissism that resonated with Warhol: he dyed his hair black (like his hero Elvis), penciled a mole on one cheek, wore pancake makeup, and crammed tin cans and rags into his cowboy boots to make himself taller than his pint-sized five feet, three inches. Schmid's story hit home with Tavel, too: in the 1950s, when he was a graduate student in Wyoming "and such things were not yet understood," the playwright recalled, Charles Starkweather and Caril Fugate's murder spree had traumatized the surrounding area. Two years after *The Chelsea Girls* was shot, Tavel rewrote "Their Town," which became his most successful play, the Obie-winning *Boy in the Straight-Back Chair*.

The scene's players—Emerson (as "Toby Short," the murderer), Pepper Davis, Ingrid Superstar, Susan Bottomly, Ronnie Cutrone, Mary Woronov, and others—stand clumped inside a cramped enclosure (built by Billy Name), stiffly reading their lines from a prompter. Name's gorgeous colors wash over them, in counterpoint to the gruel-thin language Tavel opted for. In the standard, authorized version, the scene has sound for most of its first eight minutes. "When I'm reincarnated, it'll be as a cat," says Pepper Davis's character. "I've got plans May is going away," says Emerson/Toby about one of the girls he intends to kill.

"Oh, how pinpointed his eyes are when he says that," shrills Ingrid Superstar. "Pinpoint eyes, piercing eyes, look right through you. [Charles Schmid was vain about his deep-blue eyes, considering them his best attribute.] Beautiful eyes," continues Ingrid. "Deep-set they

are, very blue. Ocean blue. Wish I had blue eyes like that. Wish I were by the ocean. I wish this town here was by the ocean. It wouldn't be so bad at all if it was by the ocean."

"Clear dark waves smashing up against the beach," Emerson/Toby half responds. "Funny world, isn't it, where no one cares about killing. . . ."

"Their Town" is still unspooling when Emerson's solo spot ends. Into Emerson's place in the right-hand frame slouches Ondine, about to begin reel 11, the most powerful scene Andy Warhol ever filmed, and one of the most powerful in the cinema of the time.

A half-dozen years after *The Chelsea Girls* was made, Ondine told Stephen Koch that he was determined to break "the spell of boredom"—the words are Koch's—"that he thought hung over the whole enterprise," that is, Warhol's film endeavor per se. "He wanted some action. Ondine was a totally histrionic flamboyant creature, and as far as he was concerned, this thing was either going to be interesting or not and it was up to him to do something about it." He'd tried and only half succeeded in his earlier scene. Now he pulls it off.

He opens, typically, with a kvetch. "Being Pope has been a horrible gruel," he says. "I haven't had *one moment*'s good time." Extracting a hypodermic needle from a crumpled paper bag, he ties off and injects himself in the back of his wrist. One is reminded of *POPism*'s paean to Freddy Herko and other Factoryites, including, of course, Ondine, the "leftovers of show business," the beautiful losers who felt they could work only when they were high.

"Shut up, Paul," he says playfully. "Did you bring soda, Gerard? I'm willing to hear anybody's confession, Paul."

He had been expecting "a rather large girl on a bicycle named Brigid," but Brigid hasn't arrived. So a substitute comes forward, a young woman named Ronna Page, Jonas Mekas's girlfriend at the time. "Sit down, darling," says Ondine. "Not on my hypodermic needle." Page hesitates, clearly ill at ease. "*Quickly*," the Pope snaps. "The cameras are rolling. Cameras, yes. This is a new kind of confessional. This is called *True Confessions*."

She has a tremendous love for Jesus Christ, says Ronna. The problem is, it's sexual.

"Blow him," comes the instant reply. "Go right down on his image."

"Then I'll be freed?"

"You'll be freed. Go up to the nearest image of Christ. Kneel down, peel away the loincloth in your mind and do what you have to do. Oh, you'll have a wonderful time, my child!"

The talk turns to the afterlife. Just where *is* heaven? Ronna asks.

"You figure it out, Mary. I'll give you a road map."

"But I don't *want* to go to heaven." She wants to stay on earth.

"Well then, leave the confessional."

"But I'm not finished!"

"All right, go on."

"I want to"—she looks at the floor—"to confess about my disrespect for your . . . listening."

"That's all right," says Ondine, all largesse. "Everyone's skeptical."

"This is not really skepticism at all," the girl says. "It's just that . . . I think you're a phony!"

His eyes slits of rage, he hurls a glass of water in her face. Leaping to his feet, he slaps her four times and shakes her hard, twice. Arms cradling her head, she tries to ward off his blows. "Don't touch me," she finally says—she had been stunned silent—and either crawls off or is helped off; no matter, she is no longer there. Just Ondine, his fury enormous. Then *he* rushes off, leaving the screen empty, then reappears, and disappears again. Shadowy figures—crew members, onlookers—hurry this way and that. Andy's English friend Mark Lancaster was holding the microphone that day. "Up to a point I'd thought it was planned. Then I realized this wasn't a situation anyone had foreseen, and I remember being terrified. All I could think was, 'I'm getting out of here,'" and I put the microphone down and backed off."

Ondine reappears, center screen. "I hit you with my vested hand, you dumb bitch! How dare you come onto my set and tell me I'm a phony? On *my* set! . . . Do you know what she had the nerve to do,

audience of mine? She came onto my set as a friend who 'didn't know what to do,'" he mimicks mincingly, "and said I was a *phony*. Well, fuck her, and I'll beat her up again, and her husband," meaning Mekas.

He slumps dejectedly, then suddenly regathers his fury. "Whore!" he shouts, pronouncing it "hoor," rage bringing out the Red Hook in him. "Only, hoors have hearts, you bitch! Why don't you raise a litter of dogs, you fool?" Head in hands, voice shaking, he hunkers on his sofa and says, "I really don't want to go on." But Andy's aesthetic has its imperatives; the reel will roll for its entire, arbitrary, thirty-three-minute length. One of the cardinal rules was that the actor betray, subtly or not, his awareness that he was on camera. Being on-screen in a Warhol film meant cultivating a self-divided awareness that bracketed every pronouncement, every description, with quotation marks.

There was no fourth wall here, no pretense of reality. In conventional movies or theater, you acted, all the while pretending not to act. Here, you paused again and again to acknowledge this contradiction, to puncture conventional film's faux authenticity—as Ondine repeatedly does in this scene, both pre- and post-assault, casually addressing Warhol, Morrissey, Malanga, Billy Name, Arione De Winter, and anyone else who happens to be hanging around the Factory. This was a type of performance at which Ondine was peerless, because it was the way he lived his life, a nonstop performer who played off his constant real-life audience.

Of *course* he knows he's not a holy father, of course he is "a phony." Poor, un-ironic Ronna, this oddly belligerent flower child bent on sincerity, on calling a spade a spade. Ondine wouldn't have minded being called "phony" by, say, Billy Name, or Ronald Tavel. They were just as insincere as he, and knew it, welcomed it, played with it—it was how they all lived, it was the vein Andy tapped.

Like others who spend their lives vilified and mostly ignored (even as penniless "superstars"), Ondine had developed—at least in the friendly confines of the Factory—a massive, self-dramatizing ego.

"Ondine was like that," said playwright Robert Heide, "so deprived that he began to develop this grandiosity. You have to be more than you are, so you become this mini-legend to yourself."

The pitiless camera unspools; off-screen, Ronna sobs. "He had no right to . . ." He hadn't. He, not she, was the transgressor. In those pre-feminist days, "Ronna understood," said Jonas Mekas. "She went through it and then dismissed it a day later," fully forgiving of Ondine and his art. Nor was Mekas upset, "because there were periods when I was surrounded by crazies. Each one, Jack Smith, Harry Smith, Kenneth Anger. Down the line, these were very, very not-easy people, each one capable of anything. And they were all geniuses, practically."

(When Warhol, Nico, Morrissey, and Ultra Violet were interviewed by Richard Ogar in the *Berkeley Barb* in November 1967, Andy talked about the violent scene in *The Chelsea Girls*. He said he felt "bad about the girl. It wasn't her fault. I mean, she just happened to be there . . ." Interestingly, he went on to say, "I don't really believe in violence and stuff, we happen to see it so often in some of the things we were filming, and I always shut the camera or something and got nervous about it. This one, I guess I've been so used to it that I didn't shut it off. I just walked away.")

The camera still running, Ondine says he'd like to go home now and jerk off, or watch his favorite Lucille Ball show. Someone sits down in the confessional but off-screen; the voice sounds like Pepper Davis's. And the reel ends. The right-hand side of the screen stays black. Opposite, the twelfth and final reel, plays itself out: Nico again, but alone now, weeping—although no emotion registers on her beautiful face. The scene was a good one for audiences to exit to, still in shock from Ondine's tantrum.

"One of the few times Andy knew that he had reached an epitome of filmmaking was Ondine slapping Ronna," said Billy Name. "It was so perilous and real because it *was* real. He knew he could never do that in a scripted manner with professional actors. He picked people

who revealed themselves. Even though you can only reveal yourself explosively, or effectively, once in a while. I mean, there are so many uninteresting Ondine films as opposed to that one incredible reel."

Were Warhol's choices deliberate—were they even choices—or were they accidents that Andy, with his lack of technical proficiency, had no way of controlling? More astute commentators on Warhol's films, such as Parker Tyler, had begun to realize that Andy wasn't so much a moviemaker as a serial portraitist, an exhibitor of bizarre, beautiful, and disturbed individuals.

But most critics lacked Tyler's patience, or insight. Bosley Crowther of the *Times* did not mince words: "So let's get it said without quibbling that this seamy 'The Chelsea Girls' is really nothing more than an extensive and pretentious entertainment for voyeurs." Crowther was unimpressed by Ondine, "a flaming homosexual man [who] rambles on in a narcotized state. . . . Clearly the aesthetic principle on which Mr. Warhol works is to saturate or hypnotize the viewer into an insensible state. . . . Mr. Warhol," he concluded, should make a film "about filmmakers who are too solemn to see the absurdity in themselves. That would be a good put-on. But it would be at [his] own expense."

But this was kind compared to *Time*'s critic who, reviewing the film December 30, called *The Chelsea Girls* "a very dirty and a very dull peep show. The characters are all homosexuals and junkies. . . . A faggot who calls himself the 'Pope' advises a lesbian [which Ronna Page was not] to sneak into church and do something obscene to the figure on the cross. There is a place for this kind of thing, and it is definitely underground. Like in a sewer."

The *Voice*'s Andrew Sarris pointed out that Andy was homing in on "a sub-species of the New York sensibility" that previous moviemakers or playwrights hadn't even known about: Lower Bohemia. And this subspecies made its croaky voice heard with flamboyant irony and camp: "when the 'Pope' of Greenwich Village talks about sin and idolatry, when a creature in drag 'does' Ethel Merman in two of the funni-

Brigid Berlin, Andy Warhol, Gerard Malanga, and Ingrid Superstar posing for Chelsea Girls *publicity photos at the Factory*

est song numbers ever, when a balding fag simpers about the Johnson administration, when a bull dyke complains about her mate getting hepatitis." Sarris's language, in an alternative newspaper, is a reminder of the era's reflexive homophobia.

"Warhol's characters are more real than real," Sarris continued, "because the camera encourages their exhibitionism. They are all 'performing' because their lives are one long performance, and their party is never over. The steady gaze of Warhol's camera reveals considerable beauty and talent. The Pope character is the closest thing to the late Lenny Bruce to come along in some time, and his . . . repartee with a girl called Ingrid is an extraordinarily sustained slice of improvisation. . . . Though I wouldn't want to live with [Warhol's

people], they are certainly worth a visit if you're interested in life on this planet."

On December 1, in a *New York Times* story entitled, "'Chelsea Girls' in Midtown Test," Vincent Canby wrote: "The Film-Makers' Distribution Centre, formed here seven months ago to release experimental, or 'underground,' films to commercial theaters, has apparently found its 'Sound of Music' in Andy Warhol's new production, 'The Chelsea Girls.'"

The *Times* article went on to conclude that *Chelsea Girls* was the first underground production to make the move to a conventional commercial theater in midtown Manhattan, the six-hundred-seat Cinema Rendezvous, on West 57th Street, for a minimum two-week run. Statements from the Filmmakers Distribution Center recorded that *The Chelsea Girls* grossed $19,500 in two weeks, from December 1 to 14, at Cinema Rendezvous. It then moved to the Regency on Broadway, where it continued to draw well. One Manhattanite who didn't join the rush to the Regency was Warhol, whom the *Times* termed "keenly disappointed" by the move from the plush Cinema Rendezvous to the dowdier Regency: "He is reported to have told one of his friends, 'Now that it's in that tacky little house, I don't go to see it anymore.'"

1967

ONDINE: *How many Andys can we make in a day?*
VIVA: *We'll flood the country with them. . . . The real Andy Warhol is an image. What difference does it make who wears the mask?*

O
n a Sunday morning in December 1967 New Yorkers opened the Arts and Leisure section of their *New York Times* to a profile of Paul America (star of *My Hustler*), a semiliterate, emotionally dissociated, drug-damaged drifter who rambled on about drugs, a recent three-month stint in the army, James Dean, and New York City. It was a measure, perhaps, of the dislocated nature of late-sixties American culture that here, in the world's most authoritative newspaper, the incoherent half-sentences of a disturbed youth were seized on, *pondered*, by the *Times*'s affluent Sunday morning readers as grains of truth, possible beacons into the future.

In its first four weeks at the Regency, *The Chelsea Girls* grossed a minimum of $9,000 per week: a weekly profit of $3,500, evenly split

by Warhol and the FDC. In late January, when it moved from the Regency to the York, the film was being readied for national distribution, with a Los Angeles premiere planned for February (it didn't occur until April). Although several commercial distributors were eager to handle the film—the president of one, Trans-Lux, told the *Times* that he could book it into a hundred theaters nationwide—the avant-gardists at the FDC wanted to distribute *The Chelsea Girls* themselves. Mekas, said the *Times*, "is beginning to sound like Darryl F. Zanuck."

Newsweek, in its February 13 issue, surveyed American avant-garde film at length, taking *The Chelsea Girls'* commercial success as proof that "the [film] underground has at last surfaced and is moving into public consciousness with a vengeance." Two days later, *Time* came out with its own underground film story: "After five years of lurid reports about an 'underground cinema,' U.S. moviegoers have caught the show." *Time,* like *Newsweek,* cited *The Chelsea Girls* as the film underground's potential spearhead into the mainstream. Andy's underground epic, predicted *Time,* "figures to gross at least $1,000,000," a sum *The Chelsea Girls* never remotely approached. "With that one blow"—*The Chelsea Girls'* box office performance—"the barricades fell, and the avant-garde came storming through." *Time* singled out Mekas, of course, as "the Marat of the revolution, a shy man with long greasy hair who looks like a slightly soiled Elijah" and proclaimed "the death of the film as an industry and the birth of the film as an art." In 1966, especially to a cultural activist such as Mekas, many dreams seemed within reach.

An internal *Time* memo, part of the magazine's research for its piece, provides an interesting glimpse into how the conventional 1960s media perceived Andy and his friends (as well as into how more than one Factory film quite possibly got made). The memo reads:

"A source on the staff of NET (Channel 13) confided at a dinner party this week that approximately 3,000 feet of raw film stock disappeared from an NET studio after Andy Warhol and his entourage

had appeared for Warhol's participation in a Channel 13 show. The source doesn't feel the evidence is strong enough for the incident to appear in *Time*'s story but offers it in corroboration of Barbara Rubin's contention"—another nugget that never appeared in the *Time* story—"that 'most film-makers who're doing underground movies have begged, borrowed, or stole their equipment.'

"It will run a year!" the *New York Times* quoted Mekas crowing about *The Chelsea Girls*' Manhattan commercial run, and as 1967 lengthened his prediction looked less and less outrageous. It grossed $130,000 in its first nineteen weeks of commercial release in Manhattan; $45,000 of this was profit, split between the FDC and Andy, who had already cleared $22,500 from the film (in addition to his portion of the take from the three autumn 1966 Cinematheque runs). By the end of April, it was playing in New York, Los Angeles, and Dallas, with openings scheduled for Washington, D.C., San Diego, Kansas City, Boston, and New Orleans. As the *Times* reported on April 25, Andy had been invited to screen *The Chelsea Girls* at the Cannes Film Festival. The only other American-made entry at Cannes, which was to begin later that week, was a very early Francis Ford Coppola feature, *You're a Big Boy Now*. *The Chelsea Girls* seemed ready to conquer Europe.

Warhol and Morrissey had been assiduously exploring other ways to cash in on the publicity that the movie was generating. On January 14, Leonard Lyons reported in the *New York Post* that "Robert Scull and Al Crown have a co-production deal for 3 movies with Andy Warhol." Two months later, Warhol's lawyer Ed Katz wrote the lawyer for Cee Ess Productions, evidently Robert Scull's venture into the entertainment business. Katz's letter went on at length about plans for what appeared to be a television movie about Warhol.

Another Katz letter, dated January 24, was addressed to a Kenneth Robinson in Detroit. Here, Katz discussed the possibility of forming a partnership with something called New World Films, presumably

Robinson's company, to make a movie with a $250,000 budget, over 150 times that of *The Chelsea Girls*.

According to Andy's friend Nelson Lyon, by mid-1967 Warhol was already trying to go to Hollywood. "I would say, 'For fuck's sake, why don't you get a real story, a real script,'" Lyon recalled. "And he said, 'Well, write one for me.' So I wrote one for him."

Warhol arrived in Cannes with an entourage that included Morrissey, Malanga, Lester Persky (to handle potential deals), Nico, Susan Bottomly, an on-and-off-again Factoryite known as Ultra Violet, Eric Emerson, and Andy's new boyfriend, a boy from the Deep South who claimed to have been the road manager for Tommy James and the Shondells. His name was Rodney Thomas but some Factory wag had dubbed him Rod La Rod, which stuck. He was bumptious and goofy—"he greased his hair and wore bell-bottoms that were too short," according to *POPism*, and their relationship seemed to revolve around physical horseplay. "He'd stomp around the Factory, grab me, and rough me up—and it was so outrageous that I loved it, I thought it was really exciting to have him around, lots of action." Malanga found Rod La Rod "an oaf. He was such a putz. A retard, obnoxious, an embarrassment. He'd be rough with Andy at big public dinners. Totally inappropriate. . . . The weird thing to me is that Andy put up with that shit. They were together for at least six months, maybe more. I think Andy was afraid of Rod La Rod." More likely Rod La Rod's tickling and goosing excited Andy. Ronnie Cutrone recalled shooting a 1967 Warhol sequence, *Jail* (not to be confused with *Girls in Prison*, from 1965), "where suddenly Rodney La Rod had Andy pinned down on a jail bunk, and he's *tickling* him. That was Andy's idea of sex. I mean, Andy had sex like an adolescent boy." Throughout the European trip, Andy and Rod La Rod shared a hotel room.

If Rod La Rod was the last person anyone (except Andy) would want to bring to a high-class party, Ultra Violet was the opposite: a French glove-manufacturing heiress (her actual name was Isabelle

Collin Dufresne) who mingled effortlessly at all levels of society. As Bourdon put it, her most remarkable gift was "a sixth sense for discovering photo opportunities." Seeing Andy and one of his superstars posing for a photographer, Ultra would squeeze into the picture, just to their right; that way, she'd be listed first in the caption. Ultra Violet was shortly to develop a mini-career speaking for "the underground" on TV talk shows such as *The Merv Griffin Show*. This tickled authentic undergrounders no end, since they'd never laid eyes on this self-proclaimed spokesperson. "She'd tell journalists 'I collect art and love,'" says *POPism*. "But what she really collected was press clippings."

The Chelsea Girls generated its share of clippings at Cannes—none, however, to Andy's liking. Despite his high hopes that it would take the festival's cognoscenti by storm and attract lucrative offers from European distributors, *The Chelsea Girls* was never shown at Cannes. Evidently afraid of attracting a flock of censors, the festival's directors claimed never to have sent Warhol an invitation. For once, Andy displayed his hurt in public—*Variety* reported his annoyance at the "fest runaround"—although he quickly settled down behind his customary smoke screen of noncommittal, inscrutable one-liners. His films were trash, he told reporters, but so were all the others at the festival; the only reason he made movies, he added, was to keep his actors off the streets. Meeting Brigitte Bardot, he told her of his old fantasy of filming her asleep for eight hours, to which Bardot's husband responded that "she may be ready for that kind of pic soon."

From Cannes, Andy went to Paris, finally managing to screen his epic at the French film museum. "Drew big buff and critic turnout . . . some bored, some not," reported *Variety*, possibly understating the case: according to Taylor Mead, in Europe since 1964 and now reunited with his fellow American undergrounders, half of the audience walked out.

European film enthusiasts may not have been ready for *The Chelsea Girls'* mix of *longueurs* and seaminess, but the film continued to roll along stateside, generating audiences and controversy (over local

intellectuals' protests, it was banned in Boston at the end of May, no doubt to Andy's delight). The best estimate of *The Chelsea Girls'* total box office receipts is probably about $300,000, the figure given by the *New York Times*'s Grace Glueck in a July 7 article. (Andy himself—if one can believe him—told a reporter in September that "*Chelsea Girls* made $350,000," which implies that $350,000 was the gross, not the net.)

Despite his claims of poverty, Andy was on his least shaky financial footing in years. For the first time since he had started making movies, he didn't need to pour his fine art and commercial art earnings into film equipment and processing; to the extent that *The Chelsea Girls* earned him profits, he was freer than before to bank his art income. Andy Warhol Enterprises, the corporation founded in 1957 to represent Andy's art-making, reported a 1967 income of $39,365 (with $38,710 claimed in deductions, including the $7,000 salary Andy paid himself); this included the commercial jobs he still took on, if fairly infrequently.

A newer business entity, Andy Warhol Films, Inc., had been founded on April 5, 1966, so its 1966 income tax return listed earnings through March 31, 1967. These were reported as $30,553 (with $23,000 subtracted in deductions). By far the bulk of this income was from *The Chelsea Girls*; this is confirmed by a statement sent Andy by the Filmmakers Distribution Center, which puts his share of *The Chelsea Girls* profits between mid-December 1966 and mid-June 1967 at $25,124. As of May 3, 1967, the Andy Warhol Films Chase Manhattan checking account contained a healthy $12,660.95.

In addition to these earnings, impressive for the mid-1960s, Andy had, since 1958, steadily built up a fairly healthy stock portfolio. By the end of 1967, he owned some $30,000 in securities, roughly equivalent to $192,000 in 2008.

All of these numbers were, of course, Andy's private knowledge. Yet the ongoing public success of *The Chelsea Girls* increasingly raised

questions. "The actors are simply his friends, who, at Mr. Warhol's direction, improvise for nothing," Vincent Canby had explained in his article "'Chelsea Girls' in Midtown Test." "Whether they will continue to work for nothing is problematical, however. One source reported yesterday that some of Mr. Warhol's friends were beginning to smell the scent of profits."

By mid-1966 they were no longer merely smelling money, but demanding it. In 1967, Eric Emerson, Paul America, Genevieve Charbin, Mary Woronov, Ron Tavel, and others either sued Andy or took other legal action to get paid. Even Ondine, who'd always made clear his unconcern with material well-being, presented Andy with a formal contract on March 16. It insisted that Ondine be paid $250 for his part in the still-unpublished novel *a* (it wouldn't come out for another two years). Ondine's request, which Andy signed, was extremely modest. It amounted to a work-for-hire contract that gave Andy sole rights to the book; all Ondine wanted was $250 to keep him in speed and cigarettes.

He probably also wanted to avoid Mary Woronov's eventual fate: banishment from Warhol's films. As Woronov recalled, "My parents suddenly realized that *Chelsea Girls* had made money. And of course, it had cost nothing, and no one had seen any money, none of us." Presumably after Mrs. Woronov, or her lawyer, had contacted Warhol, "Paul Morissey came up to me and went, 'Oh, here. Sign this.' It was a release for *Chelsea Girls*. And I said, 'No.' He said, 'This is a release, you have to sign it.' I said, 'No, I don't have to sign it, because I collaborated with Warhol on this movie. I don't have to sign jack-shit. If you don't want to make it a collaboration, Paul, then pay me.'"

Woronov never signed. "And that was the end of my career with Andy. No, the end of my career with Andy was my mother. When I told her I hadn't signed anything, she sued him. I think they settled out of court. He just gave her some money. I think it was about a thousand dollars, that's all I ever saw. But suing Warhol, that was the end of

my career with him." She still ran into Andy at some of his nighttime haunts, socially, and she kept up her close friendship with Ondine. "But I began hearing about movies being made that I was no longer asked to be in. So I assumed that I was, you know, on the outs," which is where she stayed.

Woronov's legal action occurred during the late spring and summer. In July, the two-year-old film *My Hustler* was resurrected at a 44th Street sex-film house, the Hudson Theatre, grossing $18,000 in its first four weeks, $4,000 of which went to Warhol. Two of *My Hustler*'s stars, Paul America and Genevieve Charbin, hired a lawyer, who demanded payments of $2,500 and $1,750 for America and Charbin, respectively. The case was quickly settled out of court, with Andy agreeing to pay each actor $250 up front, with monthly installments to follow.

Surprisingly, the most troublesome legal action against Warhol had the smallest impact on the Factory fortunes of the plaintiff, Eric Emerson, who continued to appear in Andy's movies into 1968. The rumor behind Eric's lawsuit was that he'd been busted for possession of LSD and needed legal funds. In any case, his suit was two-pronged. Serving Andy with a complaint on March 8, 1967, Eric's lawyers charged, first, that Warhol had never obtained a release from Eric for his participation in *The Chelsea Girls*—that Andy had, in fact, misrepresented Emerson's appearance as a mere screen test. Unlike the other claimants, Emerson asked for big damages: $250,000.

Second, the Velvet Underground's album had finally appeared (the famous peelable banana on the front of the record jacket). Prominently displayed on the back of the jacket was a still photograph of Eric taken during his *Chelsea Girls* "strip-and-tell" sequence. Naming Andy and MGM Records as codefendants, Eric demanded another $250,000. This part of Eric's suit yielded one quick result: MGM pulled all copies of *The Velvet Underground and Nico* from record-store shelves. The album, which had struggled to number 171 on *Billboard*'s Top 200, promptly vanished from the chart. When it was re-released in May,

sans Emerson's picture, the Beatles' *Sergeant Pepper's Lonely Hearts Club Band* had just come out. In the climate of peace and psychedelia *Sergeant Pepper* stimulated, the Velvets' *fleurs du mal* couldn't possibly flourish. It was the Summer of Love; Reed and Cale's dark vision was morbidly out of sync.

The Velvets (and a good many rock critics) always considered Emerson's lawsuit the death blow to the band's dreams of making it, but in truth the Velvets' music was a minority taste. By the spring of 1967, groups with whom the Velvets had competed on equal terms during their 1966 California tour—Jefferson Airplane, the Dead, even the Mothers of Invention—had captured mass audiences. When the summer brought not only *Sergeant Pepper* but the electrifying Jimi Hendrix, and the communal good vibes of the Monterey Pop Festival, the Velvet Underground was overshadowed.

Emerson's suit affected Andy more than it did the Velvets. On March 10, at the suggestion of his lawyer, Jack Perlman, Warhol agreed not to show Eric's *The Chelsea Girls* scenes in New York state; outside of New York, Eric was still in the movie. On March 27, Andy filed a counterbrief notable largely for several outrageous falsehoods, including that "my income to date from this film has not even covered my cost of production."

Emerson accepted $1,000 from Warhol in return for all rights to Eric's image and voice (the money, curiously, was deducted from the Velvet Underground's concert earnings). This settlement didn't satisfy Eric's lawyers, who insisted on prohibiting Eric's *Chelsea Girls* footage from being seen anywhere in the world. Perlman stood firm. The New York State Supreme Court sided with Perlman. Andy was free to show his Emerson footage anywhere outside of New York—a pyrrhic victory, since *The Chelsea Girls*' biggest audience continued to be Manhattanites. So, for the time being, Emerson's three *Chelsea Girls* scenes were struck from every New York showing, a genuine detraction.

None of these lawsuits altered Andy's practice of not paying his actors a regular wage. He was much more liable to write a small check when someone urgently needed cash: for years, this was his arrangement with Billy Name. As the *Times* reported in the last paragraph of its Paul America story, "Meanwhile, back at the Factory, the Griffith of the Underground was at work drawing up new contracts—contracts conspicuous for stating that for superstars of the future, Art was to be its *own* reward."

Andy's currency was notoreity—and, to a large extent, food. Ever since he had developed an entourage it had been his practice to round up a select crew for dinner after a day's filming, and he unfailingly picked up the tab. You might not earn enough as a Warhol superstar to afford an apartment, but you didn't starve.

Starting in autumn 1966, Andy and his inner circle began frequenting the back room of a new restaurant, Max's Kansas City, on Park Avenue South near East 17th Street. Max's owner, Mickey Ruskin, had started out as a lawyer and closet bohemian; after what he referred to as a "nervous breakdown," he left law and began running a string of Greenwich Village cafés. They inspired vastly faithful clienteles; Mickey worshipped artists and writers and let them run up enormous tabs. An avid collector, Ruskin accepted his favored customers' artwork as payment, a practice Andy followed: "I'd give him a painting and he'd give us credit, and everybody in our group could just sign for their dinners until the credit was used up." Warhol also paid cash, a lot of it: at the end of 1967, his tab at Max's was a whopping $2,352.62. (This was small potatoes compared to an October 27, 1968, invoice for $4,061.64.)

From 1966 on, Max's became what the Factory had been in 1964 and 1965: *the* place where the underground collided with uptown wealth and curiosity. At Max's, sixties freak culture became visible to the larger world, and more so than at the Factory—Max's mix of rock

stars (Janis Joplin and Jim Morrison were regulars), starving actors, teenyboppers, East Village street people, fashion designers, and others was much more inclusive than the Factory's demographic.

But at Max's, Andy was the star around which the other circles revolved, painters and actors at the bar, socialites at the tables, rock stars and groupies upstairs. The back room, where Andy presided nightly, became the hippest place in town.

In the back room, separated from the front by a narrow hallway, Warhol felt safe; the macho Abstract Expressionists who called him "Wendy Airhole" gathered in the front room. Michael Egan summoned up a picture of "Andy at his table, abstracted and looking like he was not there. I can understand why people thought he was some kind of zombie. He had on dark glasses and he just never looked . . . alive. He certainly wasn't the same person I'd had conversations with in early 1965. He was impassive. He received everything. Like a sonar dish, taking everything in." Flanked by two or three lieutenants, Morrissey, Malanga (though Gerard's star was fading), sometimes Billy Name, Andy presided over the sort of exhibitionist antics he'd long enjoyed at the Factory. Mary Woronov called the back room "the royal court of screaming assholes." Warhol controlled the room, Sam Green remembered, "by never saying anything, but he had the tape recorder and the Polaroid out, and people would perfom for him. Some of the great spontaneous performances of all time. Candy Darling, Jackie Curtis, Holly Woodlawn, and all those speed freaks. You'd get beautiful women to whom Andy would say, 'Oh, come on, show us your pussy.' Egging people on. And they were auditioning for Andy. It was auditions every night."

When the Factory moved in early 1968 to Union Square, it was no doubt partly because of Max's proximity. As Steven Watson points out, Max's became a Factory hangout at a time time when there were "too many people and too many complicated psyches to be accommodated at the Factory or at the rounds of evening parties. Just as the Factory

had provided an alternative social space to Andy's home, Max's Kansas City provided an alternative to the Factory."

It was likely at Max's that Valerie Solanas joined the Warhol crowd, although the Factoryites pretty much kept their distance from her. On February 9, 1967, Solanas ran an ad in the *Village Voice* for a "pre-production reading" of her play *Up from the Slime* (one of several alternate titles of *Up Your Ass*) at the Directors' Theatre School on 14th Street. The ad also mentioned Solanas's mimeographed "SCUM Book"—the title a reference to her one-woman organization, the Society for Cutting Up Men—which contained *Up from the Slime* and a 1966 *Cavalier* article, and alerted readers to her upcoming appearance on gay rights spokesman Randy Wicker's radio show.

Probably in early 1967, Solanas wrote the *SCUM Manifesto*, a call to a women's revolution and an invitation to join SCUM. The manifesto combined genuine rhetorical skill with a mad, fixated obsessiveness; juggling abstractions with deftness and ease, Solanas nonetheless slides, repeatedly and at times almost imperceptibly, into disturbed rants. The pamphlet's juxtaposition of madness and political theory gave the slogan "the personal is political" a grotesque twist, revealing a tormented woman's hellish inner world.

Although by 1967 feminism was already swelling into its biggest wave since the turn-of-the-century push for women's suffrage, Solanas scorned most "women's libbers" as deluded middle-class fools, "nice genteel ladies who scrupulously take only such action as is guaranteed to be ineffective. . . . If SCUM ever strikes, it will be in the dark with a six-inch blade."

The *Manifesto* began with a call to "civic-minded, responsible, thrill-seeking females . . . to overthrow the government, eliminate the money system, institute complete automation, and destroy the male sex." According to Solanas, "maleness"—rooted, after all, in the defective Y gene—"is a deficiency disease and males are emotional cripples." By

nature, the male is passive, dependent, vegetative. Loathing these traits in himself ("Every man, deep down, knows he's a worthless piece of shit"), he projects them onto the female, claiming for himself women's innate characteristics: "emotional strength and independence, forcefulness, dynamism, decisiveness, coolness, objectivity, assertiveness, courage, integrity, vitality, intensity, depth of character, grooviness, etc."

Her assertion that all fathers lust after their daughters—"he gives her *hand* in marriage; the other part is reserved for him"—was obviously rooted in Solanas's horrible childhood experiences: according to her sister, their father repeatedly molested Valerie. She hated him so much that she built an entire theoretical edifice on that loathing.

How to get women out from under? "A small handful of SCUM can take over the country within a year by systematically fucking up the system, selectively destroying property, and murder. . . . SCUM will kill all men who are not in the Men's Auxiliary of SCUM," a sort of fellow-travelers group, "men who are working diligently to eliminate themselves." Men interested in "playing ball with SCUM" would attend Turd Sessions, at which each man present would rise and make a speech starting with "I am a turd, a lowly, abject turd." In the end, heaven on earth would reign; the few remaining men would "exist out their puny days" or "go off to the nearest suicide center where they will be quietly, quickly, and painlessly gassed to death." Women, meanwhile, "will be busy solving the few remaining unsolved problems before planning their agenda for eternity and Utopia."

On April 21, Solanas ran her first ad recruiting members for SCUM. She mimeographed two thousand copies of the *Manifesto*, charging men more than women. "That's the only use men are today," she wrote. "To support our organization. To help with their own destruction."

Some time that spring, she visited the Factory. She brought with her a copy of *Up Your Ass*, presenting it to Andy. He was intrigued by the title but afraid she might be setting him up. "You aren't a cop, are you?" he asked, at which point Solanas unzipped her fly.

At the beginning of August, Solanas sent Andy a SCUM recruiting poster and wrote, "Maybe you know some girls who'd like to join. Maybe you'd like to join the men's auxiliary." Join he did, no doubt by saying, "Oh sure, Valerie, I'll join," just to shut her up. She'd already been pelting the Factory with phone calls—she wanted the manuscript of *Up Your Ass* back, she wanted money. At first Andy took her calls, and then he just got bored.

In mid-1967 Solanas met Maurice Girodias, a recent Parisian émigré and the publisher of Olympia Press. Like Solanas a resident of the Chelsea Hotel, Girodias had published banned literature in France: both serious writing—Nabokov's *Lolita*, Henry Miller, Genet, de Sade—and out-and-out pornography. Moving to New York in 1966, he ran an ad that piqued Solanas's interest. "You have been rejected by all existing publishers: well and good, you have a chance with us. We read everything—promptly, discrimatively, and optimistically." Solanas wrote him, and they met.

When Girodias read the *SCUM Manifesto*, he considered her "final solution" of eliminating all men "a verbal provocation à la Swift, a joke meant to emphasize her point." Solanas signed a contract with Girodias in August 1967: in exchange for $500, he agreed to publish an erotic novel-in-progress. According to Paul Morrissey, to whom Valerie appealed for advice, the contract "was this stupid piece of paper, two sentences, tiny little letter. On it Maurice Girodias said, 'I will give you five hundred dollars, and you will give me your next writing, and your other writings.' Something like that"—which Solanas took to mean that Girodias now owned all of her future writing. Morrissey set up an appointment for Solanas with Ed Katz, one of Warhol's lawyers, who assured Valerie the contract didn't give Girodias any such rights. After his meeting with Solanas, Katz reported back to Morrissey, "Oh, that girl came in. She's really crazy. She said, 'You're lying, you're stealing, you're lying, you're crazy!'" Completely ensnared by circular logic, Solanas had convinced herself that Katz had been paid by Girodias to placate her.

Late that summer, Valerie's sister, visiting from California, was struck by the change in her. "I suddenly realized that . . . she no longer smiled. . . . Only someone who knew her well could see it, the light had vanished." In October, Valerie was evicted from the Chelsea for nonpayment of rent. Girodias, meanwhile, finally realized that she was insane—"Obviously the pixies were moving in, pretty fast." A friend in whose apartment she was crashing came home one day to find the words ANDY WARHOL typed over and over, a scary sight. She was already fixating on Andy, and on Girodias, too: the former for failing to return her *Up Your Ass* manuscript, the latter for the contract fiasco.

Perhaps with a magazine paycheck in mind, Solanas interviewed (or tried to interview) Warhol in November or December; the conversation was transcribed in a manuscript entitled "Valerie Solanis [*sic*] Interviews Andy." As the tape starts to roll, Solanas says, "The first thing I can think of to say is that Andy Warhol, I think, is scared of SCUM. I think he's scared to death of SCUM." "Uh, what color are your eyes, Val," says Andy. . . . "Why don't we see what's behind that sweater of yours?" As Warhol evades or ignores Valerie's attempts to bait him, she becomes abusive. "What're you, chickenshit, man? . . . ANDY! I'm interviewing you."

Has anyone ever told him he was uptight, Solanas wants to know. Andy denies he is. What does he use for sexual stimulation, she asks—bank books? After a prolonged back-and-forth, Solanas informs Andy that he may be in SCUM's men's auxiliary but he's "by no means on the escape list."

From the first days of 1967 through late October (if not later), Warhol had been filming away in what was now his customary mode: without scripts, with minimal or no direction, and with untrained actors. "Andy seems not to stop shooting," Gerard Malanga told an interviewer early in the year. "He just continues to shoot without thinking about looking back over all the footage he's shot. It just grows and grows."

On January 15, the *New York Times* reported that Warhol was "once again up to his ears in footage." The project was being called *Vibrations*; probably quoting Andy (there is no attribution), Grace Glueck described it as "an 'abstract thriller' about extrasensory perception, starring Ivy Nicholson." Warhol and his actors had spent the New Year's holiday "mainlining it in Philly," Glueck wrote, staying with Andy's old friend Henry McIlhenny and filming in an indoor swimming pool at the Drake Hotel and at the University of Pennsylvania's archaeology museum (the latter shoot no doubt set up by Sam Green, still on the scene in Philadelphia). Aside from Nicholson, *Vibrations* featured "such familiar Warhol vedettes" as Nico, Susan Bottomly, Rod La Rod (Andy's latest crush), and Allen Midgette, who had entered Warhol's circle so memorably at 1965's Fifty Most Beautiful People party and promptly disappeared. Now he was back, on-screen frequently in 1967. An anomaly among Warhol's performers—a trained actor with actual, if not extensive, credits—Midgette could hardly have been less attuned to Andy's kind of filmmaking. "For the Warhol thing to be recognized as professional filmmaking was a joke to Allen," said Billy Name. But at the beginning of 1967 Midgette was at loose ends, bored with his job waiting tables at the Arthur Discotheque: "and Andy came after me. Andy was a stalker." On the day Warhol invited Midgette to the Philadelphia shoot, "I didn't have anything to do, I was kind of bored, so I went ahead and did it. There was no theme, you were just there. It was silly, and yet I knew that other people were going to think it was 'oh, so much.' Nobody knew what they were doing." At the museum, clad only in a loincloth, Midgette scrambled atop an ancient Egyptian sphinx. "I looked up at the thing and thought, 'I'll never get this chance again,'" and up he climbed. "The guards were there and everything—I couldn't believe they even let us in."

For the first time since *Sleep*, Warhol was editing his footage, albeit with one of the simplest possible techniques: in-camera editing, simply switching the camera off, then on, as the action continued. The effect, when projected, is of an abrupt, jarring cut. As Andy told Glueck, "I'm

cutting in the camera now. It's great. Every time you do it, it comes out 'bloop.'"

Before long, a much bigger project had swallowed *Vibrations*. During a late-winter, early-spring group interview at the Factory, Malanga mentioned that Andy was now planning "to shoot enough footage to show for twenty-four hours." Warhol and his actors had already shot dozens of reels: "a whole sequence of footage dealing with the games people play," said Gerard; a staging of President Kennedy's assassination whose working title, *Since the Assassination*, was soon shortened to *Since*; a number of what Malanga termed "love situations"; and *Vibrations*, which Gerard called "a whole sequence of footage dealing with black magic." The *New York Times* mentioned the marathon project on April 25, reporting its title as *Twenty-Four Hours*. On April 26, the *Washington Post* published an interview with Andy, in town for the opening of *The Chelsea Girls*, in which he called his current project a *twenty-five*-hour movie "about love. No, no particular kind of love. Just love." He wanted to premiere it at the New York Film Festival in September, after which it would be chopped up into much shorter segments. Movies, Andy said, tongue firmly in cheek, had gotten much too long. Like *The Chelsea Girls*, the film, which he was now calling simply **** (i.e., four stars), used multiple projectors, but three instead of two; moreover, the images were superimposed, rather than screened alongside one another. The reels' sound tracks were superimposed, too, the result a visual and auditory soup.

In July, Andy decided that his work-in-progress was ready for a Factory preview, and a group of film critics, art world insiders, and Factory hangers-on watched a three-hour chunk of ****. The title, Andy told the *Times*'s Glueck, referred to "those four-star ratings the *Daily News* gives pictures." As Billy Name put it, "We decided not to wait for the reviews to come out, since they were usually bad, and so we gave the movie our own highest rating! We thought it would look great on the marquee and in the ads." Andy told Glueck that the asterisks

could also stand for any number of censored four-letter words. "The film contains some," Glueck noted in a dry parenthesis.

Among Andy's preview guests were Michelangelo Antonioni, then between *Blow-Up* and *Zabriskie Point*, the great director's erratic opus about countercultural America; after watching the excerpt, Antonioni said that it "became more beautiful" as it went on. Film critics Andrew Sarris and Arthur Knight were there too, in their roles as judges for the New York Film Festival (**** didn't make the cut). Sarris sounded bemused after the screening, Knight less so, calling the experience "a wasted day" (one wonders how he would have felt about the full-length version).

At the July screening, Warhol said that he had no idea how much **** was costing him. "'I just keep putting money into it that I get from *Chelsea Girls*,'" he said, "which isn't much." And the footage piled up, reel after reel after reel: ninety-four 33-minute reels in all (it was ultimately shown on two, not three, projectors). It was not simply that Andy "didn't look back" over the miles of footage he shot—he expressly avoided such an organizing glance. **** was *The Chelsea Girls* without the former's quasi-unity: this time, there was no last-minute inspiration, no notion of how to make a pile of disparate footage at least seem to cohere.

The lack of internal architecture would not have been a problem for the day's audiences, who were perfectly willing to accept the fragmented nonstructure of Warhol's films. What must have been excruciating about **** was its image-on-image, sound-on-sound layering, a sort of two-dimensional version of the Exploding Plastic Inevitable at its most aggressive. Nelson Lyon called **** "the most assaultive, trying experience that Andy ever imposed on an audience." When Warhol showed him a segment of it at the Factory, Lyon recalled, "the interesting part was this: you'd be assaulted with this *noise*, this visual and audio noise, and then one of the reels would end, suddenly you'd hear one sound track and see one movie, and you were transported; it was the *relief* of seeing just one movie." His euphoria, Lyon said, would

last only three or four minutes, "and then bingo": another reel would be superimposed, and the sensory assault renewed. Lyon called this layering "unendurable. People who could even stay in the room were absolutely agonized by exposure to this." Andy, meanwhile, stood beside his twin projectors, entranced.

He had never planned more than a handful of full-length screenings of ****. In the end there was only one, at the refurbished and enlarged 41st Street Cinematheque, now the New Cinema Playhouse. The screening ran from 8:30 p.m. on Thursday, December 15, to 9:30 p.m. on Friday, followed by a two-week run of a two-hour cut.

The *New York Times*, predictably, dismissed it. ("Baby, we were stultified," wrote its critic, Howard Thompson, who was much more interested in how many cine freaks were able to tough **** out. Only a third of the original ticket buyers "were still present and upright" by midafternoon of December 16, he reported, but the theater was three-quarters full at the end, a number of viewers having returned after "respites of varying length." The *Post*'s Frances Herridge found only twenty "survivors" at the bitter end, though she called the film "a real advance technically for Warhol.") Ever-anomalous *Variety* ran a long, thoughtful review, although *Variety*'s critic found fault with the film's "random footage with no narrative or thematic framework whatsoever." Warhol's use of color, *Variety* pointed out, was so "wonderful and controlled . . . that this alone maintains awareness." The alternative press was predictably ecstatic: **** was the new cinema's *Odyssey*, Mekas wrote in his *Village Voice* Movie Journal. Another *Voice* review, by Lorenzo Mans, called the film "beautiful, monotonous, profound, and like nothing else I have ever seen in a Warhol movie or any movie. It can only be compared to Turner's late painting."

Andy was enchanted too, unable to take his eyes off the screen. The *Post*'s Herridge made a thoughtful connection between **** and the silk-screened cows of the previous year: "Warhol makes his film like wall-to-wall carpeting. You can cut any size piece to fit the occasion." For Andy, **** was no more a gimmick than *Sleep*. When critics

ridiculed its chaotic film-on-film presentation, he didn't understand why they didn't get it. To him it was "Great!—I mean a color movie over a black-and-white movie or a black-and-white movie over our color movie. I mean, it's just so fantastic, it looks like poltergeists over poltergeists in different colors and patterns and intricate divisions." Nonetheless, he was well aware that **** represented the close of a phase of his filmmaking career in which, surrounding himself with the most eccentric people he knew, he turned the camera on and hoped for the best.

Actually, *The Chelsea Girls* represented the climax of this phase: Warhol's mature film aesthetic, as it were. The four-star film represented inertia, a continuation to the point of absurdity (where Andy was wont to take things). As he knew, if he wanted to keep making movies, and he sorely did, he would have to make at least a stab at conventional, commercial filmmaking. And in fact, by the time he screened ****, he already had.

Whatever drew the avant-garde to *The Chelsea Girls*, the mainstream press headlines it generated were mostly due to its flashes of nudity, depictions of drug use, and graphic language. In early summer 1967, Maury Maurer, the manager of West 44th Street's Hudson Theatre, which specialized in racy features for gay men, approached Warhol and Morrissey. Maurer wanted Warhol films for the "sexploitation," or soft-core porn, market, a product of censorship's slackening grip. The Factory's first offering at the Hudson was *My Hustler*, with an additional thirteen minutes of previously unseen footage "calculated to make the film more appealing to 'skin-flick' audiences." *My Hustler* played at the Hudson from early July to late August; in its first week it grossed a healthy $18,000. The *Times*'s Crowther considered it "careless and amateurish"; the dialogue, between "casually noxious characters," was "sordid, vicious and contemptuous. . . . I would say that 'The Endless Conversation' would be a better title for this fetid beach-boy film."

My Hustler *at the Hudson, 1967.*
Warhol is below marquee, third
from right, holding tape recorder.

During *My Hustler*'s run, Maurer ordered up another sex film from
the Factory, asking for something along the lines of *I, A Woman*, "a
sleazy bit of Swedish pornography about nymphomania," said *Time*,
"that unaccountably was a hit on the U.S. art house circuit." Someone
at the Factory picked a not-very-inventive title—*I, A Man*—and with
this and the retooled *My Hustler*, the next phase of Factory filmmak-
ing was launched: the sexploitation films. From July through autumn,
the Hudson Theatre screened one Warhol-Morrissey soft-core porn
feature after another. In fact, every Factory movie from mid-1967
through Morrissey's 1972 *Heat* (with the possible exception of the
banned, explicit *Blue Movie*) was a sexploitation film, with a good deal
of "casual nudity" and raw language but no graphic sex.

Warhol and Morrissey's initial choice for *I, A Man*'s lead was Jim
Morrison, whose band, the Doors, had just released its first hit, "Light
My Fire." The Warhol crowd had a passing acquaintance with Mor-
rison from Max's, where the rocker had established a reputation as an

out-of-control alcoholic. "He was really, *really* stoned when he came into Max's," according to Billy Name. "He couldn't even talk." The extent of their interaction, Billy recalled, "was that I showed him where the men's room was." Andy and Morrison evidently made more substantive contact, during which Morrison agreed to come to the Factory and let Andy film him having sex with a young woman. It never happened. Reportedly at his manager's urging, Morrison backed out on the day of the shooting and sent a friend in his place.

I, A Man strings together a series of one-night stands between Morrison's replacement, a young actor named Tom Baker, and eight women, including Nico, Ingrid Superstar, Ivy Nicholson, and a new-comer named Sue Hoffman, whom Warhol and Morrissey dubbed "Viva!" (the exclamation point was shortly dropped). There is no explicit sex—Morrissey, who was beginning to have a major impact on Warhol's films, wanted to attract lots of viewers but steer clear of the censors.

Like most of the films Andy was currently shooting, *I, A Man* brims with strobe cuts, the technique noted earlier by the *Times*'s Glueck. Nelson Lyon recalled how Warhol peppered a scene from *I, A Man*, shot at Lyon's apartment, with strobe cuts; his memory captures Warhol's offhandedly self-deprecatory manner: "I had a balcony, and he had two people, a beautiful girl and Tom Baker . . . making out on the couch or at least having some dialogue. Andy, Paul, and I were out on the balcony with the camera on a tripod, shooting through my open window . . . maybe 20 feet away from the people on the couch. They were lavaliered [miked] so their dialogue could be picked up, but we couldn't hear it. . . . Andy was getting bored standing out on the balcony watching two people talk but not hearing what they said, so he'd turn the camera switch off and on. I said, 'What the fuck are you doing?' and he said, 'New technique.' With that deadpan expression and tone."

Filmed in July and shown at the Hudson in August, *I, A Man* looked

"like just another of Pop artist Andy Warhol's home movies," according to *Time*, "[But] Andy's home is unlike anybody else's." In Bourdon's judgment it was "one of the artist's most mediocre productions." One scene is riveting, but for extrafilmic reasons: Valerie Solanas makes her sole appearance in a Warhol film. Responding to her endless requests for rent money, Andy offered Solanas $25 to appear in *I, A Man*. Lit from below, she and Baker stand in the Factory's stairwell; in the improvised scenario they're outside the apartment Solanas shares with her female lover (Baker isn't supposed to know this at first). All tough talk, Solanas is more than a match for the laid-back, rudderless Baker. "What am I doin' up here with a finko like you?" she wants to know. She'd squeezed his ass in the elevator and he wants to pursue things. "Now shove off, good-bye," she growls. Trying to entice her, he takes his shirt off. "I don't like your tits," says Solanas. "What is it in your head," Baker asks, "that you don't dig about men? Is it some philosophy you have?" It comes out, to Baker's shock, that she is sexually attracted only to women. "This is a drag!" he says. "Wow, man. You're missing out on a lot of things. We could go for walks in the park, take a ferry ride for a nickel, meet my folks. . . ." She leaves him in the stairwell, smoking pensively.

A zealot like Solanas was only going to appear in a Warhol movie like *I, A Man* for rent money, so it's hardly surprising that Billy Name found her performance perfunctory: "All I remember is when we made the movie. Maybe I remember her sitting on the couch one other time. She was almost *flat*. Absolutely featureless. No personality."

I, A Man ran for six weeks; *My Hustler*, which it replaced at the Hudson, hopped to the 42nd Street Cinema. Andy now had two movies running concurrently in Manhattan's porn district. If *I, A Man* and its successor, *Bike Boy*, were nominally about heterosexual encounters—Warhol's, and especially Morrissey's, strategy for wooing the straight soft-core porn market—they were targeted far more strongly toward gays. Though "there is more display of bosoms than in a South Seas

documentary," remarked *Time*'s film critic, "Tom [Baker] steals the skin show every time, as the camera affectionately concentrates on him as it caricatures the girls."

Morrissey's rise was the beginning of the end for superstars like Ondine and Brigid Berlin—"these people addicted to the amphetamine," as Morrissey put it—who "were not useable if you wanted to make a film that somebody could sit through, with a little bit of narrative." Morrissey wanted to work with "young people, who I'd find anywhere, in the streets if necessary, and they were so much more creative and interesting than these older drug addicts." His heightened sway was bound to rile the Factory old guard. How could, say, Billy Name, to whom art, not commerce, was what mattered, not scorn somebody who praised theater owners and chains for "help[ing] me appreciate the sense that films are in business to make money first and foremost." Morrissey filled a vacuum: he could do business. As Billy recalled, "When they got the contract with the Hudson, Paul made the arrangements and set things up [although Andy remained behind the camera]. Paul became a sort of executive director, doing the casting and a lot of other stuff." And, in Billy's and others' estimation, the films lost their integrity.

When business for *I, A Man* began to slacken, Maury Maurer asked Andy for a new movie: a motorcycle film this time. As it happened, a muscular young man caught Morrissey's eye; the fellow, whose name was Joe Spencer, turned out to be a genuine biker, stranded in town with a broken bike. Morrissey invited him on board.

The Factory crowd made no secret of their low estimate of Spencer's intelligence. To David Bourdon he was "doltish," and according to the *New York Times* of September 26, 1967, the film was originally to be called *Dope*, a reference "not to narcotics but to the mentality of the motorcyclist hero." The structure of *Bike Boy* repeats that of *I, A Man*: a string of encounters between a young stud and a series of women (although Ed Hood is featured in one scene, and the movie opens

with two gay boutique clerks "fluttering," in Bourdon's words, around Joe Spencer). The rough-hewn Spencer is repeatedly flummoxed by the barbed wit of his opposites. *Bike Boy*, in other words, is about a doltish lowbrow guy who suddenly finds himself in an Andy Warhol film—although Spencer had his own wit: when Brigid Berlin observes that he could be "more refined," he comes back with, "You could go through the strainer a few times yourself."

Bike Boy opened at the Hudson Theatre in the first week of October; it was panned by the *New York Post* and the *Times* ("Andy Warhol is back with another of those super-bores," wrote Howard Thompson) and praised by the *Voice*. The film did not do as well financially as *I, A Man*, running for a week less and failing to turn a profit. Spencer, on-screen for virtually every minute, appears to have been paid $122.

Toward the end of *Bike Boy*'s run, Andy appeared at the Hudson in a midnight symposium entitled "Pornography or Reality." The ostensible host, he said little or nothing, bringing Morrissey, Ingrid Superstar, and Viva (the latter was quickly scaling the Factory hierarchy) along as mouthpieces. "There were a few chuckles at the expense of Warhol and his famed taciturnity," *Variety* reported, when someone in the audience for instance yelled, "What does Andy have against speech?" But most attendees came prepared to take Warhol very seriously; one startled even the jaded panelists when he called *Bike Boy* "an adroitly realized variation on the *Parsifal* legend."

If the sexploitation flicks weren't that titillating, Warhol's "unashamed nudes, swishy wit, and matter-of-fact documentation of gay lifestyles were a breath of fresh air" to gay men of the mid- to late sixties, according to the film historian Tom Waugh. As Paul Morrissey (happy as always to infuriate as many constituencies as possible) told a 1970 interviewer, "Most of our audiences . . . are degenerates, looking for sex and filth. . . . Degenerates are not such a great audience, but they're a step up from the art crowd. We would always rather play a sexploitation theatre than an art theatre."

When *Bike Boy* finished its Hudson Theatre run in early November, Warhol and Morrissey were ready with the fourth Warhol movie to be shown at the Hudson: *The Nude Restaurant*, filmed in a Village spot called the Mad Hatter. Andy shot two versions; the first, featuring an entirely nude, entirely male cast, was never released on its own, though it may have been screened as part of ****. The second version, which ran for four weeks at the Hudson (each of the sexploitation films of 1967, from the expanded *My Hustler* through *The Nude Restaurant*, was less of a box office success than its predecessor), added women; everybody stripped to black G-strings, a takeoff on porno-movie posters' "censored" patches. Midgette starred in both versions. "I kept telling Andy that I was bored and needed some kind of challenge," he recalled. "I said, 'Why don't you just find a diner somewhere and I'll work behind the counter; if anybody gets out of hand I'll call the police.' It wasn't my idea to be nude, but it was my idea to have the restaurant."

Despite the roomful of actors, *The Nude Restaurant* was no ensemble effort; the superstars and strays who peopled Andy's films "just never came together as an acting troupe," said Midgette. "They weren't actors. But even so, they were so competitive. Andy used to play games: 'You're in, you're out.' " Still, the film had its moments, both involving Viva: her playful banter with Mead and langorous kiss with Midgette (sculptor John Chamberlain called it the best on-screen kiss he'd ever seen). Midgette remembered having an especially good rapport with Viva, his real-life lover at the time—even if he was tripping on acid.

Throughout 1967, Andy shot lots of footage of Ondine, much of it intended for a movie to be called *The Loves of Ondine*. Though clearly belonging with the 1967 sexploitation films, it wasn't released until August 1968.

To the extent that it has one, the film's premise is that Ondine is trying to go hetero, attempting (unsuccessfully) to bed a series of

women. The movie was also a transparent attempt to recreate Ondine's epochal *Chelsea Girls* outburst—in other words, an exploitation film in more than one sense. If aesthetically negligible, it marked the first turns before Andy's camera of two of the Factory's best-known late-sixties superstars. One was Joe Dallesandro, a muscular, sweet-faced eighteen-year-old, whose breakthrough came a year later as the star of Morrissey's *Flesh*; before long, "Little Joe" would be an international film star and, in its August 15, 1971, issue, a *Rolling Stone* cover boy.

The other was Viva. Although her public appearances in *Bike Boy* and *The Nude Restaurant* came earlier, *The Loves of Ondine* was shot before them. Viva's improvisations in the movie—she proves herself Ondine's equal, if not superior, at the acerbic putdown—impressed Morrissey so much he called her "a performing genius on the order of Mick Jagger, a comic Greta Garbo." An aspiring painter, she stopped right away. "Paul said, 'Painting is a dead medium' . . . so I said, 'Fine, I'm a performing genius, painting is dead.'"

Janet Sue Hoffman—Sue, as she'd always been called—was born in 1938 near Syracuse, New York. In her affluent family "the behavior completely contradicted the spoken word," and she developed a radar for hypocrisy and pretense, learning to puncture them with what became a quick, barbed wit. Graduating from Marymount, a Catholic college ("the nuns had me from five to twenty-one"), she moved to New York, worked as a model for art classes and fashions, drew silhouettes of visitors to the 1964 World's Fair, and began hanging out at Max's—in the front room, with the Abstract Expressionists—where Chuck Wein met her and cast her in *Ciao Manhattan*, his attempt to return Edie Sedgwick to film. She met Warhol at an August party at the loft of clothing designer (and soon, John Cale's wife) Betsey Johnson, and he offered her a part in his next film, which turned out to be *The Loves of Ondine*. She was given a Factory pseudonym and, though Andy wasn't using the term anymore, she became his new Girl of the Year, the leading lady in his films and

his date of choice at soirées. As Watson puts it, "Jane Holzer had big hair, Edie Sedgwick had glamorous vulnerability, Nico had other-worldly beauty, and Viva had neurotic braininess" as well as a fragile beauty, a voice that rose from a deadpan monotone to a querulous whine, and a hair-trigger temper. Smart and independent-minded, she was capable of registering and voicing insights into Warhol that few other Factoryites could. "You always edit yourself," she told him, frustrated by his evasiveness. "You don't edit anybody *but* yourself." "Because he was so shy and complexed about his looks," she would write, Andy "had no private life. In filming as in 'hanging out,' he merely wanted to find out how 'normal people' acted with each other. And I think my own idea about *Blue Movie* [the last film Warhol directed, and, as *Variety* said, "the first theatrical feature to actually depict intercourse"] wasn't, as I believed at the time, to teach the world about 'real love' or 'real sex,' but to teach Andy."

Viva during the filming of Nude Restaurant

Not long after her Factory arrival, Viva began to write, in a witty if verbose style, for the gossip sheet *Downtown*, where she reviewed the latest Warhol movie under her real name, giving herself raves, and for Paul Krassner's *The Realist*, where she found an outlet both for her feminism and her instinct for outrageous statements. When the radical priest Philip Berrigan and others poured duck's blood on draft files,

Viva considered "this pallid priestly protest" lame and came up with her own recommendation for direct antiwar action, a mass feminist protest: "Women, stand up and be counted! You can begin with the number you're most familiar with: 28." Every twenty-eight days, women everywhere were to stage "a mass sanitary drop-in" by removing their Kotexes—or a "plug-out" if they used Tampax.

The year 1967 brought another important arrival to the Factory. Although he quickly made himself useful to Andy's film enterprise, Fred Hughes would eventually prove far more important in another sphere: revitalizing Warhol's painting career, financially if not aesthetically. Indeed, Hughes became a sort of alter ego to Andy, "[his] equal in a way that the rest of us were not," wrote one seventies Warhol associate. "Fred was the one who knew what Andy wanted even when Andy wasn't quite sure himself."

Hughes and Warhol met in September 1966, at a benefit for the Merce Cunningham Dance Company at Philip Johnson's famous Connecticut "glass house." According to Geldzahler, Hughes, who already knew Henry, grabbed him and begged, "Please introduce me to Andy Warhol." Hughes's own account of the meeting was different: "[Andy] knew who I was, and he saw the pot of gold at the end of the rainbow."

That would be the Schlumberger oilfield-equipment fortune, much of which belonged to Hughes's patrons, the world-class art collectors Dominique de Menil (née Schlumberger) and her husband Jean. Although the Menils had lived in Houston since 1941 (and Jean had anglicized his name to John), both were French-born, and in addition to their Philip Johnson–designed Houston house maintained homes in New York and Paris.

As a fifteen-year-old, Hughes had worked at the Houston Museum of Fine Arts, where he'd met the de Menils. Quickly recognizing his potential as a useful retainer—he had what Dominique called an "instinct for what was important, for quality" and an easy social grace—the de

Menils took an active interest in Hughes's development. He latched even more firmly onto them; abhorring his plebeian roots—his father was a furniture salesman—he was already a resolute social climber.

Hughes majored in art history at Houston's University of St. Thomas (whose art department was funded by the Menils) but never graduated. At the end of 1964, the twenty-one-year-old went to Paris, where the de Menils helped land him a job with the art dealer Alexander Iolas (whose Hugo Gallery in New York had been the site of Warhol's first show, in 1952). Returning to the United States in 1966, Hughes undertook various projects for the de de Menils; one of the first was helping to arrange the Cunningham benefit where he and Warhol met.

By 1967, Hughes was working for Andy. Although he started out, as everyone did, sweeping the Factory floor, he may have been the best-dressed janitor in history—at a time when most twenty-three-year-olds in Manhattan traipsed around in bell-bottoms and T-shirts, Hughes wore beautifully tailored English suits and handmade English shirts and shoes.

Fred wasn't a janitor for long. "Being attached to the de Menils," he recalled, "I immediately thought of all kinds of lucrative projects for Andy." One of the first was the film *Sunrise/Sunset*, commissioned by the de Menils as part of an upcoming exposition Hemisfair, in San Antonio. In a letter to Andy dated June 26, 1967, John de Menil writes that he is "very happy to hear from Fred of your enthusiastic response to the suggestion that you do something for the San Antonio project. . . . You told Fred that you would like to do a film. We love the idea. . . . As to the amount of the commission, Fred suggested $20,000." *Sunrise/Sunset*, filmed in August and September in the Hamptons and San Francisco, was never independently released, but was woven into ****. (According to Hughes, the leftover money was used to shoot Warhol's first film project of 1968, *Lonesome Cowboys*. Later Hughes got Andy another de Menil commission, a painting this time: a portrait of the de Menils' late friend Jermayne MaCagy, who had headed the art department at the

University of St. Thomas. This was followed by a de Menil commission to paint Dominique herself. Although Warhol was no stranger to the commissioned portrait, it was Hughes who would begin to systematically extract portrait commissions from the rich and famous; this would be Warhol's bread-and-butter work in the seventies.

Hughes has been vilified as Andy's corrupter, a mercenary without moral fiber. But Warhol's steep seventies financial ascent and, many say, aesthetic decline were his own move, not Hughes's. According to John Richardson, who knew both well, Hughes's role was to make the right connections. "What Fred did, for better or worse," said Richardson, "was, first, to clear everybody out [of the Factory] and, through his promotional savvy, to elevate Andy into a social orbit that he'd never been in before." If Hughes was a climber—"a demented social fanatic," as one sixties Factory member put it—he could also make fun of himself ("I'm *deeply* superficial," he liked to say), and he was playful: pretending to be "Frederick of Union Square," a crazed hairdresser, he'd give the Factory staff Scotch tape facials, making them all look extremely bizarre. "There, that's much better," he'd say with a flourish.

When Andy gave his speechless lecture, "Pornography or Reality," at the Hudson Theatre on November 1, he was joining a booming new market: the American lecture circuit, with an annual gross somewhere between $60 and $100 million. The thirst to behold fame incarnate, whether an eminence or the latest headline-grabber, was an offshoot of the cult of celebrity that Andy had helped to amplify. On the college circuit, the big draw was antiestablishment figures. Anyone who "upsets the trustees, because that's what it's all about," said a University of Rochester student in a 1968 *New York Times* magazine story. The American Program Bureau, one of the circuit's leading players, did three-quarters of its business on college campuses, bringing Dick Gregory, Timothy Leary, and others to rail at LBJ, Nixon, and their parents' values. "The Timothy Leary–Andy Warhol kind of nut has

taken over the college platform," said a member of an older, staider lecture bureau. "These kids are sensation-mad."

The American Program Bureau approached Andy in early 1967, offering him between $750 and $1,500 per lecture, minus expenses, and Andy hit the lecture trail. Morrissey and Viva, after her arrival, usually came along to do his talking for him. The money wasn't great, since he was paying expenses for three. Andy had a deep-seated phobia of appearing onstage; further, he constantly imagined that he was missing tons of opportunities by leaving New York, from shooting movies to appearing at parties. And he was uncomfortable leaving his mother, Julia, alone; now seventy-five, she was increasingly absentminded. So he hatched a plan.

Allen Midgette, who resembled Andy only in being slender and light-haired, recalled coming into Max's one September night and Paul Morrissey offering to buy him a drink. A black leather jacket lay draped next to Morrissey, so Midgette figured that Andy was somewhere around. "Paul said to me, 'Do you feel like going to the University of Rochester tomorrow and pretending you're Andy?' I said, 'Why would I?' He said, 'Well, you'd get six hundred dollars.' I said, 'Fine, I'll do it.'

"It was Andy's idea, obviously. He was scared shitless of the public. Paul made me stay at his apartment because he didn't trust me to get up at 9:00 a.m. At about five that morning, two narcotics agents arrived and tried to bust Paul. He'd gotten all these Warhol people out of jail, so they figured he must be a druggie too." The abstinent Morrissey was holding nothing; neither, luckily, was Midgette. "So they were out of luck. But it was a weird way to start the morning."

The next, obvious, problem posed itself: Midgette looked nothing like Andy. "I said to Paul, 'Better let me stop at a pharmacy.'" Buying the palest shade of Erase he could find, the actor Warholized his face and hands, "and I sprayed my hair silver. And I put on dark glasses and Andy's jacket. We went to the lecture and it actually came off. Mor-

Allen Midgette impersonating Andy Warhol on the lecture circuit, 1967

rissey didn't make it much fun. He didn't think I was gonna get away with it. The whole time, he just stood there observing, I think really amazed that I was pulling it off. I was surprised they bought it, too, but they didn't know who Andy was. They were only asking questions from the brochure and trying to act like they knew all about him. Even though I was impersonating him, I actually talked to the students the way that I would talk to friends. I think I talked about astrology. Anything that came into my mind. And after that lecture the press ran after me and said, 'Mr. Warhol, you're so intelligent! Everyone's got it all wrong, you're really smart!'"

Midgette went out as Andy four more times that October, to colleges in Utah, Montana, Oregon, "[having] dinner with the president and his wife almost every time I went." The students were quicker to catch on. On November 2, as Midgette and Morrissey climbed off the plane in Salt Lake City, where "Andy" was to lecture at the University

of Utah, a gust of wind whisked a big puff of talcum powder out of his hair, right in front of a bunch of students. After the lecture, and again after an appearance at the University of Oregon, students reported their suspicions to college officials. Paul Craycroft of the University of Utah contacted the American Program Bureau, wanting to know if the Warhol who'd turned up in Salt Lake City had been the real thing. Morrissey responded to Craycroft with a masterpiece of evasiveness. "We are at a loss as to how to deal with the situation you cited in your letter, therefore we would request that you suggest to us a way of resolving your doubts concerning the appearance of Mr. Warhol and myself at your school. [We] do not understand why you should believe that Mr. Warhol did not in fact appear in Salt Lake City." Morrissey managed to keep the administrators at bay for the rest of the year and into 1968. The closest Andy came to admitting the ruse, for the time being, was to put a photograph of Midgette on the rear cover of the late-sixties Factory souvenir book *Andy Warhol's Index* with the words "Andy Warhol" conspicuously printed on Midgette's upper lip.

In mid-1966, Gerard Malanga had fallen in love with an Italian beauty visiting New York, a model and aspiring actress named Benedetta Barzini (her father, Luigi Barzini, was a well-known writer on both sides of the Atlantic). When Benedetta abruptly ended the affair that autumn, Gerard was despondent, jotting a morbid revenge fantasy in his diary: he would follow Benedetta back to Rome, suffer one last rejection at her door, take an overdose of sleeping pills, and die in her city.

Gerard spent a good part of 1967 in a lovelorn funk. That summer, when the Bergamo Film Festival accepted his homage to Benedetta, *In Search of the Miraculous*, he got to live out at least the first part of his fantasy. "I was basically following Benedetta back to Italy, even though I had already planned to go" to screen his movie. Whatever prompted it, Gerard's Italian journey was the first step in a long goodbye to Andy.

Malanga bought all he could afford, a one-way ticket to Milan, thirty miles southwest of Bergamo, hoping he could "get some gigs that would pay for my ticket back." Warhol had let him know, he later said, that if he proved short of return-ticket money, Andy would send it. In Gerard's first letter back, on September 12, 1967, he excitedly took in the Bergamo Festival, flatteringly telling Warhol that Godard's new *One or Two Things I Know About Her* used "a lot of your techniques and tricks." Gerard's own film had been well received, the "Czechoslovakian" movie booed. "Do send me some money," Gerard wrote, signing off with a second request to which he appended "immediately."

According to Malanga, "I was ready to come back to New York right after the film festival. And that's where Andy's S&M kicked in, because he went back on his word." Phoning the Factory every day from a friend's, "I couldn't get Andy on the telephone. Talk about faggot revenge. This was Andy's gay revenge on me. In his mind I was going to Italy to chase after Benedetta, it didn't even count that I had a film at the film festival. So this was his way of getting even with me. And I ended up being in Italy for six months. I was stranded."

On September 16, a Malanga postcard to Billy Name reported that "Milano is fantastic! . . . PLEASE HAVE ANDY SEND ME MONEY. HE PROMISED. AM BROKE." Ten days later, Gerard importuned Andy again: "You might send me some money since I'm broke."

The poet and composer Peter Hartman, a veteran New York undergrounder, invited Gerard to stay at his apartment in Rome. Independently wealthy, Hartman gave Gerard $50 a week and a base for Malanga's increasingly busy life in Rome's literary, film, and fashion worlds. "I completely forgot about Benedetta because I got involved with so many interesting people: Elsa Morante, Pier Paolo Pasolini, Alberto Moravia, the gamut of the real heavy intellectual, incredible people." As he put it in a letter to Andy, he was "thriving creatively" but "starving physically." And a moneymaking scheme occurred to him. Never long without a girlfriend, he had lately taken up with a

young Roman socialite named Patrizia Ruspoli. She wanted Gerard to make her a big silk-screened painting just like one of Andy's; it would be an image of Che Guevara. Gerard quickly decided to make two, one for Patrizia and one for sale—as an authentic Warhol. In addition, he could screen any number of versions on paper, for sale as posters. For his source, Gerard settled on the now-iconic photograph of the just-murdered Che, lying on a table, surrounded by his killers.

In a letter to Andy of December 18, Gerard unveiled his intentions in more detail. The "monies" that the counterfeit Ches brought in would go toward Malanga's eagerly planned "2-hour sync-sound color 16mm feature film," *The Recording Zone Operator*. It was to be a "diary film" whose characters would "naturally spring from the natural pace" of each situation. Malanga had the temerity and lack of tact to boast that it would make his hopeful benefactor's *The Chelsea Girls* look like a "fairy tale." Only ten minutes of it were ever shot.

In subsequent years, Malanga would refuse to discuss the forgery episode, but it can readily be reconstructed from the flood of mail Gerard sent Warhol, Morrissey, and others between autumn 1967 and March 1968. On November 4, Gerard wrote Harry Golden, Warhol's screen-maker, asking him to build a screen of the Che photo and some silk-screening equipment (evidently hard to come by in Rome) and send them without delay. To Warhol, Gerard wrote that unless he heard from him, he would proceed with his plan. Trying to think ahead, Gerard overplayed his hand, counting on sympathy and support that had long been withdrawn. "What I'm doing is a criminal act," he wrote in December. The only person who could blow the whistle was Andy, whom Gerard trusted wouldn't get him in trouble. "OK?" wrote Gerard, providing his own answer: "OK."

Directly, Gerard mailed Andy one of the counterfeit Che posters, and continued to pelt him with cards and letters, by turns filial— Andy would be proud of his protégé—and bullying, and as a whole stunningly self-deceptive. Andy answered nothing directly, but a letter

to Malanga from Ronna Page more than adequately conveyed Warhol's feelings. Ronna had just read Gerard's latest communiqué to Andy, whom she reported to Gerard as saying, "The letter is hysterical. I mean, he must be on a trip—he's hallucinating. Oh, it's just fantastic." Malanga hoped, he wrote Warhol, that there was a twinkle in Andy's eye as he'd said that, since he was sure that Warhol had no problems with Gerard selling "an 'Andy Warhol' painting silk-screened by me."

Gerard was giving Andy full power to either rescue or condemn him. Too blind to see that even before this charade Warhol had been hardly well-disposed toward him, was in fact tired of him, ready to dump him, he worked assiduously on his "Warhols," building a trap for himself.

Andy's nonfilm work had slowed down, but by no means ceased. In January 1967, in the spirit of antiwar protest, the *World Journal-Tribune*'s Sunday supplement *New York* (soon to become *New York* magazine) had announced a contest to design a water bomb, "the happiest war toy of them all, the only one a man of peace can want to drop on Hanoi, for even Ho's *civilians* could never be hurt by a bath." First prize was to be a hundred-pound U.S. bomb painted silver by Andy Warhol. When the winner went to the Factory to pick up his prize, he was disappointed that Warhol hadn't decorated it with one of his signature images, say, a soup can. "It's so beautiful I couldn't ruin it by painting anything on it," Andy replied. "I've sat and stared at it for weeks. Isn't it beautiful?"

Another "sculpture," also painted silver, was commissioned by Philadelphia's YMHA for a May 1967 show, The Museum of Merchandise. The show was based on a recommendation by Marshall McLuhan to not "just put art in the environment—turn the environment into the work of art." Warhol's contribution consisted of three cases of Coca-Cola bottles that he'd painted in spring 1964; they'd been sitting around the Factory in their silvered state ever since. Inside the bottles was

a men's toilet water sophomorically dubbed (whether the humor was Andy's or another Factoryite's) *You're In*. (The bottles were presumably filled with a toilet water already manufactured by the perfumer Cassell; no doubt Andy couldn't resist the scent's name: Silver Lining.) In any event, eight days after The Museum of Merchandise opened, Andy and the YMHA each got a letter from Coca-Cola's counsel letting them know that their use of Coke bottles, whose design had long been trademarked, as well as Coca-Cola crates, was a flagrant violation of trademark law. Since Coke clearly meant business, the YMHA and Andy stopped selling bottles of *You're In*, offering them free with the purchase of a bottle of Silver Lining. Few of Andy's silvered Coke bottles had sold anyway.

Several months before the *You're In* imbroglio, in early February, the Castelli Gallery commemorated its tenth anniversary with a show displaying the work of sixteen of its artists, from the relatively unknown Sal Scarpitta to icons such as Johns and Rauschenberg. Andy's contribution, a brand-new work, unlike most of the other pieces, was a comment on the show itself: portraits of a dozen Castelli artists, including Johns, Rauschenberg, Stella, Lichtenstein, and Rosenquist. Andy's pictures varied in size, from a 2½-by-3-inch likeness of Donald Judd to a foot-square portrait of Rauschenberg. Warhol made many subsequent versions of these paintings, including twenty-five of his self-portrait (a different image from the finger-to-lips *Self-Portrait* of 1966), and a ten-by-fourteen-foot serial portrait of John Chamberlain, which the sculptor traded Warhol for (and sold decades later for just under $5 million).

In late April, Expo '67 opened in Montreal. The U.S. pavilion was a breathtaking structure, a geodesic dome designed by the architect and futurist R. Buckminster Fuller, then at the height of his influence. Leo Castelli's friend Alan Solomon organized an exhibit, American Painting Now, whose layout took advantage of Fuller's spectacular environment. Works by some of America's best-known painters were

fixed to huge sailcloth banners that hung from the top of the dome. Andy remade his 1966 *Self-Portraits* into six 72-inch squares, each containing six 22-inch panels. Although some of the paintings were bigger (Helen Frankenthaler's was thirty feet high), Warhol's six canvases, scattered throughout the display, conveyed a sense of omnipresence—everywhere you looked, Andy looked back at you in an act of unabashed self-promotion.

That autumn, Warhol painted two more portrait series. The first was commissioned by its subject, collector Sidney Janis. Andy went a bit overboard here: Janis asked for a portrait; Andy made thirty-nine. He sold Janis two but wanted him to take another, a huge serial portrait. Janis politely declined, writing Andy on December 27 that "I do know it would be out of character for me to include about 35 feet of Janis, almost 25 feet more than . . . any other canvas in the collection. If the subject were not myself (which you've done magnificently), I wouldn't hesitate." The other series, of Nelson Rockefeller, was probably commissioned by New York's then-governor, an avid art collector who bought four of the five panels. Caught as if in midspeech, Rockefeller looks almost brutal or enraged; apparently, he saw himself in these portraits as a forceful leader.

At some point during 1967 Warhol established a new arm of the Factory's growing miniconglomerate, a printmaking operation called Factory Additions. He had silk-screened images onto paper as early as 1962, but Factory Additions did so systematically. For the new company's first product, Warhol chose as an image his 1962 portrait of Marilyn Monroe. Two hundred and fifty folios were printed, each containing ten differently colored *Marilyns*. The colors, even gaudier than those of the Monroe paintings, were selected by Warhol's friend David Whitney, subject to Andy's approval.

Within a few years, Factory Additions had produced 250-folio runs based on 1962's *Campbell's Soup Can* paintings, 1964's *Flowers*, and a number of other limited-print editions. Judging by a mid-1968 Chase

Manhattan bank statement that put its balance at almost $10,500, Factory Additions did well. Fine-art prints as a whole were a hot new mini-industry—the mushrooming art market contained plenty of people who couldn't afford a Johns or a Lichtenstein painting but wanted something special to hang on the wall. In addition, in the wake of Pop art, especially Warhol's, more and more artists were intrigued by the conceptual puzzles of original versus reproduction and uniqueness versus multiplicity. Both issues lent themselves especially well to printmaking. Both, of course, lay at the core of Warhol's work. In fact, the difference in media (canvas and paper) and price aside, one can't really make a qualitative distinction between Warhol's paintings and his prints. His paintings *were* prints, if laboriously produced; the same technique, screen-printing, was used for both. Andy painted or had painted more than one-third as many *Flowers* as were printed (900 paintings, 250 print editions, of ten samples each). It wasn't just print-making's new profitability that drew Andy; it was also the conceptual play, the upending of fixed ideas.

A look through Warhol's 1967 financial documents sheds a good deal of light on his day-to-day life at the time. On its 1967 income tax return, Andy Warhol Films reported an income of $83,874.46, of which $61,131.47 were claimed as deductions. *The Chelsea Girls* had changed everything. Warhol now had an English distribution deal, negotiated by Lester Persky; he had films playing in art cinemas all over the United States and Canada, and although he still had to scuffle to put together a film budget, and still barely paid his actors, financing his films was no longer the nightmare it had been in 1964 or 1965.

At least six of Andy's monthly 1967 bills from his local drugstore, Plaza Apothecary, are scattered around the Warhol Museum archive. On four, he is billed for Obetrol—in other words, Andy was still a steady if moderate amphetamine user.

He was also still buying a season subscription to the Metropolitan

Opera, a habit he'd begun in the fifties. Several of Andy's friends insist that he knew more than a thing or two about opera, but a taped 1965 exchange between Andy and a real opera lover, Ondine, shows Andy's grasp of opera history (and the history of technology) to be extremely shaky. While Donizetti's *Anna Bolena* plays in the background, Ondine remarks that the aria they're listening to was written for "an Italian Jewess named Giulia di Pasta," who he claims sang the title role at the world premieres of Donizetti's *Norma*, *La sonnambula*, and *Anna Bolena*. Did she make any records? Andy asks. No, this was 1831 or 1832, Ondine says, polite enough to mask his incredulity.

In autumn 1967, overdue-payment notices swarmed around Andy like angry bees. On November 20, Eastman Kodak sent a frostily polite letter reminding him that he owed them $652.69. The October statement from his longtime art supply sources, E.H. & A.C. Friedrichs, registered an outstanding balance of $848.31. His plumber, either at 1342 Lexington Avenue or at the Factory, scribbled a note reading, "You keep saying you are mailing us a check. We never get it." After failing to make his November and December mortgage payments for 1342 Lexington Avenue, Andy received a warning that "your mortgage loan is now delinquent." Nor, by the end of January 1968, had he paid the Factory rent from October 1967 on.

This financial negligence may be attributable in part to Warhol's fabled stinginess, but it was also probably due to the departure of Stanley Shippenberg, Andy's accountant and business manager since 1957. Even if Paul Morrissey was now opening the business mail, he was as distracted from bill-paying as Andy. The Factory, moreover, was besieged by more visitors than ever. "Our small circle had expanded to hundreds and hundreds," says *POPism*'s Andy, "and we just couldn't have the all-day, all-night 'open house' anymore, it had gotten too crazy."

Further upending everybody's equilibrium, Andy was notified by the owners of 231 East 47th Street that the building was to be condemned.

Midtown's east side was becoming too desirable a commercial and residential area for a tumbledown five-story building to be left standing. Warhol, Morrissey, and Billy Name began studio-hunting. For four years the locus of an amazing amount of activity and the object of vast public curiosity, the Silver Factory was in its last days.

1968

A "male artist" is a contradiction in terms. A degenerate can only produce degenerate "art." The true artist is every self-confident, healthy female, and in a female society the only Art, the only Culture, will be conceited, kooky, funky females grooving on each other and on everything else in the universe.
—VALERIE SOLANAS, *SCUM MANIFESTO*

By late 1967, *The Chelsea Girls*, the most watched, most widely discussed underground film yet made in the United States, was being shown in commercial movie houses nationwide. Its wholly unexpected success had propelled it beyond mere avant-garde status, prompting Andy, whose vision of Hollywood glamour had been close to his heart since childhood, to dreams of mainstream movies. He was through with the avant-garde. "We're in show business now," he told Bourdon in February 1968. (The latter, having finally wangled an assignment for a Warhol profile out of his *Life* editors,

spent much of that winter and spring accompanying Andy.) In June, Warhol announced that he had "decided to give up making art movies and to produce instead two-hour color comedies." Factory-made pictures, he said, "will be directly competing with Hollywood," but on his own terms, namely, "to reproduce the glory, the glamour, and the grandeur of Hollywood studio-made films of the '30s. . . . Our period of experimental art films is over. We did it, we proved it was successful, and we are going to go on to other things."

But no matter how ready Andy felt to start producing good old-fashioned narrative movies, there was a big problem: he couldn't tell a story. "This very gifted man . . . has no gift for assembling, for putting together under his own hand, any version of human interchange," wrote Stephen Koch in 1972. "And I mean *any* version—not realism, not comedy, not Surrealism, not any available narrative concept." Nor did Morrissey, who, for all of his professed devotion to the classics of John Ford and Howard Hawks, was almost as anarchic at heart as his boss. Warhol had always relied on his performers, in their amphetamine-laced exhibitionism, to spontaneously create whatever narratives, or linear, sense-making dialogues and monologues, emerged to light up the stultifying norm. He'd depended on Ondine and Brigid Berlin, without whose improvisations *The Chelsea Girls* would not have been nearly so successful. Now Warhol decided that he was ready to rely on planning, scripting, savvy directing, and professional-quality editing to produce a narrative movie with mass appeal.

An actual treatment was provided, dreamt up by Morrissey. Commentators have called it "tightly plotted," but it was a mere two-page outline. There was no script. The filmed narrative was not off to an auspicious start.

Nor did Morrissey's treatment have the slightest mass-market potential. A western send-up of *Romeo and Juliet*, the project's working title was *Ramona and Julian* (yes, the principals' sexes were switched). The Montagues, originally Juliet's family, were now a band of gay cowboys,

among them the tender Julian, played by a handsome youngster with no performing experience, Tom Hompertz. Romeo's Capulets became a bunch of dance-hall prostitutes, with Brigid Berlin as the madam and Viva as Ramona, the brightest-shining of the whores. Reprising his *Chelsea Girls* role, Ondine was Friar Lawrence, who shares his original's name but in place of Shakespeare's wise padre was "a degenerate and unfrocked priest," according to the scenario, addicted to "opium-laced cough syrups." Instead of praying over the dead lovers in the final scene, he molests their corpses.

The cowboys included Eric Emerson, Allen Midgette, Louis Walden, and Joe Dallesandro. The sheriff (and part-time hooker) was the transvestite actor Francis Francine, a Jack Smith veteran who'd been in *Flaming Creatures*. Taylor Mead played Viva's sidekick, referred to as her "nurse." The actors' pay was $10 a day, plus room and board.

Just before the fourteen-member cast and crew left for the Factory's first-ever location shoot, a dude ranch forty miles outside of Tucson, Arizona, Ondine and Brigid declared their refusal to go—they wouldn't be able to function, they said, without speed, certainly unavailable at the Rancho Linda Vista. Morrissey decided to drop the film treatment, and when the cast sat down for a meeting on January 25, the day before shooting was to start, he announced, "Now that everybody's here, we've got to think of a script." Things were looking very familiar.

On day one, January 26, Warhol filmed at Old Tucson, a mock-up western town in use as a film set for decades—*Rio Bravo*, *The Alamo*, *Hud*, and many other Hollywood classics had been shot there. It was still in use; as the Factory gang arrived, an episode of television's *Death Valley Days*, starring Robert Taylor, was being filmed. To boost income, Old Tucson also staged gunfights and featured other entertainment, drawing daily crowds.

Coached by Morrissey, the actors improvised over the merest shred of a story: the antagonism between Ramona and the cowboys, fueled by amorous feelings for young Julian. Nothing cohered. ("I don't have

anything to talk about," was Hompertz's refrain. "Well," said Morrissey, "Talk about your rash, about how you get a chemical reaction from horses. Talk about your skin condition and if you've had your appendix out.")

About seventy Old Tucson employees and tourists gathered to watch. At first congenial, the onlookers grew uneasy, then hostile; something about the Warhol entourage, Bourdon noted, "inspires immediate distrust and dread." Scattered shouts of "pervert" began ringing out. One local, sizing up a cast member, said, "Tell you one thing, that kid's never going to Vietnam." Horrified by Viva's obscenities, mothers pulled their children back to the amusement park. A Pima County sheriff appeared and looked on silently. "People from New York are bad news," said a crowd member. As the Factoryites departed, an Old Tucson worker yelled at Viva, "Go back to your own state, pig!" and Viva, letting fly with a string of filthy language, had to be shoved inside the waiting van.

The company drove off to the Tucson Press Club, where a conference had been scheduled. "This is our two hundredth film without a script," Morrissey announced to reporters. One asked when the movie was coming out. "When it comes back from the drugstore," said Morrissey. Asked about his background, Andy answered that he was Cherokee.

The remaining four days' worth of filming took place on Rancho Linda Vista's eighty acres, shortly bristling with University of Arizona film students busily shooting 8-millimeter movies of Warhol at work. At night, peeping Toms scurried from cabin to cabin.

Throughout day two (and the rest of the shoot), the actors, left to their own devices, freely and pointlessly sprinkled their speeches with references to their real lives. The cowboys went in and out of being actual brothers. Viva and Louis Walden, ex-lovers in real life, spatted constantly, on camera and off (at least this coincided with their "scripted" antagonism). Stung by an especially nasty insult, Walden plotted an impromptu gang rape. Shouting, "Fuck her!" the cowboys

dragged Viva screaming off her horse and stripped her down to her socks. An onlooker phoned the deputy sheriff, who stayed onsite for the rest of the shoot, joined by lawmen who lurked with binoculars behind boulders and cacti.

On January 28, day three, the Phoenix FBI was notified that a porno film was being made. The agency, which had never heard of Warhol, began making phone calls and going through files, investigating the New York filmmaker for transporting obscene material across state lines. The Phoenix branch was joined by the New York, San Francisco, and Atlanta offices, which worked long after the shoot was over, compiling a thick dossier of inconsequential data.

The morning of January 29 found Andy fretting as he eyed the remaining film stock. It was obvious that the movie, and Warhol's newfound designs on Hollywood, were dead for now. "We're just going to cut out the best parts and paste them together," he sighed. On the final day, Andy shot a love scene between Viva and Hompertz. A carful of students pulled up. "Please don't follow us anymore," said Morrissey. "We're going to be doing dirty things." Viva and Hompertz disrobed. "Don't talk too dirty," Morrissey cautioned, "or we can't show it." Off camera, Taylor Mead muttered that Morrissey should be fired; he intruded too much into the improvisation and worried too much about censorship. (Viva wanted to perform actual sex: "Why can't you do it?" she whined.) In an unplanned reversion to the Romeo and Juliet storyline, Mead entered, offering the lovers poison, which they took, and died. Mead announced that since he had no water to wash the bodies, he would lick them. He addressed Ramona's corpse: "It's me that's always loved you most, Ramona. These cowboys are too rough for you." Mead and Dallesandro, who appeared from nowhere, then danced together to the Beatles' "Magical Mystery Tour." In the final scene, Emerson and Hompertz rode off together.

Lonesome Cowboys was not released for more than a year; it premiered on May 5, 1969, at the new Andy Warhol Theater. The reviews were not positive. While the improvisations in such previous Warhol

Taylor Mead, Joe Dallesandro, and Eric Emerson in a scene from Lonesome Cowboys

films as *The Chelsea Girls* and *My Hustler* had seemed "scarily relevant" to the *New York Times*'s Vincent Canby, "now, however, they are becoming cute and show-offy . . . L. C. is the least interesting . . . of his movies." "The plot hardly works as a plot," wrote Neal Weaver of the entertainment magazine *After Dark*, "but it is omnipresent enough to get in the way of the lackadaisical improvisations which were the heart of the earlier Warhol films." Andrew Sarris of the *Village Voice* also pointed to the lack of cohesion between *Lonesome Cowboys*' storyline and its improvisations. Once Warhol decided to play what Sarris called "genre games" that is, a western, "the undisciplined narcissism of his ménage clutters the screen with giggly egos out of synch with each other and with any coherent conception."

The daily pitch of Factory life was too hectic for anyone to realize it, but something was amiss. Andy Warhol had lost his way. His best artwork had emerged from largely intuitive, aesthetic decisions. *The Chelsea Girls*, and slighter film successes such as *Beauty #2*, had also

relied on well-defined foundations: train the camera on untrained but gifted performers, encourage the exhibitionism they'd been chosen for, and give the entire enterprise a graphically subversive, antibourgeois bent (not difficult, given the movies' casts).

But Warhol, turning his back on a tremendous visual-arts talent and thus forsaking his mainstays, Geldzahler and Karp, was no longer interested in the subversive cinema he'd helped pioneer. He longed to be something he had neither the skill nor the instincts for: an entertainer. "I hate art," he told David Bourdon that winter. His innate oppositional spirit, the old nose-picker, was still at work, but directed now at his previous milieu, the avant-garde.

Warhol and the Factory had come unmoored at the same time as, and largely because, they were more and more in the public eye, fodder for the new crop of slightly countercultural but basically mass-market magazines that had sprung up—*Eye*, *Evergreen*, etc. "Whether he knew it or not," wrote Koch, "Warhol's career was in a crisis by the end of 1967." After a six-year run of success, first in the art world, then in the film world, "he began utterly to fall apart, deserted by his taste, his artistic intelligence, his touch."

Whether Warhol or anyone else realized this was the case is unclear. Billy Name and Paul Morrissey set out to look for workspace. Billy found a space as down-at-the-heels and funky as the Silver Factory; Morrissey's choice was airy and uncluttered, with lots of natural light. Andy went with Morrissey's pick, the sixth floor of 33 Union Square West.

The move took place during the week of February 5. The new space's walls were painted white in the big, open front section, black in the smaller rear portion (where Billy set up his darkroom/living quarters). But Billy was no longer the guiding spirit of Andy's enterprise, and he knew it.

The first hires at the new Factory (the old name was retained out of habit) were a young Californian named Jed Johnson and his twin brother Jay. Fresh in from Sacramento, the Johnsons had taken jobs

with Western Union. Delivering a telegram to the Factory, they so disarmed Andy, Morrissey, and Billy with their quiet charm that they were hired on the spot as general gofers, replacements for the absent, disgraced Gerard. Yet Jed's real importance to Andy lay elsewhere: later in the year, he became his lover—the first since Danny Williams to reciprocate Andy's feelings.

"Jed was not in it for ulterior reasons," said Denton Cox, Warhol's physician and friend. "He loved Andy. In the early years, they were joined at the hip. And there was a lot for Andy to like." Jed was not just a physical beauty but a person of some substance, who would go on to a successful career as an interior designer. He was Warhol's housemate for more than a decade, in the only sustained love affair of Andy Warhol's life.

For Warhol's first overseas retrospective, which ran from February 10 to March 17 at Stockholm's Moderna Museet, the entire exterior of the museum was covered with cow wallpaper, turning the building into what one local critic enthusiastically termed "an optical phenomenon." The Swedish art world's reactions were intriguing, offering a look at an American artist in tumultuous times from a distant, calmer vantage point. "Never before has America received such violent images from the backside of her prosperity thrown in her face," wrote the newspaper *Svenska Dagbladet*'s Carl-Henrik Svenstedt on viewing *The Chelsea Girls* (which, even though this was a retrospective of Warhol's art, the Moderna Museet's director had expressly requested). "It is beautiful and frightening," Svenstedt continued, and showed "the enormous task Warhol has taken on when he has tried to force the violence . . . of America up to a level where it can be described and judged." Svendstedt evidently met Warhol, whom he very astutely sized up: "He sometime during his development has been so deeply hurt that he by every possible way is defending himself against attack. . . . He who has met Andy Warhol when he has taken off his obligatory black glasses sees a face

that is as dead and devastated as a war front after the action has moved on. He is a person scared to death. But he hasn't give up." Another *Svenska Dagbladet* writer, Beate Sydhoff, commented that "the Warhol exhibit comes at a time when we are flooded with psychedelic art and hippie culture. In comparison with these somewhat decadent currents, the picture world of Andy Warhol is wonderfully clean and ascetic. Andy's art and his ideals are absolute." As Warhol himself might have said, Sydhoff got things exactly wrong—so wrong that she approached, from out of left field, correctness.

Although the Modern Museet show was an impressive summation of Warhol's Pop years, its most enduring legacy was the catalogue: a photographic and graphic masterpiece, long considered one of the great achievements of art publishing. Its only text was fourteen pages of Andy Warhol aphorisms; at the time, it was unheard of to omit from exhibition catalogues lengthy discursions on the artist's oeuvre. No matter; Andy gave the job of producing the book to Billy Name. In his Silver Factory darkroom, Billy "worked on it for a few months straight," printing the photographs and designing the layout. Warhol's artwork was not even featured; instead, Billy printed 450 photographs, giving each its own page. The subjects weren't Warhol artworks but Factory denizens': 270 were Billy's; 180 were taken by Stephen Shore. When the catalogue was published, Billy's photographs became, in Dave Hickey's words, "instant classics, and have subsequently become exactly what Warhol intended them to be: official icons in the public imagination, ravishingly seductive advertisements for the corporate culture of the Factory." Billy is often approached today by admirers who "say that when they saw the catalogue they were ready to leave home and skip college so they could go to New York and work at the Factory; that was their dream because of the Stockholm catalogue."

As closely as the catalogue is identified with Billy Name, the subsequent career of his junior collaborator far overshadows Billy's. Three years later the twenty-four-year-old Shore became the second living

photographer (the first was Alfred Stieglitz) to have a solo exhibition at the Metropolitan Museum of Art. Shore and William Eggleston pioneered the use of color in art photography; "it was a radical choice . . . given an art-world prejudice that considered color to be the hallmark of commercial photography," wrote the *New York Times*'s Philip Gefter, reviewing the republication of Shore's 1982 classic *Uncommon Places*.

Hanging around the mid-sixties Factory as a sixteen- and seventeen-year-old taught Shore two important things. He began to view the world the way Andy did, "finding this detached pleasure in the banality of everyday things." He had been working "in a very untutored way. I was still very naïve. I saw Andy making aesthetic decisions. . . . I saw these decisions happening over and over again. It awakened my sense of aesthetic thought. [It was] a transition to thinking aesthetically." Shore learned something else watching Andy, which would contribute to his success as much as any aesthetic idea: "[Warhol] worked as hard as anyone I have ever encountered."

On January 29, an abject-sounding Malanga told Andy that he wasn't ready for Rome. He wanted to come home; he had no money. Quickly shifting gears, he got tough: he understood that the collector and arts patron Lita Hornick had just bought a number of Warhol portraits of her (how did Gerard, down and out in Rome, stay on top of details like this?), so Andy should stop claiming that he was too broke to send money—especially since Gerard had initiated the Hornick commission.

At the beginning of February, Gerard crossed over into the criminal. La Tartaruga Gallery, where he'd placed the counterfeits, sold all twenty prints. On the sixth, in an improvised document on gallery letterhead, Gerard certified the Ches as "the authentic works of Andy Warhol and signed by Him" (deifying his ex-boss in a slip). Next, the remaining painting sold. But La Tartaruga's owner, Plinio de Martiis, had begun to suspect the forgery, and a terrified Malanga pleaded with Andy to do something, and quick: Gerard claimed to be facing a possible fifteen-to-twenty-year prison sentence.

A few days later, a telegram from New York arrived for de Martiis: "Che Guevaras are originals. Howeer [sic] Malanga not authorized to sell contact me by letter for adjustments. Andy Warhol." Andy had saved Gerard's bacon—and was arranging for the money to be transferred to himself. A relieved Malanga sent a thank-you note, of sorts. He'd been through three sleepless nights, he wrote, feeling "trapped like a rat in Rome." Enclosing a review of the La Tartaruga show, he bragged that this was the first time Andy had ever been praised in the Italian Communist press. "Who cares?" responded Andy, reading the mail back in Manhattan.

On February 26, Gerard sent Warhol and Morrissey a newly made poster for the movie he was shooting in Rome, *The Recording Zone Operator*. He'd listed Warhol as producer, which didn't prevent him from boasting that his film would make *The Chelsea Girls* look like "a fairy tale."

"What nerve," said Andy, vowing never to speak to Gerard again. The letter went on: Rolling Stone Keith Richards had agreed to be in the movie; he wasn't name-dropping, wrote Gerard, merely trying to impress upon Andy the project's import, "the revolution it will cause upon its release," which would come about only if Andy sent money. Gerard had missed "some of the most incredible" scenes because of Warhol's "doubts and suspicions." There was a job to be accomplished in Europe. "Please believe me. Please believe me. Please have faith in me, in what I want to do."

And then a special-delivery May 11 letter from Rome arrived at the Factory for Andy. He didn't bother to open it, but Gerard had mailed a carbon to Morrissey. The letter was messily scrawled, the handwriting worsening as the writer had grown more and more hysterical. It ended in huge, underlined block letters. How, Gerard began, could he convey to Warhol and Morrissey the extent of the "serious international trouble" he was in at that very moment? As it turned out, Andy's telegram to de Martiis didn't mean "a fucking thing." De Martiis's behavior, wrote Gerard, had gone from princely to "completely monstrous." One could

hardly blame him—rumors of the Ches' inauthenticity were spreading from Rome outward, threatening the dealer's reputation. Unless Warhol contacted him immediately, de Martiis was going to call in the authorities. Forget about the money, pleaded Gerard—get this furious Italian off his back! If Andy didn't act fast, "I WILL BE IN AN ITALIAN MUNICIPAL PRISON WITHOUT BAIL. . . . PLEASE HELP ME! PLEASE HELP ME! Peace, Gerard."

Days later, in an amazing piece of good fortune, a check arrived for Gerard from Syracuse University, to whom he had sold his poetry manuscripts. In a trice he had a one-way Pan Am ticket stateside, perhaps narrowly escaping a Roman prison cell.

Back in New York, Gerard immediately headed for the Factory: the new one, whose startling difference from the old he was absorbing when Andy walked in, did a double take, and headed straight for his office. Gerard hurried behind, all explanations and apologies. "He wasn't listening," Malanga later said. "He just wasn't having it. The one remark out of his mouth was, 'I should have known better.'. . . At that point I realized my working relationship with Andy was pretty much over."

Allen Midgette was having a drink in Max's when a man he knew vaguely approached him. "'Alan Maslansky.' He was a publicist friendly with the Warhol crowd, and he said, 'Would you sit down with me for a minute? I want to ask you something. Is it true that you're going around as Andy?' And I just said, 'Yeah.' And he said, 'If you give me the story, Alan, I'll give you two thousand dollars.' That was a lot of money to me. 'And I promise you'll be on the first page or at least the second page of every newspaper in America.' I turned it down. Even though I didn't like Andy, I still played it by the rules, so to speak."

The ruse was obviously on its last legs. Don Bischoff, a reporter for the *Register-Guard* in Eugene, Oregon—one of the towns where students had been especially suspicious of Midgette—talked to several.

Deciding to pursue the story, Bischoff simply phoned the Factory and asked for Andy, who "came clean," as Bischoff reported, his story picked up by the *New York Post*. The reporter found Warhol's evasive "explanation of the hoax"—he obviously wasn't familiar with Andy's manner—"as obscure as some of his films and paintings." Warhol had to come back in person or repay the $1,000-per-appearance fee. And he had to appear in the flesh at the many winter and spring 1968 bookings scheduled for him by the American Program Bureau.

The solution turned out to be less satisfying than the deception had been; Warhol brought along Viva and Morrissey. The notion that became the leitmotif of the trio's remarks to student audiences was that Warhol was now a maker of entertainment, not art. On February 12, accompanied by Bourdon, they visited Wisconsin State University at Platteville, where they showed segments from ****. "It's just entertainment," Andy said afterward—about as far from the truth as was imaginable, given ****'s numbing boredom.

"How do you feel entertainment fits in with art?" a student asked.

"Well, I've given up art," replied Andy. "I want to do movies that have nothing to do with art." "Our movies try to be entertaining," Morrissey chipped in, "not in an intellectual, arty way—that's corny."

"Are you interested in people getting out of themselves, in the kind of transcendence you get in drugs?"

"What do you mean by transcendence?" Viva wanted to know.

"I think he means were the people high while making this film?" another student filled in. ("This is a repeatedly asked question," Bourdon scribbled in his notes).

"Is there any discipline in this kind of film acting?"

"It's a lot of work," said Viva. "Lights, camera, action. Sound. You have to be there, which is discipline in itself. And then you have to be funny. But I think everything is funny. They're burning the skin off people in Vietnam, and they're sending boys to jail for smoking pot. It's absurd."

The next day's stop was at the Wisconsin State University campus at River Falls. A seminar attendee asked about John Cage. "We thought things were going that way," said Andy, "but I guess it isn't."

"Is film the major medium of our time?"

"No, TV," said Andy.

"Was Eric Emerson turned on in *Chelsea Girls?*"

"Uh, I don't know," was Warhol's deadpan reply. "No one uses drugs anymore."

"They've gone out," added Morrissey.

An audience member complained that "the feeling is that you are not responsible, that you do not take a stand on things like Vietnam." Another wanted to know if *The Chelsea Girls*' build to a climax was planned.

"It just happened that way," Andy said.

After that evening's screening, before some six hundred people, an audience member raised the topic of homosexuality. "They're all straight now," answered Viva. "I've converted them." "They were just old movies," Andy said. "We do other things now."

On February 15, at a press conference held at the University of Minnesota's Duluth campus, he announced that he was taking his early silent films out of circulation. "They're crashing bores," Viva put in. At Duluth's East High School the next day, Viva got a round of applause when she announced, "We don't believe in art."

A girl in the back of the auditorium asked Warhol if he was Andy or Allen Midgette.

"Allen Midgette," said Andy.

On February 18, composer La Monte Young's name came up, whereupon Andy said, "Maybe the long boring stuff is out, unless you're on drugs. To tell you the truth, I never liked it. It's a big bore." Antonioni, the Beatles, Richard Burton, and Liz Taylor were the figures he aspired to now, he said.

On March 12, just back from another tour, Warhol told Bourdon how he hoped the latter would approach the *Life* feature. "We're in

entertainment. You should do that idea of leaving art behind, leaving it altogether. It's all performing. That's really what I want to do."

Even as his world unraveled, Warhol could manage a surprise—with an assist, this time, from the choreographer Merce Cunningham. For his second Castelli show in April 1966, Andy had made free-floating, three-by-four-foot pillows—silver, of course. Sensitive to the slightest air current, and to their own static electricity, they "endlessly rearranged themselves," wrote Bourdon, in Castelli's front room. Cunningham, immediately wondering how Warhol's ultrasensitive floater pillows would interact with moving humans, commissioned Andy to make some for the set for *RainForest*, the featured new piece at Cunningham's 1968 New York season. *RainForest* and its set, debuting on May 15, were a resounding success. "The smart place to be in New York last night was in Brooklyn," wrote *New York Times* dance critic Clive Barnes. "The new work was *RainForest*. . . . Andy Warhol, having had perhaps his best idea since he first looked at those soup cans, has devised a setting of dazzling ease. The stage is strung out with buoyant silver pillows—some of which did show a recalcitrant wish to join the audience—and those airborne pillows looked like floating pieces of radiant ravioli. It is simple and charming." Writer John Gruen, a longtime member of New York's art community, was at the Brooklyn Academy of Music, too. "Those helium pillows," he recalled, "it was at that moment that I was totally and completely in awe of Andy Warhol, because that was about one of the most beautiful things I'd ever seen. Watching those pillows float while people danced was just breathtaking."

One gray day in mid-1967, Gene Feist was alone in the office of the theater he'd cofounded two years earlier, the Roundabout. "When we started, I was often the only one there, manning the box office, cleaning up the theater, doing the chores," he said. That afternoon, a young

woman entered, coming right into the office. This put Feist off a little; people usually stopped at the front window.

Feist, as it happened, had been Andy Warhola's Carnegie Tech classmate. He remembered Andy well; they'd both belonged to the arts crowd. "The thing about Andy," said Feist, "was you'd go to a gathering and people would say, 'Did Andy eat today? Who fed Andy?' I used to respond, 'Andy's going to take care of Andy. Andy's going be the first of us to own a town house.' I was right. Because Andy had this quality of passive aggressiveness: 'Take care of me, because if you don't I'll break your leg.' He acted so dependent that everyone became concerned and alarmed, like a child going too near the edge of a roof. Obviously, there was some shrewdness behind that."

The woman who had invaded Feist's office introduced herself. Her name was Valerie Solanas. Feist asked what he could do for her.

"She throws this script on my desk." He remembered the title as *Up Your Ass with a Meathook*. "The lady was a lunatic. People who are either severely ill or have been institutionalized get this kind of sexless, dumb look, an oxen look. That's what she had. I was getting more and more alarmed—here I was, a natural-born coward, and it was obvious she was insane. 'I'm sorry, we only do the classics,' I said. She took her script and left. I locked the door and breathed a sigh of relief, and as soon as I calmed down, you know the first thing I thought? I should've told her to go to see Andy. She had a threatening presence. But Andy felt crazy people were gifted. Anyway, that was that."

Valerie Solanas was getting to be a public character in the West Village: running weekly ads for the *SCUM Manifesto* in the *Voice*; staging readings at the Nedick's on 8th Street and Sixth Avenue; stopping strangers to harangue them. She got herself onto *The Alan Burke Show*, a lowbrow late-night television affair in which the boorish host insulted his eccentric guests. Almost as soon as the tape started running, Solanas began swearing violently. Burke told her to stop it, to no avail, then he walked offstage and had the sound cut off, leaving Solanas facing the audience. The botched segment, of course, never ran.

William Wilson was a peripheral member of the Warhol crowd. Wilson's mother, May, lived next door to the Chelsea Hotel, and Valerie, who stayed at the Chelsea until she was evicted in late 1967 for nonpayment of rent, got to know Mrs. Wilson; undoubtedly, she'd buttonholed the older woman on 23rd Street. Wilson himself often encountered her "as I walked across 23rd Street, seeing her approach men with her query, 'Wanna hear me say a dirty word for a dollar?'"

When she left the Chelsea, Solanas had asked Mrs. Wilson if she could keep her laundry at her apartment. "She showed up with a bulky-looking flowered cloth bag and put it under the bed. One morning, Valerie arrived at my mother's door, 208 West 23rd Street," said Wilson, "saying that she had come for her laundry."

It was a Friday morning, and looked like rain. As was his habit, Paul Morrissey arrived early at the Factory. "I opened up the office, got behind the desk, answered calls, and arranged this and that. One of the things I was supposed to do that day was talk to [filmmaker] John Schlesinger's office; Schlesinger was doing Midnight Cowboy and wanted Andy to be in a scene in which he's an underground filmmaker giving a wild party and photographing people there to make underground movies. Andy had said, 'Tell them they should use Viva.'

"Andy used to come in in the afternoon. This Valerie Solanas, who had been away for a year or more, suddenly shows up in a raincoat asking for Andy. The problem with her and Andy was, she'd brought him a script a few years before called Up Your Ass. He gave her a handout and then gave the script to me and said, 'It sounds so dirty, maybe it's good.' I looked at a few pages and said, 'No, Andy, this is just junk.' He put it somewhere and it got lost. She returned over and over again, asking for it. And then she went away. Today she reappeared, asking for Andy, and I said, 'Well, he's gone for the weekend.' She came back an hour later. I said, 'I told you, Andy's gone.'

" 'Well, I gotta speak to him.'

"I said, 'I'm sorry, you've got to go out.' She came back a couple of times. And then about four o'clock she came up in the elevator with

Andy. She'd been waiting outside the building. She just had her mind made up."

Morrissey was a little embarrassed at being caught in a lie. "'You said Andy was out of town.' I said, 'Well, I did make it up, because I wanted to get rid of you, Valerie, and now I'm going to have to throw you out.' I walked toward her as if I were going to, just play-acting. She backed away from me like I was going to beat her up, and both hands went in her pockets." He paid no attention to the gesture, as he had no idea she was carrying not one but two guns. "I said, 'I'm only kidding, Valerie,' and with that I went to answer the phone." It was Viva calling to talk about the *Midnight Cowboy* stuff and I said, 'Oh, yes—well, Viva, listen.' . . . I had to go to the bathroom, so I said, 'Oh, here, talk to Andy,' and I put Andy on the phone."

Fred Hughes, sitting at his desk, looked up and asked, "You still writing dirty books, Valerie?"

Morrissey was in the bathroom. "And suddenly, 'Bang! Bang! Bang!' Andy was the first to see the gun. 'Valerie!' he yelled. 'Don't do it! No! No!'" Solanas's first shot missed. Andy fell, pretending to be hit, and smacked his head, hard, against the corner of a desk. Valerie fired again, and missed again. Andy crawled under the desk, trapping himself. She advanced on him, knelt, stuck the gun under his arm so the muzzle rested against his flesh, and fired.

Morrissey came running out of the bathroom, saw Solanas with her gun, and headed for the rear room. Someone was already inside, holding the door shut; it turned out to be critic Mario Amaya, who was visiting the Factory that day. Amaya had been shot, but not badly enough to prevent him from diving into the back room and pressing his body as hard as he could against the door.

Looking around, Morrissey saw Solanas. "She runs up next to Fred, puts the gun to his head, and says, 'I'm gonna shoot you!' And he says, 'Oh, Valerie, don't shoot!' She says, 'I have to.'" Hughes was on his knees. "I'm innocent!" he shouted. Valerie turned and pushed the elevator button, anticipating her getaway, and returned to Hughes.

"I could see she couldn't make up her mind whether to shoot me or not," Hughes later recalled. The elevator door opened. "There's the elevator, Valerie. Just get on it!" Hughes shouted, and she did. Morrissey came running over and telephoned the police.

Several minutes later, Gerard Malanga and four others arrived. Malanga, to a limited extent back in Warhol's good graces, had arrived to pick up a check; Andy had offered to help advertise a film showing of Gerard's. "The door opened on madness," said artist Al Hansen, one of the four others, a longtime friend of Warhol's. "Mario Amaya jumping around, blood all over the back of his shirt. He presents his bloody back to me, asking over his shoulder, 'Is it in me, is it in me?' Someone's legs sticking out from behind the far desk. Jed is kneeling, holding the someone's hand, tears in his eyes." Morrissey was standing at the window, cursing. "Did you see an ambulance down there?" he asked Hansen. "We called ten minutes ago!"

"Who's the other one?" Hansen asked.

"It's Andy!" shouted Morrissey. "Valerie Solanas, that ugly dyke, came in and shot him!"

"Andy was laying there the way bad gunshots do," according to Hansen, "like a sick dog or cat, his eyelids fluttering. Billy Linich, crying, stands looking down at him. I went out on the street, yelling, 'A doctor is needed! Is there a doctor?' I run to a phone, but a guy's in there telling his friend that Andy Warhol's been shot. There's a crash as a police car tangles fenders with a taxi."

"All pandemonium had broken loose," Malanga said. "We'd missed Valerie by a minute. She could easily have shot us. Andy was on the floor, his head in Billy Name's lap. People were running back and forth. Paul went running by and I grabbed him and said, 'I'm going up to get Julia.' He said, 'Good idea,' and reaches into his pocket, shoves a wad of bills at me for a taxi."

Gerard instead ran down into the Lexington IRT station, grabbing the subway. At 89th Street he leaned on the bell. "There were curtains on the window but she's coming down, she recognizes me.

As she's opening the door the phone starts ringing. I almost pushed her out of the way and said, 'I'll get it, Julia.' I run upstairs, grab the phone. It's a friend of Julia's who's already heard on the news that Andy was shot. 'I'm a friend of Andy's and Julia's,' I say, 'Everything is being taken care of, thank you, good-bye.' I turn to Julia and say, 'Andy has injured himself in the stomach.' I didn't tell her what had happened; she'd have had a heart attack right then and there. So she got out of her *shmatta* and got dressed, and I'm hailing a taxi. It took her about fifteen minutes to get ready. We go to Columbus Hospital [on 19th Street between Second and Third Avenues] and already the paparazzi are blocking the emergency entrance."

Half an hour earlier, Andy had lost consciousness in the ambulance. The other shooting victim, Amaya, rode in the ambulance as well. The driver asked if he should sound the emergency siren. "Yes!" said Amaya. "If we do," said the driver, "it'll be fifteen dollars extra."

Andy was wheeled into the emergency room. A surgeon, Giuseppe Rossi, who was about to go home, was summoned to operate. Andy regained consciousness long enough to hear a doctor say, "No chance." "No!" shouted Amaya. "Do you know who this is? This is Andy Warhol! He's famous! He's rich! You can't let him die!" If Amaya hadn't started shouting, Malanga insisted, Andy would not have made it. Indeed, six minutes after being wheeled into the operating room, he was pronounced clinically dead. Regardless, Rossi and his assistants began an operation that lasted five hours.

In another part of town, Times Square, Solanas, having wandered aimlessly north, turned herself into a rookie policeman. "The police are looking for me," she said. "I am a flower child. He had too much control over my life."

She was brought into the Thirteenth Precinct, shouting, "I was right in what I did! I have nothing to regret! I feel sorry for nothing! He was going to do something to me which would have ruined me!" "It was bedlam," wrote Howard Smith of the *Village Voice*. It

Valerie Solanas with police escort

was impossible to book her; the clicking and whirring of the cameras drowned out the sound of her voice.

In his summer home in Southampton, Henry Geldzaher sat listening to the radio with Christopher Scott. "Do you realize what this does to the values of the paintings?" Geldzahler said, quickly adding, "Don't tell anyone I said that."

At 9:35 p.m., four hours into the surgery, Columbus Hospital's medical director gave a report to the friends and reporters gathered in the waiting room. (Julia had been given a sedative and whisked off for observation.) Warhol had a fifty-fifty chance of survival. A single bullet had ricocheted through his spleen, liver, pancreas, esophagus, and both lungs. The operation continued for another hour, the doctors doing their best to repair the enormous damage. At 2:30 a.m., a hospital spokesman told the *New York Times* that the doctors weren't sure the

patient would live through the night. At 6:00 a.m., however, he was still alive. "They said later they didn't know how he lived," said Morrissey. "He was very strong. He was very willful."

The breaking stories were already rolling out: "Warhol Shot, Seriously Wounded; Actress Sought," ran the New York Times' front-page headline. "Andy Warhol Fighting for Life," said the New York Post, which insisted on calling Solanas "Valeria."

Bourdon phoned Morrissey at the hospital. "Guess what! Andy will be so happy!" The Life Warhol profile that Bourdon had been researching for months had just been designated that week's cover story. "Yes, that's his dream," Morrissey answered. "The cover of Life—that was the highest point of civilization for Andy." Just before dawn in New York, however, celebrating his win in the California primary, Robert F. Kennedy was shot and fatally wounded in Los Angeles. Bourdon phoned Morrissey. "Well, it's Kennedy on the cover."

Warhol received a total of twelve blood transfusions. Kept alive on a respirator, he remained in critical condition, but day by day his chances of living improved.

If friends and associates constantly phoned the hospital, and showed their concern in other ways (every night, Billy Name walked to Columbus Hospital to keep a sidewalk vigil, watching the windows nearest Andy's and praying), there was also a groundswell of ill will. Closing the Kennedy cover issue, Life's managing editor cursed Warhol, Bourdon recalled, "accusing him of having injected so much craziness into American society that it was leading to the killing of the country's political heroes."

Time magazine art critic Piri Halasz wrote a long memo on June 14 for a follow-up feature to the shooting. "To the extent that Warhol's art and life-style embody and glorify the abdication of moral responsibility and the condoning of petty viciousness and violence," she wrote, "they helped to create the atmosphere that made the Kennedy shooting. . . . Andy Warhol is an extraordinarily sinister, even wicked person." Halasz had interviewed Bob and Ethel Scull off the

record, but quoted them in her memo. "Andy is the wickedest person I have ever known," said Bob Scull. "More than a few parents owe Andy those bullets."

There was pro-Solanas sentiment, primarily among radical feminists. On June 13 two members of the New York chapter of NOW, the National Organization for Women, appeared in state supreme court to argue that Solanas was "being prejudicially treated because she is a woman." Her lawyer, Florynce Kennedy, called Solanas "one of the most important spokeswomen of the feminist movement," while the president of New York NOW, Ti-Grace Atkinson, compared her to Jean Genet, the French author and onetime convict.

The shooting revealed a serious antipathy toward Warhol even among his colleagues. Barbara Rose and her husband, Frank Stella, were walking down the street just after the Warhol and Kennedy shootings, and Stella said, "Bobby's going die, Andy's going to live." "Frank knew Bobby," said Rose, "and I think sort of liked him. And I don't think Frank was crazy about Andy. Because clearly Andy was bringing down high culture, and Frank *was* high culture. I think Frank felt that of those two lives, the valuable one was Kennedy's."

Warhol, in Columbus Hospital for almost two months, was finally released on July 28. His nephew, the same Paul Jr. who had helped Andy move to 1342 Lexington all those years before, brought him back home. Walking upstairs, Andy had to pause every few steps to catch his breath.

His telephone mania unchanged, Warhol had already made many calls to friends from the hospital. "When he telephoned me from his hospital bed," wrote Bourdon, "I was so startled and overcome with joy that I collapsed in a fit of choking sobs, and it was he who had to comfort me." In a very weak voice, Warhol had tried, in his own way, to keep things light: "If only she had done it," he told Bourdon, "while the camera was on!"

Gerard went to the hospital two weeks after the shooting, and Warhol instantly reached for his wallet and handed Malanga the

check he'd come to the Factory for on June 3. "He had it already written." Malanga had been the first to think of Julia when Andy was shot, and this mattered to Warhol more than Gerard's Roman caper.

Valerie Solanas was sent first to Matteawan State Hospital. In December 1968 she was declared competent to stand trial. She could have been sentenced to fifteen years, but received a three-year sentence, serving it the women's state prison in Bedford Hills, New York. ("You get less time for stealing a car," Lou Reed sang bitterly in "Hello It's Me" on 1990's *Songs for Drella*.) After she was sentenced, Solanas said, "I didn't intend to kill him. I just wanted him to pay attention to me. Talking to him was like talking to a chair." She would die of pneumonia in San Francisco at age fifty-two, in the city's down-at-the-heel Tenderloin district, alone in a welfare hotel.

"So eventually when he was out of the hospital, I went up to see him at his house," said Ronnie Cutrone. "He was frightened of everybody. I just said, 'Hey, Andy, hi. How are you?' 'I'm OK, Ronnie, I'm OK.' He was in bad shape, he was terrified, and not really responding to any of us. He wasn't the guy we knew. He was profoundly changed."

Ten years after the shooting, Emile de Antonio asked Warhol "what the bullet felt like when Valerie Solanas shot him in 1967 [*sic*]. He looked at me and said, 'I wish I had died. . . . I wouldn't have had to live through it all. I should have died. It would have been better.' "

Billy Name stayed in his Factory darkroom for almost two years. In the spring of 1970, "I just went out into the world. I used the name S, just the letter S, for 'Essence.' I never used 'Billy Name.' People would ask, 'What's your name?' and I would say 'S.' Because it was also my first Saturn return. In 1970, I turned thirty.

"As we got to 1970, we went past Woodstock and be-ins and all that, it was a changing of the time. I just had this feeling I should go out and see what was going on in the rest of the world. It wasn't a sense of loss, it was more like turning the page.

"I hitchhiked across the country, took a lot of acid and smoked a lot of reefer when I got to New Orleans. I stayed there in this hippie house, you know, when a bunch of hippies took over a house and the neighbors hated it."

He found his way out to Southern California, and stayed with the poet Diane di Prima, an old Lower East Side comrade of the A-men. "Diane told me in detail," recalled William Wilson, "about Billy staying on her porch in California doing LSD, barking like a famished dog, deteriorating, and I am certain that she said to me that Billy had died. She said that he wouldn't eat and that there was nothing she could do because he was an adult making his own choices."

Billy didn't die. One day in 1977, he came home to Poughkeepsie and settled back in. He lives there still, in a three-room house overlooking the Hudson, in a blue-collar part of town. His workroom is piled high with country music CDs. Billy has grown stout, has no hair on top of his head but plenty down his back, and has grown a full, bushy beard—in other words, he is utterly unrecognizable from the pencil-thin speed freak of 1965. He turned seventy in 2009 and is in unsteady health, but he has the voice and curiosity of a young man.

In 1988, the year after Andy died, Billy Name's friend and sometime employer of twenty-five years earlier, Henry Geldzahler, got a letter from Jan E. Adleman, director of the Vassar College art gallery in Poughkeepsie. Billy Name's trunk, out of which he'd lived at the Silver Factory, had turned up in storage, filled with twenty-five-year-old contents, and been returned to Billy, who in turn donated them to Vassar. The Vassar gallery was placing the trunk and its contents on exhibit, and would be delighted if Geldzahler could write a short accompanying essay for a small honorarium.

Henry, who had finally left the Metropolitan to serve in Mayor Edward I. Koch's administration as commissioner of cultural affairs, complied with the request. Drawing on the best memories of his life, he wrote:

It is a mistake to consider archaeology only in terms of the ancient past. . . . The clues and information [revealed by artifacts such as these] allow us to fill out the picture with sharper and clearer insights. They provide a glimpse into a community no longer available. . . . For those of us who watch art closely, it has become a commonplace to locate the spirit of the sixties, roughly between the inauguration of John Kennedy and the assassination of Martin Luther King, in the Warhol Factory on East Forty-Seventh Street. . . . Through the dramatic flare that illuminates the firsthand material of Billy Linich's trunk, we are brought to smile and to shudder one more time at the hilarious yet self-destructive life it elucidates.

Within a half-dozen years, at fifty-nine, Geldzahler himself would be dead.

In a brief accounting he made of the trunk's contents, Geldzahler failed to mention one item. When the trunk arrived, Billy had carefully sifted through the contents, and found, deep inside, what looked like some sort of pamphlet. Picking it up, he read the title: "*Up Your Ass*, a play by Valerie Solanas." Here it had been tossed and had lain during Solanas's increasingly frantic calls to the Factory. So typical of the Factory—the desultory way things were done—and so chillingly appropriate, that Solanas's opus had not been stolen, but simply mislaid.

Andy described the shooting as unreal. "[W]hen it happens, it's like it's not happening to you at all but to someone else. . . . For days afterwards I kept thinking, 'I'm really dead. This is what it is like to be dead.' You think you're alive, doing all the usual things like getting on a bus, or taking a subway, but in fact you're really dead. It was days before I realized I was actually still alive. . . ."

And so ended the first life of Andy Warhol. The end of the sixties was not far off.

EPILOGUE

How to account for the differences between Andy Warhol's early and late work, taking the events of June 3, 1968, as a convenient dividing line? The stunning impact of Warhol's great early- to mid-sixties canvases—the movie star portraits, electric chairs, suicides, car crashes, and flowers, as well as the unsettling impact of his best films, made in the same period—lies ultimately in an outsider's vision.

Of course, all innovators start, by definition, as outsiders—Henry Geldzahler once came up with an amusing image of Pop's originators as low-budget-movie monsters "rising up out of the muck and staggering forward with your paintings in front of you," lurching toward an unsuspecting art world establishment. But Andy Warhol was an outsider among outsiders. His marginality was not merely aesthetic; it was sociological. Raggedy Andy spent his childhood with his face pressed to the glass, enraptured by what he couldn't have inside: everything. "I just paint things I always thought were beautiful," he told a *Time*

reporter in 1962: namely, the best-packaged goods in the supermarket and the most glamorous mass-culture icons. Andy's Marilyn was so much sexier, with her heavy-lidded come-hither mien, than in the 1953 *Niagara* publicity shot; the soup cans, more appetizing than the ones on the shelves. He gave us, too, all of those teenagers hanging out the windows of their smashed cars, eyes open in death, their final ends garishly lit by photographers' flashbulbs. Created in three years of feverish activity, these and a handful of other works by themselves ensured Warhol's greatness. They long ago outlived their predicted life span. Moved as he was, on viewing Warhol's first, 1962, New York show, by the "beautiful, vulgar, heart-breaking icons of Marilyn Monroe," the art historian and critic Michael Fried doubted "that even the best of Warhol's work can much outlast the journalism on which it is forced to depend." He was wrong.

If Warhol's best, most striking paintings owe their impact to alienation over which he'd had no control, the Factory, in its initial, silver incarnation—arguably as important a "work" in terms of its place in our cultural consciousness—fed on marginality too, but of a willful, intentional stripe. Warhol's sixties studio was "the best thing he ever made for the best times he ever had," wrote Dave Hickey (who put in some time on the Factory's fringes). By the mid-sixties this grimy midtown loft, its doors flung open, was a magnet for a parade of characters more marginal even than Andy: amphetamine-addicted opera fanatics, poets manqués, transvestites, acid-taking renegades from Brahmin society, damaged showbiz aspirants, brilliant monologists like Ondine who could flourish only in such an unstructured milieu. Andy was, of course, a past master at image creation, and starting in early 1964, when he, Billy Linich, and Gerard Malanga furnished and decorated it (in a manner of speaking), Andy began publicizing the Factory's goings-on, its growing number of denizens' strangeness: through his films; through the mostly black-and-white photographs taken by Linich and seventeen-year-old Stephen Shore; through media appearances and

through the countless newspaper and magazine features that Andy managed to place everywhere, from the *Times* to the *East Village Other*, whose slant he subtly dictated.

His nonstop promotion of the Factory rendered the underground visible: far out on the fringes, its daily events barely imaginable (and thus the source of vivid fantasies) to a middle class ready to shed its Eisenhower-era inhibitions. Groups—rock groups, protest groups, street theater, communes—were part of the sixties collective sensibility, and the Factory was a curious and brilliant example of that group mind. Here, as in so many other instances, Andy proved to be impeccably in synch with his era.

Inevitably the craziness Andy encouraged spun out of control. Always a bellwether, the Silver Factory collapsed a year or so before America's collective nervous breakdown. After June 3, 1968, the Factory's open-door policy was revoked. Out went the superstars, perceived now as trouble to be avoided; the capacity of many of them to explode with no warning no longer inspired Andy but terrified him. To obviate any chance of another Solanas, Ondine and his speed-freak crowd were shown the door. The stereo, after blasting Callas for half a decade, was shut off. Ingrid Superstar, Dorothy Dean, Joe Campbell, Rotten Rita, Mary Woronov—gone. One morning in the spring of 1970, the Factory staff came to work to find Billy Name's door ajar. A note read, "Andy—I am not here anymore but I am fine. Love, Billy." Andy had Vincent Fremont change the locks.

The old Factory's inimitable look, product of Billy's underground aesthetic, had been replaced in the new Union Square Factory by conventional office chic: white walls, glass-topped tables, light streaming in through tall windows. While Andy recuperated, Paul Morrissey began to assemble not another coterie but an actual staff. Some even wore ties. "The wit of the old subterranean decadence gave way before the more familiar American ethic of young men in a hurry," observed Stephen Koch. "The kids," as Andy called his new employees, "saw

the old superstars as annoying bores always looking for a handout," wrote newcomer Bob Colacello, a young Republican social climber and the eventual editor of the magazine Warhol started in 1969, *Interview*. Other "kids" included Texan Fred Hughes, Andy's secretary and amanuensis Pat Hackett, office manager Vincent Fremont, and Jed Johnson, Warhol's boyfriend and man Friday.

Warhol's post-shooting artwork is widely considered inferior to his work from the sixties. Andy often thought so himself; attending a mid-seventies party of his sixties painter colleagues, he felt like a lightweight. "I guess if I thought I were really good I wouldn't feel funny seeing them all," he coyly told his "diary" (Hackett, transcribing her boss's thoughts over the phone). The kids were a lot easier on Andy's nerves than Ondine & Co., but "he would sometimes look at us all," writes Colacello in *Holy Terror*, his memoir of his dozen-year tenure as editor, factotum, and confidante, "with our short hair and clean clothes, and sigh, 'Gee, it was so much more creative in the sixties. Ondine and all those speed queens used to have an idea a minute. An idea a second.'"

Since announcing his so-called retirement from painting in 1965, Warhol had spent most of his time making films. After the move, the new Factory letterhead read "Andy Warhol Films, Inc.," and *Interview* was founded as a film journal. Ever since his "retirement," Andy had painted, for the most part, only when he needed to fund a new film project. As he'd already discovered, the commissioned portraits he'd made since the early sixties—1963's *Ethel Scull 36 Times* was the first—were his most reliable and expeditious source of cash. At first he handled only a few: gallery owner Sidney Janis, Nelson Rockefeller's wife Happy, and Domenique de Menil. But when he became Warhol's sales manager, Fred Hughes began actively seeking portrait commissions. "In a few years," writes Colacello, "Fred set [Andy] on the road to real riches. He launched the commissioned-portraits gold-

mine, drove up the sales and prices of the sixties paintings [in 1970, *Campbell's Soup Can with Peeling Label* fetched $60,000 at auction, the highest price for an American painting up to that point, outselling de Kooning's *Two Family Women*, which brought $45,000], and cultivated important new collectors and dealers." From a mere dozen or so commissions in 1970, Hughes's aggressive pursuit of clients jacked the annual number up to fifty by decade's end. A mid-seventies portrait cost $25,000, with additional panels—the same image but in different colors—going for $15,000 to $20,000 more. (One client, Denver businessman John Powers, bought twenty-four panels of his wife.) The Whitney Museum's big winter 1979 exhibition, Andy Warhol's Portraits of the '70s, kicked Andy's portrait business into still higher gear. For the rest of his life he churned out fifty to a hundred portraits a year, bringing in between $1 million and $2 million annually. In all, he handled more than a thousand commissions, most for at least two panels. The portraits served as the financial motor for the many other businesses Andy now zealously pursued: *Interview* and cable TV projects (he'd turned over the movies to Morrissey in 1968—they ceased in 1976), among others. And they made him what he'd always dreamt of being: very rich.

With Hughes or the gregarious Colacello as front man, Andy jetted at the drop of a hat to parties, country house weekends, film festivals, and art openings, anxiously urging either lieutenant to corral prospective sitters. A dozen years earlier he'd painted Elizabeth Taylor and Jackie Kennedy from news photos, adoring them from afar with the rest of the world. Now he rubbed elbows with Jackie at parties, and Liz had become his bosom buddy, urging him to feel her crushed vertebrae while he, in turn, showed her his scars. ("Oh, you poor baby," she whispered, "you poor baby.") Warhol's social, artistic, and business lives merged; his clients/subjects/friends were Halston, Calvin, Yves, Liza, Mick and Bianca, Mica and Ahmet, Diane and Egon, Jack and Anjelica, Truman, Marisa, Berry, Paloma, and the rest. "Plucked from

the bottom and plopped at the top," as Peter Schjeldahl quipped, he was a celebrity among celebrities.

The commissioned portraits' aim, wrote Geldzahler (who sat for not one but two—he rejected the first), "was always to accentuate the positive, eliminate the negative, and come up with a likeness that was recognizable but existed in a 'world that never was,' a sort of . . . limbo where everyone was a star, not only for fifteen minutes, but, in this incarnation caught permanently on canvas, 'forever.'" The portraits didn't differ essentially in method from Warhol's earliest photo silk screens. Instead of found photographs, he snapped his own Polaroids, as many as fifty per sitter. Selecting one, he had it enlarged into a high-contrast positive acetate; the higher the contrast, the more "imperfections"—wrinkles, blemishes, baggy eyes, double chins—were eliminated. The aim was idealization. Lips, eyes, hair were daubed by hand onto the canvas. Transferring the image from acetate to silk screen, on which it became a negative, Andy and an assistant squeegeed the final image through the screen and onto the canvas. This had been the final step with the *Marilyns*, *Lizes*, and *Jackies*; now, Andy usually slapped down broad, brightly colored brushstrokes on top of the image: the hand-painted look (which he'd foresworn in the early sixties) was, he declared, back in fashion.

The end result was doubly flattering. Not only did the sitter emerge a recognizable but far more attractive version of him- or herself, but each portrait bore the same "markers": decorator colors, no facial imperfections, and those juicy Abstract Expressionist splashes. The markers identified the subject as belonging to an exclusive club—"Oh, Andy did you? Me too!"—membership in which meant either celebrity or money, usually both. Early in Andy's Pop career, noted David Bourdon humorously, he'd painted celebrities to draw attention to himself; now the wealthy used him for the same purpose. The portraits were tokens of vanity, an exchange of big bucks for visual and social flattery—not a very pretty transaction.

Most critics found little to admire in them. Reviewing the 1979 Whitney exhibition, *Time*'s Robert Hughes had recourse to perhaps anti-Pop's hoariest, long-since-vanquished complaint: Warhol wasn't a real painter since he didn't create his images himself. "All problems of depiction," Hughes virtually recited, "[are] telescoped into a simple act of choosing an image, rather than making it." The *Atlantic*'s more sophisticated Sanford Schwartz disapproved, too. "The effect of the Mick Jagger portraits (and other pictures from the late sixties on)," Schwartz wrote, "is that [Warhol] is artifying photographs. He put jazzy lines and sloshed units of paint on top of photos, and it's airless; there's no feeling of an underlying canvas breathing through. What we see is a photo trapped in a lot of artistry."

It had been his poor-boy's fascination with the offerings of thirties Pittsburgh showrooms and movie theaters that gave Warhol's Pop paintings their glow, his bitterness at the elite's snubs that largely fueled his early Pop images' abrasive inelegance. But he was an insider now (though he never entirely lost his alien's outlook, a composite of timidity and sharp-eyed scrutiny); his sixties authority, rooted in marginality and transgression, was extinguished. He was just a working artist, in Robert Rosenblum's words, "court painter to [the] 1970s international aristocracy."

"The endless art he made after Valerie Solanas shot him could not assuage his morbid fear that he had run out of ideas," writes Wayne Koestenbaum in his brief Warhol biography. Unfortunately, it was less a morbid fear than an accurate self-assessment. As if desperate to avoid self-reflection, in the eighties Warhol busied himself not just with the portrait commissions but with a compulsive, nonstop flood of other projects: painting dollar signs, camouflage patterns, Rorschach blots, "piss" canvases (in which he and others urinated on copper-treated canvases to create abstract swirls and drips); highly decorative revisits of the early Pop images, their powerful crudeness excised; and half-

mentoring, half-opportunistic collaborations with the young art world sensation Jean-Michel Basquiat. "These pieces," wrote Peter Schjeldahl of Warhol's later works, "strike me more as ingenious ideas for painting than as satisfying works of art. They feel phoned in."

Still, you could never count him out. At a recent Armory show in Manhattan, the observant were rewarded with a jolt of pleasure: a small *Hammer and Sickle*, its colors gorgeous, the familiar image suddenly intriguing, proof that the older Warhol could still bring it. But he didn't do so very often.

On February 22, 1987, unexpectedly and perhaps avoidably, Warhol died after routine gallbladder surgery. The memorial service filled St. Patrick's Cathedral. Only fifty-eight, he was at the time easily the world's most famous contemporary artist; since then his fame has only grown. Perhaps the better part of his posthumous ubiquity derives not from his art (though the Campbell's soup can is certainly a universal icon) but from the seventies and eighties self-promotion that fixed the image of the ashen-faced, mothlike ghoul in the collective mind's eye: his 1985 appearance on *The Love Boat*, for instance ("Andy would go to the opening of a drawer," his friend Halston once said), or his omnipresence on the *New York Post*'s Page Six and other wide-circulation scandal sheets. That face is a retailers' staple, emblazoned on T-shirts, sunglasses, Christmas cards, skateboards, and bobblehead dolls, a glut which, as if by some Warholian ruse, all but obscures his real afterlife, which will in time outlast all this garbage he dumped on us.

Warhol ignited a revolution as forceful as any since that touched off by Picasso's *Les Demoiselles d'Avignon* one hundred years ago. "How decisive a break with tradition did Warhol bring about?" Schjeldahl wondered in the *New Yorker* in 2002. "To travel back to art before 1962 is to enter another age. But his classic paintings of the early sixties remain wide open to the present," as do the films he made in the same years. "Warhol's great moment was brief," wrote Schjeldahl on another occasion. "But his peak performance stands higher and higher, while everything that once seemed to contest it falls away."

Ivan Karp was in his midthirties when he became the first art establishment insider to believe in Andy Warhol. If he hadn't been at his job at the Castelli Gallery one early autumn afternoon in 1961 when Warhol happened by, Warhol might well have vanished back into his blotted-line drawings. For all of his involvement in Warhol's success, Karp, as intellectually restless at eighty-three as he was then, and as fulminating as he was fifty years ago, holds firmly to an unsentimental assessment of his friend's career:

"In most cases an artist's life span is ten, twelve, fifteen years," said Karp not long ago, at his desk in the back room of the West Broadway gallery he has long owned. "I don't see it much beyond that. You make art out of an obsession. All the great remarks of writers and painters and musicians in history, at the end of their lives, amount to the same thing. 'I needed to do this. I couldn't help myself. It's a dream I had.' Once the obsession is depleted, the art is not effective anymore. You start painting your old pictures again. But it's not like you stop painting. You make art out of habit; you continue to make art because you keep going to the studio."

Warhol would never have gone back to the studio if he had been able to realize his middle-aged dream—really, the eight-year-old's dream—at home in Pittsburgh projecting movies on the wall: his fantasy, that is, of conquering Hollywood and breathing forever its rarefied air. So, steered after his convalescence by the business-minded Fred Hughes, Andy found his way back to the studio, but not to paint another *Marilyn* or *Flowers*, or hit on a technique as heuristically rich as photo silkscreening. Rather, to fulfill a poor kid's dream: rubbing elbows with the world's socialites, Page Six's denizens: Halston, Diane von Furstenberg, Yves Saint Laurent, Bianca and Mick, Liza, billionaire German industrialists' wives, and—attempted but not netted—Imelda Marcos and the Pahlavis.

Andy, it turned out, had made the Achilles bargain almost every great artist accepts. "He was at the peak of his obsession," observed Karp, "when he made the *Marilyns*, the *Lizes*, the *Disasters*. When he

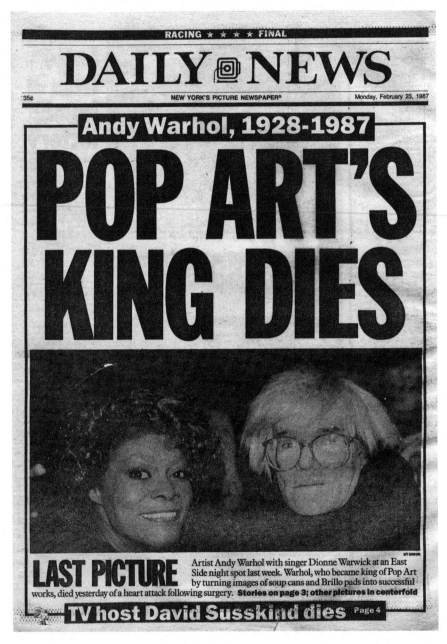

The *Daily News*, Monday, February 23, 1987

got to 1967, 1968, he had depleted his fantasy." Valerie Solanas's bullet did not end his heroic years; those were over, and Andy was confusedly mucking about with the likes of *Lonesome Cowboys* by the time Valerie got to him.

But what would contemporary art and whole realms of twenty-first-century culture look and feel like without Warhol's feverish half-decade of one inspiration after another? Not only works of lasting beauty and power, but of sly philosophical bite (those category-defying Brillo boxes), audacious challenges—as was his very art-making technique—to traditional notions of what art is and isn't. As materialistic and practical as he was, Andy was obsessed with the magical aspect of art. He was fascinated by the idea that anything a famous artist did became in itself a work of art: Picasso drawing street directions on a paper napkin, Rauschenberg *erasing* a de Kooning drawing. Duchamp, as the father of both Postmodernism and the conceptual approach to art, was Andy's true godfather, taking this idea of the artist as magician one step further: anything the artist *conceived of* was art. Here was the Duchampian finger, the index—Andy Warhol pointing out what is art and what is not.

ACKNOWLEDGMENTS

The idea for a book on Andy Warhol's life and work in the 1960s, the artist's years of triumph, emerged from a mid-2000 conversation in a Cuban restaurant in Nyack, New York, with Daniel Wolff, who in fact came up with the idea. Three and a half years of research sent me across the country and back more than once: pacing like Holmes back and forth in front of canvases and drawings; preparing and conducting some 140 interviews (more, actually—I subjected a number of people to two, three, many interrogations); reading dozens of books, hundreds of articles, and thousands of documents; and slouching, sometimes transfixed and often stupefied, in front of video machines from California to the New York island.

In Pittsburgh, the Andy Warhol Museum's archivist, Matt Wrbican, is a one-of-a-kind repository and analyst of Warholiana, blessed, or cursed, with the knowledge of exactly where to find that early-fifties dermatologist's confession of helplessness, those unmailed postcards to crushes, and the many, many pleas for payment from small businessmen,

like the plumber's scrawled 1967 note, "You keep saying you are mailing us a check. We never get it." Although Matt's assistance went far beyond the call of duty, I got valuable help from the museum's film and video technician, Greg Pierce, and former archivist John Smith.

Yale University's Beinecke Rare Book and Manuscript Library had just acquired and inventoried Henry Geldzahler's papers when I arrived on the scene, commuting to New Haven for a week to re-excavate the wide, deep swath Henry cut through the sixties New York art world.

There were enough of David Bourdon's notes, interview transcripts, and other unpublished material to keep me at the Smithsonian Institution's Archives of American Art (AAA) in Washington, D.C., for almost a week. I also went through AAA-sponsored interviews with Richard Bellamy, Robert Indiana, and Roy Lichtenstein by Richard Brown Baker; with John Coplans, Claes Oldenburg, and Emily Tremaine by Paul Cumming; and with Tom Wesselman by Irving Sandler. At the AAA's Manhattan branch, I read with interest Pop Art collector and sixties arriviste Robert Scull's papers. (For all of his out-of-control bumptiousness, Scull was, his date books reveal, a draftsman/caricaturist of talent.)

The Harry Ransom Center at the University of Texas–Austin houses the Gerard Malanga Papers, including Malanga's correspondence during his 1967–68 Italian sojourn and earlier. Bob Fagelson at the University of Texas promptly and resourcefully tracked down a number of letters for me. I spent several days each at the J. Paul Getty Museum in Los Angeles, Manhattan's Roy Lichtenstein Foundation (where Clare Bell's 1992 Lichtenstein interview was especially enlightening), and the Time Inc. Archive. Finally, weeks at the New York Public Library, with its collection of early-sixties fashion magazines—*Harper's Bazaar* in particular—let me zero in on Warhol's fascinating oscillation, circa 1960, between commercial and fine art.

The first Peter Schjeldahl article I ever read was a 1970 record review in which the young critic likened Bob Dylan's recording Paul Simon's

"The Boxer" to Shakespeare directing Arthur Miller. Even as a kid, I knew that anyone who wrote a line like that was going to stay around. As an art critic, Schjeldahl has composed hundreds of essays that, with discouraging consistency, combine unexpected imagery, a sharp self-trained eye, and something virtually absent from art criticism, a sense of humor. Schjeldahl's Warhol pieces in the *New Yorker*, the *Village Voice*, *7 Days*, *Art in America*, and elsewhere, collected now into several volumes, have been essential to my understanding of the artist.

I'm tempted to call the mensch Ivan Karp this book's conscience and perhaps even its hero. Barbara Rose, brilliance aside, is another mensch (Yiddish has never overcome its irritating male chauvinism). So are Ruth Ansel and Tina Fredericks. Other interviewees revisit my thoughts: Seymour Berlin, Robert Heide, George Klauber, the intellectually generous Stephen Koch, Tom Lacy, Mark Lancaster, the man for all seasons Alfred Leslie, the amazing wordsmith James McCourt, John Mann, Billy Name, Stephen Shore, Kenneth Silver, busy, gifted James Warhola, and Paul Warhola, Sr.

Every interviewee offered invaluable information and ideas: Callie Angell, Roger Anliker, Arman, Gordon Baldwin, Robert Benton, Gretchen Berg, Irving Blum, Andreas Brown, Stephen Bruce, John Cale, Gary Carey, Genevieve Cerf, John Chamberlain, Wyn Chamberlain, Jack Champlin, George Chauncey, Christo, William Claxton, Bob Cowan, Bob Cumming, Ronnie Cutrone, David Dalton, Sarah Dalton, Betty Lou Saxton Davis, Michael Egan, Lette Eisenhauer, Arthur Elias, Lois Elias, Gene Feist, Danny Fields, Nancy Fish, Suzi Gablik, Vincent Giallo, Bob Gill, John Giorno, Milton Glaser, Manuel Gonzales, Sam Green, Joseph Groell, Mimi Gross, John Gruen, Pat Hackett, George Hartman, Leon Hecht, Alan Helms, Geoff Hendricks, Timothy Hennessy, Robert Indiana, Gilbert Ireland, Gretchen Schmertz Jacob, Alex Katz, Ellsworth Kelly, Leonard Kessler, Nicholas Kish, Diana Klemin, Hilton Kramer, Kenneth Jay Lane, Charles Lisanby, Nelson Lyon, Donald Lyons, Gerard Malanga, Marisol, Julie Martin, Jonas Mekas,

Duane Michals, Alan Midgette, Paul Morrissey, Suzanne Moss, Patty Mucha, Claes Oldenburg, Philip Pearlstein, Susan Pile, Robert Pincus-Witten, Ed Plunkett, Buddy Radisch, Marcus Ratliff, John Righetti, Esther Robinson, Charles Rydell, Lucas Samaras, Carolee Schneeman, Richard Smith, Leo Steinberg, Harold Stevenson, Philip Sykes, Dan Talbot, Connie Trimble, George Warhola, John Warhola, Paul Warhola, Jr., John Weber, Edmund White, Robert Whitman, Jane Wilson, William Wilson, Mary Woronov, Hanford Yang, and Danny Zarem.

Sadly, a number of my informants have passed on. Edward Avedisian is no longer alive; nor are Denton Cox, Lou Dorfsman, Charles Henri Ford, Suzie Frankfurt, the dear man Nathan Gluck, Walter Hopps, Allan Kaprow, Billy Klüver, Muriel Latow, Peter Palazzo, George Plimpton, Robert Rosenblum, Sal Scarpitta, Christopher Scott, Holly Solomon, Floriano Vecchi, John Wallowitch, Chuck Wein, Tom Wesselmann, and Henry Wolf.

I made use of several interviews conducted by others: Billy Klüver's and Julie Martin's with David Bourdon, Charles Henri Ford, Ivan Karp, and Roy Lichtenstein; Steven Watson's with Nelson Lyon, Paul Morrissey, Viva, and Chuck Wein (Steven helped in many other ways); and Matt Wrbican's with Mary Woronov and Ron Tavel.

Betsy Smith tracked down hard-to-find phone numbers, Esther Robinson graciously made her uncle Danny Williams's journals available, and financial pro Dan Juechter never hesitated to put down his demanding work in order to help me hack through the jungle of Andy Warhol's finances. Two graduate students whose names are recorded only on lost, very small paychecks helped transcribe interview tapes and did valuable information-gathering in New York City: Michele, at New York University's Institute of Fine Arts, and a part-time Swarthmore College instructor whose name completely escapes me. Sorry, and thanks.

During the years I worked on this book, I was helped in innumerable ways by friends without whom I wouldn't have finished it: Enzo Bartoc-

cioli, David Corcoran, Brian Daly, Jeanne Goldstein, Stan Goldstein, Fred Goodman, Jill Keil, Nick Keil, Ken Micallef, Bert Pepper, Suze Rotolo, Diana Saaby, and Lynn Saaby. I know I'm forgetting some, but never Colleen Hughes. Our marriage ended after nineteen years, but I think we will always be friends, and we're connected in any case by the brilliant, beautiful Lulu and Evie.

My first editor at HarperCollins, Dan Conaway, got everything under way; Jennifer Barth, the second editor, brought it all back home (and force-fed me truths about professionalism I did my best for months to spit out). Maestro Simon Lipskar was my first agent at Writers House; my second, in a deft switch, was family man Dan Conaway.

This book began as my project alone. Midway through 2004, after all of the interviews and the bulk of the first draft were done, I became seriously ill. For a time, my recovery was in doubt. The publishers and I began looking for someone to put the manuscript into shape. A veteran writer and cowriter of some fifteen books and a sixties friend of Andy Warhol's, David Dalton, was chosen. David applied his substantial energy and sophistication to a half-shaped first draft. I returned seven months before the deadline, but this book was rescued by David Dalton. Though it is not quite the book I originally envisioned, it illuminates many previously unlit corners of Andy Warhol's complicated world during this, the most creative period of his life.

—T.S.

Coming from England at the beginning of the sixties, I encountered Pop art with the same jolt of excitement and joy I'd experienced on first hearing the blues. I was fortunate enough to meet Andy Warhol at the beginning of his career, and through his X-ray specs I saw America's brash, bizarre, and manic underworld of ads, supermarket products, comics, and kitsch brought to garish, teeming, jumping-out-of-its-skin life. Working on the book with Tony has prompted me to revisit my

early encounters with an outrageous and luminous cast of characters: Ivan Karp, Henry Geldzahler, Jim Rosenquist, Leo Castelli, Jasper Johns, Bob Rauschenberg, Edie Sedgwick, Ondine, Taylor Mead, and Jackie Curtis. The art world that existed in the sixties now seems remote and quaint, on the cusp of the postmodern behemoth it unwittingly gave birth to.

I would also like to thank two blasts from the past—Billy Name and Nat Finkelstein—for the stories and opinions they contributed to the book, and the radiant Julia Moore for fearlessly tracking down elusive and wonderful photographs. Thanks also to my agent, Eileen Cope, and to my editor, Jennifer Barth, who leapt undaunted right into the adventure that was this book.

And last but not least, my beloved Coco Pekelis, who kept the manuscript from rolling down the road like a tumbleweed and my brain from jumping off the nearest postmodern precipice.

—D.D.

NOTES

All interviews by Tony Scherman unless otherwise indicated.
Ninety percent were face-to-face; only if this proved impossible
was a telephone used. There were no email interviews.

PROLOGUE

Interviews: Nathan Gluck (November 29, 2000, and December 5, 2000);
Daniel Harris (December 1, 2002, and December 2, 2003); Charles Lisanby
(January 25, 2002); George Warhola (December 15, 2001); James Warhola
(April 4, 2002); John Warhola (April 19, 2002); Paul Warhola (August 18,
2001); and Paul Warhola Jr. (March 30, 2003).

ix *August 30, 1960*: All information in opening section from Andy Warhol's
personal and business documents, Andy Warhol Museum Archive, Pitts-
burgh, Pennsylvania (hereafter AWMA); visits to Andy Warhol's former
home, 1342 Lexington Avenue, New York City; Douglas Kellner, ed., *Emile
de Antonio's Painters Painting: A CD-ROM by Ron Mann*, Voyager, 1998.

xii *$12 billion a year business by 1960*: U.S. Department of Commerce, Bureau
of the Census, *Statistical Abstract of the United States, 1960* (Washington,
D.C.: GPO, 1960), 855.

xiii *"The initial impact of Pop art"*: Robert Rosenblum, "Warhol as Art His-

tory," in Kynaston McShine, ed., *Andy Warhol: A Retrospective* (New York: Museum of Modern Art, 1989), 28.

xiii *"The new vulgarians"*: Max Kozloff, "'Pop' Culture, Metaphysical Disgust, and the New Vulgarians," *Art International* 7 (March 1962): 35–36.

xiv *in 2007, Warhol's 1963 painting*: Souren Melikian, "Warhol Works Sell for $136.7 at Christie's Sale," *International Herald Tribune*, May 17, 2007.

CHAPTER 1: BEGINNINGS

Interviews: Roger Anliker (January 21, 2001); Ruth Ansel (February 14, 2001); Seymour Berlin (January 26, 2001); Stephen Bruce (December 12, 2000); Gary Carey (December 21, 2001); George Chauncey (January 27, 2003); Denton Cox (March 13, 2002, and April 22, 2003); Betty Lou Saxton Davis (November 7, 2001); Lou Dorfsman (December 18, 2000); Gene Feist (April 4, 2002); Suzie Frankfurt (January 25 and February 10, 2001); Tina Fredericks (December 4, 2000); Suzi Gablik (March 3, 2002); Vito Giallo (December 8, 2000); Milton Glaser (January 19, 2001); Nathan Gluck; Joseph Groell (December 15, 2000); Daniel Harris (December 1, 2002); George Hartman and Buddy Radisch (December 19, 2000); Leon Hecht (November 15, 2001); Robert Heide (March 28, 2001; February 11, 2003); Alan Helms (March 8, 2002); Ellsworth Kelly (January 25, 2002); Leonard Kessler (December 19, 2000); Nick Kish (August 23, 2001); George Klauber (January 31, 2001); Diana Klemin (January 2, 2002); Tom Lacy (May 8, 2001); Alfred Leslie (December 7, 2001, and January 7, 2002); Charles Lisanby, James McCourt (February 8, 2002); Paula Madawick (January 26, 2001); Paul Robert Magocsi (May 20, 2001); John Mann (February 25, 2002); Duane Michals (February 12, 2001); Billy Name (May 7, 2001, and January 15, 2003); Claes Oldenburg (March 28, 2002); Peter Palazzo (January 25, 2001); Philip Pearlstein (May 4, 2001); Edward Plunkett (November 29, 2001); Marcus Ratliff (February 28, 2001); John Righetti (September 12, 2003); Gretchen Jacob Schmertz (January 26, 2001); Richard Smith (November 17, 2000); Connie Trimble (April 4, 2001); John Wallowitch (February 15, 2001); George Warhola; James Warhola; Paul Warhola; Paul Warhola Jr.; Edmund White (February 26, 2002); Henry Wolf (November 15, 2001).

1 *Just how odd his background was*: *Absolut Warhola*, DVD, documentary directed by Stanislaw Mucha (2001; TLA Releasing, 2004).

2 *The 800,000 to 1.2 million Slavic people*: Information on Rusyns and Rusyn-Americans from Paul Robert Magocsi, *The Rusyns of Slovakia: An Historical Survey* (New York: Columbia University Press, 1993); R. Magocsi, *The Carpatho-Rusyn Americans* (New York: Chelsea House, 1989); and interviews with R. Magocsi and John Righetti.

3 *When Ondrej was unemployed or ill*: David Bourdon, *Andy Warhol* (New York: Abrams, 1989), 17.

3 *who would recall the boy as "magnificently talented"*: Victor Bockris, *The Life and Death of Andy Warhol* (London: Frederick Muller, 1989), 52.

4 *It's hardly an exaggeration to say*: Jane Dagett Dillenberger, *The Religious Art of Andy Warhol* (New York: Continuum, 1998), 19.

4 *The Warholas rented out the second floor*: This note and much of the factual material for Warhol's college years come from Bennard B. Perlman, "The Education of Andy Warhol," *The Andy Warhol Museum: The Inaugural Publication* (Pittsburgh: Andy Warhol Museum, 1994; distributed by Art Publishers), 148.

5 *Andy kept a lovingly assembled*: Bockris, *Life and Death of Andy Warhol*, 41.

5 *In late adolescence, Andy would sit*: Andy/Garbo photos in Patrick S. Smith, *Andy Warhol's Art and Films* (Ann Arbor: UMI Research Press, 1986), 2, 8.

6 *It suited the adult Warhol*: Andy Warhol, *The Philosophy of Andy Warhol: From A to B and Back Again* (New York: Harcourt Brace Jovanovich, 1975), 21.

6 *"He had the prettiest smile"*: Bockris, *Life and Death of Andy Warhol*, 43.

7 *Though he seems to have had the patches removed*: AWMA correspondence.

9 *Not only could Andy not bring himself*: Bockris, *Life and Death of Andy Warhol*, 45.

9 *"The adult Andy Warhol became a prolific author"*: Wayne Koestenbaum, *Andy Warhol* (New York: Viking, 2001), 30.

10 *"I learned when I was little"*: Andy Warhol and Pat Hackett, *POPism* (New York: Harcourt Brace Jovanovich, 1980), 108.

11 *"Is that your sister?"*: Perlman, "The Education of Andy Warhol," 154.

11 *He decided to take modern dance*: Bourdon, *Andy Warhol*, 22.

12 *"In his freshman year"*: Ibid., 21; David Bourdon Papers, Archive of American Art (hereafter AAA), Smithsonian Institution, Washington, D.C.

12 *"He couldn't put a stamp on an envelope"*: David Bourdon interview of Imilda Tuttle, April 1, 1968, Bourdon Papers, AAA.

12 *"He had an absolute flair"*: Interview of Carl Willers in Patrick S. Smith, *Warhol: Conversations About the Artist* (Ann Arbor: UMI Research Press, 1988), 144.

13 *Andy entered The Broad*: Perlman, "The Education of Andy Warhol," 164.

16 *A remark of Andy's*: Cynthia Munro, "We Hitch Our Wagons: Stuart Davis and Cynthia," *Mademoiselle* 45, no. 4 (August 1957), 266.

16 *he'd begun dropping the "a"*: Perlman, "The Education of Andy Warhol," 164.

16 *According to a college classmate*: Ibid., 158.

16 *While it may originally have been an attempt*: At least twice in the early 1950s,

Warhol got important jobs because of his work's resemblance to Shahn's: for Lou Dorfsman at CBS in 1952 and for Peter Palazzo, when the latter was art director at *America* magazine. "It was such an obvious knockoff of Ben Shahn," said Palazzo of Warhol's work.

18 *When you do something exactly wrong*: Warhol and Hackett, *POPism*, 287.

18 *As art critic Dave Hickey writes*: Dave Hickey, "The Importance of Remembering Andy," unpublished manuscript, 18.

19 *He would deliver coy innuendos*: Interview with Joseph Groell.

22 *"the freshest and newest thing in newspapers"*: Peter Palazzo, *Art Direction*, May 1956, 40.

22 *an annual retainer of $12,000*: See 1957 letter from Peter Palazzo to Andy Warhol, AWMA.

23 *One trace is the steady flow of postcards*: See AWMA.

24 *"The fact that Andy was gay"*: Charles Lisanby, interview by Tony Scherman.

24 *Thanks to the day's virulent homophobia*: Most of the insights into Manhattan's gay network in the 1950s were derived from interviews. The best historical work on New York gay life, George Chauncey's groundbreaking 1993 study, *Gay New York*, ends just before World War II. I made some use of John D'Emilio, *Sexual Politics, Sexual Communities* (Chicago: University of Chicago Press, 1983); Charles Kaiser, *The Gay Metropolis: 1940–1996* (Boston: Houghton Mifflin, 1997); John Loughery, *The Other Side of Silence* (New York: Holt, 1998); Martin Duberman, *Stonewall* (New York: Dutton, 1993); and Alan Helms, *Young Man from the Provinces* (Boston: Faber and Faber, 1995).

25 *"I moved among the smirks"*: Douglas Kellner, ed., *Emile de Antonio's Painters Painting: A CD-ROM by Ron Mann*, Voyager, 1998.

26 *In 1957 he dropped $1,900.95 there*: Warhol's financial documents, AWMA.

27 *The Warhol-Wallowitch collaboration*: See, for instance, Edward Wallowitch's many photographs in Georg Frei and Neil Printz, eds., *The Andy Warhol Catalogue Raisonné* (New York: Phaidon, 2002).

27 *Then they too drifted apart*: When Edward died in 1981, John, who hadn't seen Andy for years, decided to telephone him. When he spoke the news, he heard nothing on the line. Then Andy began to cry—not sniffles, but racking sobs. "He just kept saying, 'Oh, Eddie, Eddie, Eddie.'" John was shocked by Andy's display of feeling.

31 *They range from innocuous*: *Piss and Sex Paintings and Drawings* (New York: Gagosian Gallery, 2002), the catalogue to the exhibition of the same name, contains a number of Warhol's erotic drawings from the 1950s.

32 *"By the time we were sitting on each other's faces"*: Dick Banks quote.

34 *The shows were reviewed: an air of preciosity, of carefully studied perversity*: James Fitzsimmons, *Art Digest*, July 1952, 19; *an original style of line drawing*:

Barbara Guest, *Art News*, Summer 1954, 75; *sly, abound[ing]* . . . *Jean Cocteau on an off day*: Stuart Preston, *New York Times*, March 3, 1956, 37; *an odd elegance of pure craziness*: Parker Tyler, *Art News*, December 1956, 59; *soundly based on the artist's own pert sense of originality*: Stuart Preston, *New York Times*, December 7, 1957, 17; *this delightfully graphic horseplay*: Sidney Tillim, *Art News*, January 1960.

34 *Warhol cracked the Museum of Modern Art*: Letter to Warhol from Alfred Barr, director, Museum of Modern Art, October 18, 1956, AWMA.

35 *as the Abstract Expressionist Barnett Newman said*: Quoted in Harold Rosenberg, *The Anxious Object* (New York: Horizon Press, 1964), 172.

35 *"a monument to the human spirit"*: Erle Loran, "Pop Artists or Copycats?" *Art News*, September 1963, 49.

36 *Abstract Expressionism, wrote Clement Greenberg*: Clement Greenberg, "Post Painterly Abstraction," in *The Collected Essays and Criticism*, vol. 4, *Modernism with a Vengeance: 1957–1969*, John O'Brian, ed. (Chicago: University of Chicago Press, 1993), 193–94.

36 *Abstract Expressionism, Roy Lichtenstein recalled*: Roy Lichtenstein, interviewed by Billy Klüver and Julie Martin, August 16, 1990. Transcript loaned to TS by BK/JM.

36 *"Painting," Rauschenberg announced*: "Statement," in Dorothy Miller, ed., *Sixteen Americans* (New York: Museum of Modern Art, 1959), 58.

38 *"If you want to know all about Andy Warhol"*: Gretchen Berg, "Nothing to Lose: Interview with Andy Warhol," *Cahiers du Cinéma*, May 1967.

38 *he copied most of a page*: Heiner Bastian, ed., *Andy Warhol* (Köln: DuMont Buchverlag, 2001), 92.

39 *Two years later, he drew*: Ibid., 93.

39 *"conducting a tireless assault"*: Background on Duchamp from Calvin Tomkins, *The Bride and the Bachelors* (New York: Viking, 1965), 9–69.

40 *"Well, Duchamp lies behind Andy"*: Henry Geldzahler, unpublished interview by Jean Stein, 1973, Henry Geldzahler Papers, Beinecke Rare Book and Manuscript Library, Yale University, New Haven, CT.

41 *"Many of the assemblages of junk"*: Hilton Kramer, "Month in Review," *Arts Magazine*, November 1960, 50.

41 *Calling the show*: Thomas Hess, "Mixed Mediums for a Soft Revolution," *Art News*, Summer 1960, 45.

41 *"We must become preoccupied with"*: Allan Kaprow, "The Legacy of Jackson Pollock," *Art News*, October 1958, 56–57.

41 *"Comics, picnic tables, men's trousers, celebrities"*: Warhol and Hackett, *POPism*, 1.

42 *Emile de Antonio was an impossible man*: Background on Emile de Antonio from several sources, including Kellner, ed., *Emile de Antonio's Painters*

Painting; Douglas Kellner and Dan Streible, eds., *Emile de Antonio: A Reader* (Minneapolis: University of Minnesota Press, 2000); Randolph Lewis, *Emile de Antonio: Radical Filmmaker in Cold War America* (Madison: University of Wisconsin Press, 2000).

42 *"De was almost the first one"*: Henry Geldzahler, unpublished interview by Jean Stein, 1973, Geldzahler Papers, Beinecke Library.

43 *His initial revelation about the art world*: De Antonio to Barbara Rose, CD interview, Getty Archive.

44 *Andy had already suspected that art world success was "all promotion"*: Recounting a conversation with Warhol, in which Andy had called a Rauschenberg combine "awful" and "a piece of shit" that "anyone [could] do," Ted Carey remembered telling his friend, "Well, why don't you do it? If you really think it's all promotion."

44 *De Antonio was the first person he knew*: Warhol and Hackett, *POPism*, 4.

44 *In the early seventies*: Kellner, ed., *Emile de Antonio's Painters Painting*.

CHAPTER 2: 1961

Interviews: Irving Blum (July 12, 2001); Nathan Gluck; Timothy Hennessey (March 28, 2002); Walter Hopps (February 3, 2002); Robert Indiana (April 5, 2002); Ivan Karp (March 26, 2001); Ellsworth Kelly; Mark Lancaster (December 5, 2001); Muriel Latow (February 21, 2002); John Mann; Patty Mucha (October 22, 2002); Barbara Rose (February 2, 2002); Robert Rosenblum (December 19, 2001); Christopher Scott (April 6, 2002); Harold Stevenson (March 20, 2002); Connie Trimble (April 4, 2001); Paul Warhola; William Wilson (July 25, 2001).

48 *"[The conversations] were always basically Andy"*: Unpublished interview of Henry Geldzahler by Jean Stein, 1973, Henry Geldzahler Papers, Beinecke Library.

48 *His 1960 gross hit $70,000*: AWMA.

49 *not to mention a four-day hospital stay*: Ibid.

49 *Shortly after Valentine's Day*: "Projected Images," in Georg Frei and Neil Printz, eds., *Andy Warhol Catalogue Raisonné*, vol. 1, "Paintings and Sculpture 1961–1963" (New York: Phaidon, 2002), 20–46.

51 *According to an intriguing theory proposed*: Kenneth Silver, "Modes of Disclosure: The Construction of Gay Identity and the Rise of Pop Art," in *Hand Painted Pop: American Art in Transition 1955–62*, ed. Russell Ferguson (New York: Rizzoli International, 1992).

52 *"It's good because it's awful"*: Susan Sontag, "Notes on Camp," *Partisan Review*, Fall 1964, 515–30.

52 *"He realized that if you wanted"*: Steven Watson interview of Paul Morrissey, July 27, 2001, shared with TS.

52 *As Warhol later wrote*: Warhol, *The Philosophy of Andy Warhol*, 158.

53 *a joke million-dollar bill*: Mark Francis and Dieter Koepplin, eds., *Andy Warhol, Drawings, 1942–1987* (Pittsburgh: Andy Warhol Museum, 1998), plate 138.

53 *Three painstaking appropriations prefigure the newspaper paintings*: Ibid., plate 91.

54 *Andy, unable to contain himself*: Andy Warhol and Pat Hackett, *POPism* (New York: Harcourt Brace Jovanovich, 1980), 11.

55 *As Andy recalled, his initial, "stupid" response*: Ibid.

55 *"As for the 'swish' thing"*: Ibid.

56 *If Andy was still "surrounded"*: Douglas Kellner, ed., *Emile de Antonio's Painters Painting: A CD-ROM by Ron Mann*, Voyager, 1998.

56 *There was nothing wrong*: Warhol and Hackett, *POPism*, 12.

56 *Johns later denied*: Jasper Johns, interviewed by Paul Taylor in *Interview*, July 1990, 96–100, 122–23, republished in Kirk Varnedoe, ed., *Jasper Johns: Writing, Sketchbook Notes, Interviews* (New York: Museum of Modern Art, 1996), 250.

56 *On February 24*: AWMA.

57 *January and February marked the purchase*: AWMA.

57 *At the Museum of Modern Art*: Ted Carey, interview in Patrick S. Smith, *Andy Warhol's Art and Films* (Ann Arbor: UMI Research Press, 1986), 253–254.

57 *For ten days in late March*: Andy Warhol's date book, AWMA.

59 *this "was the beginning"*: Roy Lichtenstein, interviewed by Clare Bell, Lichtenstein Foundation, June 1, 1992.

60 *why not paint it*: Ibid.

61 *"Every remark I made"*: Walter Hopps, quoted in Jean Stein, edited with George Plimpton, *Edie: An American Biography* (New York: Knopf, 1982), 193.

61 *Finally, Warhol brought out his work*: Ibid.

62 *His tack didn't really interest me*: Ibid.

62 *Roy Lichtenstein had finished*: Roy Lichtenstein, interview by Richard Brown Baker, December 6 and 11, 1963, and January 15, 1964, AAA.

63 *Pop art would probably*: Biographical material on Ivan Karp from many sources, primarily interviews with Karp and others, and Warhol and Hackett, *POPism*.

67 *But it took something far more magnetic*: Railroad ticket in AWMA.

67 *In 1961 Warhol's commercial art earnings dropped*: AWMA.

68 *Swenson, an early 1961 visitor*: Andy Warhol, interview by G. R. Swenson, "What Is Pop Art? Part 1," *Art News*, November 1963, 24–27ff, reprinted in Stephen Henry Madoff, ed., *Pop Art: A Critical History* (Berkeley: University of California Press, 1997).

68 *A big exclamation point*: Andy Warhol's date book, AWMA.

71 *as Henry Geldzahler later put it*: Henry Geldzahler, unpublished interview by Jean Stein, 1973, Geldzahler Papers, 1973, Beinecke Library.

71 *"As long as he didn't know anything"*: Warhol and Hackett, *POPism*, 7.

74 *A $50 check dated November 23rd, 1961*: AWMA.

74 *"It was on one of those evenings"*: Warhol and Hackett, *POPism*, 18.

75 *But in fact, Warhol, as was his practice*: AWMA.

75 *In a 1978 interview, Ted Carey recalled*: Ted Carey, interview in Smith, *Andy Warhol's Art and Films*, 256–57.

76 *Warhol's POPism account echoes Carey's*: Warhol and Hackett, *POPism*, 6–7.

76 *One of her books*: Roberta Latow, *Cheyney Fox* (New York: Fawcett, 1990).

77 *Georg Frei and Neil Printz*: Frei and Printz, *The Andy Warhol Catalogue Raisonné*, 64.

78 *"In offering for sale"*: Kynaston McShine, ed., *Andy Warhol: A Retrospective* (New York: Museum of Modern Art, 1989), 434.

78 *It was, as philosopher/art critic Arthur Danto writes*: Arthur Danto, *Beyond the Brillo Box* (Berkeley: University of California Press, 1992), 140.

79 *According to Andy's friend*: Mario Amaya, interview by John Wilcock, in John Wilcock, *The Autobiography and Sex Life of Andy Warhol* (New York: Other Scenes, 1971).

81 *"Imagine the art world"*: Peter Schjeldahl, "Henry's Show," *Village Voice*, September 20, 1994.

81 *He was "the connection"*: "Henry Here, Henry There . . . Who Is Henry?" *Life*, February 18, 1966, 42.

81 *He could "find a gallery for a painter"*: Frances Fitzgerald, "What's New, Henry Geldzahler, What's New," *New York Herald Tribune*, November 21, 1965, 15.

82 *"When we see him coming around the corner"*: Ibid.

82 *Geldzahler was fond of telling how, at fifteen*: Ingrid Sischy, "An Interview with Henry Geldzahler," in Henry Geldzahler, *Making It New* (New York: Turtle Point Press, 1994), 4.

83 *Calvin Tomkins, profiling Geldzahler*: Calvin Tomkins, "Moving with the Flow," *New Yorker*, November 6, 1971, 58–113.

83 *In an essay on Warhol's 1964 film*: "Warhol Film/Geldzahler," fax from Warhol Film Project to Beaubourg, Musée National d'Art Moderne, AWMA.

83 *His homosexuality*: Henry Geldzahler Papers, Beinecke Library.

84 *According to de Antonio*: Kellner, ed., *Emile de Antonio's Painters Painting*.

84 *It was just magic*: Henry Geldzahler, interview by Jean Stein, 1973, Geldzahler Papers, Beinecke Library.

84 *The meeting would have occurred*: Andy Warhol's date book, AWMA.

84 *Warhol watched him register*: Warhol and Hackett, *POPism*, 15.

85 *Warhol and Geldzahler almost immediately*: Warhol and Hackett, *POPism*, 15–16.

85 *Contemplating a row of early Dalí masterpieces*: Henry Geldzahler, "Objects and Subjects in Warhol's Art," lecture, Gallery of Western Australia, Perth Cultural Center, Perth, Australia. March 1994.

85 *Geldzahler once said that all he remembered*: Henry Geldzahler, interview by David Bourdon, October 4, 1987, Bourdon Papers, AAA.

86 *"Once in a while," recalled Geldzahler*: Henry Geldzahler, unpublished interview by Jean Stein, 1973, Geldzahler Papers, Beinecke Library.

86 *At some point in 1962, he had "the delicious pleasure"*: Smith, *Andy Warhol's Art and Films*, 307.

87 *When Andy felt empty, Henry said*: Henry Geldzahler, "Objects and Subjects in Warhol's Art."

CHAPTER 3: 1962

Interviews: Roger Anliker; Ruth Ansel; Irving Blum; Stephen Bruce; Wyn Chamberlain (August 4, 2001); Sarah Dalton (May 20, 2001); Nathan Gluck; John Giorno (January 26, 2002); Sam Green (June 28, 2001, and July 26, 2001); Joseph Groell; Timothy Hennessey; Walter Hopps (February 3, 2002); Ivan Karp; Alex Katz (December 20, 2001); George Klauber; Diana Klemin; Billy Klüver (December 1, 2001); Tom Lacy; Alfred Leslie (January 7, 2002); Charles Lisanby; Marguerite Littman (August 5, 2001); Gerard Malanga (July 17, 2001, and March 3, 19, and 22, 2003); Marisol (January 14, 2002); Duane Michals; Patty Mucha; Edward Plunkett; Barbara Rose (February 2, 2002); Robert Rosenblum; James Rosenquist (int. by David Dalton, July 8, 2008); Richard Smith (November 21, 2000); Floriano Vecchi (February 9, 2002); William Wilson; Hanford Yang (December 5, 2002).

90 *Andy's Pop epiphany, his decisive break*: Many sources, including Douglas Kellner, ed., *Emile de Antonio's Painters Painting: A CD-ROM by Ron Mann*, Voyager, 1998; Andy Warhol and Pat Hackett, *POPism* (New York: Harcourt Brace Jovanovich, 1980), 5–6.

91 *On March 7, David Bourdon*: Bourdon Papers, AAA.

92 *Meanwhile, Andy was tirelessly working*: Andy Warhol's date book, AWMA.

92 *"Warhall [sic] (painter)"*: Robert Scull Papers, AAA, New York City branch.

94 *Jackson's rejection letter aptly depicts*: Steven Watson, *Factory Made* (New York: Pantheon, 2003), 81.

94 *As de Antonio phrased it*: Kellner, ed. *Emile de Antonio's Painters Painting.*

94 *The spring 1962 season brought about*: Clement Greenberg, "America Takes the Lead," in *The Collected Essays and Criticism*, vol. 4, *Modernism with a*

Vengeance: 1957–1969, John O'Brian, ed. (Chicago: University of Chicago Press, 1993), 215.

95 Time *profiled Dine in its February 2 issue: Time,* "The Smiling Workman," February 2, 1962, 44.

95 *In the February 1962 issue:* Sidney Tillim, "Month in Review: New York Exhibitions," *Arts Magazine,* February 1962, 34–37.

95 *Tillim's reflections were prompted:* Claes Oldenburg, *Claes Oldenburg's Store Days* (New York: Something Else Press, 1967).

96 *From its opening stanzas:* Claes Oldenburg, "Statement," in *Environments, Situations, Spaces,* exhibition catalogue, Martha Jackson Gallery, May–June 1961, reprinted in Stephen Henry Madoff, ed., *Pop Art: A Critical History* (Berkeley: University of California Press, 1997), 213–15.

97 *His generation, he wrote in his notebook:* Claes Oldenburg, *Claes Oldenburg's Store Days,* 60.

97 *On May 17, Warhol bought one:* Receipt, dated May 17, 1962, AWMA.

97 *After seeing Rosenquist's pictures:* Ted Carey, interview by Patrick S. Smith, *Andy Warhol's Art and Films* (Ann Arbor: UMI Research Press, 1986), 255.

97 *He undoubtedly knew through Karp:* Ivan Karp, unpublished interview by David Bourdon, March 7, 1962, Bourdon Papers, AAA.

99 *"What I do is form":* Swenson, reprinted in Madoff, ed., *Pop Art,* 108.

99 *"I take a cliché and try to organize its forms":* Lichtenstein, catalogue "The New Art" exhibition, March 1–22, 1964, Wesleyan University, Middletown, Conneticut, essay by Lawrence Alloway, cover design by Robert Indiana.

99 *According to the Green Gallery's Richard Bellamy:* Marvin Elkoff, "American Artist as Blue Chip," *Esquire,* January 1965, 36–41.

101 Time *magazine's report:* "The Slice of Cake School," *Time,* May 11, 1962, 52.

101 *Geldzahler would later make the claim:* In *New York Spy,* quote taken from manuscript, Henry Geldzahler Papers, Beinecke Library.

101 *The caption read: Time,* "The Slice of Cake School," 52.

102 *"I want to show the monotony":* Marguerite Lamkin, "New York Newsletter," *London Evening Standard,* September 12, 1962.

102 *"I feel like I'm very much a part":* Berg, op. cit.

102 *When the May 11 issue:* Andy Warhol's 1962 date book, AWMA. Warhol bought five copies of the magazine on May 7 and four more on the 13th.

102 *On May 3, shortly before:* Andy Warhol's date book, AWMA.

102 Life, *following its corporate stablemate's lead:* "Something New Is Cooking," *Life,* June 15, 1962, 115–16.

103 *When David Bourdon had visited:* Bourdon, unpublished interviews with Warhol, March 7 and March 12, 1962, Bourdon Papers, AAA.

104 *Years later, Henry Geldzahler liked to say:* Henry Geldzahler, *Making It New: Essays, Interviews, and Talks* (New York: Turtle Point Press, 1994).

104 *In screen printing, the artist*: For background information on silk-screening, see David Acton, David Amram, David Lehman, eds., *The Stamp of Impulse* (Manchester, VT: Hudson Hills Press, 2001); J. I. Biegeleisen and Max Arthur Cohn, *Silkscreening Techniques* (New York: Dover, 1958).

105 *Warhol seems to have begun making*: Georg Frei and Neil Printz, eds., *Andy Warhol Catalogue Raisonné*, vol. 1 (New York: Phaidon, 2002), 131.

106 *In late March and April, he screen-printed*: March 29 invoice for prepared acetate, AWMA.

107 *"The rubber-stamp method I'd been using"*: Warhol and Hackett, *POPism*, 22.

107 *Between late March and May*: Frei and Printz, *Andy Warhol Catalogue Raisonné*, vol. 1, 150–58, 182–88, 189–82.

107 *According to Bourdon*: Bourdon, *Andy Warhol*, 108.

107 *Johns, it turned out*: Ibid., 123.

108 *the Active Process Supply Company*: Invoice, AWMA.

109 *"The silkscreens were really an accident . . ."*: Kenneth Goldsmith, ed., *I'll Be Your Mirror: The Selected Andy Warhol Interviews* (New York: Da Capo Press, 2004), 294.

111 *But, as Henry Geldzahler described this meeting*: Henry Geldzahler, unpublished interview by Billy Klüver and Julie Martin, August 16, 1990, 9.

113 *as Warhol would contend some years later*: Richard Marshall and Robert Mapplethorpe, *50 New York Artists* (San Francisco: Chronicle Books, 1986), 111.

113 *"I suspect that Andy's going to feed a lot"*: Henry Geldzahler, interview by Jean Stein, 1973, Geldzahler Papers, Beinecke Library.

113 *Ruth Ansel had just put him into a* Harper's Bazaar *spread*: "The Well-Mixed Party," *Harper's Bazaar*, August 1962, 87–89.

113 *Geldzahler, however, was concerned*: Henry Geldzahler, interview by David Bourdon, October 4, 1987, Bourdon Papers, AAA.

114 *"I loved working when I worked at"*: Warhol, *The Philosophy of Andy Warhol*, 96.

114 *As he famously said of his art*: Warhol and Hackett, *POPism*, 16.

114 *"How is asking someone"*: Ibid.

115 *"The director of the Stable Gallery"*: Alan Groh, unpublished autobiographical manuscript, 1971. AAA, Smithsonian Institution, Washington, DC.

115 *Ward claimed an upper-class*: Biographical information on Ward from Kellner, ed., *Emile de Antonio's Painters Painting*; Paul Gardner, "The Stable Wasn't Just Another Gallery," *Art News*, May 1982, 108–13; Eleanor Ward, interview in Smith, *Andy Warhol's Art and Films*, 505–15, reprinted in slightly different form in Patrick S. Smith, *Warhol: Conversations About the Artist* (Ann Arbor: UMI Research Press, 1988), 200–207.

116 *Warhol's date book indicates*: Andy Warhol's date book, AWMA.

116 *Ward recalled another encounter*: Ward interview in Smith, *Andy Warhol's Art and Films*, 504.

116 *In de Antonio's version*: Kellner, ed., *Emile de Antonio's Painters Painting*.

117 *Ward's version begins at least*: Ward interviewed in Smith, *Andy Warhol's Art and Films*, 504.

118 *In 1957 he asked a mutual friend*: Buzz Miller, interview by Jill Hartz, curator, University of Virginia Art Museum, from exhibition catalogue *In Honor of Alan Groh '49: The Buzz Miller Collection of Modern Art*.

118 *"32 ptgs. arrived safely"*: Postcard from Irving Blum to Andy Warhol, AWMA.

119 *Los Angeles's avant-garde community*: Thomas Crow, *The Rise of the Sixties* (New York: Abrams, 1996), 72.

120 *"The darts he is throwing"*: Henry J. Seldis, *Los Angeles Times*, July 13, 1962, Section 4, 6.

120 *Down the street from the Ferus*: Jack Smith, "Soup Can Painter Uses His Noodle," *Los Angeles Times*, July 23, 1962, C1.

120 *a cartoon depicted two beatniks*: Frank Interlandi, *Los Angeles Times*, August 1, 1962, A5.

120 *"Enclosed, yet another witless review"*: Postcard from Irving Blum to Andy Warhol, AWMA.

120 *At that point, Walter Hopps*: In previous accounts, Blum has taken credit for the idea: seeing them day after day, he has said on a number of occasions, he started to feel that they had a "collective resonance" and belonged together. According to Hopps, the idea was his, not Blum's. Told of Hopps's claim, Blum didn't dispute it; in fact, said Blum, the critic John Coplans had suggested the same thing to him, and much more forcefully than Hopps.

121 *At Seventeen, "he was always"*: Marvin Harrison, "Marvin Israel," Exhibition Catalogue (Twining Gallery, New York, New York: 1990), 4.

123 *The piece, a four-page spread about cars*: "Deus ex Machina," *Harper's Bazaar*, November 1962, 156–59.

124 *For the December issue*: "Stop, Study and Applaud—Names and Faces Worth Remembering," *Harper's Bazaar*, December 1962, 90–91.

124 *Andy received $412 for the piece*: Receipt to Andy Warhol from *Harper's Bazaar*, November 9 1962, AWMA.

125 *It would be fitting*: As it happens, Bruce does recall suggesting a Marilyn project to Andy (as do a number of other people), but his account does not otherwise match Plunkett's

126 *"to register an advance protest"*: Michael Fried, "New York Letter," *Art International* 6, no. 10 (December 1962): 57.

127 *"Somewhere in the image"*: David Antin, "Warhol's Silver Tenement," *Art News*, Summer 1966, 47ff.

128 *Regardless of how often Lichtenstein protested*: Roy Lichtenstein, interviewed by Richard Brown Baker, December 6 and 11, 1963, and January 15, 1964, AAA.

129 *The English dealer Robert Fraser caught sight of Janis*: Letter from Robert Fraser to David Herbert, AAA.

129 *The "New Realists" opened, with a bang*: Many sources, including Sidney Janis, "On the Theme of the Exhibition," catalogue for The New Realists exhibition, Sidney Janis Gallery, New York City, October 31–December 1, 1962; Brian O'Doherty, "Avant-Garde Revolt," *New York Times*, October 31, 1962, 41; and Harold Rosenberg, "The Game of Illusion," *New Yorker*, November 24, 1962, 161–67.

131 *"With this show, 'pop' art is officially here"*: Brian O'Doherty, "Avant-Garde Revolt."

131 *"'New Realism' hit the art world"*: Harold Rosenberg, "The Game of Illusion."

131 *Hilton Kramer, Max Kozloff, and Dore Ashton*: Hilton Kramer, "Art," *The Nation*, November 17, 1962, 335; Max Kozloff, "'Pop' Culture, Metaphysical Disgust, and the New Vulgarians," *Art International* 7 (March 1962): 38; Dore Ashton, "New York Report," *Das Kunstwerk* 16, November–December 1962, 69–72; Rosenberg, "The Game of Illusion"; Thomas Hess, "New Realists," *Art News*, December 1962, 12; O'Doherty, "Avant-Garde Revolt"; Irving Sandler, "In the Art Galleries," *New York Post Sunday Magazine*, November 18, 1962, 12.

131 *"[The Pop artist] is as reticent"*: Stanley Kunitz, "What Is Pop Art?" *Arts*, April 1963, 36–44, reprinted in Madoff, ed., *Pop Art*, 65–81; Kunitz's statement is on 75.

131 *"I would say that all neo-Dadaists"*: Sidney Tillim, "Month in Review," *Arts*, November 1962, 36.

132 *For* Newsweek's *article on the show*: "Products," *Newsweek*, November 12, 1962, 94.

133 *Ward and Alan Groh had hung eighteen paintings*: The Stable Gallery's show inventory, "Andy Warhol, November 6 through November 24, 1962," lists nineteen.

135 *Henry evidently hadn't done much preparing*: Emile de Antonio's receipt to Andy Warhol, AWMA.

135 *According to Bourdon, the party was a dud*: Bourdon, *Andy Warhol*, 136.

135 *"The air of banality is suffocating"*: Dore Ashton, "New York Report," 69–72.

135 *Warhol's work, Donald Judd wrote in* Arts: Donald Judd, "Andy Warhol," *Arts*, January 1963, 49.

135 *Correctly identifying the hand-painting*: Michael Fried, *Art International*, "New York Letter," 57.

135 *Almost four decades later*: Peter Schjeldahl, "Barbarians at the Gate," *The New Yorker*, May 15, 2000, 102.

136 *Eleanor Ward sold every painting*: Patrick S. Smith, *Andy Warhol's Art and Films*, 505.

136 *A friend named Don Schrader*: Warhol and Hackett, *POPism*, 25.

137 He was invited to Zachary Scott: Ibid.

137 *On the day after Christmas*: AWMA. (Andy signed the contract in February 1963.)

137 *Days earlier, Johnson had offered*: Frei and Printz, *Andy Warhol Catalogue Raisonné*, vol. 1, 226.

CHAPTER 4: 1963

Interviews: Callie Angell (May 22, 2003); Ruth Ansel; Robert Benton (November 15, 2001); Irving Blum; Wyn Chamberlain; John Chamberlain (December 11, 2001); Sarah Dalton; Danny Fields (March 26, 2003); Vincent Fremont (June 15, 2003); John Giorno; Nathan Gluck; Sam Green; Leon Hecht (December 15, 2001); Robert Heide; Allan Kaprow (December 16, 2001); Ivan Karp; Mark Lancaster; Gerard Malanga; Jonas Mekas (February 20, 2003); Patty Mucha; Billy Name; John Richardson (March 1, 2002); Irving Sandler, May 3, 2001; Sal Scarpitta (March 15, 2003); John Weber (June 28, 2001); Chuck Wein (February 2, 2003); John Gruen and Jane Wilson (November 9, 2001); William Wilson.

139 *The leaders who had shepherded America*: Life, "The Take-Over Generation," special issue, September 14, 1962, 4–19.

140 *Suddenly every museum had to have*: Claes Oldenburg, interview by Paul Cummings, December 4, 1973, AAA.

140 *Between March and December*: 1963 Pop art museum exhibitions listed in Stephen Henry Madoff, ed., *Pop Art: A Critical History* (Berkeley: University of California Press, 1997), 407.

140 *(The "six" were originally seven . . .*: Barbara Rose, "Pop Art at the Guggenheim," *Art International*, May 1963, 20–22.

141 *"Pop Art is more than just"*: Newsweek, "Pop Culture," May 3, 1963, 138.

141 *In March, young Sam Green*: catalogue, The New Art exhibition, Wesleyan University.

141 *Listening to the radio*: Andy Warhol, interview by G. R. Swenson, "What Is Pop Art? Part 1," *Art News*, November 1963, 24–27ff.

141 *Some seventy Warhol canvases*: Georg Frei and Neil Printz, eds., *The Andy Warhol Catalogue Raisonné*, vol. 1 (New York: Phaidon, 2002), 286–387.

142 *A friend remembered accompanying him*: The friend was David Dalton.

143 *The* Burning Car *paintings*: Frei and Printz, *The Andy Warhol Catalogue Raisonné*, vol. 1, 384–87.

144 *These are "images that anybody"*: Andy Warhol and Pat Hackett, *POPism* (New York: Harcourt Brace Jovanovich, 1980), 3.

144 *"There was no profound reason"*: Berg, op cit.

144 *The emotionless tone of Andy's references*: Frei and Printz, *The Andy Warhol Catalogue Raisonné*, vol. 1, 380.

145 *The source for* Tunafish Disaster: Ibid., 342.

145 *a 1987 essay by the art historian Thomas Crow*: Thomas Crow, "Saturday Disasters: Trace and Reference in Early Warhol," *Art in America*, May 1987, 129–36.

145 *But a notation that Andy scrawled*: Frei and Printz, *The Andy Warhol Catalogue Raisonné*, vol. 1, 348.

145 *Gene Swenson's famous 1963 conversation*: Swenson, "What Is Pop Art? Part 1."

145 *"It's hard to be creative"*: Ibid.

146 *At one point in the Swenson interview*: Ibid.

146 *Not surprisingly, Eleanor Ward*: David Bourdon, *Andy Warhol* (New York: Abrams, 1989), 148.

146 *To the critic Alain Jouffroy*: Alain Jouffroy, *Les Prévoyants* (Bruxelles: La Connaissance, 1974), 138.

147 *It's also possible, as Bourdon suggests*: Bourdon, *Andy Warhol*, 158.

147 *According to his friend Nelson Lyon*: Nelson Lyon, interview by Steven Watson, August 12, 1999, shared with TS.

147 *"You literally had to hopscotch"*: Warhol and Hackett, *POPism*, 15.

147 *His pace was propelled by Obetrol*: Ibid., 33.

147 *"for that wired, happy, go-go-go feeling"*: Ibid.

148 *In late April, Wyn Chamberlain*: Andy Warhol's date book, AWMA.

149 *On May 25, 1963, Linich and Warhol*: Flyer for "Mr. New York Contest," AWMA.

150 *On June 9, Ford invited Warhol*: Andy Warhol's date book, AWMA.

151 *Edward Albee is said to have based*: Mel Gussow, *Edward Albee: A Singular Journey* (New York: Applause Books, 2000), 185.

151 *"The last of the great bohemians"*: Warhol and Hackett, *POPism*, 25.

151 *For his part, Gerard asked for $1.25*: Ibid., 26–27.

152 *They got a lot done that summer*: Frei and Printz, *The Andy Warhol Catalogue Raisonné*, vol. 1, 355–420.

154 *Through Malanga, Andy would get to know*: Reva Wolf, *Andy Warhol: Poetry and Gossip in the 1960s* (Chicago: University of Chicago Press, 1997), 134–38.

154 *In September 1963, Malanga . . . John Ashbery*: Ibid., 86.

155 *not only writing a near-rave*: John Ashbery, "Pop Artist's Horror Pictures Silence Snickers," *International Herald Tribune*, January 15, 1964, 8.

156 *The first paintings Malanga worked on*: Frei and Printz, *The Andy Warhol Catalogue Raisonné*, vol. 1, 393.

156 *"Silver was the future"*: Warhol and Hackett, *POPism*, 64–65.

157 *Irving Blum wanted a broad overview*: Irving Blum to Andy Warhol, May 28, 1963, AWMA.

157 *"Those were the quiet days"*: Warhol and Hackett, *POPism*, 27.

158 *There were group outings*: Ibid., 28.

159 *whose brother, the handsome*: Ned Rorem, *A Ned Rorem Reader* (New Haven: Yale University Press, 2001), p. 276.

160 *In the June 1963 feature*: "New Faces, New Forces, New Names in the Arts," *Harper's Bazaar*, June 1963, 64–67.

160 *Andy tried out a format*: Frei and Printz, *The Andy Warhol Catalogue Raisonné*, vol. 1, 410–21.

160 *Some five years earlier*: Cover of *Seventeen*, February 1958.

160 *The April 1963 issue*: "Instant Self-Analysis, 25 cents," *Harper's Bazaar*, April 1963, 143–44.

161 *The piece, called "Instant Self-Analysis"*: Israel was on the April masthead, but was replaced in May by Ansel and Bea Feitler.

162 *Frei and Printz date the painting*: Frei and Printz, *The Andy Warhol Catalogue Raisonné*, vol. 1, 410–21.

162 *But a September 6 invoice from Aetna*: AWMA.

163 *"I had great visions of going to Richard Avedon's"*: Douglas Kellner, ed., *Emile de Antonio's Painters Painting: A CD-ROM by Ron Mann, Voyager, 1998*.

163 *Aetna made a screen for each*: Frei and Printz, *The Andy Warhol Catalogue Raisonné*, vol. 1, 410.

164 *From de Antonio, Warhol learned*: Warhol and Hackett, *POPism*, 30.

165 *Probably early in 1962*: Ibid., 29.

165 *what was just becoming known as "underground film"*: cf. Parker Tyler, *Underground Film: A Critical History* (New York: Grove Press, 1969); David E. James, ed., *To Free the Cinema: Jonas Mekas and the New York Underground* (Princeton, NJ: Princeton University Press, 1992); Jonas Mekas, *Movie Journal: The Rise of a New American Cinema, 1959–1971* (New York: Macmillan, 1972).

165 *Mekas had starved when he had arrived in America*: Jonas Mekas, *I Had Nowhere to Go* (New York: Black Thistle Press, 1991); Calvin Tomkins, "All Pockets Open," *New Yorker*, January 6, 1973, 31–49.

165 *A self-described "raving maniac of the cinema"*: Mekas, Movie Journal, *Village Voice*, March 14, 1963, 13.

165 *"Painting is dead"*: Stan Vanderbeek, "Expanded Cinema: A Symposium, New York Film Festival 1966," in "Expanded Arts," special issue of *Film Culture*, December 1966, 1.

166 *"Films will soon be made"*: Jonas Mekas, "On Film Troubadors," Movie Journal, *Village Voice*, October 6, 1960, in Mekas, *Movie Journal*, 20.

166 *Each of these movies was*: Information on Jack Smith films drawn from Jack Smith, *Wait for Me at the Bottom of the Pool: The Writings of Jack Smith*, eds. J. Hoberman and Edward Leffingwell (London: Serpent's Tail, 1997).

167 *Mekas's chief antagonist Parker Tyler*: cf., for instance, Parker Tyler, *Underground Film* (New York: Da Capo, 1995) and *Screening the Sexes: Homosexuality in the Movies* (New York: Holt, Rinehart, Winston, 1972).

169 *During their stay, Giorno awoke*: Warhol and Hackett, *POPism*, 33.

169 *They started filming in August*: John Giorno, *You Got to Burn to Shine* (New York: High Risk, 1993), 136.

170 *Andy spent the first two weeks rewinding*: Ibid., 137.

170 *On the weekend of August 11 and 12*: Andy Warhol's date book, AWMA.

170 *Smith descended on the estate*: Various sources, including Diane di Prima, *Recollections of My Life as a Woman: The New York Years* (New York: Viking, 2001), 357–60; see also Jack Smith, *Wait for Me*, 45–52, for Smith's discussion of the making of *Normal Love*, including Smith's drawing of the giant birthday cake designed by Claes Oldenburg and built onsite.

171 *Di Prima has left a wonderful tableau*: Di Prima, *Recollections*, 359.

171 *An enormous pink birthday cake*: Ibid. and Jack Smith, *Wait for Me*, 49.

171 *Several of the* Kiss *sequences*: Andy Warhol's Filmmakers Cinematheque income and expenses balance sheet shows a December 2, 1963, screening of *Kiss* at the Filmmakers Showcase; *Village Voice*, November 28, 1963, and December 5, 1963, ran advertisements for "Chapter 2 of *Kiss, Andy Warhol's* serial starring Naomi Levine" at the Filmmakers Showcase.

171 *On September 19, meanwhile*: Mekas, *Movie Journal*, 97.

172 *Andy, who had never been west of Pennsylvania*: Chief sources for the 1963 West Coast trip: Warhol and Hackett, *POPism*, 35–45; Taylor Mead, "Son of Andy Warhol," unpublished manuscript; interviews with Wyn Chamberlain and Gerard Malanga.

173 *it would seem that*: In "Son of Andy Warhol," 75–76, Mead wrote: "The further west we had driven, the more amazed we were at how the neon lights announcing hotels, motels, and restaurants were like works by Lichtenstein, Warhol, Kenneth Noland, Jack Youngerman, Frank Stella, or Rauschenberg—reverberating or inspired by Popism—more likely inspiring Popism. It was certainly in the air!"

174 *"Warhol doesn't suggest in any of his works"*: Gerald Nordland, "Marcel Duchamp and Common Object Art," *Art International*, February 15, 1964, 30.

176 *"The show triggered a Duchamp boom"*: Calvin Tomkins, *The Bride and the Bachelors: Five Masters of the Avant Garde* (New York: Viking, 1965), 10.

176 *In reel 5 alone, Andy made 133 splices*: Callie Angell, "Andy Warhol, Filmmaker," *The Andy Warhol Museum: The Inaugural Publication* (Pittsburgh: Andy Warhol Museum, 1994; distributed by Art Publishers), 125.

179 *The final cut was five hours*: Angell, "Andy Warhol, Filmmaker," 125.

180 *As Pauline Kael wryly commented*: Pauline Kael, "Movies, the Desperate Art," in Daniel Talbot, ed., *Film: An Anthology* (New York: Simon & Schuster, 1959), 209.

181 *Which Warhol's primary scenarist, Ron Tavel, confirmed*: Ronald Tavel, interview by Matt Wrbican, May 10, 1997.

181 *"Strange things have been going on"*: Mekas, Movie Journal, 109.

181 *Many years later, in the Warhol supplement*: Village Voice, May 5, 1987, 5.

181 *Shot between August 1963 and the end of 1964*: This section owes much to Stephen Koch's insightful treatment of Warhol's earliest films in his book *Stargazer: The Life, World and Films of Andy Warhol*, rev. ed. (New York: Marion Boyars, 1991).

183 *"We watch and wait"*: Ibid., 17.

183 *"Sex . . . is always just on the verge"*: Ibid., 41.

185 *Talking to Giorno*: Andy Warhol, interview by John Giorno, unpublished manuscript, 1963, Time Capsule #32, AWMA. The Time Capsules are the cardboard boxes Warhol used from 1974 on, putting into them items from the vast miscellany that daily crossed his desk. When a box was full, he taped it shut, dated or titled it, and stored it. There are 612 Time Capsules, most still unopened, at the Warhol Museum, containing an estimated 300,000 to 500,000 objects.

185 *Using a photograph of another suicide*: Frei and Printz, *The Andy Warhol Catalogue Raisonné*, vol. 1, 286.

185 *"I don't know what it means!"*: Giorno, unpublished manuscript, 124.

185 *POPism, which has Andy painting alone*: Warhol and Hackett, *POPism*, 60.

186 *Since the mid-fifties the San Remo had attracted*: Many sources for San Remo, chiefly Ron Sukenick, *Down and In: Life in the Underground* (New York: Beech Tree Books, 1987).

186 *According to Joe LeSueur*: Joe LeSueur, *Digressions on Some Poems by Frank O'Hara* (New York: Farrar, Straus and Giroux, 2003), 20.

188 *the neighborhood, with its harsh conditions*: Many sources, including Sally Banes, *Greenwich Village, 1963: Avant-Garde Performance and the Effervescent Body* (Durham, NC: Duke University Press, 1993); Di Prima, *Recollections*; Reva Wolf, *Andy Warhol*; and interviews with Billy Name, William Wilson, and others.

CHAPTER 5: 1964

Interviews: Irving Blum; John Cale (February 24, 2004, and April 3, 2004); Jack Champlin (November 13, 2001); Denton Cox; Sarah Dalton; Michael Egan (July 1, 2001); Danny Fields; John Giorno; Nathan Gluck; Sam Green; Robert Indiana (April 5, 2002); Ivan Karp; George Klauber; Ste-

phen Koch (March 7, 2003); Mark Lancaster; Kenneth Jay Lane (June 21, 2001); Gerard Malanga; Billy Name; Paul Morrissey (int. by David Dalton, June 8, 2003, and TS, April 12, 2003); Robert Pincus-Witten (July 18, 2001); George Plimpton (July 14, 2001); Barbara Rose; Peter Schjeldahl (March 2, 2001); Christopher Scott; Edmund White; Mary Woronov (March 31, 2003); Hanford Yang.

193 *Andy had known since at least mid-1963*: Andy Warhol and Pat Hackett, *POPism* (New York: Harcourt Brace Jovanovich, 1980), 61.

193 *"New Studio 231 E. 47" reads the date book entry*: Andy Warhol date book, AWMA.

193 *One afternoon, according to Henry Geldzahler*: Henry Geldzahler, "Objects and Subjects in Warhol's Art," lecture, Gallery of Western Australia, Perth Cultural Center, Perth, Australia.

194 *Andy's fourth-floor loft had once*: Steven Watson, *Factory Made* (New York: Pantheon, 2003), 123, among other sources.

197 *According to Linich, it was chosen simply*: Billy Name, "Naming the Factory," *Splash Magazine*, Winter 1988–1989, 7.

197 *"I'm becoming a factory"*: "Glamour at Home: Cook with Cans," *Glamour*, May 1964, 169.

199 *For some reason, Warhol was scathing*: Bourdon Papers, AAA.

200 *Andy bought a 35-millimeter Pentax*: Warhol and Hackett, *POPism*, 74.

203 *The coterie POPism calls "the A-men"*: Ibid., 62.

203 *Mary Woronov, a 1965 Factory arrival*: Mary Woronov, *Swimming Underground: My Years in the Warhol Factory* (Boston: Journey Editions, 1995), 91.

204 *"Right from the beginning"*: Warhol and Hackett, *POPism*, 61.

206 *"the realm of the more or less"*: All Koch quotes in this paragraph are from Stephen Koch, *Stargazer: The Life, Wold and Films of Andy Warhol*, rev. ed. (New York: Marion Boyars, 1991), ix–xii.

206 *One of the old order's brightest eulogists*: Tom Wolfe, "Go Sample New York Night Life," *Glamour*, April 1964, 142.

206 *from "netherworld, outcast, 'pariah,' groups"*: Tom Wolfe, "Tom Wolfe's New Book of Etiquette," *The Pump House Gang* (New York: Farrar, Straus and Giroux, 1968), 170.

207 *Wolfe's fashion-writing colleague*: Eugenia Sheppard, *New York Herald Tribune*, October 4, 1964.

207 *"Well-Dressed Kibitzer"*: *New York Herald Tribune*, April 25, 1965.

207 *The March 19, 1965, Life splurged*: "Underground Clothes," *Life*, March 19, 1965, 116–22.

208 *"Bangs manes bouffants beehives"*: Tom Wolfe, "Girl of the Year," *The Kandy-Kolored Tangerine-Flake Streamline Baby* (New York: Farrar, Straus and Giroux, 1965), 199.

210 *As planned, the Factory's first party*: Warhol and Hackett, *POPism*, 86.

210 *Marguerite Lamkin and Bob and Ethel had agreed to pay*: Ibid.

212 *The show was panned*: John Canaday, "From Clean Fun to Plain Smut," *New York Times*, January 7, 1964, 31.

212 *"a very special group show of something marvelous"*: John Weber, letter to Andy Warhol, November 2, 1964. AWMA, Correspondence files.

212 *The big show, sixty-one works by thirty-nine artists*: Donald Factor, *Artforum*, April 1964, 10, 20–23.

212 *Reviewing the show for* Artforum: Ibid.

213 *Malanga's next visit was to a woodworker's*: Gerard Malanga, "How We Made the Brillo Boxes," *Archiving Warhol* (Creation Books, 2002), 147–49.

213 *"Andy's boxes . . . do not express"*: G. R. Swenson, "The Personality of the Artist," Stable Gallery, April 21–May 9, 1964, in Bourdon papers, AAA.

214 *As always, Alan Groh proved immensely useful*: Paul Gardner, "The Stable Wasn't Just Another Gallery," *Art News*, May 1982.

214 *De Antonio called it "Supermarket Day on Madison Avenue"*: Douglas Kellner, ed., *Emile de Antonio's Painters Painting: A CD-ROM by Ron Mann*, Voyager, 1998.

215 *A disappointed Ward admitted*: Interview of Eleanor Ward in Smith, *Andy Warhol's Art and Films*, 508.

215 *The most vehement answer*: Jay Walz, "Canada Rules Out Boxes as 'Art,'" *The New York Times*, March 9, 1965.

216 *"The rooms were filled"*: Sidney Tillim, "Andy Warhol," *Arts*, September 1964, 62.

216 *"One would want one of the boxes"*: G. R. Swenson, "The Darker Ariel," *Collage*, Palermo, 1965.

217 *Duchamp's well-known remark*: Marcel Duchamp, quoted in Rosalind Constable, "New York's Avant-Garde and How It Got There," *New York Herald Tribune*, May 17, 1964, 7–13.

217 *"the nearest thing"*: Arthur C. Danto, "Warhol," *Encounters and Reflections: Art in the Present Historical Moment* (New York: Farrar, Straus and Giroux, 1990).

217 *Pondering the Brillo show*: Stuart Preston, "Old and New Ways of Seeing Things," *New York Times*, April 26, 1964, 21.

217 *For Danto, the Brillo boxes*: Arthur Danto, *Beyond the Brillo Box* (Berkeley: University of California Press, 1992), 9.

217 *Warhol himself had said*: Swenson, "What Is Pop Art? Part 1," 24.

218 *"Here in New York We Are Having"*: Donald Allen, ed., *The Collected Poems of Frank O'Hara* (Berkeley: University of California Press, 1995), 480.

218 *"In preparation for the World's Fair"*: Brad Gooch, *City Poet: The Life and Times of Frank O'Hara* (New York: Knopf, 1993), 424.

218 *On December 17, 1963*: Robert C. Doty, "Growth of Overt Homosexuality in City Provokes Wide Concern," *New York Times*, December 17, 1963, 1.

219 *"I wonder what they think"*: Frank O'Hara, letter to Larry Rivers, in Gooch, *City Poet*, 424.

219 *Artists were threatened with revocation*: Susan Goodman, "State Softens on Artists, But City Will Not Relent," *Village Voice*, March 26, 1964, 1; "Lofts Still Stalled," *Village Voice*, March 26, 1964, 1; "1000 Artists at City Hall Picket for Their Lofts," *Village Voice*, April 9, 1964, 1.

219 *The Metro Cafe, a Lower East Side coffeehouse*: Stephanie Gervis Harrington, "City Puts Bomb Under Off-Beat Culture Scene," *Village Voice*, March 26, 1964, 1.

219 *At least three avant-garde theaters*: J. Hoberman, "The Big Heat: Making and Unmaking Flaming Creatures," in Edward Leffingwell, Carole Kismaric, Marvin Hoffman, eds., *Flaming Creature: Jack Smith, His Amazing Life and Times* (London: Serpent's Tail, 1997), 162.

219 *In one of two raids on the New Bowery*: Ibid; Warhol and Hackett, *POPism*, 79.

219 *Arrested twice, Jonas Mekas was convicted*: Stephanie Gervis Harrington, "Pornography Is Undefined at Film-Critic Mekas' Trial," *Village Voice*, June 18, 1964, 9.

219 *In April, Lenny Bruce, appearing at the Café Au Go Go*: "Lenny Bruce Seized on Obscenity in Act," *New York Times*, April 4, 1964, 12; "Bruce Tagged on Obscenity, Run Extended at Café Here," *Village Voice*, April 9, 1964, 3; Stephanie Gervis Harrington, "DA Presses Bruce Case, As Fair Opening Nears," *Village Voice*, April 16, 1964, 2.

219 *Philip Johnson—one of the city's leading gay cultural figures*: Georg Frei and Neil Printz, *The Andy Warhol Catalogue Raisonné*, vol. 2A (London and New York: Phaidon, 2004), 25.

219 *some three hundred demonstrators were arrested on opening day*: Homer Bigart, "Rain Soaks Crowd; Sit-ins Mar Festivities at Some Pavilions—Attendance Cut; World's Fair Is Opened by Johnson Despite Rain and Racial Demonstrations," *New York Times*, April 23, 1964, 1; Stephanie Gervis Harrington, "Heigh-Ho, Come to the Fair," *Village Voice*, April 30, 1964, 1.

220 *Andy had settled on his contribution*: "Avant-Garde Art Going to the Fair," *New York Times*, October 5, 1963, 17.

220 *until a parcel arrived at 1342 Lexington*: "The Thirteen Most Wanted," NYPD pamphlet, AWMA.

220 *Now Andy could get to work*: Frei and Printz, *The Andy Warhol Catalogue Raisonné*, vol. 2A, 24–51.

220 *"Mural Is Something Yegg-stra"*: Richard Barr and Cyril Egan, Jr., "Mural Is Something Yegg-stra," *New York Journal American*, April 15, 1964, 1, 3.

220 *Philip Johnson pronounced himself "delighted"*: Ibid.

221 *"I don't know who's in charge out there"*: Ibid.

221 *An NYPD spokesman told reporters*: Ibid.

221 *according to Johnson, there was*: Ibid.

221 *The value of the great architect's word*: Mel Juffe, "Fair's 'Most Wanted' Mural Becomes 'Least Desirable,'" *New York Journal American*, April 18, 1964, 3.

221 *Eleanor Ward took part in the whitewash*: Emily Genauer, "Fair Mural Taken Off, Artist to Do Another," *New York Herald Tribune*, April 18, 1964, 11.

221 *Years later, Johnson let it be known*: Philip Johnson, interviewed by Billy Klüver and Julie Martin, December 18, 1990.

222 *So Warhol made one last offer*: David Bourdon, *Andy Warhol* (New York: Abrams, 1989), 181.

222 *Some years later, Emile de Antonio asked*: Kellner, ed., *Emile de Antonio's Painters Painting*.

222 *According to Richard Meyer*: Meyer, "Warhol's Clones," 108.

222 *In the end, a big black cloth*: Frei and Printz, *The Andy Warhol Catalogue Raisonné*, vol. 2A, 26.

223 Thirteen Most Wanted *survived the episode*: Ibid.

223 *A brief correspondence survives*: AWMA.

223 *Powell Jr. would have been less effusive*: Frei and Printz, *The Andy Warhol Catalogue Raisonné*, vol. 2A, 241.

224 *By late August, he was at work on* Flowers: Ibid., 281.

224 *"They weren't Andy Candy very long"*: Henry Geldzahler, interview by David Bourdon, October 4, 1987, Bourdon Papers, AAA.

224 *"I never know what she's up to"*: Marisol, letter to Warhol, dated June 1964, AWMA.

224 *"All I know," Irving Blum wrote Andy*: Irving Blum letter to Warhol, AWMA.

225 *Two weeks after the Brillo show ended*: May 26, 1964, letter to "Dear Eleanor," signed by Andy Warhol, announcing intention to leave the Stable Gallery. The letter was most likely written by Ivan Karp; the rough draft is on Leo Castelli Gallery letterhead. AWMA.

225 *Leo Castelli was, in Calvin Tomkins's words*: For biographical information on Leo Castelli, see Calvin Tomkins, "A Good Eye and a Good Ear," *New Yorker*, May 26, 1980, 40–74.

227 *When he died in 1999, at age ninety-one*: James Russell, "Leo Castelli, Influential Art Dealer, Dies at 91," *New York Times*, August 23, 1999, 1.

227 *His practice was to set up a network*: Laura de Coppet, *The Art Dealers: The Powers Behind the Scene Tell How the Art World Really Works* (New York: Cooper Square Press, 2002), 98.

228 *"television, advertising and the press now constitute Art's fourth dimension"*:

Otto Hahn, "Passport No. G255300," in *Arts & Artists*, July 1966, 10.

228 *Tom Wolfe, for one, entirely missed*: Tom Wolfe, "Bob and Spike," *The Pump House Gang* (New York: Farrar, Straus and Giroux, 1968), 139–60.

229 *"Well, you have to take him"*: Interview of Leo Castelli in Smith, *Andy Warhol's Art and Films*, 268.

229 *On January 17, 1964*: Bourdon, *Andy Warhol*, 176.

229 *The New York Post's Archer Winsten*: Archer Winsten, "Rages and Outrages," *New York Post*, January 20, 1964, 16.

230 *Over the course of the four-night run*: Filmmakers Cinematheque balance book, AWMA.

230 *Eat, another slow-motion, fixed-camera portrait*: Filmmakers Cinematheque balance book, AWMA.

232 *As he said in* POPism: Warhol and Hackett, 110.

232 *"a map of the downtown New York arts scene"*: all Callie Angell quotes on Screen Tests: Callie Angell, ed. *Screen Tests, The Films of Andy Warhol Catalogue Raisonné*, vol. 1 (New York: Abrams, 2006), 12–14.

234 *"a constant open house"*: Warhol and Hackett, POPism, 75.

234 *On October 27, Freddy Herko committed suicide*: Ibid., 85; di Prima, *Recollections*, 397.

235 *He and Andy were in the Factory*: Unpublished interview of Henry Geldzahler by Jean Stein, 1973, Geldzahler Papers, Beinecke Library.

236 *Actually, there were seven*: Frei and Printz, *The Andy Warhol Catalogue Raisonné*, vol. 2A, 293.

236 *"A livelier bunch of swinging humanoids"*: Thomas Hess, *Art News*, January 1965, 11.

236 *Art International's Lucy Lippard*: Lucy Lippard, "New York Letter," *Art International*, February 1965, 40.

236 *David Bourdon, writing for* the Voice: David Bourdon, "Andy Warhol," *Village Voice*, December 3, 1964, 11.

236 *The most deeply felt praise of* Flowers: Peter Schjeldahl, *Let's See: Writings on Art from* The New Yorker (New York: Thames and Hudson, 2008), 153.

237 *A challenge to Andy's authorship of* Flowers: Gay Morris, "When Artists Use Photographs," *Art News*, January 1981, 104–5.

237 *Caulfield's lawyer claimed*: Howard Smith, "Scenes," *Village Voice*, November 17, 1966, 11.

238 *Andy gave Caulfield two* Flowers *canvases*: Morris, "When Artists Use Photographs," 105; letter to Warhol from his lawyer, Jerald Ordover, June 7, 1967, AWMA.

238 *But Caulfield was still upset*: Morris, ibid., 105.

238 *The same* Art News *story*: Ibid., 104.

238 *"You can't just rip off a photographer's work"*: Ibid., 105.

238 *Warhol received recognition*: "Sixth Independent Film Award," *Film Culture*, Summer 1964, 1.

239 Artforum, *the new bellwether of the art world*: Philip Leider, "Saint Andy: Some Notes on an Artist Who, for a Large Section of a Younger Generation, Can Do No Wrong," *Artforum*, February 1965, 26–28.

CHAPTER 6: 1965

Interviews: Gordon Baldwin (April 1, 2003); Genevieve Charbin Cerf (January 4, 2004); Ronnie Cutrone (February 27, 2003); Michael Egan (July 1 and July 8, 2001); Danny Fields; Sam Green; Robert Heide; Ivan Karp; Stephen Koch; Donald Lyons (March 8, 2003); Gerard Malanga; Allen Midgette (November 30, 2003); Paul Morrissey; Billy Name; Charles Rydell (March 25, 2003); Stephen Shore (March 19, 2003); Chuck Wein; Edmund White.

244 *On December 13, 1964, Warhol filmed* Harlot: Steven Watson, *Factory Made* (New York: Pantheon, 2003), 175.

244 *How much cash do you get for your cheeks?*: Dialogue and action from the Andy Warhol film *Harlot*, 16 mm, black and white, 70 minutes, filmed December 1964.

244 *The newly found writer Ron Tavel*: All quotes from Ronald Tavel from his interview with Andy Warhol archivist Matt Wribican, May 10, 1977.

245 *In late January, Andy & Co*: Interviews with Lester Persky, Gore Vidal, and Chuck Wein from Jean Stein and George Plimpton, *Edie: American Girl* (New York: Grove Press, 1994), 179–80.

246 *Edith Minturn Sedgwick was the second youngest of eight*: All biographical information and quotes on Edie Sedgwick in this section from Stein and Plimpton, *Edie*.

247 *"The whole family story"*: Nora Ephron, "Edie Sedgwick, Superstar," *New York Post*, September 5, 1965, Section 2, 19.

248 *Warhol had bought the nonexclusive rights*: Stephen Koch, *Stargazer: The Life, World and Films of Andy Warhol*, rev. ed. (New York: Marion Boyars, 1991), 69.

250 *As "his constant companion"*: "Edie and Andy," *Time*, August 27, 1965, 65.

251 *"I had some fantasy"*: Watson, *Factory Made*, 142.

251 *"We're going to make her our superstar"*: Ronald Tavel, interviewed by Smith, *Andy Warhol's Art and Films*, 501.

252 *"Art and film have nothing to do"*: Gretchen Berg, "Nothing to Lose: Interview with Andy Warhol," *Cahiers du Cinéma*, May 1967.

253 *Kitchen is the classic example*: Koch, *Stargazer*, 74.

254 *To Norman Mailer, the sneezing became*: Vincent Canby, "When Irish Eyes Are Smiling, It's Norman Mailer," Arts and Leisure, *New York Times*, October 27, 1968, D15.

254 *Arriving at her apartment with Malanga and Warhol:* Audiotape library, AWMA.

256 *On an audiotape Warhol made in July:* Ibid.

256 *All but a few of Edie's films were made:* Koch, *Stargazer*, 146–47.

258 *On July 19, Edie and Andy sat:* Audiotape library, AWMA.

259 *A typical check from his distributors:* Film-Makers' Cooperative income and expense balance sheet, Time Capsule 39, AWMA.

259 *That week, Andy's unpaid bill:* Video Film Laboratories, monthly statement to Andy Warhol Enterprises, Inc., June 22, 1965, AWMA.

259 *Several days later, Andy received:* Ibid.

259 *In 1965, Andy Warhol Enterprises earned:* 1965 income tax statement, AWMA.

259 *Almost a decade later:* Audiotape library, AWMA.

260 *A small sampling of phrases lost in translation:* These and all other quotes from the *a* tapes are from the Audiotape library of the AWMA.

262 *When a came out at the end of 1968:* "zzzzzzzz: a by Andy Warhol," review in *Time*, December 27, 1968, 63.

263 *An assiduous note-taker, he jotted down:* Gordon Baldwin's 1966 notebooks, as shared with TS.

264 *Writing in the* International Herald Tribune: John Ashbery, "Andy Warhol Causes Fuss in Paris," *International Herald Tribune*, May 18, 1965, 5.

264 *The Pop foursome:* Details in this paragraph from Bourdon, *Andy Warhol*, 204–5.

264 *In Paris, Andy announced he was retiring:* Andy Warhol and Pat Hackett, *POPism* (New York: Harcourt Brace Jovanovich, 1980, 113.

264 *Back in America in June:* Ibid., 115.

264 *"As I leafed through the pages":* Ibid.

265 *As he told an interviewer in 1966:* Berg, "Nothing to Lose."

266 *In July, Warhol and Paul Morrissey met:* Morrissey's and Andy's second meeting is on tape at the AWMA. The date is July 17 or July 18.

270 *"Paul was brought to Andy's studio":* Henry Geldzahler, unpublished interview by Jean Stein, 1973, Geldzahler Papers, Beinecke Library.

271 *Critic Stephen Koch considers:* Koch, *Stargazer*, 83.

272 *After dropping out of Harvard:* Biographical information about Danny Williams is from his niece Esther Robinson's 2008 documentary on Williams, *A Walk into the Sea*, and from Williams's journals.

273 *"We plan to make money from it":* Sterling McIlhenny and Peter Ray, "Inside Andy Warhol," *Cavalier*, September 1966, 89.

274 *The project received other coverage:* Leonard Lyons, *New York Post*, September 24, 1967, 47.

275 *Looking back at the broken-off affair*: Danny Williams's journals, courtesy of Esther Robinson.

275 *The movies contain passages of real beauty*: Danny Williams's films, courtesy of Esther Robinson.

275 *The most famous social event*: Warhol and Hackett, *POPism*, 101.

277 *In mid-November 1965 Andy received*: November 15, 1967 letter to AW from Alfred R. Goldstein, Elk Realty, AWMA.

277 *"It wasn't portable, it just stood there"*: Warhol and Hackett, *POPism*, 119.

278 *Warhol gave a longish technical interview*: "Pop Goes the Videotape: An Underground Interview with Andy Warhol," *Tape Recording*, September–October 1965, 15–19.

278 *It was on this machine in August*: "The Films of Andy Warhol," catalogue, The Andy Warhol Film Project, 8, collaboration between the Museum of Modern Art, the Andy Warhol Foundation, the Andy Warhol Museum, and the Whitney Museum of American Art.

279 *Reviewing* Outer and Inner Space: J. Hoberman, "Film: A Pioneering Dialogue Between Actress and Image," *New York Times*, November 22, 1998.

279 *"It was getting very scary"*: Jane Holzer, as quoted in Stein and Plimpton, *Edie*, 228.

284 *One such field trip was covered at length*: Ruth Seltzer, "What They Saw in Andy Warhol's Pop Art Factory," *Philadelphia Bulletin*, October 1965.

285 *"realiz[ed] he was up against something big"*: David Bourdon, "Andy Warhol," *Village Voice*, October 14, 1965, 13.

286 *In what POPism regarded as "the performance of her life"*: Warhol and Hackett, *POPism*, 132.

288 *Edie's ballet-pose picture in* Vogue: Stein and Plimpton, *Edie*, 243–45.

289 *As captured on tape, she berates*: Audiotape library, AWMA.

290 *Neuwirth characterized the evening*: Stein and Plimpton, *Edie*, 314.

291 *Dylan himself . . . told a 1985 interviewer*: Scott Cohen, "Don't Ask Me Nothin' About Nothin'," *Spin*, December 1985.

292 *She "stood around doing nothing"*: Warhol and Hackett, *POPism*, 123.

292 *In any case, it wasn't Andy*: Andy Warhol, interview by David Bourdon, November 23, 1971, Bourdon Papers, AAA.

292 *"I know that Bob Dylan expressed an interest"*: Stein and Plimpton, *Edie*, 283.

CHAPTER 7: 1966

Interviews: Gretchen Berg (March 28, 2003); John Cale; Jackie Cassen (February 28, 2004); Michael Egan; Ronnie Cutrone (February 26, March 3, and March 10, 2003); Nat Finkelstein (interviewed by David Dalton, October 19, 2007); Sam Green; Robert Heide; Ivan Karp; Stephen Koch; Mark Lancaster; Gerard Malanga; Jonas Mekas; Paul Morrissey; Billy Name;

Esther Robinson (May 5, 2004); Christopher Scott; Stephen Shore; Holly Solomon (July 25, 2001); Chuck Wein; Mary Woronov.

297 *According to her hero and sometime boyfriend*: Allen Ginsberg, interview by Gerard Malanga, November 17, 1982.

298 *"out to walk all over Andy"*: Gerard Malanga interviewed by John Bauldie, "Dylan and Warhol," in John Bauldie, ed., *Wanted Man: In Search of Bob Dylan* (London: Black Springs Press, 1990), 68.

300 *"I don't want this"*: Howard Sounes, *Down the Highway* (New York: Grove Press, 2002), 199.

302 *"to bring it publicity"*: Victor Bockris and Gerard Malanga, *Uptight: The Story of the Velvet Underground* (London: Omnibus Press, 1983), 13.

303 *As his friend Bourdon saw*: David Bourdon, *Andy Warhol* (New York: Abrams, 1989), 220.

303 *Three members of this incarnation*: Ellen Willis, "Velvet Underground: Golden Archive Series," in Greil Marcus, ed. *Stranded: Rock and Roll for a Desert Island* (New York: Knopf, 1979), 74.

303 *Before they were the Velvet Underground*: John Cale and Victor Bockris, *What Is Welsh for Zen?* (London: Bloomsbury, 1999), 78.

303 *Reed, who'd managed to graduate*: For Lou Reed biographical facts, see Bockris and Malanga, *Uptight*; Cale and Bockris, *What Is Welsh for Zen?*; David Fricke, essay for *Peel Slowly and See*, Velvet Underground box set, Polydor Records, 1995.

305 *In 1966 he would write an essay*: Lou Reed, "The View from the Bandstand: Life Among the Poobahs": *Aspen* 3, December 1966.

306 *"Nothing could have prepared the kids"*: Rob Norris, "I Was a Velveteen," *Kicks* 1, 1979, reprinted on the Velvet Underground Web Page, "Live Performances and Rehearsals," http:// olivier.landemaine.free.fr/vu

307 *He ain't nothin'*: Bockris and Malanga, *Uptight*, 30.

308 *A corporation was founded*: Warvel, Inc., AWMA.

308 *"Andy Warhol's Velvet Underground"*: Jack O'Brian, "Voice of Broadway," *New York Journal American*, January 27, 1966, 13.

308 *"You see, Andy Warhol and Edie Sedgwick"*: Suzy Knickerbocker, *New York Journal American*, January 21, 1966, 10.

309 *As Mary Woronov memorably described her*: Woronov, *Swimming Underground: My Years in the Warhol Factory* (Boston: Journey Editions, 1995), 25.

309 *Christa Päffgen had called herself Nico*: background info on Nico: Bockris and Malanga, *Uptight*, 34–35.

311 *championed by the* Voice's *Jonas Mekas*: Jonas Mekas, Movie Journal, *Village Voice*, February 23, 1966.

311 *The Bed was shown on April 26, 1966*: AWMA.

312 *Danny Williams's journals and notes*: Courtesy of Esther Robinson.

312 On January 13, Andy and the Velvet Underground: Grace Glueck, "Syndromes Pop at Delmonico's," New York Times, January 14, 1966, 36.

313 As the gifted neo-Beat writer: Seymour Krim, "Shock Treatment for Psychiatrists," New York Herald Tribune, January 14, 1966, 27.

313 Malanga launched into his whip dance: Bourdon, Andy Warhol, 221.

313 There was a substantial early exit: Ibid.

313 The Cinematheque's new 41st Street quarters: Jack Kroll, "Up from Underground," Newsweek, February 13, 1967, 117.

314 the New York Times's veteran film critic: Bosley Crowther, "Andy Warhol's 'More Milk, Yvette' Bows," New York Times, February 9, 1966, 32.

314 While the Post's Archer Winsten refrained: Archer Winsten, "Andy Warhol at Cinematheque," New York Post, February 9, 1966, 55.

315 In an interview for Cavalier: Sterling McIlhenny and Peter Ray, "Inside Andy Warhol," Cavalier 44, September 1966, 86–89.

315 not on speaking terms: Calvin Tomkins, "Moving with the Flow," The Scene: Reports on Post-Modern Art (New York: Viking Press, 1976), 28.

315 As Geldzahler told journalist John Wilcock in 1971: John Wilcock, The Autobiography and Sex Life of Andy Warhol (New York: Other Scenes, 1971).

316 One day he could only recall: Ibid.

316 When Geldzahler was asked to choose: Ibid.

316 after Life's February 18, 1966: "Henry Here, Henry There . . . Who Is Henry?" Life, February 18, 1966, 41–48.

316 they attended Truman Capote's famous: Warhol and Hackett, POPism, 195–96.

316 Andy had a series of conversations: Berg, op cit.

318 In the New York Times: Elenore Lester, "So He Stopped Painting Brillo Boxes and Bought a Movie Camera," Arts and Leisure, New York Times, December 11, 1966.

319 I kept notes of what people said: David Fricke, essay for Peel Slowly and See, Velvet Underground box set, Polydor Records, 1995, 21–22.

319 Malanga's dancing partner: Bourdon, Andy Warhol, 222.

320 Ondine reportedly threw a chair: Victor Bockris, The Life and Death of Andy Warhol (London: Frederick Muller, 1989), 246.

320 According to Bockris, he "began to torture her": Bockris and Malanga, Uptight, 54.

321 In addition, surmised Morrissey: Ibid., 37.

321 Those plans definitely did not include: Ibid., 44.

321 Warhol and the Velvets had reportedly been offered $40,000: Ibid.

322 The Warhol troupe was not given access: Ibid., 45.

323 Opening night was a big success: John Wilcock, "400 in a 'High' School of Music and Art," East Village Other, April 15–May 1, 1966.

324 *The story, which appeared the following Monday*: Marilyn Bender, "Black Jeans to Go Dancing at the Movies: It's Inevitable," *New York Times*, April 11, 1966, 44.

324 A college newspaper, *The Columbia Spectator*: Mitch Susskind and Leslie Gottesman, "Keep Your Cool," *Columbia Daily Spectator*, April 27, 1966.

325 *The poet was in tiptop rhetorical form*: Dennis D'Andrea and Gary Quien, "Popsters and Poets Take Trip to Andy Warhol's Disco-Flicks," *Washington Square Journal*, April 7, 1966.

325 *It may have been shortly after this*: Bockris and Malanga, *Uptight*, 54.

325 *"I don't understand this at all"*: Watson, *Factory Made*, 275.

326 *In one of the July 30, 1965 tapes*: Audiotape library, AWMA.

328 *It was a deeply cynical if sincerely held view*: Robert Pincus-Witten, "Andy Warhol," *Artforum*, June 1966, 52–53.

328 *Even Pincus-Witten found the clouds*: Ibid.

329 *"the Most Famous Artist," in Calvin Tomkins's term*: Calvin Tomkins, "The Fame Factory," *New Yorker*, December 12, 1997, 97–99.

329 *As Dolph recalled*: Norman Dolph interviewed by Steven Watson, February 14, 2001.

330 *"one of the finest rock debut albums ever"*: David Fricke, essay to *Peel Slowly and See* (5 CDs, PolyGram Records, 1995), 19.

331 *When the Scepter sessions were finished*: Watson, *Factory Made*, 276.

322 *According to Bourdon, Sonny and Cher walked out*: May 6, 1966 memo from DB to his *Life* magazine editors, Bourdon Papers, AAA.

332 *The Los Angeles Times by no means disapproved*: Kevin Thomas, "A Far-Out Night with Andy Warhol," *Los Angeles Times*, May 5, 1966.

332 *Paul Jay Robbins saw it as*: Paul Jay Robbins, "Andy Warhol and the Night on Fire," *Los Angeles Free Press*, May 13, 1966.

333 *"Our pale skin and black clothes"*: Woronov, *Swimming Underground*, 39.

333 *"there wasn't much partying"*: Bockris and Malanga, *Uptight*, 63–64.

334 *The San Francisco rock impresario*: Warhol and Hackett, *POPism*, 168.

334 *"We said, 'That's not a light show,'"*: Bockris and Malanga, *Uptight*, 67.

334 *But Graham was eager enough*: Ibid., 170.

334 *whose leader, Frank Zappa, reportedly announced onstage*: Watson, *Factory Made*, 286.

334 *writing two years later*: A. D. Coleman, ibid.

335 *"they scared the fucking socks off everybody"*: Watson, ibid.

336 *where Nico had been hired*: "Let Yourself A Go Go! Pop Into Channel 7's 'Pop Art Theater'": WNAC-TV press release, June 2, 1966, AWMA, Time Capsule 32.

337 *"You're on a temporary basis"*: Bockris and Malanga, *Uptight*, 69.

337 *"Lou was always nice like that"*: Ibid.

337 *The influential showbiz weekly called the show*: "Warhol's 'Exploding' Show Stirs Psychosis in Chi's Offbeat Poor Richard's," *Variety*, June 29, 1966.

338 *The notebooks Danny Williams kept*: Courtesy of Esther Williams.

342 *In a four-reel sequence shot at George Plimpton's*: Debra Miller, *Billy Name: Stills from the Warhol Films* (Munich: Prestel-Verlag, 1994), 76.

343 *Three color sequences were probably shot*: Dating based on Gerard Malanga's diary comment: "Saw new film, *Their Town*, on Aug 8." *Their Town* used the same lighting setup as the Eric Emerson and Nico footage.

344 *Malanga phrased things more generously*: Susan Pile and Joel Klaperman, eds., "Everything Happens: A Discussion at Andy Warhol's Factory," *King's Crown Essays* (a Columbia University student journal), Spring 1967, 33–45.

344 *"the well-known West 23rd Street hostel for bohemians"*: Vincent Canby, "Chelsea Girls in Midtown Test; Warhol 'Underground' Film Gets Commercial Booking," December 1, 1966, 56.

345 *The Chelsea Girls' earliest viewers*: There were other differences between early versions of *The Chelsea Girls* and its subsequent incarnation. According to at least one source, the two-projector film *The Bed* was at one point part of *The Chelsea Girls*. Eric Emerson's almost certainly acid-inspired monologue may originally have been two reels, not one. Also missing from the original lineup were two Nico scenes that have since become part of the standard version: "The Duchess," Brigid's tour de force (a strange omission, given its outrageousness and Andy's urge to shock), and Tavel's serial murder vignette, "Their Town." What's more, if John Giorno is to be believed, William Burroughs almost became part of *The Chelsea Girls*. That summer, Giorno recalled, "someone from the Factory called and said, 'Can't you get William to be in one of our movies?'" The author of *Naked Lunch*, with whom Giorno had become close, "would have been a great character in *The Chelsea Girls*," said Giorno, who, still smarting from Warhol's loss of romantic interest in him, didn't bother to follow up.

345 *According to Bob Cowan*: Cowan, "My Life and Times with the Chelsea Girls," *Take One*, September–October 1971, 13.

347 *The two weeks netted Andy $339.18*: Film-Makers Distribution Center accounting to Warhol, letter from Louis Brigante, FDC director, September 6, 1966, AWMA.

347 *According to observers*: Information for passage on Danny Williams's apparent suicide drawn from the following sources: Interview with Esther Robinson, May 5, 2004; Logan Smiley letter to Nadia Williams, October 8, 1966, and Nadia Williams letter to Logan Smiley, from Esther Robinson's papers; Gerard Malanga's 1966 diary, Gerard Malanga Papers, Harry Ransom Center for Humanities Research, University of Texas, Austin, Texas; "Rockport Film Editor Missing," Boston *Record American*, August

2, 1966; "Rockport Man Missing; Parents Ask for Help," Gloucester *Daily Times*, Monday, August 1, 1966.

348 *Danny had drowned, she believed*: Nadia Williams to Andy Warhol, September 1, 1966, AWMA.

349 *According to Toby Mussman, critic at large*: Toby Mussman, "The Chelsea Girls," *Film Culture* # 45, Summer 1967, Special Warhol Issue, 42. Originally published in *Artforum*, January 1967.

349 *In the magazine's November 14, 1966, issue*: Jack Kroll, "Underground in Hell," *Newsweek*, November 14, 1966, 109.

350 *Elenore Lester, in a* New York Times *article*: Lester, "So He Stopped Painting Brillo Boxes."

356 *A half-dozen years after* The Chelsea Girls *was made*: This analysis owes much to Stephen Koch, *Stargazer: The Life, World and Films of Andy Warhol*, rev. ed. (New York: Marion Boyars, 1991), 94–97.

359 *When Warhol, Nico, Morrissey, and Ultra Violet*: Richard Ogar, "Warhol Mind Warp," *Berkeley Barb*, September 1–7, 1967, 7–10.

360 *More astute commentators on Warhol's films*: Parker Tyler, *Underground Film: A Critical History* (New York: Da Capo, 1995), 200–201.

360 *But most critics lacked Tyler's patience*: Bosley Crowther, "The Underground Overflows," Arts and Leisure, *New York Times*, December 11, 1966.

360 *"a very dirty and a very dull peep show"*: "Nuts from Underground," *Time*, December 30, 1966, 37.

360 *The* Voice's *Andrew Sarris pointed out*: Andrew Sarris, "Films," *Village Voice*, December 15, 1966, 33.

360 *On December 1, in a* New York Times *story*: Vincent Canby, "'Chelsea Girls' in Midtown Test," *New York Times*, December 1, 1966, 56.

CHAPTER 8: 1967

Interviews: John Cale; John Chamberlain; Ronnie Cutrone; Michael Egan; Sam Green; Pat Hackett (June 9, 2003); Gerard Malanga; Allen Midgette; Billy Name; John Richardson; Carolee Schneeman (March 1, 2003); Mary Woronov.

363 *On a Sunday morning in December 1967*: Guy Flatley, "How to Become a Superstar—And Get Paid, Too," Arts and Leisure, *New York Times*, December 31, 1967.

363 *In its first four weeks*: Vincent Canby, "Coast Will See Warhol's Film," *New York Times*, January 19, 1967, 35.

364 Newsweek, *in its February 13 issue*: Jack Kroll, "Up from Underground," *Newsweek*, February 13, 1967, 117–19.

364 *"After five years of lurid reports"*: "Art of Light and Lunacy," *Time*, February 15, 1967, 94.

364 *"With that one blow the barricades fell"*: Ibid.

364 Time *singled out Mekas*: Ibid.

364 *An internal* Time *memo*: Jim Broadhead, New York Bureau, to Time Cinema, "The New Cinema—Add," January 31, 1967. Bourdon Papers, AAA.

365 *"It will run a year!"*: Vincent Canby, "Coast Will See Warhol's Film."

365 *It grossed $130,000*: Vincent Canby, "Cannes Will See Warhol Picture," *New York Times*, April 25, 1967, 37.

365 *By the end of April*: " 'Chelsea Girls' Film Is Seized in Boston by Vice Detectives," *New York Times*, May 31, 1967, 50.

365 *On January 14, Leonard Lyons reported*: Leonard Lyons, *The Lyons Den*, "Robert Scull and Al Crown Have a Co-production Deal," *New York Post*, January 16, 1967, 43.

365 *Katz's letter went on at length*: S. Edward Katz, April 14, 1967 letter to Herbert Schrank, Esq., AWMA, Time Capsule 11. S. Edward Katz, January 24, 1967, letter to Kenneth J. Robinson, Esq., AWMA.

366 *According to Andy's friend Nelson Lyon*: Unpublished transcript, Nelson Lyon interviewed by Steven Watson, November 6, 1999, shared with TS.

366 *"he greased his hair"*: Warhol and Hackett, *POPism* (New York: Harcourt Brace Jovanovich, 1980), 210.

366 *Throughout the European trip*: AWMA.

367 *her most remarkable gift*: Bourdon, *Andy Warhol*, 258.

367 *"She'd tell journalists"*: Warhol and Hackett, *POPism*, 211.

367 *Evidently afraid of attracting a flock*: David Bourdon, *Andy Warhol* (New York: Abrams, 1989), 256.

367 Variety *reported his annoyance*: "Chelsea Girls Draws Cannes Snub," *Variety*, May 17, 1967.

367 *Meeting Brigitte Bardot*: Ibid.

368 *The best estimate*: Grace Glueck, "Warhol Unveils * of '****' Film," *New York Times*, July 8, 1967, 15.

368 *Andy himself—if one can believe him*: from an unpublished interview with Andy Warhol, September 30, 1967, Time. Inc Archive.

368 *Andy Warhol Enterprises*: Tax returns for 1967 from Andy Warhol and Andy Warhol Enterprises, AWMA.

368 *A newer business entity*: Checking and deposit statements for Andy Warhol Films, 1967, AWMA; same source for stock portfolio figures.

369 *"The actors are simply his friends"*: Vincent Canby, " 'Chelsea Girls' in Midtown Test," *New York Times*, December 1, 1966, 56.

369 *Even Ondine, who'd always made clear his unconcern*: Robert Olivo, March 16, 1967 letter to Andy Warhol and S. Edward Katz, Esq., AWMA.

370 *Serving Andy with a complaint*: "Alfred W. Emerson plaintiff against Andy Warhol, etc.," Time Capsule 36, AWMA.

371 *On March 27, Andy filed a counterbrief*: Ibid.

372 As the Times reported: Flatley, "How to Become a Superstar," 57.

372 Starting in autumn 1966: Warhol and Hackett, POPism, 185.

372 after what he referred to as a "nervous breakdown": Ron Sukenick, Down and In: Life in the Underground (New York: Beech Tree Books, 1987), 202.

372 "I'd give him a painting": Warhol and Hackett, POPism, 187.

372 Warhol also paid cash: AWMA.

373 The macho Abstract Expressionists: Steven Watson, Factory Made (New York: Pantheon, 2003), 319.

373 "the royal court of screaming assholes": Mary Woronov, Swimming Underground: My Years in the Warhol Factory (Boston: Journey Editions, 1995), 178.

373 Max's became a Factory hangout: Watson, Factory Made, 391–92.

374 On February 9, 1967: Village Voice advertisement, February 9, 1967, 24.

374 Solanas scorned most "women's libbers": Valerie Solanas, THE SCUM Manifesto (Edinburgh: AK Press, 1996). All subsequent SCUM Manifesto quotations are from this source.

375 according to her sister: Watson, Factory Made, 35.

375 On April 21, Valerie ran her first: Watson, Factory Made, 325.

375 "That's the only use men are": Robert Marmorstein, "A Winter Memory of Valerie Solanis [sic], " Village Voice, June 13, 1968, 9–10, 20.

375 Some time that spring: Ibid.

376 "Maybe you know some girls": "Valerie Solanis [sic] Interviews Andy," 27, AWMA.

376 She'd already been pelting the Factory: Watson, Factory Made, 325.

376 In mid-1967 Solanas met Maurice Girodias: Ibid., 333.

376 Like Solanas a resident of the Chelsea Hotel: Stephanie Harrington, "The Sex Explosion: A Defeat in Victory," Village Voice, May 4, 1967, 5.

376 Moving to New York in 1966: Biographical information on Valerie Solanas in these two paragraphs comes from Watson, Factory Made, 333–352.

377 "ANDY WARHOL" typed over and over: Shades of the horrifying scene in Stanley Kubrick's The Shining, where Wendy Torrance, looking through her writer husband's "manuscript," realizes that he is insane.

377 As the tape starts to roll: "Valerie Solanis [sic] Interviews Andy," 1, AWMA.

377 "Andy seems not to stop shooting": Susan Pile and Joel Klaperman, eds., "Everything Happens: A Discussion at Andy Warhol's Factory," King's Crown Essays (a Columbia University student journal), Spring 1967.

378 On January 15, the New York Times reported: Grace Glueck, "Mainlined," Arts and Leisure, New York Times, January 15, 1967.

379 Malanga mentioned that Andy was now planning: Pile and Klaperman, eds., "Everything Happens," 33.

379 The New York Times mentioned: Vincent Canby, "Cannes Will See Warhol Picture," New York Times, April 25, 1967, 37.

379 On April 26, the Washington Post: "Andy Warhol's Innocents Chat About Movies," *Washington Post*, April 27, 1967, K2.

381 In the end there was only one: Vincent Canby, "Burgeoning Underground Adds 2 Cinemas," *New York Times*, August 2, 1967, 28.

381 followed by a two-week run: A second full-length showing of **** at the Museum of Contemporary Art in Chicago, scheduled for January 5, 1968, was canceled by the museum.

381 "Baby, we were stultified": Howard Thompson, "Film: For Andy's Hardiest," *New York Times*, December 17, 1967, 94.

381 The Post's Frances Herridge: Frances Herridge, "More Warhol at the New Cinema," *New York Post*, December 18, 1967, 23.

381 Ever-anomalous Variety: Byro, "Four Stars," *Variety*, December 27, 1967.

381 The alternative press was predictably ecstatic: Jonas Mekas, *Movie Journal: The Rise of a New American Cinema, 1959–1971* (New York: Macmillan, 1972), 304.

381 Another Voice review: Lorenzo Mans, "Speak Out the Arts," "Long Day's Journey into Night," *Village Voice*, January 1, 1968, 36. .

382 To him it was "Great!": *Village Voice*, December 20, 1967.

382 In early summer 1967: Paul Morrissey, interview by John Wilcock, in John Wilcock, *The Autobiography and Sex Life of Andy Warhol* (New York: Other Scenes, 1971).

382 The Times's Crowther considered it: Bosley Crowther, "Screen: 'My Hustler' Opens at Hudson," *New York Times*, July 11, 1967, 29.

383 "a sleazy bit of Swedish pornography": *Time*, "Stealing the Skin Show," September 15, 1967, 101.

383 "casual nudity": The term is Bourdon's; see *Andy Warhol*, 256.

384 Nelson Lyon recalled how Warhol peppered a scene: Nelson Lyon, interview by Steven Watson, November 6, 1999, shared with TS.

384 I, A Man looked "like just another": *Time*, "Stealing the Skin Show."

385 "one of the artist's most mediocre productions": Bourdon, *Andy Warhol*, 257.

385 Responding to her endless requests: Watson, *Factory Made*, 339.

385 Though "there is more display of bosoms: "Stealing the Skin Show," *Time*.

386 "these people addicted to the amphetamine": Paul Morrissey, interview by John Wilcock.

386 When business for I, A Man began to slacken: Account follows Watson, *Factory Made*, 339–40.

386 To David Bourdon he was "doltish": Bourdon, *Andy Warhol*, 260.

386 originally to be called Dope: Rosalyn Regelson, "Where Are 'The Chelsea Girls' Taking Us?" Arts and Leisure, *New York Times*, September 24, 1967.

387 two gay boutique clerks "fluttering": The term is Bourdon's; see *Andy Warhol*, 261.

387 *It was panned by the* New York Post: Archer Winsten, "Warhol's 'Bike Boy' At Hudson," *New York Post*, October 6, 1967, 65.

387 *"Andy Warhol is back with another of those super-bores"*: Howard Thompson, "More Warhol: 'Bike Boy' Opens at the Hudson Theater," *New York Times*, October 6, 1967, 31.

387 *failing to turn a profit*: According to a barbed November 22, 1967, letter from attorney Stephen H. Gross, presumably Maurer's, to Thomas Pozin, one of Warhol's attorneys.

387 *"There were a few chuckles"*: "Tonguetied Warhol in Weird Midnight Rally; 'Bike Boy' as Parsifal," *Variety*, November 8, 1967, 17.

387 *Andy's "unashamed nudes, swishy wit"*: Thomas Waugh, "Cockteaser," in Jennifer Doyle et al., eds., *Pop Out: Queer Warhol* (Durham, NC: Duke University Press, 1996), 72.

387 *"Most of our audiences . . . are degenerates"*: Interviews with Paul Morrissey and Joe d'Alessandro in Tony Rayns, "Andy Warhol Films, Inc.: Communication in Action," *Cinema*, no. 6–7 (August 1970): 42–47.

388 *Though it may have been screened*: Debra Miller, *Billy Name: Stills from the Warhol Films* (Munich: Prestel-Verlag, 1994), 124.

389 *impressed Morrissey so much he called her*: Watson, *Factory Made*, 339.

389 *"the nuns had me from five to twenty-one"*: Viva, interview by David Bourdon, Bourdon Papers, AAA.

390 *"Jane Holzer had big hair"*: Watson, *Factory Made*, 345.

390 *"You don't edit anybody"*: "Valerie Solanis [*sic*] Interviews Andy," 33, AWMA.

390 *"Because he was so shy"*: Viva, "Viva and God," *Village Voice, Art Supplement*, May 5, 1987, 8–9.

390 *"the first theatrical feature"*: "Warhol's 'Blue Movie' The Bluest of 'Em All, If and When Released," *Variety*, June 18, 1969. (In fact, *Blue Movie* was neither the first, nor even Warhol's first, to depict intercourse. *Couch*, filmed in July 1964, its centerpiece the Factory's infamously ratty sofa, was far more graphic. It premiered at the Filmmakers' Cinematheque in April 1966.)

390 *giving herself raves*: Bourdon, *Andy Warhol*, 260.

391 *"equal in a way that the rest of us were not"*: Bob Colacello, *Holy Terror* (New York: HarperCollins, 1990), 90–92.

391 *"Please introduce me to Andy Warhol"*: Fred Hughes, interview by David Bourdon, 1987, Bourdon Papers, AAA.

391 *"Hughes's own account of the meeting"*: Carol Vogel, "Frederick Hughes, Collector and Warhol's Manager, 57," *New York Times*, January 16, 2001, 21.

391 *As a fifteen-year-old*: Biographical information on Hughes from Bourdon interview.

391 *"instinct for what was important"*: Steven Aronson article on Hughes, *Vanity Fair*, quoted in Colacello, *Holy Terror*, 93.

392 *"Being attached to the de Menils"*: Ibid., 94.

392 *"Fred suggested $20,000"*: John de Menil letter to Warhol, June 26, 1967, Time Capsule 41, AWMA.

392 *According to Hughes*: Colacello, *Holy Terror*, 94.

393 *commission to paint Dominique herself*: Georg Frei and Neil Printz, eds., *The Andy Warhol Catalogue Raisonné*, vol. 2B, 386.

393 *pretending to be "Frederick of Union Square"*: Colacello, *Holy Terror*, 116.

393 *Anyone who "upsets the trustees"*: Natalie Gittelson, "No Business Like Lecture Business," *New York Times Magazine*, June 9, 1968. Because of the magazine's ten-day lead time, the article, which dwelt at length on Warhol, closed a few days before his shooting and thus ironically appeared six days after it.

394 *The American Program Bureau approached Andy*: A check from "American Programs, Boston" was deposited in the Andy Warhol Films account on April 26, 1967, AWMA.

394 *offering him between $750 and $1,500*: The $750 figure comes from a June 27 contract drawn up by Walker for an October appearance by Andy Warhol at Drew University in Madison, New Jersey, AWMA; the $1,500 figure comes from Watson, *Factory Made*, 348.

394 *Buying the palest shade of Erase*: Watson, *Factory Made*, 348.

395 *On November 2, as Midgette and Morrissey climbed off the plane*: Bourdon, *Andy Warhol*, 268.

396 *"We are at a loss"*: Morrissey letter at AWMA, Time Capsule 11.

396 *The closest Andy came to admitting the ruse*: Andy Warhol's Index Book (New York: Random House, 1967).

397 *In Gerard's first letter back*: All correspondence from Malanga, in this chapter and next, Harry Ransom Center for Humanities Research, University of Texas, Austin, Texas.

398 *Directly, Gerard mailed Andy*: Gerard Malanga, interview by David Bourdon, 1968, Bourdon Papers, AAA.

399 *"the happiest war toy of them all"*: The article containing the contest announcement, Ralph Schoenstein, "Come Bomb with Me," *New York*, January 22, 1967, is quoted in Frei and Printz, *The Andy Warhol Catalogue Raisonné*, vol. 2B, 279.

399 *"It's so beautiful I couldn't ruin it"*: Ibid. Frei and Printz cite an undated 1980s article in *Brooklyn Courier-Life*, "The Day Andy Warhol's Bomb Came to Brooklyn," for the winner's memories of his Factory visit.

399 *they'd been sitting around the Factory*: Ibid., 280.

400 *Andy and the YMHA each got a letter*: Letter from John D. Goodloe, Coca-Cola, Inc.'s counsel, May 18, 1967, Time Capsule 10, AWMA, which contains another letter from Goodloe, June 16, 1967, that asks why neither Warhol nor the YMHA have responded. One wonders, incidentally, why Coca-Cola hadn't been upset by Andy's 1961–1962 Coca-Cola paintings.

401 *"I do know it would be out of character"*: Janis donated *Seven Decades of Janis* to the Museum of Modern Art for its Sidney and Harriet Janis Collection. See Janis's letter to Warhol, December 27, 1967, Time Capsule 2, AWMA; "any other canvas in the collection" presumably refers to MOMA's Janis collection.

401 *Judging by a mid-1968 Chase Manhattan bank statement*: "Checking Account Balance Confirmation" sent to Factory Additions by Chase Manhattan, June 5, 1968, AWMA.

402 *Both issues lent themselves*: This point is well made in Wendy Weitman, *Pop Impressions Europe/USA* (New York: Museum of Modern Art, 1999), 22.

402 *A look through Warhol's 1967 financial documents*: All financial information in these two pages, AWMA.

403 *A taped 1965 exchange*: Audiotape library, AWMA.

403 *"Our small circle had expanded"*: Warhol and Hackett, *POPism*, 237.

403 *Further upending everybody's equilibrium*: AWMA, Time Capsule 39: lease termination, September 27, 1967.

CHAPTER 9: 1968

Interviews: Denton Cox; Ronnie Cutrone; Gene Feist; John Gruen; Gerard Malanga; Allen Midgette; Paul Morrissey; Billy Name; Barbara Rose; Christopher Scott; Stephen Shore; William Wilson.

405 *"We're in show business now"*: Bourdon Papers, AAA.

406 *In June, Warhol announced*: *Jaguar* Magazine, June 1968, 40.

406 *"This very gifted man"*: Stephen Koch, *Stargazer: The Life, World and Films of Andy Warhol*, rev. ed. (New York: Marion Boyers, 1991), 106.

406 *An actual treatment*: The account of the filming of *Lonesome Cowboys* draws heavily on David Bourdon, *Andy Warhol* (New York: Abrams, 1989), 269–277, and Bourdon's notes on the film, Bourdon Papers, AAA.

407 *"Now that everybody's here"*: Steven Watson, *Factory Made* (New York: Pantheon, 2003), 369.

409 *While the improvisations in such previous Warhol vehicles*: Vincent Canby, "Lonesome Warhol," *The New York Times*, May 6, 1969, 38.

410 *"The plot hardly works"*: Neal Weaver, *After Dark*, June 1969, 58.

410 *"The undisciplined narcissism"*: Andrew Sarris, "Westward Ho-Ho with Warhol," *Village Voice*, May 8, 1969, 47.

411 *"I hate art"*: Bourdon Papers, AAA.

411 *"Whether he knew it or not"*: Koch, *Stargazer*, 104.

411 *Billy Name and Paul Morrissey set out*: Watson, *Factory Made*, 371.

411 *The move took place*: Billy Name's 1968 date book, AWMA.

412 *For Warhol's first overseas retrospective*: All information on the Moderna Museet exhibition, including critics' quotes, is from a February 20, 1968 memo, "Moderna Museet, Warhol and Hulten Take One," sent by Mary

Johnson, *Time*'s Stockholm correspondent, to *"Time* Art." Bourdon Papers, AAA.

413 *Billy's photographs became:* Dave Hickey, "Naming the Colors," in Billy Name, *All Tomorrow's Parties* (New York: D.A.P., 1997), 10.

414 *On January 29, an abject-sounding Malanga:* Correspondence between Malanga to Warhol and Morrissey, winter 1967 to spring 1968, the Ransom Center, Austin, Texas.

415 *"Who cares?" responded Andy:* Source for following three paragraphs is David Bourdon notes, Bourdon Papers, AAA.

415 *The letter went on:* This and all other correspondence from Malanga in this chapter comes from the Ransom Center.

417 *Deciding to pursue the story:* Don Bischoff, "Andy Warhol or Someone Gives a Non-Lecture Tour," *New York Post,* February 8, 1968, 55.

417 *On February 12, accompanied by Bourdon:* Warhol, Morrissey, and Viva quotes from college tour from David Bourdon notes, Bourdon Papers, AAA.

419 *"endlessly rearranged themselves":* Bourdon, *Andy Warhol,* 228.

419 *"The smart place to be in New York":* Clive Barnes, "Cunningham Finally Makes It," *New York Times,* May 16, 1968, 51.

420 *Valerie Solanas was getting to be:* Watson, *Factory Made,* 352–53.

423 *"The door opened on madness":* Al Hansen, "Fragments from a Space Time Journal," *Fragments* No. 1, Fall 1968.

424 *In another part of town:* Account of Valerie Solanas turning herself in comes from Howard Smith, *Village Voice,* June 6, 1968, 54.

425 *At 9:35 p.m.:* Bourdon, *Andy Warhol,* 54.

426 *"Warhol Shot, Seriously Wounded":* Richard F. Shepard, "Warhol Gravely Wounded in Studio," *New York Times,* June 4, 1968, 1.

426 *"Andy Warhol Fighting for Life":* *New York Post,* June 4, 1968, 3.

426 *"To the extent that Warhol's art":* Piri Halasz, *Time* Magazine memo, June 14, 1968, David Bourdon Papers, AAA.

427 *On June 13, two members:* Marylin Bender, "Valeria Solanis [sic] a Heroine to Feminists," *New York Times,* June 14, 1968, 52.

427 *Walking upstairs, Andy had to pause:* Letter from Paul Warhola, Jr. to David Bourdon, in Bourdon, *Andy Warhol,* 290.

427 *"When he telephoned me":* Bourdon, *Andy Warhol,* 7.

428 *Valerie Solanas was sent first:* Biographical information on Solanas from Watson, *Factory Made,* 425.

428 *"You get less time":* "You get less time for stealing a car" from "Hello It's Me," *Songs for Drella,* a 14-song cycle written and performed by Lou Reed and John Cale. Commissioned by the Brooklyn Academy of Music and the Arts at St. Ann's at St. Ann's Church, Brooklyn. *Songs for Drella* is, according to Reed, "a brief musical look at the life of Andy Warhol." Cale and Reed

performed it on January 9, 1989, at St. Ann's and on November 29–30 and December 2–3 at BAM, and co-produced it as a 1990 Sire Records album.

428 *"I didn't intend to kill him"*: "Actress Gets Three Years in Warhol Shooting," *New York Daily News*, June 10, 1969.

428 *Ten years after the shooting*: Douglas Kellner, ed., *Emile de Antonio's Painters Painting: A CD-Rom by Mann*, Voyage, 1998.

429 *In 1988, the year after Andy died*: Henry Geldzahler, "Billy Linich and His Silver Trunk," unpublished text of a 1988 talk delivered at the Vassar College Art Gallery, Geldzahler Papers, Beinecke Library.

430 *Andy described the shooting*: Letitia Kent, "Andy Warhol 'I Thought Everyone Was Kidding,'" *Village Voice*, September 12, 1968; also Andy Warhol and Pat Hackett, *POPism* (New York: Harcourt Brace Jovanovich, 1980), 274.

EPILOGUE

Interviews: Ivan Karp.

431 *Henry Geldzahler once came up with*: Andy Warhol and Pat Hackett, *POPism* (New York: Harcourt Brace Jovanovich, 1980), 3.

431 *"I just paint things"*: "The Slice of Cake School," *Time*, May 11, 1962, 52.

432 *Moved as he was*: Michael Fried, "New York Letter," *Art International* 6, no. 10 (December 1962): 57.

432 *"the best thing he ever made"*: Dave Hickey, "Naming the Colors," in *All Tomorrow's Parties*, 11.

433 *One morning in the spring of 1970*: Warhol and Hackett, *POPism*, 300.

433 *Andy had Vincent Fremont change the locks*: Bob Colacello, *Holy Terror* (New York: HarperCollins, 1990), 60.

433 *"The wit of the old subterranean decadence"*: Stephen Koch, "The Once-Whirling Other World of Andy Warhol," *Saturday Review* 22 (September 1973): 20–24.

434 *"saw the old superstars as annoying bores"*: Colacello, *Holy Terror*, 68.

434 *"I guess if I thought I were really good"*: Pat Hackett, ed., *The Andy Warhol Diaries* (New York: Warner Books, 1989), 33.

434 *"he would sometimes look at us all"*: Colacello, *Holy Terror*, 68.

434 *After the move, the new Factory letterhead*: Ibid., 60.

434 *"In a few years," writes Colacello*: Ibid., 95.

435 *in 1970, Campbell's Soup Can with Peeling Label*: "Warhol's Soup Can Sells for $60,000," *New York Times*, May 16, 1970.

435 *From a mere dozen or so commissions in 1970*: Colacello, *Holy Terror*, 89.

435 *A mid-seventies portrait cost $25,000*: Ibid., 95.

435 *One client, Denver businessman John Powers*: Ibid., 89.

435 *For the rest of his life he churned out*: Wayne Koestenbaum, *Andy Warhol*, (New York: Viking, 2001), 168.

435 *In all, he handled more than a thousand commissions*: Colacello, *Holy Terror*, 89.

435 *Liz had become his bosom buddy*: Ibid., 152.

435 *"Plucked from the bottom"*: Peter Schjeldahl, "Warhol and Class Content," *The Hydrogen Jukebox: Selected Writing of Peter Schjeldahl, 1978–1990* (Berkeley: University of California Press, 1991), 48.

436 *The commissioned portraits' aim*: Henry Geldzahler, "Andy Warhol, Virginal Voyeur," *Making It New* (New York: Turtle Point Press, 1994), 368.

436 *he snapped his own Polaroids*: Vincent Fremont, "Sometime Around 1970, Andy Warhol Bought a Polaroid Big Shot Camera," *Andy Warhol Photography* (Hamburg and Pittsburgh: Edition Stemmle, 1999), 157–60.

436 *Early in Andy's Pop career*: David Bourdon, "Andy Warhol and the Society Icon," *Art in America*, January–February 1975, 42–45.

437 *Reviewing the 1979 Whitney exhibition*: Robert Hughes, "Mirror, Mirror on the Wall," *Time*, December 3, 1979.

437 *The Atlantic's more sophisticated Sanford Schwartz*: Sanford Schwartz, "Andy Warhol the Painter," *Atlantic Monthly*, August 1989, 73–77.

437 *He was just a working artist*: Robert Rosenblum, "Andy Warhol: Court Painter to the 70s," *Modern American Art: Selected Essays* (New York: Abrams, 1999), 205–15.

437 *The endless art he made*: Koestenbaum, *Andy Warhol*, 159.

438 *"These pieces," wrote Peter Schjeldahl*: Peter Schjeldahl, "Warhol in Bloom," *New Yorker*, March 11, 2002, 82–84.

438 *"Andy would go to the opening of a drawer"*: Michiko Kakutani, "The United States of Andy Warhol," *New York Times Magazine*, November 17, 1996.

438 *"How decisive a break with tradition"*: Peter Schjeldahl, "Warhol in Bloom," 83.

438 *"Warhol's great moment was brief"*: Peter Schjeldahl, "Barbarians at the Gate," *New Yorker*, May 15, 2000, 102–4.

INDEX

Page numbers in *italics* refer to illustrations.

ILLUSTRATION CREDITS

Grateful acknowledgment is made to the following for
permission to reproduce illustrations in the text:

—Pages 2, 5, 335, 395, 440: Collection of the Andy Warhol Museum, Pittsburgh.
—Page 14: Andy Warhol, *Women and Produce Truck*, 1946. © 2009 The Andy Warhol
Foundation for the Visual Arts, Inc./Artists Rights Society (ARS), New York. Collec-
tion of the Andy Warhol Museum, Pittsburgh.
—Page 15: *At the Met*, 1953. Collection of the Andy Warhol Museum, Pittsburgh. Photo
© Leila Davies Singelis.
—Page 37: W. Silver—photographer. Courtesy of the Rudi Blesh papers, 1909–1983,
Archives of American Art, Smithsonian Institution.
—Page 43: From the collections of the Wisconsin Center for Film and Theater Research
(negative 10651mp).
—Page 48: Robert Caplin/The *New York Times*/Redux.
—Pages 54, 170, 197, 324: Fred W. McDarrah/Getty Images.
—Page 63: Photographer unknown.
—Page 69: Photo by John Ardoin. Courtesy of Serendipity 3.
—Pages 81, 204, 276, 299, 361, 383, 390: © Billy Name/Ovoworks.
—Page 98: © James Rosenquist/Licensed by VAGA, New York.
—Page 99: John Loengard/Getty Images.
—Page 112: Andy Warhol, *Double Mona Lisa*, 1963. © 2009 The Andy Warhol Founda-
tion for the Visual Arts/ARS, New York. Photo credit: The Andy Warhol Foundation,
Inc./Art Resource, New York.
—Page 119: © Steve Schapiro.
—Pages 152, 184, 201, 268, 290, 343: © Stephen Shore.
—Page 177: Andy Warhol, *Tarzan and Jane Regained . . . Sort of*, 1963. 16mm film, black-

ABOUT THE AUTHORS

TONY SCHERMAN is the author of *Backbeat: Earl Palmer's Story*, which won a 2000 ASCAP Deems Taylor Award for excellence in music writing. He was an editor at *Musician* and *Audio* and a contributing editor at *Life*; and he has written about art, music, American history, and American culture for dozens of publications, including the *New York Times Magazine*, the *New York Times* Arts and Leisure section, *Atlantic Monthly*, *Rolling Stone*, *Smithsonian*, *American Heritage*, *New York*, *Entertainment Weekly*, and *People*. He was awarded a National Endowment for the Humanities Fellowship in 1997. A magazine article he wrote that year about the poet-activist-professor Melvin Tolson was the basis for the 2007 Denzel Washington film *The Great Debaters*. He has two daughters and lives in Rockland County, New York.

As teenagers DAVID DALTON and his sister Sarah were assistants on Andy Warhol's early Pop art paintings; Sarah also helped Warhol edit his first film, *Sleep*. Together Dalton and Warhol designed and edited the legendary *Aspen* magazine. Dalton has written extensively on art, including *A Year in the Life of Andy Warhol* (with photographs by David McCabe); *Andy Warhol: Giant Size* (two essays on the origins of Warhol's art); and *Painting Below Zero: Notes on a Life in Art*, the memoir of James Rosenquist. A founding editor of *Rolling Stone* and a writer on pop culture, Dalton is the author of some fifteen books, including *El Sid: Saint Vicious*; *Mr. Mojo Risin': Jim Morrison, the Last Holy Fool*; *James Dean: The Mutant King*; the award-winning *Faithfull* (with Marianne Faithfull); and a novel, *Been Here and Gone*. He lives in upstate New York with his wife, the painter Coco Pekelis.